Muqarnas

Muqarnas

Editor:
Gülru Necipoğlu

Founding Editor:
Oleg Grabar

Managing Editor:
Karen A. Leal

Consulting Editors:
Peri Bearman
András Riedlmayer

Imaging Consultant:
Sharon C. Smith

www.brill.com/muq

Muqarnas

An Annual on the Visual Cultures of the Islamic World

Celebrating Thirty Years of Muqarnas

Editor

Gülru Necipoğlu

Managing Editor

Karen A. Leal

VOLUME 30

Sponsored by
The Aga Khan Program for Islamic Architecture
at Harvard University and the Massachusetts Institute
of Technology, Cambridge, Massachusetts

BRILL

LEIDEN · BOSTON
2013

This paperback was originally published in hardback under ISBN 978-90-04-25576-0

Notes to Contributors: *Muqarnas* will consider for publication articles on all aspects of Islamic visual cultures, historical and contemporary. Articles submitted for publication are subject to review by the editors and/or outside readers. Manuscripts should be no more than 50 double-spaced typed pages of text (not including endnotes) and have no more than 25–30 illustrations. Exceptions can be made for articles dealing with unpublished visual or textual primary sources, but if they are particularly long, they may be divided into two or more parts for publication in successive volumes.

Both text and endnotes should be double-spaced; endnotes should conform to the usage of *The Chicago Manual of Style*, 15th edition. Illustrations should be labeled and accompanied by a double-spaced caption list. Authors are responsible for obtaining permission to reproduce copyrighted illustrations and for supplying the proper credit-line information.

For the transliteration of Arabic, Persian, and Ottoman Turkish, *Muqarnas* follows the system used by the *International Journal of Middle East Studies*. All transliterated words and phrases in the text and transliterated authors' names and titles in the endnotes must follow this system. Exceptions are proper nouns (names of persons, dynasties, and places) and Arabic words that have entered the English language and have generally recognized English forms (e.g., madrasa, iwan, mihrab, Abbasid, Muhammad); these should be anglicized and not italicized. Place names and names of historical personages with no English equivalent should be transliterated but, aside from ʿayn and *hamza*, diacritical marks should be omitted (e.g., Maqrizi, Fustat, Sanʿa). A detailed style sheet and further information can be obtained at http://agakhan.fas.harvard.edu (under Publications), or by writing to the Managing Editor, Aga Khan Program, Sackler Museum, Harvard University, 485 Broadway, Cambridge, MA 02138. E-mail: muqarnas@fas.harvard.edu; fax: 617-496-8389.

This publication has been typeset in the multilingual "Brill" typeface. With over 5,100 characters covering Latin, IPA, Greek, and Cyrillic, this typeface is especially suitable for use in the humanities. For more information, please see www.brill.com/brill-typeface.

ISSN 0732-2992
ISBN 978-90-04-25950-8 (paperback)
e-ISSN 2211-8993

Copyright 2013 by Koninklijke Brill NV, Leiden, The Netherlands.
Koninklijke Brill NV incorporates the imprints Brill, Brill Hes & De Graaf, Brill Nijhoff, Brill Rodopi and Hotei Publishing.

This book is printed on acid-free paper and produced in a sustainable manner.

CONTENTS

GÜLRU NECİPOĞLU

REFLECTIONS ON THIRTY YEARS OF *MUQARNAS*

In this volume marking the thirtieth anniversary of *Muqarnas*, I would like to take the opportunity to reflect on the evolution of our publications over the years. To that end, we sent the members of our Editorial and Advisory Boards a questionnaire, asking them to comment on the contributions of *Muqarnas* and its *Supplements* series to the field of Islamic art studies over the past three decades. We also asked them to provide suggestions for possible future directions, and to point out areas that may be improved in the coming years. I would like to thank the contributors, whose observations, thoughts, and hopes for *Muqarnas* have been anonymously incorporated into this foreword, which, in conversation with their comments, looks back on the history of the publication and offers some possibilities for the path it might take going forward.

When Oleg Grabar, the founding editor of *Muqarnas*, launched the journal thirty years ago, in 1983, he compared the state of the art then to thirty years earlier and proposed "some approaches to the further investigation of the history of the arts in Muslim countries." He observed in the first volume's opening essay, titled "Reflections on Islamic Art," that the field in those early years was essentially a "Western" endeavor, originating from three paths:

> Thirty years ago, the study of Islamic art was easy enough to define. Most people came to it along one of three simple paths. One was archaeology... Another was collecting...And finally there was the old and much-maligned Orientalism... Whatever the mix of these three preoccupations in any one scholar or essayist, the result was nearly always the same: the formation of a small group of practitioners with largely overlapping knowledge, asking many of the same questions, and using commonly accepted modes for exchanging information.[1]

By 1983, the growing complexity of the scholarship and the increasing cultural diversity of its practitioners held the potential to go beyond "traditional and restricted scholarship" (although that was necessary as well) and to offer "a unique opportunity to try something else, to use the more speculative and more theoretical approaches developed in other disciplines, or to develop an entirely new methodology that could eventually be translated into other fields."[2] Since the history of Islamic art was "still in its infancy," Grabar pointed out that this heady projection had to be tempered by solid empirical scholarship in order to fill in the gaping lacunae in basic documentation:

> Whole regions—Bangladesh, Malaysia, Indonesia, China, Africa—have hardly been explored. Barely half a dozen illustrated manuscripts have been published, and what we know of the processes of creation and beautification in the Islamic world since its inception is minimal. Ideologically, old notions of iconoclasm and ornament predominate and still percolate into the manuals and surveys that form the taste of the educated public. An argument can therefore be made for a massive effort to catch up with other subfields of the history of art. Monuments should be studied and published, stylistic and iconographic analyses pursued, written sources culled for information, theories and hypotheses tested and discussed.[3]

In this connection, Grabar stressed the need for a widely available journal "that would provide bibliographical, and other practical information about research and thinking in the field; and that would serve as a forum for the exchange of information and ideas about Islamic art."[4] He also underlined the importance of considering the historiography of the field: "for beyond the traditional scholarship of information, one of the objectives

of this annual is precisely to investigate and to reflect upon the attitudes that shape our understanding of Islamic art."[5]

It is worth highlighting the needs of the field that the founding editor outlined, so that readers may assess to what extent thirty years of *Muqarnas* has succeeded in meeting these goals. His essay provided a critical review of prevalent approaches in the few manuals and survey books existing at that time, on the basis of which several desiderata were charted for the future. Given that the annual was a publication of the newly established Aga Khan Program for Islamic Architecture at Harvard University and the Massachusetts Institute of Technology, a fundamental focus on architecture and the built environment was notable in Grabar's essay. Observing that greater attention had been paid in past scholarship to architecture and decoration than to the other arts, he speculated on the possible reasons for this preference:

> It is as though, at the level of what may be called universal prestige, architecture and its related techniques outrank painting, sculpture, and objects. The question is whether or not this corresponds to some profound truth about the Muslim world...Or have the historical circumstances of Islam in fact preserved something that is true of all cultures: that the built environment is consistently the most meaningful form of human creativity? Is the tendency to emphasize the artistic history of painting, sculpture, and objects an aberration of Western elites since the Renaissance and of Chinese literati?[6]

The Aga Khan Program's mission to improve contemporary architectural practice through meaningful engagement with historical models and values brought along with it an emphasis on how *Muqarnas* might bridge past and present. In addressing this concern Grabar commented on the expectations of differing audiences, ranging from modern practitioners of architecture, with their increasing demands on and expectations of the academic scholarship, to the general public:

> The past decades have sharpened and increased our understanding of much of Islamic art, but new concerns and questions, many of them raised outside the academic world, require that we pursue something beyond traditional and restricted scholarship. We must also deal with the protean complexities of the past as they merge into the present in ways that are attuned to contemporary quests.

What these might be is less clear, but I hope that *Muqarnas* can serve the two functions of scholarly accomplishment and imaginative, even speculative, discourse on the meaning of yesterday for today.[7]

Grabar aptly raised the issue of simplistic generalizations regarding Islamic art in discourses on its supposedly unchanging universal "character." Noting the "contemporary demands for a definition of Islamic forms independent of time and space," he also detected in general survey books the "lurking question" of "what is Islamic" about Islamic monuments. He furthermore commented on the issue of the relation of Islamic art to "regional, ethnic, and eventually national entities, and to characteristics that grew out of climactic conditions but which have become tied to ethnic and national identity."[8]

As a way of transcending these prevailing approaches, Grabar underlined the need to comprehend more fully the conceptualization and contextual specificities of monuments within time and space: "The study of Islamic art requires, first of all, a better understanding of what Islamic culture thought of itself and how it operated in any particular time."[9] This would become one of the main objectives of *Muqarnas*, which sought, among other things, to shed light on the underestimated complexity of Islamic art, as an antidote to its presumed "otherness" and easily digestible simplicity. The founding editor drew attention to the importance of scrutinizing primary written sources, which "have not been sufficiently used in dealing with Islamic art," and stated with conviction that the available information "does allow for greater depths of meaning than have been reached so far."[10] He also underscored another obligation of art historical research on the Islamic world, namely, cultivating the field's interdisciplinarity by setting up problems and posing questions for "cultural and literary historians."[11]

Grabar made several perceptive predictions about future trends in the field, which until then had been dominated by archaeologists and medievalists. He forecast the development of interest in later periods, with their linguistically more diverse and abundant primary sources:

> The concentration of scholarly effort on the early centuries of Islam, with its concomitant emphasis on the Arab world,

reflects in part the earlier concern of scholarship with unraveling and explaining the beginnings of Islamic culture and in part the influence of archaeology, a technique far more at ease with early monuments than with recent ones. It is unlikely that books written ten years from now will exhibit the same bias, for the present concentration of research on later times will provide better representation for the fourteenth century onward. An awareness of regional differences is also bound to develop further, if for no other reason than that the share of sources for the later periods is more evenly distributed among Arabic, Turkish (in several forms), Persian, Urdu, and Malay than it was for the first six centuries when Arabic prevailed.

He frankly admitted that our knowledge of Islamic art had been skewed by the prevalent focus on the early centuries of Islam, to the exclusion of the last three centuries:

> In the meantime, however, we have a vision of Islamic art in which the earliest monuments create the norms by which the whole artistic span is defined. This emphasis gives undue importance to the pre-Islamic origins of Islamic forms at the expense of their Islamic operation, and it implies that the contemporary world does not descend from an earlier time, but in some way still partakes of its culture.[12]

The founding editor's critical commentary on the state of the field was meant to induce reflection, not to prescribe a set formula for future studies. In fact, he explicitly professed that no single approach could do justice to the sophisticated complexity of Islamic art:

> These remarks are not meant to comprise either a systematic doctrine or a method of dealing with Islamic art, but rather to suggest that the artistic experience of the Muslim world in over 1,400 years is too rich, too varied, and too complex to lend itself to a single message, a single voice, or a single explanation. No one person can master its intricacies with the accuracy and commitment it deserves, and it would be a betrayal of its history to limit it to one formal system or to one set of explanations.[13]

The nine articles that accompanied this farsighted introductory essay in the inaugural volume of *Muqarnas* displayed the cutting-edge scholarship of the time, which then continued to lean heavily toward the conventional era deemed worth studying, the Middle Ages, with only two articles on the sixteenth and seventeenth century, and another on a typological study of Berber dwellings in the High Atlas Mountains. The volume was predominantly architectural in focus and featured just two articles on metalwork and painting. In subsequent years *Muqarnas* began to broaden its range of topics and methodological diversity, while consistently maintaining a high caliber of scholarship. This transformation reflected the exponential growth of the field from the late 1980s and 1990s onward, as well as the Aga Khan Program's unquestionable role in expanding the frontiers of "Islamic art" chronologically, geographically, and intellectually.[14]

As Grabar predicted in 1983, there was a subsequent shift in focus from the early period in the central zone of the Islamic lands, to other regions and eras. This transformation came about in the wake of a rising global interest in early modern and modern studies in other fields, which brought the Islamic world in these centuries to the forefront. Moreover, just as the disciplinary gulf between the fields of archaeology and art history in general was growing wider, it was also becoming increasingly difficult to attain access to early Islamic archaeological sites, particularly in Iran, Iraq, and Afghanistan. These developments shifted the primary focus of studies away from early monuments in the so-called central Islamic lands to countries where materials across media—art and architecture—were more accessible. The medium that seems to have benefited the most is the arts of the book, conducted in the safe comfort zone of easily reached manuscript libraries, even though publications in this field were not lacking before. The growth of research on Islamic manuscript painting can be correlated with the rise of "image studies" and the "visual turn" across the disciplines of art history, literary criticism, and cultural and visual studies. The current fascination with "materiality" and "the thing," however, has started to swing the pendulum toward the physicality of architectural monuments, accompanied by a renewed attention to "object studies." The latter trend partly intersects with the augmented prestige in the twenty-first century of museums, with their concern for promoting "close encounters" with rarified *objets d'art*.

Growing criticism of ahistorical approaches to Islamic art and architecture also contributed, beginning in the 1990s, to a change in emphasis from artistic/cul-

tural unity to variety. The typical question, "What is Islamic about Islamic art?" became marginalized in academic scholarship by inquiries that began to foreground diversity and intercultural exchange. This transformation brought about a diversification of concepts and approaches, often characterized by interdisciplinary frameworks and a closer engagement with primary textual and visual sources. More recently, however, outdated approaches and stereotypes have been revived in several popular venues, such as documentary films, exhibitions, and new museums of Islamic art, thereby exposing the tenacity of more easily comprehensible older paradigms. This signals a growing gap between the simplicity of populist messages preferred in public forums and the complex interpretations developed in recent academic scholarship.[15] That gap further complicates the dialogue between past and present that *Muqarnas* has aimed to foster.

My goal here is neither to assess the historiography nor the current state of the field thirty years after the opening essay of volume 1, subjects I have addressed elsewhere. In fact, these topics have recently turned into fields of inquiry in their own right, to a degree previously unforeseen.[16] Instead, I shall focus on the evolution of both *Muqarnas* and the *Supplements* series, before turning to the successes and shortcomings of these publications, as outlined by some members of our Editorial and Advisory Boards.

Both publications have benefited from the invaluable input of superb full-time managing editors: Margaret Bentley Ševčenko (vols. 1–19 [1983–2002]), Julia Bailey (vols. 20–25 [2002–2008]), and currently Dr. Karen A. Leal (vols. 26– [2008–]). Their editorial expertise and wisdom have not only assured the perpetuation of high standards but have also educated senior and young scholars alike in the tricks of the trade. The first nine volumes of *Muqarnas* (1983–92) were edited by Grabar; the tenth (1993), marking the annual's first decade and the retirement of its founding editor, was a collaboratively edited festschrift dedicated to him. The next twenty volumes (1994–2013) have, under my editorship, aimed to maintain the founding editor's forward-looking vision while at the same time introducing some changes in emphasis (fig. 1).

Faced in the beginning with the danger that financial support for the annual might no longer be forthcoming, I raised temporary funds for volumes 11 and 12, using this transitional period to secure permanent funding from the endowment of the Harvard Aga Khan Professorship. I also formulated new directions for the publication, and initiated a "peer review" system for submissions in order to ensure the highest possible standards. New Editorial and Advisory Boards were appointed to give the expanded scope of coverage and readership an interdisciplinary dimension, without changing the primary visual focus. To help solicit articles from a wider range of international contributors, the Aga Khan Postdoctoral Fellowships Program was expanded, with fellows being encouraged to submit articles to *Muqarnas* based on their new research.

In volume 13 (1996), the subtitle of the journal, *An Annual on Islamic Art and Architecture*, was changed to *An Annual on the Visual Culture of the Islamic World*, a decision that responded to debates on the controversial implications and limiting scope of the original subtitle. Earlier volumes did occasionally accommodate articles on photography, archaeology, urbanism, and vernacular or modern architecture—categories not readily identifiable as "Islamic"—and relevant monuments or objects created in non-Muslim contexts. Yet the new subtitle and call for papers in my "Editor's Note" that year announced a further expansion of horizons, which largely defines our current purview as a "scholarly journal comprising articles on art, architectural history, archaeology, and all aspects of Islamic visual cultures, historical and contemporary":

> The substitution of "Islamic Art and Architecture" with the more inclusive category of "visual culture" seemed particularly in keeping with the broader scope and interdisciplinary framework we would like to envision for *Muqarnas*. This framework will accommodate essays on the reception of Islamic art and architecture in various contexts, and encourage historical and theoretical studies on such topics as the Islamicate forms in non-Muslim settings from the Middle Ages to the present, Orientalism, and the post-colonial critique. Critical essays on the historical development of the field, with its distinctive traditions of archaeological research, epigraphy, collecting, exhibiting and scholarship are also welcome. Along these lines, we would like to elicit occasional articles assessing the state of the field by reviewing a group of books or cultural events.

Fig. 1. Celebrating thirty years of *Muqarnas* (1983–2013): the covers themselves reveal the evolution of the annual publication over three decades.

We do not, however, wish to initiate regular book reviews, a service already performed by a number of other journals.

We will, of course continue to publish articles on art and architecture that introduce new information, documentation and interpretations. From time to time, there may also be special issues dedicated to the proceedings of conferences and symposia as there have been in the past. In addition to the traditional subjects included in previous volumes, however, we would like to increase the coverage of hitherto underemphasized periods (e.g., early modern and modern) and of regions generally considered marginal to the "central" territories of the Islamic world. We would particularly like to welcome visually relevant articles within the broadly defined scope of cultural and literary studies, as well as interpretive essays capable of engaging major art historical issues. Other contributions we would like to encourage are translations or interpretations of written primary sources capable of deepening our understanding of visual artifacts, their terminology, and the contextual meanings they embody. In short we hope to increase variety in our repertoire without radically changing the primary focus on art and architecture.[17]

Some of these directions were already envisioned in the founding editor's preface, where he admitted the difficulty of realizing projected goals: "Obviously, many years will elapse before we will know whether these attempts will succeed. In large measure, success will depend as much on the response to *Muqarnas* as on the intellectual quality and excitement of the materials presented."[18] Today, thirty years later, even with the accumulation of an impressive set of thirty volumes, we are not too far removed from that initial observation.

In volume 26 (2009), I introduced another modification to the journal's subtitle, *An Annual on the Visual Cultures of the Islamic World*, a tweak meant to articulate the multiplicity of artistic traditions that can hardly be subsumed under an overarching, monolithic visual culture. Other changes include the introduction of illustrations in color (to improve visual appeal and documentary value) and greater accessibility. The founding editor's initial wish to make the journal "inexpensive, so that it could be more readily available all over the Muslim world and wherever else Islamic art is studied or collected" was not feasible, being "an almost impossible goal in inflationary times."[19] Advances in information technology and the internet, however, have partially fulfilled that goal. *Muqarnas* volumes (except

for the last three) can now be downloaded from the Archnet website (archnet.org), managed by the Aga Khan Documentation Center at MIT.[20] One of the most visited sites in ArchNet is, in fact, our publications. The articles are also available in JSTOR, and *Muqarnas* is now among publications indexed in the *Arts & Humanities Citation Index* (*A&HCI*). Brill has also made *Muqarnas* available in e-book format, which will improve distribution worldwide.

We do, however, value the journal's physicality and even its rather quaint, familiar format, which induces a sense of continuity and longevity of tradition. This was expressed by one of our board members: "I think *Muqarnas* is an outstanding journal with high scholarly standards. I love the fact that it exists in print and that, after a wait of several years, the articles are then available through ArchNet and thus to areas of the world where scholars do not have access or funds for expensive book purchases (and *Muqarnas is* expensive). I love the fact that there is such a good journal in *our field*."

Starting with *Muqarnas* 26 (2009), another innovation was the addition of a "Notes and Sources" section at the end of each volume. We announced that this new section may feature shorter articles, news about recent discoveries, archaeological reports, occasional reviews of a group of major books or exhibitions, debates on selected issues, and primary sources (both written and visual). In the latter category we are especially interested in publishing notes on specific documents and texts (fully transliterated), as well as on monuments, objects, and illustrated manuscripts with all their images reproduced.

The "Notes and Sources" section is intended to complement the *Supplements to Muqarnas*, which have started to focus largely on primary sources (visual and textual, including inscriptions), instead of monographic studies, as in the past. This change in focus, introduced under my editorship of the series, is reflected in the last five volumes (*Supplements 8–12*), and in the modification of the subtitle from *Studies in Islamic Art and Architecture* to *Studies and Sources in Islamic Art and Architecture* (fig. 2). The main reason behind this reorientation has been the higher demand for translated primary sources in scholarship and teaching, with accompanying original texts and images, whereas

Fig. 2. *Supplements to Muqarnas: Studies and Sources in Islamic Art and Architecture,* vols. 1–12 (1987–2011).

monographs, if worthy enough, can be published by ordinary university or commercial presses. In fact, it is good news that two new field-specific monograph series have just been launched, by Brill (*Arts and Archaeology of the Islamic World,* edited by Marcus Milwright, Mariam Rosser-Owen, and Lorenz Korn) and by de Gruyter (*Visual Histories of Islamic Cultures,* edited by Finbarr Barry Flood and Avinoam Shalem). Moreover, *Ars Orientalis* has recently started to focus on themed volumes, some of which are on Islamic art. These developments further testify to the expansion of the field and the healthy diversification of voices in it.

We might still consider publishing monographs occasionally, including conference proceedings (formerly featured as *Muqarnas* special issues, which have created longer waiting periods for regularly submitted articles) and festschrifts. The desire to publish primary sources more frequently than we have managed thus far (given the long gestation period of lined-up projects) has been expressed by one of our board members, a goal toward which we shall continue to strive. Nevertheless, we are reluctant to reimpose the former strict page and illustration limits on *Muqarnas* articles, as suggested below by the same colleague, since the annual should have the luxury to deviate from typical norms under particular circumstances:

The journal is the most important in the field—a landmark across its soon-to-be thirty volumes—and will continue to hold that position. It would obviously be nice to publish sources more regularly than in recent years—because they are widely used by scholars and have made such hugely important contributions. It would be good to beef up Arabic and Persian texts, especially Arabic sources....My one criticism of *Muqarnas* in recent years is its increasingly heavy weight! I remember Margie insisting on 40 pages, 20 illustrations, and the kind of argument it required from authors. Reimposing these tighter restrictions would deprive the possibility of publishing long essays, which might be better conceived as short monographs in years when a *Supplement* is not being produced.

In a highly specialized field with relatively few and short-lived or sporadic journals, the regular annual publication of *Muqarnas* (first by Yale University Press and subsequently by Brill) has been exceptional indeed. Today few would question the major impact of the journal. In fact, many of those who responded to our questionnaire characterized it as "generally excellent," "outstanding in high scholarly standards," and "the pre-eminent journal" in the field, noting its recognition and esteem among colleagues in related fields. One commentator qualified this widely shared assessment as follows:

Muqarnas started out with great ambition and became much more rigorous, experimental, and exciting than foreseen by Grabar in his initial notes. The problems that linger are those of the discipline. Despite the attempts to become more interdisciplinary, it is still very much a journal of art history and as such its concentration is on "high art." In my opinion, the re-appearance of the same authors (unlike other journals in the field of art and architectural history) underlines this shortcoming and may mistakenly give *Muqarnas* the aura of an exclusive club—a qualification I keep on hearing. This is not helped by its exuberant price and limited distribution.

My "wish list" would prioritize an even broader cast of topics and geographic regions. Perhaps theme issues could be useful to attract those scholars who work on some of the "marginal" topics. I also think that the journal would benefit from a section dedicated to exhibition reviews, to be considered as archival essays. At this point in history, *Muqarnas* would be a good home to a comparative, thorough, and critical review of the new Islamic galleries in the Louvre and the Metropolitan, but also to the new wave of exhibitions on historical topics and contemporary art throughout the world. Some of the reviews could be in a conversation format between several scholars. Finally, I wonder whether it is possible to broaden the journal's impact in the general field of visual studies, without compromising its focus on the Islamic world.

This commentator also took time to evaluate former contributions to the field:

> After volume 13, new trends in the field began to emerge in the journal. The time periods covered extended from the Middle Ages to the pre-modern, and, to a lesser degree, the modern and even contemporary eras. Hence, sixteenth-century Ottoman art and architecture became a prominent presence, but the nineteenth century (also dominated by Ottoman case studies) and twentieth century (broader in scope, including critical evaluations of Hassan Fathy's New Gourna Village and post-revolutionary Iranian architecture) also entered the repertory. This opening was accompanied by new ways of thinking about art and architecture that recall Grabar's introductory projections. If there is one overarching theme, it is a profound consideration of the meanings behind the forms. Political readings of architecture (for example, in interpreting urban images, monumental complexes, and even single buildings) and objects (for example, coins) resulted in some of the most exciting contributions, highlighted by studies of patronage. Cross-cultural relationships (for example, between Byzantium and the Islamic world, between the artistic and architectural productions of Mehmed II's reign and

the Renaissance, sixteenth-century Venice and Istanbul, the impact of Crusaders on Italian art, and the dialogue between European and Middle Eastern modernism) argued convincingly for an interconnected world. Economic issues came to the forefront with analyses of *waqf*s, as well as detailed research on the acquisition of building materials (a truly complex story was traced in the case of the Süleymaniye complex). Albeit selectively, other overlooked topics suggest productive perspectives for future work, such as environmental issues, exemplified in a recent article on the Alhambra. Along the way, geographical boundaries have been expanded considerably to include hitherto unlikely places, for example, Uganda. Even more importantly, many assumptions, among them the static nature of Islamic art and architecture, its emphasis on surface decoration at the expense of spatial and structural creativity, and the fixed formulas defining the shape of the cities, have been deconstructed for good.

Another commentator acknowledged the impact of *Muqarnas*, while thoughtfully outlining some possible new directions:

> Beyond doubt, the most important contribution of *Muqarnas* to the field has been the establishment of an annual forum in which to showcase articles of quality that represent both innovative perspectives on established topics and original research that promises to broaden the scope of the field. It is clearly the preeminent journal in the field. The recent introduction of a "Notes and Sources" section is a welcome addition. A continued commitment to equal representation for early, medieval, early modern, and modern topics is essential to ensuring the ongoing success of the journal and its ability to appeal to as wide a cross-section of Islamic art historians as possible.
>
> My impression is, however, that the readership is largely confined to those working in the field of Islamic art. Since many of the articles have the ability to appeal to a broader audience, it might be worth considering how this appeal could be brought to the attention of those working outside the field whose interests nevertheless intersect or overlap with our own. In my opinion, the most obvious room for improvement lies in expanding the geographical scope of the journal. To some extent, this reflects the limits of the canon as currently constituted, but the importance of the journal within the field is such that it could potentially initiate new trends by fostering scholarship of a high caliber on neglected periods, topics, and regions. The two most obvious regions to focus on are sub-Saharan Africa and Southeast Asia. There are colleagues undertaking pioneering work on Islamic material culture in both areas, who generally publish in archaeology or history journals, or in

dedicated area studies journals. Such individuals might be persuaded to publish occasionally in *Muqarnas*, perhaps even in the *Supplements* series.

Pre-Mughal South Asia would be another area to develop, since the important work of Howard Crane and Tony Welch on Sultanate architecture was pioneered in the journal.[21] From what I remember, recent work on the Deccan (the major growth area of scholarship on Islamicate South Asia) has yet to feature in *Muqarnas*. An article dealing with the transregional connections of the Bahmanids and their implications for artistic patronage would, for example, resonate with a long-term interest in early Ottoman connected histories, both chronologically and directly.

Rightly noting the uneven quality of articles, one board member suggested that commissioning occasional thematic volumes with guest editors might improve this shortcoming and help to further expand the frontiers of the field:

> *Muqarnas* is clearly *the* preeminent journal on Islamic art and architecture, not only in the United States, but internationally as well—I know from what I hear from my Spanish colleagues that it is held in very high esteem. That said, I do often find the quality of the articles to be uneven... It is rare that a brilliant article simply floats in over the transom...[I]t is customary for the editor to commission special issues, usually built around a theme and usually through invited guest editors. I find that those efforts often generate coherent issues with notably higher-quality contributions. This might also be a way for *Muqarnas* to help expand the "centers" of the field—into other geographic areas beyond those usually represented, into later chronologies, into other themes, into areas of contact between Islamic art and other traditions. You might start by asking if any of the board members would be interested...And also think of commissioning promising younger scholars, who are usually full of energy and eager.
>
> Another thing to be considered is commissioned review essays. The field is not plentiful enough yet to justify a full reviews section, but this might be a way to initiate conversations across the discipline (i.e., debate...), which is not something I see much of, at least on the surface, in the journal, and I think it would actually be good for it, and for the field.

A differing perspective on guest-edited thematic volumes, which we have occasionally published, is also worth considering:

> The "theme" issues provide valuable platforms to investigate heady questions from various angles and through case

studies drawn from different regions and periods. I find, for example, the volume on "Historiography and Ideology: Architectural Heritage of the 'Lands of Rum'" extremely useful in my theory and methodology courses—regardless of whether they are on "Islamic" topics or not. This is really a superb undertaking, which identifies a set of thorny questions and addresses them relentlessly based on solid empirical research. Nevertheless, there is a strategic problem with theme volumes. They are not different than edited books and could easily be published as such. Given that *Muqarnas* comes out annually, it might be wiser to save the space for articles that cover diverse topics. [Then again, I do not know the number of articles received every year and the waiting period involved.]

It is true, in fact, that special issues have tended to create backlogs and extended the waiting period for authors by more than one or two years, given the increased number of worthy submissions that have been pouring in.[22] Gone are the days when one had to scramble for suitable submissions to fill a volume, in what was a relatively small field: a welcome change that has partly contributed to the "heavy weight" criticized above. While the editors have a continued commitment to solicit works on a wide range of subjects, it is hoped that upcoming volumes might indeed feature subsets of articles with common themes, whenever possible.

Since it is not feasible to quote all the comments made by our judicious board members, I have opted to highlight thematically their assessments and "wish lists," some of which predictably point to healthy differences of opinion. Let me start with the question of coverage. A most commonly shared desideratum is to maintain the current commitment to cover all periods, from early to modern. The commendable wish for greater coverage of modern subjects, toward which the journal has been striving, without much success, was also voiced several times. One commentator, for instance, wrote: "I think more material on nineteenth- to twenty-first-century art and architecture is needed, particularly architecture. Tentative steps in this direction have been taken, but more could be done." As is well known, however, others have vociferously opposed the expansion of the field to modern and contemporary subjects. The scarcity of *Muqarnas* articles in this newly developing area is largely due to a shortage of submissions that go beyond descriptive or journalistic approaches.[23]

While some of the board members quoted above expressed the desirability of further expanding the coverage of areas and encouraging links with related non-Islamic fields, others have conveyed a resistance to watering down a field-specific traditional focus. One colleague, for example, sees little point in opening the journal to articles on Italian Renaissance artifacts with Islamic subjects, even though it can be argued that such openings might bring *Muqarnas* to the attention of a broader audience beyond the Islamic field. Here is the reasoning:

> After seeing the most recent issue [with the subtheme "Shared Histories of Islamic and Italian Art"], I thought the articles by Baskins and Pulido-Rull were of virtually no interest to Islamic art historians. They might be of great interest to historians, both of the West and the Islamic world, and to historians of Western art, but it seems a pity if more relevant articles had to be left out to accommodate them in *Muqarnas*.[24]

It is welcome news that "Notes and Sources" has generally been received enthusiastically. One commentator wrote: "I appreciate very much the new section for the straightforward information it conveys. Perhaps encouraging scholars to submit more could expand this section into a larger and more dynamic medium for exchange. We all have so much more primary material in our files than we can use in our lifetimes...." Another colleague appreciated the differentiation "between main articles (in-depth analysis of a given topic and its history, including critical literature review) and the notes (short pieces that update us on new discoveries but where conclusions may not yet be ready)." This was one of the reasons behind the introduction of the section, which aimed to accommodate valuable and newsworthy short pieces that in the past would have been rejected. However, a differing viewpoint was put forth by one of the commentators, who prefers that the section focus on primary sources, both visual and written: "I like the Notes and Sources section of *Muqarnas*, but think that it has become something of a place for shorter articles or articles without substantial argument...I think the line should be held at introductions to unknown or reinterpreted artworks, documents, and other written sources."

Reiterating the significance of written primary sources, another colleague has commented on the need for "more translations of essential sources for the *Supplements*: Something as basic as Maqrizi's *Khiṭaṭ* has never been translated in anything near its entirety. Would *Muqarnas* be willing to take up the challenge to commission several authors for this? (It is probably more than a lifetime's work for a single candidate.)" The answer would be yes, if this colleague might agree to be guest editor in charge of organizing such an important and timely long-term project. As in the past, we continue to encourage proposals for guest-edited volumes, as well as suggestions for promising projects and article submissions.

An often-underestimated contribution of the journal was acknowledged by one colleague:

> *Muqarnas* has also been quietly doing a great service by welcoming younger scholars to the broader community of art and architectural historians. The chapters derived from their dissertations disseminate information about the work they do, while registering their names into the directory of the discipline. Personally, reading many of these essays whet my appetite for the forthcoming books and, in many cases, the results have surpassed my expectations.

In the past, however, *Muqarnas* has sometimes been criticized precisely for reaching out to younger scholars. Likewise, while a number of scholars in former years have disparaged the journal as too trendy, others have found it not enough so, even conservative.

Since the quality of an annual publication depends largely on the contributions it receives, future directions outlined as a "wish list" do not always materialize. (See the chronological cumulative index of articles from volumes 1 to 25,[25] which gives a sense of the range of topics that have been covered in the journal.) It is fair to say that *Muqarnas* has been, first and foremost, a reflection and barometer of the state of the field it seeks to cover. It is also our hope that it has already made, and will continue to make, a contribution to the development of that field, by providing a much-needed forum for the exchange of new information, interpretations, approaches, and trend-setting critical perspectives. As one colleague put it,

> There is a remarkable breadth of approaches and materials, and while the journal can encourage new directions,

frontiers, geographies and chronologies, it is ultimately the reflection of what is available now in its best form. I do not think that the journal would be more widely read in art history if further changes were made to its content...nor would I make any in the hope of bringing about a wider and broader readership. I think the journal's content as it stands reflects the broad revolution conducted in our field since the 1990s.

Given the fact that the journal is one of the few stable venues for publishing scholarly articles in our field, I believe this brings with it special responsibilities toward differing constituencies. As such, *Muqarnas* constitutes a complex organism that will continue to require a tricky balancing act in negotiating the divergent needs, expectations, and viewpoints of a vigorously growing, stimulating field. Most importantly, the journal has never had a prescriptive "party line" or "politically correct" agenda. As a collective forum of the field, it is wide open to the entire spectrum of invaluable suggestions made above. Therefore, in celebration of the thirtieth anniversary of *Muqarnas*, I enthusiastically invite the members of our reinvigorated Editorial and Advisory Boards, as well as our readers, to be more proactive in taking charge of its future.

This volume comprises regular submissions rather than being a specially commissioned thirtieth-anniversary issue. Nevertheless, it charts some of the new directions outlined above. The volume begins with three historiographical articles, an ever-growing subject of inquiry: "A Field Pioneered by Amateurs: The Collecting and Display of Islamic Art in Early Twentieth-Century Boston," by Benedict Cuddon; "Ugo Monneret De Villard (1881–1954) and the Establishment of Islamic Art Studies in Italy," by Silvia Armando (winner of the 2011 Margaret B. Ševčenko Prize); and "Raqqa: The Forgotten Excavation of an Islamic Site in Syria by the Ottoman Imperial Museum in the Early Twentieth Century," by Ayşin Yoltar-Yıldırım.

The next three articles, while critically touching upon historiographical issues, explore the thriving subject of architectural and visual multiculturalism in particular geographies, between the tenth and nineteenth centuries. They focus on the Mughals and Rajputs in the Indian Subcontinent, the Fatimids in Syria and Egypt,

and the Iberian Jews with a diasporic Sephardic identity in Ottoman Salonica, respectively: "At the Margins of Architectural and Landscape History: The Rajputs of South Asia," by D. Fairchild Ruggles; "Method in Madness: Recontextualizing the Destruction of Churches in the Fatimid Era," by Jennifer Pruitt; and " 'As If She Were Jerusalem': Placemaking in Sephardic Salonica," by Peter Christensen.

This is followed by three articles focusing on questions of interpretation, patronage, text-image interactions, and aesthetics in thirteenth-century Arabic, and fifteenth- to seventeenth-century Persianate manuscript painting, an artistic medium that has attracted unprecedented attention in recent years: "In Pursuit of Shadows: Al-Hariri's *Maqāmāt*," by David J. Roxburgh; "The Patronage of the Vizier Mirza Salman," by Abolala Soudavar; and "An *Iskandarnāma* of Nizami Produced for Ibrahim Sultan," by Lale Uluç.

The volume concludes with three essays in the "Notes and Sources" section, which publish and interpret overlooked sixteenth- and seventeenth-century primary written sources from the Ottoman and Mughal empires: "Presenting *Vaṣṣāl* Kalender's Works: The Prefaces of Three Ottoman Albums," by Serpil Bağcı, with appendices by Wheeler M. Thackston providing the transcribed texts of two unpublished album prefaces, along with the English translations; " 'Virtual Archaeology' in Light of a New Document on the Topkapı Palace's Waterworks and Earliest Buildings, circa 1509," by Gülru Necipoğlu; and "The Wooden Audience Halls of Shah Jahan: Sources and Reconstruction," by Ebba Koch.

Gülru Necipoğlu, Editor
Aga Khan Professor of Islamic Art, and Director, Aga Khan Program for Islamic Architecture, Department of History of Art and Architecture, Harvard University, Cambridge, Mass.

NOTES

1. Oleg Grabar, "Reflections on the Study of Islamic Art," *Muqarnas* 1 (1983): 1–14; cited from 1–2.
2. Ibid., 4.
3. Ibid.
4. Ibid., 1, 4.
5. Ibid., 1–2.

6. Ibid., 7.

7. Ibid., 12–13.

8. Ibid., 6, 8.

9. Ibid., 4.

10. Ibid., 4, 9.

11. Ibid., 11.

12. Ibid., 7–8.

13. Ibid., 12.

14. Gülru Necipoğlu and Julia Bailey, "In Tribute to Oleg Grabar," in "Frontiers of Islamic Art and Architecture: Essays in Celebration of Oleg Grabar's Eightieth Birthday," ed. Gülru Necipoğlu and Julia Bailey, The Aga Khan Program for Islamic Architecture Thirtieth Anniversary Special Volume, *Muqarnas* 25 (2008): p. vii.

15. Gülru Necipoğlu, "The Concept of Islamic Art: Inherited Discourses and New Approaches," in *Islamic Art and the Museum: Approaches to Art and Archaeology of the Muslim World in the Twenty-First Century*, ed. Benoît Junod, Georges Khalil, Stefan Weber, and Gerhard Wolf (London, 2012), 57–75; electronically reproduced in "Islamic Art Historiography," ed. Moya Carey and Margaret S. Graves, special issue, *Journal of Art Historiography* 6 (June 2012): http://arthistoriography.wordpress.com/number-6-june-2012-2/ (accessed July 12, 2013). New exhibitions are critically reviewed in David J. Roxburgh, "After Munich: Reflections on Recent Exhibitions," in *After One Hundred Years: The 1910 Exhibition "Meisterwerke muhammedanischer Kunst" Reconsidered*, ed. Andrea Lermer and Avinoam Shalem (Leiden, 2010), 359–86.

16. Necipoğlu, "Concept of Islamic Art," 57–75. See collected essays in Junod, Khalil, Weber, and Wolf, *Islamic Art and the Museum*, and in Carey and Graves, "Islamic Art Historiography" (*Journal of Art Historiography* 6). See also Sibel Bozdoğan and Gülru Necipoğlu, "Entangled Discourses: Scrutinizing Orientalist and Nationalist Legacies in the Architectural Historiography of the 'Lands of Rum,'" in "Historiography and Ideology: Architectural Heritage of the 'Lands of Rum,'" ed. Sibel Bozdoğan and Gülru Necipoğlu, special issue, *Muqarnas* 24 (2007): 1–6.

17. See Gülru Necipoğlu, "Editor's Note," *Muqarnas* 13 (1996): p. vii.

18. Oleg Grabar, "Preface," *Muqarnas* 1 (1983): p. ix.

19. Grabar, "Reflections on the Study of Islamic Art," 1.

20. To download *Muqarnas* articles (through 2010) on ArchNet, visit http://archnet.org/library/documents/collection.jsp?collection_id=86.

21. There has been one recent article on Sultanate architecture: Elizabeth A. Lambourn, "A Self-Conscious Art? Seeing Micro-Architecture in Sultanate South Asia," *Muqarnas* 27 (2010): 121–56.

22. Out of thirty volumes of *Muqarnas*, six (i.e., 20 percent) have been special issues. The most recent ones include "Frontiers of Islamic Art and Architecture: Essays in Celebration of Oleg Grabar's Eightieth Birthday," ed. Gülru Necipoğlu and Julia Bailey, The Aga Khan Program for Islamic Architecture Thirtieth Anniversary Special Volume, *Muqarnas* 25 (2008); and "Historiography and Ideology: Architectural Heritage of the Lands of *Rūm*," ed. Sibel Bozdoğan and Gülru Necipoğlu (containing the proceedings of a symposium by the same name organized by the editors at the American Academy of Arts and Sciences in 2006), *Muqarnas* 24 (2007). Guest-edited volumes have comprised the proceedings of a conference held in 1999 on "The Making and Reception of Painting in Pre-Modern Iran," ed. David J. Roxburgh, *Muqarnas* 17 (2000); and the festschrift "Essays in Honor of J.M. Rogers," ed. Doris Behrens-Abouseif and Anna Contadini, *Muqarnas* 21 (2004). Under Grabar's editorship, the proceedings of a conference on the "Renaissance of Islam: The Art of the Mamluks" (selected papers from a symposium sponsored by the Center for Advanced Study in the Visual Arts, National Gallery of Art, Freer Gallery of Art, Smithsonian Institution, and held at the National Gallery of Art, Washington, D.C., May 13–16, 1981) were published in *Muqarnas* 2 (1984), while *Muqarnas* 8 (1991) was devoted to the proceedings of the conference "K.A.C. Creswell and His Legacy" (organized by J.W. Allan and Julian Raby and held at Oxford University in May 1988).

23. A notable resistance has been voiced by Sheila S. Blair and Jonathan M. Bloom, "The Mirage of Islamic Art: Reflections on the Study of an Unwieldy Field," *The Art Bulletin* 85, 1 (March 2003): 152–84. For a critique of this position, see Finbarr Barry Flood, "From the Prophet to Postmodernism? New World Orders and the End of Islamic Art," in *Making Art History: A Changing Discipline and Its Institutions*, ed. Elizabeth C. Mansfield (New York 2007), 31–53. The chronology of Islamic art, with its problematic omission of the modern period, is discussed in Mercedes Volait, "L'art islamique et le problème de périodisation," in "Périodisation et histoire de l'art," special issue, *Perspective* 4 (2008): 783–86.

24. The articles in question are: Cristelle Baskins, "The Bride of Trebizond: Turks and Turkmens on a Florentine Wedding Chest, circa 1460," *Muqarnas* 29 (2012): 83–100; and Ana Pulido-Rull, "A Pronouncement of Alliance: An Anonymous Illuminated Venetian Manuscript for Sultan Süleyman," *Muqarnas* 29 (2012): 101–50.

25. "Cumulative (Chronological) Index of Articles, *Muqarnas* I–XXV," *Muqarnas* 26 (2009): 377–85. See also the "Cumulative Authors' Index, *Muqarnas* vols. 1–10 (1982–92)," *Muqarnas* 10 (1993): 387–90.

BENEDICT CUDDON

A FIELD PIONEERED BY AMATEURS: THE COLLECTING AND DISPLAY OF ISLAMIC ART IN EARLY TWENTIETH-CENTURY BOSTON

In March 1958, the scholar Florence Day was commissioned to produce a survey of all the materials available for the research and teaching of Islamic art in the Greater Boston area. She was asked to carry out this task by John Coolidge (d. 1995), then director of the Fogg Art Museum at Harvard University, at the recommendation of Sir Hamilton A.R. Gibb (d. 1971), director of the newly established Center for Middle Eastern Studies at Harvard University.[1] For several years prior to this, Coolidge had been interested in setting up a program of research and teaching in the field of Islamic art; the survey was intended to develop his thinking in the area and help get the project started. Coolidge outlined the task in a letter he wrote with his offer of employment to Day: "I am anxious to have you survey the material available in Greater Boston: books, slides, photographs and, where relevant, original works of art, so that we can get some idea of what would be needed to establish a program of study in this field." He went on to outline his longer-term aims: "Broadly speaking, I dream of the Fogg doing for the whole field of Near Eastern art during the next generation what we have been able to do in the Far Eastern field during the last."[2]

Up to that time, Day had not had any affiliation with Harvard. She had studied at the University of Michigan under Mehmet Aga-Oglu (d. 1949), and was principally an authority on Islamic ceramics and textiles.[3] During the early 1950s she worked in New York at the Metropolitan Museum of Art as an assistant under the curator of Near Eastern Art, Maurice Dimand (d. 1986). When she began work at the Fogg, she had not published any research for several years, but was planning various publications, including a survey of early Islamic art to be used for teaching purposes in colleges.[4]

Day spent the next two years working on the project and submitted her completed survey in June 1960. It consisted of descriptions and assessments of all the materials relating to Islamic art in the Boston area. In compiling her report, she visited the Fogg Museum (opened 1895), the Semitic Museum (1899 [in its present location at 6 Divinity Avenue, Cambridge, since 1903]), and the Peabody Museum of Archaeology and Ethnology (1866), all at Harvard University, as well as the Museum of Fine Arts (1876 [in its present location on Huntington Avenue since 1909]) and the Isabella Stewart Gardner Museum (1903), both in Boston.[5]

While the report was comprehensively researched and meticulously produced, it did not meet with the approval of the authorities at Harvard. In a letter to his wife, Agnes Mongan, Coolidge expressed uncertainty about its worth. "I confess I have no judgement to its value," he wrote, "and I will not decide on whether it should be typed or not until Eric, Cary, or both have come through with a recommendation."[6] The Eric to whom he referred was Eric Schroeder (d. 1971), curator of the Islamic collection at the Fogg and a specialist in Persian miniature painting. Cary was Stuart Cary Welch (d. 2008), assistant curator at the Fogg and a collector and connoisseur of Persian and Indian drawings, miniatures, and manuscripts.

Schroeder's reaction to the report was rather less equivocal than Coolidge's. "The peculiar focus upon the early Islamic period and its meagre remains," he wrote, "characterizes the report so strongly that it is an archaeologist's document." He observed that there was "no attention to the great artists where they emerge in history (16th century)," which gave "a grotesque disproportion to her report as it stands." By "great artists,"

Schroeder meant Persian miniature painters such as Bihzad (d. ca. 1535), who emerged from the late Timurid period (ca. 1469–1506) onwards. He believed, along with many others in the field at that time, that Persian miniature painting represented the zenith of Islamic art history. In summarizing his findings, Schroeder decided that the report was "sweepingly and sublimely injudicious," and that as an attempt to show "the region's capacity to illustrate Islamic art with worthy representatives of its most beautiful achievements, the survey is just not a survey."[7]

The dismissal of Day's report does not indicate a failing on her part. She was a highly qualified and experienced scholar with numerous publications to her name. How, then, should we understand the reaction of the authorities in the Fogg? Rather than pointing up any incompetence of Day's, this incident highlights something of greater significance, namely, the different conceptions of the field of Islamic art that existed at that time. Coolidge and Schroeder's dismissal of the report did not derive from any greater knowledge of the field. Rather, they were critical because the report did not reflect what they understood to be the true definition of Islamic art.

Day's focus on the archaeological holdings in the Boston-area museums was a reflection of her particular understanding of what the study of Islamic art involved. Coolidge and Schroeder, in turn, each held their own very distinct perspectives on what the study of the subject entailed. The disagreement was not just a small tiff among competing scholars but a dispute that went to the very heart of what it meant to study Islamic art. And to understand its significance it is necessary to go back to the start of the twentieth century, when collections of Islamic art in Boston were beginning to be formed.

THE FORMATION OF ISLAMIC ART COLLECTIONS

In recent years, there has been considerable scholarly interest in the formation, study, and display of collections of Islamic art.[8] In Europe, Islamic art collections were assembled from the mid-nineteenth century onwards,[9] while in the United States the process started somewhat later, with the first collections being organized in the late nineteenth and early twentieth century.[10] The academic study of Islamic art began in the wake of the formation of such collections. In the United States, the scholar and dealer Arthur Upham Pope (d. 1969) was one of the first to hold a formal post in the field, with an advisory curatorial position in "Muhammadan Art" at the Art Institute of Chicago in 1919.[11] However, the first official academic post in Islamic art was created in 1933, at the University of Michigan, with an endowment from the American railroad-car manufacturer Charles Lang Freer (d. 1919); its first holder was Mehmet Aga-Oglu (d. 1949).[12]

In Boston, the first collections of Islamic art were formed in the late nineteenth and early twentieth century and were centered on three main institutions: the Museum of Fine Arts (MFA), the Fogg Art Museum at Harvard, and the Isabella Stewart Gardner Museum. At the MFA it is not clear when exactly the acquisition of Islamic art began, but by the end of the first decade of the twentieth century there were already some Islamic materials in the collection.[13] The Fogg began to assemble its Islamic collection around the same period, after the end of World War I.[14] Similarly, Isabella Stewart Gardner (d. 1924) began to collect Islamic material around the turn of the century.[15]

In the early days, the collections of these institutions were formed through the efforts of a small group of pioneer collectors. The most important of these figures was Denman Waldo Ross (d. 1935) (fig. 1).[16] Born in Cincinnati, Ohio, he graduated from Harvard in 1875. After completing a doctoral degree in economic history, he developed an additional interest in art. He became a trustee of the MFA in 1895, and in 1899 was appointed as a special lecturer on design at the Architectural School at Harvard. In 1904 he began to travel extensively to India, Cambodia, China, Japan, Mexico, and Peru, during which time he bought a considerable amount of art. Ross acquired his enthusiasm for Islamic art late in life and it was principally Persian art that intrigued him. It might at first seem curious that he should have cultivated such a pursuit; although he travelled to the Islamic world, he seems not to have liked much of the art he saw there.[17] However, over the course of his lifetime he built up a sizable collection of Persian material, in particular miniature paintings, drawings, luster tiles, and rugs. He gave many of his purchases to the Boston

Fig. 1. Kanji Nakamura, Denman Waldo Ross (1853–1935), 1928. Harvard Art Museums/Fogg Museum, Gift of Paul J. Sachs, 1938.125. (Photo: Imaging Department © President and Fellows of Harvard College)

Fig. 2. Martin Mower, Hervey Wetzel (1888–1918), ca. 1917. Harvard Art Museums/Fogg Museum, Gift of Joseph W. Valentine, 1975.63. (Photo: Imaging Department © President and Fellows of Harvard College)

museums; in total, around 1,500 objects to the Fogg, and perhaps 11,000 to the MFA.[18] He was also involved in one of the most important acquisitions for the MFA, when, in 1914, he helped to broker the purchase of the Goloubew Collection, which consisted mainly of Persian and Indian paintings and drawings.[19]

Another important figure was Hervey Wetzel (d. 1918), also a graduate of Harvard College (class of 1911) (fig. 2). Wetzel was an only child and after his parents died while he was a student he was left with considerable means. He shared many of Ross's interests in art and collecting, and in 1912 they travelled together to Asia. Later, in 1914, Wetzel became an associate of the MFA covering Persian and Indian art. After further travel in Asia, in 1916 he enrolled as a doctoral candidate in the Graduate School at Harvard, choosing

"Persian and Mohammedan Art" as his special field. He learned Arabic and was able to catalogue the manuscripts of his own collection (which he had begun to assemble after his travels with Ross) and those of the MFA. He was offered a position as curator of the Islamic collection there, but because he had already enrolled in military training he declined the offer. Like Ross, Wetzel gave generously to the museums in Boston. He died of pneumonia in 1918, while working for the Red Cross in France, and left half of his collection to the Fogg and the other half to the MFA. He also bequeathed $100,000 to the Fogg for the purchase of new objects.[20]

Besides Ross and Wetzel, another active collector was Isabella Stewart Gardner (fig. 3). She first visited the Middle East in 1874, at the age of thirty four, on a tour of Egypt. However, it was not until the 1890s that she

Fig. 3. Isabella Stewart Gardner (1840–1924), 1888. The Isabella Stewart Gardner Museum, Boston. (Photo: courtesy of the Isabella Stewart Gardner Museum)

Fig. 4. Bernard Berenson (1865–1959), ca. 1900. Biblioteca Berenson, Villa I Tatti—The Harvard University Center for Italian Renaissance Studies. (Photo: courtesy of the President and Fellows of Harvard College)

started buying Islamic art. Over the next twenty years she steadily built up a small collection of objects, purchasing pieces through dealers or through friends, though her Islamic material was never anywhere near as extensive as that of either Ross or Wetzel.[21]

For their collecting, these figures depended partly upon dealers of Islamic art who were just beginning to establish themselves in the United States. These dealer/collectors included Armenians such as Dikran Kelekian (d. 1951) and Hagop Kevorkian (d. 1962), who both played very active roles in selling and lending material to museums as well as to collectors in the United States, including Ross and Gardner. In addition, in 1903 Kelekian donated materials to the textile gallery in the MFA, and in 1910 he lent even more items to the

museum, while Kevorkian also donated objects that year.[22]

Beyond this circle of collectors and the dealers who supplied them there were other influential figures who helped to shape this early period of collecting. Foremost among them was the scholar, collector, and art connoisseur Bernard Berenson (d. 1959), who had a strong predilection for Islamic art and, although not based in Boston himself, exerted an important influence upon the art world there (fig. 4).[23] Berenson was a student of Oriental languages, learning Sanskrit, Hebrew, and Aramaic when he was at Harvard (1884–87). In the middle of his career he developed an interest in Asian art and started purchasing Chinese, Japanese, and Tibetan painting, sculpture, and ceramics. During the same

period, he also bought Persian art, forming a collection of miniatures and manuscripts between 1910 and 1913.[24] Berenson also played an active role in encouraging others to buy and collect in the field, including Gardner, who bought her Islamic miniatures through him.[25] He also strongly promoted the academic study of Islamic art. At different points he encouraged Harvard to take on someone in an academic position, promoting both Rudolf Riefstahl, a scholar/dealer based in Europe, and then Mehmet Aga-Oglu; he also pressed Harvard to publish more academic research in the field.[26]

CURATORS AND EARLY MODES OF DISPLAY

These, then, were some of the key figures involved in the acquisition and collecting of Islamic art in the United States. But who were the people looking after the collections at this time? At the Fogg, there was no one curating the Islamic collection until the 1930s. At the Isabella Stewart Gardner Museum, Gardner herself decided how the materials should be displayed and arranged. However, at the MFA there were particular individuals working in connection with the Islamic material. The principal curator of the Islamic collection was Frank Gair Macomber (d. 1941), who ran a fire insurance business (the MFA was one of his customers) and supervised the Islamic material in his spare time. He also collected in the field, specializing in Middle Eastern arms and armor.[27] Another figure was Garrick Borden (d. 1912), who was mainly involved in teaching on the subject. Originally from Pennsylvania, he had taught in England (in London, Oxford, and Cambridge) and also in the United States, at the University of California.[28] He worked as a docent in the MFA, lecturing on a range of subjects, including Islamic art, and also at the Harvard Extension School (est. 1910), where he delivered a series of forty illustrated lectures on Islamic art in the 1911–12 academic year.[29]

In this early period there was a well-established sense of an overarching category of "Islamic" art, though it was more often referred to as "Saracenic" or "Mohammedan." Within this framework, the first three centuries of the Islamic era were seen as the crucial formative phase. As Macomber reportedly explained in a lecture: "Saracenic art is supposed to have had its origin during the

Sessananian [sic] dynasty of Persia...[I]n 650 the Arabs conquered Persia and their restless fancy and taste for color and ornament added the final element to the product we now call Mohammedan or Saracenic art."[30] Macomber's ideas were echoed by Borden: the "study of Moslem history," he wrote in a pamphlet entitled "Reasons why teachers of history should study Moslem History, Civilization and Art," is "the *study of the formative period* of a great living civilization which is daily becoming of more importance to us [italics mine]."[31]

The conception of Islamic art as a tradition that was formed in the first centuries of the Islamic era had a long pedigree dating back to the nineteenth century and was based on the Hegelian meta-narrative of history that saw the rise and fall of civilizations as the key force in shaping human history. Within this framework, all civilizations passed through an initial formative phase, remained for a certain period of time, and then ultimately declined. This conception of history was passed on through generations of Western scholars like Edward Gibbon and Arnold Toynbee, and onto Orientalists such as Hamilton A.R. Gibb.[32] When applied to Islamic history, the early centuries of the Islamic era were seen as the most important phase, since it was in this period that the key features of Islamic civilization were believed to have been forged. According to this paradigm, the "essence" of Islamic art emerged in the first three centuries after the Prophet Muhammad. After this, the rest of Islamic history consisted of various derivations that could never approach the cultural accomplishments of this critical early period.[33]

But while this overarching view of the field did exist, in this period the notion of Islamic art as a distinct category had not yet acquired the rigid parameters that would define it in later years. In the early twentieth century, "Islamic art" often held an ambiguous position in conventional classification, defying any kind of neat categorization. At the MFA, for the first decade of the twentieth century, Islamic material was actually housed in the department of Western art. As the museum explained, "by western art is meant that developed in Europe (and the nearer orient), or under European influence, since classical times."[34] There was some degree of separation given to art from the Islamic world, with most of the Islamic objects displayed in a gallery

called the Nearer Orient Room. However, it did not have a purely Islamic focus, as Peruvian and Coptic textiles were displayed alongside. And indeed, not all the Islamic objects were held in the Nearer Orient Room; since the collection was by and large arranged by material, Persian ceramics were housed in the part of the museum devoted to glass and ceramics.[35]

There was a similarly nebulous situation at the Fogg. Here, early exhibitions often included both Islamic material and European works of art. A show in 1914 of loan material from the J. Pierpont Morgan Collection in New York consisted of Persian and Indo-Persian miniatures and Koran leaves, along with English, French, and Italian paintings and manuscripts.[36] Likewise, in the room at the Fogg that housed the Wetzel Collection, a whole range of different art forms were clustered together, with Persian miniatures and Arabic calligraphy displayed together with Chinese and Italian art.[37]

At the Isabella Stewart Gardner Museum, this tendency was even more pronounced. The entire museum was laid out in a highly idiosyncratic fashion, as prescribed by the founder herself. Gardner's Islamic objects were dispersed all over the museum, with little regard for grouping them according to region or period. She displayed a Persian carpet in the "Titian Room," along with Titian's *Rape of Europa* and a miscellany of European (mainly Italian) art. The "Tapestry Room" contained the majority of her Islamic material: a Persian silk, a Hafiz manuscript, a Persian lacquered box and a Persian Koran stand, an Arabic treatise on automatic devices, a thirteenth-century Arabic manuscript, and two Mongol ones. But all this sat together with a Velázquez painting of Pope Innocent X, a tapestry depicting scenes from the life of Cyrus the Great, and a host of other objects including Italian writing desks, German brass plates, and other European works of art in a variety of media.[38]

The custom of displaying very disparate objects together, a common practice in the United States at this time, derived from the influence of the Aesthetic Movement, which flourished in America in the last three decades of the nineteenth century. Drawing on the ideas of John Ruskin and the Arts and Crafts Movement in Britain, it encouraged looking abroad for designs that could be used to reinvigorate the American arts industry.[39] Above all, it promoted the idea that the search for beauty in art would inspire a new generation of American designers and artists. With this emphasis on foreign art forms and beauty, the Aesthetic Movement stressed the accessibility of styles of decoration from the past and the belief that art did not have to be viewed within its historical context in order to be appreciated. When the main objective was to find beauty in a work of art, it was not necessary to know about the culture and society that had produced that object; cross-cultural transcendent beauty could be appreciated by anyone in any context. It was partly because of the proliferation of these ideas that much art at this time was displayed divorced from its specific historical context.[40]

The Aesthetic Movement influenced some of the key figures in Boston in this period, and Ross was clearly a disciple. As one of his obituarists noted, "his contempt for the historical and archaeological point of view—as a trained historian—was a curious contradiction."[41] He acknowledged as much himself. In recalling his travels in Asia with Wetzel, he wrote, "We were not archaeologists. We were not historians. We were simply lovers of order and the beautiful as they come to pass in the works of man supplementing the works of Nature."[42] This outlook was also promoted by Berenson, who strongly believed in connoisseurship and aesthetic appreciation. He saw art objects as individual works of beauty and genius, not as products of a particular historical environment. It was this sort of formalist approach that enabled Berenson to juxtapose Persian miniatures with Chinese artifacts at *Villa I Tatti*.[43]

Another noteworthy feature of this early era of display was the attention devoted to Persian art, which, within the broad conception of the field at this time, was regarded as the highest form of Islamic art, above that of the Turks and the Arabs. This ethnically defined hierarchy was the product of a viewpoint that saw inherent racial characteristics as a central force in the evolution of human societies and the belief that race was the main determinant of artistic expression. According to this perspective, because Persians were of Indo-European racial stock they were inherently superior to the Semites

and the Turks. These ethno-racial discourses originated from Orientalist paradigms about the ethnic composition of the Middle East. However, in the nineteenth and twentieth century they also provided the framework for emerging nationalist interpretations of history. It was under the influence of these two forces that the discourse about the racial features of Islamic art flourished.[44]

In this milieu, Persian art was often favorably compared with European art. For example, on the occasion of a display of Persian and Indian manuscripts, drawings, and paintings at the MFA, the museum bulletin drew a direct comparison between these works and Renaissance art, remarking that "the drawings are some of them worthy of Clouet in minute and exact rendering of character."[45] Elsewhere, Bihzad was described as "the Raphael of the East."[46] Such attitudes were also being expressed in emerging scholarship, with academics studying Persian art for the first time borrowing ideas and frames of reference from Renaissance art and applying them to their new field of study.[47]

Aside from the Aesthetic Movement and ethno-racial discourses, early collecting habits were also shaped by emerging trends within American society, including a rapid increase in consumerism in the United States. With the growth of a consumer culture there developed a sort of commodity fetishism, as wealthy individuals built up collections of material objects with which to surround themselves in a flattering manner and establish their status in society.[48] At the same time, new public institutions were being founded that often became sites where social status was enacted. In this era, museums rapidly became prime venues for articulating social identities. Often this was the expression of individual and family status. But it could also be an expression of municipal pride: donors to museums were often motivated by the desire to boost the position of their city, and the collecting of art became one arena in which the rivalry among American cities in this period was played out.[49]

An evocative appraisal of the MFA in its early days by Matthew Prichard (d. 1936), assistant director of the Museum from 1903 to 1906, gives an idea of the forces that shaped the institution:

A few families had a special cult for it, regarded it as their appanage, practised their influence on it, discussed together their activity in its past, their aspirations for its future; on Sundays it was visited by loquacious Italians, but on week days the temple was closed to all save the initiated who appeared to bully the director and oversee their family tombs. For it was recognized that one room belonged to this family and another to that...To understand the Museum of the moment it would be necessary to study savage customs, for it was the last sanctuary of the Boston aborigines, and totem and taboo, animism and magic, custom, rite, precedent and mystery were imprinted all over it....It had its House of Levi, its inherited priesthood; and frightened tradesmen endowed it with their millions that their descendants might be smiled upon by its popes and hierarchs.[50]

Within this intensely competitive context, the desire for social status was probably an important impulse behind the collecting and display of Islamic art. Macomber on one occasion had his collection of "Mohammedan Arms and Armor" put on display in the Forecourt Room of the Museum.[51] This was also where Wetzel exhibited his collection after his round-the-world trip with Ross in 1914.[52] And there is clear evidence that Ross's collecting and donating were motivated by a concern for his status in local society. In 1912, he wrote in a letter to Morris Gray, a trustee of the MFA at that time (who would later be president):

Speaking of the Ross collection, I observe an unwillingness, on the part of those in charge of installation, to mark the objects which I have given to the museum with the words 'Ross collection'. I have repeatedly asked to have this done, but it is not done...I want the words Ross collection attached to every object or group of objects which has been given or loaned by me. By that means I shall be able to speak to the people of Boston long after I am dead, as in a book written or a picture painted.[53]

Thus, in this early period of the twentieth century, the collecting and display of Islamic art were shaped by a variety of forces. The Aesthetic Movement, the influence of ethno-racial discourses about Islamic art, the rise of consumerism, and the pursuit of social status all influenced the activities of collectors and the exhibitions that they organized.

ETHNO-RACIAL INTERPRETATIONS

After the first decade of the twentieth century, gradual changes took place in the Islamic art scene in Boston. At the MFA, Islamic art steadily moved out of its ambiguous position in the Department of Western Art. In 1909, after the museum moved from its original location in Copley Square to Huntington Avenue, the Nearer Orient Room had more of an exclusively Islamic focus. And from 1910 onwards, "Muhammedan art" started to be listed in a separate category in the museum bulletin.[54] In this period there were also changes in personnel. In 1917, Ananda Coomaraswamy (d. 1947) arrived at the museum and founded the Department of Indian Art, which subsequently absorbed the Islamic material.[55]

However, from this point on, far fewer displays of Islamic art were assembled and relatively less attention was devoted to the Islamic collection. Material continued to be acquired steadily in the 1920s and early 1930s, but, compared to the previous two decades, this was a quiet period.[56] After Ross died in 1935, activity decreased even further. From this point on, with the exception of steady donations of Persian art from Edward Jackson Holmes (president of the museum from 1934 until his death in 1950), acquisitions declined.[57]

As activity at the MFA decreased, the Fogg Museum stepped in to take its place. From the 1930s onwards, it became the most important venue for Islamic art, particularly Persian art. In 1930, the Fogg held an exhibition of Persian paintings from the thirteenth century to the seventeenth, again consisting of loans from the Morgan Library in New York.[58] Displays continued through the 1930s; in the spring of 1934, photographs of Persian architecture from the collection of Arthur Upham Pope were exhibited, followed in the winter by a display of Persian miniatures, pottery, and textiles.[59] After this, Persian miniatures from the Ross Collection were shown in 1935, Persian pottery in 1936, and Persian miniatures, pottery, and sculpture in 1937.[60]

The surge of interest in Persian art in this period was heavily influenced by the contemporary political climate and the emerging discourse on Iranian nationalism, which emphasized the existence of a single Persian national identity and saw the Persians as a pure race that had existed undiluted since the era of the Achaemenid Empire (ca. 550–330 B.C.). This conception of Persian identity was articulated simultaneously in different centers around the world. In Iran, it was being promoted by members of the Pahlavi regime, who were trying to establish their new conception of Iranian national identity based on its mythic Persian origins. In the West, it was being voiced by academics and scholars such as Arthur Upham Pope, who were promoting the study of Persian art and culture. Often these forces came to work in tandem, as can be seen, for example, in the founding of the American Institute for Persian Art and Archaeology, an academic organization set up in 1930 by Pope and others, with strong support from the Iranian government.[61]

Nationalist ideology based on the idea of a pure Persian racial identity played an important role in shaping how the Fogg's exhibitions in this period were interpreted. In his reviews in the *Boston Evening Transcript*, Henry S. Francis, an assistant to the directors at the Fogg, interpreted all the displays through an ethno-racial mode. Concerning the 1930 show, he discussed the supposed aversion of Muslims to figural representation, noting that this did not always apply in Persia, where "the time-honored inherent culture of their venerable race broke through."[62] He adopted a similar focus in his review of the 1934 winter show, in which he remarked that "we are immediately aware of an intriguing racial character that runs through it all," and went on to say (rather distatefully) that "one is tempted to guess that the Persians must be a race of large-lens like eyes and thin nervous fingers to create, or enjoy, such minute workmanship."[63]

Although the ethno-racial mode of interpretation was more marked in this period, it is important to keep in mind that a notion of "Islamic" art still existed and Persian art was usually viewed through an Islamic "lens." From this perspective, Islamic art existed within a clearly definable time frame from the 600s to the 1600s. As Francis wrote in his review of the 1930 show, "the 17th century onward showed a rapid decline. The knowledge of European models wholly supplanted native, and the character completely changed. Persian painting ceased to exist."[64] This statement expressed the persistent idea that the Islamic world constituted a "pure," self-contained artistic tradition that was disrupted and irrevocably altered by the arrival of European

modernity. Within this framework, truly "Islamic" art disappeared under the impact of the West and during the era of modernity.[65] From this point on, the narrative went, artists struggled to assimilate Western approaches toward artistic production and were forever engaged in a process of passive imitation; trapped in a cultural void between "tradition" and "modernity," their efforts to emulate Western styles effectively corrupted and polluted their own indigenous traditions. These ideas owed their origins to colonial narratives of Islamic history that emphasized the "decay" of Islamic civilization and the cultural bankruptcy of the Islamic world. The decline of indigenous tradition and the failure to assimilate exterior practices signified a lack of cultural self-confidence and the incapacity of the Islamic world to confront modernity.[66]

THE SEARCH FOR A CURATOR

The 1930s were thus a busy time at the Fogg. But despite all of this activity there was one persistent problem: the lack of a curator to supervise the collections and exhibitions. As noted, in this period the only full-time Islamic specialist in America was Mehmet Aga-Oglu, who was based at the University of Michigan and the Detroit Museum of Fine Arts (fig. 5). Aga-Oglu had grown up in Turkey and studied in Russia, Germany, and Austria before becoming director of the Museum of Turkish and Islamic Art in Istanbul in 1928. Then, in 1929, he left Turkey for America. At the time of his departure, he was connected with a move to Harvard, when he was recommended for a position by Bernard Berenson, who wrote about him to Paul Sachs, associate director of the Fogg:

> I don't see him at Detroit...My ideal for him and for Harvard would be that he profess Islamitic [sic] art in my beloved Alma Mater. It is a far more important field than I could have imagined before going to Turkey. Aga Oglu has moreover material up his sleeve, and ideas which will make him an ornament to any institution that can claim him. I should wish it to be Harvard.[67]

In the end, Aga-Oglu did go to Detroit. In the early 1930s he had occasional employment in the Museum of Anthropology at Michigan. Then, in 1933, he was invited by the University of Michigan to organize a department

Fig. 5. Mehmet Aga-Oglu (1896–1949), n.d. University of Michigan Faculty and Staff Portrait Collection, Bentley Historical Library, University of Michigan. (Photo: courtesy of the Bentley Historical Library)

of Islamic art and was appointed Research Fellow in the History of Islamic Art and Culture before going on to become, by 1935, Freer Fellow and Lecturer on Oriental Art and then Associate Professor of the History of Islamic Art. He also presided over the research seminar on Islamic art and was editor of the journal *Ars Islamica*.

However, throughout the 1930s Berenson continued to promote the idea of Aga-Oglu joining the Fogg Museum or the MFA in some capacity. In 1932, this possibility was met with suspicion by the authorities at the former, who were concerned that his motives might be suspect. Edward Waldo Forbes (d. 1969), then director of the Fogg, contacted various people to request information about Aga-Oglu, including Howland Shaw, a former Harvard student then working at the United States embassy in Istanbul. In his letter, Forbes outlined what he understood as the problem:

> There is a Turkish scholar named Aga-Oglu...he has been recommended to the Boston Museum and the Fogg Museum as a possible scholar whom we might use as an authority on Near Eastern art...[W]e have heard it inti-

mated that this man is a camouflaged dealer and hence
an undesirable person as a museum man. Would it be too
much trouble for you to drop me a line telling me whether
you believe that he is a man of first-rate integrity or simply
one of those people who tries to make use of a position in
a museum to feather his own nest. The man who made the
attack on Dr. Aga-Oglu is a man who is also a camouflaged
dealer and for whom I have little respect; so I do not neces-
sarily take the attack seriously.[68]

Shaw's response made it clear that Aga-Oglu was trust-
worthy. In his letter, he told Forbes, "I have spoken with
Halil Bey, former director of the Museum of Antiquities
in Istanbul, and Halil Bey had a high opinion of Aga-
Oglu as a scholar."[69]

The other person Forbes contacted was Joseph
Upton, assistant curator in the Department of Near
Eastern Art at the Metropolitan Museum of Art. In his
response, Upton expressed concerns about nationalist
sentiments in Aga-Oglu's work: "I believe he has a broad
knowledge of Muhammedan art and of the cultural
background but I believe his historical and stylistic
opinions are colored and biased by an attempt to make
every source of inspiration and development in the field
Turkish."[70] He also expressed concern over giving such
positions to non-Americans.[71] In the end, however, both
these issues were moot, since neither the Fogg nor the
MFA was in a position to hire anyone. As Forbes
explained to Upton: "There is no immediate question
of either the Boston Museum or the Fogg Museum
employing him at the present time because the money
does not seem to be forthcoming just now."[72]

The issue arose again in 1937, when Aga-Oglu
approached the Fogg directly. This time he enquired
about continuing the publication of *Ars Islamica*; he was
leaving Michigan and anxious to find a new home for
the journal.[73] Again Harvard was unable to pursue the
issue. It may have been because of lingering suspicions
about his motives, but there is no definite evidence to
suggest this was the case.

However, soon after this the Fogg did find a curator
for the Islamic collection—Eric Schroeder (fig. 6), hus-
band of Forbes's niece. Born in Britain, Schroeder had
studied at Oxford, where he read literary greats and
modern history.[74] After Oxford, a chance opportunity
to dig in Mesopotamia sparked an interest in the Middle
East. Then, in 1931, he encountered Arthur Upham Pope

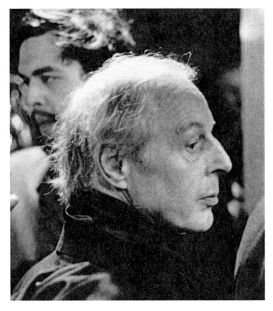

Fig. 6. Eric Schroeder (1904–71), May 1970. From Stuart Cary
Welch, "Eric Schroeder" [obituary], *Acquisitions (Fogg Art
Museum) 1969/1970*: 11. (Photo: courtesy of the Harvard Art
Museum and the President and Fellows of Harvard
College)

at the exhibition of Persian art at Burlington House in
London and soon after joined him in Iran to survey the
Masjid-i Jamiʿ in Isfahan. Pope subsequently invited
Schroeder to contribute to the *Survey of Persian Art*, for
which he wrote the sections on early Islamic architec-
ture and the architecture of the Seljuk period.[75] In the
winter of 1935–36, Schroeder came to America and
began working at the MFA as a volunteer assistant to
Ananda Coomaraswamy.

When he joined the Fogg in 1938, Schroeder was
given the title of "Keeper of Persian Art"; his principal
duty was to write a catalogue of the Persian paintings
in the collection.[76] During his first ten years at the Fogg,
Schroeder did much to promote the display of the
Islamic collection. The presentation of material contin-
ued in the same vein as before, focusing on Persian art
and its ethno-racial qualities. In many ways, Schroeder
can be seen as a direct intellectual descendent of Pope.[77]
The London exhibition of 1931, which Pope had master-
minded, and his subsequent working relationship with
Pope made a huge impression upon Schroeder and
shaped his future approach toward Islamic and Persian

art. Like Pope, he saw Persian art as an expression of the inherent racial characteristics of the Persian people, and in his writing he celebrated the timeless features of Persian artistic achievement. "As a race," he wrote, "it seems evident that the Persians have been the greatest decorators which the world has ever produced."[78] He was particularly interested in the aesthetic features of Persian art, writing in the news release for an exhibition of Persian miniatures: "those who are interested in decoration will find the unique brilliance of Persian colour-harmonies fascinating."[79]

But it is important to note that Schroeder's interest in aesthetics was not limited to Persian art but applied to the wider sphere of *all* Islamic art. As he explained in an entry on Islamic art in the *Encyclopedia of the Arts*, "Muslims…have never looked to artists for special insights or meanings. They regarded the arts as we regard the decorative arts."[80] Schroeder's statement was typical of the thinking of the time. His approach was part of a tradition of studying the Orient that celebrated what was perceived as the uniquely sensual character of that part of the world and the notion that Islamic art was "pure decoration."[81] Within this approach little effort was made to interpret or situate objects in a historical context, or to ask how objects were informed by that context.

While in the 1930s displays at the Fogg focused on Persian art and its ethno-racial character, in the 1940s there was a shift. In 1942, the museum exhibited Persian calligraphy, paintings, bronzes, pottery, and sculpture dating from the eleventh to the seventeenth century. Although this show consisted of works of Persian art, the exhibition was actually billed as a display of "Islamic" art (as opposed to the formerly current terms "Saracenic" or "Mohammedan").[82] Until then, the term "Islamic" had largely been absent from exhibitions at the Fogg. But from this point onwards, its use became increasingly common. In 1945, another exhibition was held, this time described as "Treasures from the Islamic Collection."[83] By the end of the decade, this trend was well established. The starkest illustration of it can be found in "an exhibition expository of the Islamic style" organized by Schroeder in 1949. The news release explained that the display would "emphasize the essential unity of the Islamic style…[C]onsisting of a limited

number of objects, the show will call attention to certain easily observed qualities common to all. Thus, instead of merely sensing the unity of Islamic style, the visitor will come to know in what that unity exists."[84]

A central element of this notion of Islamic art was the idea that this tradition was essentially different from that of the West. As the news release stated: "All Islamic buildings from the Alhambra to the Taj Mahal share qualities of repose and refinement which differentiate them from those on the opposite side of the Mediterranean."[85] Here the essential "otherness" of Islamic art was emphasized through the carving up of world geography into fundamentally distinct artistic zones. This otherness was directly attributed to the religion of Islam which, as the theory went, had developed an artistic outlook that permeated every aspect of artistic endeavor: "[S]ince water vessels, plates and bronzes display these same traits, there may well be some connection between the artistic forms which Mohammedanism inspired and the religion itself."[86] This conception of Islamic art thus carried with it a set of associated ideas: that all Islamic art held certain features in common and that these traits signified such art to be fundamentally different from that of other traditions.

This shift toward an Islamic mode of interpretation, as manifested in the Fogg displays of the 1940s, was almost certainly inspired by a recently published book chapter on "The Character of Islamic Art," by Richard Ettinghausen, in which he outlined the essential features of "the peculiar character of Islamic art."[87] Although he acknowledged regional differences within the Islamic world, he argued these were "only variations of the general Islamic aspect."[88] Schroeder knew Ettinghausen and in this period they also collaborated on a book about Islamic art designed as a college manual for teaching undergraduates.[89]

These ideas about Islamic art did not replace pre-existing notions about racial hierarchies but were rather grafted onto that tradition of thinking. The news release for the 1949 exhibition at the Fogg explained that in Persia the ethno-racial and Islamic influences came together in a combination of the Islamic style and the distinct character of the Persian people: "[I]n Persia, with its artistically gifted people, the idea that art is a more serious kind of endeavor than politics finds

support in the beauty of surviving monuments. It was this view of life that gave the energy necessary for the triumphs of the Islamic style."[90] The ethno-racial discourse and the universalist religious discourse had always coexisted as two sides of the same intellectual tradition. What occurred in this period was not one being eclipsed by the other, but rather the strengthening of the religious discourse within the framework of the ethno-racial one.

JOHN COOLIDGE AND NEW CONCERNS IN THE MIDDLE EAST

As the century progressed into the 1950s, further developments had an impact on the study of Islamic art in Boston. In 1948, John Coolidge was appointed director of the Fogg Museum (fig. 7). From a well-established Cambridge family, Coolidge studied at Harvard, graduating in 1935, as well as at New York University (1936–43). During World War II, he worked in the U.S. navy, and after the war taught briefly at the University of Pennsylvania, before joining Harvard in 1947 as assistant professor in the Department of Fine Arts.[91]

Coolidge arrived at the Fogg with a clear ambition to begin a new era in the study and teaching of art history at Harvard. In recent years Harvard had lost its lofty place in the field of fine arts as Yale and the Institute of Fine Arts (part of New York University) came to the fore.[92] Coolidge was anxious to restore Harvard to its position of preeminence, and one of the areas he identified where it could build up its position was Near Eastern and Islamic art. As he wrote to McGeorge Bundy (d. 1996), then dean of the Faculty of Arts and Sciences: "as far as I can make out, nowhere in this country does anybody teach Islamic art. Personally I should like this to be Harvard's specialty."[93]

To do this he brought in key new personnel. Among the first was Joseph McMullan (d. 1973), who held the position of Honorary Research Fellow in Islamic Art from 1950 to 1951. A businessman who made a fortune from steel-pipe manufacturing, McMullan had a lifelong passion for rugs, particularly those from the Islamic world, and became a high-profile collector and connoisseur. In addition to collecting, he was an important vehicle for the wider dissemination of knowledge about

Fig. 7. Portrait of John Coolidge, n.d. Papers of John Coolidge (HC15), file 134. Harvard Art Museums Archives, Harvard University, Cambridge, MA. (Photo: courtesy of the Harvard Art Museums Archives)

Islamic art, and was often invited to give lectures and talks on his subject to local intellectual groups. He also donated generously to Harvard to support the study of Islamic art.[94]

Another key person was Stuart Cary Welch (fig. 8). From 1952 to 1954 he pursued graduate studies in Islamic art at Harvard (though without gaining a doctoral degree), and in 1957 was appointed assistant curator at the Fogg. He would later become a lecturer in the Department of Fine Arts.[95] Welch's presence helped to spur on activity related to the study of Islamic art, mainly because of his contributions to the Fogg's collections. He spent much of the 1950s travelling in the Middle East and Asia, acquiring material for the museum. Most of the items he purchased were Persian and Indian paintings, manuscripts, and drawings, reflecting his particular interests and taste. With his involvement, John Coolidge's enthusiasm for the field rapidly developed. As Coolidge wrote to Welch in the summer of 1957: "Eric Schroeder soon converted me to

Fig. 8. Stuart Cary Welch (1928–2008), Hyderabad, India, 2007. (Photo: Bill Wood, courtesy of Thomas Welch)

Islamic art and anything that furthers the study of this subject at Harvard gives me keen personal happiness. Your coming here has done more to further this cause than anything since I've been around."[96]

These developments coincided with a period in which the United States was undergoing fundamental changes in its relationship with the Middle East. After World War II, just as the United States emerged as a global superpower, the Middle East, with its enormous oil reserves, began to play a critical role in the Cold War. There was widespread fear that states in the region were at risk of falling to Communism. As a result of these strategic concerns, the U.S. government had much at stake in the Middle East, and the desire to control the region's oil resources and impose a degree of hegemony upon it became central to U.S. foreign policy.[97] As part of this endeavour, a number of strategic studies centers were established, with the aim of generating policy-relevant knowledge about the region. Much of the money for these centers came from foreign policy foundations

whose interests were connected with those of the U.S. government. At Harvard, the Center for Middle Eastern Studies (CMES) was set up in 1954.[98]

From the outset, the focus of the Center was on the modern Middle East. It aimed to address contemporary issues through the multidisciplinary study of the region, covering fields such as language, history, politics, economics, and culture.[99] In 1955, Sir Hamilton Gibb left his position as professor of Arabic at Oxford to become director of CMES. He brought with him a particular vision of how the Middle East should be studied and promoted the idea of "academic amphibians," a species of scholar who would be able to cross easily between different disciplines.[100] As part of this vision, he took a keen interest in art history. In 1958, he wrote to Coolidge:

> We at this center have been thinking for some time about the ways and means in which the art of the Middle East could be activated as a subject of study. I need hardly emphasise to you the importance of the aesthetic and practical arts as one of the fundamentals by which a culture can be assessed and analysed, and while the art of the Middle East has its importance for students in many fields, the arts of the Islamic civilisation are of special significance to students working in or associated with this center.[101]

CMES undoubtedly had a marked and early influence upon the study of Islamic art at Harvard, as can be seen from an exhibition of Turkish art held at the Fogg in 1954. This display, put together by Schroeder and McMullan as part of a new course on the Turks in history, entitled "The Ottoman Empire and the Near East Since the End of the 13th Century,"[102] consisted of a wide range of materials and was meant to "identify visually the characteristics of the Turks themselves."[103] In some respects the show continued pre-existing trends. The ethno-racial paradigm was strongly apparent in the press release, which explained that "a contrast between Turkish and non-Turkish art in the medieval Islamic style will be the basis of an attempt to connect formal differences with national characteristics."[104] But in other respects this display marked a shift in the way the material was interpreted. Rather than treating the decorative aspects of Turkish art, or the characteristics of a supposed "Islamic" style, the explicit aim of the show, in keeping with the Center's interest in current affairs, was to demonstrate the development of the Turks

through history in order to understand their position in the contemporary world. By attempting to consider objects through their function and meaning in their original historical context, the show signified a moment where the study of Islamic art began to move away from a purely aesthetic approach toward situating objects in the wider sphere of socio-political history.[105]

Thus, in the 1950s a combination of factors—the arrival of new personnel, America's changing relationship with the Middle East, the creation of CMES—came together to act as a spur towards the increased study of Islamic art. While these changes were taking place, Coolidge took an ever-keener interest in the field and began to articulate his own vision of why it was important to study Islamic art. As he explained in a memorandum entitled "A Teaching Curatorship of Near Eastern Art":

> There is no need to emphasize the rapidly increasing importance of the Near East in the world today. This situation imposes new responsibilities on the United States. Our country's role is to promote peace in a part of the world peculiarly riven by national, racial, and religious hatreds. We can only begin to succeed in this role if future generations of Americans gain some understanding of the area's full range of cultures: Egyptian, Mesopotamian, Greco-Roman, Muslim, and Jewish.[106]

Elsewhere he wrote:

> The events of the past year have forced the United States to assume new, serious and permanent commitments in the Near East. Policy in a democracy is determined by public opinion, and over the long run sound policy depends upon sound public understanding. To promote such understanding Harvard should encourage the study of all Near Eastern cultures....[n]o approach is more accessible, no method more revealing than the study of Near Eastern art.[107]

While Coolidge was clearly devoted to developing the study of Islamic art for its own sake, his ambitions were also shaped by underlying geopolitical concerns such as oil, hegemony, and American power in the Middle East. And, crucially, Coolidge was an outsider to the field. Although interested in Islamic art, he was not a specialist, and many of the things he expected it to deliver were unrealistic. In relating the field of Islamic art history to contemporary political affairs, Coolidge was implicitly searching for overarching generalizations

that could be extracted from an abstract and timeless conception of "Islamic" culture and applied to a seemingly unfathomable part of the world in order to render it more understandable. Coolidge's statements are an articulation of a problem that has hung over the study of Islamic art for several decades, namely, the expectation that as an academic discipline it should be able to provide relevant knowledge about the current affairs of the Middle East.[108]

With his growing interest in Islamic art, Coolidge began to devise schemes to expand its study. One of his main concerns was how to convert Harvard's Semitic Museum into a center for teaching Islamic art, an idea first proposed in the early 1950s by McMullan and himself. At that stage, before CMES had been established, they had envisaged overhauling the entire building and converting it into a center for research and teaching about the Middle East.[109] Later, after CMES had been founded, Coolidge focused his efforts on raising money so that the museum could house a department devoted to Near Eastern art.[110] In the end, however, these plans were not realized. Funding was a problem and Coolidge also suspected that there might be strong personal feelings attached to the disbanding of the museum. In the summer of 1957 he concluded that "for the time being at least I visualise the Fogg providing the headquarters for the study of Near Eastern Art."[111]

Thus, in 1958, Coolidge was keen to press ahead with his plans, having decided that the Fogg Museum would be the best place to house a center for Islamic art. But now he needed to know what materials were available to teach the subject. He therefore commissioned Florence Day, who had originally been brought to his attention by Sir Hamilton Gibb, to produce her survey assessing all the resources in Boston that could be used to develop the field.[112] Coolidge thought that once armed with this knowledge, they would be equipped to launch a program in Islamic art.

However, as noted earlier, the report was not met with enthusiasm. But what was so problematic about it? Why were Coolidge and Schroeder unimpressed by it? The answer lies in the nature of the report Day produced. She saw the study of Islamic art as an archaeological pursuit, believing that the true essence of the subject was to be found in the early centuries of the Islamic era. As she wrote in her introduction:

It must be pointed out that the early Islamic period, especially the first three hundred years up to about 900 AD, is the most important, because it was then that artistic traditions and criteria were established, and thus it is essential to everything else that follows...But the period after 1500 AD is to all intents the modern period, so its material is simply summarized in groups—for it would be an expense of spirit to list it one by one...[113]

Throughout the report Day continued in the same vein, only ever giving scant attention to later Islamic art. It was thus a perfect encapsulation of the normative view expressed by Frank Macomber and Garrick Borden half a century previously. Neither Coolidge nor Schroeder shared this perspective. Coolidge expected Islamic art to offer insights into the contemporary Middle East, and a survey of archaeological holdings offered no prospect of this. Schroeder, meanwhile, thought the report useless because of its heavy focus on early Islamic art, to the exclusion of the later periods in its development. Operating within an ethno-racial paradigm that saw sensual decoration and the Persian miniatures of the thirteenth to the sixteenth centuries as the *ne plus ultra* of Islamic art, he felt the report grossly skewed the entire field and neglected what he regarded as the most distinguished period in the Islamic artistic tradition.[114] Denman Ross had also adhered to this point of view, though to a lesser extent.

In this way the Day report represented the convergence of several different discourses on the study of Islamic art that had been circulating continuously around Boston throughout the first half of the twentieth century, resurfacing and reemerging at different moments, depending on particular circumstances.[115]

CONCLUSION

During the first half of the twentieth century, the study of Islamic art in Boston moved through a succession of phases. In the first two decades, when the MFA was the most important center of activity, the influence of the Aesthetic Movement encouraged the de-contextualized and de-historicized viewing of art objects. Amateurs driven by a connoisseurial interest in beauty and the pursuit of social status began to form and display collections of Islamic art.

In the 1930s, activity shifted from the MFA to the Fogg Art Museum. In this period, attention was focused on Persian art, which was interpreted in terms of its racial and decorative qualities. These activities were heavily shaped by emerging discourses about Iranian nationalism that were being articulated simultaneously by scholars in the West and by nationalists in Iran.

In the 1940s and 1950s, activity continued to be focused on the Fogg. In this period, the study of Islamic art was more closely subjected to academic and intellectual agendas. Some of these were positive: as Islamic art was connected with other fields, the interpretative framework in which objects were displayed was broadened. Others, however, were problematic: with the changing position of the United States in global politics and the rise of the Middle East as an area of major strategic interest, the exigencies of contemporary politics led outsiders to the field to make demands upon it that it could not meet.

During this period, the study of Islamic art remained a field dominated by figures from Europe and America. The one scholar from the Middle East who was active at this time, Mehmet Aga-Oglu, was marginalized within the discipline.[116] Between the different figures who did play a role in shaping the subject and the outlooks they represented, the study of Islamic art was pulled in different directions, influenced by a variety of factors, some international, others unique to the United States and the social and political life of the East Coast. The legacy of this period can still be felt strongly in the field today.

Independent Scholar,
London, England

NOTES

Author's note: This article grew out of a master's thesis at Harvard's Center for Middle Eastern Studies, supervised by Professor David J. Roxburgh, which in turn grew out of a seminar paper supervised by Professor Nasser Rabbat at MIT. I am very grateful to them and to Professor Gülru Necipoğlu for their comments on drafts of this article. I would also like to express my gratitude to Susan von Salis, Curator of Archives at Harvard Art Museums, who sadly passed away in 2012. I thank as well her assistants, Jane Callahan and Erin Mackin, as well as Laura Weinstein, for their help with archival research.

1. Letter from John Coolidge to Florence Day, March 27, 1958. John Coolidge and Agnes Mongan Papers (HC 5), file 501. Harvard Art Museums Archives, Harvard University, Cambridge, MA.

2. Ibid.

3. In her capacity as a ceramics specialist, Day had reviewed the chapters on ceramics in Arthur Upham Pope and Phyllis Ackerman, eds., *A Survey of Persian Art from Prehistoric Times to the Present*, 6 vols. (London, 1938). She also had some publications on textiles and had been at the center of a controversial debate over the dating of a collection of Buyid silks, some of which she had correctly exposed as forgeries. See Florence E. Day, untitled review of *Soieries Persanes* by Gaston Wiet, *Ars Islamica* 15–16 (1951): 231–44. For a later overview of the whole debate, see Sheila S. Blair, Jonathan M. Bloom, and Anne E. Wardwell, "Reevaluating the Date of the 'Buyid' Silks by Epigraphic and Radiocarbon Analysis," *Ars Orientalis* 22 (1992): 1–41. Mehmet Aga-Oglu is discussed in greater detail later in this article.

4. Florence E. Day, "Plans for Research." John Coolidge and Agnes Mongan Papers (HC 5), file 501. Harvard Art Museums Archives, Harvard University, Cambridge, MA.

5. Day Report on Islamic Art. Archives Department, Box 127. Harvard Art Museums Archives, Harvard University, Cambridge, MA.

6. Letter from John Coolidge to Agnes Mongan, July 22, 1960. John Coolidge and Agnes Mongan Papers (HC 5), file 501. Harvard Art Museums Archives, Harvard University, Cambridge, MA.

7. Letter from Eric Schroeder to John Coolidge, undated. John Coolidge and Agnes Mongan Papers (HC 5), file 501. Harvard Art Museums Archives, Harvard University, Cambridge, MA.

8. For overviews of the development of the field, see Sheila S. Blair and Jonathan Bloom, "The Mirage of Islamic Art: Reflections on the Study of an Unwieldy Field," *Art Bulletin* 85, 1 (March 2003): 152–84; Stephen Vernoit, "Islamic Art and Architecture: An Overview of Scholarship and Collecting, c. 1850–c. 1950," in *Discovering Islamic Art: Scholars, Collectors and Collections, 1850–1950*, ed. Stephen Vernoit (London, 2000), 1–62; Sibel Bozdoğan and Gülru Necipoğlu, "Entangled Discourses: Scrutinizing Orientalist and Nationalist Legacies in the Architectural Historiography of the 'Lands of Rum,'" in "Historiography and Ideology: Architectural Heritage of the 'Lands of Rum,'" ed. Gülru Necipoğlu and Sibel Bozdoğan, special issue, *Muqarnas* 24 (2007): 1–7; Oleg Grabar, "Islamic Art and Archaeology," in *The Study of the Middle East: Research and Scholarship in the Humanities and the Social Sciences*, ed. Leonard Binder (New York, 1976), 229–63; Oleg Grabar, "Reflections on the Study of Islamic Art," *Muqarnas* 1 (1983): 1–14; and Gülru Necipoğlu, "Ornamentalism and Orientalism: The Nineteenth- and Early-Twentieth-Century European Literature," in *The Topkapı Scroll: Geometry and Ornament in Islamic Architecture; Topkapı Palace Museum Library MS H. 1956* (Santa Monica, Calif., 1995), 61–109. For a survey of the development of Islamic archaeology, see Stephen Vernoit, "The Rise of Islamic Archaeology," *Muqarnas* 14 (1997): 1–10, and John M. Rogers, "From Antiquarianism to Islamic Archaeology," *Quaderni dell'Istituto Italiano di Cultura per la R.A.E*, n.s. 2 (1974): 9–65.

9. See essays in Vernoit, *Discovering Islamic Art*, and Rémi Labrusse, *Purs décors?: Arts de l'Islam, regards du XIXe siècle: Collection des Arts Décoratifs*, exh. cat. (Paris, 2007). For a discussion of early collections in Europe, see David J. Roxburgh, "Au Bonheur des Amateurs: Collecting and Exhibiting Islamic Art, ca. 1880–1910," *Ars Orientalis* 30 (2000): 9–38.

10. See Marylin Jenkins-Madina, "Collecting the 'Orient' at the Met: Early Tastemakers in America," *Ars Orientalis* 30 (2000): 69–89; Marianna Shreve Simpson, "'A Gallant Era': Henry Walters, Islamic Art, and the Kelekian Collection," *Ars Orientalis* 30 (2000): 91–112; Stuart Cary Welch, "Private Collectors and Islamic Arts of the Book," in *Treasures of Islam*, ed. Toby Falk, exh. cat. (London, 1985), 25–31; and Julia Bailey, "Early Rug Collectors of New England," in *Through the Collector's Eye: Oriental Rugs from New England Private Collections*, ed. Susan Anderson Hay (Providence, R.I., 1991), 12–21.

11. Kishwar Rizvi, "Art History and the Nation: Arthur Upham Pope and the Discourse on 'Persian Art' in the Early Twentieth Century," *Muqarnas* 24 (2007): 47.

12. For a brief obituary of Mehmet Aga-Oglu, see Maurice Dimand, "Mehmet Aga-Oglu," *College Art Journal* 9, 2 (Winter 1949–50): 208–9. For his full biography, see Semavi Eyice, *Türkiye Diyanet Vakfı İslâm Ansiklopedisi* (Istanbul, 1988–), s.v. "Mehmet Ağaoğlu," esp. 466. In 1938, Richard Ettinghausen, who had previously taught at New York University, took over this position and the editing of *Ars Islamica*. After a successful business career, Freer devoted his life and fortune to collecting art—at first American and European, but ultimately focusing on Japan, Korea, and China. In 1920, he gave a $50,000 gift of stock to the University of Michigan to promote the study of "Oriental art." It is not clear how or why this broadly defined endowment was eventually allocated to a specific endeavor to support the study of Islamic art.

13. For a history of the museum, see Walter Muir Whitehill, *Museum of Fine Arts, Boston: A Centennial History* (Cambridge, Mass., 1970).

14. For an overview of Islamic art collecting at Harvard, see Stuart Cary Welch, "From Currant Cake to Shahnamehs, and Beyond," in *Harvard's Art Museums: 100 Years of Collecting*, ed. James B. Cuno (Cambridge, Mass., and New York, 1996), 122–27.

15. For full details of the Islamic material in the Gardner collection, see Yasuko Horioka, Marylin Rhie, and Walter B. Denny, *Oriental and Islamic Art in the Isabella Stewart Gardner Museum* (Boston, 1975). Also see Alan Chong, Richard Lingner, and Carl Zahn, eds., *Eye of the Beholder: Masterpieces from the Isabella Stewart Gardner Museum* (Boston, 2003), 161–71, for selected highlights from this material.

16. For an intellectual and cultural biography of Ross, see Marie Ann Frank, *Denman Ross and American Design Theory* (Hanover, N.H., 2011).

17. When travelling in India he noted that he was "doing this Mohammedan part of India rather rapidly, because it does not interest us so very much. The buildings and the sculpture are too late to be good. Even the Taj Mahal leaves me cold and unmoved. It is the India of Buddhism and of Brahmanism that really interests me." Later he had a similarly underwhelmed response in Morocco; although the country was "intensely interesting," he complained that there were "very few important buildings, buildings that count as works of art." See Denman Ross to Isabella Stewart Gardner, February 11, 1913, and April 6, 1921. Smithsonian Institution, Archives of American Art, Isabella Stewart Gardner Papers, 1760–1956.

18. See the obituary for Ross in *Bulletin of the Museum of Fine Arts* 33, 200 (December 1935): 18.

19. Its acquisition also depended on the brokering of Rudolf Riefstahl, a scholar/dealer based in Europe. Victor Goloubew, Russian by birth, was a scholar and collector based in Paris. His collection, one of the most extensive at that time, had been on display for several years at the Musée des Arts Décoratifs. He sold these works to the MFA in order to start collecting Chinese art. See the *Bulletin of the Museum of Fine Arts* 13, 74 (February 1915). For details of the background to its acquisition, see Erin Bauer, "The Goloubew Collection: A Transatlantic History" (PhD qualifying paper, Department of History of Art and Architecture, Harvard University, 2005). For further details on the collection, see Ananda K. Coomaraswamy, *Les miniatures orientales de la collection Goloubew au Museum of Fine Arts de Boston* (Paris, 1929).

20. For a brief summary of Wetzel's life, see *Bulletin of the Museum of Fine Arts* 16, 93 (February 1918): 88. For information on the half of his collection that he donated to the Fogg, see "Gems of Eastern Art Reach Harvard," *Boston Daily Globe*, November 2, 1919. His collection was diverse, and included Chinese, Japanese, Korean, and Persian art.

21. For information specifically about Gardner's engagement with Asian art and her travels in China, Japan, Southeast Asia, India, and the Middle East, see Alan Chong, ed., *Journeys East: Isabella Stewart Gardner and Asia* (Boston, 2009).

22. See *Bulletin of the Museum of Fine Arts* 1, 1 (March 1903): 8; and *Bulletin of the Museum of Fine Arts* 13, 45 (June 1910): 23. The role of dealers in the formation of these collections is beyond the scope of this paper. However, it is certainly a subject that deserves further research. For more information about Kelekian and his relationship with the Metropolitan Museum of Art, and the Walters Art Museum in Baltimore, see Jenkins-Madina, "Collecting the 'Orient,'" 73–76, and Simpson, "'A Gallant Era.'"

23. On Berenson's engagement with Islamic art, see Priscilla Soucek, "Walter Pater, Bernard Berenson, and the Reception of Persian Manuscript Illustration," *Res: Anthropology and Aesthetics* 40 (2001): 113–28; Gauvin Alexander Bailey, "The Bernard Berenson Collection of Islamic Painting at Villa I Tatti: Mamluk, Ilkhanid, and Early Timurid Miniatures. Part I," *Oriental Art* 47, 4 (2001): 53–62; and Gauvin Alexander Bailey, "The Bernard Berenson Collection of Islamic Painting at Villa I Tatti: Turkman, Uzbek, and Safavid Miniatures. Part II," *Oriental Art* 48, 1 (2002): 2–16.

24. For a short overview of this collection, see Richard Ettinghausen, *Persian Miniatures in the Bernard Berenson Collection* (Milan, 1961).

25. Chong, *Journeys East*, 36.

26. Letters from Bernard Berenson to Paul Sachs, October 13, 1928; March 17, 1929; and January 15, 1930. Paul J. Sachs Papers (HC 3), file 138. Harvard Art Museums Archives, Harvard University, Cambridge, MA.

27. *Bulletin of the Museum of Fine Arts* 14, 83 (June 1916): 19.

28. "Harvard Art Instructor," *Boston Daily Globe*, May 25, 1912.

29. *Annual Report of the Museum of Fine Arts, Boston* (1911): 123. Unfortunately the content of this course could not be found.

30. "Opens Series," *Boston Daily Globe*, January 6, 1911.

31. "Reasons why teachers of history should study Moslem History, Civilization and Art," undated document, Fine Arts, Harvard Depository.

32. See, for example, H. A. R. Gibb, *Mohammedanism: An Historical Survey* (London, 1949). For a critique of the Islamic civilization model, see Zachary Lockman, *Contending Visions of the Middle East: The History and Politics of Orientalism* (New York, 2004), 75–77.

33. The umbrella term "Islamic" has proved hard to shake and continues to be used as a framing device for the discipline, particularly in surveys of the field (though with declining frequency). It also continues to be used as a framing device for exhibition programming: see Sheila S. Blair and Jonathan M. Bloom, *Cosmophilia: Islamic Art from the David Collection, Copenhagen* (Chestnut Hill, Mass., and Chicago, 2006).

34. "Leaflet Guide to the New Museum Building" (addendum to *Bulletin of the Museum of Fine Arts* 7, 39 [June 1909]).

35. Whitehill, *Museum of Fine Arts*, 240.

36. Exhibition Records (HC 6), files 1832–1833. Harvard Art Museums Archives, Harvard University, Cambridge, MA.

37. Called "Gems of Eastern Art."

38. See Gilbert W. Longstreet, comp., *The Isabella Stewart Gardner Museum General Catalogue* (Boston, 1935), 149–70, and 212–30. The Gardner Museum remained unchanged in its layout from its foundation, as stipulated by Gardner herself.

39. The Arts and Crafts Movement emerged in Britain and lasted from roughly 1860 to 1910. Led by the artist William Morris, it was a reaction against the effects of industrialization and promoted the practice of traditional craftsmanship using simple forms and a return to medieval and folk styles of decoration.

40. For an overview of the Aesthetic Movement in America, see Roger B. Stein, "Artifact as Ideology: The Aesthetic Movement in Its American Cultural Context," in *In Pursuit of Beauty: Americans and the Aesthetic Movement*, ed. Doreen Bolger Burke et al. (New York, 1986), 22–51; and

Holly Edwards, *Noble Dreams, Wicked Pleasures: Oriental-ism in America, 1870–1930* (Princeton, N.J., 2000), 182–85.

41. Theodore Sizer, "Draft Article for the Dictionary of American Biography." Denman Waldo Ross Papers. Harvard Art Museums Archives, Harvard University, Cambridge, MA.

42. "The Wetzel Exhibition," *Bulletin of the Fogg Art Museum* 1, 1 (November 1931): 2.

43. For more discussion of Berenson's influence on early scholarship on Islamic art, see G.A. Bailey, "Bernard Berenson Collection of Islamic Painting at Villa I Tatti: Turkman, Uzbek, and Safavid Miniatures," 16.

44. For a discussion of issues connected with these discourses, the way they have intersected, and the implications for scholarship past and present, see Bozdoğan and Necipoğlu, "Entangled Discourses"; Gülru Necipoğlu, "Creation of a National Genius: Sinan and the Historiography of 'Classical' Ottoman Architecture," *Muqarnas* 24 (2007): 141–83; Heghnar Zeitlian Watenpaugh, "An Uneasy Historiography: The Legacy of Ottoman Architecture in the Former Arab Provinces," *Muqarnas* 24 (2007): 29; and Vernoit, "Islamic Art and Architecture: An Overview," 6–7. While the categories of "Arab" and "Turkish" have largely been deconstructed and abandoned, the idea of "Persian" art still holds strong. See, for example, *Studies in Honor of Arthur Upham Pope, Survey of Persian Art*, vol. 18, ed. Abbas Daneshvari (Costa Mesa, Calif., 2005.)

45. *Bulletin of the Museum of Fine Arts* 12, 68 (February 1914): 5.

46. *Bulletin of the Museum of Fine Arts* 13, 74 (February 1915): 3.

47. See Soucek, "Walter Pater, Bernard Berenson." The interest in Persian art was also related to the Art Nouveau Movement (ca. 1890–1910), which inspired a growing interest in non-Western art and encouraged appreciation of a wider range of arts, including textiles, furniture, glassware, book design, and jewelry. Iranian glassware in particular was a source of inspiration for Art Nouveau artists. See Vernoit, "Islamic Art and Architecture: An Overview," 29.

48. The archetypal example of this is Frederic Church and the art collection that he built up at his home, Olana. See Edwards, *Noble Dreams*, 30.

49. Neil Harris, "Collective Possession: J. Pierpont Morgan and the American Imagination," in *Cultural Excursions: Marketing Appetites and Cultural Tastes in Modern America*, ed. Neil Harris (Chicago, 1990), 267–68.

50. Quoted in Whitehill, *Museum of Fine Arts*, 212–13. Prichard was actually writing about a slightly earlier period in the museum's history, the 1890s. However, there is no reason to believe that these aspects of museum life should not have continued into the early twentieth century.

51. *Bulletin of the Museum of Fine Arts* 14, 83 (June 1916): 19.

52. *Bulletin of the Museum of Fine Arts* 12, 71 (August 1914): 41–42.

53. Denman Waldo Ross to Morris Gray, August 15, 1912. Smithsonian Institution, Archives of American Art: Museum of Fine Arts, Boston, Directors' Correspondence, 1901–1954.

54. See Whitehill, *Museum of Fine Arts*, 240. This was part of a broader trend at the museum away from classification by medium toward arranging materials by region and period.

55. Coomaraswamy brought with him to the MFA his collection of Rajput and Jaina paintings and small Indian bronzes. For a biography of Coomaraswamy, along with a select bibliography and the reproduction of some of his essays, see Roger Lipsey, ed., *Coomaraswamy*, Bollingen Series, 3 vols. (Princeton, N.J., 1977).

56. The one significant venture of this period was the excavation of Rayy undertaken by the MFA together with the Iranian government and the University of Pennsylvania. However, the MFA withdrew in 1937 after it became clear that most of the finds were of archaeological rather than artistic interest. See Whitehill, *Museum of Fine Arts*, 530.

57. After Coomaraswamy died in 1947, there was no Islamic art curator until Milo Cleveland Beach arrived in 1964.

58. Exhibition Records (HC 6), file 2011. Harvard Art Museums Archives, Harvard University, Cambridge, MA.

59. Exhibition Records (HC 6), files 2009–2010. Harvard Art Museums Archives, Harvard University, Cambridge, MA.

60. Exhibition Records (HC 6), files 2002–2008, 2478–2479. Harvard Art Museums Archives, Harvard University, Cambridge, MA. It is not clear who curated these shows. After Ananda Coomaraswamy arrived at the MFA, he occasionally lent his expertise in putting together catalogues, publicity material, and wall postings, so he might have helped with these exhibitions. Letter from Edward Waldo Forbes to Ananda Coomaraswamy, December 10, 1932. Edward Waldo Forbes Papers (HC 2), file 249. Harvard Art Museums Archives, Harvard University, Cambridge, MA.

61. See Rizvi, "Art History and the Nation."

62. *Boston Evening Transcript*, January 29, 1930. Exhibition Records (HC 6), file 2011. Harvard Art Museums Archives, Harvard University, Cambridge, MA.

63. *Boston Evening Transcript*, December 1, 1934. Exhibition Records (HC 6), file 2009. Harvard Art Museums Archives, Harvard University, Cambridge, MA.

64. See n. 62 above.

65. See Finbarr Barry Flood, "From the Prophet to Postmodernism? New World Orders and the End of Islamic Art," in *Making Art History: A Changing Discipline and Its Institutions*, ed. Elizabeth C. Mansfield (New York, 2007), 31–39. This idea has been very influential in the field and remains so to this day. In a recent appraisal of the field, Blair and Bloom, "Mirage of Islamic Art," 175, assert that twentieth-century art from the Islamic world should best be left to scholars of the contemporary arts, since it is altogether different from the true artistic traditions of the Islamic world. Although these remarks were meant as a corrective to the idea of the "unchanging East," such notions actually perpetuate the enforced dichotomy between an Islamic, "pre-modern" tradition and art produced under the era of Western-induced modernity. There is no reason why such subjects should not be of interest to both scholars of classical Islamic art *and* those of contemporary art.

66. For a standard example of the disparaging way in which such art has been viewed, see Basil Robinson, "Persian Painting under the Zand and Qajar Dynasties," in *The Cam-*

bridge History of Iran, vol. 7, *From Nadir Shah to the Islamic Republic,* ed. Peter Avery, Gavin Hambly, and Charles Melville (Cambridge, 1991), 870–89.

67. Letter from Bernard Berenson to Paul Sachs, March 17, 1929. Paul J. Sachs Papers (HC 3), file 138. Harvard Art Museums Archives, Harvard University, Cambridge, MA.

68. Letter from Edward Waldo Forbes to Howland Shaw, April 29, 1932. Edward Waldo Forbes Papers (HC 2), file 16. Harvard Art Museums Archives, Harvard University, Cambridge, MA. It is not clear who the other "camouflaged dealer" was to whom Forbes refers. However, it is worth noting that many scholars at that time were also dealers, notably Arthur Upham Pope and Rudolf Riefstahl.

69. Letter from Howland Shaw to Edward Waldo Forbes, May 19, 1932. Edward Waldo Forbes Papers (HC 2), file 16. Harvard Art Museums Archives, Harvard University, Cambridge, MA. Halil Bey had sent Aga-Oglu to study in Europe, grooming him to become director of the Islamic art collection in Istanbul. See Necipoğlu, "Creation of a National Genius," 159.

70. Letter from Joseph Upton to Edward Waldo Forbes, May 16, 1932. Edward Waldo Forbes Papers (HC 2), file 16. Harvard Art Museums Archives, Harvard University, Cambridge, MA. Concern over the influence of scholars from the Islamic world persists even now, though in a slightly different form. Today, rather than being informed by a fear of nationalist sentiment, the concern is often voiced that scholars from the Islamic world may be driven by a search for identity rather than an "objective" scholarly interest. See Blair and Bloom, "Mirage of Islamic Art," 176.

71. Ibid. As Upton explained in his letter: "I do feel very strongly, Mr Forbes, on the matter of American museums hiring Europeans for their staff. I am not one to try to always make the American eagle scream...but I do believe that there is no reason why, with patience and opportunity, we cannot develop American archaeologists and museum curators every bit as capable as those in Europe."

72. Letter from Edward Waldo Forbes to Joseph Upton, May 20, 1932. Edward Waldo Forbes Papers (HC 2), file 16. Harvard Art Museums Archives, Harvard University, Cambridge, MA.

73. Letters from Mehmet Aga-Oglu to Paul Sachs, October 11, 1937, and January 18, 1938. Paul J. Sachs Papers (HC 3), file 17. Harvard Art Museums Archives, Harvard University, Cambridge, MA. It is not clear from these letters whether Aga-Oglu was just searching for a home for the journal *Ars Islamica* or was also looking for a teaching position for himself.

74. For an account of Schroeder, memories of his contributions to life at Harvard, and his full bibliography, see the tribute to him by Stuart Cary Welch, "Eric Schroeder" [obituary], in *Acquisitions (Fogg Art Museum) 1969/1970,* 9–30.

75. Pope and Ackerman, *Survey of Persian Art.*

76. Letter from Edward Waldo Forbes to Eric Schroeder, March 26, 1938. Edward Waldo Forbes Papers (HC 2), file 1898. Harvard Art Museums Archives, Harvard University, Cam-

bridge, MA. As Forbes explained in his letter, on account of the temporary absence of Langdon Warner (a specialist in Chinese and Japanese art), the Fogg had $500 to spare with which they could employ Schroeder on a part-time basis. Initially he was only employed for a year, with no guarantee of renewal after that. For the catalogue, see Eric Schroeder, *Persian Miniatures in the Fogg Museum of Art* (Cambridge, Mass., 1942). Schroeder remained at the Fogg until his death in 1971. Although he organized many exhibitions during his time at Harvard, he did not engage in any teaching. In his letter offering him work, Forbes explained to Schroeder that: "[w]e are unable just now to invite you to give a course at Harvard but it will be perfectly possible we are sure to arrange to have you give a small course of 3 or 4 or 6 public lectures on Persian art. The decision to invite you to give this course of public lectures rather than a regular university course is the result of a difficult situation which involves various people and in no way is a reflection on your capacity to give such a course." Stuart Cary Welch believed that Schroeder was barred from teaching because there were concerns about his pro-German sentiment (telephone interview, December 2, 2006). See also Welch, "Private Collectors and Islamic Arts of the Book," 29. Schroeder's private papers contain outlines for courses he taught on Persian painting, so it is quite possible that he did some teaching privately.

77. For a discussion of Pope's approach to Persian art, see Barry D. Wood, " 'A Great Symphony of Pure Form': The 1931 International Exhibition of Persian Art and Its Influence," *Ars Orientalis* 30 (2000): 117–19; and Rizvi, "Art History and the Nation."

78. Eric Schroeder, "6000 Years of Persian Art," *Parnassus* 12, 5 (1940): 20.

79. News Release, undated. Exhibition Records (HC 6), file 2011. Harvard Art Museums Archives, Harvard University, Cambridge, MA.

80. Eric Schroeder, *Encyclopedia of the Arts,* ed. Dagobert D. Runes and Harry G. Schrikel (New York, 1946), s.v. "Islamic Art." For a similar viewpoint expressed more recently, see Blair and Bloom, *Cosmophilia.*

81. See the essays in Labrusse, *Purs décors?,* in particular Gülru Necipoğlu, "L'idée de décor dans les régimes de visualité islamiques," 10–23. See also Necipoğlu, *Topkapı Scroll,* 61–71.

82. See n. 79 above.

83. "Hand-List of the Exhibition," 1945. Exhibition Records (HC 6), file 1490. Harvard Art Museums Archives, Harvard University, Cambridge, MA.

84. News Release, June 1, 1949. Exhibition Records (HC 6), file 1492. Harvard Art Museums Archives, Harvard University, Cambridge, MA.

85. Ibid.

86. Ibid.

87. Richard Ettinghausen, "The Character of Islamic Art," in *The Arab Heritage,* ed. Nabih Amin Faris (Princeton, N.J., 1944), 251. For a corrective to Ettinghausen's analysis, see

Mehmet Aga-Oglu, "Remarks on the Character of Islamic Art," *Art Bulletin* 36, 3 (September 1954): 175–202.

88. Ettinghausen, "Character of Islamic Art," 260. Ettinghausen concluded his analysis by observing that "Islamic art usually consists of a humble base; this is often covered with some sparkling or evanescent surface decoration which purports to be of precious material and presents forms divested of corporeal substance."

89. Richard Ettinghausen and Eric Schroeder, eds., *Iranian and Islamic Art* (Newton, Mass., 1941).

90. News release, June 1, 1949 (see above n. 84).

91. Coolidge's initial aim was to become an architect, but he instead pursued an academic path, writing a dissertation at New York University on the sixteenth-century architect Giacomo Barozzi Il Vignola. For his biography, see www.dictionaryofarthistorians.org/coolidgej.htm.

92. This was part of a wider decline in the humanities at Harvard in the post-war period. See Morton and Phyllis Keller, *Making Harvard Modern: The Rise of America's University* (New York, 2007), 241–47.

93. Letter from John Coolidge to McGeorge Bundy, July 1, 1957. John Coolidge and Agnes Mongan Papers (HC 5), file 924. Harvard Art Museums Archives, Harvard University, Cambridge, MA.

94. Throughout the 1950s, McMullan gave considerable sums to support the study of Islamic art at Harvard. In 1956, the money was transferred into a special fund for "the encouragement of the study of the art and culture of the Islamic world": Letter from Joseph McMullan to Nathan Pusey, March 5, 1956. John Coolidge and Agnes Mongan Papers (HC 5), file 1643. Harvard Art Museums Archives, Harvard University, Cambridge, MA. It was named the Damon-Dilley Fund, after the two eminent rug collectors Arthur Dilley and Theron Johnson Damon, and is still being used to support travel and research related to Islamic art and architecture for Harvard students.

95. For an overview of the time Welch spent at Harvard and his contribution to life there, see Stuart Cary Welch and Kimberly Masteller, *From Mind, Heart, and Hand: Persian, Turkish, and Indian Drawings from the Stuart Cary Welch Collection*, with essays by Mary McWilliams and Craigen W. Bowen (Cambridge, Mass., 2004).

96. Letter from John Coolidge to Stuart Cary Welch, July 26, 1957. John Coolidge and Agnes Mongan Papers (HC 5), file 3099. Harvard Art Museums Archives, Harvard University, Cambridge, MA.

97. See Lockman, *Contending Visions*, 115–30.

98. For a history of CMES, see *Reflections on the Past, Visions for the Future*, ed. Don Babai (Cambridge, Mass., 2004). In this period Harvard also established the Russian Research Center (est. 1948; renamed in 1996 as the Davis Center for Russian and Eurasian Studies) and the Center for East Asian Research (est. 1955; now the John K. Fairbank Center for East Asian Research, after its founder).

99. Some of these areas, particularly the teaching of languages, were already covered by the Department of Semitic Languages and History. See ibid., 5–6.

100. H. A. R. Gibb, *Area Studies Reconsidered* (London, 1963), 14.

101. Letter from Hamilton A. R. Gibb to John Coolidge, October 3, 1957. John Coolidge and Agnes Mongan Papers (HC 5), file 925. Harvard Art Museums Archives, Harvard University, Cambridge, MA. The long-term influence of the Center for Middle Eastern Studies upon the study of Islamic art is beyond the scope of this article. However, we should not doubt that it had a strong impact upon the field, particularly by bringing the study of Islamic art and architecture much closer to the field of area studies: see Grabar, "Islamic Art and Archaeology." It almost certainly also had an important formative influence upon many future scholars of Islamic art who earned their doctorates at Harvard and who probably took courses at CMES during their graduate studies. Indeed, Oleg Grabar, who taught at Harvard from 1969 to 1990, encouraged his students to take courses at the Center before embarking on their doctoral research (telephone interview, December 5, 2006).

102. Letter from John Coolidge to Erwin Nathaniel Griswold, December 23, 1953. Registrar's Exhibition Files, file: 1954 Exhibition: The Turks in History, February 1st–March 15th. Harvard Art Museums Archives, Harvard University, Cambridge, MA.

103. News Release, undated. Registrar's Exhibition Files, file: 1954 Exhibition: The Turks in History, February 1st–March 15th. Harvard Art Museums Archives, Harvard University, Cambridge, MA.

104. Ibid.

105. The display was nonetheless problematic in other ways. Even though some of the older preconceptions about Islamic art may have been shed, the objects in the show were basically being deployed to demonstrate political narratives. The entire exhibition was organized to celebrate the emergence of the modern nation-state of Turkey from the Ottoman Empire. A rigid distinction between the pre-modern Islamic empire and the modern Turkish nation-state was articulated through the layout of the exhibition, where, as the press release described, "One section...will be devoted to the Islamic background of the Turkish empire; another will deal with modern Turkey and the influence of the West." The connections with contemporary politics can be seen even more clearly in the involvement of officials from the Turkish consulate, who were requested to provide material to cover the "modern" part of the display. As McMullan wrote to the education attaché at the Turkish consulate in New York, "The University has excellent resources for the first and second areas [covering the Seljuk and Ottoman periods], but is happy indeed to rely upon your office and the Turkish information office in NY for material which applies specifically to the remarkable results which have been achieved by modern Turkey": Letter from Joseph McMullan to Ermin Hemingil, October 30, 1953. Registrar's Exhibition Files, file: 1954 Exhibition: The Turks in History, February 1st–March 15th. Harvard Art Museums Archives, Harvard University, Cambridge, MA. The Fogg itself did not actually have much Seljuk or

Ottoman material; for this exhibition it had been borrowed from the Peabody Museum, the MFA, and the Metropolitan Museum of Art.

106. "A Teaching Curatorship in Near Eastern Art." John Coolidge and Agnes Mongan Papers (HC 5), file 913. Harvard Art Museums Archives, Harvard University, Cambridge, MA.

107. Undated document, John Coolidge and Agnes Mongan Papers (HC 5), file 913. Harvard Art Museums Archives, Harvard University, Cambridge, MA. This document is undated but presumably he is writing in 1956, in response to the Suez crisis.

108. For a discussion of these issues and the strains it has placed on the discipline, see Flood, "From the Prophet to Postmodernism?" 42–44. One of the resulting problems has been a tendency to see Islamic art as a potential "bridge" between two hopelessly divided civilizations. This viewpoint, which has been especially pronounced since the events of September 11, 2001, has promoted the idea that through Islamic art one can discover the "true," peaceful spirit of Islam, which can be used as a foundation for building better mutual understanding amid current political conflict. See Fayeq S. Oweis, "Islamic Art as an Educational Tool about the Teaching of Islam," *Art Education* 55, 2 (March 2002): 18–24.

109. Letter from John Coolidge to Paul Buck, April 21, 1952. John Coolidge and Agnes Mongan Papers (HC 5), file 1644. Harvard Art Museums Archives, Harvard University, Cambridge, MA.

110. Letter from John Coolidge to Edward Warburg, May 27, 1957. John Coolidge and Agnes Mongan Papers (HC 5), file 924. Harvard Art Museums Archives, Harvard University, Cambridge, MA. The Semitic Museum opened in 1903, courtesy of a gift from Jacob Schiff, "to Promote the Sound Knowledge of Semitic History and Literature." Its sizable collections included ancient Near Eastern and early Islamic objects, and a collection of Arabic, Syriac, and Greek papyri manuscripts. The collections were curated first by Henry Lyon and then by Robert Pfeiffer. By the early 1950s, the museum was suffering financially because the original endowment had run out after the end of World War I. Although there were still endowments attached to the museum, there was no funding available to pay for the basic maintenance of the building. By the late 1950s it had declined even further; in 1957, it was reckoned that the museum had "virtually no impact of any sort. It is not only useless, it is worse than useless, for its continued exist-

ence creates a deficit. Meeting this is a drain every year on Harvard's educational resources.": "The Problem of the Semitic Museum," July 24, 1957. John Coolidge and Agnes Mongan Papers (HC 5), file 924. Harvard Art Museums Archives, Harvard University, Cambridge, MA. In 1958, the Semitic Museum was converted into the Harvard Center for International Affairs, under the leadership of Henry Kissinger. It remained so until 1974, when it became the headquarters of the Department of Near Eastern Languages and Civilizations. I am grateful to Joseph Greene, assistant director of the Semitic Museum, for this information about the museum's history.

111. "The Semitic Museum and Some Related Problems," August 14, 1957. John Coolidge and Agnes Mongan Papers (HC 5), file 924. Harvard Art Museums Archives, Harvard University, Cambridge, MA. By "Near Eastern" he means the entire course of Near Eastern art, both pre-Islamic and Islamic.

112. Letter from John Coolidge to McGeorge Bundy, December 23, 1957. John Coolidge and Agnes Mongan Papers (HC 5), file 925. Harvard Art Museums Archives, Harvard University, Cambridge, MA.

113. See n. 5 above.

114. It ought to be noted that by this time Eric Schroeder was fading into the background at Harvard. In 1955, Coolidge approached him about putting together a series of lectures on Islamic art, but he turned down the offer saying that he wanted to concentrate on new areas of research. Coolidge was shocked and disappointed, and could not understand why he did not want to take up such an opportunity. It seems that Schroeder had gradually moved away from his interest in Islamic art and withdrawn into his own work on astrology. Letter from John Coolidge to Joseph McMullan, May 5, 1955. Letter from Joseph McMullan to Nathan Pusey, March 5, 1956. John Coolidge and Agnes Mongan Papers (HC 5), file 1643. Harvard Art Museums Archives, Harvard University, Cambridge, MA.

115. More recently, there has been renewed debate regarding what exactly the field should and should not encompass. Indeed, this has become one of the most actively discussed aspects of the discipline and has been a critical issue in recent appraisals of the state of the field. See Flood, "From the Prophet to Postmodernism?" 31–34.

116. It is important to note that the challenges Aga-Oglu made to some of the prevailing ideas about Islamic art also went unheeded: see Aga-Oglu, "Remarks on the Character of Islamic Art."

SILVIA ARMANDO

UGO MONNERET DE VILLARD (1881–1954) AND THE ESTABLISHMENT OF ISLAMIC ART STUDIES IN ITALY

An earlier version of this article was the winner of the 2011 Margaret B. Ševčenko Prize, awarded by the Historians of Islamic Art Association.

Ugo Monneret de Villard was born in Milan in 1881 (fig. 1). His bibliography comprises more than 270 works, including about twenty books and many long essays, on a wide variety of subjects relating to art, architecture, archaeology, and history, focused mainly on the medieval "Orient" and its relations with the "West."[1] This great breadth is all the more astonishing when one considers the number of recent commentaries that mention Monneret's writings as a crucial point of reference on this or that topic.[2] Notably, his studies on Islamic art, such as the posthumous *Introduzione allo studio dell'archeologia islamica*,[3] are acknowledged as fundamental pillars for further consideration of the subject.[4] His book on the painted ceilings of the Cappella Palatina,[5] now more than sixty years old, remains essential for its multidisciplinary approach to the monument. In addition to this magnum opus, published a few years before Monneret's death and today possibly his best-known work, in 1938 he dedicated another short but outstanding monograph to an Islamic artifact preserved in Italy—*La cassetta incrostata della Cappella Palatina di Palermo*. Apart from these last two texts, written more than two decades apart, only a few other short pieces by him deal with various Islamic art objects in Italy.[6] Nonetheless, throughout his career, Monneret de Villard was tireless in his efforts to record and promote the subject of Islamic art in Italy.

Furthermore, one should not forget the catalogue "Opere di arte islamica in Italia," to which Monneret devoted himself systematically in 1954,[7] during the last

Fig. 1. Ugo Monneret de Villard in 1898. Fam. Gavazzi Archive. From Andrea Augenti, "Per una storia dell'archeologia medievale italiana: Ugo Monneret de Villard," *Archeologia Medievale* 28 (2001): 8.

months of his life. Although his friend Giorgio Levi Della Vida called it the most important of the scholar's unpublished works,[8] it never appeared in print and today remains almost completely unknown, preserved among the thousands of documents and notes that comprise Monneret's archives.[9]

Fig. 2. An Islamic bowl (thirteenth century) from the Museo Civico of Bologna, sketched by Ugo Monneret de Villard. Biblioteca di Archeologia e Storia dell'Arte (BiASA), Fondo Monneret, scatola 6, cartella 31, c. 23a. (Photo: courtesy of BiASA)

The catalogue "Opere di arte islamica in Italia" contains files detailing approximately four hundred objects preserved in Italy, the result of data gathered since Monneret began his studies in Oriental archaeology, as he emphasized in the manuscript's foreword:

> Esso è nato dalle schede che io facevo per mio uso di ogni monumento di arte islamica che, all'inizio dei miei studi di archeologia orientale, ritrovavo in un museo, in un tesoro di chiesa, in una raccolta qualsiasi....Per molti oggetti la scheda conteneva una abbastanza ampia descrizione, alla quale aggiungevo i necessari richiami bibliografici; per altre l'elaborazione era molto più elementare; per molte altre infine si riduceva ad un semplice cenno dell'oggetto che avevo visto. Materiale dunque tutto di lavoro, che continuai a raccogliere sino allo scoppio della seconda guerra mondiale.[10]

Monneret systematically registered each "Islamic" artifact he encountered in a museum, church treasury, or other collection, sometimes completing the record with bibliographical references, sometimes just noting it down more briefly (fig. 2). The notes were therefore conceived as a working tool, collected over many years. This painstaking method reflects Monneret's typical way of working, as is evident in all the materials preserved in Monneret's archives.

An interest in Islamic art was quite an eccentric choice for an Italian scholar in the first half of the twentieth century. Again in the catalogue's foreword, Monneret points out how art historians in Italy studied classical and Renaissance art almost exclusively, notwithstanding the long history of exchanges with the Middle East and the tradition of collecting Islamic and

"Oriental" artifacts during the Middle Ages and even later by important art patrons. Paradoxically, since the end of the nineteenth century, it had been mostly foreign scholars who were interested in the study of Islamic monuments and objects preserved in Italy.[11]

How and when did Monneret become drawn to the subject of Islamic art in Italy? Those who first briefly described the catalogue asserted that it would be difficult to detail all the steps involved in the making of "Opere di arte islamica in Italia," or to establish when the idea for this work was first conceived.[12]

It is possible to trace a coherent trajectory through the scholar's career and bibliographical output in order to discern how he responded to the historical and cultural contexts of the time.[13] Beneath the multiplicity of issues treated in Monneret's large number of apparently unrelated writings, one can extrapolate his gradual encounter with the "Oriente," which progressively focused on the medieval Islamic world.

THE HUMANIST-ENGINEER AND THE "ORIENTE"

Monneret graduated from the Politecnico in Milan as a chemical industrial engineer in 1904.[14] He was trained among engineers and architects belonging to the Milanese high-bourgeoisie, who were guided by a belief in productivity and scientific progress current at the time that was nonetheless destined to weaken with the impending crisis of positivism. Despite having chosen a technical education, his fondness for art and history dates from the same period. He was notably a student of the neomedievalist architect Camillo Boito, who was most likely responsible for Monneret's enthusiasm for the Middle Ages.[15] The young engineer was at first concerned with aesthetics and contemporary architecture. His interests ranged from individual monuments to town planning, and he soon became concerned with issues related to the coexistence of modern structures with ancient monuments. Monneret became increasingly aware of the importance of topography, local history, and archaeology as fundamental research tools,[16] while his systematic working method reflected his training as an engineer. Fascinated by the theories that had only recently been put forth by Josef Strzygowski about the Eastern origin of early medieval architecture, Mon-

neret compared the Church of San Lorenzo in Milan with the monuments of Eastern Christianity, and started to theorize that this and other Lombard monuments found their archetypes in the "Orient."[17] Strzygowski's writings—especially the famous *Orient oder Rom*[18]—were regarded as a positive and significant model, in contrast to Giovan Battista Rivoira and Gustavo Giovannoni's nationalistic idea of an exclusively Roman origin for Italian medieval architecture.[19]

Traveling to Dalmatia and Greece, Monneret deepened his historical knowledge of ancient and Byzantine art.[20] It is not known exactly when Monneret became involved in Oriental archaeology,[21] but his interests turned eastward early on, as is demonstrated by his publications. Monneret was also part of a circle associated with the Biblioteca Ambrosiana,[22] whose prestigious tradition of Arabic studies may have stimulated the young man's curiosity. In a long letter addressed to his friend Alessandro Casati[23] in 1906, he wrote:

> ...E l'Egitto? E le Piramidi? (che domande a Borghese!) E le principesse sepolte? Grazie delle fotografie che mi prometti: te ne sarei tanto e tanto riconoscente perché qui è terribilmente difficile procurarsi fotografie di cose egiziane. E queste tanto e tanto mi interessano.[24]

It was thus an early and genuine interest, which did not altogether exclude the exotic allure of the "Oriente."

His interest in medieval architecture, combined with a special aptitude for collecting and interpreting data and archaeological materials, led Monneret de Villard to establish, in 1913, the first course on medieval archaeology in Italy.[25] He spent several years teaching at the Politecnico and improving his archaeological method through local field studies,[26] but the call of the Orient did not subside.

THE ARCHAEOLOGICAL MISSIONS IN AFRICA AND THE "DISCOVERY" OF ISLAMIC ART

Monneret de Villard's work in Africa is quite well documented.[27] In 1921, he was invited by the Ufficio delle Missioni Scientifiche in Levante (a special section of the Royal Ministry of Foreign Affairs) to undertake an archaeological mission for the study of Christian medieval monuments in Egypt, "so that Italian science would be represented in the fervent rebirth of archaeological

Fig. 3. Ugo Monneret de Villard (seated) with a group of workers at Deir Anba Simʿan (in Aswan), ca. 1924. Istituto Nazionale di Storia dell'Arte (INASA), Fondo Ugo Monneret de Villard, inv. no. 65489. (Photo: courtesy of INASA)

studies developing in the Nile Valley, after the interruption caused by the World War."[28] Monneret was well aware that the studies he and his colleagues were put in charge of were often closely correlated with colonial politics and cultural propaganda. He even proposed detailed and well-structured programs that aimed to improve the image of Italian missions in the international context.[29] This engagement with the Italian government was renewed year after year, despite the constant lack of funding. He also collaborated with the Comité pour la conservation de l'art arabe[30] and the Service des antiquités.[31] Still concerned with the "Oriental" origin of European medieval architecture, Monneret worked on Coptic monuments such as the White and Red Monasteries in Sohag (Deir el-Abiad and Deir el-Ahmar) and the Monastery of St. Simeon (Deir Anba Simʿan), near Aswan (fig. 3). His assignments became more and more

frequent, so much so that in 1924 he was forced to abandon his post as a teacher of medieval archaeology at the Politecnico.[32]

On the other hand, the missions to Egypt—a country that played a major role in the collective imagination of colonial Europe[33]—represented a great opportunity for growth: spending months in Cairo every year meant living immersed "in the fervent rebirth of archaeological studies developing in the Nile Valley,"[34] at the heart of international exchanges with scholars and Orientalists from all over the (Western) world. In a short time, Monneret became highly regarded by such specialists, his work recognized by local and foreign institutions.[35]

While Monneret had dedicated his first missions to Coptic monuments, once in Egypt the encounter with Islamic art and architecture was unavoidable and striking:

L'estensione delle ricerche è di una necessità evidente: arte copta e arte araba, vivendo e sviluppandosi fianco a fianco nello stesso paese, non potevano rimanere e non sono rimaste punto estranee l'una all'altra; i reciproci scambi sono stati quotidiani e profondi. La conoscenza di una delle arti presuppone e richiede la conoscenza dell'altra.[36]

Monneret could not help but be attracted by medieval Islamic artistic production, which he considered to be firmly linked to contemporaneous Christian production. Continual mutual exchanges throughout the centuries made it impossible to study them separately. This conception, which strictly connected art and history, was also reflected in his rigorous practical approach:

> Bisogna ricordare che l'Oriente è paese dalle molte vite e dalle molte storie, e che in ogni località si sovrappongono strati di diverse civiltà; che l'archeologo deve scavarli tutti e studiarli con eguale amore e con eguale scienza....[37]

Archaeological investigation could not overlook any sources or evidence, and excavations should examine every layer with equal attention. Monneret's comprehensive approach was once more asserted.

Thus, during his missions in Egypt, Monneret discovered Islamic architecture and became more experienced with archaeological surveys and excavations; he also acquired a good familiarity with the Arabic language, as well as with the almost unknown Islamic artifacts exhibited in newly established museums.[38] He thus achieved a particular awareness of Islamic artistic production, knowledge that was further enriched by his archaeological missions in Nubia, Iran, and eastern Africa.[39]

The extraordinary wealth of knowledge that he acquired became a precious treasure from which Monneret would benefit for years to come once he returned to Italy. Just as his scientific training influenced his research methodology and his archeological approach, in the field he learned to give material considerations and physical objects a special attention that would become a fundamental aspect of his further studies. On the other hand, his broad knowledge of the history and culture of the "Oriente" would be the basis of the many essays and works that Monneret completed in his later years.

MONUMENTI DELL'ARTE MUSULMANA IN ITALIA: UMBERTO ZANOTTI BIANCO AND THE PROMOTION OF ISLAMIC ART IN ITALY

Monneret was the only Italian specialist in Islamic art of his day. In 1938, almost contemporaneously with his last mission to Ethiopia, he published the small book (mentioned above) on the beautiful encrusted casket preserved in the Cappella Palatina in Palermo.[40] This was printed under the patronage of Umberto Zanotti Bianco. When examining Zanotti Bianco's archives in Rome, I uncovered a number of letters written by Monneret and other related documents,[41] which revealed that the interest in Islamic art in Italy was shared by a group of distinguished intellectuals who articulated this sensibility through the twin goals of promoting the discipline at an academic level and encouraging the study of connections between the Italian heritage and Islamic artistic production.

Umberto Zanotti Bianco was born in Crete in 1889 to a family of Italian diplomats; he grew up near Turin, the rich capital of the recently formed Italian Reign. His family belonged to aristocratic circles. In 1909, he travelled to Sicily to bring aid in the aftermath of a dreadful earthquake that had struck southern Italy. The young man decided to devote himself entirely to ameliorating the shocking conditions he discovered there.[42] In 1910, he was one of the founders of the Associazione Nazionale per gli Interessi del Mezzogiorno d'Italia (ANIMI). Zanotti Bianco's philanthropic awareness of the Mezzogiorno (i.e., southern Italy) gradually extended to other concerns for the region: thanks to the archaeologist Paolo Orsi—who was particularly interested in prehistoric and Byzantine Calabria and Sicily[43]—Zanotti Bianco paid special attention to the exceptionally rich, but almost completely neglected and thus seriously endangered, cultural heritage of the Mezzogiorno (fig. 4).[44] Historic and artistic treasures began to be protected through archaeological inquiries and the restoration of monuments. These activities also had a practical dimension: Zanotti Bianco was well aware of the importance of drawing attention to such treasures in order to help the future development of southern Italy.

In 1920, Orsi and Zanotti founded the Società Magna Grecia, to which a special section named the Sezione

Fig. 4. Paolo Orsi (left) and Umberto Zanotti Bianco at Sant'Angelo Muxaro (in Agrigento) during archaeological excavations. (Photo: courtesy of the Fondazione Guarino Amella)

Bizantina Medievale was added in 1932.[45] During the Fascist era, Zanotti Bianco's initiatives came to be seen as a political challenge to the lack of attention that the government gave the "Questione del Mezzogiorno." His efforts to deal with the crisis of southern Italy were seen as open opposition to the government, and were less tolerated day by day. In 1934, the Società Magna Grecia was dissolved by imperial decree. Zanotti Bianco was branded as anti-Fascist and extensively monitored and persecuted by the police; in 1941, he was even arrested.[46] Evidently, Zanotti Bianco's cultural interests were perceived as embodying an alternative to the studies proposed by scholars and academics representing the *scienza ufficiale*—the "official knowledge"—which too often forced the approach to different disciplines with propagandistic purposes. In the field of history and archaeology, scholars who supported the Fascists highlighted the Roman origins of Italy in order to strengthen

Mussolini's authority and lend legitimacy to his imperial ambitions. The studies promoted by Zanotti and Orsi, on the other hand, emphasized how Italian history was the result of the passage and blending of different civilizations throughout the centuries and thus threatened the myth of an eternal and fixed *Romanitas*.[47] The history of southern Italy included traces of such contacts with the Islamic world, but in the first decades of the twentieth century official scholars and academics in Italy had neglected this aspect of the country's past.

With Italian scholars so focused on *Romanitas*, it is not surprising that the necessity of promoting Islamic art in Italy was articulated in 1934 by a German, Friedrich Sarre; it is even less of a coincidence that his article "L'arte mussulmana nel Sud d'Italia e in Sicilia"[48] was published in the *Archivio Storico per la Calabria e per la Lucania*, the magazine Zanotti and Orsi edited for the ANIMI.[49] Sarre highlighted the Islamic legacy inherent

to the artistic heritage not only of Sicily, but also of Calabria and Apulia, stressing the importance of a better knowledge of these almost unknown treasures. To make this goal concrete, Sarre also stated that the study of Islamic art had to be included in the Italian academic system. His paper was accompanied by an extended note signed by Paolo Orsi, who emphasized the need to expand archaeological research in southern Italy and to create a chair of Islamic art, possibly in Rome.[50]

As this issue was especially dear to Zanotti Bianco, he wanted to make important Orientalists aware of his concern. In particular, he sent a copy of Sarre's article to Giorgio Levi Della Vida,[51] who replied on March 10, 1934.[52] The scholar expressed his full approval of the proposal to create a university chair, but stated that he was not in a position to support it:

> Quanto ad appoggiare la proposta, Lei sa bene che non sono in condizione di appoggiare che che sia…Certo è cosa triste che da noi gli studi di arte islamica siano così poco coltivati, e una cattedra apposita (che giustamente l'Orsi vorrebbe istituita a Roma) sarebbe utilissima.[53]

In 1931, Levi Della Vida had in fact refused to pronounce the Fascist oath, which had been imposed on all academics, and had therefore lost his post, together with his leverage in the academic environment.[54]

On March 7, 1934, a short article by the Arabist Giuseppe Gabrieli[55] appeared in the pages of the daily *Gazzetta del Mezzogiorno*: "Per la istituzione di una cattedra di storia dell'arte islamica in Italia" included a short review of Sarre's paper. Although he focused on Apulia in discussing the question of southern Italy's interactions with the Islamic world, Gabrieli joined the ranks of those demanding the creation of a professorship of Islamic art, underlining the crucial role it would play in the study and gathering of data on this topic.[56] A copy of the article survives in a file with other press clippings carefully gathered by Zanotti Bianco,[57] which may suggest that there was direct contact between the two intellectuals. Did Zanotti Bianco send Sarre's article to Gabrieli? He may have even commissioned Gabrieli to write the piece in the *Gazzetta del Mezzogiorno*. While such questions may never be answered, it is clear that many eminent scholars were involved in this attempt to promote the study of Islamic art in Italy.

Zanotti Bianco had indeed sent Sarre's article to Monneret de Villard,[58] who found it in his house in Milan on his return from an archaeological mission in Nubia.[59] The article inspired Monneret: in a letter dated July 2, 1934, he enthusiastically declared that he had been concerned with the matter of Islamic art in Italy for some years, but that unfortunately he had had to put this work aside, due to his busy archaeological activity abroad:[60]

> Ho riguardato il mio materiale: v'è molto, ma molto più v'è da fare, moltissimo anzi. Ma riguardando le mie vecchie note e rileggendo l'articolo del Sarre e la nota dell'Orsi, mi è venuta un'idea che ora le propongo. Ella mi dirà francamente che ne pensa.[61]

Regarding the question of creating a chair of Islamic art, Monneret plainly stated his total mistrust of Italian institutions:

> Pensare che il Governo faccia qualcosa è vano: al più prenderà un imbecille presuntuoso e facilone che avrà scribacchiato qualche articolo di compilazione e te lo "schiafferà" in una cattedra universitaria. Meglio niente: se si può fare qualcosa, ciò non puo [sic] venire che da privati.[62]

In his opinion, the initiative would have to come from private citizens, and Monneret formulated his own plan to help realize Sarre's proposals: Monneret's ambitious but well planned project reflected his distinctive systematic and methodological approach. The first step would be to compile a card index with all known data on the subject. Another fundamental task would be to commission photographs of all the relevant objects and monuments. The work should start with what was easiest to access: museums, monuments, and possibly archaeological excavations. Many topics could come out of this first phase of the project: the focus would be on the groups of monuments ("le cassette d'avorio dipinte, gli olifanti, le stoffe…Poi ad esempio pubblicare integralmente e in ogni dettaglio il soffitto della Cappella Palatina, repertorio meraviglioso di tutti i motivi decorativi musulmani dell'Italia meridionale"[63]) that had similar problems, above all that of determining their provenance.[64] Gradually, the results would be published in brief but rich monographs. Monneret planned to conduct wide-ranging research, rather than focusing on individual objects, as one could infer at first glance from his 1938 publication on the *cassetta incrostata*. The ultimate goal was the formation of a "corpus dei monu-

menti musulmani."[65] On the practical side, three things were needed: a coordinating figure (clearly Monneret himself), some local collaborators who could provide data, rare texts, and photographs, and, most fundamentally, the monies to sustain the project.

The proposition was formulated thusly, but Monneret openly requested financial support:

> Per parte mia l'idea mi sorride e ci metterei tutta la buona volontà e tutto il lavoro di cui sono capace e quel poco che ne so: ma intendiamoci bene, soldi non ne ho da mettere. Questi bisogna trovarli: non ha Lei sottomano qualche mecenate che ci dia 4 o 5 mila lire all'anno? Se l'idea le va ne potremo riparlare: se no getti la lettera e scusi se le ho fatto perdere del tempo.[66]

Zanotti did not throw the letter away, and so began their association.

The twenty-three subsequent letters and postcards written by Monneret to Zanotti Bianco, dated between 1934 and 1938,[67] reveal the different phases of the gradually developing project. In fact, until 1936 Monneret was mainly involved in archaeological missions;[68] even so, he started collecting data on the painted ivories, a topic he intended to deal with in the first book of the planned series.[69] The second volume would cover the painted ceilings of the Cappella Palatina in Palermo. It is surprising to discover that the idea of publishing this outstanding repertoire of paintings, already mentioned in the first letter to Zanotti Bianco, was conceived so early. The papers reveal that Monneret would have liked to have worked on it with Marguerite Van Berchem (who was a close friend of Zanotti Bianco),[70] an opportunity that was evidently never explored further, since there are no other mentions of this proposal.

In the meantime, Zanotti Bianco, acting on his own, contacted Giuseppe Agnello and Carlo Carucci to collect data on Sicilian ceramics and the Salerno ivories, respectively.[71] Zanotti clearly wanted to involve numerous specialists in his project, and he kept Marguerite Van Berchem informed, possibly even sending her Sarre's article.[72] She talked with Alfred Dessus-Lamare:[73]

> J'ai lui ai parlé des monuments arabes de l'Italie méridionale et de la nécessité de s'en occuper. Cela l'a beaucoup intéressé...Je lui ai proposé que nous lui fassions parvenir quelques photos des monuments ou objets arabes de l'Italie méridionale...Il a été enchanté par cette idée....Je crois

> que vous avez beaucoup plus d'espoir de pouvoir arriver à quelque chose avec lui qu'avec Sarre, qui est malade et trop âgé ...[74]

The involvement of foreign scholars was necessitated by the dearth of Italian specialists, but it also demonstrated the openmindedness of the Italian protagonists who initiated this endeavor, as well as their lack of an overweening nationalistic pride.

However, Monneret de Villard remained the main academic collaborator. Once the mission to Nubia was completed at the beginning of 1936, he was then able to delve into the many questions that had arisen as he collected such a large quantity of data.[75] Although his travels continued,[76] he finally seemed able to give the study of Islamic art in Italy the attention it deserved. He wrote from Milan:

> Ho quindi deciso di riprendere i miei studi sull'arte musulmana nell'Italia meridionale e in Sicilia e di mettermi a capo fitto in questo mare magnum. Dal Cairo ho portato molto materiale di confronto che sarà utilissimo, ma prima di ogni cosa si tratta per me di raccogliere il materiale in Italia. La cosa la interessa ancora come la interessava un paio d'anni o sono? Nel quale caso è disposto ad aiutarmi? L'aiuto consisterebbe per ora nel procurarmi delle fotografie, informazioni, articoli sperduti in riviste introvabili a Milano e simile.[77]

Monneret compiled a detailed list of the photographs and copies of plates that he had asked Zanotti to provide, mainly of ivory objects preserved in Italy and the painted ceilings of the Cappella Palatina.[78] He clearly planned to work primarily on books and pictures, which is understandable, given the complex nature of his project: "Ella non può immaginare la massa di materiale musulmano d'Italia sparso nei musei di tutto il mondo: il che rende lo studio piuttosto difficile."[79] This time, Zanotti Bianco helped by writing to the National Museum of Palermo. From the director, Paolino Mingazzini, he received photos of the *cassetta incrostata* and the ceilings.[80] Although the latter were not of the best quality,[81] Monneret was satisfied and eager to study them: "Con questo ricco materiale potrò far molto avanzare il mio studio sulla parte araba del soffitto della Cappella Palatina."[82] Nevertheless, it is likely that he soon realized that this heterogeneous material would not produce a coherent and comprehensive work in his accustomed style.

Fig. 5. Title page and plate 1 of *Monumenti dell'arte musulmana in Italia. I. La cassetta incrostata della Cappella Palatina di Palermo,* published with the support of Umberto Zanotti Bianco (Rome, 1938).

In May 1937 the first book was ready:

> Egregio amico, avrei terminato il primo fascicolo della serie di studi sui monumenti musulmani d'Italia, di cui abbiamo avuto altra volta occasione di trattare.... Tratta del cofanetto intarsiato della Cappella Palatina di Palermo.[83]

It did not include the ceilings or the painted ivory caskets, though Monneret promised that a second and a third volume dealing with painted and sculpted ivories would follow.[84] The documents that followed concerned practical aspects, such as the choice of paper, format, copyrights, correction of drafts, and distribution.[85]

In February 1938, *La cassetta incrostata della Cappella Palatina di Palermo* was published (fig. 5).[86] It was supposed to be the first book in a new series entitled *Monumenti dell'arte musulmana in Italia,* included in the broader *Collezione Meridionale,* directed by Zanotti Bianco.[87]

We cannot be certain as to why the project ceased, but it is likely that Zanotti Bianco's delicate political situation[88] and the lack of funds on the eve of World War II were among the main causes.[89] Moreover, the catalogues by Perry Blythe Cott and José Ferrandis dedicated to the painted ivories (and published in the same years) probably discouraged Monneret from continuing his own work on the same topic.[90] Even the study of the Cappella Palatina ceilings was temporarily sidelined.

By 1937 Monneret had moved from Milan to Rome.[91] During the war his mobility was certainly limited; it was probably in these years that he worked on the *Introduzione allo studio dell'archeologia islamica.*[92] The correspondence with Monneret preserved in Zanotti Bianco's archives ceases at the end of 1938, and it is not by chance that the next letter dates to 1954, when Monneret dedicated himself to arranging the notes collected through-

Fig. 6. One of the letters written by Ugo Monneret de Villard to Umberto Zanotti Bianco. ANIMI, Archivio Storico, A.III.03. UA29, folder *Monumenti dell'arte musulmana in Italia*. (Photo: courtesy of ANIMI)

out his life in order to publish the catalogue he referred to as "Opere di arte islamica in Italia."[93]

The documents uncovered in Zanotti Bianco's archives thus provide many answers to questions concerning the long genesis of this work, revealing how it was first conceived and articulated, how it was modified due to practical contingencies, and which *monumenti* first awoke Monneret's curiosity. The collection of letters also confirms the scholar's systematic method: his meticulous collection of data and materials, which originated from a positivist background, reveals Monneret's conviction—perhaps illusory?—that he was building an indispensable and infallible instrument for the further advancement of knowledge in this area. It also emerges that Monneret consistently used photographic images as an essential working tool.

Moreover, the close cooperation and friendship that bound Monneret and Zanotti, as well as Monneret's criticisms of the *scienza ufficiale*, as revealed in letters (fig. 6), allow us to examine from a different perspective the scholar's collaboration with Italian institutions during the Fascist era, particularly during the period Monneret spent in Africa on archaeological missions.[94]

Above all, the correspondence discloses a cultural milieu that has remained, until now, almost totally overlooked. Umberto Zanotti Bianco's involvement as a "coordinator" reveals a civic engagement behind his cultural activism. This was not a solitary, exclusively erudite initiative but rather the brainchild of a group of outstanding intellectuals and scholars with varied interests and sensibilities, who shared a common goal, namely, promoting the study of Islamic art in Italy.

FAILURE AND SUCCESS AFTER THE FALL OF FASCISM: THE UNREALIZED UNIVERSITY CHAIR, THE MASTERPIECE, AND THE UNFINISHED CATALOGUE

In the mid-1930s, the debate regarding the possible establishment of a chair of Islamic art remained confined to an exchange among members of a restricted élite. This attempt was renewed at an academic level about ten years later, just after the fall of Mussolini. In September and October 1944, Monneret led a course on "Archeologia cristiana" at the Università La Sapienza in

Rome.[95] On November 20, 1944, the Board of Lettere e Filosofia discussed the proposal, advanced by the Scuola Orientale[96] and supported by the teachers of Storia dell'Arte,[97] to found a chair of "Storia dell'arte dell'Oriente medioevale," which would be assigned to Ugo Monneret de Villard.[98] Monneret was supported mainly by Michelangelo Guidi[99] and Pietro Toesca.[100] Guidi stressed the "meriti altissimi del Monneret," as well as his "rara preparazione scientifica," "imponente attività di scavi," "fama assai diffusa fuori d'Italia," and "nobile e coraggioso passato politico,"[101] while also emphasizing the

> ...necessità di salvare per quanto è possibile le importanti posizioni già tenute dalla cultura italiana in Egitto e in tutto il vicino Oriente: si tratta di mantenere intatta una nobile e proficua tradizione. A questo fine nessuno forse potrebbe collaborare in modo efficace come il Monnaret [sic].[102]

At such a moment of rupture with Italy's dramatic past, Monneret represented an uncontroversial opportunity for continuity, thanks also to his international scholarly reputation. Moreover, the name of the chair fitted perfectly with Monneret's multifaceted conception of "Oriental art," which in his view encompassed both Islamic and Christian art and the cross-cultural exchanges between the two.

Nevertheless, some colleagues expressed an unfavorable opinion: after the many abuses of authority that had occurred during the Fascist era, it was no longer acceptable to create new academic posts without a proper competition.[103] The Board finally approved the creation of a new chair of "Storia dell'arte dell'Oriente medioevale," which would be officially advertised and not necessarily assigned to Monneret de Villard. But the chair was never established.[104] The first chair of Islamic art and archaeology would be instituted only in 1968, at the Istituto Universitario Orientale in Naples, where it would be assigned to Umberto Scerrato; only in 1975 was this chair shared with Rome.[105]

In the last ten years of his life, Monneret dedicated himself to the study of different subjects consistently related to the Middle Ages and the "Orient": he published works aimed at a general public, as well as learned essays on both specialized and broad topics.[106] This variety reflects once more Monneret's complex conception of the "Orient," and some notes in Monneret's

correspondence, preserved at BiASA (Rome),[107] confirm how aware he was of its multifaceted but unitary perspective on the East. One letter, written by Monneret to Giuseppe Tucci,[108] is particularly significant. Tucci had assigned the scholar two chapters in the collaborative work *Le civiltà dell'Oriente*,[109] one on "Oriente cristiano," the other on "Arte islamica." Monneret refused this conceptual partition, preferring instead to write one single chapter that would include "l'arte del vicino Oriente dal III secolo al periodo dei grandi imperi turchi."[110] He thus asserted his conception of the unity of artistic development in that geographic region and eventually wrote a chapter entitled "Arte cristiana e musulmana del Vicino Oriente."[111] Nevertheless, Monneret remained a man of his time in that he did not consider the later periods, because—as he stated—"dopo è finita l'arte orientale."[112]

In 1950, Monneret finally published his renowned work *Le pitture musulmane al soffitto della Cappella Palatina in Palermo*, no less than sixteen years after the genesis of this idea. With its remarkable collection of 250 photographs, it was not the kind of book that could be financed by Italian institutions in the post-war period. The funds and resources required to realize such a huge photographic campaign came instead from the United States. Monneret's correspondence includes clues as to what was happening behind the scenes of this great undertaking.[113] The main player from the United States was Richard Ettinghausen,[114] who, in a letter dated July 24, 1946, stated, "I was most interested in what you wrote me about the possibility of photographing the paintings on the ceilings of the Cappella Palatina."[115] In his 1942 essay "Painting in the Fatimid Period: A Reconstruction,"[116] the scholar had reported on the scarcity of photographs of the painted ceilings,[117] so he was excited by Monneret's proposal. With the help of Charles Rufus Morey,[118] the cultural attaché at the American Embassy in Rome, Ettinghausen managed to gather funds for the mission.[119] Two major U.S. scholars, one of Islamic art, the other concerned with Christian art and medieval iconography, were thus actively supporting the project.

The photographs were taken by the Gabinetto Fotografico Nazionale between July 1947 and May 1948,[120] that is, just before the restoration undertaken by the Istituto centrale del restauro.[121] It is likely that Monneret's

Fig. 7. Monneret de Villard's personal instructions for the photographers of the Gabinetto Fotografico Nazionale. BiASA, Fondo Monneret. From Francesca Zannoni, "Il carteggio e l'archivio di studio di Ugo Monneret de Villard nella Biblioteca di Archeologia e Storia dell'Arte di Roma," in *L'eredità di Monneret de Villard a Milano: Atti del convegno* (*Milano, 27–29 novembre 2002*), ed. Maria Grazia Sandri (Florence, 2004), 21.

frail health prevented him from leaving Rome,[122] so he provided the photographers with very meticulous instructions (fig. 7).[123] The outcome was an astonishing ensemble of scientific photographs.[124]

The endeavor to collect such comprehensive visual material was a first and indispensable step in an exhaustive research project, which took all the historical data, primary sources, and preceding literature into consideration. Ettinghausen's article clearly played a key role, and his "Fatimid Thesis," about the probable origin of the painters of the Cappella Palatina ceilings, was al-

Fig. 8. Monneret's handwritten list of the main locations in Italy containing Islamic artifacts, along with a sketch of a map of southern Italy. BiASA, Fondo Monneret, scatola 6, cartella 34, c. 32, 33. (Photo: courtesy of BiASA)

most fully repeated.[125] Monneret's manifold approach did not disregard the technical aspects of the ceiling's construction,[126] stylistic considerations, or a thorough iconographic study, thus encompassing in a single work many of the issues that would be covered in further depth in future studies. This multi-disciplinarity *ante litteram* is not only the consequence of Monneret's mentality, but perhaps also represents an attempt to free art historical study from the heavy legacy of Benedetto Croce's *Estetica*, in which the artwork was mainly considered as the outcome of an instantaneous intuitive action: during and after the Fascist era, many intellectuals had considered this philosopher their essential point of reference,[127] and art historians had adopted a purely visual and formal approach, which tended to exclude all aspects and contexts beyond the work of art itself. Monneret's *Le pitture musulmane* therefore represented a successful attempt to update the methodology, possibly also as a result of his contact with an international academic environment.[128] The book received widespread recognition, especially in the United States,[129] and in 1950 Monneret was awarded the prestigious Premio nazionale generale dell'Accademia dei Lincei,[130] which probably represented the first important acknowledge-

ment of his scholarship in Italy after so many years of hard work.

On January 1, 1954, Monneret signed a three-year contract with the Fondazione Caetani of the Accademia dei Lincei and the Istituto Nazionale di Storia dell'Arte[131]—the time had come to organize all the precious materials and notes concerning Islamic artifacts in Italy that he had collected over more than two decades (fig. 8), in order to prepare the catalogue (or "raccolta di note personali"[132]) "Opere di arte islamica in Italia." A manuscript that included a "Prefazione" and about 400 files was completed;[133] but there remained in Monneret's archives an extraordinary number of notes, photographs, and typewritten and handwritten forms, scattered in different boxes but generally grouped according to topographic criteria.[134]

Monneret de Villard died on November 4, 1954, before he had a chance to organize these materials. The Islamic art historian David Storm Rice was entrusted to carry on with this task,[135] and many of his notes are in fact preserved in the same folders, if not in the same files.[136] But the extent of the material was so overwhelming that when Rice died in 1962 he had not yet accomplished his goal.[137] Umberto Scerrato finally took

Fig. 9. Ugo Monneret de Villard, passport photo, ca. 1950. (Photo: courtesy of Accademia dei Lincei)

advantage of that wealth of material, which became the starting point for his important contribution to the 1979 volume *Gli Arabi in Italia*, entitled "Arte islamica in Italia," though he never acknowledged Monneret de Villard's fundamental contribution to it.[138] It was Giovanni Curatola who celebrated Monneret's name and work, on the occasion of the 1993–94 exhibition *L'eredità dell'Islam*, held in Venice, which was conceived in continuity with the path opened by Monneret himself (fig. 9).[139]

MONNERET DE VILLARD AND THE STUDY OF ISLAMIC ART IN ITALY

Monneret's other important essays on Islamic art were published posthumously,[140] and he would never know how well his research was received. Nonetheless, the quality and reach of his work remain an unsurpassed legacy for scholars of Islamic art today.

Monneret's journey ended far from where he started: the young engineer from Milan had gradually discovered the archaeology of the Middle Ages and the "Orient"; his fascination soon turned into a scholarly interest that brought him to Cairo, and into direct contact with the international community of Orientalists, as well as the Italian institutions that sponsored cultural propaganda. The archaeological missions he undertook in Africa allowed him to develop and establish a rigorous method of investigation that he applied almost obsessively, both to the structuring of projects and to the approach he used in analyzing individual artifacts and monuments. There the Italian archaeologist discovered Islamic artistic production; his important inquiries into medieval Islam were notable for their reliability, even in the eyes of foreign scholars. This combination of experiences enabled him to look at the unexplored Islamic monuments and artifacts of Italy from a new and enriched point of view.

Monneret's scholarly background is a lens through which we can examine the historiography of Islamic art in Italy in the first half of the twentieth century, while the documents uncovered in Zanotti Bianco's archives reveal Monneret's interests and methodology. It also appears that an awareness of the Islamic artistic heritage of southern Italy arose in the 1930s among an intellectual élite that was removed from the *scienza ufficiale*. The idea of instituting a chair of Islamic art to give value and space of action to the discipline was generated in the same milieu. The different attempts to establish an academic post were, however, inhibited by a general indifference toward an artistic phenomenon that was less evident than others in Italian territory, and which was considered irrelevant to the enhancement of national identity. The study of the *Monumenti dell'arte musulmana in Italia* began as a private initiative, far from the usual academic circles. If Zanotti Bianco was the ethical and civic core of this initiative, Monneret de Villard was the main scientific fulcrum. For him, the idea of cataloguing represented an indispensable first step toward real understanding. The approach to individual objects should not be read as merely revealing an antiquarian taste: the collection of all known data—including the pictures—was converted into a working tool to generate further conclusions. The work *La cas-*

setta incrostata della Cappella Palatina di Palermo is a good example of this approach, where the focused study of the object became a pretext for considering a wide range of comparative examples, thus providing an exhaustive study on a more general topic, the encrustation technique. At the same time, the book was supposed to be just one component of a larger work. Likewise, the catalogue files of the "Opere di arte islamica" were conceived as single "bricks" of a bigger structure that had not yet been built: the history of Islamic art in Italy.

This was clear to Giorgio Levi Della Vida:

> Sono più di 400 oggetti ... la descrizione dei quali fatta in maniera unitaria e sistematica rivelerà una ricchezza insospettata dai più di oggetti di arte islamica in Italia e gioverà in misura notevole al progresso dello studio di una disciplina purtroppo interamente trascurata tra noi, coll'eccezione, splendida sì ma unica, di Monneret de Villard.[141]

The catalogue was just the beginning of an ambitious, almost titanic, effort, which had excellent but only partial outcomes. It deserves to be published even today, in light of both its enduring scholarly importance and the historical value it has acquired over the decades.

Monneret de Villard may thus be considered the father of Islamic art history in Italy: he was concerned with the Islamic artistic heritage in Italian territory, but he also became a wide-ranging specialist of the discipline, although he focused on the Middle Ages, overlooking periods today rightly considered part of the field. Through his approach, he viewed the development of "Oriental" art as a complex phenomenon, also in constant dialogue with "Western" art." It was almost as if he were anticipating the current issue of defining the borders of Islamic art as an academic discipline. This idea was echoed in the title he would have liked for his course at La Sapienza, "Storia dell'arte dell'Oriente medioevale," and clearly articulated when Giuseppe Tucci asked him to write about the "Arte del vicino Oriente." Perhaps Monneret himself would have considered the label "master of Islamic art" reductive. Once more, it was his friend Levi Della Vida who best described Monneret's conception of art:

> ...Una concezione organica dell'unità dello svolgimento dell'arte nell'Oriente, del suo costante rapporto collo svolgimento dell'arte dell'Occidente, della stretta interdipendenza tra storia dell'arte e storia generale. A metter in chiaro questa unità...Monneret de Villard ha contribuito quanto assai pochi dei suoi contemporanei.[142]

Dipartimento Studi Internazionali, Facoltà di Lingue e Letterature Straniere, Università di Urbino "Carlo Bo"

APPENDIX

BIBLIOGRAPHY OF UGO MONNERET DE VILLARD (1881–1954)

Preliminary note

The following bibliography is based mainly on the "Bibliografia delle opere di Ugo Monneret de Villard (1871–1954)," compiled by M. A. Piemontese (*Rivista degli Studi Orientali* 58 [1984, but printed in 1987]: 1–12). The abbreviations have generally been maintained, as well as the commentaries to the texts, which Piemontese took in part from Giorgio Levi della Vida, "Ugo Monneret de Villard. Bibliografia degli scritti," *Rivista degli Studi Orientali* 30 (1955): 172–88. Piemontese's list has now been integrated with new entries: some of them come from my own research, while many others were gathered from the studies of Alessandro Piccinelli, "Alle origini del Novecento: Arte, architettura e città nell'opera di Monneret de Villard (1903–1921)" (MA thesis, Istituto Universitario di Architettura di Venezia, 1985–86), and Elisabetta Susani, "Gli 'scritti rifiutati.' Indagando sui retroscena della formazione al collegio degli ingegneri e architetti di Milano e della *damnatio memoriae* di certi '*delicta iuventutis*' di Ugo Monneret de Villard," in *L'eredità di Monneret de Villard a Milano: Atti del convegno (Milano, 27–29 novembre 2002)*, ed. Maria Grazia Sandri (Florence, 2004), 45–61.

The updated bibliography includes 272 entries, a considerable number of which are monographs and books. The wealth and variety of topics are truly remarkable, reflecting Monneret's wide range of interests. It is nonetheless possible to trace their development throughout the decades.

A *fil rouge* is particularly evident when browsing the scholar's bibliography, namely, his gradual opening to the "Orient." As seen in his correspondence with

Alessandro Casati (see above, p. 37), in which the region is first regarded as an exotic land of "buried princesses," a common thread manifests itself in occasional references to "Oriental" medieval architecture in some early articles dealing with apparently disparate subjects (for example, see nos. 53, 55, 64, and 78); it then emerges gradually as Monneret's main interest, the many diverse aspects of which are to be studied using a multidisciplinary methodology and a more scientific approach.

This itinerary started with a precocious but quite generic interest in art and architecture: Monneret's early writings were dedicated to modern and contemporary painting, and to contemporary architecture (see most of the titles in nos. 1–63). Broad topics, such as Benedetto Croce's *Estetica* (nos. 14, 18, 40, 64, 69, and 114), the theory and history of architecture (nos. 53, 55, and 70), and town planning (nos. 46–49, 52, and 71) also intrigued the young engineer. Well aware of the importance of reconciling urban expansion with the preservation of monumental historical heritage, Monneret soon dedicated himself to topographic, archaeological, and historical studies. Western medieval architecture—especially Lombard—and its relationship with the "East" (from the Byzantine territories to Egypt, Persia, and India) captivated him as early as 1908, and remained the main focus of his interest from 1914 to 1924, when he taught a course entitled "Archeologia medievale" at the Politecnico in Milan (see most of the titles in nos. 72–128).

In the early 1920s, he began to travel abroad more frequently, and it was at this time that his writings dedicated exclusively to Oriental art and architecture first appeared (beginning with no. 129). Research missions afforded him the opportunity to investigate Eastern Christian art and improve his methodology; it also allowed him to discover Islamic art and architecture.

He regularly published works related to the research and archaeological surveys he conducted, as well as to excavations he led in Egypt (nos. 136–70, most titles), Nubia (nos. 171–85, 191), Eastern Africa (nos. 180, 186, 189, 190, and 196), and even Iran (nos. 183, 187, and 192–94). Monneret's last archaeological missions abroad date to the late 1930s. The last fifteen years of his life were spent mostly in Rome, where he dedicated himself not only to the completion and publication of research he had carried out in previous decades (nos. 198–207, 210–16), but also to the systematic study of Islamic art in Italy (only a few such articles and papers were published: nos. 203, 208, and 225). He also wrote erudite essays dealing with the relationship between East and West during the Middle Ages (nos. 221, 222, 227, 230, 231, 240, 252, and 253), along with encyclopedia entries, most notably for the *Enciclopedia cattolica* (nos. 234, 235, 237, 238, 244, 245, 247–51, 254, 255, and 266), while also completing some other fundamental works that remain essential references for scholars today (nos. 241, 271, and 272).

Abbreviations

ACIA	Atti del Collegio degli Ingegneri ed Architetti di Milano, Milan.
Aegyptus	Aegyptus. Rivista Italiana di Egittologia e Papirologia, Milan.
ASL	Archivio Storico Lombardo, Giornale della Società Storica Lombarda, Milan.
Emporium	Emporium. Rivista mensile illustrata d'arte, letteratura, scienze e varietà, Bergamo.
It. Mon.	L'Italia Monumentale. Collezione di Monografie sotto il patronato del Touring Club Italiano e della "Dante Alighieri."
Il Politecnico	Il Politecnico, Giornale dell'Ingegnere Architetto Civile ed Industriale, Milan.
Il Rinnovamento	Il Rinnovamento, Rivista critica di idee e fatti, Milan.

LP	La Perseveranza, Giornale del Mattino, Milan.
MT	Il Monitore Tecnico. Giornale d'Ingegneria, Architettura, Meccanica, Elettrotecnica, Ferrovie, Agronomia, Catasto ed Arti Industriali, Milan.
OCP	Orientalia Christiana Periodica, Pont. Institutum Orientalium Studiorum, Rome.
OM	Oriente Moderno, Istituto per l'Oriente, Rome.
Orientalia	Orientalia, Commentarii Periodici Pontificii Instituti Biblici, nova series, Rome.
RANL	Atti della (Reale until s. VI) Accademia Nazionale dei Lincei. Rendiconti, cl. di scienze morali, Rome.
RIL	Reale Istituto Lombardo di Scienze e Lettere. Rendiconti, Milan.
RINSA	Rivista Italiana di Numismatica e scienze affini, Milan.
RSE	Rassegna di Studi Etiopici, Rome.

Bibliography of Ugo Monneret de Villard

(1) "Artisti contemporanei. Bolesla Biegas," *Emporium* 17, 98 (February 1903): 83–92.
(2) "Note sui concerti del Giorgione," *Emporium* 18, 104 (August 1903): 114–20.
(3) *Giorgione di Castelfranco. Studio critico. Con 91 illustrazioni e una tavola* (Bergamo, 1904).
(4) "Arte retrospettiva: Note su Pietro Longhi," *Emporium* 21, 123 (March 1905): 200–211.
(5) "L'architettura dell'avvenire," *LP* (April 26, 1905) (attributed to Monneret by Piccinelli, "Alle origini del Novecento").
(6) "Note sull'Esposizione," *LP* (April 27, 1905).
(7) "Note sull'Esposizione di Venezia—Dai paesi del Nord," *LP* (May 5, 1905).
(8) "Note sull'Esposizione di Venezia—La nostra maschera," *LP* (May 13, 1905).
(9) "Note sull'Esposizione di Venezia—Mur Céramique," *LP* (May 27, 1905).
(10) "Note sull'Esposizione di Venezia—Scultori," *LP* (June 21, 1905).
(11) "Note sull'Esposizione di Venezia—Arte in Lombardia," *LP* (July 11, 1905).
(12) "Per la pittura lombarda," *LP* (July 22, 1905).
(13) "Gli affreschi di Palazzo Labia," *LP* (August 1, 1905).
(14) "La supremazia della critica," *LP* (August 7, 1905).
(15) "La Torre Umberto I in Milano," *LP* (September 24, 1905).
(16) "Il Congresso Artistico Internazionale," *LP* (October 5, 1905).
(17) "L'arte al Monumentale," *LP* (October 30, 1905).
(18) "Per l'estetica di Benedetto Croce e l'architettura," *Leonardo* 3, 2nd ser. (October–December 1905): 174–76.
(19) "La facciata del S. Lorenzo in Firenze," *LP* (November 25, 1905).
(20) "Cronache d'arte. Alle fonti della pittura moderna," *LP* (December 10, 1905).
(21) "Vittore Carpaccio," *LP* (January 3, 1906).

(22) "Due quadri del Giorgione passati all'estero," *L'Illustrazione italiana* 33 (February 11, 1906): 140–41.

(23) "Le vicende del Cenacolo Vinciano," *LP* (February 15, 1906).

(24) "Le cronache d'arte—Domenico Morelli," *LP* (March 20, 1906).

(25) "Il campanile di Venezia," *LP* (April 15–16, 1906).

(26) "Come utilizzare il cattolicismo," *Leonardo* 4 (April 1906): 93–102.

(27) "La scultura," *La Perseveranza all'Esposizione del 1906*, Supp. 177 (July 1, 1906).

(28) "A proposito di alcuni disegni," *La Perseveranza all'Esposizione del 1906*, Supp. 191 (July 15, 1906).

(29) "Libri d'arte," *Supplemento alla Perseveranza* (December 25–26, 1906).

(30) "La città senza piante," *LP* (1906).

(31) "I Santi del Duomo," *Il Secolo* 20 (1906).

(32) "Sull'architettura inglese," *MT* 22 (August 10, 1906): 429–30.

(33) "Esposizione di Milano 1906. Le nuove mostre dell'Arte Decorativa," *MT* 25 (September 10, 1906): 482–84.

(34) "I vetri decorati nell'architettura moderna," *MT* 25 (September 10, 1906): 493–95 (pt. 1).

(35) "I vetri decorati nell'architettura moderna," *MT* 26 (September 20, 1906): 513–14 (pt. 2).

(36) "Esposizione di Milano 1906. Architettura ungherese," *MT* 27 (September 30, 1906): 523–25.

(37) "Esposizione di Milano 1906. L'architettura moderna belga," *MT* 28 (October 10, 1906): 543–44.

(38) "Esposizione di Milano 1906. La mostra d'Architettura," *MT* 35 (December 20, 1906): 688–91.

(39) "Le architetture di F. Boberg," *MT* 35 (December 30, 1906): 715–16 (pt. 1).

(40) "Le antinomie della critica," *LP* (January 2, 1907).

(41) "Le architetture di F. Boberg," *MT* 36 (January 30, 1907): 54–56 (pt. 2).

(42) "Esposizione di Milano 1906. Il Padiglione Austriaco," *MT* 4 (February 10, 1907): 70–71.

(43) "La Statistica e l'Archeologia," *MT* 15 (May 30, 1907): 289–90.

(44) "La nuova Haus Reingold a Berlino," *MT* 17 (June 20, 1907): 327–28.

(45) "I progetti per la nuova stazione di Milano," *MT* 21 (July 30, 1907): 414–15.

(46) "Questioni di edilizia," *MT* 24 (August 30, 1907): 473–74.

(47) "Sull'arte di costruire le città," *MT* 25 (September 10, 1907): 491–93 (pt. 1).

(48) "Sull'arte di costruire le città," *MT* 26 (September 20, 1907): 514–17 (pt. 2).

(49) "Sull'arte di costruire le città," *MT* 28 (October 10, 1907): 552–54 (pt. 3).

(50) "La chiesa della Madonna di Vico," *L'Illustrazione Italiana* 34, 46 (November 17, 1907): 496.

(51) "Prefazione di Ugo Monneret de Villard," in *L'architettura di Giuseppe Sommaruga* (Milan, 1907?).

(52) *Note sull'arte di costruire le città* (Milan, 1907). [Italian urban architecture, with special reference to Brescia, Florence, Lucca, Milan, Padua, Parma, Perugia, Pisa, Ravenna, Rimini, Siena, and Verona.]

(53) *La teoria delle proporzioni architettoniche* (Milan, 1908). [Covers Egyptian, Achaemenid, Syrian, Greek, Islamic Umayyad, and Christian medieval architecture.]

(54) "Il Cattolicismo Rosso," *LP* (January 8, 1908).

(55) "Del simbolismo architettonico," *Il Rinnovamento* 2 (1908): 125–74. [Covers, in particular, medieval Christian and Islamic architecture.]

(56) "Anglada," *Vita d'arte. Rivista mensile illustrata d'arte antica e moderna* 2 (1908): 81–97.

(57) "Note d'edilizia," *MT* 12 (April 30, 1908): 233–34.

(58) "Congresso ed Esposizione d'Architettura a Vienna," *MT* 16 (June 10, 1908): 305–7 (pt. 1).

(59) "Congresso ed Esposizione d'Architettura a Vienna," *MT* 17 (June 20, 1908): 328–30 (pt. 2).

(60) "Congresso ed Esposizione d'Architettura a Vienna," *MT* 19 (July 10, 1908): 370–73 (pt. 3).

(61) "Congresso ed Esposizione d'Architettura a Vienna," *MT* 21 (July 30, 1908): 406–8 (pt. 4).

(62) "Congresso ed Esposizione d'Architettura a Vienna," *MT* 22 (August 10, 1908): 426–28 (pt. 5).

(63) *Esposizione d'Architettura a Vienna* (Lodi, 1908). Excerpts from *MT* 16, 17, 19, 21, and 22 (1908). [A different publication from those in nos. 58–62, though with the same title. Summary: Introduction; the Austrian School; German architecture; Boberg and the Swedish School; English and American architecture; Russia; Hungary; Belgium and France; Italy.]

(64) "La forma architettonica e la materia," *MT* 22 (August 10, 1908): 433–35. [With reference to the architecture of Asia Minor, Achaemenid Persia, and Buddhist India.]

(65) "Il palazzo della Camera dei Deputati," *MT* 25 (December 20, 1908): 686–87.

(66) *Opere di architettura moderna: Con note di Ugo Monneret de Villard* (Milan, 1909). [Introduction and photo gravures of architectural works in Italy, Austria, France and Belgium, Germany, Great Britain, Holland, the United States, Hungary, Sweden, and Finland.]

(67) "Le case giapponesi e il terremoto," *La lettura: Rivista mensile del Corriere della Sera* 2 (February 1, 1909): 102–5.

(68) "Note d'Architettura messinese," *Vita d'arte: Rivista mensile illustrata d'arte antica e moderna* 3 (1909): 71–80.

(69) "La libertà nell'architettura," *MT* 15 (May 20, 1909): 268–70.

(70) "Gli ordini monastici e l'architettura," *Il Rinnovamento* 3 (1909): 369–77.

(71) "Intorno al nuovo piano regolatore," *LP* (May 30, 1910).

(72) *Il battistero e le chiese romaniche di Firenze. Sessantaquattro illustrazioni*, It. Mon. 3 (Milan, 1910). [Text in Italian and French; legends in Italian, French, English, and German.]

(73) *Le chiese di Roma I. Sessantaquattro illustrazioni*, It. Mon. 4 (Milan, 1910), in Italian, French, and English.

(74) *Le chiese di Roma II. Sessantaquattro illustrazioni*, It. Mon. 8 (Milan, 1910), in Italian, French, and English.

(75) "L'architettura romanica in Dalmazia," *Rassegna d'Arte* 10 (1910): 77–82, 90–94, 107–114, 128–30. [Summary: 1. The last monuments of Ravenna and the national monuments of Croatia; 2. Lombard decoration in Dalmatia before the year 1000; 3. Eleventh-century central dome monuments; 4. Dalmato-Lombard architecture between the twelfth and fourteenth century: Influences from Apulia.]

(76) *L'architettura romanica in Dalmazia. A cura della "Rassegna d'Arte"* (Milan, 1910).

(77) "La chiesa di S. Lorenzo in Milano. Studio del tracciato planimetrico," *MT* 16 (1910): 388–90.

(78) "Intorno a S. Lorenzo di Milano. Note sull'origine del tipo planimetrico," *MT* 16 (1910): 591–93, 631–34, 651–54 [Includes comparisons with Egyptian monuments: Sohag, Deir el-Ahmar and Deir el-Abyad, Madaba, etc.]

(79) "La chiesa di S. Lorenzo in Milano," *MT* 20 (July 20, 1910): 28–30.

(80) "Il palazzo di Costantino e di Giustiniano," *MT* 17 (September 30, 1910): 530–31.

(81) "Note artistiche—Una nuova Accademia," *LP* (October 31, 1910).

(82) "Grattanuvole e grattacapi," *LP* (November 9, 1910) (attributed to Monneret de Villard by Piccinelli, "Alle origini del Novecento").

(83) "Intorno alla chiesa di S. Lorenzo," *LP* (November 10, 1910).

(84) "Ancora del S. Lorenzo," *LP* (December 2, 1910).

(85) "La colonna torta (Note sull'origine di un motivo architettonico)," *Il Politecnico* 58 (1910): 749–56 (pt. 1).

(86) "La colonna torta (Note sull'origine di un motivo architettonico)," *Il Politecnico* 59 (1911): 22–28 (pt. 2). [Deals especially with late Roman, Syrian, Coptic, and early Christian monuments and column sarcophagi.]

(87) "La chiesa di S. Lorenzo in Milano," *Il Politecnico* 59 (1911): 332–45, 398–409.

(88) "Antichi disegni riguardanti il S. Lorenzo di Milano," *Bollettino d'Arte del Ministero della P. Istruzione* 5 (1911): 271–82.

(89) "Il Battistero di Riva S. Vitale," *MT* 17 (1911): 34–35. [Includes a comparison with Qal'at Sem'an (Monastery of St. Simeon).]

(90) "Edifici del Piemonte," *MT* 17 (1911): 112–14 [Churches of Settimo Vittone and S. Ponzo Canavese, Chieri Baptistery; comparisons with the Octagon of Gregory of Nyssa and with building VIII of Binbir Kilise.]

(91) *Aosta: Sessantaquattro illustrazioni*, It. Mon. 19 (Milan, 1911), Italian and French.

(92) *I monumenti dei Lago di Como. Sessantaquattro illustrazioni*, It. Mon. 27 (Milan, 1912).

(93) *Iscrizioni cristiane della Provincia di Como anteriori al secolo XI* (Como: Premiata Tipografia-Editrice Ostineffi di Bertolini Nani e C., 1912) = *Rivista Archeologica della Provincia e antica Diocesi di Como* 65–66 (1912). [Corrections added in appendix of following essay (no. 94).]

(94) "Note di epigrafia comasca," *Periodico della Società Storica della Provincia e Antica Diocesi di Como* 20 (1912): 179–98. [Summary: Notes on sepulchral epigraphs of Peredo and Amalrico, bishops of Como. New inscriptions from Como, in the churches of S. Andrea, S. Carpoforo, and S. Giovanni. Corrections to the previous essay.]

(95) "Valentinus Ostiarius," *Revue Charlemagne* 11 (1912): 127. [Sepulchral epigraph from the Como Museum.]

(96) "Inedita Byzantina," *MT* 18 (August 10, 1912): 431–34. [Architectural structures of the following churches: H. Soter, Galaxidi; Skripu, Boeotia; H. Teodora, H. Sotero, Assomaton, Kapnikarca, H. Nicolao, Panaghia Monastirini, Athens; H. Giovanni in Koroni, H. Moni in Arcia, Argolis; H. Giasone and Sasopiter, Corfu; Catolikon of Gastouni, Elis; H. Strategos in Boularivi, Laconia; H. Soter and Haufissa, Salona; H. Giovanni, Patmos; and H. Demetrio, S. Demetrio of Rethymnon.]

(97) Review of "A. Kingsley Porter, *Santa Maria Maggiore di Lomello,*" *Arte e Storia* (1911); "A. Kingsley Porter, *L'Abbazia di Sannazzaro Sesia,*" *Arte e Storia* (1911); "A. Kingsley Porter, *The Construction of Lombard and Gothic Vaults,*" New Haven 1911," *ASL* 31 (1912): 144–48.

(98) "Necrologio per F. De Dartein," *ASL* 39 (1912): 197.

(99) "Le iscrizioni sepolcrali di Ecclesio e Savinio (sec. V) rinvenute nella chiesa di S. Vincenzo di Galliano," *ASL* 40 (1913): 471–73.

(100) "Studi sull'arte di costruire le città. Spalato," *MT* 19 (1913): 428–30. [Includes comparisons with Ukhaydir, Mshatta, Palmyra, and Antioch, and references to Umayyad and Sassanid architecture.]

(101) "La biblioteca del Regio Istituto Tecnico Superiore," written in cooperation with Guido Petrocchi and Giuseppe Adamoli, in *Le Biblioteche milanesi,* ed. Giovanni Bognetti (Milan, 1914), 1–105, 203–6.

(102) *L'isola Comacina. Ricerche storiche ed archeologiche* (Como, 1914) = *Rivista Archeologica della Provincia e antica Diocesi di Como,* fasc. 70–71 (1914).

(103) "Note di Archeologia lombarda," *ASL* 41 (1914): 5–70. [Summary: Chap. 1. Diocletian's mausoleum in Split and its influence on Lombard architecture; Chap. 2. The origin of the planimetric form of San Lorenzo in Milan (includes comparisons with architectural structures of: the Deir Seta Baptistery, Qal'at Sem'an, the Octagon of Gregory of Nyssa, Binbir Kilise, the Baptistery of St. George of Ezra, Bosra Cathedral, St. Sophia of Adrianople, Rusafa churches—Sergiopolis, St. Gregory of Echmiadzin, the Suwasa Octagons—Isaura-Hierapolis-Derbe, the Monastery of St. Simeon Stylites near Antioch, the eurhythmic plan of the Mosque of Omar.]

(104) "The Vatican Gardens"; "The Chapel of Nicholas V"; "The Pauline Chapel"; and "The Hall of the Geographical Charts," in *The Vatican: Its History, Its Treasures,* ed. Ernesto Begni (New York, 1914): 37–48; 51–60; 101–5; and 425–29.

(105) "L'influsso lombardo sull'architettura romanica in Catalogna," *ACIA* 47 (October 25, 1914): 385–405.

(106) *Catalogo delle iscrizioni cristiane anteriori al secolo XI* (Milan, 1915) ("Il Castello Sforzesco di Milano. Le sue raccolte storiche e artistiche.") [Contains forty-eight entries concerning inscriptions from Milan (the ancient cemetery of Porta Vercelliana, the Cathedral neighborhood, and various sites), Lombardy, and unknown sites; bibliography and indices.]

(107) "Delle Mura e del Palazzo Imperiale di Milano romana," *ACIA* 48 (1915): 299–310. [Includes comparisons with monuments from es-Suhba, Mshatta, Henchir-Tamesmida, Diyarbakir, al-Lajjun, and Odruh.]

(108) "L'architettura romana degli ultimi secoli dell'Impero," *ACIA* 48 (1915): 349–70; 397–420.

(109) "I dati storici relativi ai musaici pavimentali cristiani di Lombardia," *ASL* 43 (1916): 341–92.

(110) "La 'legenda' di S. Eligio in Lombardia," *ASL* 43 (1916): 628–32.

(111) Review of "C. Enlart, *Manuel d'archéologie française depuis les temps mérovingiens jusqu'à la Renaissance*, T. III, Le Costume," *ASL* 43 (1916): 872.

(112) "Di Goffredo da Busseno e del Liber Notitiae Sanctorum," in *Liber Notitiae Sanctorum Mediolani. Manoscritto della Biblioteca Capitolare di Milano*, ed. Marco Magistretti and Ugo Monneret de Villard (Milan, 1917).

(113) "L'antica basilica di S. Tecla in Milano," *ASL* 44 (1917): 1–24.

(114) "Del metodo nello studio dell'architettura medioevale," *ACIA* 51 (July 1917–December 1918): 22–62.

(115) *Gerusalemme e i luoghi Santi* (Milan, 1918).

(116) *Le vetrate del Duomo di Milano. Ricerche storiche*, 3 vols. (vol. 1 [Milan, 1918]; vols. 2 and 3 [Milan, 1920]). [Vol. 1: text; vol. 2: pls. 1–100; vol. 3: pls. 101–90.]

(117) "Contributi alla storia delle biblioteche milanesi," *ASL* 45 (1918): 296–301.

(118) Review of "E. A. Stuckelberg, *Cicerone in Tessin. Ein Führer für Geschichts-Kunst und Altertumsfreunde*," *ASL* 45 (1918): 562–63.

(119) "Il più antico documento relativo all'ospizio del S. Gottardo," *ASL* 45 (1918): 578–79.

(120) "Ancora sull'ospizio del Gottardo," *ASL* 46 (1919): 321.

(121) "L'organizzazione industriale nell'Italia Longobarda durante l'Alto Medioevo," *ASL* 46 (1919): 1–83.

(122) "Documenti milanesi riguardanti Rolandino de Romanzi," *Studi e memorie per la storia dell'Università di Bologna* (1919): 139–143. (Biblioteca de "L'Archiginnasio," ser. I, V.)

(123) "La monetazione nell'Italia Barbarica," *RINSA* 32 (1919): 22–38, 73–112, 125–38 (pt. 1).

(124) "La monetazione nell'Italia Barbarica," *RINSA* 33 (1920): 169–232 (pt. 2).

(125) "La monetazione nell'Italia Barbarica," *RINSA* 34 (1921): 191–218 (pt. 3). [Summary: 1919: Coins of Lombard Italy until the end of the Carolingian Empire; the mancus coin and the circulation of Arab and Byzantine gold in Barbarian Europe; gold coinage in the German Empire; 1920: monetary legislation. I. Monetary law; 1921: Types and issues of coins under the Lombards and Charlemagne.]

(126) "Note sul memoratorio dei maestri commacini," *ASL* 47 (1920): 1–16.

(127) "Un diploma di Ludovico il Pio e le Chiuse longobarde," *ASL* 48 (1921): 167–70.

(128) "Chiese medioevali delle pievi di Blenio e della Levantina," *Bollettino Storico della Svizzera Italiana* 36, 4 (1921): 83–89.

(129) "Il Museo degli Evgaf a Costantinopoli," *Rassegna d'Arte Antica e Moderna* 8 (1921): 123–27.

(130) "Sull'origine della doppia cupola persiana," *Architettura e Arti Decorative* 1 (1921): 315–24. [Includes comparisons with Indian and Chinese monuments.]

(131) Review of "J. Strzygowski, *Ursprung des Christlichen Kunst*, Berlin 1920," *Architettura e Arti Decorative* 2 (1921): 210–11.

(132) "Un monumento romano di tipo egizio nel Museo Archeologico di Milano," *Aegyptus* 2 (1921): 281–84.

(133) "Il Faro d'Alessandria secondo un testo e disegni arabi inediti da Codici Milanesi Ambrosiani," *Bulletin de la Société Archéologique d'Alexandrie* 18 (1921): 13–35. [Drawings, especially from Ms. A 113.]

(134) "Sul faro di Alessandria," *Aegyptus* 3 (1922): 193.

(135) "Oggetti egizi in una tomba germanica," *Aegyptus* 3 (1922): 315–20.

(136) A. Patricolo, *La chiesa di Santa Barbara al Vecchio Cairo: Illustrata da A. Patricolo e da U. Monneret de Villard* (Florence, 1922), in Italian and English.

(137) Review of "A. Sartorio, *Flores et humus. Conversazioni d'arte*, Città di Castello 1922," *RIL* 55 (1922): 344.

(138) Review of "P. Radiot, *Les vieux arabes (L'art et l'âme)*, Paris 1901," *RIL* 55 (1922): 344.

(139) "Exagia bizantini in vetro," *RINSA* 35 (1922): 93–107.

(140) "Saggio di una bibliografia dell'arte cristiana in Egitto," *Bollettino del Reale Istituto di Archeologia e Storia dell'Arte*, I (1922): 20–32. [Two parts: historical sources and archaeological studies.]

(141) *La scultura ad Ahnas. Note sull'origine dell'arte copta* (Milan, 1923).

(142) "Pittura su vetro," in *La corte di Lodovico il Moro. IV. Le arti industriali, la letteratura, la musica*, ed. Francesco Malaguzzi Valeri (Milan, 1923): 77–103.

(143) "Le transenne di S. Aspreno e le stoffe alessandrine," *Aegyptus* 4 (1923): 64–71.

(144) "La fondazione del Deyr el-Abiad," *Aegyptus* 4 (1923): 156–62.

(145) "Sui diversi valori del Soldo Bizantino," *RINSA* 36 (1923): 33–40.

(146) "Arte manichea," *RIL* 56 (1923): 971–84. [Covers architecture, painting, miniatures, and the art of the book.]

(147) "Sull'impiego di vasi e tubi fittili nella costruzione delle volte (excursus)," in Christiano Huelsen, *S. Agata dei Goti* (Rome, 1924): 147–54. (Associazione fra artisti e cultori di Architettura a Roma. Monografie delle chiese di Roma I.)

(148) "Ricerche sulla topografia di Qasr es-Sam," *Bulletin de la Société Royale de Géographie d'Egypte* 12–13 (1924): 54.

(149) "L'arte di Samarra e il così detto fregio tulunide," *Aegyptus* 5 (1924): 39–44.

(150) "Sul castrum romano di Babilonia d'Egitto," *Aegyptus* 5 (1924): 174–82.

(151) "Gli scavi di Capharnaum," *Vita e Pensiero, Rassegna italiana di cultura* 10, n.s., 15 (1924): 82–84.

(152) "Rapporto preliminare sugli scavi al Monastero di S. Simeone presso Aswan 1924–1925," *RANL* 6, 1 (1925): 289–303.

(153) "Una pittura del Deyr el-Abiad," in *Raccolta di scritti in onore di Giacomo Lumbroso (1844–1925)* (Milan, 1925): 100–108. (Pubblicazioni di Aegyptus, serie scientifica, vol. III.)

(154) "Iscrizione di Anibah," *Aegyptus* 6 (1925): 250.

(155) *Les couvents près de Sohag (Deyr el-Abiad et Deyr el-Ahmar). Ouvrage publié sous les auspices du Comité de conservation des monuments de l'art arabe*, 2 vols. (Milan, 1925–26).

(156) "Descrizione generale del monastero di San Simeone presso Aswàn," *Annales du Service des Antiquités de l'Egypte* 26 (1926): 211–45.

(157) "Un pressoio da vino dell'Egitto medioevale," *RIL* 59 (1926): 520–28.

(158) "La numismatica sasanide," *RINSA* 39 (1926): 111–13.

(159) "Il problema dell'arte sasanide," in *Art Studies: Medieval, Renaissance, and Modern* 5 (1927): 57–63.

(160) "Amboni copti e amboni campani," *Aegyptus* 8 (1927): 258–62.

(161) *Il Monastero di S. Simeone presso Aswân*, vol. 1., *Descrizione archeologica* (Milan, 1927).

(162) *Description générale du monastère de Saint Siméon à Aswân. Ouvrage hors commerce publié sous les auspices du Comité de conservation des monuments de l'art arabe* (Milan, 1927).

(163) *Les églises du monastère des Syriens au Wadi en-Natrun. Ouvrage publié sous les auspices du Comité de conservation des monuments de l'art arabe* (Milan, 1928).

(164) *Deyr el-Muharraqah. Note archeologiche* (Milan, 1928).

(165) "La Missione Archeologica Italiana in Egitto, 1921–28," *OM* 8 (1928): 268–77.

(166) "Note storiche sulle chiese di al-Fustât," *RANL* 6, 5 (1929): 285–334.

(167) "La tomba di San Macario" *Aegyptus* 10 (1929): 149–52.

(168) "La prima esplorazione archeologica dell'Alto Egitto," *Bulletin de La Société Royale de Géographie d'Egypte* 17 (1929): 19–48.

(169) "Christian Art in Egypt," in Karl Baedeker, *Egypt and the Sûdân: Handbook for Travellers*, 8th rev. ed. (Leipzig, 1929), 187–91.

(170) *La necropoli musulmana di Aswan* (Cairo, 1930). (Publications du Musée Arabe du Caire.) [*Avant-propos* by Gaston Wiet, 7–8.]

(171) "La missione per lo studio dei monumenti cristiani della Nubia e i suoi lavori del 1930–31," *Aegyptus* 11 (1931): 514–15. [The article is not signed, but Monneret registered it as no. 65 in his own personal bibliography (manuscript).]

(172) "Rapporto preliminare dei lavori della missione per lo studio dei monumenti cristiani della Nubia 1930–1931," *Annales du Service des Antiquités de l'Egypte* 31 (1931): 7–18.

(173) "La missione italiana nella Nubia Cristiana," *Associazione Internazionale Studi Mediterranei. Bollettino* 2, 3 (August–September 1931): 19–23.

(174) "Note nubiane. 1. Articula (Plin. N.H., vi, 184); 2. La Chiesa Melkita di Nubia," *Aegyptus* 12 (1932): 305–16.

(175) "Un santuario di Min-Pan in Nubia," *Aegyptus* 13 (1933): 42–44.

(176) *Iscrizioni copte e greche del cimitero di Sakinya (Nubia)* (Cairo, 1933).

(177) "I vescovi giacobiti della Nubia," *Mémoires de l'Institut français d'archéologie orientale du Caire* 67 = *Mélanges Maspéro* II, fasc. 1 (1934): 57–66.

(178) "Oreficeria barbarica in Africa," *Memorie Storiche Forogiuliesi* 30 (1934): 217–22.

(179) *La Nubia Medioevale. Volume Primo, Inventario dei Monumenti; Volume Secondo, Tavole I–C; Volume Terzo, Origine e sviluppo delle forme monumentali; Volume Quarto, Tavole CI–CCIII* (vols. 1–2 [Cairo, 1935]; vols. 3–4 [Cairo, 1957]). (Service des Antiquités de l'Egypte. Mission Archéologique de Nubie 1929–1934.)

(180) "Un tipo di chiesa abissina," *Africa Italiana, Rivista di storia e d'arte a cura del Ministero delle Colonie* 6 (1935): 83–91. [Fremonte's church near Adowa, and relationships with the Nabatean, Syrian, and Iranian worlds.]

(181) "L'esplorazione della Nubia medievale," *Bollettino del Reale Istituto di Archeologia e Storia dell'Arte* 6 (1936): 195–96. [Conference summary.]

(182) "Da Philae a Meroe sulle tracce della civiltà nubiana," *Le Vie d'Italia e del Mondo* 4 (1936): 1063–83.

(183) "The Fire Temples," *Bulletin of the American Institute of Persian Art and Archaeology* 5, 4 (December 1936): 175–84.

(184) "Die Kuppelbasilika in Nubien," *Artibus Asiae* 6, 3–4 (1937): 203–20.

(185) "Iscrizione meroitica di Kawa," *Aegyptus* 17 (1937): 101–3.

(186) "L'origine dei più antichi tipi di chiese abissine," in *Atti del Terzo Congresso di studi coloniali Firenze-Roma, 12–17 Aprile 1937* (Florence, 1937), 137–51.

(187) "La preparazione del Survey of Persian Architecture," in *Atti del XIX Congresso degli Orientalisti Roma, 23–29 settembre 1935* (Rome, 1938), 644–45.

(188) *Monumenti dell'arte musulmana in Italia, I. La cassetta incrostata della Cappella Palatina di Palermo* (Rome, 1938).

(189) "Note sulle influenze asiatiche nell'Africa Orientale," *Rivista degli Studi Orientali* 17 (1938): 303–49. [Specifically deals with: Christian and Arab-Muslim diffusion, Sasanid expansion into Yemen, Persian immigration on the Shiraz-Mombasa trajectory, and contacts between Eastern Africa, Mesopotamia, and Persia; the import of goods and artifacts from India to Egypt; Abyssinian art and architecture; Persian and Chinese ceramics; Islamic monuments.]

(190) *Aksum. Ricerche di topografia generale*, Analecta Orientalia, Commentationes scientificae de rebus Orientis antiqui 16 (Rome, 1938).

(191) *Storia della Nubia cristiana*, Orientalia Christiana Analecta 118 (Rome, 1938).

(192) "The Iranian Temple of Taxila," in *A Survey of Persian Art from Prehistoric Times to the Present*, ed. Arthur U. Pope and Phyllis Ackerman, 6 vols. (London, 1938; repr. 1967), 1:445–48.

(193) "The Relations of Manichean Art to Iranian Art," in Pope and Ackerman, *Survey of Persian Art*, 5:1820–28.

(194) "The Westward Expansion of Sasanian Architectural Forms," in *III Congrès international d'art et d'archéologie iraniens. Mémoires* (Moscow-Leningrad, 1939), 138–39. [English and Russian summary of a paper read by A. U. Pope on behalf of the author.]

(195) "Per la storia del portale romanico," in *Medieval Studies in Memory of A. Kingsley Porter*, ed. Wilhem R. W. Koehler (Cambridge, Mass., 1939), 1: 113–24.

(196) "Note sulle più antiche miniature abissine," *Orientalia* 8 (1939): 1–24.

(197) "Per una nuova iscrizione greca ad Aksum," *OM* 19 (1939): 520.

(198) "La basilica cristiana in Egitto," in *Atti del IV Congresso internazionale di Archeologia Cristiana, Città del Vaticano 16–22 ottobre 1938*, Studi di antichità cristiana 16 (Rome, 1940): I, 291–319.

(199) *Le chiese della Mesopotamia*, Orientalia Christiana Analecta 128 (Rome, 1940). [The churches of Ctesiphon, al-Hirah, and Tur Abdin; the monasteries of Tur Abdin; the expansion of Mesopotamic forms; late medieval churches.]

(200) "La necropoli di Ballaňa e di Qōstul," *Orientalia* 9 (1940): 61–75.

(201) Review of "A. Adriani, *Le goblet d'argent des Amours vendangeurs du Musée d'Alexandrie*, Alexandrie 1939," *Orientalia* 9 (1940): 197–98.

(202) "L'iscrizione etiopica di Ham e l'epigrafia meroitica," *Aegyptus* 20 (1940): 61–68.

(203) "Una iscrizione marwanide su stoffa del secolo XI nella Basilica di S. Ambrogio a Milano," *OM* 20 (1940): 504–6.

(204) "Le fortezze cristiane della Nubia," in *Miscellanea Gregoriana raccolta di scritti pubblicati nel I centenario della fondazione del Pont. Museo Egizio (1839–1939)*, Monumenti, musei e gallerie pontificie (Vatican City, 1941), 135–43.

(205) *La Nubia Romana* (Rome, 1941).

(206) "Gli studi sull'archeologia cristiana d'Egitto, 1920–1940," *OCP* 7 (1941): 274–92. [Includes 288 entries.]

(207) "La chiesa monolitica di Yakkā Mikā'ēl," *RSE* 1 (1941): 226–33.

(208) "Un codice arabo-spagnolo con miniature," *La Bibliofilia* 43 (1941): 209–23. [Illustration of Ms. Vat. Ar. 368.]

(209) "Un avorio dell'Asia centrale scoperto nei pressi di Roma," *Asiatica* 8 (1942): 3–10.

(210) "Il culto del Sole a Meroe," *RSE* 11 (1942): 107–42. [Includes references to Persian Achaemenid monuments.]

(211) "Di una possibile origine delle danze liturgiche nella chiesa abissina," *OM* 22 (1942): 389–91.

(212) "La coronazione della Vergine in Abissinia," *La Bibliofilia* 44 (1942): 167–75. [With emphasis on the miniatures of *Taumra Mairyam's* manuscript, completed in 1571, from Biblioteca Giovardiana in Veroli.]

(213) "Problemi sulla storia religiosa dell'Abissinia," *Rassegna Sociale dell'Africa Italiana* 5 (1942): 583–91.

(214) "Perché la chiesa abissina dipendeva dal patriarcato d'Alessandria," *OM* 23 (1943): 308–11.

(215) "La Majestas Domini in Abissinia," *RSE* 3 (1943): 36–45 [Especially focused on the illustration of Ms. Or. 148, Biblioteca Medicea Laurenziana, Florence.]

(216) "I minareti di Mogadiscio," *RSE* 3 (1943): 127–30. [Includes references to Persian monuments.]

(217) Review of "K. Erdmann, *Das Orientalische Feuerheiligtum*, Leipzig 1941," *Orientalia* 12 (1943): 166–67.

(218) Review of "C. J. Lamm, *Oriental Glass of Medieval Date Found in Sweden and the Early History of Lustre-Painting*, Stockholm 1941," *Orientalia* 12 (1943): 271–73.

(219) Review of "P. M. D'Elia, *Fonti Ricciane edite e commentate*, vol. I. *Storia dell'introduzione del Cristianesimo in Cina*, Roma 1942," *OM* 23 (1943): 87–88.

(220) Review of "E. Kühnel, *Islamische Schriftkunst*, Berlin-Leipzig 1942," *OM* 23 (1943): 88.

(221) "Lo studio dell'Islam in Europa nel XII e nel XIII secolo," Studi e Testi 110 (Vatican City, 1944): iv–86. [Anastatic reprint, 1972.]

(222) "La vita, le opere e i viaggi di frate Ricoldo da Montecroce O. P.," *OCP* 10 (1944): 227–74.

(223) Review of "H. J. Lenzen, *Die Entwicklung der Zikkurat von ihren Anfängen bis zur Zeit der III. Dynastie von Ur*, Leipzig 1942," *Orientalia* 13 (1944): 270–71.

(224) "Miniatura veneto-cretese in un codice etiopico," *La Bibliofilia* 47 (1945): 1–13. [Illustration of Ms. Eth. 81 (Ancien fonds 74, formerly Saint-Germain 510), Bibliothèque nationale de France, Paris.]

(225) "Le chapiteau arabe de la Cathédrale de Pise," *Académie des Inscriptions & Belles-Lettres. Comptes rendus des séances de l'année 1946* (1946): 17–23.

(226) "La tessitura palermitana sotto i Normanni e i suoi rapporti con l'arte bizantina," in *Miscellanea Giovanni Mercati*, Studi e Testi 123 (Vatican City, 1946): III, 464–89. [Summary: I. Historical documents; II. Graphic documents.]

(227) "Antiochia e Milano nel VI secolo," *OCP* 12 (1946): 374–80 [Importation of cultural elements and Oriental architectural forms, attesting to "stretti rapporti fra Antiochia e la valle del Po nei primi secoli dopo la pace della Chiesa" (tight relationships between Antioch and the Po Valley in the first centuries after the Peace of the Church [i.e., after the 313 Milan Edict]).]

(228) Review of "R. Devresse, *Le Patriarcat d'Antioche depuis la paix de l'Église jusqu'à la conquête arabe*, Paris 1945," *OM* 26 (1946): 62–63.

(229) "Mosè, vescovo di Adulis," *OCP* 13 (1947): 613–23 (= *Miscellanea Guillaume de Jerphanion*). [Deals especially with cultural exchanges and the relationship with Christianity between the Red Sea and Indian regions, stretching to Ceylon and Socotra.]

(230) "La Madonna di S. Maria Maggiore e l'illustrazione dei miracoli di Maria in Abissinia," *Annali Lateranensi* 11 (1947): 9–90. [With related documentation concerning Ms. Et. Vat. 91, Vatican Library; Mss. Éth. 61 and 144, D'Abbadie 83, 114, 222, Bibliothèque nationale de France, Paris.]

(231) *Il Libro della Peregrinazione nelle parti d'Oriente di Frate Ricoldo da Montecroce* (Rome, 1948). (Dissertationes Historicae, fasc. XIII.) [Summary: his life; sources; medieval itineraries in Asia Minor; the journey to Tabriz; the Tatars and Buddhism; the Kurds; Baghdad; the Sabaeans; history and knowledge of the Koran; virtues of the Saracens.]

(232) "Le monete dei Kushāna e l'impero romano," *Orientalia* 17 (1948): 205–45.

(233) "Aksum e i quattro re del mondo," *Annali Lateranensi* 12 (1948): 125–80. [Historical and cultural aspects of the four parts of the world, in particular: the spread of Manichaeism in Egypt and, from the center of Hirah, among the Arabs of the Syrian-Palestinian desert; the river Σίλις and the Kushana Kingdom; Buddhism in Central Asia, India, China, and related artistic cultures.]

(234) *Enciclopedia cattolica* (Rome, 1948–1954), s.v. "Abu Hennis" [Coptic village].

(235) *Enciclopedia cattolica* (Rome, 1948–54), s.v. "Akhmim" [Middle Egypt].

(236) "Codici magrebini decorati della Biblioteca Vaticana," *Istituto Universitario Orientale. Annali*, n.s., 3 (1949): 83–91 (= *Scritti in onore di Francesco Beguinot*). [Concerns Mss. Vat. Ar. 205, 210–14, 368.]

(237) *Enciclopedia cattolica* (Rome, 1948–54), s.v. "Baqawāt" [Necropolis of Hibis, Egypt].

(238) *Enciclopedia cattolica* (Rome, 1948–54), s.v. "Bāwit" [Middle Egypt].

(239) "Il culto di S. Taisía nella diocesi di Milano," *Studi Medievali*, n.s., 16 (1943–50): 269–72.

(240) *Liber Peregrinationis di Jacopo da Verona a cura di U. M. de V.* (Rome, 1949). (Il Nuovo Ramusio I).

(241) *Le pitture musulmane al soffitto della Cappella Palatina in Palermo* (Rome, 1950).

(242) "Una chiesa di tipo georgiano nella necropoli tebana," *The Bulletin of the Byzantine Institute* 2 (1950): 495–500 = *Coptic Studies in Honour of Walter Ewing Crum*.

(243) "Sulla festa del battesimo in Abissinia," *RANL* 8, 5 (1950): 513–25.

(244) *Enciclopedia cattolica* (Rome, 1948–54), s.v. "Egitto, Arte cristiana."

(245) *Enciclopedia cattolica* (Rome, 1948–54), s.v. "Etiopia. Antichità cristiane."

(246) "La fiera di Batnae e la traslazione di S. Tommaso a Edessa," *RANL* 8, 6 (1951): 77–104.

(247) *Enciclopedia cattolica* (Rome, 1948–54), s.v. "India. Antichità cristiane."

(248) *Enciclopedia cattolica* (Rome, 1948–54), s.v. "Isauria" [Province of Antioch's patriarchate].

(249) *Enciclopedia cattolica* (Rome, 1948–54), s.v. "Mesopotamia. Antichità cristiane."

(250) *Enciclopedia cattolica* (Rome, 1948–54), s.v. "Mileto. Archeologia cristiana."

(251) *Enciclopedia cattolica* (Rome, 1948–54), s.v. "Nubia."

(252) *Le Leggende Orientali sui Magi Evangelici*, Studi e Testi 163 (Vatican City, 1952). [Anastatic reprint, 1973]. [Summary: I. The primitive Syriac texts; II. The Magi and the Messiah's gift; III. The prophecies and the geographical environment of the legends; IV. The Magi from Central Asia and the king of Tarsa; V. John of Hildesheim and the European summary of the Oriental legends. Addenda.]

(253) "Sul palazzo di Theodorico a Galeata," in *RANL* 8, 7 (1952): 26–32. [Outlines, in particular, "che le rovine del palazzotto da caccia fattosi costruire da Teodorico a Galeata, che è un paesetto sulla via tra Forlì e Arezzo, ripetono identica la pianta caratteristica dei palazzotti della regione iranica, dove i Goti erano giunti nelle loro conquiste orientali" (that the ruins of the hunting palace built by Teodoricus in Galeata—a small village between Arezzo and Forlì—have a plan that is identical to those palaces of the Iranian area where the Goths arrived with their Oriental conquests): R. Bianchi Bandinelli.]

(254) *Enciclopedia cattolica* (Rome, 1948–54), s.v. "Oriente cristiano. L'Arte cristiana."

(255) *Enciclopedia cattolica* (Rome, 1948–54), s.v. "Osroene."

(256) Review of "O. G. S. Crawford, *The Fung Kingdom of Sennar with a Geographical Account of the Middle Nile Region* (Gloucester, 1951)," in *OM* 32 (1952): 57–58.

(257) "Il tāǧ di Imru'l-Qais," *RANL* 8, 8 (1953): 224–29.

(258) "The Temple of the Imperial Cult at Luxor," *Archaeologia or Miscellaneous Tracts Relating to Antiquity* 95 (1953): 85–105.

(259) "Il trono dei leoni," *Annali Lateranensi* 17 (1953): 321–52. [Possible origins of the Kushana art throne and connections with Egyptian, Iranian, and Jewish traditions; also about Atargatis' cult.]

(260) "Il frammento di Hannover e la tessitura palermitana di stile bizantino," *Rivista dell'Istituto Nazionale d'Archeologia e Storia dell'Arte*, n.s., 2 (1953): 162–70. [Also about Iranian connections.]

(261) *Enciclopedia cattolica* (Rome, 1948–54), s.v. "Siria. Arte cristiana."

(262) *Enciclopedia cattolica* (Rome, 1948–54), s.v. "Sohàg" [Egyptian site].

(263) *L'arte iranica* (Verona, 1954). [Historic and artistic summary, from prehistory to the Safavids.]

(264) *The Large Church in the Second Court of the Great Temple*, in *Post-Ramessid Remains* (*The Excavation of Medinet Habu*, vol. 5), ed. Uvo Hölscher, ed. and trans. E. B. Hauser (Chicago, 1954). [Report written in 1934, trans. Catherine Shaw Phillips.]

(265) "Islam und Abendland. Geistige Einflüsse auf das europäische Mittelalter," in *Handbuch den Weltgeschichte*, ed. Alexander von Randa, 2 vols. (Olten and Freiburg im Breisgau, 1954–56), 1:1143–47. [Summary: the impact of Arab philosophy; astronomy and astrology; and natural science.]

(266) *Enciclopedia cattolica* (Rome, 1948–54), s.v. "Yemen. Antichità cristiane."

(267) "Le filigrane delle carte milanesi dalle più antiche alla fine del XV secolo," *ASL* 81–82 (1954–55): 24–54.

(268) "Tessuti e ricami mesopotamici ai tempi degli Abbàsidi e dei Selǧuqidi," *Atti della Accademia Nazionale dei Lincei. Memorie, cl. di scienze morali* 8, 7 (1955): 183–234.

(269) "Iscrizioni della Regione di Meroe," *Kush, Journal of the Sudan Antiquities Service* 7 (1959): 93–114. [Phototype print of the original manuscript by the author and editor's note.]

(270) "Testi Meroitici della Nubia Settentrionale," *Kush* 8 (1960): 88–122. [Phototype print of the original manuscript by the author. Editorial summary: Meroitic texts from Northern Nubia, 123–24.]

(271) "Arte cristiana e musulmana del Vicino Oriente," in *Le Civiltà dell'Oriente*, ed. Giuseppe Tucci, 4 vols. (Rome, 1962): 4:451–62 [Summary: Christian architecture in the Byzantine Orient and Mesopotamia; painting in Egypt. Islamic art from the Umayyad to the Mongol-Tartar period; under the Fatimids and Mamluks in Egypt and Syria. Turkish-Ottoman and Persian-Safavid art. Photographic illustrations from p. 563. Bibliography, ed. Umberto Scerrato, 554–62.]

(272) *Introduzione allo studio dell'archeologia islamica. Le origini e il periodo omayyade* (Venice and Rome, 1966). [Foreword by G. Levi della Vida, 13–20; introduction (pp. xxi–xxiii) and bibliographic notes (pp. xxv–xxviii) by Oleg Grabar.]

NOTES

Author's note: The present article is in part the result of research I conducted for my MA thesis, "'L'Oriente è paese dalle molte vite e dalle molte storie...': Ugo Monneret de Villard e gli studi di arte islamica in Italia" (Università degli Studi della Tuscia, 2005–6), under the supervision of Prof. Maria Andaloro. I continued this research in Paris at the Institut national d'histoire de l'art (INHA), thanks to a fellowship from the Fondazione per l'Arte della Compagnia di San Paolo (Nov. 2007–Oct. 2008). In 2013, I was awarded the *Prix Marc de Montalembert* (Fondation Marc de Montalembert) for a study dedicated to Monneret de Villard, based mainly on his correspondence with other scholars and intellectuals, and on other archival materials. This work is currently in preparation and I would be particularly appreciative of any information or references that readers might offer.

I wish to express my sincere thanks to Maria Andaloro, Maria Vittoria Fontana, and Mariam Rosser-Owen for their assistance and encouragement during the preparation of this paper. I would also like to thank Gülru Necipoğlu, the anonymous *Muqarnas* reader, and William Tronzo for their invaluable advice.

1. Until now, the most comprehensive bibliography of Monneret's work, containing 197 titles, was that published by Angelo Michele Piemontese, "Bibliografia delle opere di Ugo Monneret de Villard (1871–1954)," *Rivista degli Studi Orientali* 58 (1984, but printed 1987): 1–12. An updated list, containing 272 titles, is found in the appendix to the present article.

2. See, for example, the postscript by Eugenio Galdieri in Oleg Grabar, *The Great Mosque of Isfahan* (New York, 1990), 76; G. J. Toomer, *Eastern Wisdom and Learning: The Study of Arabic in Seventeenth-Century England* (Oxford, 1996), 9; *The Cambridge History of Africa*, ed. J. D. Fage and Roland Olivier, 8 vols. (Cambridge and New York, 1975–86), vol. 2, *From c. 500 B.C. to A.D. 1050*, ed. J. D. Fage, 559; Gawdat Gabra and Hany N. Takla, eds., *Christianity and Monasticism in Upper Egypt*, 2 vols. (Cairo and New York, 2008), vol. 1, *Akhmim and Sohag*, 226.

3. Ugo Monneret de Villard, *Introduzione allo studio dell'archeologia islamica. Le origini e il periodo omayyade* (Venice, 1966).

4. See Oleg Grabar, *The Formation of Islamic Art* (New Haven, 1973). In the first chapter, Monneret's name and books are repeatedly mentioned as fundamental references.

5. Ugo Monneret de Villard, *Le pitture musulmane al soffitto della Cappella Palatina in Palermo* (Rome, 1950).

6. Ugo Monneret de Villard, "Una iscrizione marwanide su stoffa del secolo XI nella Basilica di S. Ambrogio a Milano," *Oriente Moderno* 20 (1940): 504–6; Ugo Monneret de Villard, "Un codice arabo-spagnolo con miniature," *La Bibliofilia* 43 (1941): 209–23; Ugo Monneret de Villard, "Le chapiteau arabe de la Cathédrale de Pise," *Académie des Inscriptions & Belles-Lettres. Comptes rendus des séances* (1946): 17–23; Ugo Monneret de Villard, "Codici magrebini decorati della Biblioteca Vaticana," in *Scritti in onore di Francesco Bégui-*

not, Annali (Istituto universitario orientale di Napoli), n.s., 3 (Naples, 1949), 83–91.

7. With Giorgio Levi Della Vida's encouragement, Monneret undertook the important task of reorganizing the material collected throughout his career; the project, which was never completed, was supposed to have been financially supported by the Fondazione Caetani (Accademia Nazionale dei Lincei) and the Istituto Nazionale di Archeologia e Storia dell'Arte (henceforth INASA) in Rome: see above pp. 47–48, and Maria Adelaide Lala Comneno, "Monneret islamista: Il catalogo Opere di arte islamica in Italia," in *L'eredità di Monneret de Villard a Milano: Atti del convegno (Milano, 27–29 novembre 2002)*, ed. Maria Grazia Sandri (Florence, 2004), 63.

8. Giorgio Levi Della Vida, "Premessa," in Monneret de Villard, *Introduzione allo studio dell'archeologia islamica*, pp. XII–XIV.

9. Monneret's working archives were donated in 1966 to INASA in Rome: the Fondo Monneret is preserved in the Biblioteca di Archeologia e Storia dell'Arte (BiASA) in Rome, once the library of the Istituto. See also Francesca Zannoni, "Il carteggio e l'archivio di studio di Ugo Monneret de Villard nella Biblioteca di Archeologia e Storia dell'Arte di Roma," in Sandri, *L'eredità di Monneret*, 15–21. This valuable collection, which deserves a thorough study, includes some correspondence (dating between 1937 and 1954) and a large number of working materials; the numerous cards and folders, strictly divided by subject and containing bibliographical references, reveal Monneret's systematic approach. The unpublished manuscript "Opere di arte islamica in Italia" is preserved in the Fondo Monneret, together with many related documents and notes (BiASA, Fondo Monneret: scatola 6, cartella 31). The BiASA also holds Monneret's personal library (given to INASA in 1955). A valuable collection of approximately 6,000 photographs is preserved at INASA, while more than 1,600 negatives are preserved in the Gabinetto Fotografico Nazionale (ICCD, Rome).

10. "It came from the files I made up, for my own use, for every Islamic art monument that, at the beginning of my Oriental archaeology studies, I found in a museum, in a church's treasure, or in whichever collection....The files for many of the objects contained fairly broad descriptions, to which I would add the necessary bibliographical references; for others the elaboration was a lot simpler. Finally, for many others [the files contained] merely a mention of the object I had seen. This was, therefore, all working material, which I kept collecting until World War II": see Ugo Monneret de Villard, "Prefazione," in "Opere d'arte islamica in Italia" (unpublished), 9, in BiASA, Fondo Monneret: scatola 6, cartella 31.

11. Monneret also complained about the absence of a museum and of a chair of Islamic art in Italy, and he listed a series of Oriental items mentioned in ancient inventories, thereby tracing a short history of Italian taste and of collectors of Oriental artifacts, such as the Medici and Este families. Ibid.

12. Lala Comneno, "Monneret islamista," 63–64: "La travagliata storia di questo Catalogo non può essere ricostruita nel dettaglio...Non è possibile ricostruire quando sia nata in Monneret la prima idea del lavoro" (The turbulent history of this Catalogue cannot be reconstructed in detail...It is not possible to say when this idea first came to Monneret's mind).

13. Monneret de Villard's academic development can be divided into three main phases, somewhat corresponding to his various interests and activities: an early formative period, from his graduation in 1904 to the early 1920s, spent in Milan; a second phase, which included numerous archaeological missions in Africa (about 1921–37); and a third, less dynamic, but strongly reflective and productive moment, spent in Rome from 1937 until his death in 1954. These three phases were proposed by Andrea Augenti in his seminal essay "Per una storia dell'archeologia medievale italiana: Ugo Monneret de Villard," *Archeologia Medievale* 28 (2001): 7–24.

14. Maria Grazia Sandri, "Monneret de Villard nell'archivio del Politecnico di Milano," in Sandri, *L'eredità di Monneret*, 9; Augenti, "Per una storia," 7.

15. Monneret attended courses characterized by a humanistic openness that would probably be inconceivable today in a school for engineers. For Camillo Boito and Monneret de Villard, see Alessandro Piccinelli, "Alle origini del Novecento: Arte, architettura e città nell'opera di Monneret de Villard (1903–1921)" (MA thesis, Istituto Universitario di Architettura di Venezia [IUAV], 1985–86). I am grateful to Mr. Piccinelli for giving me a copy of this interesting work. See also Guido Zucconi, *L'invenzione del passato. Camillo Boito e l'architettura neomedievale, 1885–1890* (Venice 1997), and Augenti, "Per una storia."

16. The key steps in this complex trajectory can be deduced by cross-referencing Monneret's early writings with the many articles in Sandri, *L'eredità di Monneret*. Another important text concerning Monneret's scholarly formation is Piccinelli, "Alle origini del Novecento." See also Silvia Armando, *Dizionario biografico degli Italiani* (Rome, 1960–), s.v. "Monneret de Villard, Ugo."

17. See as examples: Ugo Monneret de Villard, "La chiesa di S. Lorenzo in Milano. Studio del tracciato planimetrico," *Monitore Tecnico* 16 (1910): 388–90; Ugo Monneret de Villard, "Intorno a S. Lorenzo di Milano. Note sull'origine del tipo planimetrico," *Monitore Tecnico* 16 (1910): 591–93, 631–34, 651–54; Ugo Monneret de Villard, "La chiesa di S. Lorenzo in Milano," *Monitore Tecnico* 20 (1910): 28–30. References to Eastern architecture are frequent in Monneret's early writings (see commentaries on his writings in Piemontese, "Bibliografia delle opere," also noted in the appendix to the present article).

18. Josef Strzygowski, *Orient oder Rom: Beiträge zur Geschichte der Spätantiken und Frühchristlichen Kunst* (Leipzig, 1901). Monneret was fascinated by the scholar's early writings, which did not include the pseudo-Nazi ideas expressed in his later works. On the relation between Monneret de Vil-

lard and Josef Strzygowski, and the influence of the latter on Monneret's work, see Silvia Armando, "Ugo Monneret de Villard et la découverte de *l'Oriente* entre Croce et Strzygowski," in *Le Caire dessiné et photographié au XIXe siècle*, ed. Mercedes Volait (Paris, 2012).

19. Giovanni Teresio Rivoira, *Le origini dell'architettura lombarda e delle sue principali derivazioni nei paesi d'oltr'Alpe*, 2 vols. (Rome, 1901–7); Gustavo Giovannoni, "Recenti studi sulle origini dell'architettura lombarda," *Nuova Antologia* 37 (July 1902): 773. For an analysis providing a framework for the issue, see Annabel Jane Wharton, *Refiguring the Post Classical City: Dura Europos, Jerash, Jerusalem and Ravenna* (Cambridge, 1995), 4–11.

20. Monneret was in Dalmatia in July 1909, and spent two months in Greece in 1912: see Nora Lombardini, "Carteggio Corrado Ricci-Ugo Monneret de Villard (1904–1917)," in Sandri, *L'eredità di Monneret*, 26, 27, and n. 28. Some details about his travel to Greece can be found in an unpublished letter he wrote from Corfu to Adolfo Venturi, discovered in Venturi's correspondence: see Armando, "Ugo Monneret de Villard et la découverte de *l'Oriente*," 385n33.

21. Only a brief anonymous biographical entry mentions some courses on Oriental archaeology that Monneret would have attended in Germany and Great Britain: *Chi è? Dizionario biografico degli italiani d'oggi* (Rome, 1948), s.v. "Monneret de Villard, Ugo"; if we could fully rely on this text, it would be easier to explain Monneret's interests and training. His first documented travels to the Middle East (mainly Egypt, but also Istanbul and Jerusalem) date from the early 1920s. Monneret mentions his trips to the "Oriente" beginning in 1908, likely (and interestingly!) referring to his visits to Byzantine lands such as Greece and Dalmatia. See Ugo Monneret de Villard, "La missione archeologica italiana in Egitto, 1921–28," *Oriente Moderno* 8 (1928): 268.

22. During my research in the Biblioteca Ambrosiana in Milan, I discovered letters and notes sent by Monneret to Achille Ratti (the future Pope Pio XI), as well as to Tommaso Gallarati Scotti and Alessandro Casati, two young members of the Milanese aristocracy; the correspondence with Casati (54 documents dated between 1912 and 1948, Biblioteca Ambrosiana: Casati 42, busta 16) is particularly interesting. The Biblioteca also owns two fragments of parchment given by Monneret in 1937 (file: Y 225 sup.). Another letter in the Fondo Casati, written by Antonio Meli Lupi di Soragna, concerns the trip he made to Greece with Monneret: see Lombardini, "Carteggio Corrado Ricci," 27n28. A possible connection between Monneret and the Arabist Eugenio Griffini, who worked at the Biblioteca Ambrosiana, is proposed in Sandri, "Monneret de Villard nell'archivio del Politecnico," 12n27. Griffini was appointed as curator of the Palatine Library in Cairo. See also Bruna Soravia, *Dizionario biografico degli Italiani*, s.v. "Griffini, Eugenio."

23. Piero Craveri, *Dizionario biografico degli Italiani*, s.v. "Casati, Alessandro."

24. "And what about Egypt? And the Pyramids? (What bourgeois questions!) And the buried princesses? Thanks for the

photographs you promised me: I would be ever so obliged, because here it is terribly hard to get hold of photographs of Egyptian things. And these are so very interesting to me.": Biblioteca Ambrosiana, Casati 42, busta 16, letter no. 2, written in Milan, February 14, 1906.

25. Monneret attained his Libera Docenza (university teaching qualification) to teach a course on architectural history he entitled "Archeologia medievale": see Augenti, "Per una storia," 9, and Sandri, "Monneret de Villard nell'archivio del Politecnico" 12.

26. See, among others, Ugo Monneret de Villard, *L'isola Comacina. Ricerche storiche ed archeologiche* (Como, 1914); Ugo Monneret de Villard, "Note di Archeologia lombarda," *Archivio Storico Lombardo* 16 (1914): 5–70; Ugo Monneret de Villard, *Le vetrate del Duomo di Milano*, 3 vols. (Milan, 1918–20); Ugo Monneret de Villard, "Note sul memoratorio dei maestri commacini," *Archivio Storico Lombardo* 47 (1920): 1–16.

27. The main reference is Marta Petricioli, *Archeologia e Mare Nostrum. Le missioni archeologiche nella politica mediterranea dell'Italia 1898/1943* (Rome, 1990). The book is based on documents from the Ministero degli Affari Esteri dated between the end of nineteenth century and World War II. Monneret's name appears repeatedly: see Petricioli, *Archeologia e Mare Nostrum*, index; see also Augenti, "Per una storia," and the many writings by Monneret himself.

28. "...affinché la scienza italiana fosse rappresentata nella intensa rinascita degli studi archeologici che si delineava nella Valle del Nilo, dopo l'interruzione causata dal conflitto mondiale": Monneret de Villard, "La missione archeologica in Egitto," 268.

29. In 1921, Monneret wrote to Roberto Paribeni (head of the Ufficio delle Missioni Scientifiche in Levante) and to the Khedive, proposing a structured study of Coptic art in order to change the general direction of archaeological studies in Egypt: see Petricioli, *Archeologia e Mare Nostrum*, 252–53. In 1925, he drew up the "Programma per una missione storico-archeologica italiana in Oriente," which included many expressions of cultural propaganda: Petricioli, *Archeologia e Mare Nostrum*, 256–57.

30. For five years beginning in 1922 Monneret was in charge of completing the study and publication of Coptic monuments. Petricioli, *Archeologia e Mare Nostrum*, 254.

31. In 1924, Monneret became the director of restoration for Deir Anba Sim'an. Ibid., 255.

32. See Augenti, "Per una storia," appendix, p. 22.

33. As vividly depicted by Donald M. Reid, "Westerners stepping ashore variously imagined themselves entering the world of the pharaohs, the Bible, the Greeks and Romans, and the Quran and the *Arabian Nights*." Donald Malcom Reid, *Whose Pharaohs? Archaeology, Museums, and Egyptian National Identity from Napoleon to World War I* (Berkeley, 2002), 2.

34. See above n. 28.

35. Beside the cooperation of the Comité de conservation des monuments de l'art arabe, in 1926 the Service des antiquités appointed him director of archaeological excavations

of Christian monuments in Egypt: Petricioli, *Archeologia e Mare Nostrum*, 261–63. It is also worthwhile to mention the words of Gaston Wiet, who defined the Italian archaeologist as "l'archéologue le plus compétent, le plus documenté sur l'Egypte du moyen âge": Gaston Wiet, "Préface," in Ugo Monneret de Villard, *La necropoli musulmana di Aswan* (Cairo, 1930). At that time Wiet was director of the Cairo Museum of Islamic Art: Petricioli, *Archeologia e Mare Nostrum*, 250n117, and André Raymond, "Bibliographie de l'œuvre scientifique de M. Gaston Wiet," *Bulletin de l'Institut français d'archéologie orientale* 59 (1960): p. IX.

36. "The broadening of my research is an obvious necessity: Coptic and Islamic art, living and developing side by side in the same country, could not and did not remain unrelated to each other; the mutual exchanges were daily and deep. The knowledge of one art implies and requires the knowledge of the other.": Monneret de Villard, "La missione archeologica," 276.

37. "We must remember that the Orient is a place of many lives and stories, and that in every area layers of different civilizations overlap; the archaeologist must excavate them all and study them with equal love and equal science": Monneret de Villard, "La missione archeologica," 270. See also Augenti, "Per una storia," 10–15, highlighting how Monneret was possibly a pioneer of the stratigraphic method.

38. Notably, Monneret often visited the Museum of Islamic Art in Cairo: many folders in Monneret's photographic archives (INASA, Rome) contain photographs of artifacts preserved in the museums. Also, many of the encrusted panels mentioned or illustrated in his book *Monumenti dell'arte musulmana in Italia. I, La cassetta incrostata della Cappella Palatina di Palermo* (Rome, 1938), were preserved in the same museum, while others were in the Egyptian Museum. See, respectively, ibid. pls. VIII–XI, and pls. XII, XIII, XVI, XVII, XVIII, XIX, XXXV.

39. Monneret's mission to Nubia for the study of medieval (Christian and Islamic) monuments took place between 1928 and 1936. He also travelled to Iran many times and contributed to Arthur U. Pope and Phyllis Ackerman, *A Survey of Persian Art from Prehistoric Times to the Present*, 6 vols. (London and New York, 1938–39): see Ugo Monneret de Villard, "The Iranian Temple of Taxila," and "The Relations of Manichean Art to Iranian Art," in Pope and Ackerman, *Survey of Persian Art*, 1:445–48, fig. 1, and 5:1820–28, respectively; Ugo Monneret de Villard, "La preparazione del Survey of Persian Architecture," *Atti del XIX Congresso degli Orientalisti Roma, 23–29 Settembre 1935* (Rome, 1938), 644–45. When Italian troops took Addis Ababa in 1936, the scholar was assigned to a double mission in Axum: a topographic study of the area and the sadly famous transport of the Axum obelisk (destined for Rome) to Massaua: see Ugo Monneret de Villard, *Aksum. Ricerche di topografia generale* (Rome, 1938), and also Zannoni, "Il carteggio e l'archivio di studio di Ugo Monneret de Villard," 17–18.

40. Monneret de Villard, *La cassetta incrostata della Cappella Palatina*. For an updated study on this technique, see Mariam Rosser-Owen, "Incrusted with Ivory: Observations on a

Casket in the Victoria and Albert Museum," in *Siculo-Arabic Ivories and Islamic Painting 1100–1300: Proceedings of the International Conference, Berlin 6–8 July 2007*, ed. David Knipp (Munich, 2011). I am very grateful to Mariam Rosser-Owen for allowing me to preview the paper. I dedicated a study to this object on the occasion of the second seminar, "Tracciati di studio in corso d'opera," organized by doctoral students at the Università degli Studi della Tuscia and held in Viterbo, May 19, 2010: see Silvia Armando, "La cassetta incrostata della Cappella Palatina di Palermo. Memoria e materia," in *La ricerca giovane in cammino per l'arte*, ed. Chiara Bordino and Rosalba Dinoia (Rome, 2012), 88–103.

41. To be more precise, the items examined belong to the ANIMI (Associazione Nazionale per gli Interessi del Mezzogiorno d'Italia, see p. 39 above. They are the Archivio Storico ANIMI and the Fondo Archivistico Umberto Zanotti Bianco, both preserved in the Biblioteca Giustino Fortunato, Rome: see www.animi.it, where general indices of the documents can be found. See also Valeriana Carinci and Antonio Jannazzo, "Sul riordinamento dell'Archivio Zanotti Bianco (Palazzo Taverna, Roma)," *Archivio Storico per la Calabria e la Lucania* 49 (1989): 229–34, and Aida Giosi, *Inventario del Fondo Umberto Zanotti Bianco (1902–1963)* (Rome, 2009). Many other papers regarding Zanotti Bianco's private and public life (including letters written by Monneret) have different classifications, which will be specified below. Concerning the letters, it is worthwhile to observe that in all cases we are confronted with passive correspondence, that is to say, we can only deduce information from what Zanotti Bianco received, not from what he wrote. I wish to thank Dr. Cinzia Cassani Craveri and the staff of the library Giustino Fortunato for their kind cooperation.

42. For a short bibliographic profile, visit www.animi.it; see also Giulio Ielardi, ed., *Umberto Zanotti Bianco, 1889–1963* (Rome, 1980), and Sergio Zoppi, *Umberto Zanotti-Bianco, Patriota, educatore, meridionalista. Il suo progetto e il nostro tempo* (Soveria Mannelli, 2009).

43. On Paolo Orsi, see Umberto Zanotti Bianco, "Paolo Orsi e la società Magna Grecia," in "Paolo Orsi," special issue, *Archivio Storico per la Calabria e la Lucania* 5, 3–4 (1935): 317–52; Marcello Barbanera, *L'archeologia degli Italiani* (Roma, 1998), 80–84. See also Paolo Enrico Arias, "Zanotti Bianco e Paolo Orsi," *La Nuova Antologia* 125, 2174 (1990): 396–400. After Orsi's death in 1935, Zanotti Bianco collaborated with the archaeologist Paola Zancani Montuoro.

44. As regards Islamic archaeology, Zanotti Bianco carried on some archeological excavations in the vicinity of Lucera.

45. Cf. Maurizio Paoletti, "Umberto Zanotti-Bianco e la Società Magna Grecia," *Bollettino della Domus Mazziniana* 38 (1992): 5–30; Maurizio Paoletti, "Paolo Orsi (1859–1935): La 'dura disciplina' e il 'lavoro tenace' di un grande archeologo del Novecento," in *Magna Graecia. Archeologia di un sapere*, ed. Salvatore Settis and Maria Cecilia Parra (Milan, 2005), 192–97; Claudio Sabbione and Roberto Spadea, "La società Magna Grecia e la ricerca archeologica," in *Umberto*

Zanotti-Bianco, meridionalista militante, ed. Pasquale Amato (Venice, 1981), 115–35. See also Nathalie de Haan, "Umberto Zanotti Bianco and the Archaeology of Magna Graecia during the Fascist Era," *Fragmenta* 2 (2008): 233–49, and Nathalie de Haan, "The 'Società Magna Grecia' in Fascist Italy," *Anabases* 9 (2009): 113–25; http://anabases.revues.org/367.

46. See www.animi.it; Paoletti, "Umberto Zanotti Bianco e la Società Magna Grecia," 9 and 14. The author reports the opinion of Achille Starace, secretary of the Partito Nazionale Fascista: "... il nome stesso dell'Associazione Nazionale per gli interessi del Mezzogiorno suonava come affermazione di critica e di sfiducia" (...even the name, National Association for the Interests of Southern Italy, sounded in itself as a claim of criticism and mistrust). After the fall of the Fascists, the value of Zanotti's activities was also recognized at an institutional level. He was among the founders of Italia Nostra, and the Italian Red Cross.

47. About the "culto della Romanità" during the period of Fascist rule, see Barbanera, *L'archeologia degli Italiani*, 144–46. See also Massimo Bernabò, *Ossessioni bizantine e cultura artistica in Italia: Tra D'Annunzio, fascismo e dopoguerra* (Naples, 2003), 92–99, notably for the political opposition between National (Roman) art and Oriental art. In order not to make the proposed cultural framework misleading, I must note that it is not my intention to depict a rigid opposition between "serious," independent scholars and scholars influenced by the Fascist regime. Rather, they all comprised an intellectual community in which people were often connected by scientific as well as personal relationships. For instance, consider that Paolo Orsi was a senator of the Reign and that his political ideas were more moderate than Zanotti's. This did not prevent a cultural collaboration between the two. Moreover, the 1920 list of the members of the Società Magna Grecia includes names such as Riccardo Gualino, Lionello Venturi e Giorgio Levi Della Vida, Roberto Almagià, Ugo Ojetti, and Gustavo Giovannoni, people who represented very different cultural and political convictions. What is undeniable is the fact that some subjects—Islamic art among them—were overlooked by the *scienza ufficiale* because they did not fit well with its propagandistic goals.

48. Friedrich Sarre, "L'arte mussulmana nel Sud d'Italia e in Sicilia," *Archivio Storico per la Calabria e la Lucania* 3 (1933): 441–50.

49. The magazine was founded in 1931: see Giovanni Pugliese Carratelli, "L'archeologo," in Ielardi, *Umberto Zanotti Bianco (1889–1963)*, 120.

50. Sarre, "L'arte mussulmana," 447–48.

51. Bruna Soravia, *Dizionario biografico degli Italiani*, s.v. "Levi Della Vida, Giorgio."

52. The letter is preserved in the folder *Monneret de Villard, Monumenti dell'arte musulmana in Italia* (ANIMI, Archivio Storico ANIMI, A.III.03.UA29).

53. "As for supporting your proposal, you know well [that] I am not in a position to support it whatever it is...It cer-

tainly is very sad that over here the study of Islamic art is so little cultivated, and a dedicated chair (which Orsi would like created in Rome, and rightly so) would be very useful": ibid. In the letter Levi Della Vida also insisted on the importance of assigning a possible chair of Islamic art to a broad specialist: "Occorrerebbe tuttavia che chi fosse chiamato a ricoprirla avesse conoscenza dell'arte islamica *in generale*, per essere in grado di dare ai suoi allievi quella cultura preliminare che è indispensabile introduzione a ogni specializzazione ulteriore. Occorre sempre diffidare delle specializzazioni premature! Senonché, ripeto, si tratta di iniziative che non mi riguardano. *Videant consules*" (Nevertheless the person designated to occupy this chair should have a broad knowledge of Islamic art *in general*, in order to be able to transmit to his pupils that preliminary cultural background that is an essential introduction to any further specialization. We must disregard early specializations! Anyway, I repeat, these are initiatives that do not concern me. *Videant consules* [Let the consuls see to it (that the state suffers no damage)]). Levi Della Vida apparently referred to someone in particular, possibly a scholar suggested by Zanotti, but being discreet— unfortunately for us!—neglected to mention the individual by name in his answer, where a contrasting opinion was expressed. Since the letter is preserved in the file *Monneret de Villard, Monumenti dell'arte musulmana in Italia* (see n. 52 above), one could infer that the possible candidate suggested by Zanotti Bianco was Monneret de Villard himself. Levi Della Vida's negative judgment would, in this case, be particularly interesting, especially considering the longlasting friendship and mutual respect that would bind him and Monneret in subsequent years.

54. Regarding his refusal to swear the oath, see Giorgio Levi Della Vida, *Fantasmi ritrovati* (Venice, 1966). See also the new edition: Giorgio Levi Della Vida, *Fantasmi ritrovati*, ed. Maria Giulia Amadasi Guzzo and Fulvio Tessitore (Naples, 2004), 167–71; and Maria Giulia Amadasi Guzzo, "Un ricordo," in Levi Della Vida, *Fantasmi ritrovati*, 194–207. See also Helmut Goetz, *Il giuramento rifiutato. I docenti universitari e il regime fascista* (Milan, 2000), 50–61, and Giorgio Boatti, *Preferirei di no. Le storie dei dodici professori che si opposero a Mussolini* (Turin, 2001), 89–273. In his obituary for Monneret, the American scholar Arthur Upham Pope declared that Monneret refused to take the Fascist oath, but this statement cannot be considered reliable: see Arthur U. Pope and Phyllis Ackerman, *Survey of Persian Art from Prehistoric Times to the Present* (Oxford, 1967–), vol. 14, *New Studies 1938–1960*, p. O/xi.

55. Giuseppe Gabrieli, "Per la istituzione di una cattedra di storia dell'arte islamica in Italia," *La Gazzetta del Mezzogiorno*, March 7, 1934. On Giuseppe Gabrieli, see Bruna Soravia, *Dizionario biografico degli Italiani*, s.v. "Gabrieli, Giuseppe," with other bibliographic references. See also http://www.lincei-celebrazioni.it/igabrieli.html

56. "...è tutta una ricerca e un inventariamento da fare, nelle piccole e grandi collezioni private, registrando, illust-

rando, questi oggetti e manufatti d'arte musulmana ancor reperibili nei palazzi, nelle chiese, nei conventi..." (broad research [should be carried out] and inventories [should be compiled] [working] in small and big private collections, recording, illustrating those objects and artifacts of Islamic art still traceable in palaces, churches, monasteries...): Gabrieli, "Per la istituzione di una cattedra."

57. ANIMI, Fondo Zanotti Bianco, *Ritagli di giornale ordinati da U. Zanotti Bianco (1934–39)*, A.5.17 (1934–39).

58. We do not know where or when Monneret and Zanotti first met. However, they had both been involved in the movement known as Italian Catholic Modernism. A possible connection may have been their mutual friend Tommaso Gallarati Scotti, a fervent follower of "Modernismo," who had worked with Monneret on a project to publish the mystical poets: see the correspondence between Monneret de Villard and the writer and intellectual Giuseppe Prezzolini, in Alfonso Botti, "Giuseppe Prezzolini e il dibattito modernista (II)," in *Fonti e Documenti*, 11–12 (1982–83), 79–127. Zanotti and Gallarati Scotti, a prominent member of the ANIMI, first met in Sicily, after the 1908 earthquake. It is worth remarking that Gallarati Scotti did not share Zanotti's concern for the archaeological heritage of the region, as can be gleaned in a letter he wrote to Zanotti in 1913: "...io di denaro per i vecchi cocci non ne cerco e ti prego di non dirmene più parola perché io sono esasperato di vedere che mentre mi preoccupo delle finanze dell'Associazione, tu non ti curi che dell'archeologia" (... I am not looking for money for old pottery, and please do not speak about it anymore because I have had more than enough of worrying about the Association's finances, while you do not care about anything else but potsherds): Paoletti, "Umberto Zanotti Bianco e la Società Magna Grecia," 16n32.

59. This is the first letter in the folder *Monneret de Villard. Monumenti dell'arte musulmana in Italia* (ANIMI, Archivio Storico ANIMI, A.III.03.UA29); it is dated July 2, 1934.

60. Monneret wrote: "Debbo dirle che già anni or sono avevo cominciato a raccogliere materiale per uno studio dell'arte musulmana in Italia—note, schede ecc...Poi tutto fu messo da parte, causa il troppo lavoro dei miei scavi in oriente" (I must tell you that years ago I had already started collecting materials for a study of Islamic art in Italy—notes, files, etc....Then I had to put everything aside, because of the amount of work my excavations in the Orient required). Ibid.

61. "I looked at my materials again: there is a lot, and I mean a lot, an awful lot more to do. But looking at my old notes and reading Sarre's article and Orsi's note again, I had an idea that I am going to propose to you. Please let me know frankly what you think about it." Ibid.

62. "To believe that the Government will do anything is vain: the best they can do is to take some presumptuous, happy-go-lucky idiot who might have scribbled some compilation article and stick him [on] a University chair. Better to do nothing: if anything can be done, it will have to come from private citizens." Ibid.

63. "...the painted ivory boxes, the oliphants, the textiles.... Then, for example, to publish in full and in every detail the Cappella Palatina's ceiling, a marvelous repertoire of all the Islamic decorative motifs in southern Italy." Ibid.

64. "Sono veramente roba siculo-Italia meridionale? E non piuttosto della Siria, Egitto o Mesopotamic? Vede che la cosa non è lieve" (Is this really stuff from Sicily or southern Italy? And not rather from Syria, Egypt, or Mesopotamia? You will agree that is not to be taken lightly). Ibid. This concern is here expressed quite generically, but we know in particular that the scholar would later attribute the painted ivory caskets to the Mesopotamic area. Monneret de Villard, *Le pitture musulmane*, 29–30; Monneret de Villard, "Arte cristiana e musulmana del Vicino Oriente," 508. See also Silvia Armando, "*Avori arabo-siculi: cassette, pissidi, olifanti*. Un taccuino inedito di Ugo Monneret de Villard," in *Studi in onore di Maria Andaloro* [tentative title, forthcoming].

65. ANIMI, Archivio Storico ANIMI, A.III.03.UA29, folder *Monneret de Villard. Monumenti dell'arte musulmana in Italia*, letter dated July 2, 1934. The idea of gathering all the data in a corpus reflects Monneret's positivist approach; this was due to his personal background, but it was also typical of his time. In a related field of interest, one could recall the work by Max Van Berchem, *Matériaux pour un corpus inscriptionum arabicarum* (Paris, 1894), as the output of a similarly positivist approach. Nevertheless, while Van Berchem worked with a big team of researchers charged with collecting inscriptions from all over the Eastern world, Monneret de Villard carried out this enormous compiling endeavor almost entirely on his own.

66. "For my part I like the idea and I would put all the good will and hard work I am capable of and the little I know about it into it: but let's be clear, I have no money to give. We must find money: you wouldn't have some benefactor at hand, who could give us four or five thousand liras a year? If you like the idea, we can discuss this further; if not, throw away this letter and I'm sorry for wasting your time": ANIMI, Archivio Storico ANIMI, A.III.03.UA29, folder *Monneret de Villard. Monumenti dell'arte musulmana in Italia*, letter dated July 2, 1934.

67. With the only exception a letter dated 1954; see n. 93 below.

68. The last mission dates to 1938, but after 1936 Monneret had only occasional assignments (see above n. 39).

69. He had located about fifty painted ivory caskets throughout Europe (letter dated March 28, 1935, folder *Monneret de Villard, Monumenti dell'arte musulmana in Italia* [ANIMI, Archivio Storico ANIMI, A.III.03.UA29]). See also n. 64 above.

70. Letter dated March 28, 1935, folder *Monneret de Villard, Monumenti dell'arte musulmana in Italia* (ANIMI, Archivio Storico ANIMI, A.III.03.UA29). By 1932 Marguerite Van Berchem had already published her studies on the mosaics of the Dome of the Rock in Jerusalem and of the Great Mosque of Damascus in Creswell's *Early Muslim Architecture* (Oxford, 1932–40). The discovered letters written by Marguerite Van Berchem to Zanotti Bianco, which are scattered throughout the archives, testify to a close friendship between the two. They shared not only a concern for artistic heritage but also their engagement with the International Red Cross. For a short biographic note on Marguerite Van Berchem, see the website of the Fondation Max Van Berchem: http://www.maxvanberchem.org/fr/marguerite.cfm.

71. Letter from Agnello (an architectural historian from Syracuse), and postcard from Carucci (director of the Archivio Storico Salernitano), from Naples, both dated March 27, 1935 (ANIMI, Archivio Storico ANIMI, A.III.03.UA29, folder *Monneret de Villard. Monumenti dell'arte musulmana in Italia*).

72. This letter (dated September 10, 1934) is also in ANIMI, Archivio Storico ANIMI, A.III.03.UA29, folder *Monneret de Villard. Monumenti dell'arte musulmana in Italia*.

73. "Conservateur du Musée d'art musulman d'Alger, un très bon orientaliste." Ibid.

74. "I spoke to him about the Islamic monuments in southern Italy and about the necessity of studying them. He was very interested...I proposed that we send him a few photos of the Islamic monuments and objects of southern Italy... He was charmed by the idea. I believe that you have a much better chance to get somewhere with him rather than with Sarre, who is sick and aged." Ibid.

75. In a letter dated February 6, 1936, he announced: "Sono ritornato ieri in Italia dai miei lavori archeologici a Meroe. Ormai credo che con la Nubia non avrò più nulla a che fare se non elaborare il materiale raccolto e pubblicarlo: lavoro da tavolino" (I came back to Italy yesterday from my archaeological work in Meroe. I do not think I will have any more to do with Nubia, except to elaborate on the materials I collected and publish them (office work): ANIMI, Archivio Storico ANIMI, A.III.03.UA29, folder *Monneret de Villard. Monumenti dell'arte musulmana in Italia*.

76. After his return from Nubia, Monneret planned a trip to London; in April he would have gone to Egypt, then to Iran for a couple of months (ANIMI, Archivio Storico ANIMI, A.III.03.UA29, folder *Monneret de Villard. Monumenti dell'arte musulmana in Italia*, letter dated April 15, 1936). Between January and March 1937 he was in Axum (Augenti, "Per una storia," 7); the following year he went again to Ethiopia (Addis Ababa, Gondar, and Axum), between March and April (see ANIMI, Archivio Storico ANIMI, A.III.03.UA29, folder *Monneret de Villard. Monumenti dell'arte musulmana in Italia*, letter from Addis Ababa dated March 10, 1938).

77. "So I decided to take up again my studies of Islamic art in southern Italy and Sicily and to rush headlong into this mare magnum. I brought back a lot of comparative materials from Cairo, which will be very useful, but first of all I must collect the materials in Italy. Are you still interested in the matter as much as you were a couple of years ago? In that case would you be willing to help me? The help I need right now is to find photographs, information, and articles

buried in magazines unobtainable in Milan and things like that." See the letter from Milan dated February 6, 1936, ANIMI, Archivio Storico ANIMI, A.III.03.UA29, folder *Monneret de Villard. Monumenti dell'arte musulmana in Italia.*

78. Letter dated February 25, 1936, ANIMI, Archivio Storico ANIMI, A.III.03.UA29, folder *Monneret de Villard. Monumenti dell'arte musulmana in Italia.* Besides many painted ivories, Monneret also requested some photographic details of the "cofanetto intarsiato in avorio." The letter also informs us that the plan had slightly changed in the meantime: the proposal of two distinct short books, dedicated, respectively, to the painted ivories and to the Cappella Palatina ceilings, had been replaced with the idea of a single work dedicated to Islamic painting.

79. "You cannot imagine the large number of Islamic materials from Italy scattered across museums all over the world: this makes it quite difficult to study them." Letter dated March 10, 1936, from Milan (ANIMI, Archivio Storico ANIMI, A.III.03.UA29, folder *Monneret de Villard. Monumenti dell'arte musulmana in Italia*).

80. Two typescripts dated May 29 and June 5, 1936, as well as a receipt for £34,5, for the purchase of photographic reproductions of the Cappella Palatina ceilings (ANIMI, Archivio Storico ANIMI, A.III.03.UA29, folder *Monneret de Villard. Monumenti dell'arte musulmana in Italia*).

81. "...non sono un gran che" wrote Mingazzini (ANIMI, Archivio Storico ANIMI, A.III.03.UA29, folder *Monneret de Villard. Monumenti dell'arte musulmana in Italia*). It is likely that some of these photos appeared in Monneret de Villard, *Le pitture musulmane*; see n. 124 below.

82. "With this abundance of materials, I will be able to progress in my study of the Arabic part of the Cappella Palatina's ceiling.": letter dated September 26, 1936 (ANIMI, Archivio Storico ANIMI, A.III.03.UA29, folder *Monneret de Villard, Monumenti dell'arte musulmana in Italia*).

83. "My dearest friend, I have completed the first issue of the series of studies on the Islamic monuments of Italy, of which we had an opportunity to speak before....It is about the encrusted casket at the Cappella Palatina in Palermo." Letter dated May 14, 1937 (ANIMI, Archivio Storico ANIMI, A.III.03.UA29, folder *Monneret de Villard, Monumenti dell'arte musulmana in Italia*).

84. "Io sarei dell'opinione di pubblicare la serie Monumenti musulmani d'Italia in fascicoli, ognuno trattante un solo argomento. Questo sulla cassetta della Cappella Palatina di Palermo sarebbe il primo. Ho già raccolto moltissimo materiale per il II (gli avori dipinti) e per il III (gli avori scolpiti) ma in Italia mi mancano troppi libri e debbo attendere l'occasione di andare a passare un paio di mesi all'estero per terminarli. Ad ogni modo ogni fascicolo tratterebbe di un argomento ben delimitato, perciò credo debba stare a se [*sic*]. Salvo poi magari a rilegare i fascicoli in un volume. Anche dal punto di vista vendita un fascicolo a prezzi limitati si vende più facilmente che non un grosso volume di alto prezzo" (I would be inclined to publish the series Islamic Monuments of Italy as individual issues, each dealing with a single topic. This one, on the casket at the Cap-

pella Palatina in Palermo, would be the first. I have already collected a lot of material for the second (on painted ivories) and third (on sculpted ivories), but in Italy I am missing too many books and I have to wait for a chance to spend a couple of months abroad to complete them. In any case, each issue would deal with a very specific topic, so I believe they should be kept separate. Except, perhaps in the future, they might be bound into a single collection. Also from a commercial point of view, a single issue at a lower price is easier to sell than a large, high-priced collection). Ibid.

85. In regard to such matters, many important names emerge from the documents—some of them wishing to buy the book, others to be informed about the publication—among them Bernard Berenson, Ranuccio Bianchi Bandinelli, Ernst Herzfeld, Ernst Kühnel, Arthur Kingsley Porter, and François Béguinot. Marguerite Van Berchem had also expressed interest in the forthcoming book: "J'ai été fort intéressée par l'annonce d'une série de publications sur le monuments Musulmans d'Italie. Bravo. Voilà qui vient combler une lacune que je déplorais depuis longtemps. Je vous félicite d'avoir mis ce projet à exécution. Je souscrirai bien volentiers au volume de Monneret de Villard. Réservez m'en donc un exemplaire" (I have been really interested in the announcement of a series of publications on the Islamic monuments of Italy. Bravo. It finally fills a void I have been lamenting for a long time. Congratulations on initiating this project. I will happily subscribe to Monneret de Villard's series. Please put aside a copy for me.). ANIMI, Fondo Archivistico Zanotti Bianco A.1.3. UA13 (1935), *Corrispondenza in ordine cronologico,* letter from Paris, dated July 7 (no year marked).

86. Four typewritten copies announce the publication: ANIMI, Archivio Storico ANIMI, A.III.03.UA29, folder *Monneret de Villard, Monumenti dell'arte musulmana in Italia*, letter dated February 23, 1938.

87. For a comprehensive list of the publications of the Collezione Meridionale, see Umberto Zanotti Bianco, *L'Associazione Nazionale per gli interessi del Mezzogiorno d'Italia nei suoi primi cinquant'anni di vita* (Rome, 1960), 325–27.

88. Please remember that Zanotti Bianco was persecuted and arrested: see p. 40 above.

89. Still, in the 1950s, Monneret stressed how these problems prevented him from easily accomplishing his studies: "La guerra, dapprima rendendo impossibile [*sic*] i viaggi, e poi la sconfitta, la catastrofe economica, la svalutazione della moneta distruggendo completamente le mie risorse finanziarie mi resero impossibile ogni continuazione del lavoro" (War, which made travel impossible, and then defeat, the economic catastrophe, and the devaluation of the currency, which destroyed completely my financial resources, made it impossible for me to continue my work.): see Monneret de Villard, "Prefazione," in "Opere d'arte islamica in Italia" (unpublished), 9, in BiASA, Fondo Monneret: scatola 6, cartella 31.

90. Perry Blithe Cott, *Siculo-Arabic Ivories* (Princeton, N.J., 1939); José Ferrandis, *Marfiles árabes de Occidente*, 2 vols.

(Madrid, 1935–40). Regarding Monneret's writings on the so-called Siculo-Arabic ivories, see above n. 64.

91. We know precisely when the change was made, thanks to a letter dated September 30, 1937 (ANIMI, Archivio Storico ANIMI, A.III.03.UA29, folder *Monneret de Villard. Monumenti dell'arte musulmana in Italia*): Monneret moved to his new house in Via Catalana at the beginning of October 1937.

92. See Levi Della Vida reporting Oleg Grabar's deduction: "Premessa di Giorgio Levi Della Vida," in Monneret de Villard, *Introduzione allo studio dell'archeologia islamica*, p. XIII. After 1938, Monneret published other scattered papers concerning Islamic artifacts preserved in Italy (see above n. 6).

93. Monneret wrote requesting information about some Islamic ceramics found by Zanotti Bianco and Paola Zancani Montuoro during archaeological excavations at Foce del Sele, as well as about some *bacini* walled in the churches of Calabria. Letter dated March 17, 1954 (ANIMI, Fondo Archivistico Zanotti Bianco, Sezione B, Serie 5.53, *Società Magna Grecia (corrispondenza 1954)*). The tone of the message suggests that no falling-off had occurred between Zanotti and Monneret in the time they had not been exchanging letters, and that the two scholars always maintained a friendly relationship.

94. The scholar's disdain for public institutions is frequently expressed in letters sent to Zanotti. See also n. 62 above. Monneret's involvement in missions financially promoted by the Italian government, as well as in formulating and disseminating cultural propaganda (see n. 29 above), could raise "Saïdian" questions concerning the scholar's cooperation with the *scienza ufficiale* and his possible connection with the Fascist government. Regarding this last aspect, it is true that Monneret worked for Italian institutions in the Fascist era; nonetheless, there is no damning evidence against him, only some absolving declarations of anti-Fascism, all dated 1945 onward: Ranuccio Bianchi Bandinelli, *Dal diario di un borghese e altri scritti* (Rome, 1976), 470n16; Zannoni, "Il carteggio e l'archivio di studio di Ugo Monneret de Villard," 18. In regards to this question, see also Augenti, "Per una storia," 20, 21, and 20–21nn81–83. It is, in any case, worthwhile to recall Marcello Barbanera's admonition not to measure an archaeologist's scholarly value in relation to his adherence to Fascism or any other political ideology: Barbanera, *L'archeologia degli italiani*, 85. See also Armando, "Ugo Monneret de Villard et la découverte de l'*Oriente*," 379–80

95. The documents preserved in the Archivio Storico della Sapienza (*fascicolo del docente* 1717) inform us that Monneret held a *corso accelerato* of only two months (letter of assignment, October 5, 1944): "Insegnamento Archeologia Cristiana per i corsi accelerati nei mesi di settembre e ottobre dell'a.a. 1943–44"; other documents written in December 1944 (Archivio Storico della Sapienza, *fascicolo del docente* 1717) attest to the payment rendered after the courses were concluded; this leads us to infer that information about an annual course reported by Levi Della Vida

and often repeated by other scholars is imprecise: see Giorgio Levi Della Vida, "Ugo Monneret de Villard (1881–1954), Bibliografia," *Rivista degli Studi Orientali* 30 (1955): 177.

96. Even if the Scuola Orientale had not given any official space to disciplines connected to art history before 1944, it was nevertheless founded, in 1903, by teachers concerned with Eastern studies, such as Angelo De Gubernatis, Ignazio Guidi, Baldassarre Labanca, Ludovico Nocentini, and Celestino Schiaparelli; this group was formally part of the Facoltà di Lettere, but administratively independent. See Raniero Gnoli, "La scuola orientale romana," in *Le grandi Scuole della facoltà* (Rome, 1996), 383.

97. The first chair in art history had been established in Rome by Adolfo Venturi in 1890.

98. Records of the gathering of the Consiglio di Facoltà, November 20, 1944 (Archivio Storico della Sapienza, *fascicolo del docente* 1717).

99. Bruna Soravia, *Dizionario biografico degli Italiani*, s.v. "Guidi, Michelangelo," with other bibliographic references.

100. Emilio Lavagnini and Elena Toesca, "Pietro Toesca," *Atti della Accademia Nazionale di San Luca. Note commemorative di accademici defunti*, n.s., 6 (1962); Monica Aldi, "Pietro Toesca tra cultura tardopositivista e simbolismo. Dagli interessi letterari alla storia dell'arte," *Annali della Scuola normale superiore di Pisa, Classe di lettere e filosofia* 2, 1 (1997): 145–91.

101. From the records of the gathering of the Consiglio di Facoltà, November 20, 1944 (Archivio Storico della Sapienza, *fascicolo del docente* 1717): "Monneret's great merits ... scientific expertise...impressive excavating activity...huge popularity outside Italy... noble and brave political past." The latter statement could suggest once more that, despite Monneret's collaboration with Fascist government institutions, he was not involved from an ideological point of view.

102. "Necessity to preserve as much as possible the important position of Italian culture in Egypt and all the Near Orient: it is a matter of keeping intact a noble and fruitful tradition. To this end perhaps nobody could help as effectively as Monneret." Ibid.

103. This was the opinion of Oliverio, supported by De Sanctis, Carabellese, and Cardinali (Archivio Storico della Sapienza, *fascicolo del docente* 1717). The episode is also mentioned in Levi Della Vida, "Ugo Monneret de Villard, Bibliografia," 177.

104. It is worth highlighting a document preserved in the Archivio Storico della Sapienza, *fascicolo del docente* 1717, and dated November 21 (one day after the board gathering), in which the Ministry of National Education asked for clarification: "Si prega la S.V. di far conoscere a questo ministero se codesta Facoltà di Lettere e Filosofia abbia mai formulata una proposta per la nomina del Prof. U. Monneret de Villard a ordinario di Storia dell'arte Muslmana e Copta presso codesta R. Univeristà" (Pray inform this Ministry whether the Facoltà di Lettere e Filosofia has ever proposed that Prof. U. Monneret de Villard be nominated

as full professor of Islamic and Coptic art history at this University). The interpretation of the document is intriguing but remains uncertain, since in the two documents the course is given different names: *Storia dell'arte dell'Oriente medioevale* and *Storia dell'arte musulmana e copta*

105. The teaching post was held by Umberto Scerrato, both in Rome and Naples. For this piece of information I am grateful to Maria Vittoria Fontana, currently professor of Islamic art and archaeology at La Sapienza University, Rome.

106. See in Monneret's bibliography, published in the appendix, the many entries written for the *Enciclopedia cattolica*, 12 vols. (Vatican City, 1948–54); see also his small but rich book *L'arte iranica* (Verona, 1954). As an example of a paper dedicated to a specific topic, see Ugo Monneret de Villard, "Le monete dei Kushāna e l'Impero romano," *Orientalia* 17 (1948): 205–45. Monneret's studies concerning contacts between the Christian West and the Islamic world merit special attention: see especially Ugo Monneret de Villard, *Lo studio dell'Islam in Europa nel XII e nel XIII secolo* (Vatican City, 1944); Ugo Monneret de Villard, *Il Libro della Peregrinazione nelle parti d'Oriente di Frate Ricoldo da Montecroce* (Rome, 1948); Jacopo da Verona, *Liber Peregrinationis*, ed. Ugo Monneret de Villard (Rome, 1950).

107. For general information about the correspondence, see above n. 9.

108. See *Giuseppe Tucci: Commemorazione tenuta dal Presidente dell'Istituto Gherardo Gnoli il 7 maggio 1984 a Palazzo Brancaccio* (Rome, 1984); Raniero Gnoli, *Ricordo di Giuseppe Tucci* (Rome, 1985); Beniamino Melasecchi, ed., *Giuseppe Tucci nel centenario della nascita: Roma, 7–8 giugno 1994* (Rome, 1995).

109. Giuseppe Tucci, ed., *Le civiltà dell'Oriente*, 4 vols. (Rome, 1962). For the letter written by Tucci, see Rome, BiASA, *Fondo Monneret*, Ms. I.6., letter dated January 23, 1950.

110. "…the art of the Near Orient since the third century until the great Turkish empires," Rome, BiASA, *Fondo Monneret*, Ms. I.6. The letter is undated, but it can be assigned to 1950, thanks to the presence of other related documents. See also Zannoni, "Il carteggio e l'archivio di studio di Ugo Monneret de Villard," 21.

111. Monneret de Villard, "Arte cristiana e musulmana del Vicino Oriente," 451–62.

112. "…later on, Oriental art was finished"; similar considerations can also be found in the printed text. Ibid.

113. See above n. 9; see also Zannoni, "Il carteggio e l'archivio di studio di Ugo Monneret de Villard," 19–20, regarding the photographic campaign. Documents relating to the publication of Monneret De Villard's *Le pitture musulmane* are preserved in Rome, BiASA, *Fondo Monneret*, Ms. I.4. The earliest letter is dated July 24, 1946; the last document was written in September 1950.

114. See Robert Hillenbrand, "Richard Ettinghausen," in *Discovering Islamic Art: Scholars, Collectors and Collections, 1850–1950*, ed. Stephen Vernoit (London and New York, 2000), 171–81; Eleanor Sims, *The Dictionary of Art* (New York, 1996), s.v. "Ettinghausen, Richard." Ettinghausen was of German origin but emigrated to the United States in the mid 1930s.

115. It would be extremely worthwhile to check whether letters by Monneret are preserved in Richard Ettinghausen's correspondence.

116. Richard Ettinghausen, "Painting in the Fatimid Period: A Reconstruction," *Ars Islamica* 9 (1942): 112–24.

117. Ettinghausen, "Painting in the Fatimid Period," 117. The main visual references for the ceilings were, in fact, Andrea Terzi's chromolithographies in Andrea Terzi, *La cappella di S. Pietro nella Reggia di Palermo dipinta e cromolitografata da Ana. Terzi ed illustrata dai Professori M. Amari, Cavallari, L. Boglino ed I. Carini* (Palermo, 1889), and the drawings in Pavlovski's publications: Alexey Pavlovski, *Zhivopis Palatinskoi kapelly v Palermo po snimkan pensionerov Imperatorskoi Akademii Khudozhestv A.N. Pomerantseva i F.J. Chagina* (St. Petersburg, 1890); Alexey Pavlovski, "Décoration des plafonds de la Chapelle Palatine," *Bizantinische Zeitschrift* 2 (1893): 361–412.

118. Many letters in the folder (Rome, BiASA, *Fondo Monneret*, Ms. I.4) are signed by Morey, who acted as an intermediary; concerning Morey, see W. Lee Rensselaer, "Charles Rufus Morey, 1877–1955," *The Art Bullettin* 37, 4 (December 1955): pp. iii–vii, and Ranuccio Bianchi Bandinelli, "Charles Rufus Morey," *Atti della Accademia Nazionale dei Lincei, Classe di Scienze morali, storiche e filologiche. Appendice, necrologi di soci defunti nel decennio dicembre 1945–1955* 1 (1956); Erwin Panofsky, "Charles Rufus Morey," *American Philosophical Society Year Book* (1955): 482–91.

119. The funds were provided by Dumbarton Oaks, the Institute of Fine Arts at New York University, and Princeton University, which also made available negatives and chemical products (Morey's letters to Monneret, Rome, BiASA, *Fondo Monneret*, Ms. I.4: August 30, 1946; October 18, 1946; March 25, 1948). These and other American institutions (together with the Warburg Institute and the British Museum) were promised a complete set of the photos as compensation for the costs of the photographing campaign. The list of the buyers is in Monneret de Villard, *Le pitture musulmane*, 9.

120. This can be inferred from the BiASA archives: there are, in fact, no documents for this period, which is followed by a series of letters related to the publication of the book.

121. Restoration work was conducted between May 1948 and 1953. I wish to thank my friend and colleague Francesca Manuela Anzelmo for providing me with this information, also included in Francesca Manuela Anzelmo, "I soffitti islamici della Cappella Palatina di Palermo e le coperture lignee dipinte della Sicilia Normanna. Struttura decorazione vicende conservative" (MA thesis, Università degli Studi della Tuscia, 2003–4), 74–81; see as well Francesca Manuela Anzelmo, "Un illustre inedito. L'ICR e la prima campagna di restauri dei soffitti della Cappella Palatina di Palermo (1948–1953)," in *Studi in onore di Maria Andaloro* (tentative title, forthcoming). A detailed study of the restoration work done on the ceilings is found in Francesca Manuela Anzelmo, "I soffitti della Cappella Palatina di Palermo e l'orizzonte mediterraneo" (PhD diss., Università degli Studi della Tuscia, 2013).

122. Monneret's delicate health is mentioned by the scholar himself in many letters and writings, as well as by friends, such as Levi Della Vida, "Ugo Monneret de Villard, Bibliografia," 179. We learn from the correspondence related to the Cappella Palatina ceilings that between November 1946 and February 1947 he moved from his house in Via Catalana in Rome to Via dei Monti Parioli 64, where the nursing home Villa San Francesco is located.

123. Document dated July 4, 1947: *Istruzioni del prof. Monneret per il Gabinetto Fotografico da tener presente nella esecuzione delle fotografie della Cappella Palatina*; there are also Monneret's sketches and notes: Zannoni, "Il carteggio e l'archivio di studio di Ugo Monneret de Villard," 21.

124. Beside those taken in the late 1940s, some of the photos published in the book date back to the 1930s: "Indice sommario delle figure," in Monneret De Villard, *Le pitture musulmane*, 75. Monneret specified that some details came from "negative eseguite dalla Soprintendenza dei Monumenti di Palermo" (p. 76). We have seen that in 1936 Zanotti Bianco provided Monneret with some photos of the painted ceilings (see above n. 81), likely matching the "12 fotografie 13 x 18 che feci fare io anni fa" mentioned in a list of the images to be published in the 1950 book (note preserved in BiASA, Fondo Monneret, Ms. Monneret I.4.).

125. Monneret also hypothesized a possible origin in northern Syria. Ettinghausen later proposed a possible Tunisian provenance: see Richard Ettinghausen, *Arab Painting* (New York, 1962), 50. The hypothesis of a Fatimid origin for the painters of the ceilings remains one of the most credible today: see, in particular, Ernst J. Grube, "La pittura islamica nella Sicilia normanna," in *La pittura in Italia, L'Altomedioevo*, ed. Carlo Bertelli (Milan, 1994), 416–31; Ernst J. Grube and Jeremy Johns, *The Painted Ceilings of the Cappella Palatina* (Genoa and New York, 2005); Jeremy Johns, "Le pitture del soffitto della Cappella Palatina" and "Iscrizioni arabe nella Cappella Palatina," in *La Cappella Palatina a Palermo = The Cappella Palatina in Palermo*, ed. Beat Brenk, 4 vols. (Modena, 2010), vol. 1 [tome I], Atlante I, figs. 158–194, 369–384; vol. 1 [tome II], Atlante II, figs. 473–1220; vol. 2 [tome III], Saggi, 353–386, 387–407; vol. 2 [tome IV], Schede, 429–456, 487–510, 540–665; Lev Kapitaikin, "The Twelfth-Century Paintings of the Ceilings of the Cappella Palatina, Palermo" (PhD diss., University of Oxford, 2011).

126. The issue of the construction of the ceilings reveals the limits of a study realized from afar: Monneret in fact referred to the necessity of dismantling part of the roof in order to understand the assembly technique. The extrados of the ceiling is actually visible through a cavity wall: see Vladimir Zorić, "Sulle tecniche costruttive islamiche," in *Scritti in onore di Giovanni D'Erme*, ed. Michele Bernardini and Natalia L. Tornesello, 2 vols. (Naples, 2005): 2:1281–1349. For a detailed study of the structure of the central ceiling, see Fabrizio Agnello, "Rilievo e rappresentazione del soffitto della navata centrale della Cappella Palatina," in Brenk, *La Cappella Palatina a Palermo*, vol. 2 [tome III], pp. 295–352; and Fabrizio Agnello, "The Painted Ceiling of the Nave of the Cappella Palatina in Palermo: An Essay on Its Geometric and Constructive Features," *Muqarnas* 27 (2010): 407–48.

127. The young Monneret was himself influenced by Croce to a certain extent: see Santino Langè, "La teoria artistica di Ugo Monneret de Villard: Un testamento previo," and Amedeo Bellini, "La critica d'arte di Monneret de Villard al primo apparire del crocianesimo; Un nuovo restauro architettonico?" in Sandri, *L'eredità di Monneret*, 33–36, and 37–43, respectively. See also the slightly different opinion in Augenti, "Per una storia," 21. For a general framework explaining the connections between Croce and Monneret de Villard, see Armando, "Ugo Monneret de Villard et la découverte de l'*Oriente*."

128. It is perhaps not a coincidence that in 1950 Charles Rufus Morey stressed Croce's influence on the history of art in Italy, underlying the "tendency to minimize the importance of content, environment and historical evolution." Charles Rufus Morey, "Art and the History of Art in Italy," *College Art Journal* 10, 3 (1951): 219–22.

129. See, among others, Maurice S. Dimand, "*Le pitture musulmane al soffitto della Cappella Palatina in Palermo* by Ugo Monneret de Villard," *Artibus Asiae* 14, 3 (1951): 263–66; B.W. Robinson, "*Le pitture musulmane al soffitto della Cappella Palatina in Palermo* by Ugo Monneret de Villard," *The Burlington Magazine* 93, 584 (1951): 361; Alfons Maria Schneider, "*Le Pitture musulmane al soffitto della Cappella Palatina in Palermo* by Ugo Monneret de Villard,"*Oriens* 4, 1 (August 15, 1951): 162–64.

130. See Levi Della Vida, "Ugo Monneret de Villard, Bibliografia," 177: "...nel 1950 gli fu conferito, senza che egli vi concorresse, il Premio nazionale generale dell'Accademia dei Lincei, l'elezione a socio nazionale dell'accademia stessa gli offrì un compenso (soltanto morale peraltro) della trascuranza passata e confortò gli ultimi anni della sua vita" (... in 1950 he was awarded, without competition, the Accademia dei Lincei General National Prize, and being made a national member of the same academy gave him compensation [if only moral] for having been disregarded in the past and comforted him in the last years of his life).

131. Lala Comneno, "Monneret islamista," 63.

132. A collection of personal notes: Monneret de Villard, "Prefazione," in "Opere d'arte islamica in Italia" (unpublished), 1: BiASA, Fondo Monneret: scatola 6, cartella 31.

133. Monneret de Villard, "Prefazione," in "Opere d'arte islamica in Italia" (unpublished), 1: BiASA, Fondo Monneret: scatola 6, cartella 31. It is worthwhile to note here that some files are preserved in other folders. In particular, there is a typewritten version of the catalogue, divided into different folders (BiASA, Fondo Monneret: scatola 6, and scatola 9), while some handwritten files are scattered in different folders.

134. Following what is called the "temporary classification" by Zannoni, "Il carteggio e l'archivio di studio di Ugo Monneret de Villard," I can affirm that the most important

cache of materials is preserved in BiASA, Fondo Monneret: scatola 6, scatola 7, and scatola 9. It is evident that the actual order does not always match that presumably given by Monneret.

135. In BiASA, Fondo Monneret, scatola 6, cartella 34, c.7, a letter from the Ministero della Pubblica Istruzione testifies to the assignment of the work to D. S. Rice. We learn from a letter that Monneret and Rice met for the first time between 1950 and 1951: see BiASA, Fondo Monneret, scatola 1, cartella 5, 1951: " J'étais très heureux de faire votre connaissance et j'espère que nous nous venons à voir [?] très prochainement" (I was delighted to meet you and hope you will come to see me very soon).

136. This material (also containing correspondence with museums) is particularly scattered and to understand Rice's approach would require a wide-ranging analysis.

137. He mainly published metal objects: see Giovanni Curatola, *L'eredità dell'Islam* (Cinisello Balsamo, 1993), 37, and Anna Contadini, "Ugo Monneret de Villard: A Master of the Italian Orientalist School," in Vernoit, *Discovering Islamic Art*, 160. On Rice, see J.B. Segal, "Obituary: David Storm Rice," *Bulletin of the School of Oriental and African Studies* 25, 1–3 (1962): 666-671 and the obituary by Ralph H. Pinder-Wilson, *The Journal of the Royal Asiatic Society* 95 (1963): 121–23.

138. Umberto Scerrato, "Arte islamica in Italia," in *Gli Arabi in Italia: Cultura, contatti e tradizioni*, ed. Francesco Gabrieli and Umberto Scerrato (Milan, 1979), 275–71. Scerrato notably exploited the material to compile the commentaries accompanying the photographic repertoire. I owe this information to Maria Vittoria Fontana. See also Contadini,

"Ugo Monneret de Villard," 160.

139. Curatola, *L'eredità dell'Islam*, 37.

140. Monneret de Villard, *L'arte iranica*, which actually deals with Persian art from prehistoric times until the Safavids, but is remarkable for the study of the Iranian origin of many architectural elements in Islamic art; Ugo Monneret de Villard, "Tessuti e ricami mesopotamici ai tempi degli Abbàsidi e dei Selğuqidi," *Atti della Accademia Nazionale dei Lincei. Memorie, cl. di scienze morali* 8, 7 (1955): 183–234; Monneret de Villard, "Arte cristiana e musulmana del Vicino Oriente," 451–62; Monneret de Villard, *Introduzione allo studio dell'archeologia islamica*. See also Levi Della Vida, "Ugo Monneret de Villard, Bibliografia," 178–79.

141. "The unitary and systematic description of more than 400 objects will reveal a richness, unsuspected by most, of Islamic art objects in Italy and will hugely help the progression of studies within a discipline we have sadly been disregarding, with the exception—wonderful indeed, but isolated—of Monneret de Villard.": Levi Della Vida, "Ugo Monneret de Villard, Bibliografia," 179.

142. "An organic conception of the unitary development of Oriental art, of its steady relation with artistic developments in the West, of the strong interconnection between the history of art and general history. Monneret contributed, as few of his contemporaries have, to highlighting this unity.": Giorgio Levi Della Vida, "Ugo Monneret de Villard (16 gennaio 1881–4 novembre 1954)," *Atti della Accademia Nazionale dei Lincei, Classe di Scienze morali, storiche e filologiche. Appendice, necrologi di soci defunti nel decennio dicembre 1945-1955* 2 (1957): 100.

AYŞİN YOLTAR-YILDIRIM

RAQQA: THE FORGOTTEN EXCAVATION OF AN ISLAMIC SITE IN SYRIA BY THE OTTOMAN IMPERIAL MUSEUM IN THE EARLY TWENTIETH CENTURY

The site of Raqqa in northern Syria was first excavated in the early twentieth century by the Ottoman Imperial Museum. It was, indeed, the first and only Islamic site to be excavated by that institution. However, until recently the very fact that these early excavations in Raqqa took place was overlooked in the scholarship. It is now possible not only to document these excavations concretely but also to assert that Raqqa was among the earliest Islamic sites subject to archaeological investigation.

RAQQA AS AN ARCHAEOLOGICAL SITE

Traditionally, Samarkand, first excavated in 1885 by the Russian scholar N.I. Veselovsky,[1] has been regarded as the first Islamic site to undergo archaeological investigation.[2] However, since the areas excavated by him were in the oldest part of the Islamic city and his focus was on the ancient Soghdian center of Afrasiyab,[3] it is necessary to reassess the purpose, duration, methods, and finds of this excavation—particularly in light of original Russian publications and documentation related to it—in order to understand its significance for Islamic archaeology.

The other notable early excavation of an Islamic site is Qal'at Bani Hammad, in Algeria, in 1898.[4] However, it appears that the excavations begun there under the auspices of the Archaeological Society of Constantine, with very modest resources, lasted only a few days.[5] More methodical excavations were conducted later, in 1908, by Beylié, under the auspices of the French society of archaeological excavations.[6]

In comparison with the two excavations above, Raqqa appears to have been a relatively long one, conducted with a focus on the medieval Islamic city and especially its ceramic production, which was thought to date to the late eighth century of the Abbasid era. While determining the earliest excavation of an Islamic site has some importance in terms of the scientific methods employed, the duration of the expeditions, and the outcomes achieved, it is possible that today none of these would be regarded as scientific digs based on current standards.

For the historiography of Islamic archaeology, I believe it is important to understand the relative significance of these early excavations of Islamic sites in their own context. Leaving the large task of Afrasiyab to other scholars, in this article I will focus on the case of Raqqa.

The old town of Kallinikos, which was rooted in Hellenistic, Roman, and Byzantine times, was renamed Raqqa after the Arab conquest in 639–40. The Umayyads (661–750) built two palaces and a mosque, along with a new market, a bridge, and a canal to supply water to the city. In the eighth century, a larger establishment in mudbrick was built to the west as a companion town, Rafiqa. In fact, what is mostly referred to as Raqqa throughout this study actually concerns Rafiqa. This new town in the shape of a horseshoe was designed to house troops. Later, between 786 and 808, the Abbasid caliph Harun al-Rashid, well known from the tales of *The Thousand and One Nights*,[7] built a complex of palaces further to the north along with canals. A separate industry of ceramics was established in 771 outside the old city walls of Raqqa in the northeastern extremity to satisfy the everyday needs of the garrison city of Rafiqa. This activity more or less ceased in the ninth century due to security problems in northern Mesopotamia, but a similar industrial development picked up pace after

815 in the area between Raqqa and Rafiqa. A long-term ceramic production took place in the city much later: in the eleventh and twelfth centuries, production focused on unglazed and glazed earthenware, and goods were sold mainly in Syria and Iraq. More luxurious fritware ceramics, known today as Raqqa ware, were produced in the second half of the twelfth to the mid-thirteenth century. These items were exported more widely in the Middle East and even reached southern Europe.[8] After its destruction by the Mongols in 1265, Raqqa never resumed its former glory. The Ottomans took control of Syria in the sixteenth century and Raqqa remained only a small town that functioned as a customs and military outpost.[9] In the late nineteenth and early twentieth centuries, Raqqa was a nominal administrative center within the province of Aleppo (Halep). From its old glory days in the medieval period a few parts of the old Islamic city were still visible.

In this context we can easily begin asking the basic questions: why did the Ottoman Imperial Museum decide to begin excavating at Raqqa in 1905–6 and 1908? Was it due to a genuine interest among the Ottomans in the cultural and archaeological heritage of Islam and specifically this city? Were the Ottomans pioneers among their Muslim counterparts in choosing an Islamic site to excavate?

The Raqqa excavations defy a simple answer to these questions. The project can largely be seen as part of a long-term effort by the Ottoman Imperial Museum to put an end to the illegal smuggling of Islamic ceramics that fed the art markets of Europe and America in the early twentieth century. Yet the communications that took place between the local officers and the Museum show that the Museum wanted to conduct excavations in a systematic way, first by acquiring local knowledge about an excavation site, then by appointing an experienced excavation officer from the Imperial Museum with necessary funds, and finally by bringing artifacts to the Museum to display and publish. Unfortunately, the process was not as smooth as planned and many opportunities were missed. Examining the context in which the excavations took place provides a better understanding of their importance not only for the Ottoman Imperial Museum but also for the broader historiography of Islamic art and archaeology.

As mentioned above, the Ottoman Imperial Museum conducted two excavation campaigns at Raqqa, in 1905–6 and 1908. Each lasted a few months and the finds were immediately sent to the Museum in Istanbul. More items from Raqqa reached the Imperial Museum after being confiscated. Objects from the excavations were exhibited early on in the Imperial Museum. However, as the supply and demand for Raqqa ceramics dwindled in the foreign art markets, no further studies were conducted on the Raqqa finds owned by the Museum. The story of the first excavations in Raqqa remained undiscovered for over a hundred years,[10] completely forgotten and overlooked by art historians who studied the famous ceramics of Raqqa. As part of a larger study on the Raqqa ceramics, I translated and published fifty documents on the history of these early excavations, primarily correspondence between local officers in Raqqa and the Imperial Museum.[11] This initial study unequivocally established the time and duration of the excavations, and also brought to light some information on the circumstances that led to their being undertaken, as well as on the finds sent to the Imperial Museum. Many of these documents are now preserved in the library of the Istanbul Archaeological Museum, heir to the Ottoman Imperial Museum after the fall of the empire, as well as in the Ottoman Division of the Prime Ministry State Archives of the Turkish Republic in Istanbul.

This article results from my translation and study of the remaining correspondence on Raqqa in the Istanbul Archaeological Museum Archives, consisting of over 150 documents, which allows us to look at the history of the excavations in their entirety, rather than as snapshots. The interesting series of events that prompted the Ottoman Imperial Museum to excavate the site became especially clear after this study. In addition, unpublished letters of the Museum officer Theodore Macridy, written while he was digging in Raqqa, provide new details on conditions at the site. This discussion of the history of the excavations will be followed by a review of the finds from Raqqa and how they were displayed in the early collection of Islamic art in the Ottoman Imperial Museum; the Raqqa excavations will also be compared with those in Samarra, an important Islamic site and the focus of an early excavation.

THE LEGAL CONTEXT OF THE IMPERIAL MUSEUM EXCAVATIONS

The Ottoman Imperial Museum was established in Istanbul in 1869 as a venue in which to preserve and display within the country antiquities excavated by foreign archaeologists. The first Ottoman state bylaw was quite protectionist: excavations would be possible only with the permission of the Ottoman authorities, with the stipulation that none of the artifacts (except for coins) could be exported. Only the sultan could override these rules.[12] With large shipments of antiquities expected, Hagia Eirene, the former Byzantine church, which was being used as the imperial armory and already housed a collection of antiquities, was selected as a suitable building for the new museum. The first director was Edward Goold, an Irish teacher at the Galatasaray Lycée, between 1869 and 1871. After this brief term, the German art historian and archaeologist Anton Philip Déthier became the Museum's second director in 1872, remaining in this position, despite an illness, until his death in 1880. During Déthier's tenure, the first Ottoman antiquities law was enacted, in 1874. Compared to the bylaw, the law itself was less forceful. While the Ottoman authorities continued to grant excavation permits, they agreed to divide the finds equally, among the excavator, the landowner, and the Ottoman government. It is interesting that within five years the Ottoman authorities had backtracked from the more protectionist stance of the bylaw to a more negotiable—but also troublesome—system.[13] It is possible that sending an officer to each excavation that was granted permission and then transporting the finds to Istanbul proved too burdensome for the Ottoman Imperial Museum. During the period in which the bylaw of 1869 and the later law of 1874 were consecutively in effect, several legal foreign excavations were conducted in Ottoman territories, although none were yet done under the auspices of the Imperial Museum itself. After Déthier's death, the first Ottoman director was appointed to head the Museum: Osman Hamdi Bey (d. 1910), the scion of an educated and influential Ottoman family, was trained as a painter in France[14] and had become a commission member of the Imperial Museum a few years before Déthier's death.[15] In 1884, during his long tenure as director (1881–1910),

a new antiquities law was enacted. Similar in intent to the 1869 bylaw, it placed more restrictions on foreign excavations, allowing only copies of excavated artifacts to be removed from Ottoman territory, rather than the one-third of excavated finds permitted in the 1874 law. All finds were to be given to the Imperial Museum or its local branches. The new law, despite its obvious unpopularity among foreign archaeologists, remained in effect even after the fall of the Ottoman Empire and the establishment of the Republic of Turkey, until it was further modified in 1973.[16] Like the initial bylaw, however, the 1884 law was often less than perfectly followed by foreign archaeologists, and many finds were not sent to the Imperial Museum.

Under the 1869 bylaw and the subsequent antiquities laws of 1874 and 1884, numerous foreign excavations took place in the Ottoman territories of Iraq, Syria, Jordan, Lebanon, Palestine, and Anatolia,[17] mostly of classical or ancient Near Eastern sites. The Ottoman Imperial Museum also conducted its own excavations in eighteen different places—again mainly ancient Near Eastern and classical sites, as well as Hittite ones, along with Raqqa, the only Islamic venue with which the Museum was involved.

THE HISTORICAL CONTEXT

As noted earlier, in the late nineteenth century Raqqa was only a nominal administrative center. An area nearby had been chosen as the new settlement grounds for the Circassian immigrants who arrived by ship at the Eastern Mediterranean port of Iskenderun from the region of present-day Kabardino-Balkaria in Russia to "escape military service, forced religious conversion, and the imposition of the Russian language."[18] They began arriving in substantial numbers as early as 1885, and especially after 1900.[19] The Ottoman government provided Circassian families with land around Raqqa and permitted them to look for bricks to build their houses. This caused an archaeological disaster and paved the way for the illicit but pervasive unearthing of artifacts. Although local government officials were quick to inform the Imperial Museum about the illegal digging up of artifacts, the responses of the Museum

were neither immediate nor extensive, since messages about similar developments were arriving from various other sites as well, and the Museum had only limited resources and personnel to deal with these matters.[20]

The Imperial Museum's 1905–6 campaign at Raqqa took place under the directorship of Theodore Macridy,[21] while the one in 1908 was led by Haydar Sümerkan.[22] Each of these expeditions lasted a few months. However, the campaign in 1905–6 appears to have been accorded more importance, since it was the first active response of the Ottoman Imperial Museum to a long series of complaints and proposals submitted by local government authorities in Raqqa and Aleppo.

Early Correspondence

The archival documentation from the Imperial Museum shows that as early as 1899 Raqqa had become a focus of interest for smugglers of antiquities. Based on the 1884 antiquities law, confiscated finds were reaching the Imperial Museum.[23] By 1906, about 208 confiscated objects had come to the Imperial Museum from Raqqa.[24] The Imperial Museum also inventoried a total of 126 objects from its own excavations in Raqqa, although more objects from the excavations may have arrived directly or indirectly, since a large group of ceramic wasters from Raqqa is now in the Karatay Museum in Konya.

We find correspondence regarding the urgent need to conduct excavations in Raqqa as early as 1899.[25] According to one such letter, a dealer named Jamil Tabah purchased a bowl, a large jar, and another decorated bowl found in the ruins of Raqqa from the financial officer of Raqqa, Husayn Efendi, for 40 Ottoman lira. These were later sold to a British traveler Jamil Tabah met on a boat from Iskenderun, for 42 lira. Jamil and his brother, Jorji Tabah, whom we also encounter in other archival records from Raqqa, were most likely the art dealers known in the West as Émile and George Tabbagh, who were stationed in Paris and sold Raqqa ceramics on the art market.[26] If one considers that the total amount spent by the Ottoman Imperial Museum for the entire 1906 excavation was 150 to 200 liras,[27] it becomes clear that 40 lira was an incredibly large sum at that time.

Seven months later, local authorities seized from the same dealer, Jamil Tabah, ten small crates filled with pottery for inspection.[28] After they sent a sample of the contents for further evaluation, the Imperial Museum determined that this was old Damascus pottery and worthy of exhibition. Thus, the Imperial Museum requested that the rest of the material seized from Jamil Tabah be confiscated and shipped to Istanbul.[29]

In short, as ceramics from Raqqa began garnering high prices on the European and American art markets, the local government officers started to inform the higher authorities in Istanbul about the illegal diggings. The Imperial Museum then began to exercise its legal right to confiscate such pieces from the dealers involved. According to the Imperial Museum inventories, a total of 153 objects originating from Raqqa[30] entered the Museum in 1900. Most likely they included all or a large part of the items taken from Jamil Tabah, although the Museum inventories do not mention any name.

Letters dating to 1900 show that the houses of other dealers[31] were also searched for antiquities, since there were continuous reports of illegal trade in such goods coming from Raqqa.[32] On December 4, 1900, an interesting missive was sent to the Imperial Museum from the Directorate of Education of the Province of Aleppo:

> The areas within 15 minutes' walking distance of the government office in town and surrounded with a ruined city wall are full of antique pottery, including colored and figural vases, and similar colored objects. Until now, antique dealers hired several men to dig in this area. This pervasive activity is based on the permission granted by the government to the Circassian refugees[33] to look for bricks in the ruins to build houses for themselves. The government asks for a tax of 4 *kuruş* [piastres] on every thousand bricks collected from the site. So far 300 *kuruş* have been collected as tax. Since this leads to the removal of bricks and antiquities from the site, the government is advised to conduct its own excavations to remove the bricks and sell them for at least 30 *kuruş* per thousand bricks (since there is such a demand). The workmen should cost 4,000 to 5,000 *kuruş*. In six months' time, the total area would be excavated for bricks and in the meantime antiquities would be recovered. The antiquities would then all be sent to the Imperial Museum in crates. An officer from the museum should also be appointed for this purpose. The revenues from the selling of the bricks should cover the cost of the museum

officer and the shipment of the antiquities.[34]

The Imperial Museum appears not to have taken this suggestion into serious consideration, and letters describing the problems of removing the bricks and the smuggling of antiquities continued to be sent from Aleppo at a greater frequency. That same year (1900), a request by the Germans for permission to dig in Raqqa[35] was denied.[36]

In 1902, three crates full of pottery were confiscated and sent to the Imperial Museum. Although the Imperial Museum acknowledged that they were received that July,[37] it was only in 1903 that a group of fifty-two objects from Raqqa was recorded in the Imperial Museum inventories.[38] In 1902, the local authorities again asked for an officer to conduct excavations at Raqqa,[39] and in the spring of 1903 the Imperial Museum agreed to begin excavations by sending an officer.[40] However, by July no one had yet been sent,[41] and on August 1, 1903, the Museum explained that the funds required to conduct excavations were not available in the museum budget that year.[42]

There was also not enough money in 1903 to ship antiquities to Istanbul. As a result, the Imperial Museum suggested that a large decorated stone[43] be kept in the government office in Raqqa, since it could not afford to have it shipped to Istanbul.[44]

A letter sent by the Aleppo director of education, (Mehmed) Nadir Bey, on January 18, 1904, documents explicitly what had been illegally taken from Raqqa: "Among the finds smuggled from Raqqa and then confiscated are a large glazed vase with three handles, with smaller handles in between; a smaller dark-green vase with three handles; a cream-colored vase; a black vase with no handles; a small light-green glazed vase; a small spherical vase; a green vase that was repaired; and several bricks."[45] Exact matches can be found among the three entries of the Imperial Museum inventories of 1904:[46] inv. nos. 2027, 2028, and 2029 describe, respectively, a jar with six handles (three small and three large), a blue glazed pot with three handles, and a vase with a missing upper part (fig. 1).[47]

In a letter dated April 7, 1904, the director of education of Aleppo warned the Imperial Museum that more gendarme officers would be necessary to protect the site, since there were only three of them. He also reminded the Museum that an excavation officer it had promised to send the previous summer was never actually dispatched, with the excuse that the weather was too hot then for digging. The director of education further noted that it was now spring, the ideal time in which to conduct excavations.[48]

Some amazing information is offered in a letter the Aleppo director of education wrote to the Museum Directorate on May 10, 1904 (fig. 2). In response to an inquiry from the Imperial Museum about the feasibility of appointing a local officer to conduct excavations, the director relayed information gathered by Kazim Efendi, a teacher at the Aleppo high school (*mekteb-i idādī*) who had been sent to Raqqa a few years earlier for this purpose. According to Kazim Efendi, the area that really needed to be excavated in Raqqa was a shopping district once used by the pottery sellers, an area encompassing about 300 m × 30 m × 2 m (approximately 18,000 cubic meters). It was thought that 3,000 workmen would be needed, at a cost of 4 *kuruş* each per day, in all 12,000 *kuruş*. The director suggested that the local government accountant, Mehmed Salim, be appointed to conduct excavations there, at a rate of 60 *kuruş* per day, in compensation for the time he would spend there under difficult conditions. Each of the four guards who would protect the excavated finds would be paid 300 *kuruş*, while an additional four gendarme officers would supplement the three already there. The director calculated the total expenses to be between 18,000 and 20,000 *kuruş*. While acknowledging that this was a large sum, he noted that if the area were not totally excavated, smuggling from the site would continue. The director also said that some of the bricks coming from the pottery sellers' shops could be sold locally to offset the cost of the excavation.[49] Despite the detailed excavation proposal submitted by the director and the information he included from Kazim Efendi about the pottery sellers' street, the Imperial Museum postponed the excavations in Raqqa once more in 1904, again due to a shortage of funds: instead of 20,000 *kuruş*, the Museum could only spare 3,000 *kuruş* that year.

According to a letter dated June 13, 1904, there were still only three gendarmes protecting the entire site when the dealer Yusuf Jorji Tabah or, more correctly, the previously mentioned George Tabbagh, brother of

Fig. 1. Çinili Köşk inventory registers. Istanbul, Topkapı Palace Museum, register (defter) no. II 1454-3057. (Photo: Ayşin Yoltar-Yıldırım, courtesy of the Topkapı Palace Museum)

Fig. 2. Official letter. Istanbul Archaeological Museum Library, Box 9, 27 Nisan 1320 (May 10, 1904). (Photo: Ayşin Yoltar-Yıldırım, courtesy of the Istanbul Archaeological Museum Library)

Émile Tabbagh, tried to smuggle out valuable antiquities collected there through the Austrian consulate. The officer warned in the letter that if the Museum excavation were to be further delayed, smugglers would continue to excavate the site and nothing would be left for the Museum.[50] As predicted by the officer, Yusuf Jorji Tabah was reported to have gone to Raqqa on July 10, 1904, most likely to acquire antiquities.[51]

In a letter dated May 6, 1905, the Aleppo director of education warned the Imperial Museum that the excavation season was almost over and that smugglers were fast at work. He also complained that dealers were trying to bribe him to ensure his cooperation with them.[52] Between August and November 1905, several letters[53] were sent to report various illegal digs and the urgent need to send an officer to begin excavations in Raqqa. Finally, in mid-November, the Museum officer Theodore Macridy left the excavations in Ayasuluk (Ephesus), arriving at Aleppo in the company of the excavation commissar of Babil (Babylon) on December 5, 1905, to begin legal excavations at Raqqa.[54]

The Macridy excavation of 1905–6

Macridy excavated for about two and a half months and had at his disposal fifty-five day workers. He sent reports by post to the Museum's administration,[55] as well as several telegrams about the state of the excavations in Raqqa and what was needed to continue work there. There were also three letters[56] that Macridy sent to Halil Edhem, the assistant director of the Imperial Museum as well as the brother of Osman Hamdi, the museum director. These three letters add a great deal to our knowledge of the Imperial Museum's excavations in Raqqa.

In the first, dated December 27, 1905, we learn that Macridy, joined by Haydar, who must have been the commissar of Babylon mentioned above, made a long and tiring journey, first to Aleppo, where they saw the necessary officials to receive the allocated money for the excavation. Unfortunately, Macridy became ill in Aleppo and had to remain there until December 21st. As soon as he recovered, he embarked, again with Haydar, on another arduous journey to reach Raqqa. The trip was made even more treacherous by the uncom-

monly frigid temperatures. When they finally arrived in Raqqa, Haydar left via the same route.

In the first days Macridy spent in Raqqa, twenty-five centimeters of snow fell and the Euphrates froze. Macridy complained about the difficult climate in Raqqa, as well as the food there. Describing the modern village as situated to the west of the walled enclosure of the Abbasid city, he explained that the walls were built with unbaked brick but that due to erosion from rainfall they resembled mounds. In the middle of the walled enclosure was a grand mosque with a standing minaret. It was possible to see the arcades of the mosque's façade; in the middle was a large inscription, part of which was missing. To the southeast were the remains of the palace known as the Kiosk of Harun al-Rashid. Macridy included a sketch in which it is possible to see mihrab-like niches with stalactite forms and mentioned that excavating the ruins in this area would be extremely dangerous. He made note of the Baghdad Gate at the east end of the enclosure wall, remarking that within such walls were ditches dug by clandestine diggers. The entire surface was littered with ceramic fragments and thousands of terracotta cylinders[57] that must have served as supports in the kilns.

Based on his observations, Macridy concluded that Raqqa had been an important center for the production of ceramics. He dug a trench in the eastern section of the walled city, where he also unearthed the foundations of private buildings. In the same place he found 182 Abbasid silver coins stuck together.[58] Other finds included two oenochoes (small jugs or ewers),[59] bowls, plates, a small animal figurine,[60] a lid of a jar, a bronze ring with a bezel-set carnelian and a Kufic inscription,[61] chipped vases, and 20,000 ceramic fragments, most of which were uninscribed. Macridy mentioned huge quantities of ceramics stuck together by a vitrified material that covered them. Since it would have been very costly to take these items to Istanbul, Macridy decided to leave them *in situ*, while promising to bring a collection of the best fragments to the Museum. Macridy also mentioned the need to conserve the ruins. He was, however, well aware that the illegal diggers would be ready to resume work immediately after his departure. Indeed, everyone at the site was involved in the trafficking of antiquities, including the gendarme, who usually received a small amount of money (*bahşiş*) in return for

allowing the illegal diggers to pursue their activities. Macridy noted that in order to stop this, the law had to be strictly enforced. He then mentioned budgetary issues regarding expenditures for travel, excavation, and the transfer of objects. In closing his letter, Macridy openly expressed his displeasure with excavating in Raqqa. He said that he would not be able to publish anything but would bring the most valuable pieces to the Museum.

In his second letter, dated January 5, 1906, Macridy mentioned finding some beautiful fragments that he pieced together himself, laying the shards in square grids in the courtyard of the mosque. When he was able to detect parts coming from the same vessel, he immediately put them together with an adhesive called Seccotine.[62] Apparently preoccupied with this arduous task, he was unable to sleep or eat. Saying that he had never imagined that "Arab art" had reached such perfection, he put together a sample collection that included beautiful fragments with inscriptions. In packaging a portion of the finds, he listed two "krassés,"[63] a large green-glazed jar with three handles,[64] small bowls, and a fragmented plate with an inscription.[65]

In his third letter, dated January 19, 1906, Macridy mentioned that he was preparing four crates, with one reserved for fragments and the other three for more presentable objects such as a large basin,[66] a container for fruit (fig. 3),[67] a drinking cup (fig. 4),[68] small bowls, and plates. Macridy did not think he would find any more good pieces, since the entire area had already been worked over by illicit diggers. He also mentioned that once the pottery was unearthed it became friable upon contact with air. Macridy alluded to the beautiful iridescence on the pottery, which unfortunately obscured the design and colors. He also mentioned seven crates from Deir Zor, further along the Euphrates, which, due to having been poorly packed, were badly damaged. He had new crates made, repacked their contents, and sent them to the Museum, along with the inventory register. The finds from Deir Zor were, he said, extremely inferior to the Raqqa pottery:[69] they had no inscriptions and were not worth publishing. Macridy concluded his letter by mentioning his interest in the site of Rusafa, another site in Syria.

Fig. 3. Fruit bowl. Istanbul, Turkish and Islamic Arts Museum, inv. no. 1579 (formerly Çinili Köşk inv. no. 4004). (Photo: Ayşin Yoltar-Yıldırım, courtesy of the Turkish and Islamic Arts Museum)

Fig. 4. Drinking cup. Istanbul, Turkish and Islamic Arts Museum, inv. no. 1594 (formerly Çinili Köşk inv. no. 3921). (Photo: Ayşin Yoltar-Yıldırım, courtesy of the Turkish and Islamic Arts Museum)

Macridy's letters to Halil Edhem do not continue after January 19, 1906, although he did send official telegrams after this, including three dispatched on January 22, 1906. These provide more data on the excavation, including the total amount required to transport the recent finds from the excavation to Istanbul, which was reported to be at least 30 liras from the site to a boat. Macridy placed whole pieces and less damaged finds in crates, and sent the lists of the contents by post. He left in Raqqa those finds that could not be put together, as well as pieces exceeding a few meters. Macridy stated that the money allotted to conduct excavations would only last twenty more days and requested 5,000 *kuruş* more.[70] In his capacity as an officer of the Museum, Macridy also sold ordinary bricks and marble from Raqqa to raise money for the institution. Macridy was also responsible for collecting the fines illicit diggers paid to the Museum for excavating illegally.[71]

Macridy reported that antiquities arriving from Deir Zor (probably the confiscated pieces mentioned in his letter to Halil Edhem dated January 19, 1906) along with those unearthed in Raqqa were placed in fifteen crates and shipped to Iskenderun via Aleppo on February 17, 1906.[72] From there the crates were sent by boat to Istanbul on March 6, 1906.[73] Macridy estimated the material excavated from Raqqa to be worth 1,500 lira.[74]

According to the Imperial Museum's inventory registers, thirty-nine items from the Macridy excavations arrived at the Museum in 1906:[75] thirty-six ceramic, two glass, and one metal (fig. 5).[76] The pottery fragments that came in separate crates were not inventoried and their exact whereabouts are unknown to this day.[77] All but one of the thirty-nine objects can now be found in the Turkish and Islamic Arts Museum in Istanbul. A few of them are on display (figs. 6 and 7),[78] but several are stored in the museum depots (figs. 3, 4, 8–12). The display information and museum records of several of these objects neither acknowledge Macridy's excavations by provenance nor distinguish them from the confiscated pieces from Raqqa.[79]

Based on four pieces of kiln furniture that were found in the Macridy excavations[80] and the huge number of scattered terracotta cylinders used as kiln supports[81] mentioned in his letters, it would seem that Macridy was digging in the vicinity of kilns, which, following his description of the excavation in his letter to Halil

Edhem, must have been located in the eastern part of the walled city known as Qasr al-Banat. In April 1906, the British consul in Aleppo, Henry Barnham, also reported that the remains of an earthenware factory had been discovered a few years prior, and that earlier that year Macridy had been engaged in collecting specimens of this work.[82] Macridy should have been aware of the pottery sellers' street reported by Kazim Efendi and mentioned in the letter the director of education wrote to the Museum on May 10, 1904. It is not completely clear whether that street[83] and the kilns were in the same area, but it appears that Macridy missed a great opportunity to bring the best pieces of Raqqa to the Imperial Museum. Instead, the opportunity fell into the hands of dealers, who perhaps conducted digs in the exact place that Kazim Efendi had described.

Sometime after March 1906, perhaps immediately after Macridy left and more Circassian refugees were settled in Raqqa by the Ottoman government in April 1906,[84] a series of huge jars containing approximately sixty well-preserved examples of Raqqa pottery, known collectively as the "Great Find," were unearthed. As early as 1908, these ceramics were sold on the art market,[85] fetching huge sums of money. In a detailed description of the Great Find given in 1923, the dealer Fahim Kouchakji noted that these pieces were found in the same area that Macridy had excavated, and his explanations matched quite well with Kazim Efendi's descriptions of the pottery sellers' street. Kouchakji stated that in the middle of the nineteenth century the Turkish government relocated a hundred (Circassian) colonists from Aleppo and other areas to Raqqa. He dated the "Turkish" (i.e., Ottoman Imperial) Museum excavations to 1903, noting that they took place under thirty feet of soil, in the vicinity of Harun al-Rashid's palace and also in the same district where the Great Find was made.[86] Scholarship has made clear that Harun al-Rashid's palace was in fact situated outside the city walls and that the palace once thought to be his was actually the medieval Qasr-al Banat. But the location of the Imperial Museum excavations was probably near the same place as the Great Find. Although some details in Kouchakji's description cannot be proven with accuracy, he gives this account of the discovery of the Great Find:

Fig. 5. Çinili Köşk inventory registers. Istanbul, Topkapı Palace Museum, register (defter) no. III. (Photo: Ayşin Yoltar-Yıldırım, courtesy of the Topkapı Palace Museum)

Fig. 6. Bowl with restored foot. Istanbul, Turkish and Islamic Arts Museum, inv. no. 1585 (formerly Çinili Köşk inv. no. 3925). (Photo: Ayşin Yoltar-Yıldırım, courtesy of the Turkish and Islamic Arts Museum)

Fig. 7. Drinking glass. Istanbul, Turkish and Islamic Arts Museum, inv. no. 2056 (formerly Çinili Köşk, inv. no. 4016). (Photo: Ayşin Yoltar-Yıldırım, courtesy of the Turkish and Islamic Arts Museum)

Fig. 8. Flattened bowl. Istanbul, Turkish and Islamic Arts Museum, inv. no. 1584 (formerly Çinili Köşk inv. no. 3922). (Photo: Ayşin Yoltar-Yıldırım, courtesy of the Turkish and Islamic Arts Museum)

Fig. 9. Fluted footed pot. Istanbul, Turkish and Islamic Arts Museum, inv. no. 1592 (formerly Çinili Köşk inv. no. 3932). (Photo: Ayşin Yoltar-Yıldırım, courtesy of the Turkish and Islamic Arts Museum)

Fig. 10. Flared bowl, restored. Istanbul, Turkish and Islamic Arts Museum, inv. no. 1597 (formerly Çinili Köşk inv. no. 3926). (Photo: Ayşin Yoltar-Yıldırım, courtesy of the Turkish and Islamic Arts Museum)

Fig. 11. Ewer with (missing) handle. Istanbul, Turkish and Islamic Arts Museum, inv. no. 1672 (formerly Çinili Köşk inv. no. 4137). (Photo: Ayşin Yoltar-Yıldırım, courtesy of the Turkish and Islamic Arts Museum)

We came now to the Great Find. It was made by a Circassian, one of a colony transported from its original home to Er Raqqa. To construct houses, bricks and other material were necessary. These the colonists could not buy, so the Turkish government authorized one of them to dig among the ruins for his supplies. He started a trench at what he considered to be the lowest practicable level and in the vicinity of the old palace of Harun al-Rashid. This trench led him to the market place, and there in a shop opening on the ancient scene of trade he came upon a series of huge jars, each of which contained perfectly preserved specimens of the finest Er Raqqa pottery. We may consider these pieces a little later than the palace ware since the Great Find probably was buried just before the destruction of the city and its final desertion.[87]

The market place mentioned above by Kouchakji is most likely the pottery seller's street reported by Kazim Efendi even before 1904. It is hard to understand why Macridy was not able to find the pottery sellers' street or why he did not even directly consult Kazim Efendi, who knew the exact location. Needless to say, the pieces unearthed by Macridy do not approach the quality of the pieces that comprise the Great Find.[88]

Since illegal digging resumed at the site immediately after the 1906 Macridy excavations,[89] the local

Fig. 12. Pot. Istanbul, Turkish and Islamic Arts Museum, inv. no. 1847 (formerly Çinili Köşk inv. no. 3999). (Photo: Ayşin Yoltar-Yıldırım, courtesy of the Turkish and Islamic Arts Museum)

authorities tried to convince the Museum to conduct another campaign of excavations, even offering to cover the expenses of the excavations locally.[90]

In the meantime, more items were confiscated and sent to the Imperial Museum.[91] Yet no finds from Raqqa entered the Museum's inventories in 1907; indeed none were entered until a second campaign of excavations was conducted by the Imperial Museum a year later, in 1908.

The excavation of Haydar Bey in 1908

That year the local authorities in Aleppo reported more illegal digging by the Circassians,[92] and more confiscations,[93] even as they continued to submit more requests for legal excavations.[94] Finally, in the summer of 1908, the Imperial Museum sent another officer, Haydar Bey, who had assisted Macridy on his journey to Raqqa in late 1905, to begin a second campaign. On August 3, 1908, Haydar Bey began excavations but stopped in late September. From his letter dated September 29, 1908, we learn that he had already placed the finds in crates and was about to send them to Istanbul.[95] In a telegram dated October 5, 1908, he wrote, "Beyond what has been already sent to the museum, further excavations will most likely not result in any antiquities. Thus, no further funds are necessary."[96] This is noteworthy given that only a month earlier he had requested more money to continue the excavations.[97] It is as though even before the Museum could decide what to do, Haydar Bey had become convinced that further excavations would not yield any more worthwhile results. Yet directly before Haydar Bey's excavations began, jars and vases had been confiscated and sent to the Imperial Museum.[98] We could perhaps say that Haydar Bey was not as lucky or as informed as the smugglers: he was ready to quit after two months, despondent over the number of illegal diggers who were at work day and night even while he was there.[99]

By late November, six[100] crates of Haydar Bey's finds had been sent to Istanbul via Iskenderun.[101] The Imperial Museum inventories show that eighty-seven objects were recorded from his excavations in 1908,[102] more than double the thirty-nine objects from Macridy's excavations in 1906: the new finds included thirty ceramic objects, as well as five semi-precious stone items, twenty-eight glass items, three bone items, and eighteen metal ones. As with the earlier objects, today most of these have been transferred to the Turkish and Islamic Arts Museum in Istanbul,[103] with a few of the metal objects going to the Ankara Ethnographical Museum. Although Haydar Bey also sent weekly reports,[104] these have not yet been located in the Istanbul Archaeological Museum Archives. Like the objects from the Macridy excavations, the specific provenances of the finds of the Haydar Bey excavations are not recorded in the present inventories of the Turkish and Islamic Arts Museum, and no distinction has been made between the excavated finds and the confiscated pieces from Raqqa.[105]

Such was the history of the two excavation campaigns in Raqqa by the Imperial Museum in 1905–6 and 1908. Even after the excavations, items from Raqqa continued to be confiscated and sent to the Imperial Museum until 1914. One important group of seized objects was related to a prominent family in Aleppo that was involved in the antiquities trade. According to the Imperial Museum inventories, in 1913 twenty-one objects were confiscated from a member of the Marcopoli family.[106] André, Georges, and Vincenzo Marcopoli all had positions as consuls of Spain and Portugal in Aleppo for many years in the late nineteenth and early twentieth centuries.[107] They also sold antiquities there, including Raqqa ware.[108] Two of the objects confiscated from one of the Marcopoli family members are well known and currently on display in the Museum of Turkish and Islamic Art in Istanbul.[109]

Further items from Raqqa, all well documented in the archival records, were seized from Max Oppenheim.[110] Even though Oppenheim had permission to excavate in Tell Halaf, he was accused of having illegally acquired excavated material from Raqqa when he was caught attempting to smuggle eleven crates and five bales of antiquities from the site in 1913.[111] Archival records show that the crates taken from Oppenheim were not returned and the contents were kept by the Imperial Museum.[112] Although objects seized from Oppenheim are recorded in the Imperial Museum inventories, these are noted as having entered the Museum in 1912. Therefore, the objects taken from Oppenheim in 1913 can perhaps be linked to a group of Raqqa ceramics now in the Karatay Museum in Konya.[113]

These Konya objects are inventoried as having come from Aleppo during World War I (1914–18), but how they came from Aleppo to Konya is not explained.[114] During an interview, the late director of the Karatay Museum, Mehmed Önder, suggested that they had arrived via Istanbul.[115]

THE DISPLAY OF RAQQA FINDS IN THE IMPERIAL MUSEUM

Despite having missed chances to acquire more spectacular objects, such as those discovered in the Great Find, the Imperial Museum immediately put on exhibit the objects it received from Raqqa. These were placed in its Islamic gallery, which was established most likely in 1896, since a new publication issued in 1897 included a description of it.[116] The gallery was a large single room on the second floor of a new museum building completed in 1891, which was designed in a neoclassic style and included classical antiquities on its first floor.[117]

This permanent gallery devoted solely to Islamic art was, in fact, established before those in Europe and the United States, although several European and American museums had begun collecting Islamic art in the nineteenth century, displaying it among their other collections. At that time a few collections of Islamic art were placed in museums in other Muslim countries. Although a permanent display of Islamic items was established in 1854 in Algiers, it was not until 1897 that a museum built just for those items along with antiquities was created there: this was the Musée national des antiquités algériennes et d'art musulman. Similarly, in Tunisia an Arab collection was inaugurated at the Bardo Museum (Musée Alaoui) in 1899,[118] while the Cairo Arab Museum was established in 1883. The latter's first building, used as a museum until 1903, was the Mosque of al-Hakim; however, this setting was far from optimal since the numerous collected objects were heaped together without any sense of selection or order, due to a lack of space, according to the museum director at that time.[119] In the first twenty years after the museum was established, objects were acquired from mosques, tombs, and public buildings in Cairo whenever major renovations, restorations, and demolitions took place in the city itself.[120] The Arab Museum's new building, which opened in 1903, was constructed and organized with separate rooms and display cases resembling those in European museums.

In 1903 (1319), the Ottoman Imperial Museum issued a guidebook written by Mehmed Vahid[121] and also used other written media to publicize its display, such as the avant-garde journal *Servet-i Fünun*. In the issue dated March 10, 1904, information was provided on the galleries. There is no author mentioned in the journal and it is most likely that the text was adapted from Vahid's museum guidebook of 1903, with the addition of recent photos.[122] The journal depicted the exhibition of items found at Raqqa thusly: "The fourth cabinet displays ceramics found in the vicinity of Raqqa in the province of Aleppo. The decorations and inscriptions on these ceramics merit attention."[123] In 1908, all the Islamic artifacts were moved to the Çinili Köşk, which was originally built in 1472 as a highly decorated pavilion in the Timurid style as part of the Topkapı Palace. Between 1880 and 1891 it was used as the main building of the Imperial Museum. When the museum was expanded with additional buildings in 1908, it was decided that the Çinili Köşk would house only the Islamic artifacts of the museum, since the building's architectural style was deemed more suitable for the Islamic nature of the display. Objects from Raqqa continued to be exhibited there. This time, however, Raqqa ceramics from the Museum's own excavations must have also been included. Mehmed Vahid, who published the third edition of the Museum's guidebook in 1909 (1325), more or less repeats the information he gave before in 1903: "Room number six contains pottery that was found in the ruins of Raqqa, in the province of Aleppo. Their colors and unique metallic shine, as well as their decoration and calligraphy, merit attention."[124]

Gustave Mendel gave more detailed information in his 1909 article about the Raqqa ceramics of the Imperial Museum,[125] which he described as consisting of many fragments, including wasters. Despite this, Mendel considered the group important, as it was a large collection with a secure provenance, thanks to the Macridy excavations, which, he said, were concentrated near the kilns. For some reason, he did not mention Haydar Bey's excavations of 1908, perhaps because the article was prepared before the finds from that campaign reached the Museum.

Although we see that the excavated finds from Raqqa immediately found a place in the Museum's Islamic gallery, they could not be studied as quickly. In 1907, Osman Hamdi, the director of the Imperial Museum, wanted Yakub Artin Pasha in Cairo to publish the material from the Macridy excavations.[126] An archaeologist of ancient Egypt, Artin Pasha was an influential figure in the establishment of the Cairo Arab Museum in 1883. For unknown reasons, but perhaps due to a lack of expertise in the Islamic field, he did not accept Osman Hamdi's request and the Raqqa finds were left unpublished. The Raqqa display most likely remained unchanged in the Çinili Köşk. In 1920, the scholar Friedrich Sarre remarked that the results of this Turkish excavation were still on exhibit there but had not been researched.[127] Only in 1938 did a relatively long discussion of the Museum's Raqqa collection, including the confiscated pieces, appear in the publication of the Çinili Köşk Collection, published in German and Turkish. In this work, Ernst Kühnel included a paragraph about the Raqqa finds in the Museum. Like Mendel, he emphasized the fact that the Museum's Raqqa collection was acquired through excavation, unlike those in European and American collections. Interestingly, while this is true for two of the three Raqqa objects individually catalogued and photographed in this publication, one of the objects, a ceramic stool, was not an excavated piece[128] but was acquired in 1913. Checking its inventory number (3511) among the Çinili Köşk inventories, we learn that it had been confiscated from Marcopoli.

Beyond these short notes, it is unfortunate that finds from the two excavations were never published or studied at length during the Ottoman period and have continued to be overlooked since the founding of the Turkish Republic. Once the popularity of the Raqqa ceramics waned in the art market in the 1920s[129] there may not have been much impetus left to publish them.

Friedrich Sarre, a self-proclaimed archaeologist who later excavated at Samarra with Ernst Herzfeld, with the permission of the Ottoman Imperial Museum, thought that the excavations of the Imperial Museum in Raqqa were not scientifically conducted. He said that the excavations were limited to searching for and salvaging ceramic fragments, without any consideration of the connection to the existing architectural remains or to the depth of the layer in which objects were found.[130] Although Macridy and Haydar were not university-trained archaeologists, they had gained experience and expertise while working at several excavations conducted by foreigners and the Imperial Museum before commencing their work at Raqqa. Their inability to excavate stratigraphically was most likely due to the disturbed state of the site, which had already been haphazardly dug up by illicit workers. And unlike Samarra, this was not a site that the Imperial Museum had researched and decided to excavate in order to learn about the early and medieval history of the city. In today's terms, this was a rescue excavation. And given the small allocations that the Museum could contribute and the conditions at the site, the Raqqa excavations were no different than many other excavations of that time. In Raqqa it is perhaps unfortunate that the Great Find was not unearthed during the official excavations, despite the detailed description of this area provided to the Museum by Kazim Efendi. When Sarre led the Samarra excavations, he had Herzfeld as his field director, along with a large group of skilled team members who contributed to the understanding of the site with birds-eye photography and drawings. The Samarra excavation campaigns in 1911 and 1912–13 lasted a total of nineteen and seven months, respectively, with relatively large allocations and workers ranging in numbers of 250 and 300. Conveniently, due to the limited period of settlement at Samarra, Sarre and Herzfeld did not have to bother with stratigraphy in their own excavations.[131] Sarre had wished to excavate Raqqa even before Samarra, and his inability to secure a permit may have been what prompted him to critique the Imperial Museum excavations.

Summing up the various documents discussed above, it becomes clear that although the Imperial Museum did not come up with Raqqa as a specific Islamic site to excavate initially as part of its larger archaeological program, it wanted to respond to the illicit digging early on by conducting its own excavations in Raqqa. However, pressed by financial and logistical concerns, it had to delay its excavations until late 1905, when enough funds, approximately 150 to 200 lira, could be allocated and an officer to direct the excavations assigned. In the mean-

time, while inquiring about the possibility of conducting a less costly dig administered by local officials in 1904, the Imperial Museum acquired very valuable information regarding the ancient pottery seller's street in Raqqa, from a school teacher who had examined the site on behalf of the Aleppo Directorate of Education. For some reason, Macridy was not able to take advantage of this information when he conducted his excavations in Raqqa between January and March 1906, but the illicit diggers who excavated right after him appear to have used this exact information in April 1906, resulting in the discovery of the Great Find. The excavations of Haydar Bey two years later did not change the luck of the Imperial Museum in terms of spectacular finds. Primarily small objects or kiln wasters were discovered. Despite their quality, however, the finds were deemed important from an archeological point of view and immediately displayed in the Imperial Museum to garner international scholarly attention. Unfortunately, the results were not published, despite Osman Hamdi's early efforts. And that remained unrectified throughout the years the objects traveled from the Çinili Köşk to other museums after the establishment of the Turkish Republic. The letters examined above reveal the dire situation confronted by officials of the Ottoman Imperial Museum as well as local authorities in Raqqa and Aleppo during the time of the official excavations in Raqqa; the documents also reflect the attitudes of Museum staff members and various local and international communities toward an Islamic archaeological site in Syria that presented those who wished to excavate it with myriad problems in the early twentieth century.

Harvard Art Museums,
Cambridge, Mass.

NOTES

Author's note: I wish to thank the Turkish Cultural Foundation, for supporting the continuation of my studies on Raqqa and the Islamic collections of the Ottoman Imperial Museum; the Istanbul Archaeological Museum, for allowing me to study the archival documents, and librarian Havva Koç, for her extensive help; the Topkapı Palace Museum, for allowing me to study the Çinili Köşk inventory registers; the Istanbul Turkish and Islamic Arts Museum, for allowing me to study the Raqqa collection; Prof. Edhem Eldem of Boğaziçi University, for sharing his knowledge and kindly offering the transcribed letters of Macridy in his possession; and last, but not least, my father, Fahri Yoltar, for helping me with the Ottoman documents.

1. J. Michael Rogers, "From Antiquarianism to Islamic Archaeology," *Quaderni dell'Istituto Italiano di cultura per la R.A.E*, n.s., 2 (1974): 51.

2. Stephen Vernoit, "The Rise of Islamic Archaeology," *Muqarnas* 14 (1997): 3; Wendy M. K. Shaw, *Possessors and Possessed: Museums, Archaeology, and the Visualization of History in the Late Ottoman Empire* (Berkeley, 2003), 174; Marcus Milwright, *An Introduction to Islamic Archaeology* (Edinburgh, 2010), 11.

3. V. V. Bartold excavated the same site in 1904. Igor Tikhonov, "Archaeology at St. Petersburg University (from 1724 until Today)," *Antiquity* 81 (2007): 450–51.

4. Vernoit, "Rise of Islamic Archaeology," 3; Milwright, *Introduction to Islamic Archaeology*, 11.

5. M. P. Blanchet, "Description des monuments de la Kaala des Beni Hammad, commune mixte des Maadid, Province de Constantine (Algérie), avec notes de M. H. Saladin (1904–1905)," *Nouvelles archives des missions scientifiques et littéraires; Choix de rapports et instructions, pub. sous les auspices du Ministère de l'instruction publique et des beaux-arts* 17 (1908): 2.

6. Léon Marie Eugène de Beylié, *La Kalaa des Beni-Hammad: Une capitale berbère de l'Afrique du nord au XIe siècle* (Paris, 1909).

7. Marilyn Jenkins-Madina, *Raqqa Revisited: Ceramics of Ayyubid Syria* (New York, 2006), 11.

8. Milwright, *Introduction to Islamic Archaeology*, 11.

9. Michael Meinecke, *Encyclopaedia of Islam, New Edition* (Leiden, 1954–2002), s.v. "Al-Rakka"; Jenkins-Madina, *Raqqa Revisited*, 6–7; Ross Burns, *Monuments of Syria: A Guide* (New York, 2009), 258–59.

10. Marilyn Jenkins-Madina's recent publication, *Raqqa Revisited*, addressed the excavations in detail for the first time. The talk on which the present article is based, "Excavation of Raqqa by the Ottoman Imperial Museum in the Early 20th Century," was given at the international conference "Owning the Past: Archaeology and Cultural Patrimony in the Late Ottoman Empire" (February 29–March 1, 2008), organized by Diane Favro, UCLA, and Zeynep Çelik, New Jersey Institute of Technology. The Ottoman Imperial Museum's own excavations in Raqqa were unfortunately not addressed to any extent in the important and relevant recent publication *Scramble for the Past: A Story of Archaeology in the Ottoman Empire, 1753–1914*, ed. Zainab Bahrani, Zeynep Çelik, and Edhem Eldem (Istanbul, 2011), which brings to light mostly foreign involvement in the archaeology of Islamic sites within the Ottoman Empire. In this same volume, Raqqa, the site Sarre once desired to excavate in Mesopotamia, is absent from the list of early Islamic digs before Samarra, which includes digs in Algeria and

Spain: Filiz Çakır Phillip, "Ernst Herzfeld and the Excavations at Samarra," in Bahrani, Çelik, and Eldem, *Scramble for the Past*, 385n13.

11. Ayşin Yoltar-Yıldırım, "The Ottoman Response to Illicit Digging in Raqqa," in Jenkins-Madina, *Raqqa Revisited*, 218–20.

12. See Edhem Eldem, "From Blissful Indifference to Anguished Concern: Ottoman Perceptions of Antiquities, 1799–1869," in Bahrani, Çelik, and Eldem, *Scramble for the Past*, 281–329, and, for the details of the bylaw and the previous regulations that led to its drafting, 314–20.

13. The difficulty of this system had been raised in the discussions of 1868 that led to the bylaw. Ibid., 318–19.

14. Shaw, *Possessors and Possessed*, 83–99; Mustafa Cezar, *Sanatta Batı'ya Açılış ve Osman Hamdi*, 2 vols. (Istanbul, 1995), 1:208–9; Edhem Eldem, "Making Sense of Osman Hamdi Bey and His Paintings," *Muqarnas* 29 (2012): 339–83.

15. Cezar, *Sanatta Batı'ya Açılış*, 251.

16. Ibid., 328–32.

17. Ibid., 289–311.

18. Jenkins-Madina, *Raqqa Revisited*, 24. Here the date of the Circassian settelements is given as 1905.

19. Stefan Heidemann, "Die Geschichte von ar-Raqqa/ar-Rafiqa: Ein Überblick," in *Raqqa II: Die Islamische Stadt*, ed. Stefan Heidemann and Andrea Becker (Mainz, 2003), 55.

20. Documents show that the Imperial Museum officer Theodorc Macridy was moving from site to site with no apparent break. See Uğur Cinoğlu, "Türk Arkeolojisinde Theodor Makridi" (MA thesis, Marmara University, 2002), 4.

21. Macridy signed his name thusly in his French letters; in Ottoman script, he signed his name as *Māqrīdī*. However, he is also commonly referred to as *Makridy* in various publications, especially foreign-language ones. For more information on him, see Aziz Ogan, "Th. Makridi'nin Hatırasına," *Belleten* 5, 17–18 (1941): 163–69; and Edhem Eldem, ed., *Osman Hamdi Bey Sözlüğü* (Ankara, 2010), s.v. "Theodoros Makridi," 366–67.

22. *Sümerkan* is the last name he took after the passage of the surname law in 1934.

23. The unpublished Imperial Museum inventories for Islamic objects (known as the Çinili Köşk inventories) include provenance, date of entry into the museum, and a description of each object. The relevant entries for Raqqa were examined in my previous study, Yoltar-Yıldırım, "Ottoman Response," 214–20.

24. Inventory nos. 1416–1541 and 1542–68 entered the museum in December 1900, inventory nos. 1932–83 in June 1903, and inventory nos. 2027–29 in April 1904.

25. Yoltar-Yıldırım, "Ottoman Response," 195, doc. 1.

26. Jenkins-Madina, *Raqqa Revisited*, 17, 120.

27. Yoltar-Yıldırım, "Ottoman Response," 199, doc. 14.

28. Copy of official letter, Istanbul Archaeological Museum Library (henceforth IAML), Box 9, 16 Kanunuevvel 1315 (December 28, 1899).

29. Response to the above letter, IAML, Box 9, 14 Kanunusani 1315 (January 26, 1900).

30. The term *Maareh* as in "*Kaza* (district) *de Rakka et Maareh*" is also used in the Imperial Museum registers. The ruins must be within the *kaza*s of both Raqqa and Ma'arra, at least according to the land division in 1899. A copy of the correspondence from the Directorate of Education from Aleppo mentions the ruins within the "*kaza*s of Raqqa and Ma'arra" (copy of official letter numbered 188, IAML, Box 9, 16 Kanunuevvel 1315 [December 28, 1899]).

31. A dealer in Urfa, his brothers Kosta and Yorgaki, and their uncle (copy of official letter, IAML, Box 9, 12 Teşrinievvel 1316 [October 25, 1900]). A certain Kostaki Homsi was visited by Gertrude Bell in February 1909 at his house in Aleppo, where she saw pieces from Raqqa (Jenkins-Madina, *Raqqa Revisited*, 28). This could well be the Kosta mentioned in this document; Homsi probably stands for "from Homs," a city close to Aleppo.

32. Official letter, IAML, Box 9, 28 Teşrinisani 1316 (December 11, 1900).

33. Decree is dated to 13 Kanunusani 1314 (January 25, 1899).

34. Copy of official letter, IAML, Box 9, 21 Teşrinisani 1316 (December 4, 1900).

35. Although no name is mentioned in the documents, Sarre and Herzfeld were the likely candidates. Sarre was looking for a site to excavate as early as 1894. Çakır Phillip, "Ernst Herzfeld," 408n25.

36. The reason is given as such: "The area the Germans want to excavate in the Raqqa ruins is located near the tribes living in the desert. Thus a squadron of horsemen is needed to protect the Germans from molestation. However, we do not have such power." See Yoltar-Yıldırım, "Ottoman Response," doc. 5.

37. Copy of letter and response, IAML, Box 9, 16 Temmuz 1318 (July 29, 1902).

38. Yoltar-Yıldırım, "Ottoman Response," 219.

39. An officer was requested from the museum to excavate and sell the bricks. The revenues collected would be used to stop the smuggling of antiquities by foreigners. Copy of telegram, IAML, Box 9, 22 Eylül 1318 (October 5, 1902).

40. Response note, IAML, Box 9, 21 Teşrinievvel 1318 (November 3, 1902).

41. Official letter, IAML, Box 9, 30 Haziran 1319 (July 13, 1903).

42. Draft of official letter, IAML, Box 9, 19 Temmuz 1319 (August 1, 1903).

43. A stone with a cross decoration in relief (100 cm × 80 cm × 8 cm), from Raqqa to the Museum. Official letter, IAML, Box 9, 25 Ağustos 1319 (September 7, 1903).

44. Copy of official letter, IAML, Box 9, 8 Eylül 1319 (September 21, 1903).

45. Telegram, IAML, Box 9, 5 Kanunusani 1319 (January 18, 1904).

46. Yoltar-Yıldırım, "Ottoman Response," 220, entries 2027–29.

47. Istanbul, Topkapı Palace Museum Registrar, Çinili Köşk Inventory (Defter) II.

48. Official letter, IAML, Box 9, 25 Mart 1320 (April 7, 1904).

49. Ibid., 27 Nisan 1320 (May 10, 1904).

50. Ibid., 31 Mayıs 1320 (June 13, 1904).

51. Yoltar-Yıldırım, "Ottoman Response," 198, doc. 10; also another official letter, IAML, Box 9, 27 Haziran 1320 (July 10, 1904).

52. "I had requested that Salim Efendi be appointed for the excavation, but when we learned that the entire place was going to be excavated by a museum officer, several dealers came to me and attempted to convince me to become involved in the smuggling of valuable antiquities to Europe. They tried to bribe me as well. After receiving a negative answer from me, they are applying to other places. An officer from the museum is desperately needed." Copy of telegram, IAML, Box 9, 23 Nisan 1321 (May 6, 1905).

53. Copy of telegram IAML, Box 9, 27 Temmuz 1321 (August 9, 1905); official letter, IAML, Box 9, 23 Ağustos 1321 (September 5, 1905); letter, IAML, Box 9, 15 Teşrinievvel 1321 (October 28, 1905); telegram, IAML, Box 9, 19 Teşrinievvel 1321 (November 1, 1905); official letter, IAML, Box 9, 24 Teşrinievvel 1321 (November 6, 1905).

54. Telegrams, IAML, Box 9, 18 Teşrinisani 1321 (December 1, 1905), and 25 Teşrinisani 1321 (December 8, 1905).

55. These have not yet been located in the Archaeological Museum Archives.

56. The actual letters, which are written in French, are in the possession of Professor Edhem Eldem. I have worked from Eldem's transcription of these letters and summarized relevant parts for this study.

57. Inv. no. 4144 is an example of such an object brought to the Imperial Museum by Macridy. See Yoltar-Yıldırım, "Ottoman Response," 215. However, the measurement must have been mistakenly recorded as 59 cm rather than 5.9 cm.

58. Mentioned also in Yoltar-Yıldırım, "Ottoman Response," 198, doc. 11.

59. Yoltar-Yıldırım, "Ottoman Response," 215, Çinili Köşk inv. nos. 4054 and 4137.

60. No such object is recorded among Macridy's finds in the Çinili Köşk inventories, but there are a few recorded among the Haydar Bey excavations of 1908. Yoltar-Yıldırım, "Ottoman Response," 214–16.

61. Yoltar-Yıldırım, "Ottoman Response," 214, Çinili Köşk inv. no. 2548.

62. This word was read as "sefotin" in my previous study, and the meaning could not be determined from Macridy's description: see Yoltar-Yıldırım, "Ottoman Response," 198, doc. 12. In this letter, Macridy makes it clear that this substance was used as a fast-drying adhesive. Seccotine is a refined liquid fish glue that dissolves in water, allowing adhering pieces to be separated easily when necessary.

63. This word is possibly "carafe." Çinili Köşk inv. no. 3928 is an example. See Yoltar-Yıldırım, "Ottoman Response," 214.

64. Ibid., 214, Çinili Köşk inv. no. 4000.

65. Çinili Köşk inv. no. 3927.

66. Çinili Köşk inv. no. 3998.

67. Çinili Köşk inv. no. 4004.

68. Çinili Köşk inv. no. 3921.

69. A ceramic bowl from Deir Zor that came from the Imperial Museum is now in the Turkish and Islamic Arts Museum in Istanbul. See Türk ve İslâm Eserleri Müzesi, ed. Nazan Ölçer (Istanbul, 2002), 74, inv. no. 1979 (formerly Çinili Köşk inv. no. 4645).

70. Three telegrams, IAML, Box 9, 9 Kanunusani 1321 (January 22, 1906).

71. "The local authorities object to the payment of the fines to the museum. This is unlawful according to the twenty-seventh article of the antiquities law. The province directorate should remind the local government of this. Maqridi": IAML, Box 9, 17 Kanunusani 1321 (January 30, 1906). "The bricks and the marbles from the Raqqa excavations will be sold by Maqridi Bey. The fines that were and will be collected from those who smuggle antiquities from the site should also be paid to Maqridi Bey." Letter from Osman Hamdi, IAML, Box 9, 19 Kanunusani 1321 (February 1, 1906).

72. Telegram, IAML, Box 9, 4 Şubat 1321 (February, 17, 1906).

73. Ibid., 13 Şubat 1321 (February 26, 1906).

74. Yoltar-Yıldırım, "Ottoman Response," doc. 14; also copy of official letter, IAML, Box 9, 30 Mart 1322 (April 12, 1906).

75. Yoltar-Yıldırım, "Ottoman Response," 214–15.

76. The Çinili Köşk registers do not include any coins, which were inventoried separately.

77. There are uninventoried crates of mixed pottery in the depots of the Turkish and Islamic Arts Museum, which the late curator of ceramics, Cihat Soyhan, showed to me, thinking that they might hold some ceramics from Raqqa.

78. Ölçer, Türk ve İslâm Eserleri Müzesi, 71, inv. no. 1582 (formerly Çinili Köşk inv. no. 3923); and 74, inv. no. 1591, mistakenly published as having come from Tel Halaf (formerly Çinili Köşk inv. no. 3930).

79. Ölçer, Türk ve İslâm Eserleri Müzesi, 70–71, inv. no. 1582 (formerly Çinili Köşk inv. no. 3923 and excavated by Macridy); 74–75, inv. nos. 1591 (formerly Çinili Köşk inv. no. 3930 and excavated by Macridy), 1585 (formerly Çinili Köşk inv. no. 3925 and excavated by Macridy), and 1557 (formerly Çinili Köşk inv. no. 3502 and confiscated from Marcopoli).

80. Yoltar-Yıldırım, "Ottoman Response," 214, object no. 4143, "four roundels serving as platform for firing of vases"; Jenkins-Madina, Raqqa Revisited, figs. 2.1, 2.2, and 2.3.

81. Yoltar-Yıldırım, "Ottoman Response," 215, object no. 4144: "Cylindrical rods probably for use in kiln."

82. Jenkins-Madina, Raqqa Revisited, 23.

83. Better suited to the street grid marked as no. 13 in Baudenkmäler und Paläste, ed. Verena Daiber and Andrea Becker (Mainz am Rhein, 2004), Karte 3.

84. Yoltar-Yıldırım, "Ottoman Response," 199, doc. 14; Jenkins-Madina, Raqqa Revisited, 24.

85. Jenkins-Madina, Raqqa Revisited, 27n41.

86. Fahim Kouchakji, "Glories of Er Rakka Pottery," International Studio 76 (March 1923): 515–16.

87. Ibid., 524.

88. Jenkins-Madina, Raqqa Revisited, 150–57, MMA (Metropolitan Museum of Art), 35, 37, 38, 40, 41, 42.

89. "Since antiquities continue to be smuggled from the site, an officer from the museum should be appointed to excavate in the spring." Official letter, IAML, Box 9, 6 Kanunuevvel 1322 (December 19, 1906). Another officer is requested for

further excavations in a copy of a letter, IAML, Box 9, 22 Eylül 1323 (October 5, 1907).

90. "It is understood from the previous excavation of the museum that valuable antiquities can be found in Raqqa. The Aleppo Directorate of Education is able to spare 20,000 *kuruş* to be used for the further excavation of the site. The excavations should be conducted by an appointed officer, under the control of the Aleppo Directorate of Education. If necessary, more funds will be allocated." Copy of a telegram, IAML, Box 9, 3 Nisan 1323 (April 16, 1907).

91. The director of education of Aleppo reports: "Munjayil, the son of Yusuf 'Asufurun, who is a merchant from Aleppo, was reported to have smuggled antiquities, such as a jam plate, in a crate. The crate was stopped on the railroad. Inside the crate were finds from Raqqa such as vases and cups. These have been sent to the museum. In relation to this, we know that three brothers, Ilyas, Yusuf, and Iskandar, are continuously involved with the smuggling of antiquities. Due to the late notice, we were unable to catch a shipment to Beirut the same morning. If Raqqa is not continuously and seriously excavated, similar smuggling will continue. Also, more funds need to be allocated to those who report to us any smuggling activity." Official letter, IAML, Box 9, 29 Teşrinievvel 1323 (November 11, 1907).

92. "We learned that a few Circassians dug in the ruins for four nights and took out valuable finds and removed them from the site at night by a carriage...if necessary their house will be searched, and if antiquities are found they will be prosecuted...Raqqa Governor": Official decree, IAML, Box 9, 16 Şubat 1323 (February 29, 1908).

93. We learn that nine items from Raqqa were found in the shop of Farjah Vardi (the father of the three brothers named above, Ilyas, Yusuf, and Iskandar). Among them, one brick decorated with a human figure and calligraphy, one black stone with two human figures and calligraphy, one ink bottle, one silver coin, and one copper coin were listed. In addition, two ceramic jars and four rings were confiscated from other individuals (names given) and sent by boat in a crate to the Imperial Museum. Official letter, IAML, Box 9, 5 Mart 1324 (March 18, 1908). Another item originating from Raqqa was seized from Husayn Husni Bey of Harput in April 1908, and again sent to the Imperial Museum. The objects included four rings, fifteen silver coins, one carnelian bezel-set ring, and twenty-eight copper coins. Addendum to letter dated 7 Nisan 1324 (April 20, 1908), IAML, Box 9.

94. Another request was made for a museum officer to conduct another campaign of excavations. Official letter, IAML, Box 9, 18 Şubat 1323 (March 2, 1908).

95. Telegram, IAML, Box 9, 16 Eylül 1324 (September 29, 1908).

96. Telegram, IAML, Box 9, 22 Eylül 1324 (October 5, 1908).

97. Yoltar-Yıldırım, "Ottoman Response," 201, doc. 22.

98. Ibid., 200, docs. 17, 18, and 20.

99. Ibid., 201, doc. 22.

100. It must have been written mistakenly as five; other relevant letters indicate six crates. See Yoltar-Yıldırım, "Ottoman Response," 201, doc. 23.

101. Yoltar-Yıldırım, "Ottoman Response," 201–2, doc. 24; also copy of a letter sent from the Museum, IAML, Box 9, 6 Teşrinisani 1324 (November 19, 1908).

102. Yoltar-Yıldırım, "Ottoman Response," 216–18.

103. Ölçer, *Türk ve İslâm Eserleri Müzesi*, 68, inv. no. 1548 (formerly Çinili Köşk inv. no. 3005), 69 (with mistakes in inv. nos. 2273 and 2046, formerly Çinili Köşk inv. nos. 2968 and 2982).

104. Yoltar-Yıldırım, "Ottoman Response," 201, doc. 21.

105. Ölçer, *Türk ve İslâm Eserleri Müzesi*, 68 (inv. no. 1547 was confiscated from Marcopoli; inv. no. 1548 excavated by Haydar Bey).

106. In my previous study, I interpreted the letter as "N." However, it is probably "M," signifying a generic Monsieur Marcopoli, without giving the first name. See Yoltar-Yıldırım, "Ottoman Response," 219. Based on Georges Marcopoli's participation in the sale of the "Great Find" pieces, it is likely that these objects were confiscated from him too.

107. *Almanach de Gotha: Annuarie généalogique, diplomatique et statistique* (Gotha, 1884), 1049; 1888 ed., p. 1033; 1892 ed., p. 1189; 1898 ed., p. 1303; 1907 ed., p. 1128; 1908 ed., p. 1125; and 1910 ed., p. 1155.

108. Jenkins-Madina, *Raqqa Revisited*, 28.

109. Ölçer, *Türk ve İslâm Eserleri Müzesi*, 68, inv. no. 1547; 75, inv. no. 1557.

110. Yoltar-Yıldırım, "Ottoman Response," 194–95.

111. Ibid., doc. 41.

112. Ibid., 205–12, docs. 33–47.

113. Jenkins-Madina, *Raqqa Revisited*, 38–113.

114. "Turkish tile-ceramic section:...In addition to these, there are Arab ceramics that were brought from Aleppo during World War I. These include an ordinary and irregular plate, a bowl, a small bowl, and jug-like objects in various shapes and sizes. As they show the development of ceramic-making by the Arabs, they are noteworthy for the history of ceramics." (List of objects in the Konya Asar-i Atika Museum, IAML, Box 112, Dossier 11920, March 18, 1928.

115. Yoltar-Yıldırım, "Ottoman Response," 195.

116. Halil Edhem, "Müze-i Hümâyûn," in *Tercümân-ı Hakîkat ve Muşavver Servet-i Fünûn = Numéro spécial et unique des journaux Terdjuman-i Hakikat et Servet-i Funoun, publié aux profits des necéssiteux musulmans de Crète* (Istanbul, 1313 [1897–98]), 104–7, esp. 106. The year 1313 has been interpreted by scholars and libraries to be the Hijra year (e.g., Wendy M. K. Shaw, "Islamic Arts in the Ottoman Museum, 1889–1923," *Ars Orientalis* 30 [2000]: 60), but it is, in fact, in the *Rūmī* calendar, and therefore should correspond to 1897–98.

117. Scholars have omitted the placement of this gallery from most discussions of the museum, as though Islamic artifacts were not exhibited until 1908 in the Çinili Köşk, which was reserved entirely for them. Wendy Shaw quotes the section of the article (which, as mentioned in n. 112, she mistakenly dates to the year 1895 rather than the *Rūmī* calendar year of 1897) in which the gallery is discussed for the first time but does not draw attention to the location

of the gallery, which she fails to note is in the new building: Shaw, "Islamic Arts," 60. The Islamic Collection of the Ottoman Imperial Museum, starting from 1883 on, along with displays of Islamic art both in the new Imperial Museum building and the Çinili Köşk, are a focus of my continuing research based on their unpublished inventories. I am thankful to the Aga Khan Program for Islamic Architecture at Harvard University for supporting my studies through an Aga Khan Postdoctoral Fellowship during the 2010–11 academic year.

118. Stephen Vernoit, "Islamic Art and Architecture," in *Discovering Islamic Art: Scholars, Collectors and Collections 1850–1950*, ed. Stephen Vernoit (London, 2000), 26.

119. Max Herz, *A Descriptive Catalogue of the Objects Exhibited in the National Museum of Arab Art, preceded by a historical sketch of the architecture and industrial arts of the Arabs in Egypt*, trans. G. Foster Smith (Cairo, 1907), ix.

120. Max Herz, *Catalogue of the National Museum of Arab Art*, ed. Stanley Lane-Poole (London, 1896), ix.

121. Meḥmed Vaḥīd, *Müze-i Hümāyūn: Rehnümā* (Istanbul, 1319 [1903]). Unfortunately a copy of this first issue could not be found in libraries in Turkey, including the Istanbul Archaeological Museum itself, nor in the United States. Therefore, we cannot claim for sure that the Islamic collection was included in this guidebook.

122. "Müze-i Hümāyūn," *Servet-i Fünūn* 672 (26 Şubat 1319 [March 10, 1904]): 338–42. The date is in the *Rūmī* calendar. The journal continued the article in subsequent issues up to no. 676.

123. "Müze-i Hümāyūn," *Servet-i Fünūn* 674 (11 Mart 1320 [March 24, 1904]): 377.

124. Meḥmed Vaḥīd, *Müze-i Hümāyūn-ı 'Osmānī'ye Maḥṣūṣ Muḫtaṣar Rehnümā* ([Istanbul] 1325 [1909]), 78–79.

125. Gustave Mendel, "Les nouvelles salles du Musée de Constantinople," part 2, *La Revue de l'Art Ancien et Moderne* 26 (July–December 1909): 337–52, esp. 344–46.

126. Artin Pacha [Yakub], "Description de quatre lampes en verre émaillé et armoiriées, appartenant à M. J. Pierpont-Morgan, des État-Unis d'Amérique, et déposées au South-Kensington Museum, à Londres," *Bulletin de l'Institut Égyptien*, 5th ser., 1 (1907): 69–92, esp. 89–90. Jenkins-Madina suggests that Osman Hamdi did not know the association of the Raqqa ceramics with Harun al-Rashid (Jenkins-Madina, *Raqqa Revisited*, 24), but Macridy's letters to Halil Edhem, Osman Hamdi's brother and collaborator, indicate otherwise.

127. Friedrich Sarre, "Die Keramik im Euphrat- und Tigris-gebiet," in *Archäologische Reise im Euphrat- und Tigris-gebiet*, ed. Friedrich Sarre, Ernst Herzfeld, Max van Berchem, and Samuel Guyer, 4 vols. (Berlin, 1920), 4:1–25, esp. 20.

128. Ernst Kühnel, *Die Sammlung türkischer und islamischer Kunst im Tschinili Köschk*, vol. 3 of *Meisterwerke der archäologischen Museen in Istanbul* (Berlin, 1938), 11, 31, pls. 22, 23.

129. Jenkins-Madina, *Raqqa Revisited*, 17–18.

130. Sarre, "Die Keramik," 20.

131. Sheila Canby, "Islamic Archaeology: By Accident or Design?" in Vernoit, *Discovering Islamic Art*, 132.

D. FAIRCHILD RUGGLES

AT THE MARGINS OF ARCHITECTURAL AND LANDSCAPE HISTORY: THE RAJPUTS OF SOUTH ASIA

Mughal architecture and gardens are much loved and well studied by historians of South Asia, and the Taj Mahal's shimmering pool, axial vistas, and majestic domed mausoleum appear in nearly every textbook surveying the history of art. In contrast, little scholarly attention has been bestowed on contemporaneous Rajput sites, built by the Hindu princes of a warrior caste who ruled before and during the Mughal Empire (1526–1857).[1] This is not due to any aesthetic shortcomings or lack of Rajput architectural complexes in India for historians and architects to study: there are beautiful and well-preserved palaces with gardens at Amber, Udaipur, Orchha, Bundi, and Nagaur, among others. The various Rajput kingdoms were largely located in Rajasthan, although they eventually spread to Malwa and Bundelkhand, and to the Punjab Hills and what is today Pakistan (fig. 1). Their palaces are visually stunning and every bit as sophisticated as their Mughal counterparts in their cultural symbolism, political expression, architectural ornament, hydraulic engineering, and artistic innovation. Rajput palace architecture belongs to a broadly defined South Asian visual culture in which many forms were shared by both Mughal and Rajput patrons, although historians of Islamic architecture have generally treated this as an example of cultural influence, in which distinct entities swapped artistic elements and style, rather than the highly complex interweaving that it was.

The purpose of the following exploration of Rajput palace gardens is not to promote an imagined binary that separates Mughal from Rajput forms of art. Most scholars of South Asian art move flexibly between Hindu and Muslim art forms and recognize the futility of trying to distinguish one from the other, especially given the mobility of artists and artistic motifs and the com-

petition among patrons. But scholars who focus on the Islamic world rarely look beyond the Taj Mahal and the Agra Fort to see what sites like Amber, Bundi, and Orchha can tell us about Islamic architecture and particularly landscape. If they did, they would see that the premise of the Islamic garden as an expression of Muslim religious beliefs falls apart when it is applied to Rajput gardens, which often use the same quadripartite form to express entirely different meanings. My point here is not to castigate historians of Islamic architecture, who, admittedly, cover vast world areas, spanning from western China to the Maghreb, and from Central Asia to Mali. Rather, I wish to show that, because of the asymmetrical way various areas of art have been defined—according to religion, ethnicity, geography, dynasty, and language—we often lack a useful framework (or even a concern) for areas of significant cultural overlap and complexity like *mudéjar* Spain, Coptic Egypt, and Hindu South Asia. I will focus primarily on palace garden architecture, although buildings and painting must also be considered.

One exception to the general blindness to Rajput architecture is the palace at Amber Fort (fig. 2). The Amber Fort was built by Raja Man Singh (r. 1590–1615), a Rajput ruler of the Kachhwaha clan and one of the highest-ranking officials in the Mughal court, on a mountain in the Aravalli range (about 14 kilometers from the site where, in 1727, Jaipur would be founded).[2] Rectangular in plan, it was built in successive stages and was significantly extended during the reign of Mirza Raja Jai Singh I (r. 1623–67/8), who built an outer reception courtyard as well as a handsome inner courtyard to serve as his own quarters. This inner court closely matches Mughal models, with a central garden divided

Fig. 1. Map of the Indian subcontinent, showing the boundaries of the Rajput kingdoms (seventeenth century). (Map: C. Scott Walker, Harvard Map Collection, Harvard College Library)

Fig. 2. Amber Fort, plan of Raja's court, 1623–68. (Plan: D. Fairchild Ruggles and Binaifer Variava)

into quadrants and subdivided by a stellar geometry into smaller sunken beds crisscrossed by narrow raised walkways (fig. 3). The garden court is flanked on either side by the elaborately ornamented pavilions of Sukh Nivas (to the west) and Jai Mandir (to the east), which open towards it through columnar arcades and raised terraces. Following the typology of the classic Mughal waterfront garden complexes at Agra and Lahore (the Delhi Fort had not yet been constructed), the palace had an elevated position on a hilltop overlooking an artificial lake.[3] In Mughal fashion, water was prominently and dynamically displayed: from the Sukh Nivas and Jai Mandir pavilions, water cascaded over a *chādar* (chute) and a panel of *chīnī khāna* (tiered niches) to flow through white marble channels towards the central pool, which took the shape of an eight-pointed star.

On the edge of the manmade Maota Lake below, the Maunbari Bagh, also known as the Kesar Kyari, similarly adhered to the geometrical formalism of the cross-axial four-part garden, commonly called a *chahār bāgh*. The garden is laid out symmetrically, with dominant central axes connecting the stepped levels of the ground plane

Fig. 3. Amber Fort, Raja's court. (Photo: D. Fairchild Ruggles)

(fig. 4). The precise date of this garden is unknown, but it was built before 1711, when it appears on a cloth map of Amber, and probably after the Mughals' surge of garden building in Kashmir, which ended in the mid-seventeenth century.[4] The downward cascade of the

Fig. 4. Amber, Maunbari Bagh, seventeenth century. (Photo: D. Fairchild Ruggles)

Fig. 5. Nishat Bagh, Srinagar, 1625. (Photo: D. Fairchild Ruggles)

Fig. 6. Orchha, Rai Praveen Mahal, probably 1672–75. (Photo: D. Fairchild Ruggles)

Maunbari Bagh's terraces and the dramatic panoramic views of the surrounding landscape owe a clear debt to the Mughal garden estates of Kashmir to the north. There, the Nishat Bagh (1625) and Shalamar Bagh (1619–20), both built on the shores of Lake Dal in Srinagar, mediated in tiered levels between the high snow-capped mountains and the silvery lake, their central water channels forming powerful axes that stretched the *chahār bāgh* from a centralizing plan into a linear series with pronounced directionality (fig. 5).[5] On the north bank of Amber's lake, a second garden, the early eighteenth-century Dilaram Bagh, likewise followed a quadripartite plan with four pavilions.[6] In all three of the Amber Fort gardens, the legacy of the Islamic *chahār bāgh* is evident, a distinctly Mughal contribution to South Asian garden forms.

Elsewhere, Rajput patrons departed from Mughal modes. At Orchha, the capital of the Rajput state of Bundelkhand from 1531 to 1783, the principal palace garden followed neither the classic model of the *chahār bāgh* nor the stepped linear model of Kashmir. Orchha's Jahangiri Mahal, begun in 1605 and finished circa 1619 by Bir Singh Dev, occupies the highest point of an island formed by the natural bend of the Betwa River and an artificially enhanced moat, in both size and altitude eclipsing the older Raj Mahal built by his father. At the foot of these two palaces stands the Rai Praveen Mahal, an airy two-storied garden pavilion with rooftop terrace (fig. 6). The pavilion and its garden served as the residence of the consort of Indramani (r. 1672–75), named Rai Praveen, but it is not absolutely clear whether it was built by that patron or earlier, by Bir Singh Deo (r. 1605–27), who had built the Jahangiri Mahal. In his recent study of Orchha, Edward Rothfarb speculates that the pavilion and garden may have replaced an earlier garden, and indeed such rebuilding—especially of gardens—was not uncommon.[7] The Rai Praveen Mahal overlooks the large Anand Mahal Bagh, a garden divided into two halves, each enclosed by high walls (figs. 7 and 8).[8] The dominant axial path that runs from the main pavilion to a diminutive one set against the north wall suggests bilateral symmetry, but in fact neither the enclosures nor the organization of walkways and plants within them is symmetrical. Instead of division into halves or quadrants, the garden follows a gridded system in which the planting is confined to relatively small, sunken octagonal cavities (approximately 1.5 meters in diameter) in a packed-mortar horizontal surface (fig. 9). The cavities today hold tall slender Ashoka trees and more broadly canopied Orange Jasmine (*murraya paniculata*), giving the effect of an orchard. The present trees have only recently been planted,[9] but in the seventeenth century the area was also probably arranged as an orchard garden, although more likely with small fruit trees. Rather crudely built conduits running across the mortar surface supply the garden with water.

This preference for planting in pits excavated in a hard surface is not unique to Orchha; it is also seen at Ahhichatragarh Fort at Nagaur (Rajasthan) and the City Palace of Udaipur. The garden in the City Palace's Amar

Fig. 7. Orchha, Anand Mahal Bagh, probably 1672–75. (Photo: D. Fairchild Ruggles)

Fig. 8. Orchha, plan of Anand Mahal Bagh. (Plan: courtesy of the Department of Landscape Architecture, University of Illinois)

Vilas courtyard (1698–1710) is laid out neither as a strictly cross-axial *chahār bāgh* nor as a linear Kashmiri type with stepped esplanades. Instead, the courtyard is divided into a grid with a square pool in its center (fig. 10). Surrounding this, each square of the grid is further divided into nine small, individual pockets excavated from an otherwise hard surface. These are filled with flowering plants and shady trees.[10]

At the seventeenth- and eighteenth-century Rajput Ahhichatragarh Fort at Nagaur, a palace with elegant halls and gardens stands within an enclosure of high, fortified walls.[11] The palace is divided between the women's quarters (*zenāna*) on the western side (a rabbit's warren of small residential units arrayed around an oblong courtyard, simplified as generic blocks on the axionometric view) and the more open and expansive public halls to the east (fig. 11). Moving from the western

Fig. 9. Orchha, Anand Mahal Bagh, planting detail. (Photo: D. Fairchild Ruggles)

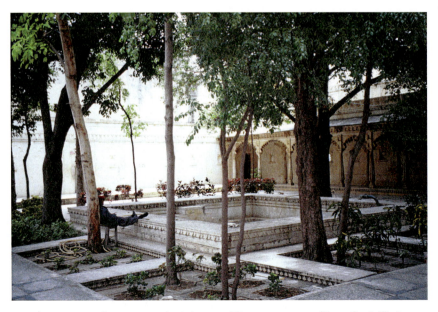

Fig. 10. Udaipur, City Palace, Amar Vilas courtyard, 1698–1710. (Photo: courtesy of Jennifer Joffee)

Fig. 11. Nagaur, Ahhichatragarh Fort, axionometric view. (Plan: courtesy of Minakshi Jain)

to the eastern areas of this more public part of the complex, there is a courtyard with garden; overlooking it are the elevated upper-story windows of the Rani Mahal, with the Sheesh Mahal (a type of *bāradarī*, meaning a rectangular pavilion with arched or trabeated openings on its sides) standing in the center. The courtyard garden between the Sheesh Mahal and the smaller, airy *bāradarī* that it faces to the south takes the form of a classic *chahār bāgh*, with a central water basin and a *chādar* (now missing) on its east wall (fig. 12).

Further to the east is a larger esplanade, with the Main Baradari at the north end, overlooking an enormous rectangular pool with two elegant smaller kiosks arrayed along its southern perimeter (fig. 13). These look down upon a quadripartite garden at a slightly lower level. Beyond this is a paved terrace with a square *bāradarī* in the center, overlooking the large Jal Mahal tank. In the northeastern corner of this area is the Abha Mahal ensemble. This hall has an ingenious system of rooftop water catchment that captures water from large rainfall events on its terraced roof and broad eaves and directs it into the large pool in the courtyard below. It also stores water in small rooftop tanks and, when necessary, lifts it up from a cistern in the garden below via a bucket and chain mechanism. When the rooftop tanks hold sufficient quantities, the water can be slowly released to flow down the surface of a nearly vertical *chādar* in the hall's interior below (fig. 14). The water from this inspired ornamental display flows from the Abha Mahal out into the open area of gardens or orchards that fills the eastern portion of the palace enclosure. In the desert environment of Nagaur, where slightly less than 4 centimeters of rain falls annually, and where there are no lakes, rivers, or streams nearby, water is not wasted and its presence is admired.

The garden that fills the large oblong courtyard between the Main Baradari and the Jal Mahal tank merits closer attention because it is highly unusual. Instead of deep beds of earth filled with vegetation, as in a typical Mughal garden, the quadrants that are divided by the four water channels form a shallow depression of hard-packed mortar. In the surface of each are pits approximately deep enough for the root ball of a shrub (fig. 15). Water conduits run between these pits below

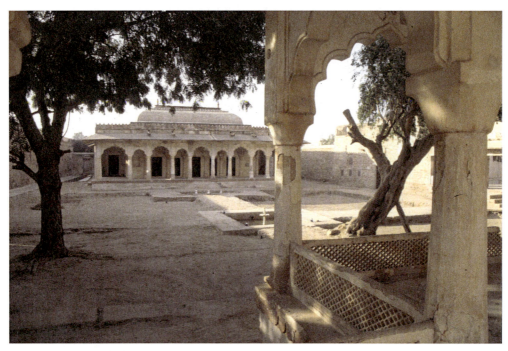

Fig. 12. Nagaur Fort, Sheesh Mahal's *chahār bāgh*, seventeenth century. (Photo: D. Fairchild Ruggles)

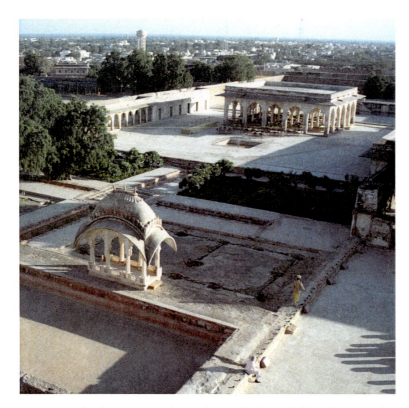

Fig. 13. Nagaur Fort, main courtyard: a large rectangular pool is in the lower left-hand corner, the lotus garden is beyond the small *bangla*-roofed kiosk, and the square *bāradarī* is in the upper right. (Photo: D. Fairchild Ruggles)

Fig. 14. Nagaur Fort, Abha Mahal, *chādar*. (Photo: D. Fairchild Ruggles)

trees that rose above the ground plane, but more likely it was a type of low vegetation that spilled beyond the edges of the cavity. If this had been a water-thirsty species that could not tolerate drought, the container method and its sub-surface piping would have preserved moisture and facilitated irrigation; but if, as some scholars believe, the pits were filled with water and planted with lotuses or water lilies, the slightly sunken quadrants may have been designed to fill with water after the rains, flooding to a level slightly higher than the pits and covering the flat mortar surface with a thin silvery film. It would have been a seasonal event—but gardens are always characterized by such ephemeral moments of exceptional beauty. The "lotus pools" had an intermediary position between the Main Baradari's enormous pool and the large Jal Mahal tank, and the effect of viewing all three bodies of water at once must have been spectacular. In the dry season, only the pits themselves would have held water. With either the abundance or scarcity of water, and whether potted with low shrubs or afloat with lotuses, the vegetation

the surface of the mortar paving, forming an interconnected system for irrigation in which evaporation would have been minimized. Such underground channelization would have been advantageous in arid Nagaur. The pits could have been planted with shrubs or small fruit

Fig. 15. Nagaur Fort, detail showing the Lotus garden. (Photo: D. Fairchild Ruggles)

Fig. 16. Nagaur Fort, Sheesh Mahal, water tank. (Photo: D. Fairchild Ruggles)

would have spilled beyond the confines of the cavities, forming islands of colorful blooms and green foliage. The display could have been enjoyed from any of the surrounding pavilions, but it would have been especially impressive in the two diminutive kiosks, which may have given the illusion that they were poised between two seas of water.[12]

A second form at Nagaur that eludes the Mughal typology is that of the courtyard with the large tank enclosed by walls and fronted by hypostyle pavilions, as exemplified by the Jal Mahal tank and the smaller tank in the Sheesh Mahal ensemble. The Sheesh Mahal tank is enclosed by an arcade that extends from the pavilion itself, and the pool serves in place of an interior courtyard (fig. 16). The interpretation of this courtyard is complicated by the historic sequence of architectural change and augmentation in the Fort. The Sheesh Mahal has interior wall paintings that closely match a similar mural program in the Hadi Rani Mahal, which lies on the same north-south axis and belonged to the women's quarters of the palace. This correspondence suggests that the Sheesh Mahal was at some point

incorporated into the women's quarters. If so, the pool may have been a later addition, providing the women with a private place to swim, as seen in Rajput miniature paintings and murals in which women are shown bathing and cavorting in such pools. The typological source for this kind of enclosed courtyard with tank appears to lie within Indic domestic tradition because there is evidence for such galleried tanks in the fifteenth and sixteenth centuries at the city of Vijayanagara (Hampi) (in the south), as, for example, in the so-called Queen's Bath. Although the Deccan plateau in the peninsular south was far from the northeastern desert where Nagaur was located, there seems to have been an awareness, and even exchanges, between the courts of northern and southern India.[13] Therefore, when analyzing artistic exchanges, it is not only the relationship between the Mughals and Rajputs that must be considered, but also relations among the Rajput kingdoms, as well as between the Rajputs and other Hindu kingdoms.

These gardens and courtyards provoke typological questions that force us to reexamine the prevalence of the Mughal aesthetic and to ask whether there were, in

fact, not only multiple Mughal types but also a reper-toire of alternative types that developed within a Rajput (as well as broader South Asian) context. However, to do this we must first acknowledge the existence of an architectural category—the "Rajput Garden" (in which are included courtyards and tanks)—that exists together with its Mughal counterpart, and second, we must recognize that, as tools for political and cultural expression, the built works of the Rajputs followed different strategies and may have had different goals.

Considerable scholarly study has been given to the history, motivations, and meanings of the palaces and gardens of the Mughals.[14] This is in remarkable contrast to the situation with the built works of their contemporaries, even though Rajput palaces and gardens attract tourism and are strikingly photogenic. There are many possible explanations for this omission from histories of culture and art. One is that the textual sources are invariably more numerous for imperial rulers than for regional dynasts, and while many of the Rajput rulers were powerful and proved to be formidable foes in resisting Mughal conquest, none of them ever attained the territorial breadth that the Mughals had won by the end of Akbar's reign in 1605. Nonetheless, there exist dynastic histories and historical poems written for Rajput rulers that, while not chronicles in the Mughal sense, are historically revealing.[15] Furthermore, there are architectural inscriptions and archival records of individual Rajput houses that document household expenditures, temple donations, and social protocol, and provide an economic description of the province.[16] Such texts could have been read by British officials, many of whom were linguistically well trained, but if the texts were read or translated, they were rarely published and thus did not reach a wide audience. There were accounts written by English historians as well: James Tod's lengthy *Annals* (1829–32) provided a detailed, entertaining, and factually reliable history (although colored by biased interpretation) of the Hindu rulers of Rajasthan.[17] These works ought to have generated interest in the Rajputs, but in actuality their impact was limited. This may have been due to contemporary circumstances: whereas the Rajputs were politically active and thus still able to control their own histories, the formerly powerful Mughals had been defeated.

The Mughal imperial histories, while not necessarily more numerous, were for the most part available in translation throughout the twentieth century, due to the keen interest of British historians in the great empire they had colonized, which they could not help but see in terms of their own imperial ambitions, as well as to the nature of the texts themselves. As Allison Busch has explained, the Mughals preferred a kind of historical writing that was recognizable to Europeans as a chronicle, whereas the Rajputs wrote about history differently, through poems and writings that revealed historical values rather than a straightforward sequence of events.[18] In consequence of these biases, there were far more translations of Mughal dynastic histories than Rajput histories, and the Mughals became more widely known at both the scholarly and popular level. The greatest Mughal histories were the *Baburnāma* (the memoirs of Emperor Babur [r. 1526–30], first translated in 1826), *Akbarnāma* (the history of Emperor Akbar and his reign [1556–1605], translated beginning in 1868), and *Jahangirnāma* (the history of Emperor Jahangir and his reign [1605–27], translated beginning in 1909).[19] But while the translations may have made Mughal history available to a wide audience, the fact that such works were translated and published is a reflection—not a cause—of an already deep fascination with the Mughals on the part of British historians and empire-builders.

The scarcity and lack of translated sources on the Rajputs do not entirely explain the imbalance in the scholarship. Because there were a great many Rajput dynastic houses that coexisted with the Mughals, serving variously as allies or foes, there are many more Rajput forts and palaces than Mughal ones. Here the imbalance would seem to favor the Rajputs, suggesting that there ought to be a great many more publications on Rajput palaces and their gardens than on Mughal residential architecture of the same period. But this is not the case. While in recent years scholarly and handsomely illustrated publications have appeared focusing on regional capitals, the classic survey works on Rajput palaces continue to be those of Oscar Reuther (1925), Giles Tillotson (1987), and George Michell (1994).[20] Historians of South Asian landscape are grateful to have serious studies of Rajput palace architecture, but while architectural publications often include plans that indicate the presence of courtyard gardens as an element

of the built form, they rarely extend beyond the formal to address the iconography, specific plantings, water systems, and climatic conditions that are key aspects of garden design. Moreover, the field of Rajput architectural study is still small enough that palatine sites such as the Nagaur Fort are generally unknown. In general, while Mughal palaces receive serious scholarly analysis, Rajput palaces are dismissed as merely scenic.[21]

There are reasons for this. In the nineteenth and early twentieth century, Mughal forts were empty and could be coopted by the British for both use (as occurred in Delhi) and study; Rajput palaces, on the other hand, were inhabited by their princely families (and many still are). Even when the Rajput owners chose to live elsewhere, outsiders were not typically allowed into their empty palaces. Thus, the architecture was more likely to be viewed in that superficial scenic sense, rather than understood as a result of serious methodical study. Until Independence in 1947, the art and architectural history of South Asia was written mostly by British rather than Indian scholars, and the former often looked at form without inquiring further, emphasizing classification and ignoring (or not having access to) the texts that could have provided the social context for the material culture and explain the original meaning of the architecture. The outstanding exception to this was Ananda Coomaraswamy (d. 1947), who served as curator of Indian art at the Boston Museum of Fine Arts from 1916 until his death.[22]

Even the architecture of the Mughals, one of the three great Muslim empires, is sometimes relegated to the margins of Islamic architectural history.[23] Because the emphasis has historically been placed on the central Islamic lands, the Sultanate and Mughal eras in South Asia have been treated as Ghaznavid and Timurid spin-offs, whose architecture can only be explained through reference to more central, mainstream precedents.[24] Ernst Kühnel began the short Mughal chapter in his 1962 survey by acknowledging this tendency to explain Mughal art solely in terms of derivation from Persian precedents. Kühnel allowed for the originality of the Mughal artists but seemed to take it for granted that "an unadulterated Indian-Muhammadan style" could be differentiated from the "pure Hindu stream."[25] In the more recent *Pelican History of Art* series, where

the second of the two volumes on Islamic art covers South Asia from the Sultanate through the Mughal periods, the authors are sensitive to the eclectic nature of Islamic art in South Asia, but the specific examples of Indic ornament and Hindu temples to which comparisons would logically be drawn are relegated by the Pelican's overarching serial structure to a separate volume on Indian art.[26] A similar division occurred in Stokstad's *Art History* (to which I contributed), where Islamic and South Asian art comprised separate chapters.[27] Worse, although David Talbot Rice's *Islamic Art* (published in 1965, and revised in 1975) and Robert Hillenbrand's *Islamic Art and Architecture* (1999) purported to be comprehensive, they ignored South Asian Islam entirely.[28] In history writing, the Mughals suffer sometimes by being excluded from the rest of the Islamic world and at other times by being included in Islam but separated from other South Asian artistic traditions.

Within art history, the most cogent explanation for why most historians have paid little or no attention to Rajput gardens and palace architecture is that while the Mughals occupy a niche in the broad history of Islamic architecture, and Hindu temple architecture and city planning occupy their own niche in South Asian studies, the Rajputs straddle the two. Their religious affiliation and worldview were Hindu,[29] and yet they adopted many of the outward signs associated with the Mughals. Although Hindus constituted a demographic majority within the Mughal Empire, historians outside of India have typically treated them as a subcategory in a time and place generally categorized as Islamic.[30]

A similar observation can be made with respect to manuscript painting, where Rajput paintings have generally received less attention from art historians than Mughal paintings, largely because they were regarded as a deviation from a centralized courtly tradition, according to a model that defined artistic relationships as those inevitably between an influencer, who is seen as actively creative, and the one so influenced, who passively receives artistic forms and ideas from a position of inferiority.[31] It is true that court painters who served Rajput patrons employed many of the same craft techniques, media, and themes as their contemporaries working for Mughal patrons, and many of them appear to have been trained by artists working for the Mughal

court. Although there is evidence of much earlier Hindu painting at, for example, the Ajanta caves (culminating in the second half of the fifth century) and in sacred manuscripts donated to temples, Rajput painting changed with the introduction of a new style by Muslims in the Sultanate period. And it was again profoundly altered in 1554, when Emperor Humayun (r. 1530–40, 1555–56) brought Persian artists to India from the court of Shah Tahmasp (r. 1524–76).

However, as is so often the case in South Asian visual culture, the flow of influence was not unidirectional: if artists working for Rajput courts acquired some of their practices and motifs from their counterparts in the Mughal court (who in turn were affected by imported Persian ideas and expertise), it is also true that the early Mughal artists received ideas and motifs from their Hindu contemporaries. Local plants and dark-skinned figures started to appear in Mughal scenes; fields of color were sometimes rendered without the Persian taste for intense pattern; the figure seen in profile became more prevalent.[32] Emperor Akbar even commissioned an illustrated manuscript copy of the great Sanskrit epic the *Rāmāyana* (Rama's Journey, 1587–99).[33] In the case of the *Ṭūṭī-nāma* (Tales of a Parrot), a relatively early Mughal manuscript (ca. 1570), it appears that about a third of the illustrations were extensively overpainted by artists in the Mughal atelier working on an earlier set of pages painted by Hindu artists (fig. 17). According to John Seyller's analysis, the manuscript's apparent mixture of Hindu and Mughal styles was due not to different painters working side by side—although Akbar's workshop did accommodate diverse artists—but rather to the drive to update the style of the existing illustrations so that they would better match the newer ones that were added later by artists in the Mughal atelier. However, he also notes the incorporation into the manuscript of new paintings in an older Hindu style, although the phenomenon was not continued in subsequent manuscripts.[34] In other words, the "flow of influence" was by no means as passive as that phrase suggests: at times, old visual modes were selectively employed; at other times they were actively wiped out and replaced or updated by newer ones.

Later, when painters were hired from Rajput courts, they had to change their style for their Mughal patrons.

Regarding the patronage of the Mughal emperor Jahangir, Milo Beach notes, "Jahangir's great Album contains Mughal, Deccani, Persian, and European works (both prints and paintings by European artists), and Jahangir was famous for his cosmopolitan interests. But nowhere does he even acknowledge any tradition of painting in Rajasthan, despite the fact that a Rajput noble such as Raja Man Singh (who held the highest rank in the Mughal administration) was decorating his spaces in Rajput style back home in Amber."[35] The rejection was surely because of the prevalence of Hindu religious themes among Rajput court workshops, but it may also have been because of the different ways that Hindu artists chose to represent narrative. Instead of a realistic picture of plausible events, as in Mughal painting, Hindu painters invited their viewers into a visual world represented in multiple moments in time, in multiple places, and even in two worlds (the human and the divine).[36]

Rajput and Mughal painting traditions responded to each other over the course of three hundred years (and Hindu princes competed not only with Mughals but also among themselves). It was not only the artists who were adept at moving among visual modes: Rajput patrons themselves freely commissioned painters working in either Mughalizing or distinctly Rajput idioms, as was the case among the Kachhwahas of Amber.[37] In *The Intelligence of Tradition*, Molly Aitken asserts that the Rajput encounter with Mughal art was by no means a steady assimilation, describing it variously as "adaptive," "selective," and rejecting.[38]

Despite significant overlap among the style, technique, and artists who moved from court to court, Rajput painting is less well known than Mughal painting. Nonetheless, it has received more study than Rajput architecture, in part due to the art market. A number of collections of Rajput manuscript paintings came up for sale in the mid-twentieth century, spurring collectors and connoisseurs to treat them as something other than Mughal derivatives. Study and classification were ways to make them more marketable.[39] Additionally, art history's high regard for the artists themselves prompts analysis of the hand of individual artists, whereas in the more collaborative endeavor of architecture, the hand of the master workman can rarely be identified—just the traditional practices of artisanal workshops.

Fig. 17. *Tūtī-nāma, (Tales of a Parrot): Tale XII: Gardener Releasing the Merchant's Daughter from Her Promise,* ca. 1560. India, Mughal, Reign of Akbar, 16th century. Color and gold on paper, 20.3 × 14.0 cm. The Cleveland Museum of Art, Gift of Mrs. A. Dean Perry 1962.279.100.b

The fact that the Rajputs do not fit neatly into either the Muslim or the Hindu category of architecture as framed by the international canon of South Asian visual studies is a methodological problem. Rajput patrons are rarely included in studies of Mughal architecture, although many of them were full participants in Mughal culture and the military and administrative construction of the empire. To take one example, the Rajput Kachhwaha rulers of Amber served as high-ranking members of the Mughal administration and married their daughters to Mughal emperors so that they eventually became enmeshed in the Mughal dynastic line. As described above, their palace at Amber has an

enclosed courtyard with white pavilions that look outward toward the dramatic exterior landscape in one direction and open inward, through delicate arches, onto the central garden. The quadripartite garden consists of sunken beds traversed by a geometrical array of walkways and water channels, flowing from a *chādar* and *chīnī khāna* (fig. 3). It has all the attributes of a Mughal garden. Similarly at Bundi (Rajasthan), the palace of the Chauhan Rajputs has a large garden terrace (probably eighteenth century) that forms a *chahār bāgh* with a central water pool (fig. 18). However, despite their clearly Islamicate form and planning, Amber and Bundi are omitted from surveys of Islamic architecture and, less surprisingly, introductions to world art history. Their cultural hybridity disqualifies them from histories that identify linear chronological development within a well-defined context. These are problems that occur not for reasons intrinsic to the works themselves but because of the way that geographical and historical areas have been defined.

"Hybridity" itself is a problematic term because it begs the questions of identity and agency. It assumes that there were original identities—stable and clearly bounded—that interacted to form a hybridized union while ignoring imbalances of power such as relations of dependency due to conquest, economic forces, and gender inequalities that may have caused or given meaning to the union. But the stability of those human identities is by no means as clear as the differentiating terms Rajput and Mughal would suggest. The Mughals themselves were produced by the coupling of Mughal fathers with Rajput mothers, both of whom were themselves produced through sexual union—by nature, a commingling of difference—in which there is no absolute, stable identity, only a constant coming into being.[40] This is not to say that the clans lacked identity and were indistinguishable. By their visible worshiping at mosques and temples, the difference in their burial rites, the celebration of different holy days, and the markings made on the body itself, they created external signs that insisted on distinct identities. It is in the act of making (always in the process), rather than in being (denoting something complete), that people perform their cultural identities. The making of things and shaping of spaces are thus critical.

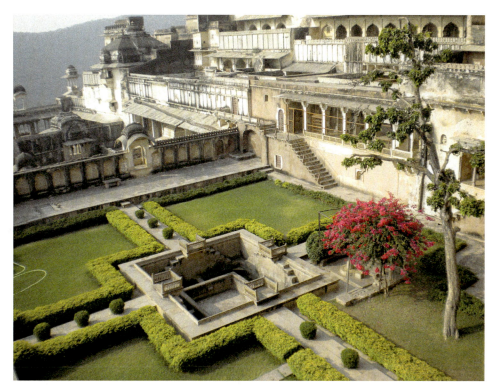

Fig. 18. Bundi, Chitra Shali Palace garden, eighteenth century. (Photo: D. Fairchild Ruggles)

The term "hybridity" does not disclose the extent to which formal typology was associated with identity: it does not explain why and under what conditions typological forms were exchanged between the Mughals and Rajputs. The question has been addressed by architectural historians, who have called attention to the indigenous roots of forms such as the distinctively curving *bangla* roof (so-called for its Bengali origins), *chhatrī* (a cupola raised on slender supports), corbelled arch, serpentine bracket, and rooftop terrace, as well as the locally quarried red sandstone used in Hindu palace architecture and, subsequently, in imperial Mughal monuments.[41] From the perspective of the twenty-first century it may be easy to attribute the *bangla* and *chhatrī* to Indic origins and the *chahār bāgh* and *hesht behesht* (a square or octagonal shape divided into nine bays) plan to Muslim (and specifically Timurid) sources. Historians make these distinctions for the reasons explained above, but did patrons in the seventeenth century understand them according to such culturally specific Rajput/Mughal or Hindu/Muslim binaries?

Would they, for example, have regarded the exquisitely carved and pierced stone screen (*jālī*) at the Tomb of Sheikh Salim al-Din Chisti (tomb built 1581–82, *jālī* screens added ca. 1605) (fig. 19), in the Mosque of Fatehpur-Sikri, as derived from Hindu temple architecture, with origins at least as early as the seventh-century temple at Aihole? Or would they have associated it with the ceramic screens filling the windows of Timurid and Safavid architecture of Iran? They could have found the immediate source in fifteenth-century Sultanate mosques in India, and with such a history of commingling already permeating the subcontinent well before the beginning of the Mughal Empire in 1526, perhaps they would have refused to imagine a binary set of paths by which such an element had to have arrived in Fatehpur-Sikri through either Muslim or Hindu carriers.

"Hybridity" also does not clarify the degree to which architectural forms were simply interchangeable signs that could be appropriated or shed for political expedience.[42] Just as the Mughals were quick to borrow beautiful forms and employ the structural techniques and

Fig. 19. Fatehpur-Sikri, tomb of Sheikh Salim al-Din Chisti: *jālī* screen. (Photo: D. Fairchild Ruggles)

Fig. 20. New Delhi, Tomb of Humayun, detail showing water channels on tomb terrace. (Photo: D. Fairchild Ruggles)

talented Hindu and Muslim artists of the Indic region that they conquered, the Hindus appear to have also embraced the arts, forms of dress, and other cultural signs associated with the Mughals.[43] They adopted and adapted forms with freedom but also selectivity. Because the artistic syntax and meanings were different from their own art, the appropriation was not a direct transfer but a reworking and renegotiation of form and expression. However, paradoxically, while historians have celebrated the cultural eclecticism of the Mughals as a source of strength, by which the strands of smaller kingdoms were strategically woven into the larger Mughal imperial fabric, this same eclecticism among the Rajputs has caused them to be excluded from the international canon of South Asian visual studies.

If it is difficult to classify the various schools of Rajput painting and explain their various relationships to the Mughal workshops, and to find a way of discussing Rajput architecture that does not insist upon assigning it to either a Muslim or Hindu context, the problems only increase with landscape because the matter of cultural identification is exacerbated by a disciplinary one. For many landscape historians, especially those trained in the discipline of art history, the analytical apparatus of architectural history provides the starting point for landscape studies. Indeed, two of the best books on Rajput architecture—those of Tillotson and Michell— are useful studies of the evolution of architectural typol-

ogy, patronage and regional style, and the dynastic expression of power and legitimacy, but as they were written with the intent of explaining the buildings, other aspects of palatine architecture, such as furnishings, murals, and gardens, appear only as a subset. This is often the case in histories written from the architectural perspective: gardens appear as secondary dependencies, designed and inserted into the palatine environment *after* the construction of the major buildings, even though the material evidence contradicts this imagined sequence. The Tomb of Humayun (New Delhi, finished 1572) (fig. 20) and the Nagaur Fort, to give two examples, were constructed with water channels and spouts embedded in their roofs and terrace floors, which were designed to collect precious rainwater and direct it into irrigation cisterns. The water catchment of the main buildings contributed to the functioning of the irrigation system of the whole complex, but it also became a powerful visual effect, as the water thus captured was then displayed in the large rectangular pool at Nagaur Fort and in the grid of water channels and pools running through the garden of Humayun's Tomb. These were not afterthoughts, added after the completion of the architecture in response to the gardener's sudden demand for adequate water supplies. The gardens were conceived in tandem with the buildings.[44]

But the weight of architectural history is such that landscape historians often consciously or unconsciously adopt the values of the architectural historian, examin-

Fig. 21. New Delhi, Tomb of Humayun. (Photo: D. Fairchild Ruggles)

ing gardens with an eye to the identification of typologies (such as the *chahār bāgh*), artisanal technique (such as cut-stone channels and carved marble basins), and patronage (categorized as either Mughal or Rajput, but not both). They focus on permanent elements such as walkways and fountains, and often do not even attempt to answer the question of the character of the garden that was planted.[45] They view gardens as stable categories with well-defined forms, created by an architect according to a plan and having a distinct moment of origin. This is as reductive as the way that historians treat cultural identities.

However, it is possible to conceive of gardens in entirely different terms: not as grand manipulations of the built environment reflecting deep-seated religious beliefs and centralized governmental control, but as, first, local responses to the climate, soil, and topography and, second, expressions of diverse political and cultural identities. Considered thus, the question of gar-

den meaning can depart from the rigidly unilateral theological explanation, which in the field of Islamic gardens usually takes the familiar form of the garden being a foretaste of the paradise promised in the Koran to the faithful, and the *chahār bāgh* as an earthly reflection of the four rivers of paradise. Humayun's Tomb garden often provokes such an interpretation. The Persianate tomb is characterized by a *hesht behesht* plan, monumental central double-shell dome, and iwans rendered on the façade at various scales (fig. 21). It stands majestically within a *chahār bāgh* garden that, given the commemorative and funerary purpose of the site, was certainly intended to connote "paradise on earth." Of course, *any* Muslim tomb garden built during or after the Timurid dynasty (1370–1506) had paradisiac meaning—by then it was so ubiquitous as to be a cliché. However, the political motivations underlying the construction of Humayun's tomb and garden were by no means so commonplace and generalized: the site

Fig. 22. Raghubir Rai, photograph. (Photo: courtesy of Magnum Photos)

was intended to express a specific set of meanings that would link the Mughals to their Timurid forebears and thus confer authority and legitimacy upon Humayun's son Akbar, who (possibly together with Humayun's widow) had built the tomb as much to honor his deceased father as to assert Humayun, and by extension himself, as the rightful ruler of the nascent Mughal Empire.[46] This political meaning is a more probing explanation than the more obvious paradisiac explanation of the garden because it requires an examination of the particular motivations of the patron, the political conditions of the moment, and the specific cultural conditions of the audiences.

If the symbolism of Islamic gardens can be attributed to a complex array of economic and political as well as environmental concerns, it is especially important for the interpretation of Rajput gardens, since the interpre-

tation of the latter as reflections of paradise simply does not serve. When used in a Rajput context, the *chahār bāgh* plan must perforce have had an entirely different symbolic resonance, because in Hindu philosophy and religion, the understanding of death and the afterlife, and the rituals by which those attitudes are expressed, are wholly different from those of Islam.[47] An extraordinary photograph by Raghubir Rai shows the dry edges of the Yamuna River as it passes through Agra (fig. 22): the contrast between the human skull in the foreground and the monumental Taj on the far bank calls to mind the difference between Muslim observance of burial and entombment and the Hindu practice of cremation, particularly along the banks of the sacred Ganges, of which the Yamuna is a tributary. It hardly needs to be said that Rajput gardens, as well as Hindu gardens in general and Buddhist gardens, connoted something dif-

ferent than Islamic gardens: the question is why the quadripartite plan, with its well-recognized paradisiac iconography, was used and what it meant.

Followers of Hinduism did not construct comparable tombs for interment, but they did embrace the four-part garden plan for palatine complexes, where pleasure and politics were defining attributes, and by the sixteenth century they had developed commemorative monuments such as the large-scale memorial *chhatrī*.[48] Hindu cenotaphs were often situated near bodies of water, either natural or manmade, and sometimes had a park-like setting, as in the sixteenth- and seventeenth-century commemorative *chhatrī*s that still stand outside of Amber (fig. 23). But, unlike Islamic mausolea, they were not situated in *chahār bāgh*s because the *chahār bāgh* layout of gardens such as those at the Amber Fort did not have a direct association with burial, the human body, and eternity. They were not read as metaphorical references to paradise by their patrons or the patrons' associates. Therefore, when the quadripartite plan was employed at the center of the Amber Fort, the easily recognizable *chahār bāgh* was a sign not of paradise but of the contemporary political landscape and the cultural situation of the patrons, the Rajput Kachhwahas, who had very close political and family alliances with the Mughals.[49] One of the Kachhwaha daughters was married to the Mughal emperor Akbar in 1562 and produced the son that became the next Mughal emperor. That son, Jahangir, married another daughter of the Kachhwaha House, who gave birth to his first son, Khusrau (the future Shah Jahan [r. 1628–58]), in 1592.

In later palaces of the Rajputs and other princely Hindu dynasties, the *chahār bāgh* garden plan may have harkened back to a golden age of empire, before the Mughals began to weaken and the British presence became threatening. It is even more likely that by the late seventeenth century, in those cases when the *chahār bāgh* was employed by non-Muslim patrons, it held no particular significance as a specifically Mughal or Muslim sign but was simply a common and available South Asian garden form.[50] Even among the Mughals, the quadripartite plan did not always signal paradise in the eschatological sense and was not used exclusively in tombs: it was also used in palace gardens, where it

Fig. 23. Amber, *chhatrī*s (date unknown). (Photo: D. Fairchild Ruggles)

was a sign of pleasure, in the more general sense of "heavenly."

The Rajput gardens that most adhere to the Islamic garden canon are easiest to study because we can apply to them our knowledge of their Islamic counterparts and because that very process of translation into an Islamic idiom leaves the categories of Muslim/Mughal and Hindu/Rajput intact. Thus the courtyard and terrace gardens of the Amber Fort receive the most attention, while those in Orchha, the Nagaur Fort, and the City Palace of Udaipur—where the gardens are neither strict cross-axial *chahār bāgh*s nor Kashmiri-style stepped terraces and indeed fit no recognized typology—are hardly known. These cases suggest that the widespread (but myopic) insistence on the *chahār bāgh* as the quintessential Islamic garden form may have distracted scholars from recognizing other kinds of formal planning, even in contexts such as Rajput forts, where the patrons and primary audience were not Muslim and did not look to the same tradition of landscape planning and meaning. Moreover, in pursuing a model defined by precise geometrical form (a practice learned from architectural history), scholars have too often overlooked the rich trove of references to sacred landscapes such as pools and groves in Sanskritic literature, which are characterized not by form but by function and meaning.[51] In addition to references to the deities and the sacred spaces associated with them, the literature also sheds light on early Indian court gardens,

which Daud Ali shows to have been idealized spaces with formulaic components: spectacular waterworks, wooded bowers, and a hill (often an artificial mound). They were sumptuously appointed with textiles and wall paintings that invited recreation, romance, and festivity. Most importantly, he argues that in Buddhism, "celestial gardens developed in close dialogue with their earthly counterparts." Early royal patrons sometimes tried to emulate the magnificent wonder of heavenly gardens, with pools of perfumed water, artificial trees with gold flowers, and embankments of sand made from pearls: these "formed an important space where the realm itself was projected and thought about."[52] This is very close to the kind of arguments regarding the garden as political and environmental metaphor that I made in *Gardens, Landscape, and Vision in the Palaces of Islamic Spain* (2000), and indicates a commonality among early gardens that may have been due to the garden's expressive capacity as an aestheticized environmental response rather than the result of stylistic or technical evolution (as in architecture).

The blindness to autochthonous formal types and conceptual models has given rise to the assumption that all designed landscape forms in South Asia were an Islamic, and more specifically Persian, importation, with the result that Rajput gardens have either been regarded as derivative or ignored altogether. Ultimately, it may be useful to discard the category of "Islamic garden"—and with it the corollary "Rajput garden"—and instead acknowledge the complexity and interdependence of South Asian visual culture, as South Asianists have already done. This is particularly appropriate in the case of gardens because, responding to specific geoclimatic conditions such as the monsoon, intense heat, hilly or flat landscape morphology, and a regional palette of trees and plants, the gardens of both Muslims and Hindus in South Asia drew upon the same repertoire of traditional cultivation practices. There were a great many pragmatic concerns that garden architects had in common, regardless of whether they served a Muslim patron, who perceived the garden as a foretaste of the paradise promised in the Koran, or a Rajput patron, who saw in pools and groves the presence of the gods. Historians have typically understood the Hindu approach to nature as responsive—seeing gods present in those places where nature has distinctive characteristics, such as springs, ponds, rivers, crossings, mountains, forests, and trees. But perhaps we should consider the other response, which is to seek to design and create places of worldly pleasure for mortals as well as places that might, in their shady arbors and deep waters, actually invite the gods to dwell there.

Department of Landscape Architecture,
University of Illinois, Urbana-Champaign

NOTES

Author's note: This paper began as a presentation in the Nagaur (Rajasthan) Garden Workshop, January 28–February 1, 2006. I am grateful to the Mehrangarh Museum Trust, His Highness Maharaja Gaj Singh II, and James L. Wescoat Jr., for the invitation to participate in that workshop. Research on Orchha and Amber was conducted with a senior fellowship from the American Institute for Indian Studies. I wish to express my deep thanks to Milo Beach and Catherine Asher for their thoughtful comments on the paper at various stages, to Amita Sinha, with whom I have had many productive conversations about Orchha, and to Kathryn Gleason, who generously shared her preliminary excavation findings after the Nagaur Workshop.

1. Rajput is a Sanskrit word meaning "prince." The Rajputs, who claim to be descended from deities, are not a dynasty but a large group of warriors who gained dominance in northern India sometime between the sixth and ninth century. In this essay, regnal dates are given for individual dynasties of Rajput rulers, but the dates are not those of the clan as a whole.

2. On the Amber Fort, see Oscar Reuther, *Indische Paläste und Wohnhäuser* (Berlin, 1925), and G. H. R. Tillotson, *The Rajput Palaces: The Development of an Architectural Style, 1450–1750* (New Haven, 1987). Specifically on its gardens, see D. Fairchild Ruggles, "Gardens," in *Art of India: Prehistory to the Present*, ed. Frederick Asher (Chicago, 2003), 258–70, and D. Fairchild Ruggles, "The Framed Landscape in Islamic Spain and Mughal India," in *The Garden: Myth, Meaning, and Metaphor*, ed. Brian J. Day, Working Papers in the Humanities 12 (Windsor, Ontario, 2003), 21–50. On the Kachhwahas' patronage, see Catherine Asher, "Excavating Communalism: Kachhwaha *Rajadharma* and Mughal Sovereignty," in *Rethinking a Millennium: Perspectives on Indian History from the Eighth to the Eighteenth Century; Essays for Harbans Mukhia*, ed. Rajat Datta (Delhi, 2008), 222–46.

3. Ebba Koch, "The Mughal Waterfront Garden," in *Gardens in the Time of the Great Muslim Empires: Theory and Design,*

ed. Attilio Petruccioli (Leiden, 1997), 140–60; Ebba Koch, *The Complete Taj Mahal and the Riverfront Gardens of Agra* (New York and London, 2006).

4. A map of Amber, made of cloth, was drawn in 1711 for M. S. Jai Singh (collection of the National Museum, New Delhi). It was published by Susan Gole, *Indian Maps and Plans: From Earliest Times to the Advent of European Surveys* (New Delhi, 1989), 170–71, and is discussed in C. Asher, "Excavating Communalism," 222–46, esp. 231–32.

5. D. Fairchild Ruggles, *Islamic Gardens and Landscape* (Philadelphia, 2008), chap. 10.

6. B. L. Dhama, *A Memoir on the Temple of Jagatshiromani at Amber* (Jaipur, 1977). I was also fortunate to hear Giles Tillotson deliver a paper on this subject at a garden workshop held in Nagaur (January 30–February 3, 2006).

7. Edward Rothfarb, *Orchha and Beyond: Design at the Court of Raja Bir Singh Dev Bundela*, published as a special issue of *Marg* 63, 3 (Mumbai, 2012), 99–101.

8. Ruggles, *Islamic Gardens*, 135–36, 220–21.

9. Probably added during the 2002 INTACH heritage preservation campaign: see Priyaleen Singh, "Working in Historic Cities," http://www.india-seminar.com/2004/542/542%20 priyaleen%20singh.htm (accessed December 12, 2005).

10. On this, see Jennifer Joffee and D. Fairchild Ruggles, "Rajput Gardens and Landscapes," in *Middle East Garden Traditions*, ed. Michel Conan (Cambridge, Mass., 2007), 278–80.

11. Minakshi Jain, *Architecture of a Royal Camp* (Ahmedabad, 2009). Minakshi Jain and team, "Ahhichatragarh, the Fort of Nagaur; Conservation Works Report to Facilitate Garden Workshop 30/01/06–3/02/06" (unpublished). My observations on Nagaur were made on the basis of fieldwork on site, but the following conclusions were made in discussion with Minakshi Jain, James Wescoat, Giles Tillotson, Ratish Nanda, Milo Beach, Kathryn Gleason, Catherine Glynn, Amita Sinha, and others who attended the 2006 Nagaur Garden Workshop.

12. Because of the difficulty of supplying enough water, I was not convinced of the lotus hypothesis, imagining the garden as an orchard, like Orchha. But Rahul Mehrotra persuaded me by pointing out the visual logic of the kiosks' placement: positioned on the edge of the large pool yet providing an overview of the garden that the presence of trees would have blocked.

13. On artistic exchanges with the Deccan, see Catherine Glynn, "Bijapur Themes in Bikaner Painting," in *Court Painting in Rajasthan*, ed. Andrew Topsfield (Mumbai, 2000), 65–77; Shanane Davis, *The Bikaner School: Usta Artisans and Their Heritage* (Jodhpur, 2008); and Molly Aitken, *The Intelligence of Tradition in Rajput Court Painting* (New Haven and London, 2010), 31.

14. The most important comparative works on the Mughal garden are: Sylvia Crowe, Sheila Haywood, and Susan Jellicoe, *The Gardens of Mughal India* (London, 1972); Elizabeth Moynihan, *Paradise as a Garden in Persia and Mughal India* (New York, 1979); Mahmood Hussain, Abdul Rehman, and James L. Wescoat Jr., eds., *The Mughal Garden: Inter-pretation, Conservation and Implications* (Washington, D.C., and Lahore, 1996); James L. Wescoat Jr. and Joachim Wolschke-Bulmahn, eds., *Mughal Gardens: Sources, Places, Representations, and Prospects* (Washington, D.C., 1996); Koch, *Complete Taj Mahal*; and Ruggles, *Islamic Gardens*, especially chap. 10 and "List of Gardens and Sites."

15. Allison Busch, "Literary Responses to the Mughal Imperium: The Historical Poems of Keśavdās," *South Asia Research* 25, 1 (2005): 31–54. On Rajput histories in general, see Allison Busch, *Poetry of Kings: The Classical Hindi Literature of Mughal India* (Oxford, 2011). On Bundi, in addition to Busch, "Literary Responses," see the multivolume (and unpublished) epic *Vamsha Bhaskar*, by Suraj Mal Mishran (1841), discussed in *The Historians and Sources of History of Rajasthan*, ed. V. S. Bhatnagar and G. N. Sharma (Jaipur, 1992). The *Ishvaravilasa Mahalavya*, by the court poet Krishna Bhatta (ca. 1749), describes Jaipur in the second quarter of the eighteenth century: Krishna Bhatta and Mathuranatha Shastri, *Ishvaravilasamahakavyam* (Jayapura, 1958), cited in Ashim K. Roy, *History of the Jaipur City* (New Delhi, 1978). On Mewar, see Richard D. Saran and Norman P. Ziegler, *The Meṛtīyo Rāṭhors of Meṛto, Rājasthān: Select Translations Bearing on the History of a Rajpūt Family, 1462–1660*, 2 vols. (Ann Arbor, Mich., 2001).

16. For example, the inscriptions from Udaipur published by N. P. Chakravarti and B. Ch. Chhabra in multiple volumes of *Epigraphia Indica* (1951–53) and discussed in Jennifer Joffee, "Art, Architecture, and Politics in Mewar, 1628–1710" (PhD diss., University of Minnesota, 2005).

17. James Tod, *Annals and Antiquities of Rajast'han or the Central and Western Rajpoot States of India*, 2 vols. (New Delhi, 1971; orig. pub. 1829–32).

18. Busch, "Literary Responses," 31–33.

19. Abū'l Fazl Allāmī, *Ā'īn-i Akbarī*, (which itself constitutes one third of the much larger *Akarbarnāma*), vol. 1 trans. H. Blochmann (Calcutta, 1873), vol. 2 trans. H.S. Jarrett (Calcutta 1891), vol. 3 trans. H.S. Jarrett (Calcutta 1896); *The Akbar nāma of Abu-l-Fazl: History of the Reign of Akbar, Including an Account of His Predecessors*, trans. H. Beveridge, 3 vols. (Calcutta, 1902–39); Gulbadan Begam, *The History of Humāyūn (Humāyūn-nāma)*, trans. Annette Beveridge (London, 1902)—a new translation of Gulbadan Begam's work is found in *Three Memoirs of Humāyun*, trans. and ed. Wheeler M. Thackston, 2 vols. (Costa Mesa, Calif., 2009); *Memoirs of Zehir-Ed-Din Muhammed Baber, Emperor of Hindustan*, trans. John Leyden and William Erskine, 2 vols. (London, 1826); *The Bābur-nāma in English (Memoirs of Bābur)*, trans. Annette Beveridge, 2 vols. (London, 1912–21); *The Baburnama: Memoirs of Babur, Prince and Emperor*, trans. Wheeler Thackston (Washington, D.C., 1996); *The Tūzuk-i Jahāngīrī, or Memoirs of Jahāngir*, trans. Alexander Rogers and Henry Beveridge (London: Royal Asiatic Society, 1909–14), with new trans. by Wheeler Thackston (Washington, D.C., and New York, 1999). However, in the acknowledgements to the 1990 translation of 'Ināyat Khān, *The Shah Jahan nama of 'Inayat Khan: An Abridged History*

of the Mughal Emperor Shah Jahan, Compiled by His Royal Librarian; The Nineteenth-century Manuscript Translation of A.R. Fuller (British Library, add. 30,777), ed. and comp. Wayne Begley and Z. A. Desai (Delhi and New York, 1990), Wayne Begley laments the lack of translated materials recording the reign of Shah Jahan. He notes the exception of 'Inayat Khan's history of Shah Jahan, which was translated in the mid-nineteenth century by A. R. Fuller, but points to the fact that it remained an unpublished manuscript in the collection of the British Library. Nonetheless, there were even fewer available translations for the Rajputs and they mostly attracted only local interest.

20. Reuther, *Indische Paläste und Wohnhäuser*; Tillotson, *Rajput Palaces*; and George Michell and Antonio Martinelli, *The Royal Palaces of India* (New York and London, 1994). To these can be added less comprehensive works such as Sidney Toy, *The Strongholds of India* (Melbourne, 1957), as well as G. S. Ghurye, *Rajput Architecture* (Bombay, 1968), which, despite the book's title, ignores all the Rajput palaces except Gwalior. Prominent among the older works is James Fergusson, *History of Indian and Eastern Architecture* (London, 1891), which included Rajput palaces in a short chapter called "Civil Architecture," 470–88. The inclusion of Rajput architecture in such surveys, however, does not necessarily mean that the authors ever visited the more distant sites.

21. I am focusing on the Rajputs, but the same lament could be voiced for the Marathas, Jats, and other groups who patronized art and architecture in South Asia.

22. Pramod Chandra, *On the Study of Indian Art* (Cambridge, Mass., 1983).

23. The interest in South Asia is relatively recent among historians of Islamic art from Europe and North America, stemming in part from the political events of 1979–80, when the Iranian Revolution effectively closed the doors of Iran to Western visitors. The taking of hostages in Lebanon and the Gulf War in Kuwait and Iraq made those areas less accessible and safe for Western scholars. With archaeological fieldwork rendered difficult or impossible in Iran and Iraq, the next two generations of graduate students in art history turned their attentions to South Asia.

24. Finbarr Flood, "Lost in Translation: Architecture, Taxonomy, and the Eastern 'Turks'," *Muqarnas* 24 (2007): 79–115.

25. Ernst Kühnel, *Islamic Art and Architecture*, trans. Katherine Watson (German first edition 1962; Ithaca, Cornell University Press, 1966), 159 and 164. The sentiment is echoed in modern India, where for political reasons some prefer to see Muslim and Hindu as utterly distinct. Such a perspective obviously impedes the ability to study Rajput palace architecture, where the distinction argument does not hold.

26. The *Pelican History of Art* series divides Islamic art and architecture into the periods 650–1250 and 1250–1800: The first volume contains only a few pages on India, but the second volume covers South Asia from the Sultanate through the Mughal periods. Richard Ettinghausen, Oleg Grabar,

and Marilyn Jenkins-Madina, *Islamic Art and Architecture 650–1250* (New Haven and London, 2001; a significant revision of the earlier book by the same title published in 1987), and Sheila S. Blair and Jonathan M. Bloom, *The Art and Architecture of Islam 1250–1800* (New Haven and London, 1994).

27. Ruggles, "Islamic Art" (chap. 8), and Frederick Asher, "Art of South and Southeast Asia before 1200" (chap. 9) and "Art of South and Southeast Asia after 1200" (chap. 23), in *Art History*, ed. Michael Cothren and Marilyn Stokstad, 4th ed. (Upper Saddle River, N.J., 2010), 260–89, 290–323, 770–89. Unfortunately, the Cothren-Stokstad volume does not clearly acknowledge the specific authorship of individual chapters.

28. David Talbot Rice, *Islamic Art* (London, 1965; rev. ed. 1975), and Robert Hillenbrand, *Islamic Art and Architecture* (London, 1999).

29. The term "Hindu" is used here with considerable unease. It is convenient as a term that broadly describes a set of religious practices and philosophies, and the architecture and artifacts that were produced by those religious and philosophical practices. But used to describe people and their cultural identity, it first conflates religion with culture and then condenses a variety of cultural identities into a single, simple, homogenous group. However, there is nothing homogenous about the group of South Asians typically defined as Hindu, other than that they are not Muslim. Nonetheless, I have used the word cautiously, simply for want of a better term and following the justification of S. Radhakrishnan, "Hinduism," in *A Cultural History of India*, ed. A. L. Basham (New Delhi, 1975), 60.

30. A welcome exception to this is Catherine Asher and Cynthia Talbot, *India before Europe* (Cambridge, 2006). The myth of stable Muslim and Hindu cultural identities in an earlier period is the topic of Finbarr Flood's *Objects of Translation: Material Culture and Medieval "Hindu-Muslim" Encounter* (Princeton, N.J., 2009).

31. Milo Cleveland Beach, *Early Mughal Painting* (Cambridge, Mass., 1987), esp. 2–3; Aitken, *Intelligence of Tradition*; Joanna Williams, ed., *Kingdom of the Sun: Indian Court and Village Art from the Princely State of Mewar* (San Francisco, 2007); and Debra Diamond and Catherine Ann Glynn, eds., *Garden and Cosmos: The Royal Paintings of Jodhpur* (Washington, D.C., 2008).

32. John Seyller, *Workshop and Patron in Mughal India: The Freer Rāmāyana and Other Illustrated Manuscripts of 'Abd al-Rahīm*, Artibus Asiae, Supplementum 42 (Zurich, in association with the Freer Gallery of Art, Washington, D.C., 1999), 284–88.

33. C. Asher, "Excavating Communalism," 224.

34. John Seyller, "Overpainting in the Cleveland *Ṭūṭīnāma*," *Artibus Asiae* 52 (1992): 283–318. Seyller refutes an earlier theory of Pramod Chandra and Daniel J. Ehnbom, *The Cleveland Tuti-Nama Manuscript and the Origins of Mughal Painting* (Graz, 1976).

35. Personal communication, June 2006.

36. Aitken, *Intelligence of Tradition*, 17–22.

37. Catherine Glynn, "A Rājasthānī Princely Album: Rājput Patronage of Mughal-Style Painting," *Artibus Asiae* 60, 2 (2000): 222–64.

38. Aitken, *Intelligence of Tradition*, 41.

39. On Rajput Painting, see Ananda Kentish Coomaraswamy, *Rajput Painting* (London, 1916); Pratapaditya Pal, *Court Paintings of India, 16th–19th Centuries* (New York, 1983); Beach, *Early Mughal Painting*; Milo C. Beach, *Mughal and Rajput Painting* (Cambridge, 1992); Topsfield, *Court Painting in Rajasthan*. Aitken, Williams, Seyller, and Diamond and Glynn are cited in nn. 31 and 32 above. An important international exhibition of Rajput painting was held December 1960– January 1961 at Asia House in New York (catalogue edited by Sherman Lee, *Rajput Painting* [New York, 1960]). Interestingly, when the Metropolitan's Museum of Art's exhibition *India!* opened in 1985, it received stinging reviews because of the evident absence of Hindu culture in the show's presentation of Indian art. See, for example, Arthur Coleman Danto, "The Near Pavilions!" in *The Nation* 241, 13 (October 26, 1985): 412–14. The observation about marketability was made by Milo Beach, personal communication, May 2006.

40. A parallel example is discussed in D. Fairchild Ruggles, "Mothers of a Hybrid Dynasty: Race, Genealogy, and Acculturation in al-Andalus," *Journal of Medieval and Early Modern Studies* 34, 1 (2004): 65–94.

41. Glenn D. Lowry, "Humayun's Tomb: Form, Function, and Meaning in Early Mughal Architecture," *Muqarnas* 4 (1987): 133–48; Ebba Koch, *Mughal Architecture: An Outline of Its History and Development (1526–1858)* (Munich, 1991); Catherine Asher, *Architecture of Mughal India* (Cambridge, 1992); Flood, "Lost in Translation."

42. There is a burgeoning literature on "composite culture" and the idea of essential versus composite (or "hybrid") categories of identity. Cynthia Talbot succinctly summarizes the debate in "Inscribing the Other, Inscribing the Self: Hindu-Muslim Identities in Pre-Colonial India," *Comparative Studies in Society and History* 37, 4 (1995): 692–722.

43. Phillip Wagoner, "'Sultan among Hindu Kings': Dress, Titles, and the Islamicization of Hindu Culture at Vijayanagara," *Journal of Asian Studies* 55, 4 (1996): 851–80. With regard to differing cultural uses of space, see Amita Sinha and D. Fairchild Ruggles, "The Yamuna Riverfront, India: A Comparative Study of Islamic and Hindu Traditions in Cultural Landscapes," *Landscape Journal* 23, 2 (2004): 141–52.

44. Similarly, the rooftop catchment system in the Mosque of Córdoba collects water for the courtyard of orange and palm trees below. D. Fairchild Ruggles, "From the Heavens and Hills: The Flow of Water to the Fruited Trees and Ablution Fountains in the Great Mosque of Cordoba," in *Rivers of Paradise: Water in Islamic Art and Culture*, ed. Sheila Blair and Jonathan Bloom (London, 2009), 81–103.

45. This is a particularly vexing problem in South Asia, where the type of planting done in the Mughal era was almost entirely replaced by British-style planting. Few historians or archaeologists have explored this colonial layer. Recent exceptions are Eugenia Herbert, "The Taj and the Raj: Garden Imperialism in India," *Studies in the History of Gardens and Designed Landscapes: An International Quarterly* 25, 4 (2005): 250–72; Eugenia Herbert, *Flora's Empire: British Gardens in India* (Philadelphia, 2011); and A. Mukherji, *Red Fort of Shahjahanbad* (New Delhi, 2004).

46. Lowry, "Humayun's Tomb"; D. Fairchild Ruggles, "Humayun's Tomb and Garden: Typologies and Visual Order," in Petruccioli, *Gardens in the Time of the Great Muslim Empires*, 173–86.

47. Historians of South Asia have understood this more quickly than historians of Islamic art. For examples of discussions of Indian gardens as expressions of political power, environmental control, and pleasure, see Catherine Asher, "Gardens of the Nobility: Raja Man Singh and the Bagh-i Wah," in Hussain, Rehman, and Wescoat, *Mughal Garden*, 61–72, as well as the various contributions to Diamond and Glynn, *Garden and Cosmos*, and Ruggles, *Islamic Gardens*, 131–45. For the early centuries of the common era and Buddhist associations with the garden (which may have been absorbed into later Hindu belief), see Daud Ali, "Gardens in Early Indian Court Life," *Studies in History*, n.s., 19, 2 (2003): 221–52.

48. On Maratha *chhatrī*s built in emulation of Rajput practices, see Melia Belli, "Keeping Up with the Rajputs: Appropriation and the Articulation of Sacrality and Political Legitimacy in Scindia Funerary Art," *Archives of Asian Art* 61 (2011): 91–106. An extensive list of cenotaphs, mostly Rajput, is given in Ratanlal Mishra, *Memorial Monuments of Rajasthan: The Cenotaph* (Udaipur and Delhi, 2004); however, his refusal to admit any Islamic influence on commemorative architecture in South Asia reflects a narrow-minded and inaccurate view of history.

49. For a detailed explanation of the close political and kinship relations between the two houses, see Catherine Glynn, "Evidence of Royal Painting for the Amber Court," *Artibus Asiae* 56, 1–2 (1996): 67–68, and Glynn, "A Rājasthānī Princely Album," 222–64.

50. Joffee and Ruggles, "Rajput Gardens and Architecture," 269–85.

51. On references to nature in Sanskritic literature, see Amita Sinha, "Nature in Hindu Art, Architecture and Landscape," *Landscape Research* 20, 1 (1995): 3–10. For painted scenes, see M. S. Randhawa, *Kangra Paintings of the Gita Govinda*, 2nd ed. (New Delhi, 1982). On how Hindu patrons might have understood a Mughal garden such as the Bagh-i Wah, see C. Asher, "Excavating Communalism."

52. Ali, "Gardens in Early Indian Court Life," 248–49.

JENNIFER PRUITT

METHOD IN MADNESS: RECONTEXTUALIZING THE DESTRUCTION OF CHURCHES IN THE FATIMID ERA

The reign of the controversial Fatimid Egyptian caliph al-Hakim bi-Amr Allah (r. 996–1021) has been derided as a "psychotic" blip within the general context of the Fatimid period (909–1171), which usually is regarded as one of multi-confessional tolerance and artistic efflorescence. Within the context of interfaith collaboration, al-Hakim is often considered to be the single exception to this culture of tolerance and artistic production. While Fatimid courtly arts thrived under the reigns of his predecessors, al-Muʿizz (r. 953–75) and al-ʿAziz (r. 976–96), who founded the new capital city of Cairo, sponsored courtly luxury objects, and initiated major architectural projects, al-Hakim's reign is most notorious for its destructive elements.

In the history of Christian-Muslim relations, al-Hakim is infamous for ordering the destruction of all the Christian churches in his realm, most notably that of the Church of the Holy Sepulcher in Jerusalem—an act that would later mobilize Latin Crusaders to liberate the Holy Land from Muslim reign. Due to the capricious nature of al-Hakim's reign, the precise context for these pivotal acts of destruction has been underexplored by scholars of architectural history, in spite of their key contribution to the history of church and mosque construction in the Middle East and their crucial role in the history of multi-confessional relations.

This essay takes a closer look at al-Hakim's program of church demolition, bringing to light broader political, economic, and cultural forces that ultimately marked a change in Fatimid sectarian identity during his reign. An analysis of urban pressures at the time, together with a consideration of Islamic religious law (sharia), removes these acts of widespread church destruction, so iconic to his reign, from the context of psychotic whimsy, and places them within a larger socio-historical framework. This study suggests that al-Hakim's destruction of churches was consistent with other extreme measures he took specifically tied to questions of faith—such as his persecutions of urban *dhimmī*s (non-Muslim subjects of a Muslim state), the public cursing of the Companions of the Prophet Muhammad and the first three caliphs, and his harsh, religiously-based restrictions against women. Rather than being reductively attributable to a personal psychological imbalance, al-Hakim's dramatically negative treatment of churches signaled a general shift from an esoteric form of Ismaili Shiʿism to one more appealing to the broader Islamic umma. In considering this shift, this article draws not only on the frequently discussed Mamluk sources on the Fatimid period, but also on Christian and newly published Ismaili sources.

It is difficult to determine the chronology of al-Hakim's destruction of churches with precision. As most sources focus on extant monuments, these acts have not always been recorded in detail. Many Muslim sources simply state that al-Hakim destroyed churches, without documenting any details of the particular structures. Christian sources, however, are more useful in recording the phases of church destruction under this caliph. Based on these accounts, al-Hakim's treatment of churches may be divided into three distinct periods: 1) from his ascension to the throne as a young boy in 996 to circa 1009; 2) from 1009 to 1015; and 3) from 1015 to his mysterious death in 1021. The first two periods, which coincide with a marked shift in his reign and behavior, are the focus of this article.

THE STATUS OF EGYPTIAN *DHIMMĪ*S BEFORE AL-HAKIM'S REIGN

After the Fatimid conquest of Egypt in 969, Christians and Jews in the Fatimid realm rose to prominent positions, and generally lived in favorable conditions.[1] Continuing in the tradition of prior rulers of Egypt, the Fatimids took advantage of skilled *dhimmī*s in the administration of their empire. Notably, following the conquest of Cairo, al-Mu'izz appointed as his vizier the famous Jewish convert to Islam Ya'qub ibn Killis, who continued to serve his son, al-'Aziz.[2] After Ya'qub died, al-'Aziz later relied on the services of an unconverted Christian, 'Isa ibn Nasturus.[3] Under these early Fatimid rulers, the Christian communities flourished, as did their churches.[4]

The synergy between *dhimmī* and Islamic monuments is a subject that has gained increasing attention in art historical studies. Particularly in the arts of medieval Islam, the artistic traditions of Muslims, Christians, and Jews were often indistinguishable from one another. In the pre-Fatimid period, the mingling of shared forms between Islam and Christianity is elegantly demonstrated by the early tenth-century stucco decoration from the Church of al-'Adhra' at Dayr Suryani in the Wadi al-Natrun monastic complex (fig. 1).[5] With its undulating arabesques, executed in characteristic stucco, these forms fit firmly within the tradition of the international Abbasid ornamental mode, based in Samarra but spread as widely as the ninth-century mosques of Ibn Tulun in Cairo and Samanid sites in Afghanistan and Nishapur. While the style was associated with the Abbasid caliphate, its incorporation into the Christian monument suggests that Abbasid imperial design transcended religious boundaries. The integration of crosses into the decorative program is the only indication that the stucco belongs within a Christian context.[6]

This synergy continued and flourished in the Fatimid period, in which Christian and Muslim works of art shared similar motifs and styles. The restoration of the Church of Saint Mercurius (Dayr Abu Sayfayn), under the caliph al-'Aziz, employed a technique in dome construction that paralleled those used at the Mosque of al-Hakim in the royal city of al-Qahira (990–1013), utilizing an octagonal transition from the square base to the

Fig. 1. Early tenth-century stucco decoration from the Church of al-'Adhra' at Dayr Suryani in the Wadi al-Natrun monastic complex. (Photo: Herbert Ricke, 1929)

dome, with niches in the corner (figs. 2 and 3). In woodwork, the church screen of Saint Barbara in Old Cairo recalls the wooden beams from the Fatimid palace, discovered in the Qalawun complex (figs. 4 and 5). In these examples, the delicate vegetal scrollwork occupies the background, while scenes of courtly life animate the foreground.[7]

AL-HAKIM, "THE WILY AND FLAMBOYANT FATIMID"

In his poem "The Caliph," which appeared in *The New Yorker* in 1996, Eric Ormsby colorfully characterized the dominant view of al-Hakim:

Fig. 2. Dome of the Church of Saint Mercurius (Dayr Abu Sayfayn), Cairo. (Photo: Jennifer Pruitt)

Fig. 3. Dome over the mihrab of the Mosque of al-Hakim. © Creswell Archive, Ashmolean Museum, Neg. EA.CA.3183. (Photo: courtesy of the Fine Arts Library, Harvard College Library and ArchNet)

Fig. 4. Wooden screen from the Church of Saint Barbara, Old Cairo, now in the Coptic Museum, Cairo. (After Edmond Pauty, *Bois sculptés d'églises coptes (époque Fatimide)* [Cairo, 1930], pl. 1)

Fig. 5. Wooden beam from the Fatimid palace, now in the Museum of Islamic Art, Cairo. (Photo: Jennifer Pruitt)

> The wily and flamboyant Fatimid, the intricate Caligula of God, the neurasthenic delegate of prophets (may God pray for them!), forbade all women to wear shoes.[8]

Indeed, al-Hakim is a unique figure in the history of the medieval Mediterranean. His cruelty, bizarre edicts, and large-scale destruction of churches and synagogues are usually considered evidence of his mental defects and despotism. Many medieval chronicles document the reign of al-Hakim in great detail, attesting to its singularity. The contemporary Christian chronicler Yahya ibn Saʿid al-Antaki even regarded al-Hakim's unusual actions as possible evidence of mental illness.[9] Some of al-Hakim's actions do suggest eccentricity and perhaps mental imbalance, such as his penchant for wandering the streets of Fustat alone at night, his order to kill all

the dogs in Cairo, and his forbidding both the consumption of *mulukhiyya* (a popular green vegetable) and the playing of chess. His behavior was rendered even more puzzling by the vacillation he showed in actually enacting the edicts he issued, many of which were first enforced, then retracted, and then reinstituted, sometimes repeatedly.[10]

While many of his actions in his early life were enigmatic, his demise is perhaps still more mysterious. After becoming increasingly ascetic in his practices, reversing many of his prohibitions against *dhimmīs*, al-Hakim was declared divine by a group now known as the Druze, led by al-Darazi, whom the ruler eventually had put to death, in 1018.[11] In 1021, al-Hakim disappeared on an evening walk in the Muqattam Hills of Cairo, though his clothes were later found, pierced with daggers. Many historians suspect that his sister, Sitt al-Mulk, ordered his execution, but the Druze believe in his divinity and proclaim that he will appear again at the end of days.[12]

During al-Hakim's reign, the Fatimid Empire ruled over Ifriqiya, Egypt, the Hijaz, and Jerusalem, with intermittent control over lands in Syria. As Ismaili Shi'is, the Fatimids declared themselves caliphs in opposition to their Sunni rivals, the Abbasids in Iraq (750–1258) and the Spanish Umayyads (711–1031). The unified nature of the Islamic caliphate was thus splintered into three competing dynasties. However, during the time of al-Hakim, the Iraqi Abbasid caliphs were under the control of Shi'i Buyids (945–1055). Thus, sectarian divisions and identity were of paramount importance in the caliphal rivalry of the tenth and eleventh centuries.

Although this essay focuses on the destruction of churches under al-Hakim, his reign was not predominantly defined by architectural demolition. On the contrary, it was a productive period of architectural patronage, with the completion of the Mosque of al-Anwar (now known as the Mosque of al-Hakim), the Mosque of al-Maqs, the Rashida Mosque and the Mosque of al-Lu'lu'a, as well as the establishment of the *Dār al-ḥikma* (or *Dār al-'ilm*, house of knowledge), and the patronage of a major observatory in the Muqattam Hills. These projects, in fact, often coincided with the destruction of churches.[13]

While his predecessors and successors are noted for their openness to the *dhimmī* populations in their realm, al-Hakim is considered a singular exception in an era of interfaith cooperation. As in all medieval Muslim societies, Christians and Jews were considered "people of the book" (*ahl al-kitāb*) and as such were treated as a protected population. The *dhimmī*s were allowed to practice their religion in return for their loyalty to the state and the payment of an extra head tax known as the *jizya*. However, as mentioned earlier, under the Fatimids, these communities rose to particular prominence and were generally granted the freedom to practice their faith openly.

In his seminal work on inter-confessional relations in the medieval Mediterranean, S. D. Goitein suggests that the Fatimid Empire was characterized by "a spirit of tolerance and liberalism."[14] In contrast, he characterizes al-Hakim's large-scale destruction of Christian and Jewish monuments as a "fit of religious insanity" and vividly describes the ruler as "the interesting psychopathic caliph, who ordered the destruction of churches and synagogues."[15] Goitein's diagnosis of insanity as the reason behind al-Hakim's decision to raze churches and synagogues dominates the modern scholarly assessment of this destructive aspect of al-Hakim's architectural program.

Although the dominant narrative in modern scholarship links al-Hakim's bizarre behavior with his demolition of church buildings, medieval accounts suggest a more complex dynamic. Rather than viewing the destruction of churches and synagogues as a symptom of his madness, medieval Muslim sources often praise al-Hakim on this account, while criticizing the decision to rebuild these monuments at the end of his life.[16]

AL-HAKIM'S EARLY REIGN, A "TIME OF PEACE" FOR THE CHURCHES

In the first years of al-Hakim's reign, from 996 until circa 1010, the young caliph continued the general pattern of church tolerance established by the early Fatimid caliphs.[17] The *History of the Patriarchs* refers to these early years as a "time of peace" for the churches, even though harsh sumptuary laws against Christians were instituted at this time. Several accounts offer examples of al-Hakim visiting monasteries early in his reign, and there are some Christian and Jewish sources that mention him positively.[18] An account in the *History of the Pa-*

triarchs of the conversion of a Muslim named Ibn Raga to Christianity is particularly revealing for its depiction of al-Hakim's tolerance toward Christians. According to the source, al-Hakim sides with the Christian convert against his Muslim family, who imprisons him and tries to force him to renounce Christianity and convert back to Islam. The son stays true to his new religion and begins construction of a church. The ensuing events demonstrate the pattern of tolerance characteristic of the reigns of al-Hakim's predecessors al-Muʿizz and al-ʿAziz. The story records that when the people of the district, Ramadiyat in Misr, stole the precious wood meant for the church, Ibn Raga saw this and told them to return the wood or he would complain to the *walī* (governor) of Cairo. When they denied his claim, Ibn Raga responded with the threat: "I shall go to al-Hakim bi-Amr Allah, and he, if God will, will order the wood to be taken from where ye have put it and ye shall suffer harm from that."[19] This account suggests not only that there was a church constructed at some point in al-Hakim's reign, but also that he actually followed in the footsteps of his predecessors in supporting the Christian builder over the Muslim masses who wished to plunder it. Based on the developments outlined by the Christian sources, I would suggest that this event occurred early in al-Hakim's reign, in the "time of peace" for the churches.

Despite such examples of tolerance, there is documented evidence for two episodes involving the destruction of *dhimmī* monuments that took place during this phase of al-Hakim's reign. Yet even these cases point to motivations that reach beyond the mere whims of al-Hakim. According to Yahya al-Antaki, in 1000 al-Hakim oversaw the destruction of two churches, their conversion into mosques, and the forced expulsion of Greek Melkites from their quarter, in order to turn the entire area into one mosque. Another demolition occurred in 1003, in the district of Rashida, on a site that had contained the graves of Christians and Jews.[20] In its place was built the Mosque of Rashida, known in its time as the Mosque of al-Hakim.[21] The accounts of this destruction, preserved by both Yahya al-Antaki and al-Maqrizi, point to simmering tensions between local Muslims and Christians surrounding this event. Both historians record that Christians had begun rebuilding a ruined church in the area when the destruction in Rashida took place, suggesting that it was the rebuilding itself that

had caused offense. Yahya al-Antaki recounts that it was, in fact, a group of Muslims who attacked the Christians and destroyed the building and other nearby churches. This highlights the fact that the Muslim segment of the urban populace was often in conflict with the Christians regarding the issue of church restoration.[22] Interestingly, however, in these early cases of church demolition, the sources suggest that the Christians were allowed to reconstruct their houses of worship elsewhere; this may indicate that the religious structures were not destroyed merely out of intolerance, but as a part of a constructive plan to build new Muslim structures, and as an attempt to Islamicize the Fatimid city.[23]

While al-Hakim's early reign did not result in the destruction of many churches, it did introduce a series of harsh sumptuary laws against the Christians and Jews in his realms. These include the prohibition of wine in 1003 (393) and again in 1005 (396), and the order to wear the *zunnār* (a black belt designated for *dhimmī*s) in 1004 (395).[24] Additionally, in 1003, he had the Christian administrator, Fahd ibn Ibrahim, executed, and arrested several Jewish and Christian secretary-scribes (*kuttāb*).

CURSING THE COMPANIONS AND THE FIRST THREE CALIPHS: AN ANTI-SUNNI PUBLIC TEXT

However, in these years al-Hakim's harsh persecutions extended beyond the *dhimmī* context to include the Sunnis in his realm, indicating a desire to orient his rulership toward a specifically Ismaili faith. In 1005, al-Maqrizi recorded that al-Hakim changed the face of the architectural structures of Cairo and Fustat by ordering that curses on the Companions of the Prophet Muhammad and the first three caliphs be inscribed throughout the city. These imprecations were placed on the mosques of the city, including the central mosque of Fustat, and the oldest in Cairo, the Mosque of ʿAmr (*jāmiʿ ʿatīq*). According to al-Maqrizi, the curses were recorded on the inside (*bāṭin*) and the outside (*ẓāhir*) of all the mosques, on the doors and walls of shops, and on graves. He adds that these curses were painted in various colors and in gold, and that residents of the city were forced to place them on the doorways of the markets and houses. The act seems to have been correlated

Fig. 6. Inscription from the Mosque of al-Hakim. (After K.A.C. Creswell, *The Muslim Architecture of Egypt,* 2 vols. [Oxford, 1952–59], 1, pl. 30b)

with increasing Ismaili activity, as more people from Cairo-Fustat came to join the *da'wa* (Ismaili mission) shortly thereafter. Al-Maqrizi records that the Ismaili crowds were so large that people were crushed in the confusion.[25]

Although the text does not record the epigraphic style of the curses, al-Maqrizi's reference to the variety of colors and gold used to inscribe them confirms the attention given to their aesthetic dimension, while the sheer scale of this project—on the mosques, shops, tombstones, and houses of Cairo-Fustat—points to a well-organized caliphal initiative, manifest in a particularly Shi'i tradition. In this way, these early actions of al-Hakim, as expressed in the built environment, not only were intended to persecute *dhimmī*s, but also represented an effort to "Ismailize" the urban space and its inhabitants. The tradition of cursing the first three caliphs and the Companions of the Prophet Muhammad was not limited to the Fatimid context, but also occurred in the Shi'i-Sunni conflicts of Abbasid Baghdad, highlighting the centrality of sectarian identity in the contestation of power in the Islamic world in the tenth and eleventh centuries. The episode also points to the increasing importance of the public display of prominent texts in the Fatimid realm, a development seen in the inscriptions of the minarets of the Mosque of al-Anwar (now known as the Mosque of al-Hakim), constructed at roughly the same time (fig. 6).[26]

Indeed, in these early years many of al-Hakim's persecutions and prohibitions are described in a particularly anti-Sunni context. Even the sumptuary laws against Christians and Jews were characterized in such a way. Al-Maqrizi notes that the special waistband (*zunnār*) and badges (*ghiyār*) worn by Christians and Jews should be black, since this was the color of the Sunni Abbasids. Even seemingly bizarre edicts, such as the banning of *mulukhiyya* and *jirjir* (two popular Egyptian vegetables) were associated with anti-Sunni sentiments, as *mulukhiyya* had been favored by the Umayyad caliph Mu'awiya b. Abi Sufyan and *jirjir* was associated with the Prophet's wife, 'Aisha, the daughter of Abu Bakr, who opposed the succession of 'Ali as caliph.[27]

SEEDS OF CHANGE: THE ABU RAKWA REBELLION PLACES PRESSURE ON THE CALIPHATE

Al-Hakim's treatment of the Sunnis and *dhimmī*s in his realm shifted markedly following the revolt of the North African rebel known as Abu Rakwa. Born Walid b. Hisham b. 'Abd al-Malik b. 'Abd al-Rahman, Abu Rakwa claimed to be a descendant of the Spanish Umayyad dynasty. Once rivals to the Abbasid and Fatimid empires, the power of the Spanish Umayyads had waned in the previous years, resulting in the persecution of the Umayyad family in al-Andalus. Apparently, this persecution partially motivated Abu Rakwa's flight from Spain to North Africa, where he sought to establish his own power, in contestation with the Fatimid dynasty.[28] Abu Rakwa used his Umayyad heritage as a source of legitimacy, traveling throughout North Africa, where he taught the Koran and hadith, and promoted Sunni doctrine. Eventually, Abu Rakwa gained the support of the Banu Qurra, a vehemently anti-Fatimid Bedouin tribe in Libya; he also brought the Berber Zanata to his anti-Fatimid, Sunni cause.[29] The mission of Abu Rakwa was couched largely in sectarian terms, aimed at wresting power from the heretical Shi'i Fatimids and reclaiming it for the rightful Sunni heirs to the caliphate. The sectarian message of Abu Rakwa's revolt was demonstrated in his use of al-Hakim's cursing of the Prophet's Companions and the first three caliphs in Cairo as a rallying point against the Fatimid rulers.[30]

Abu Rakwa had begun his anti-Fatimid mission as early as 1004, although it would take a few years for him to become a discernible threat to the authorities in Cairo. His movement first caught the attention of the Fatimid caliph when he marched into Barqa, in Palestine. Al-Hakim sent troops to quash the rebellion, after initial diplomatic efforts proved unsuccessful. When the troops failed to contain the rebels, al-Hakim sent five thousand more men under the command of the Turkic general Yanal. In an upsetting shift in power, the Fatimid armies were defeated by Abu Rakwa's troops. In October 1005 (Dhu 'l-Hijja 395), the rebel claimed victory in Barqa and declared himself al-Walid b. Hisham, the Umayyad Qa'im (a messiah-like figure), and Amir al-Mu'minin (a caliphal title, meaning "commander of the faithful"). He assumed the title *al-Nasir li-Din Allah* (the Victor of God's Religion), which was struck on coins in the realm, and had the khutba read in his name. According to sources, upon Abu Rakwa's victory in Barqa "Sunni law [was] declared supreme throughout the land of his conquest."[31]

The true urgency of the Abu Rakwa revolt became clear to al-Hakim when the Umayyad pretender advanced toward Cairo, besieging Alexandria and progressing as far as Giza. Abu Rakwa's swift conquest sent waves of panic throughout the Fatimid administration and, it would seem, the general population. Under the leadership of the general Fadl b. Salih, Abu Rakwa was finally defeated. After fleeing to Nubia, where the Nubian king was paid to give him up, he was finally captured, brought to Cairo, and executed in 1006–7. Abu Rakwa's revolt not only brought territorial losses, but also precipitated an economic crisis in Egypt. Al-Musabbihi noted that prices rose significantly and bread became scarce. Al-Hakim reacted by executing anyone found guilty of inflating prices or hoarding coins.

Abu Rakwa did not look to the Sunni rulers of the Spanish Umayyads or Abbasids for assistance in his quest for power but instead operated on a grassroots level in North Africa, appealing to the popular masses, who would support his own private, Sunni caliphate as an antidote to the heretical Shi'i Fatimids. The complexity of this relationship is illustrated by the fact that although Abu Rakwa preached a Sunni doctrine, he was resisted fiercely and feared by the populations of Alexandria and Cairo-Fustat. Although there is no evidence that Abu Rakwa garnered the general support of local Egyptian Sunnis, his reliance on tales of al-Hakim's anti-Sunni measures as a catalyst for revolt marked a turning point in al-Hakim's treatment of the Sunni populations in Egypt and the empire's strategy in gaining support throughout eastern Islamic lands. While much of the rebellion could be said to have been politically opportunistic, taking advantage of the region's economic hardship and al-Hakim's ill treatment of the North African tribes, the rhetoric of the revolt was based in sectarian divisions. Using al-Hakim's cursing of the Companions as an illustration of Shi'i heresy, Abu Rakwa gathered enough Sunni sympathizers to pose a threat to the powerful Fatimids. While there was probably never a real danger of Abu Rakwa overthrowing the Fatimid caliphate, his surprising victories served as a wakeup call to the Fatimid ruler that would alter the tenor of Sunni-Shi'i relations in the years to come. Thus, Abu Rakwa's revolt marks a turning point in sectarian relations during the reign of al-Hakim.

SUNNI RAPPROCHEMENT AND THE DESTRUCTION OF THE CHURCH OF THE HOLY SEPULCHER (CA. 1010)

It seems that after the threat posed by Abu Rakwa subsided, al-Hakim instituted a policy of rapprochement with the Sunni majority of his realm. In 1007, he pardoned the Arab Berber Banu Qurra tribe, which had been an instrumental supporter of Abu Rakwa, and he also began to mitigate his own persecutions of his Sunni subjects. The new, favorable, Sunni-oriented policy literally altered the face of Cairo and Fustat's buildings as al-Hakim ordered that the curses inscribed in gold denouncing the Rashidun be removed from all the mosques.[32] In an apparent concession, al-Hakim ordered that the Companions be mentioned only in connection with the good deeds they had done, especially Abu Bakr. In addition, the caliph allowed for a practice that resulted in a decrease in explicitly Shi'i expressions in the city fabric: in 1009 (399), he decreed that his subjects could begin and end their fasting by sighting the moon, according to Sunni practices, rather than by Shi'i

calculations. He reinstated the *qunūt* and *ḍuḥā* (forms
of prayer), which had been forbidden by the Fatimids
since 980–81,[33] and also declared that muezzins would
not be punished if they omitted from the call to prayer
the Shi'i formula *ḥayya 'alā khayr al-'amal* (come to
good works), which had been in use since Jawhar es-
tablished it at the time of the conquest. In this way,
al-Hakim began to shift the focus of his reign away from
expressly Shi'i concerns to address the Sunni majority.[34]

Concurrent with this Sunni rapprochement was the
large-scale destruction of churches. It is important to
note that popular fervor for such demolitions had
already been rising during the reigns of al-Mu'izz and
al-'Aziz.[35] Yet it reached another level in the second
phase of al-Hakim's reign, most notably with the
destruction of one of the most sacred buildings for
Christians, the Church of the Holy Sepulcher in Jerusa-
lem. Sources disagree on the precise date of this water-
shed moment, with Muslim sources generally stating
that the destruction happened in 1007 and Christian
sources suggesting a slightly later date of 1009 or 1010.[36]
At the time of the monument's destruction, Jerusalem
was under the control of the Fatimid caliphs, yet the
church remained an important Christian pilgrimage site
and was protected by a Fatimid treaty with Byzantium.
Jerusalem had stood at the center of disputes between
the Islamic caliphates and Christian Byzantium since
the Arab conquest of the city in 638. The Church of the
Holy Sepulcher symbolized the Christian presence in
the Holy Land, standing as a testament to the most cen-
tral mystery in the Christian faith, marking the site of
Christ's Crucifixion, Entombment, and Resurrection.

The Byzantine empress Helena (d. ca. 330) famously
discovered the rock-hewn tomb of Christ in 326, and a
martyrium was constructed around it between 325–26
and 336. While the monument was destroyed under al-
Hakim and its exact form prior to destruction is
unknown, a series of tenth-century ivories represent it
as a cylindrical structure, typical of Byzantine-era mar-
tyria. In one surviving ivory, dated to the early tenth
century, and now at the Cloisters museum in New York,
the three Marys are depicted at the Tomb of Christ. The
cylindrical structure is similar to the reconstructed edi-
cule, which continues to mark the site of the tomb today
(fig. 7).[37] Connected to the rotunda of the sepulcher was

Fig. 7. Three women at the Holy Sepulcher. Tenth-century
ivory, northern Italy. The Metropolitan Museum of Art, New
York, inv. no. 1993.19. Image © The Metropolitan Museum
of Art.

a basilica, linking the tomb to Golgotha, the site of
Christ's Crucifixion. In this way, the church housed the
central aspects of the Christian miracles, enclosing the
site of Christ's Crucifixion and Resurrection in a single
monument.[38] While the architectural details of the pre-
Fatimid church are known primarily through textual
and archaeological projects, we do have a few remain-
ing images of the early structure. The Holy Sepulcher is

Fig. 8. A sixth-century mosaic, illustrating the major monuments of Jerusalem, from the Church of St. George in Madaba, Jordan. The rotunda and basilica of the Church of the Holy Sepulcher may be seen at the bottom of the mosaic.

represented in two mosaics, from Madaba and Um al-Rasas, in Jordan. In these the key rotunda, marking the spot of Christ's tomb, and basilica are indicated (fig. 8).[39] The account of the Holy Land provided by the Frankish bishop Arculf (late seventh century) contains documented plans of the church, indicating a rotunda with twelve columns, three aisles, and three recessed altars, and, in the center, the sepulcher.[40]

Byzantine accounts describe repeated attempts to reclaim the city, often situating the Holy Sepulcher at the symbolic heart of the struggle. For example, in 975 the emperor John Tzimiskes sent a letter to the king of Armenia describing his military campaign: he noted that "we were also intent on the delivery of the Holy Sepulcher of Christ our God from the bondage of Muslims," and detailed his military endeavors to secure it.[41] The emperor's focus on the monument and the importance of liberating it from Muslim rule illustrates the historic centrality of the church in the spiritual, political, and ideological struggle for dominance between religions in a city that was of primary importance to both faiths.

The tension surrounding control of the holy city existed on both an elite and a popular level. While Tzimiskes' letter exemplifies the significance of imperial control of the city as a form of religious legitimacy, the confessional demographics of the urban population were also a concern for contemporary chroniclers. Muslim authors of the period lament the fact that although Jerusalem was controlled by Muslim dynasties, Christians and Jews were the primary inhabitants. Not surprisingly then, many of the same religious-based power struggles appear in the Jerusalem literature as in the local Egyptian literature.[42] In 985, al-Muqaddasi, the most famous Muslim chronicler of Jerusalem, wrote: "Her streets are never empty of strangers…Everywhere the Christians and Jews have the upper hand."[43] Before the Fatimids took control, Abbasid Jerusalem was attacked frequently and Christian monuments plundered, a sign of the multi-confessional tensions in the city.[44] Ultimately, al-Hakim's destruction of the Holy Sepulcher symbolically asserted Muslim domination over the contested city.[45]

Although this act invalidated the Fatimid treaty with Byzantium, Byzantine reports did not take much notice of the razing of the church. Moreover, at that time, Fatimid-Byzantine relations were relatively secure, unlike in the earlier reign of al-'Aziz, which was defined by wars over Syrian territory. Although the destruction of the church would later be taken up as a theme in restoring Byzantine relations under the reign of al-Zahir (r. 1021–36) and subsequent rulers, there was not a loud outcry among the Eastern Christian population at the time of its destruction. However, the later Christian Crusaders used this episode as a rallying cry to defend the Holy Land from the Muslim empires.

Ultimately, the precise reason for the destruction of the church remains unknown. According to the Buyid chronicler Hilal al-Sabi (d. 447 [1056]) as well as al-Maqrizi, al-Hakim was curious about the Christians who made a pilgrimage to the church every Easter. When the caliph inquired about this practice, one of his *dā'īs* (Ismaili missionaries) informed him that the church was so significant to the Christians that the Byzantine emperor sometimes attended Easter celebrations in disguise and gave the church expensive gifts. The sources also lament that the Christians visited the church much as Muslims visited Mecca, and that there was too much pomp surrounding this act. They also suggest that al-Hakim was especially angered that Christian pilgrims regarded it as the locus of miracles, particularly the miracle of the Holy Fire.[46]

Although the precise reasons as to why al-Hakim destroyed the church remain a mystery, the multivalent results of its demolition were praised by many writers in the medieval Muslim world, and the apparently strong support for the act became leverage for al-Hakim's ambitions.[47] By destroying a formerly protected monument that had resided at the heart of Muslim-Christian struggles for centuries, al-Hakim had accomplished something that previous Muslim rulers were reluctant or unable to do.[48] Ibn al-Qalanisi (d. 1160) noted that when the church was destroyed, Muslims rejoiced and that when word of this reaction reached the caliph, he was overjoyed and encouraged to demolish more churches in his realm. To enlist popular support for this act, al-Hakim did not collect its precious objects for his own treasury upon its razing, but instead allowed the local populations to rob and plunder it, making them complicit in the deed. The fervor of the destruction is attested in Yahya al-Antaki's report that it was "plucked up stone by stone," and was accompanied by the razing of other churches in Jerusalem, in addition to the desecration of a graveyard and a convent.[49] The demolition of the Church of the Holy Sepulcher, together with the acclaim it brought al-Hakim throughout the Muslim world, seems to have emboldened the caliph to embark on an intensified program of church destruction and persecution of Christians and Jews in the following years.

RAZING EGYPT'S CHURCHES: THE ISLAMICIZATION OF THE FATIMID EMPIRE

It is particularly difficult to piece together the precise policy for church demolition instituted by the Fatimids following the destruction of the Holy Sepulcher. Many Muslim sources state simply that all the churches were destroyed. In analyzing this phenomenon, we are faced with the difficult task of assessing structures that are no longer extant and, therefore, were not always recorded in medieval accounts. In examining some of the specific instances of destruction, I have relied particularly on the analysis of Abu Salih, an Armenian Christian who recorded the history of Egyptian churches in the late twelfth and early thirteenth centuries.[50] As several

of the churches and monasteries he documented were initially destroyed under al-Hakim and then rebuilt, his account allows for a consideration of key demolitions.

The Monastery of Qusayr offers a rare example of a dated Egyptian church destruction and, by all accounts, this event occurred after the obliteration of the Holy Sepulcher. The description of its demolition suggests a tide of public support for such acts. The monastery, a favorite location for the early rulers of Egypt, was particularly famous for its mosaic depictions of the Virgin Mary. However, according to al-Maqrizi, in 1010 al-Hakim ordered it razed, and the subsequent plundering lasted several days. Abu Salih also recorded this event, corroborating the theme of plunder. According to his account, "a band of the common people came here, and seized the coffins of the dead, the timbers from the ruins."[51] In this manner, a fervor for destruction was given a caliphal endorsement in the middle period of al-Hakim's reign. However, accounts suggest that grave robbers raided this church so extensively that al-Hakim finally had to put a stop to it, providing further evidence that church destruction was encouraged by populist urban pressures. While unique in their impact, the destructions attest more to political ambition buttressed by popular support than to the maniacal whims of a mentally unhinged ruler.

Church destructions may have functioned as something more than an indicator of al-Hakim's personal anti-Christian zealotry. Instead, they appear as part of his political program of shoring up support for his rule and for the Fatimid caliphate through an urban renewal project aimed at further Islamicization of the empire, oriented toward the Sunni majority. The case of the Church of Saint Mennas, located in al-Hamra, between Cairo and Fustat, provides the first of several examples (fig. 9). Much information about the Monastery and Church of Saint Mennas comes to us through Abu Salih, who described it as having experienced various periods of decay and restoration prior to the Fatimid period. It also contained the bodies of many saints. He further writes, "this church was wrecked, and its columns were carried away and it was turned into a mosque, in the caliphate of al-Hakim; and a minaret was built for it."[52] According to Abu Salih, al-Hakim did not simply destroy the church; he changed certain confessional signifiers,

Fig. 9. The Church of Saint Mennas, Cairo, 2012. (Photo: Jennifer Pruitt)

for example, through the addition of a minaret.[53] Likewise, in the case of the Monastery of St. John the Baptist, near the lake of al-Habash, Abu Salih recounts that "al-Hakim seized upon part of this monastery and church, and rebuilt it as a mosque, with a minaret, and his name was inscribed on it."[54] By such means al-Hakim in effect transformed Christian monuments into mosques. It is particularly interesting to note the inscription of the caliph's name on the newly Islamicized structures, as his name also appeared on the original minarets of the Mosque of al-Anwar. Indeed, in most of the accounts given by Abu Salih, the churches destroyed by al-Hakim were turned into mosques, suggesting a larger movement to Islamize the city and country. A church in al-Ashmunayn was also turned

into a mosque.[55] Likewise, Abu Salih mentions a large monastery and church "composed of tessarae of glass gilded and colored; and its pillars were of marble; but it was wrecked by al-Hakim."[56]

The specific trajectory of reconstruction after demolition can perhaps best be thought of as part of a larger urban renewal project designed to win political favor.[57] The obliteration or conversion of non-Islamic monuments signaled a shift in architectural priorities toward Islamic structures that was further supported by a program of endowment. In 1010, the year of the most intensive demolitions, al-Hakim endowed the *Dār al-ʿilm/Dār al-ḥikma* in Cairo, along with the mosques of Al-Azhar, Rashida, and Maqs.[58] These would be guaranteed financing, thereby ensuring their continuation and solidifying the significance of the caliph's Islamic architectural projects. The endowment of these structures indicates the extent of al-Hakim's architectural and urban concerns, and suggests that al-Hakim's treatment of Christian monuments was not merely destructive, but part of a larger pattern of urban Islamicization and renewal.

CHURCH DESTRUCTIONS AND CALIPHAL LEGITIMACY

News of al-Hakim's rapprochement with his Sunni subjects and his policy of razing churches spread beyond the Egyptian context and was embraced by Muslims in Abbasid territory. Evidence exists that this broader program did bear fruit in terms of the caliph's influence and popularity. In 1010, shortly after al-Hakim had had several churches destroyed, Qirwash b. Muqallayd, the Iraqi governor, pledged his allegiance to the Fatimid rather than to the Abbasid caliph, reading the khutba in the name of al-Hakim and striking the Fatimid ruler's name on coins, both of which were purely caliphal prerogatives. The centrality of al-Hakim's role in destroying churches is noted in the text of this khutba:

> Thanks to God Who by His light dispels the flood of anger and by His majesty demolishes the pillars of graven images and by His power causes the sun of righteousness to rise in the west.[59]

By evoking the "pillars of graven images" that al-Hakim destroyed, Qirwash uses the ruler's program of church

destruction as a rallying cry to the Muslim faithful. Al-
though this pronouncement lasted only one month, it
demonstrated both the success of the Ismaili *da'wa* and
the increasing popularity of the Fatimid caliph beyond
Egyptian lands as a result of his demolition of Christian
monuments and increasing sympathy to the Sunni and
Shi'i populations beyond his empire.[60]

While al-Mu'izz and al-'Aziz explicitly sought con-
trol of the Eastern lands of Islam through military incur-
sions, al-Hakim focused on gaining ideological inroads
into Abbasid territories through increasing *da'wa* activ-
ities and other propagandistic efforts. Yahya al-Antaki
noted his non-military propaganda in the Abbasid
realm, writing:

> [al-Hakim] drew most of the people of distant places to
> support him and follow him. He was recognized in the
> prayer in al-Kufa and his propaganda reached the gate of
> Baghdad and into the city of al-Rayy. He sent many splen-
> did articles to the governors and rebels in the districts of
> Iraq to win them to his side.[61]

Yahya also mentions al-Hakim's eastern ambitions,
noting that when a visiting merchant had his goods con-
fiscated, he praised the caliph by claiming that the ruler
would soon hold Baghdad "and the territory which he
did not as yet control"; this pleased al-Hakim so much
that he gave the merchant thousands of dinars.[62]

The impact of al-Hakim's ideological program out-
side Egypt is reflected in the chants that Shi'i protesters
shouted in Baghdad in 1008, "*Yā Ḥākim! Yā Manṣūr!*"
referring to the Ismaili caliph as the preferred ruler.[63]
Two years later, around the same time that Qirwash b.
Muqallayd pledged his loyalty to al-Hakim, 'Ali al-Asadi,
the chief of the Banu Asad, also proclaimed his alle-
giance to the Fatimid caliph in Hilla.

The increasing popularity of al-Hakim in the Abba-
sid realm was a critical threat to the Abbasids and the
Shi'i Buyids, who controlled them. As such, Qirwash was
forced to retract his earlier message of support just one
month after offering it. Indeed, al-Hakim's influence
had spread through Abbasid territory to the point that,
in the following year, under the Buyid vizierate of Fakhr
al-Mulk, the Abbasid caliph al-Qadir (r. 991–1031) gath-
ered important members of his empire, including vari-
ous Twelver Shi'i leaders and the *ashraf* (sing. *sharif*,

one claiming descent from Muhammad) nobility, and
compiled a manifesto denouncing the Fatimid lineage,
accusing the dynasty of destroying Islam.[64] In 1011, this
decree was read at all of the mosques in Abbasid terri-
tory, testifying to their role as sites for religio-political
propaganda in the tenth and early eleventh centuries.
The so-called "Baghdad Manifesto" marked a turning
point in Fatimid history, confirming that the dynasty
posed a substantial threat to the Iraqi-based leadership.
It underscored the importance of the claim to 'Alid
descent for their power, and the importance of uniting
Sunnis and Shi'a against them.[65] At the same time the
manifesto was drafted, a treatise was composed against
Ismaili doctrine, once again demonstrating the per-
ceived threat of the Fatimid worldview in this crucial
period of al-Hakim's reign, coinciding with massive
church destructions.[66]

The writings of al-Kirmani (d. 1021), the most impor-
tant *dā'ī* of al-Hakim's age and his chief apologist, pro-
vide further support for the idea that al-Hakim's
destruction of churches was integral to a wider program
of political propaganda and shifting sectarian relations.
Al-Kirmani's treatises, recently translated by Paul
Walker, offer tremendous insight into the Fatimid *zeit-
geist* during al-Hakim's reign.

Originally from Iran, al-Kirmani was active in the
eastern Islamic lands until he came to Cairo to serve at
al-Hakim's court. He can be credited with altering the
philosophical discourse of medieval Ismaili thought.
Perhaps the most revealing window into al-Hakim's
approach to sectarian relations can be found in al-Kir-
mani's treatise *al-Maṣābīḥ fī ithbāt al-imāma* (Lights to
Illuminate the Proof of the Imamate).[67] Unlike many
Ismaili treatises, this work was not intended for the
da'wa, but was instead addressed to the Buyid vizier in
Baghdad, Fakhr al-Mulk. Rather than explicate the phil-
osophical details of the Ismaili faith, the work acted as
an overt piece of political propaganda, aimed at shift-
ing the vizier's alliances to the Fatimid cause.[68] Al-Kir-
mani's treatise was written as a series of proofs, aimed
at demonstrating to the eastern Shi'a the necessity of
the imamate and al-Hakim's legitimacy as the living
imam. In his proofs, al-Kirmani does not emphasize al-
Hakim as the source of esoteric (*bāṭin*) knowledge but
as a lawgiver and figure who commands his subjects in

Islamic law. In the second half of the treatise, al-Kirmani considers al-Hakim in an international context, noting that he was preceded by a series of "false imams."[69] In this proof al-Kirmani emphasizes al-Hakim's fulfillment of the requirements to "command the good and forbid the bad," as well as his success safeguarding property and sexual relationships. These acts are consistent with the exoteric (*zāhir*), non-Ismaili laws, which are accepted universally by all Islamic sects.[70] The emphasis on al-Hakim as a commander of morality appears repeatedly throughout the text. In particular, al-Kirmani argues that al-Hakim was far more dedicated in his commitment to this injunction than were his Spanish Umayyad and Abbasid rivals. Central to this effort is his swift, harsh justice of tearing down churches. Al-Kirmani notes:

> There is ample evidence of his commanding the good and prohibiting the bad, which none can deny, in the way he lives, devoting his nights and days to strengthening the word of truth, aiding the oppressed, *building mosques, tearing down churches*, preserving the communal prayer, applying the regulations of the law and confirming them and the corporal punishment [emphasis mine].[71]

Al-Kirmani specifically suggests that tearing down churches was a central aspect of al-Hakim's Islamic legitimacy, considered in the vein of "commanding the good, prohibiting the bad," and regarded alongside mosque construction as a core caliphal prerogative. He notes that this is in direct contrast to the permissive nature of the families of the Umayyads and Abbasids. Al-Kirmani's text suggests that al-Hakim, by addressing the Buyid ruler, was striving for wider Islamic support.

"COMMANDING THE GOOD AND FORBIDDING THE BAD": AL-HAKIM AND ISLAMIC SHARIA

The relation of al-Hakim's acts to a strict interpretation of the sharia is demonstrated by comparing his deeds to the tenets set forth in the so-called Covenant of 'Umar, a treaty between Sophronius (d. 638), the Patriarch of Jerusalem, and the second caliph, 'Umar b. Khattab (r. 634–44), outlining the rights and responsibilities of Christians under Muslim rule. Although modern scholars have debated the precise dating of this pact, it is based on the treaties made by 'Umar b. Khattab as he conquered lands dominated by Christians and Jews.[72] In all the versions of this covenant, the treatment of churches is of central importance, as can be seen in the decree that Christians may not repair dilapidated houses of worship or build new ones.

In his study, Tritton translates one version of the pact, which is in the form of a letter from the Christians:

> When you came to us we asked of you safety for our lives, our families, our property, and the people of our religion on these conditions; to pay tribute out of hand and be humiliated; not to hinder any Muslim from stopping in our churches by night or day, to entertain him there three days and give him food there and open to him their doors; to beat the *nāqūs* (a board beaten to announce the prayer) only gently in them and not to raise our voices in them in chanting; not to shelter there, nor in any of our houses, a spy of your enemies; *not to build a church, convent, hermitage or cell, nor repair those that are dilapidated, nor assemble in any that is in a Muslim quarter*, nor in their presence; not to display idolatry nor to invite it, nor show a cross on our churches, nor in any of the roads or markets of the Muslims...to tie the *zunnār* round our waists; to keep to our religion; not to resemble Muslims in dress, appearance... [emphasis mine]."[73]

Other aspects of the Covenant of 'Umar directly correspond to al-Hakim's persecutions of the Christians and Jews in his lands, including the prescription to wear distinctive clothing and the banning of the ringing of the *nāqūs* and general public displays of Christianity, provisions that al-Hakim seems to have been addressing in many of his anti-*dhimmī* edicts. Another version of the covenant restates these prohibitions regarding overt displays of religion and further declares that Christians are not to engage in Easter or Palm Sunday processions. These restrictions relate directly to the pomp and unseemly ceremony that al-Hakim learned had been taking place at the Church of the Holy Sepulcher, engendering his wrath. Whether or not the final form of the Covenant of 'Umar was codified at the time of Fatimid rule, it is significant that many of the most condemned acts of the caliph were promoted in this Sunni text, and that the relative tolerance of al-Hakim's ancestors in the treatment of *dhimmī* monuments was, in fact, against 'Umar's precedent.

Although the pact does not call for the destruction of any of the churches, as carried out by al-Hakim, it does challenge the precedent of tolerance of church repair established by al-Hakim's Fatimid predecessors, under whom many churches were restored and new structures built. While the precise form of the Covenant of 'Umar may or may not have been recorded by the time of the Fatimid caliphate, it is clear from the accounts of church destructions that many of them resulted from violations of the basic tenets of the covenant.

Another example of the codification of behavior toward *dhimmī*s, as well as the governing of the urban masses, can be seen in *ḥisba* manuals of the medieval Islamic world. Indeed, Caliph 'Umar was also to be the first to perform the role of Islamic market inspector (*muḥtasib*), whose duties were consistent with the Covenant of 'Umar in its treatment of the *dhimmī*s and its obligation to "order good and forbid evil." The *muḥtasib* had two primary functions: first, to ensure the "orderly and equitable running of the market," and second, to guarantee "public morals and the correct execution of Islamic ritual and law."[74] Once again, the earliest preserved examples of *ḥisba* manuals slightly postdate the Fatimid period. However, Fatimid sources demonstrate the increasing prominence of the *muḥtasib* in their administrative system. Al-Maqrizi describes robes of honor and a turban being given to a *muḥtasib*, whose name was read out in the Mosque of Ibn Tulun and the Mosque of 'Amr.[75] Al-Hakim himself is said to have taken on the position of the *muḥtasib* during his reign, a claim that is not entirely surprising given his demonstrated interest in morality and the urban environment. Although the earliest preserved *ḥisba* manual from the eastern Islamic realm postdates al-Hakim's reign, written by al-Shayzari (d. 1193) in the twelfth century, the treatment of the *dhimmī*s outlined by this author is consistent with the unusual caliph's acts.[76]

The role of the *muḥtasib* is at times specifically conceptualized as embracing the outward laws of Islam, as opposed to the esoteric dimensions of the Ismaili faith. For example, in discussing the *muḥtasib*'s duty to oversee mosques and ensure that people pray diligently, al-Shayzari argues that this is:

> ...in order to show the characteristic outward forms of the religion and the sign of Islam. This is especially important

in this time of many innovations, differing sects, various forms of the *bāṭiniyya* and those who have declared the destruction of Islamic law and the abolition of the norms of Islam.[77]

Another treatise on the *ḥisba*, by the Sunni scholar al-Ghazali (d. 1111), written in the Seljuq context, echoes these sentiments, noting:

> The strange thing is that the Shi'ites have gone to extremes in this, and have stated that it is not permitted to order good until the infallible appears, their Imam of Truth.[78]

While these texts postdate al-Hakim's reign, their place in Sunni religious practice sheds new light on his treatment of churches and the tension between Shi'i esoteric faith and the Sunni sharia. Many of the harsh prescriptions and destructions of this caliph are, in fact, consistent with a puritanical strain of medieval Sunni thought. In his study of *'amr bi'l-ma'ruf* (commanding the good), Michael Cook identifies al-Hakim as the one Fatimid caliph to concern himself with this injunction, while other rulers who embraced esoteric dimensions of Ismailism did not.[79]

DHIMMĪ MONUMENTS AT THE END OF AL-HAKIM'S REIGN

The intense persecutions of *dhimmī* subjects and large-scale destruction of *dhimmī* monuments resulted in mass conversions to Islam and *dhimmī* emigration to Byzantine territory. Among those who emigrated at this time was the Fatimid chronicler Yahya al-Antaki. While the conversions and razing of churches that took place within his realm may have been supported by many members of the community, al-Hakim enigmatically reversed these decisions in 1021. The *History of the Patriarchs* noted that for three years, "no one was able to make the oblation in the lands of Misr, except in the monasteries alone," and people who "could not endure to be away from Holy Mysteries" would offer bribes to go at night to "remote and ruined churches" and hide church vestments. It continued:

> After this, after another three years, they began to restore the churches in the houses and to consecrate them secretly and to pray in them and to communicate (in them). The Possessor of the Order used to write to the Sultan who was

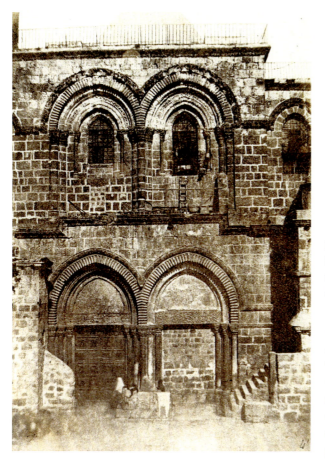

Fig. 10. Nineteenth-century view of the Church of the Holy Sepulcher. The Metropolitan Museum of Art, New York, inv. no. 2005.100.373.90. Image © The Metropolitan Museum of Art. (Photo: Auguste Sálzman, 1854)

Fig. 11. Nineteenth-century view of the Church of the Holy Sepulcher. The Metropolitan Museum of Art, New York, inv. no. 2005.100.373.96. Image © The Metropolitan Museum of Art. (Photo: Auguste Sálzman, 1854)

in Jumada II 411 (September–October 1020), al-Hakim allowed the reconstruction and reestablishment of the *waqf*s of churches in and around Jerusalem and the Church of Lydda. In Sha'ban 411 (November–December 1020), he allowed all converted Christians to return to their faith.[82] Significantly, while modern scholars deride the intolerance of al-Hakim's destruction of Christian monuments, medieval Muslim sources often praise him for the obliteration of *dhimmī* structures and his harsh edicts, which led to mass conversions, while criticizing his reversal of these persecutions (figs. 10 and 11).[83]

CONCLUSION

This discussion of the razing of churches during the reign of al-Hakim bi-Amr Allah has illustrated a series of religious and political consistencies in the seemingly "psychotic" acts of this controversial ruler. The pivotal years of intense church destructions suggest a consistency in method, beyond the whims of an unstable mad man. They reveal a ruler responding to the very real challenges of his empire. While the early years of his reign were characterized by an attempt at Ismailization of the empire that was marked by persecutions of Christians and Sunnis alike, following the Sunni threat of the Abu Rakwa revolt, al-Hakim aimed to proclaim himself the ruler of the universally Islamic *umma*, and

al-Hakim, that the Christians had built churches in Misr and in al-Rif secretly and that they were communicating in them, but he (al-Hakim) ignored them.[80]

The author suggests that at this time, in addition to allowing the reconstruction of churches, al-Hakim allowed converted *dhimmīs* to return to their religion without consequence.[81]

Yahya al-Antaki notes three specific instances of churches that were allowed to be rebuilt during al-Hakim's reign. A decree dated Rabi' II 411 (July–August 1020) permitted the reconstruction of the monastery of Dayr al-Qusayr, including the reestablishment of its endowments, and granted permission for Christians to gather there together again. Al-Antaki also specifies that

thus made concessions to the Sunni threat of the Abu Rakwa revolt. By contrast, early in his reign, al-Hakim did not feel the need to diverge from the tradition of tolerance toward the public symbols of resident Christians. His large-scale destruction of Christian monuments may be seen in light of this shifting emphasis of the empire: when it became clear, following the destruction of the Church of the Holy Sepulcher, that the church demolitions had strong popular support, they became part of a campaign to legitimate his rule. The destruction of churches, often accompanied by an Islamicization of the church site, can be understood as part of a common political and economic tactic—the use of urban renewal to employ and placate targeted populations. Certainly, this attempt to destroy Christian spaces in order to Islamicize his realms was by no means unique. Similar measures were carried out by the Abbasid caliph al-Mutawakkil (r. 847–61), who instituted similar sumptuary laws and ordered the destruction of Christian monuments, while also patronizing productive architectural projects.

While modern scholars deride the destruction of churches under al-Hakim, the medieval reality was considerably more complex. Rather than being evidence of his madness, al-Kirmani's writings emphasize al-Hakim's destruction of churches as proof of his legitimacy—as these acts were evidence of his "commanding the good and forbidding the bad," a central prerogative of a medieval Islamic ruler. Ultimately, the destruction of churches under al-Hakim was consistent with a larger shift in public sectarian identity among the Fatimids— away from an esoteric form of Ismailism, adopted by a minority of medieval Muslims, toward one concerned with a puritanical adherence to Islamic law. Rather than being broadly destructive, the demolition of churches was accompanied by the construction of mosques, thereby suggesting that the program was part of a larger re-orientation of the city and empire. Al-Kirmani's text suggests that the church destructions were part of a larger claim for legitimacy beyond the confines of the Fatimid empire, ultimately establishing al-Hakim's caliphate as the legitimate rival to those in Córdoba and Baghdad.

Department of Art History,
University of Wisconsin-Madison

NOTES

1. See Terry Wilfong, "The Non-Muslim Communities: Christian Communities," in *The Cambridge History of Egypt*, vol. 1, *Islamic Egypt, 640–1517*, ed. Carl F. Petry (Cambridge: Cambridge University Press, 1998), 175–97.

2. Yaacov Lev, "The Fatimid Vizier Ya'qub ibn Killis and the Beginning of the Faṭimid Administration in Egypt," *Der Islam* 58 (1981): 237–49.

3. For an overview of the reign of al-'Aziz, see Marius Canard, *Encyclopaedia of Islam, New Edition* (henceforth *EI2*) (Leiden: Brill, 2007), s.v. "al-Azīz bi-llāh Nizār Abū Manṣūr." The relative tolerance shown toward the *dhimmī*s in the Fatimid period stands in contrast both to various times of persecution in the Abbasid period, particularly under al-Mutawakkil, and to later persecutions of the so-called Sunni revival. For a comparison of later injunctions against *dhimmī*s, see Seth Ward, "Taqī al-Dīn al-Subqī: On Construction, Continuance, and Repairs of Churches and Synagogues in Islamic Law," in *Studies in Islamic and Judaic Traditions II: Papers Presented at the Institute for Islamic-Jewish Studies, Center for Judaic Studies, University of Denver*, ed. William M. Brinner and Stephen D. Ricks, Brown Judaic Studies 178 (Atlanta: Scholars Press, 1989), 169–88.

4. In Egypt, churches were located in monastic communities outside of Cairo and in smaller urban churches, centered around the area of "Old Cairo," south of Fustat, near the Mosque of 'Amr. This area had served as the Roman fortress of Babylon. For a consideration of churches, see Lucy-Anne Hunt, "Churches of Old Cairo and Mosques of al-Qāhira: A Case of Christian-Muslim Interchange," in *Byzantium, Eastern Christendom and Islam: Art at the Crossroads of the Medieval Mediterranean,* 2 vols. (London: Pindar Press, 1998), 1:319–42; Peter Sheehan, *Babylon of Egypt: The Archaeology of Old Cairo and the Origins of the City* (Cairo: American University in Cairo Press, 2010); Gawdat Gabra, *The Treasures of Coptic Art in the Coptic Museum and Churches of Old Cairo* (Cairo: American University in Cairo Press, 2010); Gawdat Gabra, *Coptic Monasteries: Egypt's Monastic Art and Architecture* (Cairo: American University in Cairo Press, 2006).

5. Abbot Moses, under whom the stucco works were carved, had been to Baghdad ca. 927. Thelma K. Thomas, "Christians in the Islamic East," in *Glory of Byzantium: Art and Culture of the Middle Byzantine Era, A.D. 843–1261*, ed. Helen C. Evans and William D. Wixom (New York: Metropolitan Museum of Art, distr. by H. N. Abrams, 1997), 367–68. See also Pierre Du Bourget, *Art of the Copts* (New York: Crown Publishers, 1971).

6. Similar phenomena occur in portable objects, in which the image of Christ and a Coptic priest appears in luster ceramics, a hallmark medium of the Fatimids.

7. Hunt, "Churches of Old Cairo," 325–26. Many parallels can be drawn from the woodwork published by Edmond Pauty, *Bois sculptés d'églises coptes (époque fatimide)* (Cairo: Imprimerie de l'Institut français d'archéologie orientale,

1930); cf. Edmond Pauty, *Catalogue général du Musée arabe du Caire: Les bois sculptés jusqu'à l'époque ayyoubide* (Cairo: Imprimerie de l'Institut français d'archaeologie orientale, 1931).

8. Eric Ormsby, "The Caliph," *The New Yorker*, June 10, 1996, 48. This poem is also published in Paul E. Walker, *Caliph of Cairo: Al-Hakim bi-Amr Allah, 996–1021* (Cairo, New York: American University in Cairo Press, 2009), 283–84.

9. See Yaḥyā b. Saʿīd al-Anṭākī, *Histoire de Yahya-ibn-Saʿīd d'Antioche*, ed. and trans. Ignace Kratchkovsky and Aleksandr Vasiliev, 2 vols., Patrologia Orientalis 18 (Paris: Librairie de Paris, 1924); Yaḥyā b. Saʿīd al-Anṭākī, *Histoire de Yahya-ibn-Saʿīd d'Antioche*, ed. and trans. Ignace Kratchkovsky and Aleksandr Vasiliev, 2 vols., Patrologia Orientalis 23 (Paris: Librairie de Paris, 1932); Yaḥyā b. Saʿīd al-Anṭākī, *Histoire de Yahya ibn-Saʿīd d'Antioche*, ed. Ignace Kratchkovsky, trans. Françoise Micheau and Gérard Troupeau, Patrologia Orientalis 47 (Ternhout: Brepols, 1997). For a discussion of Yahya's account of al-Hakim's madness, see Michael Dols, *Majnūn: The Madman in Medieval Islamic Society* (Oxford: Oxford University Press, 1992), 150–51; Walker, *Caliph of Cairo*, 249–50.

10. For a literary consideration of al-Hakim's reign, see Ben-salem Himmich, *Majnūn al-ḥukm bi-amr Allāh: Riwāya fī al-takhyīl al-tārīkhī* (Rabat: Maṭbaʿat al-Maʿārif al-Jadīda, 1989); English trans: *The Theocrat*, trans. Roger Allen (Cairo: The American University in Cairo Press, 2005).

11. For an analysis of the historical development of the Druze, see Nejla M. Abu-Izzeddin, *The Druzes: A New Study of Their History, Faith and Society* (Leiden: E.J. Brill, 1984).

12. See Taqī al-Dīn Abu'l-ʿAbbas Aḥmad al-Maqrīzī, *Ittiʿāẓ al-ḥunafāʾ bi-akhbār al-aʾimma al-Fāṭimiyyīn al-khulafāʾ*, ed. Jamāl al-Dīn al-Shayyāl, 3 vols. (Cairo: al-Hayʾa al-ʿĀmma li-Quṣūr al-Thaqāfah, 1996), 2:115–23.

13. Jennifer Pruitt, "Fatimid Architectural Patronage and Changing Sectarian Identities (969–1021)" (PhD diss., Harvard University, 2009), 127–43; Jonathan Bloom, "The Mosque of al-Hakim in Cairo," *Muqarnas* 1 (1983): 15–36; Jonathan Bloom, *Arts of the City Victorious: Islamic Art and Architecture in Fatimid North Africa and Egypt* (New Haven: Yale University Press, 2008).

14. S. D. Goitein, *A Mediterranean Society: The Jewish Communities of the Arab World as Portrayed in the Documents of the Cairo Geniza*, 6 vols. (Berkeley: University of California Press, 1967–93), 1:29. In the first chapter of volume one, Goitein situates the "classical Geniza" period of the tenth to thirteenth century as the apogee of interconfessional relations in the Mediterranean; he contrasts this with the growing "intolerance and fanaticism" of the thirteenth century.

15. Ibid., 21 and 34.

16. Marlis Saleh demonstrates that "[t]he caliph's inconsistency was universally condemned. Ibn Khallikan complains that 'he was constantly doing and undoing.' Ibn Taghribirdi concurs that his worst quality was the fact that he would 'do something, then undo it, then do its opposite.' Al-Suyuti says firmly 'al-Hakim was the worst caliph; no one worse ruled Egypt after the Pharaoh. Among his faults is that he was fickle in words and deeds; he destroyed the churches of Egypt then restored them, and destroyed the [Church of the Holy Sepulcher] then restored it.'" She also notes that Ibn al-Dawadari considers the prohibitions against Jews and Christians as "among the good religious deeds that al-Hakim did." Al-Qalqashandi summarizes the restrictions thusly: "He did well in what he did to them." Marlis J. Saleh, "Government Relations with the Coptic Community in Egypt during the Fāṭimid Period (358–567 A.H./969–1171 C.E.)" (PhD diss., University of Chicago, 1995), 250–51.

17. During the first few years of his reign, al-Hakim was essentially a puppet of his tutor, Barjawan. Following the defeat of Ibn ʿAmmar in 387 (997), Barjawan became even more powerful, and was named *wāsiṭa* (similar to a vizier). Barjawan then bestowed the honorific *raʾis* on his Coptic secretary, Christian Fahd b. Ibrahim, demonstrating that in the early years of al-Hakim's reign, Christians continued to be incorporated into the Fatimid administration. It appears that Barjawan's power eventually became a threat to al-Hakim, and the fifteen-year-old caliph ordered his execution in 1000. See al-Maqrīzī, *Ittiʿāẓ*, 2:25–28. For a discussion, see Walker, *Caliph of Cairo*, 15–42 and 98–107.

18. See *Taʾrīkh baṭārikat al-Kanīsa al-miṣriyya* (History of the Patriarchs of the Egyptian Church, Known as the History of the Holy Church by Saōirus ibn al-Muqaffaʿ), vol. 2, pt. 2, ed. and trans. ʿAziz Sūryal ʿAṭiyya, Yassā ʿAbd al-Masīḥ, and O. H. E. Khs.-Burmester (Cairo: Jamʿiyat al-Athār al-Qibṭiyya, 1948), 163–64. The theme of al-Hakim's role as a "good mediator" and just ruler is echoed in other *dhimmī* sources. Yahya al-Antaki praises him for providing justice, and a Geniza fragment likewise commends him for providing "unparalleled justice." For a discussion, see Sadik A. Assaad, *The Reign of al-Hakim bi-Amr Allah (386/996–411/1021): A Political Study* (Beirut: The Arab Institute for Research and Publishing, 1974), 83 and 94.

19. ʿAṭiyya, Masīḥ, and Burmester, *History of the Patriarchs*, 163–64.

20. Taqī al-Dīn Abu'l-ʿAbbas Aḥmad al-Maqrīzī, *Al-Mawāʿiẓ wa'l-iʿtibar fi dhikr al-khiṭaṭ wa'l-āthār*, ed. Ayman Fuʾād Sayyid, 5 vols. (London: Muʾassasat al-Furqān lil-Turāth al-Islāmī, 2002–3), 4:126.

21. The mosque known today in Cairo as "the mosque of al-Hakim" was called Masjid al-Anwar in medieval texts.

22. Al-Maqrizi notes that a dispute arose regarding whether the church had existed prior to the Muslim conquest of Egypt, suggesting a possible application of the tenets of the so-called Covenant of ʿUmar (to be discussed further below). Although the reigns of al-ʿAziz and al-Muʿizz are praised by modern scholars, their leniency toward the *dhimmī* communities was often met with fierce protest from the local communities. See Pruitt, "Fatimid Architectural Patronage," 127–43; Jennifer Pruitt, "Miracle at Muqattam: Moving a Mountain to Build a Church in the Early Fatimid Caliphate (969–995)," in *Sacred Precincts: Non-*

Muslim Religious Sites in Islamic Territories, ed. Mohammad Gharipour (forthcoming, Leiden: Brill, 2014).

23. This follows early patterns in the foundation of Cairo, in which the monastery of Dayr al-Khandaq was destroyed in order to build the new city of al-Qahira, allowing the Christians to rebuild their structure outside the new Fatimid city: al-Maqrīzī, *Khiṭaṭ*, 4:130–31.

24. For a discussion of sumptuary laws under al-Hakim, see Saleh, "Government Relations with the Coptic Community"; Marius Canard, *EI2*, s.v. "Al-Ḥākim bi-Amr Allāh"; Walker, *Caliph of Cairo*. For sumptuary laws for *dhimmī*s, see A. S. Tritton, *The Caliphs and Their Non-Muslim Subjects: A Critical Study of the Covenant of ʿUmar* (London: Oxford University Press, 1930); Albrecht Noth, "Abgrenzungsprobleme zwischen Muslimen und Nicht-Muslimen. Die ʿBedingungen ʿUmar (aš-Šurūṭ al-ʿumariyya)," *Jerusalem Studies in Arabic and Islam* 9 (1987): 290–315; Sidney H. Griffith, *The Church in the Shadow of the Mosque: Christians and Muslims in the World of Islam* (Princeton, N.J.: Princeton University Press, 2010).

25. Al-Maqrīzī, *Ittiʿāẓ*, 2:54. For further discussion, see Irene A. Bierman, *Writing Signs: The Fatimid Public Text* (Berkeley: University of California Press, 1998), 76–78, and Paula Sanders, *Ritual, Politics, and the City in Fatimid Cairo* (Albany: State University of Albany Press, 1994), 52–57. For a consideration of the aesthetic dimensions of the public text, see Yasser Tabbaa, *The Transformation of Islamic Art during the Sunni Revival* (Seattle: University of Washington Press, 2001).

26. George Makdisi, *Ibn ʿAqīl et la résurgence de l'Islam traditionaliste au XIe siècle, Ve siècle de l'Hégire* (Damascus: Institut français de Damas, 1963), 312; Bierman, *Writing Signs*, 79–100.

27. Al-Maqrīzī, *Ittiʿāẓ*, 2:53.

28. Many medieval historical accounts discuss this event. See especially al-Maqrīzī, *Ittiʿāẓ*, 2:60–66. For an overview of events, see Walker, *Caliph of Cairo*, 169–73. On the teaching of the Koran, see Assaad, *Reign of al-Hakim bi-Amr Allah*, 135.

29. Both groups had been hostile to the Fatimids prior to Abu Rakwa's rebellion. The Banu Qurra had previously been oppressed by al-Hakim, while the Zanata had never accepted the Fatimids as the rightful caliphate.

30. Yahya records that this was actually the entire reason for Abu Rakwa's revolt. Given that the cursing occurred at approximately the same time, it is unlikely that this event was the single reason, but certainly, it must have been used in Abu Rakwa's propaganda.

31. Assaad, *Reign of al-Hakim bi-Amr Allah*, 140. It seems that there were also economic forces at work, as both Barqa and much of North Africa were experiencing economic hardship at the time. For a discussion of the Abu Rakwa revolt, see also Sanders, *Ritual, Politics, and the City*, 57–60; Bloom, "Mosque of al-Hakim"; and Yaacov Lev, *State and Society in Fatimid Egypt*, Arab History and Civilization, Studies and Texts 1 (Leiden: E.J. Brill), 27–30.

32. This edict would be repeated by al-Hakim several times during his reign, suggesting that there were Shiʿi contingencies within Cairo who continued this practice.

33. Al-Maqrīzī, *Ittiʿāẓ*, 2:86.

34. This shift is also seen in the changes in architectural projects and urban ceremonial practices. See Pruitt, "Fatimid Architectural Patronage," 202–73.

35. Ibid., 62–143.

36. See Saleh, "Government Relations with the Coptic Community," 82–85

37. For a recent study on the Holy Sepulcher, see Colin Morris, *The Sepulchre of Christ and the Medieval West: From the Beginning to 1600* (Oxford: Oxford University Press, 2008). It is this centrally planned construction, executed around a rock outcropping, that was echoed in the construction of the Dome of the Rock by ʿAbd al-Malik in 692–93. See Oleg Grabar, *The Formation of Islamic Art* (New Haven: Yale University Press, 1973 and 1987), and Rina Avner, "The Dome of the Rock in Light of the Development of Concentric Martyria in Jerusalem: Architecture and Architectural Iconography," *Muqarnas* 27 (2010): 31–49.

38. For a reconstruction of the fourth-century monument, see Hugue Vincent and F.-M. Abel, *Jérusalem nouvelle: Fascicule 1 et 2, Aelia Capitolina, le Saint-Sepulcre et le Mont des Oliviers* (Paris: Victor Lecoffre, 1914); Virgilio Corbo, *Il Santo Sepolcro di Gerusalemme: Aspetti archeologici dalle origini al periodo crociato,* 3 vols. (Jerusalem: Franciscan Print Press, 1981–82). For an image of a bread mould representing the monuments of Golgotha, see George Galavaris, *Bread and the Liturgy: The Symbolism of Early Christian and Byzantine Bread Stamps* (Madison: University of Wisconsin Press, 1970); Richard Krautheimer, *Early Christian and Byzantine Architecture*, 4th ed. rev. by Richard Krautheimer and Slobodan Ćurčić. (New Haven: Yale University Press, 1986), 63.

39. The original church would have been substantially altered even by the time of the Fatimids, as Jerusalem was sacked and the church burned by the Persians in 614. For an account of the early church, see Kenneth J. Conant, "The Original Buildings at the Holy Sepulchre in Jerusalem," *Speculum* 31, 1 (January 1956): 1–48.

40. This account is translated in Saint Adamnan, *The Pilgrimage of Arculfus in the Holy Land, about the Year A.D. 670*, trans. and annot. James Rose Macpherson, Palestine Pilgrims' Text Society 3 (London: Palestine Pilgrims' Text Society, 1889).

41. Quoted in F. E. Peters, *Jerusalem: The Holy City in the Eyes of Chroniclers, Visitors, Pilgrims, and Prophets from the Days of Abraham to the Beginnings of Modern Times* (Princeton, N.J.: Princeton University Press, 1985), 243.

42. Pruitt, "Fatimid Architectural Patronage," 127–43.

43. The use of architecture as a competitive discourse in Jerusalem was also emphasized by al-Muqaddasi, who suggested that ʿAbd al-Malik (r. 685–705) and al-Walid (r. 705–15) constructed the lavish programs at the Dome of the Rock and the Great Mosque of Damascus in direct response to

the preexisting Christian monuments. For a discussion of competitive discourse in Umayyad buildings, see Grabar, *Formation of Islamic Art*, 61.

44. Joshua Prawer and Haggai Ben-Shammai, eds., *The History of Jerusalem: The Early Muslim Period, 638–1099* (Jerusalem: Yad Izhak Ben-Zvi; New York: New York University Press, 1996), 19.

45. One of the most provocative theories regarding the church's destruction was that offered by William of Tyre, a twelfth-century resident of Jerusalem, who suggested that al-Hakim demolished the church to counter rumors that he was a Christian, on account of his Christian mother. William of Tyre, *A History of Deeds Done Beyond the Sea*, trans. and ed. Emily A. Babcock and A. C. Krey (New York: Columbia University, 1943). Ultimately, it is unlikely that al-'Aziz's Christian wife was indeed al-Hakim's mother. While his conclusion may be flawed, William of Tyre's analysis suggests the importance of clarifying religious identity during al-Hakim's reign. It also serves as a reminder of just how intertwined the early Fatimid caliphs were with the Christian power structure—William of Tyre notes that a member of the Fatimid royal family had recently served as the patriarch of Jerusalem. Whether or not this figure was a blood relative, the fact remains that al-Hakim's destruction of churches firmly distanced his rule from the contested interfaith alliances of his predecessors, something that was still resonant in the Crusader-occupied Jerusalem of William's time.

46. Marius Canard, "La destruction de l'Église de la Résurrection par le calife Hakim et l'histoire de la descente du feu sacré," *Byzance* 35 (1955): 21; al-Maqrīzī, *Itti'āz*, 2:74–76.

47. The disdain for the Church in medieval Muslim thought is evidenced in the medieval nomenclature used to reference it: the term *al-Qumāma* ("the trash heap") is often adopted in place of *al-Qiyāma* ("the Resurrection").

48. For a further consideration of Muslim-Christian relations, see Griffith, *Church in the Shadow of the Mosque*.

49. Saleh, "Government Relations with the Coptic Community," 82–85; Yaḥyā al-Anṭākī, *Histoire de Yahya ibn-Sa'īd d'Antioche* (1932), 195–96. It seems that the Egyptian Christians had warned the Jerusalem patriarch about the attack and as a result many of the most precious objects had been removed. A Western medieval source alludes to the wealth of the church when Benedict suggests that in the year 1000 Charles came to the holy city and "adorned the holy place with gold and jewels, and he also placed on it a large gold standard." As quoted in Peters, *Jerusalem*, 217.

50. Abū Ṣālih, *The Churches and Monasteries of Egypt and Some Neighbouring Countries, Attributed to Abû Ṣâlih, the Armenian* (Oxford: Clarendon Press, 1895).

51. Ibid., 147.

52. Ibid., 108.

53. For a consideration of early churches, see Mattia Guidetti, "The Byzantine Heritage in the *Dār al-Islām*: Churches and Mosques in al-Ruha between the Sixth and Twelfth Centu-

ries," *Muqarnas* 26 (2009): 1–36. For the significance of the minaret in the history of Islamic Art, see Jonathan Bloom, *Minaret, Symbol of Islam* (Oxford: Oxford University Press, 1989).

54. Abū Ṣālih, *Churches and Monasteries*, 130.

55. Ibid., 219.

56. Ibid., 282.

57. Christian sources often point to the conversion of Muslims to Christianity as the main reason that al-Hakim punished the *dhimmī*s. William of Tyre's description highlights the importance of religious identity in the medieval world. Moreover, the story of Ibn Raga in the *History of the Patriarchs* reveals the high stakes involved in medieval conversion. My theory that al-Hakim was trying to appeal to universal Islamic goals is supported by the fact that under his reign we find many indications of Christians and Jews converting, or pretending to convert, to Islam. However, it does not appear that they converted to Shi'i Islam, particularly since the majority Sunni population protested widely when the Christians were allowed to reconvert. Yahya al-Antaki noted that al-Hakim relied heavily on Christians and Jews in his administration, but he also tried to convert them. Ultimately, whether al-Hakim destroyed churches for popular appeal, financial gain, caliphal ambition, religious fervor, or a combination of all of these, it is clear that such actions received broad popular support.

58. Al-Maqrīzī, *Khiṭaṭ*, 4:96–99.

59. Trans. in Paul Walker, "The Ismaili Da'wa in the Reign of the Fatimid Caliph al-Ḥākim," *Journal of the American Research Center in Egypt* 30 (1993): 173.

60. See Lev, *State and Society in Fatimid Egypt*; Assaad, *Reign of al-Hakim bi-Amr Allah*; Paul Walker, *Ḥamīd al-Dīn al-Kirmānī: Ismaili Thought in the Age of al-Ḥākim*, Ismaili Heritage Series 3 (London, New York: I. B. Tauris, in Association with the Institute of Ismaili Studies). Walker asserts that although this popularity grew outside the Egyptian capital, those closest to al-Hakim recognized the difficulty of defending his caliphate. His arrival in Cairo was met by a crisis in the Ismaili *da'wa* (mission), culminating in the shutting down of the *majālis al-ḥikma* (sessions of wisdom): Walker, *Ḥamīd al-Dīn al-Kirmānī*, 16–24. For an earlier study of al-Kirmani's works, see Daniel De Smet, *La quiétude de l'intellect: Néoplatonisme et gnose ismaélienne dans l'oeuvre de Ḥamīd ad-Dīn al-Kirmānī (Xe/XIe s.)* (Louvain: Peeters, 1995).

61. Translated in John Harper Forsyth, "The Byzantine-Arab Chronicle (938–1034) of Yaḥyā b. Sa'īd al-Anṭākī" (PhD diss., University of Michigan, 1977), 227.

62. Translated in ibid., 228.

63. Al-Maqrīzī, *Itti'āz*, 2:65.

64. At the time, the Abbasid Empire itself was defined by complicated sectarian divisions and allegiances, as the Sunni Abbasids were controlled by their Shi'i Buyid viziers. The conflict between the Sunnis and Shi'a, as seen in the Fatimid context, was just as complicated, if not more so, in Baghdad.

65. This manifesto has also altered later historical works, which accept its contestation of Fatimid genealogy and make it difficult to determine the precise historical circumstances of the beginning of the Fatimid Empire. Ultimately, the anti-Fatimid treatises by the Abbasids at this time became inextricably part of later Sunni histories on the Fatimids, making it particularly difficult to ascertain accurate information on the dynasty.

66. Walker, *Ḥamīd al-Dīn al-Kirmānī*, 14–16. Described in Ibn al-Athīr, *al-Kāmil fī'l-ta'rīkh*, 14 vols. (Beirut: Dār Ṣādir, 1965 [repr. of ed. published by C. J. Tornberg under the title *Ibn-el-Athiri Chronicon quod perfectissimum inscribitur* (Leiden, 1853–67)]).

67. Paul Walker, *Master of the Age: An Islamic Treatise on the Necessity of the Imamate; A Critical Edition of the Arabic Text and English Translation of Ḥamīd al-Dīn Aḥmad b. 'Abd Allāh al-Kirmānī's al-Maṣābīḥ fī ithbāt al-imāma* (London: I.B. Tauris, 2007), 118. Once again, the precise dates of this work are not known. It was most likely completed between 1011 and 1015, while al-Kirmani was in Iraq. However, it is likely that al-Kirmani adapted it from writings and thoughts prior to this. Therefore, the text can be considered as both a reflection of and reaction to the Fatimid developments outlined above, including al-Hakim's increasingly harsh edicts, his destruction of churches, and his simultaneous growing popularity in some regions of the Islamic world and within Egypt itself. On one hand, the text may be conceived as an outline of al-Hakim's vision for the caliphate; on the other, it is an apology for his acts. In either case, it offers a fascinating insight into the dynamics of sectarian relations in this period.

68. Although the Buyids themselves were Shi'i, they did not recognize the Fatimid ruler as the living imam and instead supported the Sunni Abbasid caliph in Baghdad.

69. These "false imams" include "Ahmad b. Ishaq (al-Qadir), al-Haruni (al-Mu'ayyad billah), the Zaydi imam in Hawsam in Gilan; Umar al-Nazwani, the Ibadi imam in Oman; the Umayyad ruler in Spain and the Maghrib; and the leaders of the Qarmati remanant in al-Ahsa," as well as the expected Hidden Imam of Twelver Shi'ism. Walker, *Master of the Age*, 114.

70. Al-Kirmani writes, "He who has the august authority, glorious kingship, established proof, sword unsheathed in support of Islam, commands the good and forbids the bad, applies the corporeal punishments, preserves the borders, cares for the populace, revives the *sunna*, safeguards society, endeavors to conduct the holy war, shatters the opposition, extends justice and mercy, without having to mention the condition of the designation and appointment and the nobility of universal high regards, is al-Hakim bi-amr Allah. From that it follows that he is the imam, fealty to whom is incumbent on them and obedience to him is required of them." Walker, *Master of the Age*, 114.

71. Ibid., 114.

72. On the Covenant of 'Umar, see Tritton, *Caliphs and Their Non-Muslim Subjects*; Noth, "Abgrenzungsprobleme zwischen Muslimen und Nicht-Muslimen"; and Yohanan Friedmann, *Tolerance and Coercion in Islam: Interfaith Relations in the Muslim Tradition* (Cambridge: Cambridge University Press, 2003). While the precise dates of the codification of this pact are debated, Griffith notes that it seems to have "reached its classical form" by the ninth century. Griffith, *Church in the Shadow of the Mosque*, 15.

73. Tritton, *Caliphs and Their Non-Muslim Subjects*, 5–6.

74. 'Abd al-Raḥmān ibn Naṣr Shayzarī, *The Book of the Islamic Market Inspector = Nihāyat al-rutba fī ṭalab al-ḥisba: The Utmost Authority in the Pursuit of* Ḥisba, trans. and ed. Ronald Paul Buckley (Oxford: Oxford University Press on behalf of the University of Manchester, 1999), 16.

75. Al-Maqrīzī, *Itti'āẓ*, 2:135.

76. The text reads "The *dhimmī*s must be made to observe the conditions laid down for them in the treatise on *jizya* written for them by 'Umar b. al-Khattab, and must be made to wear the *ghiyār*. If he is a Jew, he should put a red or yellow cord on his shoulder; if a Christian, he should tie a *zunnār* around his waist and hang a cross around his neck; if a woman, she should wear two slippers, one of which is white and the other black. When a protected person goes to the baths, he must wear a steel, copper or lead neckband to distinguish him from other people. The *muḥtasib* should stop them from riding horses and carrying weapons and swords. When they ride mules, they should do so with side saddles. Their buildings should not be higher than those of the Muslims nor should they preside over meetings. They should not jostle Muslims on the main roads, but should rather use the side streets. They should not be the first to give a greeting, nor be welcomed in meetings. The *muḥtasib* must stipulate that they offer hospitality to any Muslim who passes by and give him lodging in their houses and places of worship. They must not be allowed to display any alcoholic drinks or pigs, to recite the Torah or Bible openly, to ring the church bells, to celebrate their festivals or to hold funeral services in public. All this was stipulated by 'Umar b. al-Khattab in his treatise, so the *muḥtasib* must keep an eye on their affairs regarding these things and force them to comply": in Shayzarī, *Book of the Islamic Market Inspector*, trans. and ed. Buckley, 121–22. The manual also includes other acts of al-Hakim, such as prohibiting women from lamenting or wailing at funeral ceremonies, and in fact, discouraging them from attending burials altogether (p. 127); cf. al-Hakim's acts of 1013, in al-Maqrīzī, *Itti'āẓ*, 2:93–94. Earlier, though less extensive *ḥisba* manuals are preserved in Umayyad Spain. See Claude Cahen, *EI2*, s.v. "Ḥisba."

77. Shayzarī, *Book of the Islamic Market Inspector*, trans. and ed. Buckley, 128.

78. Shayzarī, *Book of the Islamic Market Inspector*, trans. and ed. Buckley, 149. Also see Michael Cook, *Commanding Right and Forbidding Wrong in Islamic Thought* (Cambridge: Cambridge University Press, 2001).

79. Cook, *Commanding Right and Forbidding Wrong*, 302.

80. 'Aṭiyya, Maṣīḥ, and Burmester, *History of the Patriarchs*, 205.

81. The source ascribes many of these reversals to al-Hakim's personal relationship with a monk named Bimin, a convert to Islam who had returned to Christianity and asked the caliph for permission to construct a monastery in Sahran, outside of Misr. After the construction of this structure, al-Hakim visited the monasteries on his nightly outings, staying with and conversing with the monks. According to the account, al-Hakim and Bimin the monk became friends, and arranged for the release of the patriarch Zacharius and the reconstruction of the churches. The text also links al-Hakim's increasing asceticism to the influence of Christian clergy, as the caliph remarks that the community reveres the patriarch, even though he is dressed humbly. 'Aṭiyya, Maṣīḥ, and Burmester, *History of the Patriarchs*, 208.

82. For a discussion of these events, see Walker, *Caliph of Cairo*, 239–61.

83. Saleh, "Government Relations with the Coptic Community," 250–51.

PETER CHRISTENSEN

"AS IF SHE WERE JERUSALEM": PLACEMAKING IN SEPHARDIC SALONICA

A MEDITERRANEAN CIRCLE: A CONCEPTION OF SEPHARDIC SALONICA

The Sephardic poet and moralist Samuel Usque seemed pleasantly surprised when he first set eyes on Salonica (Thessaloniki). His three-part book, *Consolação às tribulações de Ysrael*, published in Portugese in Ferrara in 1553, documents the significant trials of the Sephardic diaspora in adjusting to their new homes in Amsterdam, Vilnius, Nimes, Bari, Otranto, and Hamburg, to name a few of the locales in which they had recently settled. After an eastbound tour beginning in Amsterdam, he states "the Jews of Europe and other countries, persecuted and banished, have come here to find refuge, and the city [Salonica] has received them with love and affection, as if she were Jerusalem, that old and pious mother of ours."[1] Usque's depiction of a harmonious and cosmopolitan scene of Jewish life in Salonica is evocative of the privileged role the city has played in more recent Ottoman, early modern, and Jewish historiography. Salonica's Jews were the third in a triad of religious groups living contently together in this important yet still understudied Mediterranean city.[2] Salonica's cultural polyvalency is able to operate at a nexus of several critical historiographic concerns—from pluralist societies and the development of intercultural tolerance to geographic peripheries and second- (or even third-) order urban centers.

To be sure, there was a Jewish presence in Salonica much earlier than Usque's sixteenth-century account. In the realm of legend, one may cite an account of the founding of Salonica preserved in the writing of the seventeenth-century Ottoman traveler Evliya Çelebi:

The first builder of the city of [Salonica] was the prophet Solomon. There he built a huge palace, the traces of which are visible to this day. The prophet Solomon lived in [Salonica] for many years.[3]

More significant, however, is Paul's First Epistle to the Thessalonians, in which he reports the presence of Hellenized Jews in the city in about 52 B.C.[4] Hungarian Jews arrived in the thirteenth century, living alongside Romaniote Jews. After Murad II (r. 1421–44, 1446–51) captured Salonica in 1430, the city's Jewish population declined, leaving none when cadastral surveys (*tahrīr defterleri*) were taken in 1478.[5] This was the result of the Ottoman policy of *sürgün*, or deportation, referring to the transfer of non-Muslim populations from within the empire to Istanbul, including significant numbers of other Jews from the Balkans and Anatolia. With the expulsion of Jews from Spain in 1492 under Ferdinand and Isabella's Alhambra decree, Bayezid II (r. 1481–1512) was presented with the opportunity to welcome considerable numbers of highly talented immigrants, most notably in the fields of medicine, banking, and publishing (fig. 1).

Although no explicit directive from 1492 exists in Ottoman records, a chronicler later documents orders that the sultan sent to the provincial governors of Salonica instructing them to warmly welcome the Jewish populations under the aegis of the *dhimma* (the covenant of protection between an Islamic state and members of Koranically recognized religious communities living within its boundaries).[6] Within just a few years, the Sephardim were joined by other Jewish refugees, in particular Ashkenazim from Austria, Transylvania, and Hungary. By 1519, a mere twenty-seven years

Fig. 1. Map illustrating Sephardic immigration after 1492. The Ottoman terms for Thessaloniki, Adrianople, and Smyrna are, respectively, Salonica, Edirne, and Izmir. (Map: C. Scott Walker, Harvard Map Collection, Harvard College Library)

after the expulsion, Jews represented a remarkable 56 percent of Salonica's population, rendering the city the most diverse Jewish center in Europe, as well as the nexus of the Sephardic diaspora.[7]

The impetus for an investigation of, in particular, the Sephardic thread in Salonica's material history is two-fold. On the one hand, traditional histories of Ottoman multiculturalism have focused on the political and, to a lesser extent, economic ramifications of the *millet* "system," which established, after the fall of Constantinople, national corporations with written charters that provided certain benefits to minority populations. Recent historiography has been critical of the facile tendency to infer that the *millet* system was the pre-mod-

ern practice of enlightened religious pluralism.[8] The *millet* "system" was anything but systematic and is more plausibly characterized as an ad hoc, semi-organized framework[9] for preventing certain multiethnic communities from becoming cultural powder kegs and thus problematic for the Porte.

The stopgap nature of this framework and the improvisational tactics it implies have yet to be sufficiently transposed to Jewish material culture in the Ottoman Empire in general and Salonica in particular. Life for the Jews of Salonica may not have been as easy as Usque saw and depicted in his short visit; neither was it uniformly a product of *millet* social organization ipso facto. As but one counterexample to the notion that the early

millet framework promoted inter-religious tolerance and harmony, an account of early Sephardic life in Salonica recalls a rabbi woefully imploring his congregation to "stop cursing the Almighty and to accept as just everything that has happened."[10] While he may have been invoking the expulsions from Iberia, it is nonetheless evident that life in Salonica was no antidote or mythic paradise, as Usque implies with his suggestion of a new Jerusalem.

As I will outline in this paper, Sephardic culture in Salonica, roughly up until the beginning of the nineteenth century, remained markedly distinct from other Jewish groups in the city, most notably through its continued use of the Ladino language and because of its stronghold on certain sectors of the material economy. Additionally, the Sephardic populace of Salonica adhered to myriad subdivisions ordered by their city or region of origin in Iberia, a fact demonstrated by the creation of numerous small synagogue congregations named for the territories where they formerly lived. It demonstrates the vicissitudes rather than the stereoptypification of the *millet* system and the internal diversity of the Jewish population of the Ottoman Empire, neither monolithic nor indivisible entities.

Yet perhaps more importantly, and certainly more synthetically, the Sephardic entrée into Salonica can and should be considered in the context of two millennia of Jewish encounters with the Mediterranean littoral. From regular trade and contact with officials of the court of King Solomon, through a longstanding and largely peaceful coexistence with Moorish and Christian populations in Spain prior to 1492, the Sephardic population of Salonica invokes a non-national yet remarkably cogent and variegated demographic group whose identity is linked more to the Mediterranean than it is to any other place. From the *convivencia* of Iberia to the manner in which they lived under the Ottomans, Sephardim continued on a Mediterranean journey of both hardship and remarkable assimilability.[11]

This investigation is bookended on one side by the Alhambra decree of 1492 and on the other by the advent of the nineteenth century, a period that marked the end of Sephardic cultural ascendancy in both Salonica as well as the Ottoman Empire at large. The erosion of the community's coherence may have begun as early as 1648, when many of its members were gripped by a messianic movement. The rise of the *dönme* (practicioners of a Sabbateanist crypto-Judaism) in the seventeenth century and an increase in Kabbalistic studies among the Salonican Sephardic community in the seventeenth and eighteenth century resulted in a number of corrosive effects such as secrecy, paranoia, and apocalyptic thinking that rendered the greater Sephardic cultural unit discordant and largely unintelligble by the early nineteenth century.[12] This discordance was only further accelerated by additional events of the nineteenth century, including the *Tanzimat* reforms and the *Hatt-ı Hümayun* of 1856, a decree which declared the unqualified parity of the empire's Muslim and non-Muslim subjects.

Historians documenting early modern aspects of Sephardic Salonica have tended toward histories that illustrate how the city's Sephardim, along with other Jews, staked their place in the Ottoman economic, social, and political systems. Less consideration has been given towards the literal places and things they forged in their new Ottoman context. From the Holy Land to Spain to Salonica, tracing the material nature of this Sephardic population provides an opportunity to embellish an already rich history that makes good on a Braudelian concept of Mediterraneity, examining its colors, textures, and spatial configurations.

The challenge is a formidable one, as textual accounts are scant, with works on material culture being yet more rare, at least partially the result of a fire that leveled the entire Jewish quarter in 1917. This blow was compounded by the extermination of the Jewish population of the city during the Nazi occupation of Greece and the destruction of their possesions and spaces, both sacred and profane. As such, my analysis often relies heavily on the textual records available, using visual support whenever possible.

In this paper I discuss fabrics and woolens, color schema, and the built environment, while also examining a specific literary reflection on synagogue typology. Each offers the opportunity to explore discrete facets of Sephardic, Salonican, and Ottoman articulations of domestic life, worship, ceremonial, and commemoration by means of textual and visual linkages. These the-

matic areas of concentration are not arbitrary but rather demonstrate the earliest and most open windows the Sephardim found in their effort to penetrate, change, and assimilate into the Salonican and Ottoman surroundings in which they now found themselves. The interdependence of these facets of Salonican Sephardic life as forms of creative production may not be immediately evident, yet these variegated aspects and scales of material output do speak to what the Sephardim, as both a whole entity and a collection of subgroups with particular vested interests, sought to and could produce, actualize, and forge. Their creative output also demonstrates how much they were allowed to infiltrate an Ottoman visual culture that continued to wrestle with its own concepts of religious, cultural, and aesthetic autonomy. It is my hope that these vignettes will actually lead to a more holistic understanding of what the apex of Sephardic life in Salonica quite literally looked like, as I simultaneously attempt to furnish propositions as to how this landscape related to its highly consequential urban, Ottoman, and Mediterranean contexts.

CASTING THE DYE: ASPECTS OF FABRIC, WOOL PRODUCTION, AND GARB

Sephardic influence on Salonican material culture is best documented in the sphere of the wool trade, which these new immigrants to the city overhauled after their arrival in 1492. As had occurred in other centers of the Sephardic diaspora, the Jews from Iberia almost immediately assumed a prominent role in the economic life of the city. In Salonica, this was made most manifest through the production of wool and its attendant industries. The study of woolen goods in Jewish life is typically limited to the realms of the home and synagogue, including Torah ark curtains, Torah mantles, and Torah binders, as well as bedspreads, reader desk covers, and prayer rugs.[13]

Before elaborating upon the importance of the wool industry, it is important to juxtapose it with the production and use of non-woolen fabrics, most importantly silks, few of which still remain due to the difficulty in conserving them. The oldest surviving fabric of Jewish Salonica appears to be an eighteenth-century Torah ark

Fig. 2. Torah ark curtain, attributed to Salonica, ca. eighteenth century. Ribbed silk, metal-thread embroidery, silk thread, satin stitch, 166 × 144 cm. Jerusalem, Israel Museum Collection, inv. no. 152/057 689-9-48, gift of Jakon Michael, New York, in memory of his wife, Erna Michael. (Photo: courtesy of the Israel Museum)

curtain (fig. 2). The composition of this Torah ark curtain, like those of many others, centers on the depiction of two columns supporting grillwork and a sizable hanging lamp. The columns recall the sinewy twisting of Bernini's Baldacchino di San Pietro (1623–33). Embroidered with metal thread and satin stitch, this Torah ark curtain required considerable handicraft.

This piece is also notable for its compositional similarities to woolen synagogue rugs produced in other Ottoman cities, such as a surviving example of a seventeenth-century synagogue rug from Cairo (fig. 3), which recalls the nearly identical architectural motifs found in Islamic prayer rugs being produced in Anatolia, particularly in the workshops of Bursa. In this case, the typical formation of the mihrab has given way to an arch that deviates from the cusped or horseshoe arches generally found in known Iberian synagogues. Nonetheless,

Fig. 3. Torah curtain, Cairo, early seventeenth century. Wool, Senneh knot, 186 × 155 cm. Washington, D.C., Textile Museum Collection, inv. no. R. 16.4.4. (Photo: courtesy of the Textile Museum)

the micrographic edgings and floral patterns are remarkably similar in both composition and scale, suggesting that both the Torah ark curtains and synagogue rugs of the Ottoman Empire were in dialogue with contemporaneous Islamicate models. Yet more curious is the appearance of the paired columns in a synagogue rug of Cairo, which indicates, in all likelihood, a familiarity with the paired columns found in the Alhambra.[14]

These are fabric arts that had an application tied specifically to Judaism, but there was, as Bejamin Braude has demonstrated, a much greater, supra-religious reality of raw material, produced by Sephardic weavers and designers, that permeated the décor, furnishing, and, most importantly, clothing of the region.

Wool in Macedonia had traditionally come from the Balkan hinterland.[15] The area of Kalamaria at the slopes of Mount Hortiatis provided productive lands for raising sheep.[16] After spending the cold months in the lowlands grazing, the sheep would be shorn of their wool

and brought to Salonica.[17] This proximate wool supply was supplemented by wool from other parts of Macedonia, Albania, Morea, Euboea, Thessaly, and Thrace.[18] Locales as disparate as Sofia, Larissa, Lepanto, and Plovdiv all have records of funneling local raw wool to Salonica.[19]

As Braude has explained, regional weaving techniques had until then remained fairly crude since Byzantine times, despite the high quality of the wool, which was comparable to that available to the Sephardim in Iberia.[20] As in Iberia, it seems as though the pigmenting of raw wool was of major importance in the art of wool production. All evidence suggests that in addition to perfecting undisputedly sophisticated weaving techniques (already some of the finest in Europe), the Sephardim in Salonica promoted the importance of dyeing wool and thus enriched the palette of ordinary wardrobes and interiors with more brilliant and varied colors.[21] Their base palette consisted of the primary colors of red, blue, and yellow, derived from madder root, kermes, indigo, and yellow-seed, which in the correct proportional mixtures could create the full range of hues.[22]

Madder root, or *rubia tinctorum*, was the most readily available—produced in the district of Boeotia in Thebes, a three- to four-day journey from Salonica, near Izmir (Smyrna).[23] Kermes, or *coccus ilicis*, was derived from an insect common to oak trees in the Mediterranean region and could be found in Livadia, a five- to seven-day journey from Salonica.[24] Both madder and kermes produced red pigments. Numerous accounts reveal that madder was behind the creation of the colorfast "Turkish red" of which European travelers were so envious.[25] The term *kermes*, which is etymologically related to the English word *crimson* and common to Arabic, Turkish, and Persian alike, yielded a very prized hue of scarlet, known to be popular in Ottoman silks and woolens.[26] Yellow-seed, or *rhamnus catharicus*, was found in the berry of the buckthorn plant.[27] The color was notorious for fading quickly, but it was also the cheapest of the dyes.

Indigo, the only one of the four primary dyes that did not come from the lands of *Rūm*, became the one most commonly imported into the city by the early fifteenth century, which implies that blue-toned fabrics had begun to surpass red ones in popularity in Salonican

wool production after the arrival of the Sephardim.[28] It is a substance derived from the powder of plants in the genus *indigofera*, which Maqrizi notes was cultivated in Egypt, as one can see reflected in the deeper tones of the rugs from Cairene workshops.[29] Despite this, Salonica's indigo appears to have derived mostly from India by way of Western Europe.[30] It was not until the Ottomans developed an overland trade route for indigo from Lahore to Aleppo that Salonica would be able to obtain the dye from the East at much less cost, a development that coincided roughly with the arrival of the Sephardim in Salonica.[31] Whether by boat or by means of the Via Egnatia, the pigments would have arrived in the city directly through the Jewish quarter by virtue of its central location adjacent to the city's port and its straddling of the main east–west thoroughfare (an urban corridor of the Via Egnatia). Besides indigo, none of these pigments were of the same organic constitution as that available to the Sephardic wool producers in Iberia, and thus the Sephardic wool dyers would have had to recalibrate all of their chromatic formulas based on the new versions they were using.

Four types of woolen cloths were produced by Jews in Salonica. Kersey was the lightest and least expensive variety, a coarse and narrow weave that Braude has likened to the kerseys of Hampshire, England, which were produced at the same time, and were similar to the weave known today as jersey.[32] The next grade of wool was *sobremanos*, of a wider loom than kersey and of a "superfine" nature.[33] The Sephardic weavers used a green *sobremanos* when given the important task of producing a good number of the imperial janissarial uniforms, which I shall discuss below.[34] Yet one grade higher was Salonica broadcloth, a plain-weave fabric, fulled, napped, and sheared, and available at various lengths.[35]

The most coveted fabric was that dubbed *pano de cuenta*, meaning roughly, in both its Ladino and Hebrew derivations, "fabric of calculation."[36] The term *cuenta* (calculation), Braude has suggested, may also refer to the city of Cuenca, a prominent Castilian textile center.[37] The techniques for producing *pano de cuenta* varied but the price of the fabric, nearly three times that of Salonica broadcloth, remained largely conistent.[38] If it is indeed true that the name of the fabric was related to

the Castilian city, it seems probable that it was the émigrés of Castile who monopolized the production of *pano de cuenta* wool.

S. M. Imamuddin describes the production of wool in medieval Castile thusly:

> In the 12th century Idrisi speaks of a flourishing wool-industry in Chinchilla, fifty miles from Murcia, and in Cuence [Cuenca], two days journey from Chinchilla. Wool was also a staple industry in the mountains of Toledo, where sheep were reared in abundance and exported all over the county. Good-quality wool was raised on the Shashin island, where women rubbed it with pig-fat and made it gleaming white or turquoise blue. In Santaren a kind of wool was obtained from a marine animal, probably Abu Qalmun. This wool was of a very bright golden colour and used in making expensive dresses.[39]

This reveals a preference in the Castilian wool industry for fabrics that were white and shades of blue and gold, which is substantiated by the rapid increase in the importation of indigo to Salonica after 1492. It would seem particularly likely, then, that the *pano de cuenta* wools were characterized by hues of blue, from light indigo to nearly black, and that the color blue itself may have distinguished Castilian Sephardim from their fellow Iberians.

It is also important to keep in mind the relative insularity of the wool industry in Castile immediately before émigrés from that region arrived in Salonica. As a result, it is possible to understand not only how the industry was transposed to Ottoman lands but also how both the state of Ottoman trade and the natural resources of Macedonia may have actually altered the nature of Sephardic woolens more broadly.

In 1438, Juan II of Spain requested, in response to a petition known as the *Cortes*, that the export of Castilian wool be halted and that the import of foreign wool be banned. According to Joseph O'Callaghan,

> The Castilian weavers obviously wanted to reserve for themselves good, cheap, raw wool, but the *Mesta* [a union of sheep ranchers] opposed their petition because the sheep-raisers were anxious to sell their product at the highest price on the international market. For the moment, the king sided with [the weavers], but in 1462 Enrique IV allowed the export of only one-third of the total production of raw wool; this represented a triumph for the native woolen industry.[40]

Fig. 4. "Carpet page" from the Damascus Keter, Burgos, Spain, ca. 1260. Jerusalem, Jewish National and University Library, Ms. Heb 790. (Photo: © Jewish National and University Library)

The weavers' stronghold over the native woolen industry resulted in a generation of increasingly idiosyncratic woolen design prior to the *Reconquista*. While no woolens from medieval Spain survive, it seems probable that the development at this time of the "carpet page," an ornate insert preceding the Bible's main divisions, reflected, both in name and design, the actual designs of woolen carpets. A "carpet page" from a Damascus Keter (Bible) from Burgos (1260) provides suggestive evidence as to what Sephardic woolen motifs may have looked like (fig. 4). This Bible is one of the earliest to survive from Jewish Spain. The most prominent aspect of the design on the carpet page is a simple stem flanked by interlacing scrolls and fillets accentuated by micrographic outlines. The entire page is framed by a border of script that is also delineated by micrography.

The Jews of Burgos, in Aragon, from which this Bible hails, were far fewer in number in comparison with those from Castile, directly to their south. As evidenced by the dark hues of red and black, and the golden shade of the stem, the color palette outside of Castile seemed to make less use of the indigos and whites noted by Imamuddin. However, the central stem, the micrography, and the scrolling all appear in the synagogues of Toledo, which suggests that formal motifs among Sephardic woolens may have been similar, while color schema varied from region to region. Both palettes share the distinct gold and red that characterize so much of pan-Iberian heraldry and medieval imagery of the time, which I shall reflect more upon shortly.

As the highest-end fabric available on the Ottoman market (apart from silk), *pano de cuenta* wool provides an interesting window into the historical evolution of Jewish wool production. It also functions as a measure of the assimilation of the Castilian weavers into Salonica's upper middle class, to the extent that one can be identified.[41] It seems quite possible that the less profitable production of kerseys, *sobremanos*, and Salonica broadcloth relegated non-Castilian Sephardim to a slightly lower economic level, and that the more common woolens were less likely to have been white and hues of blue in comparison with the Castilian-based *pano de cuenta*.

As the caliph was also the protector of the Holy Word of the Prophet, the early Ottoman Empire has been characterized by some as a novel experiment in a relatively egalitarian form of governance that rejected the caste and monarchical systems of its eastern and western neighbors.[42] This, compounded with the Muslim disinclination for the "dirty trades" of banking and diplomacy, left the perceivedly entreprenurial Sephardim with a plethora of opportunities. But it is also important to keep in mind that the supposed opportunities of this egalitarianism were not universal. The Koran did enforce hierarchies: those of master and slave, man and woman, and believer and non-believer.[43] Only the latter was thought to be volitional, and while *millet* protection was largely secure, Ottoman Jews were nonetheless the source of considerable suspicion and fear. Jewish women, unable to become men and highly unlikely to become Muslim, were thus operating under the double imprint of Jewish and Ottoman law and thus

Fig. 5. Woodcut of a "Jewish Maiden from Adrianople." From Nicolas de Nicolay, *Quatre premiers livres des navigations* (Lyon, 1568), fol. 164. Houghton Library, Harvard University. (Photo: courtesy of Houghton Library)

characterized by robes, chemises, and long *şalvar* trousers.[45]

A 1568 woodcut by the geographer Nicolas de Nicolay, entitled "Jewish Maiden from Adrianople," illustrates an "*hebrezza*" from Edirne (as the city is known in Turkish) in a floral outfit, though it is difficult to determine whether she is wearing very baggy *şalvar* trousers or more traditional European dress. Nevertheless, the presence of a central hem with branching scrolls is reminiscent of the formal arrangement of the Burgos carpet page, indicating that the stem and scroll may have become codified decorative and organizational motifs popular in other designs in addition to religious ones (fig. 5). The motifs adorning the dress of the Jewish woman of Edirne also appear to be similar to those seen on the cloth fabrics depicted in myriad late medieval Iberian paintings.

A picture of an eighteenth-century Sephardic woman demonstrates the normalization of Sephardic fashion into a more Ottoman mode. For formal occasions, she wears a very long and wide-sleeved silk shift called a *kamiza* (in Ladino), several varieties of which were so fine as to be nearly transparent (fig. 6).[46] According to the Jewish Museum of Thessaloniki, her ordinary attire would have been made of cotton or linen, with narrow sleeves and visible *şalvar* trousers and, occasionally, a lace bib.[47] The dress of this late eighteenth-century woman differed from that of her predecessors not only in its more varied color palette but also in its motifs. It appears that wool had been banished altogether.

Fewer images exist of Sephardic men, but the following account from the Bohemian traveler Hans Dernschwam is revealing:

> In Turkey you will find in every town innumerable Jews of all countries and languages. And every Jewish group sticks together in accordance with its language...As is their custom, everyone wears clothes in accordance with the language he speaks. Usually the garments are long, just like those of the Wallachians, the Turks, and the Greeks, too—that is, a caftan. This is a long tunic, tied about at the waist, over which is a sort of skirt made of cloth of good quality and silk. Just as the Turks wear white turbans, the Jews wear yellow. Some foreign Jews still wear the black Italian birettas. Some who pretend to be physicians or surgeons wear the red-pointed, elongated birettas.[48]

All of this would change in 1580, when the sultan decreed that the Jews wear red hats like their "forebears."[49]

situated in a societal station where *millet* benefits were doubly negated by the less tangible phobia of Jews in general and the expected subordination of women in particular. This station, potentially revealing something as to the precarious threshold of tolerance and discrimination, merits additional examination.

It has been argued that Jewish women of certain ancestral groups in Salonica and Istanbul wore dress "similar in design and fabric to contemporary European or Italian clothes," a practice put an end to by sultanic decree by the end of eighteenth century. Prior to this, the attire of Ottoman Muslim and Jewish women would have been virtually indistinguishable, apart from their headgear.[44] The dress of Sephardic women had been

Fig. 6. A mid-eighteenth-century depiction of a young Salonican woman. Photo: The Jewish Museum of Thessaloniki and Dr. Nicolas Stavroulakis.

Fig. 7 . "Judeus medicus, judoeus." Lambert de Vos, Collection of 110 original drawings (ca. 1574) of Turkish costumes, including a portrait of Selim III, pl. 92. American School of Classical Studies at Athens, Gennadius Library, inv. no. B/A 986q. (Photo: © The Gennadius Library)

The decree makes no distinction among Jewish groups nor does it specify the exact hat being prescribed. An example of a "supposed" physician can be seen in a 1574 watercolor entitled "A Jewish merchant and doctor in ottoman dress" (fig. 7). The doctor and his companion are both wearing black caftans that are open down the center front and cut at the elbows. Beneath, they both wear robes, the physician's blue and the companion's beige. The caftans appear to be lined in red fabric. It is not clear which elements are made of wool and which of silk, but the embroidered, patterned designs of the women's dress described above are nowhere to be found. It is the physician who is wearing a blue robe—which may indicate that the fabric is *pano de cuenta*

wool—a reflection of his elevated standing in society. In another illustration from the late eighteenth century, we see a rabbi garbed in a deep blue dress, illustrating the less colorful attire of the clergy and also indicating the potential use of *pano de cuenta* for important religious figures (fig. 8).

Yet another illustration depicts a Sephardic man of Salonica from the mid-eighteenth-century (fig. 9). Again, according to the Jewish Museum of Thessaloniki, his clothes would have consisted of knee-length knickers of linen or light wool, known as a *pernil*, an undershirt known as a *kamiza,* and, in winter, another shirt over this made of heavier wool, known as a *kamis*. Visible on top is an *antari* robe of striped silk or bur-

Fig. 9. Mid-eighteenth-century depiction of a man from Salonica. Photo: The Jewish Museum of Thessaloniki and Dr. Nicolas Stavroulakis.

Fig. 8. "Haham başı, the chief rabbi of Istanbul," 1790. *Costumes turcs*, vol. 2, fol. 108, from an album showing Turkish costumes. London, British Museum, Mss. 1947-6-17 (012) 2. (Photo: © The Trustees of the British Museum)

nished cotton, made of raw weaves from Aleppo or Lahore.[50] Gone were the simple days of muted, single-color garments made in town.

Braude has suggested that the wool commissioned from the Salonican Sephardim for the janissaries was most typically green *sobremanos*. One of the most proximate color renderings of janissary garb appears in a drawing entitled "Ottoman janissaries and the defending Knights of St. John, Siege of Rhodes" (fig. 10). This image features janissaries and *solak*s (imperial guards) alternately bedecked in hues of green, red, indigo, and yellow. Their garments are largely unadorned, and of particular note is the pairing of green and red in alternate layerings of pants and short-sleeved overcoats. This

garb is remarkably similar to that seen in Lokman's well-known and contemporaneous depiction of the "Siege of Vienna by Süleyman the Magnificent" (fig. 11). As they engage in a battle on the other side of the empire, we note the remarkable consistency in the uniforms worn by the janissaries, most notably the recurring green–red pairing. Note the difference in the length of the uniforms, most likely an adaptation to the colder climes of Central Europe.

One might speculate that the influence of Sephardic weavers was most evident in the sixteenth century, as it was steadily normalized by sultanic decrees such as the one from 1580 already mentioned. Moreover, as knowledge of European fashion accelerated in the eighteenth century, we can see how the distinct character of Sephardic attire, particularly that of Sephardic men, may have been both transformed and subsumed into a

Fig. 10. Detail of "Ottoman janissaries and the defending Knights of St. John, Siege of Rhodes, 1522," showing the sultan surrounded by his *solak*s and some janissaries, several of whom are dressed in uniforms in a plain red-green scheme. From the *Süleymannāme*, 1558. Istanbul, Topkapı Palace Museum Library, Ms. H. 1517, fol. 149a. (Photo: courtesy of the Topkapı Palace Museum Library)

Fig. 11. Detail of "Siege of Vienna by Süleyman I the Magnificent, 1529," showing Ottoman forces, including *solak*s and janissaries, in the red-green color scheme. From Lokman, *Hünername,* 1588. Istanbul, Topkapı Palace Museum Library, Ms. 1524, fol. 257b. (Photo: courtesy of the Topkapı Palace Museum Library)

less idiosyncratic posture, and also one less tied to the wool industry.

SCANNING THE IBERO-JUDEO COLOR PALETTE: RED/GREEN AND CHROMATIC GENEALOGIES

As the Inquisition gripped Spain and then Portugal, the Jews of Iberia were forced to convert to Christianity (though they sometimes continued to practice their original religion in secret [crypto-Judaism]); many others were killed, although about half of the Sephardic population in Spain around 1492 were able to flee the country. Traces of their presence in Spain were largely stamped out. All they could take to their new homes in Europe and the Mediterranean was what they could bear on their persons; thus, portable goods like fabrics codified Sephardic identity in perpetuity.

As has been argued with wool, it is probable that this codification came simply through color schema by way of the art of pigmenting, which the Sephardim had already mastered in Iberia. Medieval heraldry and flags in general demonstrated the large role played by color schema in signifying cultural groups. The Ottoman system was no different. As Nicolas de Nicolay recounts of Salonican Jewry:

> Their headgear is a saffron yellow turban. That of the Greek Christians is blue, and that of the Turks is pure white so that by the difference in colour they may be known apart.[51]

While Nicolay's 1568 account indicates color schemes for the three groups of the Salonican populace, it is important to question whether this delineation, at least within the Jewish population, occurred voluntarily and immediately upon arrival in 1492 or was a result of an increase in sultanic decrees on dress. Moreover, it is interesting to postulate to what extent the qualities of an Ottoman-Jewish color scheme, with yellow as the key color, were the product of will as opposed to, or in tandem with, law.

As has been noted in the discussion of green *sobremanos* and the attire of the janissaries and *solak*s, the red-green schema appears to be by far the most striking in the Sephardic Salonican chromatic output. The 1482 manuscript *Rimado de la Conquista de Granada* (Rhyme of the Conquest of Granada) offers some suggestions as to why. On one page from the manuscript we see Philip I (r. 1506) and his wife Joanna of Castile meeting with their subjects (fig. 12). The composition of

Fig. 12. Page from Pedro Marcuello, *Rimado de la Conquista de Granada* (Rhyme of the Conquest of Granada [1482]), depicting Phillip I and Joanna of Castile. Bibliothèque et archives du Château de Chantilly, CNRS-IRHT. (Photo: Bibliothèque et archives du Château de Chantilly)

Fig. 13. Page from Pedro Marcuello's *Rimado de la Conquista de Granada* (1482), depicting arrows and an olive branch. Bibliothèque et archives du Château de Chantilly, CNRS-IRHT. (Photo: Bibliothèque et archives du château de Chantilly)

the page recalls the traditional composition of a Torah ark curtain, with two columns framing a scene behind. The columns, which appear to be carved of wood, depict two split shafts, one with evergreen on top and crimson on the bottom and the other vice versa.

On another page from the manuscript, a heraldric-like motif depicts two bundles of arrows with alternating red and blue-green fletchings (fig. 13). A pairing of red and green is seen in the sectional view of a Spanish olive, suggesting that this may have been the foundation of a distinctly Iberian color scheme, perhaps even linked to the native olive, that began to fade from Spanish art after 1492.

This color pairing is suggested to be particular to the Aragon-Castilian region in two additional sources: a 1495 painting entitled *Santo Domingo y los Albigenses* by the Spanish painter Pedro Berruguete, and the circa 1400 wall motifs of the El Tránsito Synagogue in Toledo. In Berruguete's painting, Saint Dominic presides over the burning of the heretical texts of the Albigensian Catharists (a Manichean Christian sect) (fig. 14). Both the book in the fire and those about to be tossed in (or repelling a thrust towards the fire) have covers of similar shades of red and green. The main feature of the El Tránsito Synagogue of Toldeo, which I shall discuss more briefly, is its florid, diamond-patterned wall with a chromatic substrate of red and green nearly identical to that seen in the painting.

I would like to suggest here that the red–green pairing is an important one, particularly as it is echoed in the post-expulsion wool production of Salonica. Although it may not be unique to the Sephardic population, its diadic continuity and resonance in both Christian and Jewish artistic production in Iberia before the expulsion but not after suggests that its promulgation as a color scheme was probably linked to the Sephardim.

There is another intriguing and specifically Mediterranean genealogy that may link the Sephardim to a unique orange hue that appears in Italy, eventually arriving in all corners of Europe in the form of the lustrous varnish coating of the famed Stradivari violin. Finlay contends that the rise of the violin in the Italian city of Cremona reveals something of Sephardic chromatic sensibilities. She notes how the instrument-making tradition came to full fruition through the master craftsmanship of lutes produced by a Sephardic man named Giovanni Leonardo da Martinengo.[52] Martinengo arrived in Cremona in 1499, which indicates that he had likely spent the years between 1492 and 1499 traveling. Upon settling in Cremona, he taught his craft to his two brothers, Andrea and Giovanni Antonio Amati.[53] According to Finlay, it was Andrea who fashioned one of the first violins, after a man in the nearby town of Brescia "decided to take a bow to the lute-guitar and play it like an Arabic *rebab* rather than plucking it." Andrea's grandson Niccolò taught the craft to Antonio Stradivari, who became the first major producer of violins, circulating his iterations of the instrument across Europe in the latter half of the seventeenth century.[54]

In an effort to postulate the chemical roots of Stradivari's lustrous and wholly unique orange varnish— namely, safflower, madder, and brasilwood—Finlay suggests that Martinengo brought the special coloring techniques with him from Spain to Italy, supplementing them with pigments acquired on his seven years of travel through the Mediterranean before settling in Cremona. This would include the safflower pigments available in the bazaars of Tunis, Tripoli, and Algiers, as well as the previously mentioned madder found in the Ottoman Empire. Finlay also supposes that while in Constantinople Martinengo picked up brasilwood orig-

Fig. 14. Pedro Berruguete, "Santo Domingo y los Albigenses," ca. 1493–99. Tempera and oil on wood, 122 × 83 cm. Madrid, Museo nacional del Prado, inv. no. P00609. (Photo: courtesy of the Museo nacional del Prado)

inating from the East Indies; this was the source of the third and final hue required to create the varnish pigment that sealed countless lutes and violins for over three centuries.

In reflecting upon the green–red diad and the orange varnish of the Stradivari violin, one may conceive of color itself as yet another form of Mediterranean transmission. A particularly nimble artistic tool, color can be seen as both rooted to place in its peculiar organic composition and able to transpose and transmute itself along with an itinerant population such as the Sephardim.

THE SYNAGOGUE: IMAGINING SPACE, FEMALE WORSHIP, AND THE MOTHER REGION

Much can be gleaned from medieval Iberian Jewish manuscripts about Judaic iconography (or aniconography) and the built realm of the Sephardim, particularly the synagogue.[55] As Katrin Kogman-Appel has pointed out, two different worlds present themselves to the scholar of Hebrew illuminated manuscripts from Spain, the earliest of which dates to the thirteenth century. She explains the distinct split in Jewish manuscript arts:

> One is nonfigurative, non-narrative, an almost aniconic idiom, with a clear preference for ornament in a style that reveals strong Islamic influence. The second tells the story of ancient Israel in a richly narrative, figurative mode, while in style it echoes in every respect the artistic taste of Christian Europe.[56]

While she argues that the two trends overlap in the major Jewish regions of Castile, Aragon, and Catalonia, nearly all of the later iconographic imagery emerges from Catalonia, in the form of Passover Haggadot (sing. Haggadah), small volumes of texts meant to be read on that holiday. While figurative art is abundant in "primitives" of Christian Aragon and Castile, the Jewish art pieces that remain from those regions from the thirteenth to fifteenth centuries consist primarily of the carpet pages discussed above, which often have striking similarities to Islamic carpet pages from other parts of Iberia, particularly Granada.[57]

The manuscript is stunning evidence of *convivencia* and has hitherto been invoked as an exemplar of it. One may understand quite clearly how all three groups (Christans, Jews, and Muslims) were already engaged in an artistic dialogue, but focusing on the dialogue itself may obscure what actually made Sephardic synagogue architecture and religious life distinct from as opposed to similar to its neighbors. Thus, a consideration of pre-Salonican Sephardic religious culture may aptly begin by looking at the Catalonian Haggadot, as they depict the figures found less frequently in the arts of Castile and Aragon besides providing additional, albeit more nebulous, architectural information about Sephardic synagogues beyond the three that remain in the more familiar regions of Castile and Andalusia.

The most studied of the Iberian Haggadot is the Golden Haggadah, dating from the first half of the four-

Fig. 15. "Synagogue scene from the Golden Haggadah." Gouache on parchment, first half of the fourteenth century. London, British Library, Ms. Or. 2884, fol. 17v. (Photo: © British Library Board)

teenth century. Its 128 illustrations contain only limited depictions of synagogues. One example has a tripartite composition, demarcated by four slender columns forming three bays (fig. 15). It is only the left bay that reveals a familiar Sephardic motif, a once-cusped arch recalling the mihrab motifs of both Islamic prayer rugs and dome motifs of Islamic as well as Jewish prayer rugs. The other two bays have more typical shallow arches. A total of seven hanging lamps, similar to those of Iberian mosques, adorn the upper portion, including three in the left bay and three in the right, which appear to be suspended from the wall from bars that cross the arches. The lamp in the center bay, which appears to hang from the ceiling, hovers directly above the rabbinical *bimah* (podium), which is articulated in a crude perspective so as to render its depth. The congregation, wearing unadorned red, white, and blue robes, contains

Fig. 16. "Jews leaving the synagogue from the Sarajevo Haggadah." Gouache on parchment, fourteenth century. Sarajevo, National Museum of Bosnia-Herzegovina. (Photo: courtesy of the National Museum of Bosnia-Herzegovina)

both men and women, young and old. What appears to be the Torah ark sits directly on the floor in the left bay. The slender columns have the same sinewy forms as the eighteenth-century Salonican Torah ark curtain in figure 3.

To contextualize this scene with respect to the closest substantive haggadot found in the environs of Salonica, we may look at yet another well-known example from Sarajevo. Like the Golden Haggadah, the Sarajevo Haggadah, also from the fourteenth century, has but a few illustrations of synagogues. In one titled "Jews leaving the synagogue," men, women, and children are garbed in plain blue and red robes that cover them from head to toe in nearly indistinguishable fashion (fig. 16). They emerge from a rounded archway unlike the horseshoe or cusped arches found in the synagogues of Castile and Andalusia. Lamps similar to those adorning

Iberian and Ottoman mosques hang on either side of the ark, which contains three torahs, lifted aloft by a gridded structure. The ark has hinged doors rather than the more common Torah ark curtain.

In comparing the haggadot from Barcelona and Sarajevo one may begin to consider the architectural differences between the synagogues of the Iberian and Balkan peninsulas, respectively, prior to the arrival of Iberian congregations in Salonica. While the congregational attire in both images is quite similar, the Iberian synagogue itself seems to be of a more transparent quality, airy with slender columns and definitive Iberian architectural forms in the articulation of the arches; the Torah arks were situated differently in each image, and, as noted above, in the Sarajevo Haggadah hinged doors fulfill the role of the Torah ark curtain. The lamps, however, appear to be nearly identical.

According to Ottoman records, there were twenty-six synagogues established in Salonica between 1492 and 1680 (fig. 17). As already noted, the congregations remained divided and established themselves not only by country but by city of origin. In total, twelve synagogues were of Italian origin, seven were Spanish, four Portuguese, and one Moorish; there were also two multi-congregational synagogues, one, the Talmud Torah Synagogue, being particularly large and reserved for community-wide functions.[58] The first five congregations established were all erected in 1492–93 and hailed from Spain. These included (in their English transliterations): the Gerush Sepharad Synagogue (Castile), the Castilia Synagogue (Castile), the Mayor Rishon Synagogue (Majorca), the Catalan Yashan Synagogue (Catalonia), and the Aragon Synagogue (Aragon). They were followed by two additional synagogues established between 1535 and 1537: the Catalan Hadas Synagogue (Catalonia) and the Mayor Seni Synagogue (Majorca). Synagogues of Portugese origin included the Évora Synagogue in 1512 or 1535 (Évora), the Lisbon Yashan Synagogue in 1519 (Lisbon), the Portugal Synagogue in 1525 (various cities of Portugese origin), the Lisbon Hadas Synagogue in 1537 (Lisbon), and the Yahia Synagogue in 1560 (Lisbon).[59]

As a general rule, the Spanish synagogues identified with the region of origin, the Portugese synagogues with the city of origin. Although the reasons for this are not clear, it may likely be a corollary to the relatively more

Congregation	Place of Origin	Year Established
1. Gerush Sepharad	Spain	1492
2. Castilia	Spain (Castile)	1492
3. Mayor Rishon	Spain (Mallorca)	1492
4. Catalan Yashan	Spain (Catalonia)	1492
5. Aragon	Spain (Aragon)	1492
6. Neve Shalom	Italy (Calabria)	1497
7. Pulia	Italy (Apulia)	1502
8. Evora	Portugal	1512 or 1535
9. Ishmael	Italy (Calabria)	1517
10. Lisbon Yashan	Portugal	1519
11. Talmud Torah	(central synagogue)	1520
12. Portugal	Portugal	1525
13. Estrug	Italy (Apulia)	1535
14. Catalan Hadas	Spain (Catalonia)	16th century
15. Mayor Seni	Spain (Mallorca)	16th century
16. Lisbon Hadas	Portugal (Lisbon)	1537
17. Otranto	Italy (Apulia)	1537
18. Kiana	Italy (Calabria)	1545
19. Neve Sedek	Italy (Calabria)	1550
20. Yahia	Portugal	1560
21. Sicilia Hadas	Italy (Sicily)	1562
22. Beth Aaron	Italy (Sicily)	1575
23. Italia Hadas	Italy	1582
24. Italia Shialom	Italy	1606
25. Shialom	(mixed)	1606
26. Ar Gavoa	Italy (Apulia)	1663
27. Mograbish	North Africa	17th century, before 1680

Fig. 17. Table of Jewish synagogue congregations established in Salonica, 1492–1680, demonstrating the congregation names, origin and year of establishment. The table is extrapolated from Iōannēs Chasiōtēs, ed., *Tois agathois vasileuousa: Thessalonikē, historia kai politismos* (Thessaloniki, 1997), 278. The table is reprinted from Vasilēs Dēmētriadēs, *Topographia tēs Thessalonikēs kata tēn epochē tēs Tourkokratias, 1430–1912* (Thessaloniki, 2008 [repr., orig. pub. 1983]), 347.

urbanized nature of Portugal in 1492 in comparison with Spain. It may very well also indicate the ways in which the Spaniards and Portugese Sephardim electively chose to identify themselves as urban or rural, Portugese or Spanish, Needless to say, linguistic dialects would have also been another important reason for subdividing congregations by their place of origin.

From tables published on congregation information one can glean the respective numbers of married and unmarried members in each particular congregation, a fact crucial to Ottoman census takers.[60] Their locations within the Jewish quarter, culled from Ottoman records and censuses, are shown in a map denoting the Muslim, Christian, and Jewish quarters of Salonica in the mid-sixteenth century (fig. 18). Sadly, there is no reliable evidence as to the location of a bazaar or public space. If this information were known, it would indicate the spatial relation of the synagogue to the commercial sphere and also whether or not the Jews had regular public interaction with their Christian and Muslim counterparts in the city. Here it is best to operate under the assumption that the Salonican model of urban interaction between Jews, Muslims, and Christians followed roughly contemporaneously with that of the imperial capital, Istanbul, where the groups and their houses of congregations remained delimited to neighborhoods like Galata and Balat, while there was also a certain amount of free flow of individuals for market purposes,

Municipal
Hospital

St. Sophie Street

St. Demetrius Street

Jewish
Cemetery

Konak

Muslim
University

Royal
Baths

El-Venizelou

Via Egnatia

Ottoman
Bank

Bank of
Salonica

Jewish
Baths

French Street

Tsimiski Street

Saint Sophie
Baths

LEGEND

Predominantly Jewish
Quarter

Predominantly Christian
Quarter

Predominantly Muslim
Quarter

Synagogues

Mosques

Churches

Greater Boundary of the
Jewish Quarter

Fig. 18. Map of Salonica, ca. mid-sixteenth century, illustrating the locations of synagogues, mosques, churches, and other important landmarks, including the Via Egnatia, which runs roughly east-west through the Jewish quarter, parallel to the port. Adapted from Gilles Veinstein, *Salonique, 1850–1918: La "ville des Juifs" et le réveil des Balkans* (Paris, 1992). (Map: C. Scott Walker, Harvard Map Collection, Harvard College Library)

particularly where specialized service economies required it.

As Heath Lowry and Mark Mazower have indicated, in Salonica the synagogues were most often not located on the street front, which was fairly common for reconstituted as well as newly-constructed synagogues (a rather rare occurrence) in other Ottoman Jewish quarters.[61] Often, as is amply documented in synagogues refashioned from prior uses in Istanbul, they were meager rooms no larger than about 2,000 square feet.[62] One must remember that all new synagogues and churches were built in conformance with the restrictions Ottoman law placed on the construction of non-Muslim places of worship: there were limits on the materials that could be used, the architectural heights that could be reached, the visibility of iconography from the street and, in the case of rich congregations, the level of architectural decoration considered acceptable in accordance with Islamic and caliphal values. Two things are yet further important to note: the enforcement of these strictures varied depending on historical circumstances and petitioners had been known to argue that a project was a reconstruction as opposed to a new construction, even if that is in essence what they were doing.[63] This inevitably made for what would have been a more muted material palette than was found in Sephardic synagogues in Iberia. In short, the appearance of the synagogue was, at least from the outside, to be as discreet as possible. While halakhic guidelines closely regulated the formal appearances and arrangements of synagogues in Spain, there is no evidence that the Sephardic population reconstituted any halakhic principles for the interior redesign of synagogues after the expulsion, which would signal the far less regulated nature of the practice of design of new synagogues (both veritably new constructions and "retrofitted" older buildings) across Europe, within Ottoman boundaries, and in Salonica in particular.[64] As such, the building and furnishing of synagogues by the eleven earliest congregations of Sephardic Salonica were probably done stealthily, and were highly contingent on subtle, local artistic trends and the available financial means of the respective members, all executed in what one author has duly described as the "spirit of the times."[65]

All evidence indicates that the Gerush Sepharad Synagogue was the most prominent Jewish structure in

Fig. 19. El Tránsito Synagogue, Toledo, exterior view. (Photo: courtesy of Dr. James Bartholomay Kiracofe)

Salonica, at least at first. It was located closest to the Via Egnatia, the city's (and region's) most important thoroughfare, perhaps with direct access to it, from its appearance on the map. Cited in all accounts as the first of the five synagogues built in 1492, it is the only one whose rabbi's name, Levi ben Habib, was also recorded.[66] Along with the Castilian synagogue, it is attributed to the region of Castile. Both synagogues likely received the majority of their congregants from the Sephardic community of Toledo, which was the largest and richest of all Sephardic populations in Iberia.[67]

Architecturally, this wealth is nowhere more elegantly demonstrated than in the previously mentioned Synagogue of El Tránsito in Toledo, which was commissioned as a private house of worship by the King of

Fig. 20. El Tránsito Synagogue, Toledo, interior view, showing ornamental wall with green-red color scheme and the wooden dome. (Photo: courtesy of Dr. James Bartholomay Kiracofe)

Fig. 21. El Tránsito Synagogue, Toledo, wall detail showing inscriptions and a heraldic crest alluding to Castille y Leon's ties to the throne of the king. (Photo: courtesy of Dr. James Bartholomay Kiracofe)

Castile's treasurer, Don Samuel HaLevi Abulafia, and built circa 1356.

As has been noted, the Spanish, like the Ottomans, limited the material palette and heights of synagogues. HaLevi Abulaifa plainly flouted these strictures—a luxury afforded him by virtue of his governmental post. The synagogue features Nasrid-style polychrome stucco work, numerous Hebrew inscriptions invoking God's grace, multi-foil arches, and a *mudéjar*-paneled ceiling of wood that was said to have come to Toledo all the way from Lebanon (figs. 19–21).[68]

The builders of the synagogue, who were brought to Toledo from Andalusia, were most likely Muslim, as can be inferred from the significant Moorish characteristics of the interior. The multi-foil arch is by far the most salient characteristic of what one might call Sephardic architecture, at least that which remains in Spain, while only one example of such an arch is evident today in downtown Thessaloniki, at the art nouveau Casa Bianca, built in 1912 by the architect P. Arrigoni for a wealthy family by the name of Fernandez.[69] Stand alone single-foil arches can also be seen in the Santa María La Blanca Synagogue, also in Toledo, built in 1203.

Gerush Sepharad's first known rabbi, Levi ben Habib, was born in Toledo in 1483.[70] At the age of nine he escaped to Portugal and eventually Salonica with his

father.[71] For a number of years he served as the spiritual leader of what was until about 1540 the largest congregation in the city. Some time after that he emigrated to Safed and then eventually to Jerusalem.[72] It is probable that Levi ben Habib and his father before him were instrumental in shaping the Gerush Sepharad Synagogue in its early years, soliciting the congregation for money to build up and furnish the new building. Ben Habib would have found it prudent to keep the styling of the synagogue in conformity with the spatial traditions of the Toledo synagogue, at least to the best of his ability, given the material and financial resources available to him and his congregation, as well as the strictures placed on him by Ottoman regulations on non-Muslim constructions.

By the time of the 1589 census, the Aragon Synagogue seemed to have usurped ben Habib's congregation in importance.[73] The Aragon Synagogue, also established in 1492, had 404 members in its congregation by this time, compared to the 171 members of Gerush Sepharad.[74] The Aragon Synagogue was, in fact, the largest congregation in all of Salonica, both in 1589 and in the next census of 1613, surpassing several of the sizable congregations of Italian Jews as well.

While it is not clear why this happened, it is most logically the result of a significant influx of Aragonese Sephardim in the mid-sixteenth century, which would have coincided with the ascendant influence of Don Joseph Nasi, also known as Jaoū Miguez (d. 1579), of the Aragonese House of Mendes. Nasi served as a diplomat and administrator during the reigns of both Süleyman I (r. 1520–66) and Selim II (r. 1566–74), and was a preeminent champion of myriad policies that supported the equanimity of Ottoman Jews.[75] Nasi, along with an extended and influential family spread across Europe, garnered the admiration of the Seraglio by virtue of his myriad trade connections across the continent. Nasi's immense wealth was spread both to his relatives across Europe and to his Aragonese brethren, which had major implications for the congregation in Salonica, both in terms of their numerical growth and their material affluence.[76] The Aragon Synagogue was situated close to the port, flanked by a then unnamed thoroughfare and Tsimiski Street, just down the block from the Jewish bathhouse and immediately next to the other Castilian congregation, the Castile Synagogue.[77] A particular

issue regarding gender affected the Aragon Synagogue. In comparison with the Gerush Sepharad, which was built on a relatively generous plot of land, the Aragon Synagogue was on a site so narrow that the requisite 'erzat nashim (women's enclosure) and bet knesset nashim (women's synagogue) were probably not built. The Aragon congregation served more than twice the number of members as the Gerush Sepharad, in one third the space, and the proximity of men and women would have been virtually impossible to control, particularly if the synagogue had been retrofitted from an extant structure.

When addressed in the vast secondary literature on the expulsion of the Jews from Spain, the issue of women's autonomy is related to the desideratum to establish "the chronology and geography of the deterioration in the status of women in Jewish diaspora society," as Paul Wexler puts it.[78] In short, it is believed that the dissolution of halakhic principles actually created the conditions that led to the worsening of the status of women in Jewish diasporic society, a fact perhaps enhanced by the caliphal support of the belief that women were inferior to men. Nowhere was this made more manifest, even if only symbolically, than in the synagogue. Wexler elaborates:

> There is evidence that in Christian Spain, major changes may have taken place in the status of women not long before the expulsion in 1492. Two of three surviving synagogue buildings in Spain, "El Tránsito" in Toledo and the one in Córdoba that were both constructed in the fourteenth century (i.e., when both cities were long in Christian hands), have a separate upper section for women worshippers which suggest that the latter played a purely passive role in the synagogue service. However, I. Epstein has noted that Iberian women could own and dispose of men's seats in the synagogue that they bought and sold. Conversely, two illuminated manuscripts from fourteenth-century Aragon display men and women side by side in the synagogue, which implies the absence of segregated worship.[79]

Wexler goes on to compare this phenomenon with the architectural arrangements of men and women in Ashkenazi Europe, where the separation of men and women appears in thirteenth-century synagogues built in Cologne, Speyer, and Worms. While being able to buy and sell a husband's seat in the synagogue does not necessarily mean a wife could sit in it herself, the

point raises interesting questions as to the potentially divergent practices of Sephardim in Castile and Aragon, respectively. Given the marked volumetric differences of the congregational synagogues in Salonica, one may ask: did Aragonese Sephardic women, by way of the more limited spatial envelope of their synagogue, in turn enjoy greater liberty through the sharing of synagogue space with men than did their neighbors, and did this manifest itself outside the synagogue in the everyday life of their Ottoman microcosm?

If so, the Aragonese tradition of segregated worship may have continued in Salonica. The predominant view that the expulsion exacerbated the marginalization of women in the Sephardic community may have held true for other congregations, such as Gerush Sepharad, but at least in the case of the Aragon Synagogue, an important spatial as well as societal distinction of self-autonomy among the city's Jewish female population was maintained.

Moreover, it seems probable that the poorer congregations, such as that of Aragon, as well as other congregational groups comprising the manufacturers of cheaper woolens, would have required a higher proportion of prayer rugs with inscripted prayers, since their congregants would not have been able to afford personal copies of Scripture. The abundance of prayer rugs and woven wall hangings in the poorer congregations would have significantly distinguished the interior ambiance of their houses of worship.

MEMORY IN THE BUILT REALM:
LAS INCANTADAS, THE BRIDGE AT LARISSA, AND THE JEWISH NECROPOLIS

With the influx of Jewish immigrants to numerous urban centers across Europe there came, for the first time, a systematized urban strategy for constructing Jewish quarters at breakneck speed. This entailed new approaches to land speculation and architectural reappropriation that demonstrated heady efficiency nowhere better than in sixteenth-century Florence. As Stefanie Siegmund has illustrated, the Medici state harnessed the legal system to delimit Tuscan Jews both spatially and socially, constructing a massive new Jewish quarter from scratch on the site of the old Roman forum.[80] She notes:

The creation of a ghetto in Florence was undertaken by the grand-ducal government as a public works project and as an investment. It was built, owned and administered by the state. The construction of the ghetto employed workers to turn a run-down, disreputable area in the heart of the city into a solid commercial neighborhood that also served as an architectural and religious symbol of the power and piety of the grand duke. The project was, in addition, to become a profitable rental property with a guaranteed and self-perpetuating tenant population.[81]

Salonica had some similarities to Florence in the way it housed its new Jewish population, which, like the Tuscan Jews, inhabited the oldest part of the city, including the site of the old Roman forum. But, as both Lowry and Mazower have illustrated, Salonican Jews were more likely to have simply reappropriated the domiciles and ruins abandoned by Christian communities than they were to build new ghettos wholesale.[82] The new Jewish quarter of Salonica, indeed appears to have been far more ad hoc than its counterpart in Florence:

South of Egnatia, with the exception of the market districts to the west, the twisting lanes of the lower town belonged to the newcomers. Here wealthy notables lived together with the large mass of Jewish artisans, workmen, hamals, fishermen, pedlars and the destitute, cooped up in small apartments handed down from generation to generation. The overall impression of the Jewish quarters was scarcely one of magnificence. Clusters of modest homes hidden behind their walls and large barred gates were grouped around shared *cortijos* [small courtyards] into which housewives threw their refuse. As the city filled up, extra storeys were added to the old wooden houses and overhanging upper floors jutted out into the street. Every so often the claustrophobic and airless alleys opened unpredictably into a small *placa* or *placeta* [plazas of medium and small scale]. Rutted backstreets hid the synagogues and communal buildings...These were the least hygienic or desirable residential areas, where all the refuse of the city made its way down the slopes to collect in stagnant pools by the dank stones of the sea walls. The old harbour built by Constantine had silted up and turned into a large sewage dump, the Monturo, whose noxious presence pervaded the lower town.[83]

Two images of the classical ruin known as the arcade of the *Incantadas* in Ladino (*Ta Idola* in Greek; no consistent name in Turkish) substantiate a convincing visual record of what this residential community may have looked like. The first, a color drawing attributed to the

Fig. 22. James Stuart, "Propylaea of the Hippodrome seen from the courtyard of a private house, Salonica (Thessaloniki)," 1750–60. Gouache, 31.5 × 46 cm. Royal Institute of British Architects (RIBA) Library Drawings & Archives Collection, SD146/3. (Photo: courtesy of RIBA)

British antiquarians James Stuart and Nicholas Revett, who passed through on a trip to Thessaloniki in 1754, depicts the British consul to the Ottoman Empire arriving at the home of a Sephardic merchant (fig. 22). The merchant, apparently a wealthy notable, as indicated by his outfit, the presence of a young servant, and the generous size of his private *cortijo*, offers coffee to his guest. In the background, Stuart and Revett can be seen dressed in Ottoman attire donned specifically for their travels; they are accompanied by the consul's young son, the only one dressed in European clothing, and the consul's Greek interpreter. Three women, apparently the merchant's wife and two daughters, watch from the balcony above, excited by the far-flung company in their home.

The reason for the visit by the consul-cum-antiquarian was no small secret. This particular merchant resided in the very heart of the old city, literally on top of what had once been the Roman forum. His house abutted a Roman ruin speculated to have belonged to a collection of thermae (baths) dating from the third century A.D. The rise of antiquarianism, particularly in Britain, meant more and more foreign visitors to the Jewish quarter.

The ruin itself consists of a nineteen-foot high unfluted Corinthian colonnade supporting a three-band epistyle, frieze, and cornice. It also supports an attic arcade with four seven-foot-high sculpted columns that have been alternately described as double-faced caryatids or embossed double-pilasters. These in turn

support an epistyle and a second cornice. The Greeks identified the figures on the pilasters as Dionysus, Maenad, Ariadne, Leda, Nike, Avra, Dioskoros, and Ganymede.[84]

Folk tradition in Salonica considered the figures to be "petrified" within the pilasters where they stood adjacent to the *Via Regia* (King's Street).[85] For many Salonicans of the time, this particular ruin was held to be the city's identifying architectural symbol. The name *Las Incantadas* (the enchanted ones) referred to the fact that the figures depicted were pagan gods, built by pagan sculptors, and thus patently mystical, abhorrent, and blasphemous. They would continue to be known by the Sephardic title until French antiquarians managed to seize the pilasters from the Ottomans in 1865 and renamed them the *Piliers décorés de Las Incantadas* (fig. 23).[86]

The arcade had become part of the urban-scale palimpsest that characterized so much of the transformation of the city center's Roman and Byzantine heritage during the height of the development of Salonica under Ottoman rule. One *portique* (portal) of the colonnade serves as an exterior vestibule wherein a tall wooden gate provides a transition space from the Via Regia to the *cortijo*. The other three *portiques* form either the frontal end of the house's elevation or, in fact, cut through its interior, delineating the space within. A taller building appears across the street.

Under a direct order from Louis XVII, the French consul general traveled to Salonica and had an additional image of *Las Incantadas* produced by Esprit Marie Cousinéry (and sometimes attributed to Serrieu and Fauvel) (fig. 24).[87] The illustration is taken from precisely the same vantage point as that of the British illustration seventy-seven years prior, but there are some very striking differences. The ground plane appears to have swollen upwards, engulfing the lower level so that it is no longer inhabitable. The house's stucco façade appears to have been entirely stripped, revealing the uneven stonework below. The roof sags at the corner and rubble litters the *cortijo*. The entry portal is but a skeleton of its former self and the building across the street seems to have given way to two new, larger buildings a bit further away. Moreover, some of the original details of the illustration are redrawn, such as the mullions of the window and the composition of the banister of the veranda.

Fig. 23. Portique of *Las Incantadas*, Paris, Musée du Louvre. Andover-Harvard Theological Library, New Testament and Archaeological Slide Collection, inv. no. Harvard Divinity School 11B6. (Photo: Helmut Koester)

Fig. 24. M. Fauvel, "Ruines d'un Cirque à Salonique." From Esprit Marie Cousinéry, *Voyage dans la Macédoine, contenant des recherches sur l'histoire, la géographie et les antiquités de ce pays*, 2 vols. (Paris: Imprimerie royale, 1831), 1:32. (Photo: courtesy of Widener Library, Harvard College Library)

What does remain exactly the same is *Las Incantadas*, in yet greater and more picturesque splendor. A forlorn woman carrying a jug on her head and with a small child at her side appears in front of the house. The nature of her headgear most likely identifies her as Sephardic. Is this her house or is she merely passing by? Is this woman who fetches her own water squatting in the former home of a merchant who once had servants to do such tasks? This was the last image of record of *Las Incantadas* to be produced before the French dismantled the ruin and installed the pillars in the Louvre, where they remain on view today.

Yet another palimpsest concerning the built environment comes to us from the realm of folklore. Samuel Armistead and Joseph Silverman have commented on the appearance of a ballad in Ladino in fifteenth-century Salonican sources known as "The Bridge of Arta." The song, which was a mainstay of what Armistead and Silverman describe as the "complex, multi-lingual, and yet strikingly homogenous folklore of the Balkan Peninsula," concerns the ritualistic practice of immuring a human being into the base of a building or a bridge as a sacrifice to ensure the structural integrity of its foundation. The ballad, one of the most well-known folk narratives of the region, outlines the story of how the work accomplished each day by a master builder and his associates collapses each night. Eventually the master builder is made aware, through some supernatural source, that the building (most commonly a bridge) will remain standing at night and into the next day if a human, typically a female, is sacrificed and immured into the structure's foundations. Versions in Greek, Macedo-Roumanian, Albanian, Serbian, Macedonian, Hungarian, Daco-Roumanian, and Bulgarian all refer to either the Bridge of Arta in western Thrace or the Citadel of Deva.[88] It has been argued that the ballad has yet deeper origins, and initially referred to various Hellenistic sites: most commonly the *Taşköprü* of Adana.[89]

The most extensive Ladino version of the ballad begins thusly:

> Under the bridge of Larissa
> there was a graceful maiden.
> Her father has kept her guarded
> for a handsome lord.
> The girl, who was shameless,
> went to visit the vizir.

Fig. 25. Engraving of the Pineios River Bridge and the environs of Larissa. From Victor Duruy, *History of Greece and the Greek People: From the Earliest Times to the Roman Conquest*, 4 vols. (Boston: Estes and Lauriat, 1890), vol. 4, sect. 2, p. 430. (Photo: courtesy of Period Paper, Whitewater, WI)

> Along the way
> she met a *boza* [a drink made from fermented millet] vendor

It is noteworthy that the Ladino version moves the bridge from Narda to Larissa, which is much closer to Salonica. I venture that the ballad refers to the Pineios Bridge, which spans the Pineios River and was at the time the oldest bridge in the area of Larissa (fig. 25).[90] As in her previous incarnations, the victim is found "under" the bridge, but important distinctions have been transposed by the new settlers from the original Greek version. Armistead and Silverman note that:

> The Sephardic anecdote is so terse that only the barest outlines of a narrative emerge. Distinctive features which might facilitate comparison and identification with a specific ballad subtype are almost totally lacking. However, the Sephardic vignette can be shown to differ significantly from the Greek ballad in two important details. In contrast to the matter-of-fact intervention of the river spirit (*stoicheion*) in many variants of The Bridge of Arta, there is a notable and possibly intentional, avoidance of the supernatural in the Jewish text. Here the bridge is not carried away as a result of a jealous malevolence of an elemental spirit, but merely because of the December floods and, belaboring the obvious, because the "bridge was not erected upon a solid foundation." In the Sephardic text, the Greek master builder's wife has become the engineer's daughter...[91]

As with the figures they referred to as *Las Incantadas*, the Sephardim of Salonica deliberately discredited any

sense of the supernatural from their found surround-ings. Rather, they rewrote the myth, ascribing to it the most profane meaning possible—the laws of physics: any failure of the bridge outside the city limits must be the fault of the engineer, whose daughter is forced to pay the ultimate price for her father's shortcomings. Can we see the Ladino alterations of the ballad as meaning-ful in either a spiritual or architectural sense, or both? Perhaps, but such ideas would be creative guesswork. If there were more allegories of this kind, one could poten-tially piece together a more holistic ethos for the ways in which the Sephardim approached the structures they found in Salonica, such as, in this case, *Las Incantadas* and the Bridge at Larissa. What is ascertainable is that the bridge and *Las Incantadas* present structures that, on the one hand, are practically useful yet, on the other, proffer potentially dangerous and heretical qualities left over from former pagan inhabitants, demonstrat-ing the far greater threat of the pagan thought of the dead than that of the Islamic or Christian theology of the living.

One locale with a more easily determined prove-nance is the Jewish cemetery of Salonica, one of the few places where the unity of the Jewish population could not be disputed. It is not clear when the Jewish ceme-tery first became established on a parcel of land outside the city's Byzantine-era fortifications, in the foothills of the old city's northeast corner. It was located just north of the Muslim cemetery and from the foothill, looking toward the sea, one can imagine the distinct topograghi-cal difference between the above-ground, horizontal graves of the Jewish cemetery and the vertical head-stones of the Muslim cemetery.

Both cemeteries would eventually limit growth of the Christian quarter in the eastern part of the city. It is, nonetheless, well known that the space occupied by the Jewish cemetery was continually coveted during the Ottoman period and that several parts of it were grad-ually seized as the city expanded eastward.[92] Regard-less of the permutations in the cemetery's boundaries, maps suggest that any Jew or Muslim traveling to their respective cemetery would have had to traverse the Christian quarter. In many ways, both cemeteries spa-tially symbolize the political impulse of the sultan—to keep the Christian population of Salonica contained; indeed, he had censuses taken with unusual frequency

in order to make sure that the Greek Orthodox never became a majority of the city's population.[93] As such, the cemeteries must have been crucial elements in the repeated gerrymandering of the definitive limits of the city proper. It is interesting to note that Bayezid II was not concerned about the city having a Jewish majority, as would happen by the sixteenth century.

Virtually all discussion of the Jewish cemetery of Salonica has been limited to its tragic fate in World War II. The Jewish cemetery survived the devastating fire of 1917 because of its distance from the old town, which included the Jewish quarter, the epicenter of the destruction. A plethora of photographs of the cemetery were taken in the interwar years, probably because it demarcated all that was left of the heritage of a major portion of the city's culture.

Yet when the Nazis entered Thessaloniki in March 1941, one of the first things they did was plunder the Jew-ish cemetery, smashing the low, horizontal tombstones into pieces and leaving only their foundations behind.[94] Fragments of tombstones, some dating as far back as the early fifteenth century, were soon thereafter used to line a swimming pool built for the German forces occupying the city.[95] This gut-wrenching modern-day spolia is the most deeply embedded recollection of Jew-ish memory in Salonica.

CONCLUSION

A well-known passage from the *Seder Eliyahu Zuta* makes note of how members of Bayezid II's imperial circle were bemused by the King of Spain's readiness to dispose of such a large and talented group of its citizens, endowing its "enemies," particularly the Ottomans, with such useful migrants.[96] This makes plain how the utility of the Sephardim, at least in the first few centuries of their residence in Ottoman lands, trumped any concern over their religious and cultural qualities, and indicates the vagaries of *millet* and *dhimmī* policies that may have either been the foundational reason for their open in-vitation to cities like Salonica or, alternately, simply a legal and conceptual overlay made post facto. The answer, as this article hopes to have articulated, lies somewhere in between.

The varied array of sources and subjects considered in this analysis does not lend itself to polemical commentary on either Salonica and its environs or the city's residents. Broad in its material scope, it facilitates what may at best be described as educated conjecture about the nature of a high point of Jewish culture in the Eastern Mediterranean.

The Eastern Mediterranean of the early modern era played a significant, polyvalent, and multi-pronged role in architectural, artistic, urban, and perhaps even chromatic transformation. Moreover, the evidence regarding the role of the Sephardic community in Salonica deepens our understanding of the Mediterranean as a space of an incredible degree of assimilation and adaptation, of both conscious and subconscious, formal and informal means.

Seen together, Sephardic fabrics and color schemes, as well as synagogues and other built domains, illustrate a Jewish presence in Salonican and Ottoman material culture that is at once fleeting and palpable, heterogeneous and universal. The material culture of this itinerant, Mediterranean population is not reducible to simple delineations of the place of the Sephardic community of Salonica vis-à-vis Ottoman society and the Ottoman state, as it is highly unlikely that the Sephardim, as I hope I have argued, were indistinguishable among themselves. From distinctions between male and female societal positioning, Castilian and Aragonese factions, and the economies of the well-off and not-so-well-off, there were more differences than similarities among the Sephardim of Salonica. It was not a monolithic minority. Instead, its material, urbanistic, and economic involvement with Ottoman Salonica reveals variations and similarities that speak to the Sephardic community's Ibero-Jewish antecedents, their aspirations in a new context, and their experience of the Ottoman administration of its non-Muslim subjects as a visual and material as well as political and economic system, replete with its own strictures, points of penetrability, and ability to change over time. What is shared is the Mediterranean, a space not of immutable fixture but of movement and perpetual exchange.

Aga Khan Program for Islamic Architecture,
Harvard University Graduate School of Design,
Cambridge, Mass.

NOTES

Author's note: This paper began as a research project for a Fall 2009 seminar on the early modern Mediterranean co-taught by Professors Gülru Necipoğlu and Alina Payne at Harvard University. I am grateful to them for their direction and encouragement of the idea from its inception. Earlier portions were also presented at two conferences, "Spirituality of Place" at the Savannah College of Art and Design (SCAD) on February 18, 2011, and "Beyond the Author," organized by Yavuz Sezer, Igor Demchenko, and Jennifer Chuong at the Massachusetts Institute of Technology on March 5, 2011. I received useful commentary at the latter conference from Laura Adams, Lecturer in Sociology at Harvard University. Professor Carol Herselle Krinsky at New York University read a draft of this essay early on and provided invaluable insights and lines of inquiry on certain aspects of Jewish art and architecture. At Harvard I received useful source advice from András Riedlmayer at the Fine Arts Library. Additional time and resources to research and write this paper were provided in part by a grant from the Fulbright Foundation and a predoctoral post at the Lehrstuhl für Architekturgeschichte und kuratorische Praxis at the Technische Universität München. The Aga Khan Program for Islamic Architecture at Harvard University generously provided funding to cover the cost of the image rights.

1. Samuel Usque, *Consolation for the Tribulations of Israel*, trans. Martin Cohen (Philadelphia, 1965), 211–12.
2. I owe a debt to the work of Mark Mazower for the investigation of such plurality. His book *Salonica, City of Ghosts: Christians, Muslims and Jews, 1430–1950* (New York, 2005), has proven particularly important for understanding the history of the city, and the citations have been valuable as a portal towards myriad further readings.
3. Nicephoros Moschopoulos, "Hē Hellás kata ton Ebliá Tselempē" ["Greece according to Evliya Çelebi"], *Annual of the Society for Byzantine Studies* 16 (1940): 321–24. I would like to thank my friend Olga Touloumi, Ph.D. candidate in Architecture at Harvard University, for verifying the original Greek version of this passage.
4. Gilles Veinstein, *Salonique, 1850–1918: La "ville des Juifs" et le réveil des Balkans* (Paris, 1992), 42–45. The term "Jerusalem of the West" is one that appears primarily in twentieth-century literature on Jewish history. It is not clear whether it derived from actual usage at the time, but the term has also been used to describe Amsterdam in the early modern period. The significance of this designation depends on whether Thessaloniki is being considered in its Ottoman context or in its modern Greek context, eliciting the "East vs. West" and "Oriental vs. Occidental" problematic.
5. Ibid.
6. Mazower, *Salonica,* 49.
7. Veinstein, *Salonique, 1850–1918,* 42–45.
8. A wide array of examples of such appear throughout the excellent volume edited by Benjamin Braude and Bernard Lewis entitled *Christians and Jews in the Ottoman Empire: The Functioning of a Plural Society,* 2 vols. (New York, 1982).

See also Yavuz Ercan, "Osmanlı Devleti'nde Müslüman Olmayan Topluluklar (Millet Sistemi)" ["The Non-Muslim Communities in the Ottoman State: The *Millet* System"], in *Osmanlı*, ed. Güler Eren, Kemal Çiçek, and Cem Oğuz (Ankara: 1999), 4:197–207; Cemal Kafadar, *Between Two Worlds: The Construction of the Ottoman State* (Berkeley, 1996), 171; Mazower, *Salonica*, 56–58; Michael Ursinus, "Zur Diskussion um 'Millet' im Osmanischen Reich," *Sudest-Forschungen* 48 (1989): 195–207, repr. in *Quellen zur Geschichte des Osmanischen Reiches und Ihre Interpretation*, ed. Michael Ursinus (Istanbul, 1994); and Carol Weisbrod, *Emblems of Pluralism: Cultural Differences and the State* (Princeton, N.J., 2002), 128–29.

9. Benjamin Braude, "Foundation Myths of the Millet System," in Braude and Lewis, *Christians and Jews*, 69–88.

10. Joseph Hacker, "Superbe et désespoir: L'existence sociale et spirituelle des juifs ibériques dans l'empire ottoman," *Revue Historique* 578 (April–June 1991): 261–95.

11. It is worthwhile to contrast the historiographic critique of the *millet* system with that of *convivencia*, the term generally noting the amicable political, economic, and social ties between the Muslims, Christians, and Jews of Medieval Iberia. According to Jonathan Ray, "[i]n the field of Jewish Studies, the fascination with the relative acceptance of Jews in medieval Spain and the resulting rapprochement between the Sephardim and their host societies date back to the German-Jewish Wissenschaft historians of the late nineteenth century. Frustrated by the Jews' problematic encounter with modern European culture, the founders of Jewish Studies thought they had found, with the medieval Sephardim, a paradigm of a Jewish society that could integrate into its host culture without losing its own identity.": Jonathan Ray, "Beyond Tolerance and Persecution: Reassessing Our Approach to Medieval *Convivencia*," *Jewish Social Studies*, n.s., 11, 2 (Winter 2005): 1–2. Ray goes on to argue that this is something of historical wishful thinking, contending, much in the same way I attempt to do here, that the Jewish populations were neither discernible as a single group, nor were the interreligious interactions as convivial before 1492 as they have hitherto been described.

12. Benjamin Braude and Bernard Lewis, "Introduction," in Braude and Lewis, *Christians and Jews*, 25–26. Braude and Lewis note here that "[t]he social background and social impact of Sabattianism have not been as thoroughly examined as has been the spiritual. It has been claimed that in the aftermath of exhaustion and disappointment Ottoman Jewry reinforced the power and authority of rabbinic leadership and in the process lost the wellsprings of its cultural and economic vitality. However, since the signs of the decline had first appeared somewhat earlier it is more likely that the Sabbatian outburst hastened and exacerbated an already ongoing process."

13. The most impressive compendium of Sephardic material culture in the Ottoman Empire is the diverse catalogue for the exhibition *Sephardi Jews of the Ottoman Empire: Aspects of Material Culture*, which was staged at the Israel Museum in Jerusalem in 1989, followed by the Jewish Museum in New York in 1990: see Esther Juhasz, ed., *Sephardi Jews in the Ottoman Empire: Aspects of Material Culture* (Jerusalem, 1990). Chapters are organized thematically, with a handful of objects attributed to Salonica. See also Gilles Veinstein, "Sur la draperie juive de Salonique (XVIe–XVIIe siècles)," *Revue du Monde Musulman et de la Méditerranée* 66 (1992–94): 55–62.

14. I am indebted to Professor Gülru Necipoğlu for pointing out these similarities to me and for encouraging me to consult Walter Denny with Sumru Belger Krody, *The Classical Tradition in Anatolian Carpets* (Ann Arbor, Mich., 2002), which offers numerous examples of mihrab and twin-column prayer rugs of both Jewish and Muslim patronage.

15. Benjamin Braude, "Community and Conflict in the Economy of the Ottoman Balkans, 1500–1650" (PhD diss., Harvard University, 1978), 25.

16. Esprit Marie Cousinéry, *Voyage dans la Macédoine, contenant des recherches sur l'histoire, la géographie et les antiquités de ce pays*, 2 vols. (Paris, 1831), 1: 53–54.

17. Braude, "Communities and Conflict," 26.

18. Ibid.

19. Ibid.

20. Jean de Jonville, "Mémoires de Jean Sire de Jonville," May 10, 1744, Archives nationales, Affaires étrangères, B1-996, #489, as quoted in Nicolas Svoronos, *Le commerce de Salonique au XVIII siècle* (Paris, 1956), 240n2.

21. Braude, "Communities and Conflict," 26.

22. Ibid.

23. Louis-Auguste Félix, baron de Beaujour, *A View of the Commerce of Greece, formed after an annual average, from 1787 to 1797*, trans. Thomas H. Horne (London, 1800), 162–67.

24. Ibid., 168–71.

25. Ronald T. Marchese, *The Fabric of Life: Cultural Transformations in Turkish Society* (Binghamton, N.Y., 2005), 130. Marchese indicates that what became known as "Turkish red" actually derived from earlier references to "Edirne red," a pigment associated with a particular variant of madder-dyed fabric that passed through trade routes connecting Edirne and Bursa around 1515.

26. Braude, "Communities and Conflict," 27. See also Marchese, *Fabric of Life*, 130–32.

27. Beaujour, *View of the Commerce of Greece*, 175–76.

28. Braude, "Communities and Conflict," 28–29.

29. Aḥmad ibn ʿAlī al-Maqrīzī, *Kitāb al-Mawāʿiẓ waʾl-iʿtibār fī dhikr al-khiṭaṭ waʾl-āthār*, ed. Gaston Wiet, 5 vols. (Cairo, 1913), 1:101–2.

30. Braude, "Communities and Conflict," 29.

31. Ibid.

32. Ibid., 30.

33. Ibid.

34. Mazower, *Salonica*, 52.

35. Braude, "Communities and Conflict," 31.

36. Ibid.

37. Ibid.

38. Ibid.

39. S. M. Imamuddin, *Muslim Spain, 711–1492 AD: A Sociological Study* (Leiden, 1981), 90.

40. Joseph F. O'Callaghan, *A History of Medieval Spain* (Ithaca, 1983), 618.

41. Mazower, *Salonica*, 54, notes how certain Jewish women in Salonica were derided by observers, travelers and neighbors alike, for wearing excessive jewelry. These were most likely pieces they brought with them from Spain rather than jewelry produced in the city—heirlooms that would be passed from mother to daughter. I would argue that since only certain women were wearing jewelry, it was probably the Castilian women, who were known to be richer than their Catalonian and Aragonese counterparts, which would confirm the supposition that it was the Castilian sector that controlled the production of *pano de cuenta*.

42. Braude and Lewis, "Introduction," in Braude and Lewis, *Christians and Jews*, 3–4.

43. Ibid.

44. Juhasz, *Sephardi Jews in the Ottoman Empire*, 126. Juhasz further cites Cecil Roth, *Doña Gracia and the House of Nasi* (New York, 2006), 103–4, who relates: "Dona Gracia and her entourage, who arrived in Istanbul in 1553, wore Venetian clothes by special permission from the authorities." Incidentally, in drawing conclusions from the paintings of European painters, we must take into account that they depicted Turkish women in European clothes, with which the painters would have been more familiar.

45. Juhasz, *Sephardi Jews in the Ottoman Empire*, 126.

46. This information is courtesy of the Jewish Museum of Thessaloniki, from flyers produced on Sephardic costumes, the text of which is available on their website: http://jmth.gr/web/thejews/pages/pages/ethno.htm, accessed on December 10, 2009.

47. Ibid.

48. Hans Dernschwam, as cited in Roth, *Doña Gracia and the House of Nasi*, 94, and Juhasz, *Sephardi Jews in the Ottoman Empire*, 124. It is, of course, also important to note that Moses Hamon, imperial physician to Süleyman the Magnificent, was also Sephardic. Extant depictions of him, however, do not necessarily fall in line with this particular chromatic characterization of his attire. In *Les quatre premiers livres des Navigation et peregrinations orientales* (Lyon, 1568), Nicolas de Nicolay includes a portait of Hamon wearing a tall red cap and long robes whose color cannot be deciphered because the engraving is rendered in black and white. The robe, nonetheless, appears to be of a lighter shade. It seems quite likely that as imperial physician, Hamon's sartorial protocol would have followed rules not applied at the imperial scale, if they were applied at all. Another engraving of a Jewish doctor, entitled "Juif de la Terre Sainte," by Henri Bonnart, from *Recueil d'estampes de costume du XVIIe siècle* (Paris, ca. 1680), also differs from this paradigm, showing a far more colorfully clad physician in a lush outfit that includes a tall cap and a robe lined with ermine. This physician had made a fortune proffering medicinal concoctions from rhubarb and some of his garments take on the light reddish hue of that plant. Bonnart based this etching on that of Eugene Roger, who recorded the same physician in his travelogue *La Terre Sainte* (Paris, 1646).

49. Juhasz, *Sephardi Jews in the Ottoman Empire*, 124.

50. See n. 44 above.

51. Nicolay, *Quatre premiers livres,* as cited by Mazower, *Salonica*, 56.

52. Victoria Finlay, *Color: A Natural History of the Palette* (New York, 2003), 174. For a more scientific analysis, see Jean-Philippe Echard, "The Nature of the Extraordinary Finish of Stradivari's Instruments," *Angewandte Chemie International Edition* 49, 1 (2010).

53. Ibid.

54. Ibid., 175–78.

55. As a relative newcomer to the architectural study of synagogues, I owe a debt of gratitude to Professor Krinsky, who oriented me toward some of the important issues to consider. I also wish to thank Professor Alina Payne for putting me in touch with Krinsky.

56. Katrin Kogman-Appel, "Hebrew Manuscript Painting in Late Medieval Spain: Signs of a Culture in Transition," *The Art Bulletin* 84, 2 (June 2002): 247.

57. Kogman-Appel, "Hebrew Manuscript Painting," 258. See also José Pijoán, "Aragonese Primitives," *The Burlington Magazine for Connoisseurs* 24, 128 (November 1913): 74–85, for a discussion that sets the figural images of the Haggadah from Aragon in the context of contemporaneous church paintings of the same region and period.

58. Albertos Nar, "Κοινοτική οργάνωση και δραστηριότητα της εβραϊκής κοινότητας της Θεσσαλονίκης," in *Tois agathois vasileuousa: Thessalonikē, historia kai politismos,* ed. Iōannes Chasiōtēs (Thessaloniki, 1997), 266–95.

59. The Yahia Synagogue is not attributed to a city of origin in any of the accounts consulted, but I am venturing that "Yahia" is referring to Yahia Ben Yahi III, also known as Jahia Negro Ibn Ya'isch, a Sephard born in Córdoba in 1115 into a line of rabbis said to be direct descendants of the Exilarchs of Babylon. Yahia Ben Yahi III was elected by King Alfonso I of Portugal (r. 1139–85) to be the chief rabbi of Portugal and spent the balance of his life in Lisbon, where he died in 1185. Interestingly, his descendants converted to Christianity at the time of the Inquisition, among them King Alfonso's mistress, Madragana Ben Aloandro, who happened to be a great-great-great-grandmother of Queen Victoria, by virtue of ties between the Portugese and British royal families. See António Caetano de Sousa, *História genealógica da Casa real portuguesa*, 13 vols. (Colmbra, 1946–54).

60. These can be found in Yaron Ben-Naeh, *Jews in the Realm of the Sultans: Ottoman Jewish Society in the Seventeenth Century* (Tübingen, 2008), 88–89.

61. Ben-Naeh, *Jews in the Realm of the Sultans*, 227–31. There is hardly any information on early-modern-era Ottoman synagogues, and there is only a bit more on the nineteenth

century: see Juhasz, *Sephardi Jews in the Ottoman Empire*, 37–51; Gila Hadar, "The Jewish Community of Tyre in the Nineteenth and Twentieth Centuries" (MA thesis, Tel Aviv University, 1996), 114–17 (in Hebrew); Marie-Christine Varol, *Balat, faubourg juif d'Istanbul* (Istanbul, 1989), 9–21. The Akhrida Synagogue in Istanbul now serves as an excellent reminder of the grander styles known in the seventeenth and eighteenth centuries. Also of note is the renovation of a synagogue in Ankara, which is documented by İlter Fügen in "Ankara'nin Eski Kent Dokusunda Yahudi Mahallesi ve Sinagog," *Belleten* 60 (1996): 719–31 (contains over thirty photographs). All of these authors cite Heath Lowry's work on Salonica.

62. See Abraham Galanté, *Histoire des juifs de Turquie* (Istanbul, 1984), 45–48, 217–21, 259–69. While these documents date from the nineteenth century, the dimensions of the buildings would likely not have changed over the years due to legal restrictions. This is also echoed in descriptions given by Veinstein, *Salonique*, 42–63.

63. I thank Dr. Karen A. Leal, Managing Editor of *Muqarnas*, for suggesting these ideas to me.

64. Ben-Naeh, *Jews in the Realm of the Sultans*, 227.

65. Ibid.

66. Aryeh Shmuelevitz, *The Jews of the Ottoman Empire in the Late Fifteenth and the Sixteenth Centuries: Administrative, Economic, Legal, and Social Relations as Reflected in the Responsa* (Leiden, 1984), 191.

67. See, for example, Nancy F. Marino, *Don Juan Pacheco: Wealth and Power in Late Medieval Spain* (Tempe, Ariz., 2006), 21.

68. Carol Herselle Krinsky, *Synagogues of Europe: Architecture, History, Meaning* (New York, 1996), 401–3.

69. Veinstein, *Salonique*, 172.

70. Shmuelevitz, *Jews of the Ottoman Empire*, 191.

71. The possibility seems quite strong that Levi ben Habib's father was the very first rabbi of the Gerush Sepharad congregation, as the rabbinical positions were often kept within the same family.

72. Levi ben Habib published his *responsa*, the Ladino equivalent of memoirs, under the title *Sh'elot u Tshuvot ha-Ralbah* in Jerusalem; these records have been translated by modern-day Ladino scholars and are referred to in Shmuelevitz, *Jews of the Ottoman Empire*, 191.

73. Ben-Naeh, *Jews in the Realm of the Sultans*, 88–89.

74. Ibid.

75. Jacob Rader Marcus, *The Jew in The Medieval World: A Source Book, 315–1791* (Cincinnati, 1999), 363–65.

76. Mazower, *Salonica*, 53.

77. This information is gleaned from a map insert in the back of Vasilēs Dēmētriádēs, *Topographia tēs Thessalonikēs kata tēn epochē tēs Tourkokratias, 1430–1912* (Thessaloniki, 2008 [repr., orig. pub. 1983]).

78. Paul Wexler, *The Non-Jewish Origins of Sephardic Jews* (Albany, 1996), 54.

79. Ibid.

80. See in particular Stefanie B. Siegmund, *The Medici State and the Ghetto of Florence: The Construction of an Early Modern Jewish Community* (Palo Alto, 2006), chap. 5, "Locating, Financing and Constructing the Ghetto," 201–22.

81. Ibid., 201.

82. Mazower, *Salonica*, 55.

83. Ibid.

84. As labeled in Cousinéry, *Voyage dans la Macédoine*, 1: 32–33. See also Pierre Pedrizet, "L'Incantada' de Salonique," *Monuments et Mémoires* 31 (1930): 51–90.

85. Mazower, *Salonica*, 55.

86. Cousinéry, *Voyage dans la Macédoine*, 1: iii.

87. As in Cousinéry, *Voyage dans la Macédoine*, 1: 32. See also Anonymous, *The Foreign Quarterly Review* 13 (1834): 445.

88. Samuel G. Armistead and Joseph H. Silverman, "A Judeo-Spanish Derivative of the Ballad of *The Bridge of Arta*," *The Journal of American Folklore* 76, 299 (Jan.–Mar. 1963): 16–17. An anonymous reviewer of this article has differed with Armistead and Silverman, contending that the Bridge of Arta actually refers to a bridge in Epirus, located further north, within modern Greek borders, close to the Albanian border. The reviewer contends that the toponym Narda is certainly that of Arta.

89. Ibid., 17–19.

90. Stuart Rossiter, *Greece*, The Blue Guide (Ann Arbor, Mich., 1977), 502.

91. Armistead and Silverman, "A Judeo-Spanish Derivative," 16–17.

92. Eyal Ginion, "Musulmans et non-musulmans dans la Salonique ottomane (XVIIIe siècle): L'affrontement sur les espaces et les lignes de démarcation," *REMM* (2005): 107–10. See also Michaël Molho and Joseph Nehema, *In Memoriam: Hommage aux victimes juives des Nazis en Grèce* (Thessaloniki, 1998).

93. Mazower, *Salonica*, 49.

94. Katherine Elizabeth Fleming, *Greece: A Jewish History* (Princeton, N.J., 2008), 121.

95. Ibid.

96. Mark A. Epstein, "The Leadership of the Ottoman Jews in the Fifteenth and Sixteenth Centuries," in Braude and Lewis, *Christians and Jews*, 104.

DAVID J. ROXBURGH

IN PURSUIT OF SHADOWS: AL-HARIRI'S *MAQĀMĀT*

During a short visit to the town of Rayy, in Iran, al-Harith b. Hammam al-Basri encounters crowd upon crowd of people "spreading with the spread of locusts, and running with the running of steeds," eagerly talking among themselves about a preacher,[1] who, they tell al-Harith, was even better than Ibn Sam'un.[2] Even though al-Harith realizes that he will face a noisy, bustling throng, he goes to the assembly place where men of all ranks are gathered, "ruler and ruled," "eminent and obscure," and finds an "old man, bowed and with a breast-hunch," wearing a turban in a conical form (*qalansuwa*) and a cloak (*ṭaylasān*), both external signs of the man's position as a preacher (fig. 1).[3] The man delivers a series of admonitions, exhorting the assembled company to abstain from greed and forbidden things, mend their ways, and live out their lives according to religious precepts. This continues until sunset approaches, when a petitioner comes forward and claims that he has been wronged by an official and that the governor—who is present at the assembly—has refused to hear his complaint. At the wronged man's urging, the preacher admonishes the governor and then launches into criticism of his behavior in a discourse directed at the prince, who is also at the gathering. The basic premise of the preacher's speech is that "the happiest of rulers is he whose people are happy in him."[4] The preacher publicly shames the governor and persuades him to repent and redress the wrongs inflicted on the petitioner. To make further amends, the governor not only thanks the preacher but also gives him presents and extends an invitation to his home.

After the preacher finishes his discourse, he revels in his success among the company and then exits the

place. Al-Harith, the narrator of the story, follows the preacher and "show[s] him a sharp glance." When the preacher notices al-Harith, he recites in verse:

> I am he whom thou knowest, Harith,
> The talker with kings, the wit, the intimate.
> I charm as charm not the triple-twisted strings,
> At times a brother of earnest, at times a jester.
> Events have not changed me since I met thee,
> Nor has vexing calamity peeled my branch;
> Nor has any splitting edge cloven my tooth;
> But my claw is fixed in every prey:
> On each herd that roams my wolf is ravaging;
> So that it is as though I were the heir of all mankind,
> Their Shem, their Ham, and their Japhet.[5]

It is through this poetry and the earlier discourse, an alternation between prose and poetry, that al-Harith recognizes the preacher's true identity—Abu Zayd al-Saruji—and credits him with a genuine act of piety exceeding that of 'Amr b. 'Ubayd.[6] Abu Zayd then leaves, "trailing his sleeves." The story ends when, to al-Harith's regret, Abu Zayd disappears from Rayy.

This *maqāma* (assembly, session, or séance), named for the town of Rayy, is the twenty-first of fifty.[7] It highlights key features of the other forty-nine assemblies. As in the majority of *maqāma*s (forty-nine out of fifty), al-Harith is the narrator and serves as a witness to Abu Zayd's profound linguistic eloquence, broad knowledge of the history of literature and culture, and erudition in all areas of human inquiry, as well as their highly specialized vocabularies. Abu Zayd is the hero—though one might also propose "anti-hero," depending on the reader's moral makeup and personal proclivities. In

Fig. 1. Abu Zayd preaches in the mosque before a crowd, *maqāma* 21, of Rayy. From a *Maqāmāt* of al-Hariri, copied and illustrated by Yahya b. Mahmud b. Yahya b. Abi al-Hasan b. Kuwarriha al-Wasiti, dated 7 Ramadan 634 (May 4, 1237), Baghdad (?), Iraq. Paris, Bibliothèque nationale de France, Ms. Arabe 5847, fols. 58b–59a. (Photo: © Bibliothèque nationale de France)

numerous *maqāma*s, it is only Abu Zayd's language—delivered mostly in oral discourse but sometimes also in written form—that gives him away. Sometimes Abu Zayd's identity is revealed to al-Harith in private, after al-Harith has pursued Abu Zayd; at other times it is discovered through a written note (*ruq'a*) left by Abu Zayd before his departure, and in still other *maqāma*s it is told by al-Harith to the assembled crowd in Abu Zayd's presence. The general purpose of Abu Zayd's use of language is alluded to in his final poem of *maqāma* 21, of Rayy, where he mentions the various roles that he assumes: Abu Zayd opines that whether in seriousness or in jest he is more beguiling than the "triple-twisted strings," a reference to the treble-toned string of a lute; that nothing and nobody have prevented him from

doing what he does; that through language he ensnares everyone he meets; he is unto a crowd of people what a wolf is to a sheepfold; and to emphasize his wide-reaching influence over humanity, Abu Zayd likens himself to Shem, Ham, and Japhet, the sons of Noah and heirs of mankind, all combined into one person.[8] Although Abu Zayd uses his linguistic brilliance and guile to dupe people, no one is ever really hurt as a result but is instead deprived of money, valuables, other personal possessions, or the kindness expected in light of the hospitality they extended to a stranger. Those tricked by Abu Zayd survive with bruised egos, their human frailties exposed.[9]

In *maqāma* 25, of Karaj (between Isfahan and Hamadan), al-Harith begins his narration by noting that

he had come to town to settle some business but that the winter weather was so severe there that he stayed indoors as much as possible. Work required that he leave his lodging one day and he came upon a crowd of people who had gathered around an old man nearly naked, save for a turban wrapped from a handkerchief and "breeched with a napkin" (i.e., a loincloth). (Later overpainting, perhaps a repair, has almost entirely concealed the naked man, who stands in the archway.) The inadequately dressed man addresses the crowd in verse (fig. 2):

> O people, nothing can announce to you my poverty
> More truly than this, my nakedness in the season of cold.
> So from my outward misery, judge ye
> The inward of my condition, and what is hidden of my
> state.
> And beware a change in the truce of fortune:
> For know that I was once illustrious in rank,
> I had command of plenty, and of a blade that severed;

> My yellow coins served my friends, my lances destroyed
> my foes.[10]

But his fortunes changed and he lost his social status. The man ends his poem with the final lines, "Who will cloak me either with embroidered garment or ragged coat/Seeking the face of God, and not my thanks?" and reverts to a discourse composed of rhymed prose (*sajʿ*). It is here that the nearly naked man makes an allusion to the "winter with its *kāf*s," and states that in prior years he had always been able to prepare for "the cold weather." Now, he remarks, "my arm is my pillow, my skin is my garment, the hollow of my hand is my dish." A person in the crowd challenges the man's pedigree, now that he has proved his erudition—evident from his speech—to which the old man retorts, "A curse on him who boasts of mouldering bones! There is no glory but in piety and choice scholarship," a sentiment amplified by a verse on the same theme.[11] The man then sat down,

Fig. 2. Abu Zayd, nearly naked, stands in a doorway and recites poetry to a crowd, *maqāma* 25, of Karaj. Paris, Bibliothèque nationale de France, Ms. Arabe 5847, fols. 74b–75a. (Photo: © Bibliothèque nationale de France)

collapsing into a shivering mass. It is at this moment that al-Harith, struck by literary elegances resembling those of al-Asma'i, takes a very close look at the man and recognizes him as Abu Zayd, who, he concludes, is using nakedness as a "noose for the prey."[12] Perceiving al-Harith's dawning recognition, Abu Zayd fears being exposed. On the spot he recites: "I swear by the shade of night and the moon, by the stars and the new moonlight, that none shall *cloak* me [*laysa yasturunī*] save one whose disposition is goodly, whose face is imbued with the dew of benevolence."[13] Here, Abu Zayd's choice of the word for "cloak me" (*yasturunī*: from the verb *satara*) was an intentional ambiguity. He knew al-Harith would understand the figurative meaning —"conceal me"—of his imperative, while other members of the audience would understand it simply in the literal sense of giving him clothes.[14] This appeal played to al-Harith's vanity and he took pity on Abu Zayd, giving him his fur coat. The other men at the gathering were similarly moved to feel sorry for the skimpily clad man and donated their furs and colored coats—so many that the man could hardly carry them away.

Al-Harith pursues Abu Zayd (fig. 3), who, in response to al-Harith's instructions not to go naked again, rebukes him for speaking about things of which he has no knowledge. Wanting to leave, agitated and angry, Abu Zayd adds that al-Harith should know his nature (*shinshinatī*) too well by now to hope for reform. Trying to cajole Abu Zayd, al-Harith offers that he could have exposed him to the crowd of onlookers but did not; if he had, Abu Zayd would not have received the donated clothing and "come off more coated than an onion."[15] And then comes the *quid pro quo*. When al-Harith asks Abu Zayd what he meant in his speech by the phrase "the *kāf*s of winter," Abu Zayd reminds him of a poem by Ibn Sukkara (d. 995–96) in which seven things—all beginning with the Arabic letter *kāf* ("k")—are spoken of as necessary to pass a winter in comfort: "A home, a purse, a stove, a cup of wine after the roast meat, and a pleasant wife, and clothing" (*kinn wa kīs wa kānūn wa kā's ṭil ba'd al-kabāb wa kuss nā'im wa kisā'*).[16] Abu Zayd concludes: "Surely an answer that heals is better than a

cloak that warms; so be content with what thou hast learnt and depart."[17] Al-Harith spends the winter missing his fur coat.

In *maqāma* 31, al-Harith travels from his home to the region of Syria (Sham) with the intention of trading. He pitches his tent at Ramla, where he encounters an encampment of pilgrims preparing to leave and continue their pilgrimage to Mecca. Al-Harith is moved to change his plans and joins them. When the caravan reaches Juhfa—the Syrian pilgrims' station—the pilgrims alight from their camels and start to unpack their belongings; a partly clothed man emerges from the mountains and starts to address the pilgrims in rhymed prose and verse on the duties of religion (fig. 4 [a and b]). According to him, the *ḥajj* did not consist simply of traveling to Mecca and enduring various physical ("emaciating of bodies") and emotional hardships ("separation from children") on the long road, but was also about abstaining from sin, maintaining "purity of submissiveness," and the "fervor of virtue." Thus, he urged the pilgrims to comprehend the full significance of what they were doing and continued to offer moral guidance through another extended oration. Once again al-Harith recognizes the man's true identity—he "sniffed the breeze of Abu Zayd"—and, happy to encounter him again, approached Abu Zayd, attaching himself "like the *lām* to the *alif*"—a metaphor of the written Arabic letters "L" and "A" spooning each other. But Abu Zayd rejects al-Harith, announcing that he had vowed not to associate with anyone, "neither ride together nor alternately with any one, neither make gain nor boast of pedigree, neither seek profit, nor companionship, nor else accommodate myself to him who dissembles."[18] As Abu Zayd was departing, he made one more speech to the pilgrims. In al-Harith's words, Abu Zayd then "sheathed the blade of his tongue, and went on his way." As the caravan journeyed on to Mecca, al-Harith continued to look everywhere for Abu Zayd but could never find him. *Maqāma* 31 is one of only a few of the fifty assemblies in which Abu Zayd behaves honestly—using eloquence for good purposes without any trace of a swindle.

Fig. 3. Abu Zayd confronted by al-Harith, *maqāma* 25, of Karaj. Paris, Bibliothèque nationale de France, Ms. Arabe 5847, fol. 76a. (Photo: © Bibliothèque nationale de France)

Fig. 4, a and b. Abu Zayd addresses a caravan of pilgrims, *maqāma* 31, of Ramla. Paris, Bibliothèque nationale de France, Ms. Arabe 5847, fols. 94b–95a. (Photo: © Bibliothèque nationale de France)

AL-HARIRI'S *MAQĀMĀT*: APPROACHES TO ITS STUDY AND THE WORD-IMAGE DEBATE

As these introductory selections suggest, there is much humor in Abu Muhammad al-Qasim b. 'Ali b. Muhammad b. 'Uthman al-Hariri al-Basri's *Maqāmāt* (Assemblies),[19] a *tour-de-force* of medieval Arabic literature, and chief among its works of belles-lettres. Although it is a text about the power of language to persuade, mostly discourse delivered by Abu Zayd *viva voce*, it was also transmitted in written forms, and al-Hariri's brilliance as an author could only be completely appreciated by actually seeing his text written in a manuscript. For its complete meaning and registers of literary operation to be properly understood, this was a text that required access to the physical book—seeing the writing and not merely hearing it recited. This aspect of the *Maqāmāt* is exemplified by such elements as palindromic sentences and poems or other texts written entirely with, or without, diacritical marks, such as in *maqāma* 26, "the spotted," where alternate lines in one discourse are composed of dotted or undotted letters. Arabic is a fully phonetic language, with each one of its letters corresponding to a unique sound (the use of homonyms, a set of repeated shapes to build the written alphabet, was remedied by a system of dots of various numbers and configurations to designate individual phonemes). While the audition of a correct recitation of the *Maqāmāt* would reveal differences between dotted and undotted letters, it was only through seeing the written text that the ingenuity and play of al-Hariri's constructions could be completely appreciated.

Apart from these ingenious devices—and al-Hariri's *Maqāmāt* is replete with them—the special difficulty and lexical gamesmanship of the author dictated that manuscript copies were fully vowelized and letter pointed, carrying the whole panoply of conventional orthographic signs (such as intensifications [doublings of consonants] and markers for indefinite nouns). In this respect, it approaches manuscript copies of the Koran and makes it unlike the vast majority of medieval Arabic texts.[20] Despite the many difficulties of its arcane and archaizing language (a lexicon of outmoded and learned meanings), countless copies of the *Maqāmāt* were produced—some 700 were authorized during al-Hariri's life—twenty commentaries were made, the best known by al-Sharishi (d. 1222), and an impressive number of illustrated copies, eleven in all, are extant from the period between the early thirteenth and fourteenth centuries.[21] Of these examples, this essay is concerned with one: the manuscript copied and illustrated by Yahya b. Mahmud b. Yahya b. Abi al-Hasan b. Kuwarriha al-Wasiti, dated May 4, 1237.[22] Notwithstanding its fame through frequent reproduction, this manuscript has been selected for three main reasons, each one related to its special status: the first is that al-Wasiti copied the text and painted the narrative images, strong evidence of his agency in conceptualizing an interpretation of al-Hariri's text; the second concerns al-Wasiti's capacity to innovate while at the same time working within the bounds of established practices of the art of the book and painting; the third—and perhaps most important—has to do with the incomplete, often misleading, presentation of the 1237 *Maqāmāt* manuscript through scholarly publications.

Although al-Hariri (d. 1122), poet and philologist, became synonymous with the genre, he notes in the preface to his *Maqāmāt* that it had been "devised" by Badi' al-Zaman al-Hamadhani (d. 1008).[23] Al-Hariri probably composed his *Maqāmāt* between 1101 and 1108. In the field of literary studies, much of the scholarship about the *Maqāmāt* has focused on the relationship between the texts composed by al-Hamadhani and al-Hariri, in addition to the origins and features of the genre. The concept of a gathering of anecdotes is believed to stem from such models as Abu 'Uthman 'Amr b. Bahr b. Mahbub al-Jahiz's *Kitāb al-Bukhalā'* (Book of Misers; before 869), a penetrating, humorous, and satirical work on the avarice of non-Arabs, with a whole chapter devoted to vagabonds; Abu Hanifa Ahmad b. Dawud al-Dinawari's *Al-Akhbār al-ṭiwāl* (Tales of Long-Lived Men; before 903), an entertaining history written from an Iranian perspective; and Abu 'Ali al-Muhassin al-Tanukhi's *Nishwār al-muḥāḍara* (Desultory Conversations; before 994), a massive record of events, anecdotes, and actions that the author deemed important enough to commit to writing.[24] Al-Husri (d. 1022), a scholar living in North Africa, asserted that al-Hamadhani's *Maqāmāt* imitated a collection of forty tales composed by Ibn Durayd (d. 934),

another Arab poet and philologist born in Basra.[25] A. F. L. Beeston observes the staggering range of variables in the anecdote: it may be very short or long, and "in content it may deal with a humorous or pithy saying, a remarkable event, a piece of literary criticism, a riddle, or even (in the Arabic ambience) a grammatical observation or a well-expressed piece of religious homily."[26] But he identifies three traits common to all: the anecdote is introduced against a background of contingent detail, which enlivens it; the author presents the anecdote as true or truthfully narrated; and each anecdote stands alone as an autonomous, independent component.[27]

In the 800s, developments in Arabic literature took place of importance to the later *Maqāmāt*, especially al-Hariri's work. These changes involved the combination of the oratorical style of the Friday sermon (*khuṭba*), "marked by strong parallelism and 'balance' but devoid of rhyme," which were "married to ornamental features derived from verse, namely rhyming and tropes (the latter collectively referred to as *badī*'), producing a new kind of *saj*'..., which rapidly achieved a tremendous dominance over prose writing."[28] By the mid-900s, the use of *saj*' became commonplace in religious sermons and in secular epistles (*risāla*).[29] *Saj*' has been described as a rhythmical prose that uses "rhythmic units which are generally quite short..., terminated by a clausula," with the units "grouped sequentially on a common rhyme."[30] Al-Hamadhani's contribution was to apply *saj*' to a compilation of anecdotes of the sort made by al-Tanukhi, whose dominant theme was, in Beeston's words, "the tatterdemalion who is nevertheless a miracle of cleverness and eloquence, and the final anagnorisis in which he proves to be something other than he appears."[31] Unlike al-Tanukhi, al-Hamadhani presents the majority of his anecdotes on the authority of one man.[32] Building on al-Hamadhani's model, al-Hariri consistently introduces each anecdote on the authority of the narrator, al-Harith b. Hammam al-Basri, always paired with the same hero, Abu Zayd al-Saruji. This establishes a consistent structure of narrative presentation throughout al-Hariri's *Maqāmāt*. Another development from al-Hamadhani's model is al-Hariri's systematic application of *saj*' to his *Maqāmāt*, fashioning a text dominated by rhymed and rhythmic prose

interspersed with poetry. He also demonstrates a capacity for poetic composition and invention that outstrips al-Hamadhani: of all the poems appearing in his *Maqāmāt*, al-Hariri borrows only a handful from other authors.[33]

While historians of Arabic literature and language have studied al-Hariri's *Maqāmāt* in a relatively continuous chain of scholarship and publication going back to the 1800s—with recent research on the text as a literary work to be discussed later—the same cannot be said for art historians. Illustrated copies of the *Maqāmāt* of al-Hariri were only occasionally exhibited and published over the course of the early 1900s, and enjoyed their greatest public exposure in 1962 in Richard Ettinghausen's book titled *Arab Painting*,[34] which focused on two illustrated manuscripts, the 1237 *Maqāmāt* made by al-Wasiti and the undated copy in St. Petersburg (Institute of Oriental Manuscripts, S23), datable to circa 1225–35. Ettinghausen styled both as embodiments of the "apogee" of painting in Arabic manuscripts, made at a watershed, on the eve of the long "decline" that he traces from the second half of his book until the eighteenth century (the two *Maqāmāt* appear precisely in the middle of *Arab Painting*, a true fulcrum!). The most comprehensive effort to analyze the illustrated *Maqāmāt*s as a group was offered by Oleg Grabar in 1984.[35] Grabar focused on thirteen illustrated copies of al-Hariri's *Maqāmāt*, eleven of them made in the 1200s through 1300s, to prepare the groundwork for an examination of how the Arabic text was visualized and integrated with its images, adopting an approach forged through the study of manuscripts from Byzantium and medieval Europe.[36]

But ultimately Grabar's interest migrated to other questions he had considered in earlier studies: how the illustrated *Maqāmāt* participated in a widespread contemporary production of objects bearing figural imagery—described by Ettinghausen as an "efflorescence" or "flowering" of the arts—and how such objects, particularly ceramics, metalwork, and books, reflected the interests and impulses of a broad medieval clientele, "the mercantile, artisanal and scholarly bourgeoisie of the larger Arabic-speaking cities."[37] For Grabar, the *Maqāmāt* both reflected and embodied the personal and collective priorities of a literate, Arabic-speaking,

urban social formation that became active as patrons and consumers.[38] In a subsequent monograph, Shirley Guthrie developed Grabar's line of thought, seeing in the illustrations to al-Hariri's *Maqāmāt*—especially the 1237 copy fashioned by al-Wasiti—a "visual evidence amplifying and complementing literary and historical accounts of the medieval Near East," hence approaching the paintings as a form of medieval social reportage.[39] Guthrie was also responding to Ettinghausen's notion of a "realism" in subject matter and pictorial style that originated in the art of the Fatimid dynasty of North Africa and Egypt between the late 900s and 1179 and which continued under the Seljuq and Ayyubid dynasties of Greater Iran, Syria, and Egypt up through the 1250s, when the Mongol conquests brought about a large-scale aesthetic and artistic realignment across these lands.[40] When Grabar had the opportunity to revisit the 1237 *Maqāmāt* through the publication of a facsimile edition in 2003, he did not develop new positions on the manuscript but reiterated his main formulations of 1984.[41] In his 2013 book about the same *Maqāmāt* manuscript, David James hews close to approaches to the study of the *Maqāmāt* that he developed beginning in the mid-1960s and published in an article in 1974.[42]

Despite frequent acknowledgements of the extraordinary artistic accomplishments evident in the 1237 *Maqāmāt*, as well as in related manuscripts, and of the complex and ambitious pictorial cycles created to accompany al-Hariri's text, art historians have not attended to the full range of ways in which the text—along with the manuscript as a complete object—is affected by narrative paintings.[43] The absence is easy to explain because general assessments of al-Hariri's text—adopted by art historians from the field of literary study—curtailed the variety of possible approaches to interrelations between word and image. Already in 1959 David Storm Rice remarked that the text "requires no illustration" and that the stories were "a mere pretext for the masterly display of lexicographical knowledge," suggesting that the illustrations were "so many distractions to the reader." After all, Rice argues, there is no evidence of illustrated copies from al-Hariri's lifetime, or in the immediate generations that followed, including an extant manuscript copied by the author's

very own grandson in 1162.[44] In 1962, Ettinghausen opined that the artists of the *Maqāmāt* were "oblivious to the philological pyrotechnics of the *Maqāmāt*;"[45] in 1974, James observed that "[t]he illustrative potential of the 50 tales is meagre;"[46] and in 1974, and again in 1984, Grabar framed a series of provocative questions about the role of images in manuscripts of al-Hariri's *Maqāmāt* based on the same set of assumptions: "And what do these images do to a text which was only valued for its verbal acrobatics?... Are these images commentaries to be seen and appreciated with the text or pictures which were perhaps inspired *by* the text but which are meant to be enjoyed separately as visual experiences?"[47] and "Why was this particular text illustrated? And how were subjects found to illustrate a text that a priori did not lend itself to visual expression?" All the while Grabar maintained that "the purpose and success of the story lie exclusively in its language, not in its narrative."[48]

These observations only yield a conundrum for art history: if the primary function and interest of al-Hariri's *Maqāmāt* do not lie in the frame stories, narrative emplotments presented through fifty discrete components, but rather concern feats of language that could not be visualized in forms commensurate to the complex registers of the text, why were so many of the extant *Maqāmāt* from the 1200s illustrated? Indeed, why is the *Maqāmāt* among the most *heavily* illustrated Arabic texts of the early 1200s? In response to these questions, Grabar and other scholars offered answers extrinsic to the text, conceiving of the extensively pictorialized *Maqāmāt* as indices of real life, reflective of the tastes, proclivities, and concerns of an urban and literate "bourgeoisie," even though it was not possible to link any manuscript to a specific patron.[49] It was this presumed audience, catered to by artists, that found in al-Hariri's text—specifically through its narrative components, its entertaining and satirical stories—an opportunity to express cultural and social symmetries between their time and that of al-Hariri's text. But it bears emphasis that this approach to the text—which prioritizes al-Hariri's narratives—was simply a supplement to another audience, the learned commentators on the *Maqāmāt*, who in their long history of critical reception had focused on linguistics and lexicography, as well as on al-Hariri's command of Arabic language

and literature, rather than on his gifted storytelling. By privileging what medieval commentators valued most about al-Hariri's *Maqāmāt*, modern literary historians prompted art historians to move away from the text and explain the preponderance of paintings through other causes.

At one level, the conundrum is easily dismissed, or abated, if one restores the visual properties of the written text. Al-Hariri's *Maqāmāt* is certainly a mode of verbal play, a form of game, which Abd al-Fattah Kilito has described as a "poetic calligraphy" and an "expression of the desire to explore the possibilities of language, to tantalize experience through the resources of an alphabet."[50] As noted above, al-Hariri deploys, among other feats of mastery, palindromic prose sentences and verses, and sentences written entirely with, or without, diacritical marks, both pointed and unpointed letters

(fig. 5). On a sensorial register, these effects can be more readily *seen* than heard. When he copied al-Hariri's text, moreover, al-Wasiti structured it to render monologue distinct from dialogue, to separate out poetry from prose, and to emphasize for his reader/viewer, among many other literary phenomena, a sequence of riddles (fig. 6). Here the assembled company are presented with ten versified riddles—each one introduced by the prose line "then…. he said/saying/recited" (*thamma … qāla/inshā yaqūlu/anshada*). The riddles themselves consist of two couplets each, but use different meters.[51] Throughout the manuscript, prose text is written across the full width of the page—the ligatures connecting letters subtly stretched or contracted to make the words in a line comfortably fit the assigned width without bunching or over extension—to produce the impression of blocks of text contained within an invisible

Fig. 5. Text page with palindromic sentences and verses, from *maqāma* 16. Paris, Bibliothèque nationale de France, Ms. Arabe 5847, fol. 43a. (Photo: © Bibliothèque nationale de France)

Fig. 6. Text page with versified riddles, from *maqāma* 36, of Maltiyya. Paris, Bibliothèque nationale de France, Ms. Arabe 5847, fol. 111a. (Photo: © Bibliothèque nationale de France)

rectangular border (the effect is comparable to a justi-
fied text), framed by a margin on four sides. Poetry is
arranged in one, two, three, or four columns, centered
on the page when single and double, extending to the
full width of the prose text when tripled or quadrupled.
On the page, the voice of each speaker—al-Harith and
Abu Zayd—is emphasized amid continuous text by the
expansion of the letter *lām* making up the verb *qāla* ("he
said"), for example. The formal patterning of text
emphasizes and renders legible the various structures
and modes of discourse. And on a larger level, each of
the fifty *maqāma*s is introduced by a separate title in
thuluth script, executed either in gold outlined in black
ink or in red pigment, that follow a consistent pattern
of naming the *maqāma*s by their number (1–50).[52]

In doing all of these things, al-Wasiti was simply fol-
lowing a set of scribal practices developed long before
in the culture of the Arabic book and used throughout
earlier dated copies of al-Hariri's *Maqāmāt*, whether
illustrated or not.[53] In light of all of these features, it is
clear that the written Arabic text was a sufficiently ade-
quate visual manifestation to obviate pictorial attempts
at its translation, whether abstract or figural. One might
imagine the improbable representation of the list com-
prising the seven "*kāf*s" of winter from *maqāma* 25, of
Karaj—home, purse, stove, cup of wine, roast meat,
wife, clothing—and not the figural depiction of Abu
Zayd carrying a bag of looted furs and robes confronted
by al-Harith (fig. 3). But such a conceptual form of visual
rendering was not developed anywhere among the
broad range of genres of Arabic literature that were
joined by painted or drawn images. A vast number of
images in different kinds of Arabic texts from the medi-
eval period favor the mimetic representation of people
or things and depictions of narrative, even when the lat-
ter are not called for by the text.[54]

There is one *maqāma*, among others, in which the
written text plays a prominent role. In *maqāma* 7, of
Barqa'id, a town near Mosul, a blind man appears in a
mosque with an old woman to guide him (fig. 7). As the
preacher delivers his sermon from the pulpit, al-Harith
watches the man—who has his eyes closed—and
woman move through the mosque. The man takes
"scraps of paper that had been written on with colours
of dyes in the season of leisure" from a bag slung over

his arm, and the woman delivers them to the laps of
members of the congregation who appear to be chari-
table.[55] One falls into al-Harith's hands, and when he
reads it he discovers alliterative and punning verses.
Al-Harith immediately suspects that the blind man
might be Abu Zayd. Now the woman works her way
through the assembly to collect the papers and dona-
tions and then leaves. When she is united with Abu
Zayd, she discovers that one scrap of paper is still miss-
ing. As the woman returns to the mosque to retrieve it,
she meets al-Harith, who says that he will pay her one
dirham if she reveals its author's identity. She tells him
only that the man is from Saruj and grabs the coin.
Al-Harith, fearful that it is Abu Zayd and that he has
actually gone blind, eventually meets up with the trick-
ster. When al-Harith is alone with Abu Zayd, the hero
opens his eyes to reveal perfect eyesight. In its use of
the written text as a means of exchange, this *maqāma*
further thematizes the written form of language and
hence discourse as a visual medium.

A second dimension to the word-image conun-
drum—which has persisted as a red herring—relates
to the modern critical reception of al-Hariri's *Maqāmāt*.
Though early literary historians, the learned people who
wrote commentaries on the text, clearly favored its ver-
bal acrobatics and scholarly language—really an anach-
ronism in its own time—recent approaches to the fifty
*maqāma*s have restored the importance of narrative
and also suggested a thematic coherence across the fifty
assemblies.[56] But of course this new appreciation of the
text is one already suggested by those several medieval
manuscripts that contain developed programs of paint-
ings: the point to be emphasized here is that the
Maqāmāt was illustrated not only because the stories
were appealing and entertaining but because the sto-
ries also played an integral role in the larger themes of
al-Hariri's text, one of which is the play between truth
and falsehood, between semblance and dissemblance.[57]

These problems between word and image can also
be addressed by a shift in emphasis. What happens if
we view the *Maqāmāt* text as staging a particular form
of collaboration with images, a potential to be realized
in some illustrated versions of it? Instead of emphasiz-
ing what is perceived as an irreconcilable difference
between the capacities of word and image—and

Fig. 7. Abu Zayd in a mosque pretending to be blind and led by a woman through the congregation of worshippers, *maqāma* 7, of Barqaʿid. Paris, Bibliothèque nationale de France, Ms. Arabe 5847, fol. 18b. (Photo: © Bibliothèque nationale de France)

lamenting the absence of unlikely visual manifestations of the text—can we think of proper content not only as information but also as theme? If we approach the text of al-Hariri's *Maqāmāt* as thematizing discourse, the pragmatics of communication between people, then the narrative components would be a highly appropriate choice for the illustrations precisely because of their discursive potential. If this is accepted, it is hardly surprising that the frame stories should have been al-Wasiti's primary choice.

The next four sections of this study expand upon this hypothesis about illustrated copies of al-Hariri's *Maqāmāt* to explore some of the implications of the parallel life of word and image, in addition to gauging their cumulative effect in relation to each other (intertwined as they are on the page). Through analysis of the 1237

Maqāmāt, I examine the frame story and visualizations of discourse; the structure of the *maqāma* and the *Maqāmāt*; "Confession," *maqāma* 50, of Basra; and, in the conclusion, the "pursuit of shadows."

THE 1237 *MAQĀMĀT* COPIED AND ILLUSTRATED BY AL-WASITI

The 1237 *Maqāmāt* opens with an illuminated title—a broad rectangle flanked by two discs—executed in gold, black ink, white, and blue opaque pigments. The simple title, *al-maqāmāt al-ḥarīrīya*, is rendered in a white *thuluth* script set over an animated leafy scroll (fig. 8). It is followed by a double-page painting (fols. 1b–2a) of an audience divided over the two pages,

Fig. 8. Illuminated title page. Paris, Bibliothèque nationale de France, Ms. Arabe 5847, fol. 1a. (Photo: © Bibliothèque nationale de France)

parting knowledge to students.[60] These kinds of images establish through representation the basis of the authority of the text as a form of visual license, but also underscore a cultural concern with the transmission of knowledge and the biographical foundation of each discipline.[61] Al-Hariri's preface begins immediately on the next page, introduced by a caption in *thuluth* script, painted in gold and outlined in black, and each individual *maqāma*, also separately captioned, follows in sequence number one through fifty, the ninety-nine paintings interspersed among the remaining folios (see table 1).[62]

The 1237 *Maqāmāt* is one of only a very few medieval illustrated Arabic manuscripts that gives the name of the illustrator, in this case the same person who copied the text. While the colophon provides these details, al-Wasiti's extended name tracing four generations, and a detailed timing of the manuscript's completion—"at the conclusion of the day, Saturday 7 Ramadan, [in] the year 634 [May 4, 1237]" (*ākhir nahār yawm al-sabt sādis shahr Ramaḍān sanati arba'a wa thalāthīn wa sittami'a*)—there is no mention of a place or patron (fig. 9). The location of production of the 1237 *Maqāmāt* is generally believed to have been Baghdad, a hypothesis based on stylistic comparisons to other dated and located manuscripts, as well as sheer probability.[63] These brief details provide some sense of the scope of the work—the general sequence and internal organization of the manuscript—and underscore a key point, one noted by several scholars: because al-Wasiti was both scribe and illustrator, when he wrote out al-Hariri's text he decided where to leave gaps for illustrations, how they would be sequenced, and how to position the illustrations on each page.[64] The paintings are often closely keyed to specific lines of the text. As a totality, the paintings must be thought of as completely integrated with the written text.

The frame story and visualizations of discourse

Kilito reduced each of the fifty *maqāma*s to a scheme: the arrival of the narrator (*rāwī*) in a town; the encounter with the hero (*balīgh*), who is disguised; the discourse; reward; recognition; reproach; justification; and parting.[65] This scheme is applicable to almost every *maqāma*—with some permutations/reversals in se-

each scene framed inside borders filled with vegetal forms, the innermost one also inhabited by animals. In each of the framed images a crowd gathers below a secular ruler and a scholar, who are elevated above the fray on fancy seats. The gesture of the seated scholar figure—posed sideways, the secular ruler frontal—indicates that the discourse is underway.[58] The page probably depicts the action of dedication, the formal recitation of a work by its author to its intended dedicatee, in this instance a member of the Turkic or Kurdish military elite (shown by the fur hat bearing a metal plaque).[59] While the addition of a figural frontispiece is a common practice in Arabic books, it can also be connected to the author-portrait tradition developed in manuscripts like the *De Materia Medica*, Dioscorides' herbal, which opened with a portrait of the author im-

Table 1. The 1237 *Maqāmāt* of al-Hariri (Paris, Bibliothèque nationale de France, Ms. Arabe 5847).

Maqāma number and name	Folios with paintings					# of images	Double-page compositions
Prefatory materials							
Illuminated title	1a						
Enthronement and audience	1b	2a				2	1
1. "of San'a"	3b					1	
2. "of Hulwan"	4b	5b	6b			3	
3. "of the coin" (of Qayla)	7a	8b				2	
4. "of Damietta"	9b	10a	11b			3	1
5. "of Kufa"	12b	13b	14b			3	
6. "of Maragha"	16a					1	
7. "of Barqa'id"	18b	19a				2	1
8. "of Ma'arra"	21a	22a				2	
9. "of Alexandria"	25a					1	
10. "of Rahba"	26a	27a				2	
11. "of Sava"	29b					1	
12. "of Damascus"	30b	31a	33a			3	1
13. "of Baghdad"	35a					1	
14. "of Mecca"	37b	38a				2	1
15. "the legal"	40a	41a				2	
16. "of the Maghrib"	42a	43b	44a			3	
17. "the reversed"	46b					1	
18. "of Sinjar"	47b	48a	50b	51a		4	2
19. "of Nasibin"	52b	53a				2	1
20. "of Mayyafariqin"	55b	56a	57a			3	1
21. "of Rayy"	58b	59a				2	1
22. "of the Euphrates"	61a					1	
23. "the poetic"	63b	64a	67b			3	1
24. "of Qati'at al-Rabi'"	69b					1	
25. "of Karaj"	74b	75a	76a			3	1
26. "the spotted"	77a	79a				2	
27. "the Bedouin"						0	
28. "of Samarqand"	84b	86a				2	
29. "of Wasit"	89a	90a				2	
30. "of Tyre"	91b	92a				2	1
31. "of Ramla"	94b	95a				2	1
32. "of Tayba"	100b	101a				2	1
33. "of Tiflis"	103a					1	
34. "of Zabid"	105a	107a				2	
35. "of Shiraz"						0	
36. "of Maltiyya"	110a					1	
37. "of Sa'da"	114b	117b				2	
38. "of Merv"	117b					1	
39. "of Oman"	118a	119b	120b	121a	122b	5	1
40. "of Tabriz"	125a	126a				2	
41. "of Tinnis"	130a	130b				2	
42. "of Najran"	131b	133b				2	
43. "the virginal"	134a	138a				2	
44. "the wintry"	139b	140a	143a			3	1
45. "of Ramla"	146a					1	
46. "of Aleppo"	148b	152a				2	
47. "of Hajr"	154b	155b	156a			3	
48. "of Haram"	158b					1	
49. "of Sasan"	160b	162b				2	
50. "of Basra"	164b	166a				2	

Fig. 9. Colophon. Paris, Bibliothèque nationale de France, Ms. Arabe 5847, fol. 167b. (Photo: © Bibliothèque nationale de France)

quence—and serves as a useful diagram for the literary structure of the frame story in each one. James divided the fifty *maqāma*s into three kinds, which he names "standard plot," "continuous dialogue," and "compound" or "extended" plot. In the standard plot there is one major and minor part, and a change of scene and character (*maqāma*s 1, 2, 3, 6, 7, 11–14, 17, 20, 21, 25, 28, 32, 33, 35, 37, 38, 40, 41, and 48); the continuous dialogue is marked by a "constancy of characters, and permanence of location" (*maqāma*s 24, 36, 42, 46, and 49); and in the compound, or extended plot, the *maqāma* is not easily divided into two or three areas of dialogue because frequent changes of scene and character occur (James further subdivides this category into three sections: A) *maqāma*s 5, 15, 16, 18, 26, and 43; B) *maqāma*s 29, 34, 39, 47, and 50; and C) *maqāma*s 4, 8–10, 19, 22, 23, 30, 31, 44, and 45).[66]

Many of the individual paintings in the 1237 *Maqāmāt* depict discrete moments in time, developed from often extremely short descriptions in the text, while some double-page paintings—appearing on facing pages of a manuscript opening ("b" folio to "a" folio)—represent a single moment divided between two images, which are meant to be read as a continuous temporality (figs. 1, 2, and 4). On rare occasions, paintings appearing on either side of an opening are to be understood as discrete moments in time happening in different locations (fig. 22).[67] The ninety-nine paintings in the 1237 *Maqāmāt* are evenly distributed across the fifty *maqāma*s, which can be broken down thusly: two have no paintings; fourteen have one painting; twenty-three have two paintings; ten have three paintings; one has four paintings; and one has five paintings (table 1).[68] Art historians have explained the distribution through the inherent narrative potential of each *maqāma*—for example, *maqāma* 39, of Oman, richly illustrated by five paintings—by the additional artistic impulse to envision and depict scenes scarcely mentioned in, or even required by, the text.

Maqāma 2, of Hulwan, is illustrated with three sequential images over six pages (or three folios). In the first, al-Harith meets Abu Zayd at Hulwan and they leave each other's company, although moving in a direction opposite to the text (fig. 10). Al-Harith next travels to Basra, where a man "with a thick beard and a squalid aspect" (Abu Zayd) enters the town library (a "meeting place of residents and strangers"), sits in the back row, and proceeds to join the assembly in a learned discussion of poetry, demonstrating his excellent knowledge of poetry, its interpretation, and criticism (fig. 11).[69] In the third painting, Abu Zayd is portrayed standing up and leaving a group of seated men at the end of the *maqāma*, after al-Harith has recognized him (fig. 12). Before Abu Zayd does this, al-Harith asks what has caused his beard to go gray and make him unrecognizable. Abu Zayd responds with another verse in which he cautions al-Harith that no man can escape the deleterious effects of time and fortune: though life may go well one day, it is but a deceitful impression for it will turn bad the next.

Maqāma 10, named after Rahba, is illustrated with two paintings: a disagreement between an old man and

Fig. 10. Al-Harith meets Abu Zayd, *maqāma* 2, of Hulwan. Paris, Bibliothèque nationale de France, Ms. Arabe 5847, fol. 4b. (Photo: © Bibliothèque nationale de France)

a handsome slave boy (*ghulām*)—the old man had accused the slave of killing his son—results in their appearance before the governor (*wālī*) (fig. 13). During their meeting with the governor, who is portrayed holding a lance and seated on an elevated throne attended by a boy who hides behind him, the old man attests, in a number of verses, to the accused slave's beauty. This ruse—the old man is of course Abu Zayd—was pursued with the intention of moving the governor to buy the slave and take him into his household. Abu Zayd,

meanwhile, grabs the arm of the beautiful slave, dressed in enviable finery. Desiring to save the slave from the old man's clutches, the governor promises to pay a sum of one hundred *dīnār*s, except the purse cannot be raised immediately. Later it transpires that the slave is none other than Abu Zayd's son and his accomplice. Abu Zayd promises to wait with him in the courtyard until the sum can be raised and is joined by al-Harith, the meeting depicted in the second of the two paintings illustrating *maqāma* 10 (fig. 14). Like the other paintings

Fig. 11. Abu Zayd and al-Harith meet in a library at Basra, *maqāma* 2, of Hulwan. Paris, Bibliothèque nationale de France, Ms. Arabe 5847, fol. 5b. (Photo: © Bibliothèque nationale de France)

discussed so far, a single narrative moment is represented and the principal visual elements pick up on cursory textual cues. Various props are used to identify the location—a strip of brick for the courtyard and a large cushion. Across the sequence of paintings in the 1237 *Maqāmāt*, these "locators" include a range of furnishings (pillows, curtains, thrones, stools, and lamps), portable objects of different types and use (glass, ceramic, and metalwork), minbars (fig. 1), mihrabs (fig. 7), and tents. In some paintings, these elements are

incorporated into developed architectural spaces defining specific building types—mosques (fig. 7), libraries (fig. 11), and domestic spaces, among others.

Similar visual devices are used to portray outdoor activities. For example, the seafaring scene from *maqāma* 39 (fol. 119b), named after Oman, shows a boat floating on rippled water. Gardens or other outdoor venues can be shown by the economy of a single tree or a flowering, verdant ground line (*maqāma* 32, of Tayba, fol. 100b). In paintings of buildings, the environments

Fig. 12. Al-Harith and a crowd of people say goodbye to Abu Zayd, *maqāma* 2, of Hulwan. Paris, Bibliothèque nationale de France, Ms. Arabe 5847, fol. 6b. (Photo: © Bibliothèque nationale de France)

of discourse are staged as cutaways composed of single or multi-storied spaces, as in the tavern of *maqāma* 12, of Damascus (the taverns were located in the town of 'Ana, fol. 33a).

Throughout these discrete temporalities—depicted as single paintings or as pairs of paintings appearing on facing pages of the open manuscript—a shorthand of repetitive visual forms is applied that together make up the morphology of al-Wasiti's pictorial means. In each painting, a distinct emphasis is given to representing acts of communication. Scenes are very rarely populated by a single figure (fols. 51a, 101a, 121a, and 143a); more frequently they comprise two people, Abu Zayd and al-Harith (fols. 4b, 8b, 14b, 37b, 40a, 41a, 44a, 57a, 76a, 79a,

86a, 100b, 117b, 130a, 130b, 134a, 160b, 162b, and 166a), three people (fols. 3b, 10a, 11b, 13b, 27a, 67b, and 90a), or, with still greater frequency, groups, even throngs, of people assembled in different venues (fols. 5b, 6b, 7a, 9b, 12b, 16a, 18b, 19a, 21a, 22a, 25a, 26a, 29b, 30b, 31a, 33a, 35a, 38a, 42a, 43b, 46b, 47b, 48a, 50b, 52b, 53a, 55b, 56a, 58b, 59a, 61a, 63b, 64a, 69b, 74b, 75a, 77a, 84b, 89a, 91b, 92a, 94b, 95a, 103a, 105a, 107a, 110a, 114b, 118a, 119b, 120b, 122b, 125a, 126a, 131b, 133b, 138a, 139b, 140a, 146a, 148b, 152a, 154b, 155b, 156a, 158b, and 164b). These scenes universally emphasize verbal communication, but the most emphatic and dramatic exchanges are projected by those paintings composed of fewer figures. Though mute, the paintings conjure discourse of various

Fig. 13. Abu Zayd and the youth before the governor, *maqāma* 10, of Rahba. Paris, Bibliothèque nationale de France, Ms. Arabe 5847, fol. 26a. (Photo: © Bibliothèque nationale de France)

Fig. 14. Al-Harith with Abu Zayd and the youth, *maqāma* 10, of Rahba. Paris, Bibliothèque nationale de France, Ms. Arabe 5847, fol. 27a. (Photo: © Bibliothèque nationale de France)

forms—monologue, dialogue, and communication among groups of people—and bustle with the activities of human exchange: the primary mode of sociability, human interaction, occurs in al-Hariri's *Maqāmāt* through speech. In pictorial terms, discourse is conveyed through the pose of the figure, whether sitting or standing, the tilt of the head, and variations in a vocabulary of hand and arm gestures, including the outstretched open hand or hands, a raised and extended arm, a pointed finger. A finger held to the lips signals astonishment or cogitation. In nearly every painting, regardless of the number of figures involved, al-Wasiti portrays a speaker and his audience. The viewer's apprehension of communication in process is further enhanced by the constant animation of bodies that adopt different positions in relation to each other and

to the viewer. The visual code of discourse is made especially dramatic by al-Wasiti's richly polychromed compositions, which form sharp contours and stark contrasts against the unpainted paper grounds that enclose them. The general absence of framing—except in those examples where architecture becomes a *de facto* frame inhabited by people and their actions—lends the paintings a still more immediate relationship to the text and the paper folios that they occupy.

The structure of the Maqāma *and the* Maqāmāt

Al-Hariri's *Maqāmāt* begins with a preface and ends with a confession—which finds a contrite Abu Zayd in al-Hariri's hometown of Basra—but nothing requires that the intervening forty-nine *maqāma*s be read in nu-

merical order: "there is no chronological implication in the sequence."[70] D. S. Richards' analysis of manuscripts of al-Hamadhani's *Maqāmāt* indicates that the order of the *maqāma*s differs in the earliest manuscripts of the text, a fact that causes him to question J. N. Mattock's supposition that al-Hamadhani intended his *Maqāmāt* to be read in order, operating cumulatively as a "'running gag,' a joke that provokes...an increasingly exasperated, but at the same time amused, reaction from the audience."[71] As Mattock proposed, if the text were to have the effect of a running gag, it would require a linear reading to produce a "sustained and cumulative" effect.[72] Evidence suggests that the same concern does not apply to the manuscript corpus of al-Hariri's *Maqāmāt*, however: throughout the century leading up to its illustration in the early 1200s, a fixed sequence of the fifty *maqāma*s was maintained assiduously in manuscript copies. Despite this evidence, of course, there is no guarantee or requirement that a reader would go through the assemblies in numerical sequence, and one might add that the autonomous *maqāma*s were sufficiently brief to be read singly.

The narrative breakdown between successive, individual *maqāma*s of al-Hariri's *Maqāmāt*—a feature that seems to reinscribe the independence of each *maqāma* as a unit—has also been a topic of discussion in the field of Arabic literary history. As Jareer Abu-Haidar observes, "we never see Abū Zayd on his travels. He seems to move from one city of the Islamic world to another in the interval or intermission, so to speak, between two *Maqāma*s, and the setting of the *Maqāma* is unimportant if one does not say altogether trivial."[73] Elsewhere, Abu-Haidar concludes that the *Maqāmāt* as a genre did not "present a framework story with which the separate tales could be more closely integrated to form a novel."[74] In other words, the *Maqāmāt* was an aggregate of parts whose coherence, if any, lay not in sequence but in theme: the individual *maqāma*s were interrelated more paradigmatically than syntagmatically.

These assessments of al-Hariri's *Maqāmāt*—if one does not accept Kilito's and Zakharia's arguments in favor of the sequential implications of the total text—come across as balanced and accurate, but it must be said that the illustrations function in another way. While the illustration of an individual *maqāma* obeys

the anecdote's autonomy, and each *maqāma* is pictorialized through images that show a chain of causes and their effects—with paratactical gaps left between the series of images making up each *maqāma* and between each successive *maqāma*—the cumulative effect of the illustrations has a different result. Just consider the rate of illustration. In the year of its production, the 1237 *Maqāmāt* had the highest rate of illustration, with ninety-nine paintings spread across 168 folios. A painting appears every 3.4 pages. The *Maqāmāt* dated 1256 (London, British Library, Or. 1200) is the next closest, with eighty-seven paintings appearing across 155 folios; hence a painting occurs every 3.5 pages on average.[75] The highest rate of illustration would have been achieved if the 1323 *Maqāmāt* (London, British Library, Or. Add. 7293) had been completed, but the ambition of its planner—more than three hundred spaces are left for paintings, a fraction of them completed—presumably outstripped the capacities, or patience, of those persons making it. The main point of these basic statistics is to demonstrate the high rate of illustration in the 1237 *Maqāmāt*. This feature allowed for several images to appear in an individual *maqāma*, and dispersed across the whole book they created a sense of coherence and cyclicality.

Some additional examples from *maqāma* 3, "of the coin," and *maqāma* 16, of the Maghrib, underscore these observations. In the frame story of *maqāma* 3, an old man comes before an assembly and, feigning lameness, describes his former wealth and current poverty in eloquent prose (fig. 15). The first of two paintings in *maqāma* 3 depicts the seated assembly, animated by bodily posture and gesture, and a standing lame man—who slightly lifts his left foot—in an act of recitation signified by an open left hand. Al-Harith pities the old man but would also like to hear what he can do with poetry. So he offers the old man a gold coin (*dīnār*), asking him to praise it in verse: this he does on the spot, "borrowing nothing" from other poets. Al-Harith and the company are deeply impressed and so another coin is offered, with the request this time to deprecate it in verse. This is easily accomplished. The old man puts the two coins in his mouth and walks away. The poems of praise and dispraise are arranged to mirror each other across the two pages of text (fols. 7b-8a) intersected

Fig. 15. Al-Harith and an assembly of men listening to Abu Zayd who pretends to be lame, *maqāma* 3, of "the coin" (*al-dīnarīya*). Paris, Bibliothèque nationale de France, Ms. Arabe 5847, fol. 7a. (Photo: © Bibliothèque nationale de France)

between the pages bearing paintings (fols. 7a and 8b).

Again al-Harith realizes that the old man was Abu Zayd "and that his going lame was for a trick." He goes after him, calling out: "Thou art recognized by thy eloquence, so straighten thy walk." The second painting shows the closing sequence of the *maqāma*, where the narrator and hero meet (fig. 16). Abu Zayd initially does not recognize al-Harith, who again asks him about his present condition and reprimands him for playing the fool and simulating disability. But Abu Zayd prevails when he recites another verse before parting:

> I have feigned to be lame, not from love of lameness, but that I may knock at the gate of relief.
> For my cord is thrown on my neck, and I go as one who ranges freely.
> Now if men blame me I say, "Excuse me: sure there is no guilt on the lame."[76]

Fig. 16. Abu Zayd and al-Harith, who asks why Abu Zayd is lame, *maqāma* 3, of "the coin" (*al-dīnarīya*). Paris, Bibliothèque nationale de France, Ms. Arabe 5847, fol. 8b. (Photo: © Bibliothèque nationale de France)

Maqāma 16 contains three paintings. The frame story begins in "one of the mosques of the West," where al-Harith joins four scholars (fig. 17). Their conversation turns to sentences that maintain their sense when they are reversed, and the men decide to test their ability in constructing them. Each man takes his turn, advancing from palindromic sentences composed of three words to ones of four, five, and then six. Just as al-Harith fails to construct one of seven words, an old man enters and immediately pronounces just such a sentence. He then dazzles the group of men by saying that he can also offer verse palindromes. This he does in short order, reciting two poems each one composed of five lines (five distichs, ten hemistichs). After this, al-Harith recognizes Abu Zayd and introduces him to the company. The group of men invite Abu Zayd to stay with them in conversation that night, "on the condition that they should mend his poverty," but he claims that his children are hungry and that he must go home and feed them. Stipulating that he return after his children have been fed, the men release Abu Zayd, joined by a servant who holds the wallet of money. In the second painting, organized as a double-page, Abu Zayd pulls on the wallet (the collateral), snatching it away from the servant, and counsels and chastises the latter in verse (fig. 18): Abu Zayd had led the servant down long and "branching paths" until they reached a "ruined hut" that he claimed as "the nest of my chicks."[77] The scene on the facing page depicts a group of seated men. The solitary servant returns to al-Harith and company, instructed

Fig. 17. Disguised as a beggar, Abu Zayd joins al-Harith and his companions in a mosque, *maqāma* 16, of the Maghrib. Paris, Bibliothèque nationale de France, Ms. Arabe 5847, fol. 42a. (Photo: © Bibliothèque nationale de France)

by Abu Zayd to repeat the cautionary poem to them. The basic message is to take what is available, cut one's losses, and not hold out in expectation of more in the future. The discovery of Abu Zayd's deceit causes al-Harith and the scholars to fight among themselves for letting him go and also being fooled by him.

Visualizing multiple moments from the frame story of each *maqāma* established coherence across the manuscript as a whole, an impression amplified by a high rate of illustration. Recurring typologies of image-conceptualization—from frequent pairs of gesticulating figures standing on a simple ground line,

equally commonplace groups of figures ranging from three to four or five in number, or another set of still more populated and developed settings (the cemetery in *maqāma* 24, fol. 29b; the waterwheel in *maqāma* 11, fol. 69b; the pilgrim caravan in *maqāma* 31, fol. 94b)—also created a visual continuity across the manuscript by repetitive paradigms. The images might be seen as sequentially parallel to the text but they can also be experienced independently of it. And although the story episodes do not add up to an overarching, coordinated narrative totality, their frequent incidence and visual form give the impression through sheer accumulation

Fig. 18. Watched by a group of seated men, Abu Zayd sends away the servant who accompanied him home, *maqāma* 16, of the Maghrib. Paris, Bibliothèque nationale de France, Ms. Arabe 5847, fols. 43b–44a. (Photo: © Bibliothèque nationale de France)

of a persistent and consistent theme. In that respect they are also paradigmatic and not syntagmatic, but the capacity of the paintings to constitute immediately legible abstractions of the text made structure perceptible in a manner that the text could not. This experience of al-Wasiti's *Maqāmāt* can only be obtained by direct access to the manuscript, or through its facsimile. Though Grabar's 1984 book included a microfiche of all the paintings and other authors, like James, described the image typologies in some detail, publications of the 1237 *Maqāmāt* always favored reproduction of the same highly developed compositions—like those of the cemetery, waterwheel, village, and scenes of childbirth—and not the highly repetitive scenes of Abu Zayd meeting al-Harith.

Confession: Maqāma *50, of Basra*

After forty-nine assemblies showing verbal trickery in various guises, the final one, *maqāma* 50, transports the reader to Basra. Al-Harith resolves to go to the Friday mosque, where he sees a man dressed in rags sitting on a stone and encircled by a large crowd of people (fig. 19). After he had drawn near, al-Harith immediately recognized Abu Zayd because he wore "no disguise to conceal him." Abu Zayd recites an extraordinary praise of the city of Basra and its inhabitants. He continues by saying that he will now "disclose truly my character" (*fasa-āṣduquhu ṣifatī*). Abu Zayd speaks of his many travels and adventures, his capacities to remove obstacles, change people's moods and attitudes, and

Fig. 19. Sitting on a rock, Abu Zayd addresses a crowd gathered in a mosque, *maqāma* 50, of Basra. Paris, Bibliothèque nationale de France, Ms. Arabe 5847, fol. 164b. (Photo: © Bibliothèque nationale de France)

how often I have beguiled the minds of men, and devised novelties and snatched opportunities, and made lions my prey, how many a high-flown I have left prone, how many a hidden one I have brought out by my spells, and made spring its sweet water by my wiles. But there has passed what has passed, while the bough was fresh and the temple raven-haired, and the raiment of youth yet new; whereas now the skin has withered, the straight grown crooked, the dark night waxed light, and naught remains but repentance, if it avail, and to patch up the rent that has widened.[78]

Abu Zayd then asks the audience to pray to God for him—without expecting financial reward—and recites a poem on his sins, errors, arrogance, greed, and deceit.

The assembled crowd begins to pray for Abu Zayd, answering his request. As Abu Zayd leaves, heading toward the riverbank, he is pursued by al-Harith, who questions him there on the nature of his repentance, still doubting Abu Zayd's sincerity. Abu Zayd then leaves.

Al-Harith continues in his quest to find Abu Zayd, yet again, and hears news from a group of travelers that they had seen Abu Zayd in Saruj, the town of the scoundrel's birth, where he had "donned the wool cloth, and was leading the rows of the praying and had become a famous devotee." Al-Harith asks them if they speak of the man "of the Assemblies," in reference to the *Maqāmāt* itself. He journeys on to Saruj, where he sees

Fig. 20. Al-Harith and Abu Zayd eat together in their final meeting, *maqāma* 50, of Basra. Paris, Bibliothèque nationale de France, Ms. Arabe 5847, fol. 166a. (Photo: © Bibliothèque nationale de France)

Abu Zayd in the mosque standing in "his prayer-niche, wearing a cloak stitched together with a tooth-pick, and a patched wrapper."[79] Abu Zayd, who had become a mendicant, continues with his readings from the Koran and performs his five prayers until the next day arrives. Al-Harith then joins Abu Zayd in his home (*bayt*), where they dine on bread and olive oil (fig. 20). Abu Zayd withdraws to his oratory (*muṣalla*) and continues his dialogue with God (*munājā*) until the next morning, when he rises and makes another speech in praise of God (*tasbīḥ*) that brings al-Harith to tears. They then hurry to the mosque again to pray with the congregation. Abu Zayd's devotions cause him to wail and weep,

prompting al-Harith to do the same. Narrator and hero then take leave of each other for what will be the last time.

CONCLUSION: IN PURSUIT OF SHADOWS

Perhaps more than any other, *maqāma* 18, named after Sinjar,—encapsulates in its imagery the central theme of the fifty assemblies. In the 1237 *Maqāmāt* made by al-Wasiti, this particular *maqāma* is illustrated with four paintings arranged in two double-page openings (figs. 21 and 22). Traveling from Damascus to Baghdad

a

Fig. 21, a and b. Abu Zayd at the wedding banquet, fleeing the scene as the glass bowl of sweetmeats is presented, *maqāma* 18, of Sinjar. Paris, Bibliothèque nationale de France, Ms. Arabe 5847, fols. 47b–48a. (Photo: © Bibliothèque nationale de France)

b

أَمْ أَشْكُرَ امْتِنَاسِي فِعْلَتِهِ أَمْ اذْكُرَ فَإِنَّهُ وَإِنْ كَانَ أَسْلَفَ الْجَرِيَّةِ وَمِنْكُمْ مَنْ عَنْهُ أَنْهَلَتْ
هَذِهِ الْبُرْمَةِ وَسَتُبْقِيهِ الْجَارَتْ لِي هَذِهِ الْغَنِيمَةِ وَقَدْ خَطَرَ بِبَالِي أَنْ أَرْجِعَ إِلَى الشَّبَابِ
وَاقَعَ بِمَا سَنَبِّي لِي لَا أَتَعِيبُ يُفْنِي وَلَا أَجْمَالِي وَأَنَا أُوَدِّعُكُمْ وَدَاعَ مُحَافِظٍ وَأَسْنُودِعُكُمْ
خَبْرَ حَافِظٍ ثُمَّ اسْتَوَى عَلَى ظَهْرِ أَجَلِهِ رَاجِعًا فِي حَافِرِهِ وَلَاوِيًا إِلَى زَأَرَ نَفَعَادِرْنَا

بَعْدَانَ وُخِذَتْ عِشْتَهُ وَزَالَبِنَا النَّسْهُ كَنَّتْ غَابَ صِدْرَهُ أَوْ لَيْلِ الْفَلَبَدَرَهُ

Fig. 22, a and b. Abu Zayd leaves the banquet joined by a servant who carries dishes of food; Abu Zayd departs on his camel, *maqāma* 18, of Sinjar. Paris, Bibliothèque nationale de France, Ms. Arabe 5847, fols. 50b–51a. (Photo: © Bibliothèque nationale de France)

منّوا ليحكم فيها بهوى فأقبل علينا أبو زيد وقال إقرأوا سورة الفتح
وانتظروا ما بعدها مال الفرج فقد جبر الله ثكلكم وسنى لكم وجمع في ظل الحلوا
شملكم وعسى أن تذكروا أشيا وهو خير لكم ولما هم بالانصراف أهل إلي
استندآء الصحاف فقال اللّآدب إذ نزل لا بل الظرف بماجة المهدي بالظرف فقال
كليهما والغلام فأحدف الكلام وانهض بلاذكر فوثب في الجواب وشكر الرؤض

للسجاب ثم إنقاد أبو زيد الى حوآيه وحكمنا في خلوآيه وجعلك يقلب
الآوآني بيده ويفض عددها على عدده ثم فأ لست أدرى أشكوا إذلك النمآم

with a caravan, al-Harith and Abu Zayd stop at Sinjar, where a merchant is hosting a wedding feast. Following custom, everyone is invited. Toward the end of the meal, sweetmeats are presented to the guests in a glass bowl (*jām*). Al-Harith relates that the bowl "was as though it had been congealed of air, or condensed of sunbeam motes, or molded of the light of the open plain, or peeled from the white pearl: And it had been furnished with assortments of comfits, and affused with a pervading perfume, and there had been poured into it a draught from Tasnim [a fountain in paradise], and it disclosed a fair aspect, and the fragrance of a gentle breeze."[80] He continues: "Now when our appetites were kindled at its presence, and our palates were eager for the trial of it; and it was imminent that the squadrons should be sent forth against its train…Abu Zayd sprang up like a madman, and sundered from it as far as the lizard is sundered from the fish."[81] The last line refers to an Arabic proverb about the opposing climates of lizards and fish, and the belief that the lizard only inhabits arid climates.[82] Abu Zayd fled the circle of guests— al-Wasiti depicts him running for the door, casting a glance back at the green-colored bowl—and said that he would only return on condition that the glass be removed. The glass bowl is sent away, to the dismay of the guests.

When he is asked to explain his actions, Abu Zayd answers that "glass is a betrayer" (*innā al-zujāj nammām*) and that he had sworn an oath not to stay near anything that is transparent (fig. 22). He continues to tell a story that he had befriended a neighbor "whose tongue cajoled while his heart was a scorpion," and that he once owned a slave girl (*jārīya*) possessing many virtues, but kept her hidden from sight.[83] After drinking too much wine one time, Abu Zayd told the treacherous neighbor about her and his trust was betrayed. The neighbor informed the governor about her and the governor, in turn, wanted to present the slave girl as a gift to the prince. Abu Zayd was forced to "barter the black" of his eye "for the yellow of coin." Then and there he made a vow not to be in the "presence of a betrayer," and because glass has this quality, his oath applied to it.[84] Speaking for the group, al-Harith states that they accepted Abu Zayd's stance and the host of the wedding invited him to return and take up the most honored

position. He was then presented with ten silver trays (which as objects made from opaque matter could keep secrets) laden with sweets and honey as a gift. A servant boy carried them to Abu Zayd's tent, where Abu Zayd distributed the sweets among the men. After declaring that he must leave and attend to his children, he mounts his camel and departs (fig. 22). "And when his strong camel coursed along and his sociableness quitted us, he left us as an assembly whose president is gone, or a night whose moon has set."[85] Abu Zayd's ruse was brilliant: he had exchanged a possible present, glass, for one more valuable, a set of silver trays, which to their further advantage could be liquidated.

Despite the fact that Abu Zayd uses the occasion of the wedding feast to speak of a treacherous friend who vowed "not to rend veils of confidence" and revealed all secrets to sight, we are more than well aware of the symmetry between Abu Zayd and his contra-ideal presented through the figure of the glass bowl. Whether animate or inanimate, the physical properties of a person or an object should be such that a secret, or a true nature, is not disclosed. Opacity is favored over transparency. And of course, throughout the *maqāma*s, Abu Zayd enacts his ideal by appearing in various guises that make him unrecognizable, even to al-Harith, who has met him on innumerable occasions. Abu Zayd assumes various identities through a transformation of clothing (once in the guise of his wife [fig. 23]), or even its near total absence, or by simulating bodily impairments such as blindness and lameness, or assuming other characteristics associated with advancing age—such as graying hair and beard. In one of the most humorous *maqāma*s, no. 21, of Mayyafariqin, Abu Zayd claims to have lost his sexual virility in old age. Al-Harith and his company of friends do not know what to do, whether to refuse the man's request for money or ask him to prove his impotence. The prose is filled with extraordinary figurative imagery: e.g., "Fie on him whose rock is not moist, whose gravel oozes not!"[86] The *maqāma* ends dramatically when al-Harith asks Abu Zayd to show him his "shrouded corpse" and Abu Zayd obliges (fig. 24). In conclusion, although we are cognizant of Abu Zayd's oceanic erudition and eloquence, we get no sense from his body or his speech of the inner Abu Zayd. Notwithstanding Abu Zayd's many physical disguises as related by al-Hariri,

Fig. 23. Al-Harith and a group of men in discourse are approached by an old woman and children, *maqāma* 13, of Baghdad. Paris, Bibliothèque nationale de France, Ms. Arabe 5847, fol. 35a. (Photo: © Bibliothèque nationale de France)

the artist al-Wasiti shows him as an identifiable person among the crowd. In a large number of paintings he can be pinpointed through his white beard, for example.[87]

It is impossible to establish any kind of biographical coherence for Abu Zayd across the fifty *maqāma*s. In some of them he claims to be married, in others he is a bachelor; in still others he professes to have a son, or children; in others he denies progeny. The effect of these constant switches is to destabilize the link between what a person says and how they appear and behave, to shake the cultural understanding that an individual's appearance, actions, and speech can be equated with the person.[88] In Abu Zayd we confront a figure of protean identities whose only consistent traits are eloquence and learning—and yet, even this firmer ground is shaken because his speech is used to trick and manipulate people into certain beliefs and actions. Despite his frequent admonitions and pious counsel, Abu Zayd's behavior contradicts his advice, especially in his various forms of personal indulgence.[89] Spoken and written language can be meaningful, but can also be used duplicitously.

And what of al-Harith b. Hammam? He is the most generic of narrators, a non-identity signaled by a name

Fig. 24. Abu Zayd exposes his penis to al-Harith, *maqāma* 20, of Mayyafariqin. Paris, Bibliothèque nationale de France, Ms. Arabe 5847, fol. 57a. (Photo: © Bibliothèque nationale de France)

that commentators compared to a tradition of the Prophet Muhammad: "every one of you is a Harith, and everyone of you is a Hammam." In the proverb, Harith denotes the person who earns a living from trade, and Hammam the person who has anxieties and worries. Al-Harith is everyman and nobody at the same time. In this respect, Abu Zayd is his double. As Kilito observes, "Zayd is, with 'Amr, the name privileged in examples of Arab grammarians: it is therefore a synonym of 'someone like everyone.'"[90] Al-Hariri chose these most generic of Arabic names—al-Harith b. Hammam and Abu Zayd—in response to his model Badi' al-Zaman al-Hamadhani, about whose chief protagonists—Abu al-Fath al-Iskandari and 'Isa b. Hisham—he notes in the preface to his own *Maqāmāt* "each is an unknown about whom one knows nothing, an undefined person whom one cannot identify."[91] Kilito has also discussed the scarcity of proper names in al-Hariri's work, and that when

they are given, most frequently to historical persons, the author's objective was for names of specific people to signal abstract qualities, attributes associated with those individuals (examples mentioned previously include Ibn Samʿun and al-Asmaʿi).[92]

In composing the preface for the *Maqāmāt*, al-Hariri anticipated criticism for his work and attempted to excuse it by making a comparison to the *Kalīla wa Dimna* (Kalila and Dimna) of Ibn al-Muqaffaʿ ("the fables that relate to brutes and lifeless objects"):

> I can hardly escape from the simpleton who is ignorant, or the spiteful man who feigns ignorance; who will detract from me on account of this composition, and will give out that it is *among the things forbidden of the law*. But yet, whoever scans matters with the eye of intelligence, and makes good his insight into principles, will rank these *Assemblies* in the order of useful writings, and class them with the fables that relate to the brutes and lifeless objects. Now none was ever heard of whose hearing shrank from such tales, or who held as sinful those who related them at ordinary times. Moreover, since deeds depend on intentions, and in these lies the effectiveness of religious obligations, what fault is there in one who composes stories for instruction not for display, and whose purpose in them is the education and not the fablings?[93]

Al-Hariri was correct to expect criticism. Because he did not identify his chief characters as based on historical persons, Ibn al-Khashshab al-Nahwi (d. 1172) proclaimed al-Hariri's *Maqāmāt* a "lie, dressed with the traits of the real, something which resembles the truth while at the same time denying it."[94] He stated that al-Hariri's work ran against fundamental principles of religious law. Al-Hariri's supporters—Ibn al-Barri (d. 1187), who composed a refutation of Ibn al-Khashshab, and the later biographers Yaqut (d. 1229) and Ibn Khallikan (d. 1288)—were quick to resist these claims and to do so explained that *maqāma* 48 (named al-Haramiyya) was founded in historical fact: they identified Abu Zayd with the person whom al-Hariri mentions meeting in the mosque of the Banu Haram in Basra. As Zakharia notes in her brilliant study of this reception history, al-Harith b. Hammam is not mentioned but the conflation between him and al-Hariri is obvious enough.[95] These historical and autobiographical functions gave license to al-Hariri's fictions. His preface addresses the perpetual anxiety over fiction in Islamic literature and letters,

asserting that his *Maqāmāt* should be understood in the same class of text as the *Kalīla wa Dimna*, hence bolstering the instructional value of his work, stressing the message and meaning of the *maqāma*s over the act of storytelling. This is a good example of having one's cake and eating it too.

In essence, al-Hariri's *Maqāmāt* is a pursuit of shadows: whatever Abu Zayd might cast, it is impossible to discern its purpose; is it semblance or dissemblance? At the very end, in *maqāma* 50, al-Harith expresses his doubt about Abu Zayd's intention in the midst of their several meetings. Up until then, al-Harith, who has an affection and admiration for Abu Zayd (although he views his behavior disapprovingly on most occasions), spends much of his time lamenting the absence of Abu Zayd and searching for him in vain, only to fail to comprehend the rascal's identity in his presence, until the weight of the discourse makes Abu Zayd's identity dawn on al-Harith. Audition is followed by suspicion and only in the very end verified by vision: al-Hariri employs a number of subtle metaphors to convey the sensory apprehension of Abu Zayd, mostly by vision but sometimes by smell. Like other characters in the *Maqāmāt*, al-Harith is tricked by Abu Zayd, but most often he does not seem to care. Running parallel to this linguistic framework of successive, autonomous "assemblies" is a cycle of paintings that depict elements from the narrative, showing a series of causes by their effects. The paintings concretize the fact of human discourse by repeatedly emphasizing it, and depend on visual narrative to translate the complex registers of the text.

When studied in comparative terms, the illustration of the 1237 *Maqāmāt*—or, for that matter, the entire corpus of illustrated *Maqāmāt*s made in the years before or just after—produced no particularly unique visual traits or practices of picture-making: their conventions are found across a number of contemporary illustrated Arabic texts, from works of science to *belles-lettres*. As noted above, al-Wasiti's chief innovations within the production of the images themselves include the extensive use of the double-page composition and an expanded number of details and characters in his most developed paintings. Many years ago, Ettinghausen compared what he held to be a "realist" visual idiom current in portable objects and illustrated manuscripts to

the "realist" subjects of the contemporary shadow play (*khayāl al-ẓill*, lit. "shadow fantasy").[96] Without a complete formal analysis from Ettinghausen, we can only surmise the visual affinities between the *Maqāmāt* illustrations and the shadow puppets that he had in mind. One could mention the preponderance of profiles; the dramatic outlines of gesturing and animated figures; the stark contrast between figure and ground; the emphasis on crafting compositions into bold, contoured shapes set against the stark paper sheet, inner details painted amid the overall "shadow." The flatness of form and position of figures on a single and shallow spatial plane are other conventions that might be linked to the shadow play. Many visual aspects of the *Maqāmāt* illustrations embody the theatricality of discourse. But of course the finished paintings *do not resemble* shadows. They are not the shadows, but the things themselves fully colored and brightly lit, unless one is to take the entire formal language of Arabic manuscript painting from the late 1100s through the 1200s as a complex commentary on the nature of representation itself.

The shadow play, other forms of popular entertainment, and their reception by contemporaries such as Ibn al-Haytham (d. 1040), Ibn Shuyad (d. 1035), and Ibn Hazm (d. 1064), as well as the evident connections between literary, structural, and thematic aspects of the plays and the *Maqāmāt*, have been explored in literary scholarship. The best-known examples of the shadow play are those composed by Muhammad b. Daniyal (d. 1311).[97] The reception of the shadow play manifests its metaphorical function commenting on the illusory and transitory nature of earthly existence, where each shadow pointed to a truth (but was not the truth). Several medieval authors give voice to this concept in their writing, including some of the better-known writers, such as ʿUmar b. al-Farid (d. 1235) and ʿUmar Khayyam (d. 1123).[98]

The several connections between the shadow play and the *maqāmāt*, and their plausible shared visual effects may have prompted associations between the two media for contemporary readers/viewers of al-Hariri's *Maqāmāt* and extended the notion of deceptive speech to painted images. In other words, any affinities between play and painting might have caused the transposition of cultural values and concepts about earthly

semblance and ultimate reality.[99] Moreover, given that a theory of images as we know it for the time had still not defined the ontology of painting—a distinction between what it is and what it represents—the paintings arguably held a position similar to al-Hariri's text, flickering between transparency and opacity, between the basic polar opposites of history and fiction, which were consciously muddled by al-Hariri. (This generic uncertainty, and the ultimate purpose of al-Hariri's work, was a prime factor in the critical reception of the *Maqāmāt*: how should it be placed, was it useful, and, if so, how?).

Recent renewed contextual approaches to the study of the *Maqāmāt*, such as those by James and George, are comparable in effect to earlier art historical approaches that quickly moved away from the text and considered factors extrinsic to it to offer an account. And all this before we developed an understanding of al-Wasiti's version of al-Hariri's *Maqāmāt*. By holding our focus on the manuscript, let us first consider how it works as an object, what effects its paintings had on their reader/viewer, how the book as a whole object structures an experience for its user. Then, one of the most pressing questions in this inquiry concerns the presumed balance between modes of reading and seeing, and a tendency to always privilege audition and oral recitation over silent reading; somehow the role of seeing is marginalized by each model.[100] The role performed by the illustrated book in these experiences is obviously different, not least of them the contrast between collective and solitary experience, but there can be no doubt that al-Wasiti devoted an abundance of skill, labor, and thought to the way his pictures functioned throughout al-Hariri's text.

Al-Wasiti's images emphasized discourse as a paradigmatic theme of al-Hariri's *Maqāmāt*, concretizing the reality of the assemblies by insistently showing their events and characters, but at the same time denying its viewers firm knowledge of anything. His "realism," advanced through several paintings—those paintings most frequently praised and published by art historians—exceeded any previous or subsequent models that might have been available to him, but had the effect of laying a trap in a manner comparable to those set by al-Hariri. An abundance of depicted things—of things

rendered visible—amounted to nothing, just as Abu Zayd's linguistic eloquence finally amounted to nothing. Elsewhere, in al-Wasiti's most common paintings—those depicting smaller-scaled, more intimate acts of discourse—a formal generic was a suitable analogue to the verbal play of al-Hariri's text, to its endless, even if educational, deceptive fictions.

Department of History of Art and Architecture,
Harvard University, Cambridge, Mass.

NOTES

Author's note: I have held onto this essay for longer than I had intended. It seemed an especially suitable contribution to the thirtieth volume of *Muqarnas*, which is in part an appraisal of the history of the field of Islamic art and architecture as reflected through the journal, whose founding editor, Oleg Grabar, wrote so extensively about al-Hariri's *Maqāmāt*. Since 2002, I have been fortunate to present my thoughts on the *Maqāmāt* at different institutions. I thank Marcus Milwright, Sheikha Hussah Sabah Salem al-Sabah, Kishwar Rizvi, the graduate students of the Institute of Fine Arts, and Heather Ecker, for their invitations to lecture and the responses of audience members at the University of Victoria, Victoria, British Columbia; Dar al-Athar al-Islamiyya, Kuwait; the Medieval Renaissance Forum, Yale University, New Haven; the Institute of Fine Arts, New York University; and the Society of Fellows in the Humanities, Columbia University, New York. I am also deeply grateful to Annie Vernay-Nouri and Marie-Geneviève Guesdon of the Bibliothèque nationale de France for giving me generous access to Ms. Arabe 5847, and many other sources, in December 2009. This essay is dedicated to my mother, who let me leave her and family in Kelso for work in Paris in difficult times.

1. In preparing this essay I have used the excellent translations and commentaries of al-Hariri's *Maqāmāt* published by Thomas Chenery and F. Steingass. Though it had been Chenery's intention to undertake a complete study of the fifty *maqāma*s making up al-Hariri's opus, he only managed the first twenty-six. Steingass published the remaining twenty-four *maqāma*s some years later. Abū Muḥammad al-Qāsim b. ʿAlī b. Muḥammad b. ʿUthmān al-Ḥarīrī al-Baṣrī, *The Assemblies of al-Ḥarīrī*, trans. with notes by Thomas Chenery, 2 vols. (London: Williams and Norgate, 1967), 1:224.

2. Abu al-Husayn b. Samʿun (d. 997), trained as a Hanbali but also sympathetic to Sufism, lived in Baghdad, where he was widely celebrated for his preaching and eloquent discourse. Extensive biographical commentary is provided in al-Ḥarīrī, *Assemblies*, trans. Chenery, 1:456–58.

3. Ibid., 1:224.

4. Ibid., 1:227.

5. Ibid., 1:228.

6. ʿAmr b. ʿUbayd (d. ca. 761) was renowned in his life as an ascetic (*zāhid*) who spoke out to the Abbasid caliph al-Mansur on questions of religion and morality, and constantly rejected remuneration or reward. See al-Ḥarīrī, *Assemblies*, trans. Chenery, 1:467–69, and W. Montgomery Watt, *Encyclopaedia of Islam, New Edition* (henceforth *EI2*), s. v. "ʿAmr b. ʿUbayd."

7. There has been some disagreement about how to translate the term, which is commonly translated as "assembly" or "sessions" in English and "séance" in French. The Arabic triliteral root *q-w-m* has the sense of "standing forth" or "rising up." In assessing the origins of the genre, chiefly in the *Maqāmāt* of Badiʿ al-Zaman al-Hamadhani (d. 1008)—whom al-Hariri credits as his inspiration—A. F. L. Beeston offers a reason for al-Hamadhani's choice of the term to title his work: "Anecdotes were customarily exchanged at 'sessions,' *majālis*. By eschewing this term in favour of *maqāmāt*, B. [Badiʿ al-Zaman al-Hamadhani] may have intended to emphasize that his anecdotes, drafted in *sajʿ*, were using the linguistic medium of the orator, *khāṭib*, whose traditional posture was standing": A. F. L. Beeston, "The Genesis of the *Maqāmāt* Genre," *Journal of Arabic Literature* 2 (1971): 1–12, at 8–9.

8. In a commentary on this poem, Theodore Preston suggests that by mentioning Noah's sons Abu Zayd "means that he had succeeded in enriching himself from all mankind, so that he had become as it were like those patriarchs the heir of all the world." Preston, following medieval commentators on al-Hariri's *Maqāmāt*, follows their interpretation of *muthallath* as a reference to the "treble-toned string of a lute." Al-Ḥarīrī, *Makamat or Rhetorical Anecdotes of al Hariri of Basra*, trans. and annot. Theodore Preston (London: James Madden, 1850), 306–7.

9. Perhaps the boldest move made by Abu Zayd against his audience is in *maqāma* 29, named after Wasit, where the hero proposes to engineer a marriage between al-Harith, who is presently destitute, and one of the female occupants at the inn (*khān*). Abu Zayd promises to deliver an oration such as has never been heard before and in preparation for the wedding he makes sweetmeats. Al-Harith is more eager to hear the speech than to move ahead with the rite, and so Abu Zayd delivers his address and asks al-Harith to distribute the delicacies among the guests. No sooner had they been consumed than the people lost consciousness and fell to the ground. Abu Zayd had drugged the sweetmeats; he was then free to roam through the rooms of the inn and cherrypick the most valuable possessions.

10. Al-Ḥarīrī, *Assemblies*, trans. Chenery, 1:254.

11. Ibid., 1:255.

12. Abu Saʿid ʿAbd al-Malik b. Qurayb al-Asmaʿi (d. ca. 828) was a famous Arabic philologist active in Basra and Baghdad. He is known, among many other things, to have collected poetry from the Bedouins. See al-Ḥarīrī, *Assemblies*, trans. Chenery, 1:520–21; and B. Lewin, *EI2*, s. v. "Al-Aṣmaʿī."

13. Al-Ḥarīrī, *Assemblies*, trans. Chenery, 1:256.

14. As Chenery notes in his commentary on al-Ḥarīrī's *Maqāmāt*. See ibid., 1:521.

15. Ibid., 1:257; also see Chenery's gloss of the phrase, ibid., 1:522–23.

16. Ibid., 1:257–58. Ibn Sukkara (al-Hashimi) was a prolific and humorous poet, son of the caliph al-Mahdi, and descendant of ʿAli. See ibid., 1:523.

17. Al-Ḥarīrī, *Assemblies*, trans. Chenery, 1:258.

18. Al-Ḥarīrī, *The Assemblies of al-Hariri*, trans. with notes by F. Steingass, vol. 2 (London: Royal Asiatic Society, 1898), 35.

19. For a detailed biography of al-Hariri, see D. S. Margoliouth and Ch. Pellat *EI2*, s. v. "Al-Ḥarīrī."

20. Formal aspects of the written text of al-Hariri's *Maqāmāt* are also described by Alain George, "Orality, Writing and the Image in the *Maqamat*: Arabic Illustrated Books in Context," *Art History* 35, 1 (2012): 10–37, at 18–21. But these observations are directed toward a larger argument that proposes the use of illustrated *Maqāmāt* by storytellers before audiences where the aural aspect is complemented by a visual one.

21. The illustrated manuscripts of the *Maqāmāt* were studied by Oleg Grabar, *The Illustrations of the Maqamat* (Chicago: University of Chicago Press, 1984). Dated manuscripts span the years 1222 and 1337, with others dated through the comparative stylistic analysis of their paintings. The earliest known copy of al-Hariri's text (Ms. Cairo Adab 105), dated 504 (1110–11), contains a large number of marginal annotations recording its use over time for readings that produced licensed copies of the text. Early in this history of use, the manuscript was described as an "archetype" (*aṣl*). For an analysis of the notations, the manuscript, and licensed processes of dissemination, see Pierre A. MacKay, "Certificates of Transmission on a Manuscript of the *Maqāmāt* of Ḥarīrī (MS. Cairo, Adab 105)," *Transactions of the American Philosophical Society*, n. s., 61, 4 (1971): 1–81. Some scholars have argued that the difficulty of the *Maqāmāt*s of al-Hamadhani and al-Hariri made them especially useful as tools for teaching grammar and to preserve vocabulary and expression in their full richness. For example, see H. Nemah, "Andalusian *Maqāmāt*," *Journal of Arabic Literature* 5 (1974): 83–92, at 88. A Hebrew translation of al-Hariri's *Maqāmāt* was made by Yehuda al-Harizi between 1205 and 1216 in Spain. Based on the poor command of Hebrew demonstrated by Jews living in the East, which he experienced on a visit there, al-Harizi was moved to write his own *Maqāmāt* titled *Sefer tahkemoni*: he believed that its engaging stories would encourage readers to learn Hebrew and develop a strong knowledge of its grammar and expressions. See Rina Drory, "Al-Harizi's *Maqāmāt*: A Tricultural Literary Product?" in *The Medieval Translator 4*, ed. Roger Ellis and Ruth Evans (Binghamton, N.Y.: Medieval and Renaissance Texts and Studies, 1994), 66–85, esp. 68–74.

22. Paris, Bibliothèque nationale de France, Ms. Arabe 5847: 168 fols., 37 x 28 cm, 101 illustrations, with approximately 15 lines of text, copied in a fine *naskh* script, on pages without illustrations.

23. I follow D. S. Richards, "The *Maqāmāt* of Al-Hamadhānī: General Remarks and a Consideration of the Manuscripts," *Journal of Arabic Literature* 22, 2 (1991): 89–99, who has questioned the meaning of the verb *ibtadaʿa* in the preface of al-Hariri's *Maqāmāt*. Beeston suggests that al-Hamadhani's originality lay in the systematic use of *sajʿ* and the explicit fictionality of the characters that appear in his anecdotes, which no author had done before; al-Hariri's reference to the "invention" of al-Hamadhani was thus probably understood as the unmasking of the author. See Beeston, "Genesis of the *Maqāmāt*," 8–9. J. N. Mattock questioned Beeston's hypothesis about *sajʿ*, pointing to evidence of the extensive use of *sajʿ* before the emergence of the *maqāmāt*: J. N. Mattock, "The Early History of the *Maqāma*," *Journal of Arabic Literature* 15 (1984): 1–18, at 2.

24. See A. F. L. Beeston, "Al-Hamadhānī, al-Ḥarīrī and the *Maqāmāt* Genre," in *ʿAbbasid Belles-Lettres*, ed. Julia Ashtiany et al. (Cambridge: Cambridge University Press, 1990), 125–35, at 125–26.

25. Richards, "*Maqāmāt* of Al-Hamadhānī," 90.

26. Beeston, "Al-Hamadhānī, al-Ḥarīrī and the *Maqāmāt* Genre," 125.

27. Ibid.

28. Ibid., 126.

29. Ibid. A more complex definition and analysis of *sajʿ* is offered by Tamas Ivanyi, "On Rhyming Endings and Symmetric Phrases in al-Hamadhani's *Maqāmāt*," in *Tradition and Modernity in Arabic Language and Literature*, ed. J. R. Smart (Richmond, Surrey: Curzon, 1996), 210–28. Ivanyi actually recommends avoiding its usage, preferring instead "rhyming ending" and "symmetric phrases" (p. 210).

30. Afif Ben Abdesselem, *EI2*, s.v. "Sadj.'"

31. Beeston, "Genesis of the *Maqāmāt* Genre," 7.

32. In al-Hamadhani's *Maqāmāt*, the authority is a fictional character named ʿIsa b. Hisham and the hero is Abu al-Fath al-Iskandari, though there are frequent exceptions to this pattern. See Beeston, "Al-Hamadhānī, al-Ḥarīrī and the *Maqāmāt* Genre," 127.

33. For the poetry of al-Hariri, see Beeston, "Al-Hamadhānī, al-Ḥarīrī and the *Maqāmāt* Genre," 133; Jaakko Hämeen-Anttila, *Maqama: A History of a Genre* (Wiesbaden: Harrassowitz, 2002), esp. 151; and Katia Zakharia, "Les références coraniques dans les *Maqāmāt* d'al-Ḥarīrī: Éléments d'une lecture sémiologique," *Arabica* 34, 3 (1987): 275–86, at 277. Hämeen-Antilla counts two borrowed verses, Zakharia four.

34. Richard Ettinghausen, *Arab Painting* (Geneva: Skira, 1962).

35. Grabar, *Illustrations of the Maqamat*. His study includes a complete and subtle review of scholarship through the early 1980s (esp. chaps. 1 and 2).

36. The approach and method were shaped by the notion of a program of illustration, the idea that for each text there existed a set of conventional practices of illustration and that each new copy is always an imitation or mediation of earlier tradition. Grabar's chief model was Kurt Weitzmann, *Illustrations in Roll and Codex: A Study of the Origin and*

Method of Text Illustration (Princeton, N. J.: Princeton University Press, 1947). In the end, however, it became clear to Grabar that this model of analysis was untenable.

37. These ideas were developed in several articles by Oleg Grabar, including "The Illustrated *Maqamat* of the Thirteenth Century: The Bourgeoisie and the Arts," in *The Islamic City*, ed. A. H. Hourani and S. M. Stern (Oxford: Cassirer, 1970), 191–222, at 210; "Pictures or Commentaries: The Illustrations of the *Maqāmāt* of al-Ḥarīrī," in *Studies in Art and Literature of the Near East in Honor of Richard Ettinghausen*, ed. Peter J. Chelkowski (Salt Lake City: Middle East Center, University of Utah, 1974), 85–104; and "Les arts mineurs de l'orient musulman à partir du milieu du XIIe siècle," *Cahiers de Civilisation Médiévale* 11 (1968): 181–90. The notion of a bourgeoisie was first developed as a concept in the arts of the Islamic lands by Richard Ettinghausen, "The Bobrinski 'Kettle,' Patron and Style of an Islamic Bronze," *Gazette des Beaux-Arts* 24 (1943): 193–208. Ettinghausen's later studies on the diffusion of figural themes across a variety of objects in different mediums include "The Flowering of Seljuq Art," *Metropolitan Museum of Art Journal* 3 (1970): 113–31.

38. Though some criticisms have been made questioning the suitability of the term "bourgeoisie" to describe the medieval Islamic setting, many of the hypotheses about objects, patronage classes, and the flow of themes and subject matters between societal elites and common folk have been adopted and developed by Boaz Shoshan, "High Culture and Popular Culture in Medieval Islam," *Studia Islamica* 73 (1991): 67–107.

39. Shirley Guthrie, *Arab Social Life in the Middle Ages: An Illustrated Study* (London: Saqi Books, 1995), 13.

40. The earlier study by Ettinghausen was "Early Realism in Islamic Art," in *Studi orientalistici in onore di Giorgio Levi Della Vida*, 2 vols. (Rome: Istituto per l'Oriente, 1956), 1:250–73. Within a few years he described the paintings of the *Maqāmāt* as a "mirror of medieval Arab civilization" and opined that the "realism of these paintings reveals many features of medieval life otherwise unknown": Ettinghausen, *Arab Painting*, 104.

41. *Maqamat al-Hariri Illustrated by Y. al-Wasiti*, introduction by Oleg Grabar (n. p.: Touch@rt, 2003).

42. David James, *A Masterpiece of Arab Painting: The 'Schefer'* Maqāmāt *Manuscript in Context* (London: East and West Publishing, 2013). The book appeared after this essay was already drafted and it has not been possible to offer a complete and detailed assessment of it here. The questions examined in James' book, however, directly stem from the body of scholarship undertaken through the late 1980s, with important refinements made to them, particularly to our understanding of the interrelationship among the corpus of "Baghdad" manuscripts. The bibliography of the book—based on research James completed for a master's degree at the University of Durham in 1965—shows an uneven awareness of scholarship in the fields of Islamic art and literature since the 1990s and art history in general. For the 1974 essay, see David James, "Space-Forms in the Work

of the Baghdād *Maqāmāt* Illustrators, 1225–58," *Bulletin of the School of Oriental and African Studies* 37, 2 (1974): 305–20.

43. As is often the case in scholarship, materials that have gone without much attention suddenly return to full visibility. Apart from James' 2013 monograph, three essays on the *Maqāmāt* have appeared recently: Bernard O'Kane, "Text and Paintings in the al-Wāsiṭī *Maqāmāt*," *Ars Orientalis* 42 (2012): 41–55; Alain F. George, "The Illustrations of the *Maqāmāt* and the Shadow Play," *Muqarnas* 28 (2011): 1–42; and George, "Orality, Writing and the Image."

44. D. S. Rice, "The Oldest Illustrated Arabic Manuscript," *Bulletin of the School of Oriental and African Studies* 22, 1–3 (1959): 207–20, at 214.

45. Ettinghausen, *Arab Painting*, 104.

46. James, "Space-Forms," 306. These opinions are voiced again in *Masterpiece of Arab Painting*, 35–37.

47. Grabar, "Pictures or Commentaries," 90.

48. Grabar, *Illustrations of the Maqamat*, 3–4.

49. The 1237 *Maqāmāt* contains no documentation linking it to a patron and the history of its ownership—its subsequent readers and owners—is unknown. The illuminated heading on fol. 1a bears two partly erased and cropped notes in Arabic and the seal of Charles Schefer (the Bibliothèque nationale acquired the manuscript from him in the late 1800s). The textblock is also remarkably clean, with scarcely any additions or emendations (the predominantly red zigzagging marginalia are glosses contemporary to al-Wasiti's production). James, *Masterpiece of Arab Painting*, 13–15, provides a comprehensive biography for Schefer. The near total absence of notes of ownership and catalogue records—common in other Arabic manuscripts of the period, mostly unillustrated books—from the 1237 *Maqāmāt* is a feature shared by other copies of the same text. It is not possible to rule out their existence, however, given the loss of the original endpapers/flyleaves.

50. The point was made by Abd al-Fattah Kilito, "Contribution à l'étude de l'écriture 'littéraire' classique: L'exemple de Ḥarīrī," *Arabica* 25, 1 (1978): 18–47, at 38.

51. Questioning the idea that "visual patterning of the text had been paramount" to al-Wasiti, O'Kane points out that some of the palindromes in *maqāma* 16 are not separated out from the text but continuous with it (O'Kane, "Text and Paintings," 51–52, and fig. 13) and produces a highlighted text to show this. But the palindromes embedded in continuous text are examples exchanged among al-Harith and his company. These are the prose sentences composed of three, four, five, and then six words. When al-Harith fails to produce a sentence of seven words, Abu Zayd jumps in and meets the challenge. Abu Zayd then composes two poems consisting of palindromic verses (the first in *rajaz*, the second in *kāmil* meter). These are arranged as single columns of text on fols. 43a–43b in the 1237 *Maqāmāt*. Each poem is composed of five lines (ten *bayts* in each), though al-Wasiti has skipped over the fourth line in the first poem. See the detailed commentary in F. Steingass, *The Assemblies of*

Ḥarīrī: Student's Edition of the Arabic Text (London: Kegan Paul, Trench, Trubner and Co., Ltd., 1897), 121–22.

52. The red titles could be later additions, replacing damaged ones or filling in blanks that were left after the first phase of manuscript production under al-Wasiti. Examples occur on fols. 27b, 38a, and 57a. Other portions of the text, including the commentary (*tafsīr*) titles, are written in red. Occasionally the phrase "his speech" (*qawluhu*) is written in a thicker line of black ink or in red, to enhance its visibility on the page.

53. The same features appear in an unillustrated *Maqāmāt* dated October 1162 (middle ten days of Dhu'l-Qaʿda 557) in London, British Library, Or. 2790. Copied in *naskh* script, the text is fully vowelized and letter pointed, larger sizes of script are used for titles, the text is arranged as a rectangle on each page, and poetry is configured in different columnar arrangements. Titles for individial *maqāmas* are given as numbers but also by name, and the fifty *maqāmas* are divided into two parts (*juzʾ*), the first running from 1 to 28, the second 29 to 50. Other dated *Maqāmāt*s, copied between the 1100s through the 1237 *Maqāmāt*, from the western and eastern Islamic lands, share the same features (though few are divided into two *juzʾ*). Sometimes the individual *maqāmas* are introduced only by number and not also by name, and different kinds of ink might have been used for the titles (black, red, gold outlined in black), while in other manuscripts transitional phrases that structure discourse (*allāhumma, wa baʿd, ashada, shiʿr*) are highlighted with a different color of ink than that used in the main text (e.g., Oxford, Bodleian Library, Pococke 172, dated Muharram 632 [Sept.–Oct. 1234]).

54. The most sophisticated discussion of this feature of Arabic illustrated manuscripts was offered by Oya Pancaroğlu, "Socializing Medicine: Illustrations of the *Kitāb al-Diryāq*," *Muqarnas* 18 (2001): 155–72.

55. Al-Ḥarīrī, *Assemblies*, trans. Chenery, 1:142.

56. Responding to the common notions that al-Hariri is "a writer devoured by virtuosity" and an "embalmer of a dead language," Zakharia has written about the author as a master also of narrative structure. See Katia Zakharia, "Norme et fiction dans la genèse des *Maqāmāt* d'al-Ḥarīrī," *Bulletin d'Études Orientales* 46 (1994): 217–31, at 226. In the same essay she also argues that although the chronology of the production of *maqāmas* 1–50 is uncertain—and they were probably written out of sequence—the organization of the whole leads up from *maqāma* 1—where Abu Zayd and al-Harith meet for the first time and where the word *fātiḥa* is used uniquely—to *maqāma* 48, generally held to be the first one al-Hariri actually composed and based on an autobiographical experience: ibid., 226–27. Kilito has also argued for a sense of structure conveyed by the ordering of the first and fiftieth *maqāmas*: the first is named after Sanʿa, because this was the first town built after the flood, the fiftieth after Basra and Saruj, because these are the towns of al-Harith and Abu Zayd, a fitting twinning of sites given that this is the narrator-hero duo's last encounter. Despite

the fact that the order of reading of the intervening fortheight *maqāmas* is unimportant, he argues for coherence among the whole based on thematic echoes. See Kilito, "Contribution à l'étude de l'écriture 'littéraire' classique," 21–23.

57. In response to these new text-image approaches—and to a much curtailed published version of a lecture in which I introduce some of these points (David J. Roxburgh, "Books of Stars, Mechanical Devices, *Maqamat*, and Animal Fables: Image and Genre in Medieval Arabic Manuscripts," *Hadeeth ad-Dar* 30 [2009]: 2–7), O'Kane writes that "we really don't need the musings of literary theorists to tell us why this text or any other was illustrated so often." O'Kane believes instead that painters selected manuscripts for their narrative potential because these were the kinds of books most likely to sell. He also mentions al-Hariri's preface, where the author reveals that changes in location will engage the reader and encourage more people to read his work: O'Kane, "Text and Paintings," 51. Al-Hariri's preface is discussed at the end of this essay, though for entirely different reasons than those framed by O'Kane. James also commented on the role of the paintings in the illustrated *Maqāmāt*s, concluding that "the text was amusing, diverting, even astounding and thigh-slapping enough, without pictures. Paintings simply added a little something extra for those readers who liked the idea of an illustrated version": James, *Masterpiece of Arab Painting*, 11.

58. The most recent analysis of the double-page frontispiece presents an exhaustive treatment of its iconography and carefully considers it relation to other frontispieces. Earlier scholarship is also discussed. See Robert Hillenbrand, "The Schefer Ḥarīrī: A Study in Islamic Frontispiece Design," in *Arab Painting: Text and Image in Illustrated Arabic Manuscripts*, ed. Anna Contadini (Leiden: Brill, 2007), 117–34.

59. Grabar, *Maqamat al-Hariri Illustrated by Y. al-Wasiti*, 8.

60. See Eva R. Hoffman, "The Author Portrait in Thirteenth-Century Arabic Manuscripts: A New Islamic Context for a Late-Antique Tradition," *Muqarnas* 10 (1993): 6–20; and Pancaroğlu, "Socializing Medicine."

61. Despite intensive analysis of the 1237 *Maqāmāt* frontispiece, there are still some problems of interpretation, especially if we are to believe that it relates somehow to the original patron/recipient of the manuscript, for which there is no direct internal evidence. See O'Kane, "Text and Paintings," 42.

62. Several changes have been made to the manuscript since its production, and some folios and illustrations are missing. For a description of these, see Grabar, *Maqamat al-Hariri Illustrated by Y. al-Wasiti*, 7–8; O'Kane, "Text and Paintings," 43; and James, *Masterpiece of Arab Painting*, 18.

63. Questions of patronage and location of production are not of great importance to this essay. For the most recent discussions of these problems, see James, *Masterpiece of Arab Painting*, esp. 1–34; O'Kane, "Text and Paintings," 42; and Grabar, *Maqamat al-Hariri Illustrated by Y. al-Wasiti*, 7.

64. The innovations of al-Wasiti in conceptualizing the sequence—the nearly sixteen double-page paintings

(there could have been more based on O'Kane's proposed identification of missing folios), one full-page painting without text, and two paintings arranged in a manuscript opening with no text—are discussed at length by O'Kane, "Text and Paintings," *passim*.

Only one other manuscript copied by al-Wasiti is presently known. I was able to study it in Paris in December 2009. It is a copy of Abu al-Qasim Mahmud b. ʿUmar al-Zamakhshari's *Rabīʿ al-abrār wa fuṣūṣ al-akhbār fī al-muḥāḍarāt*, a collection of anecdotes and maxims on various subjects: Paris, Bibliothèque nationale de France, Ms. Arabe 6742. It consists of 230 fols., 25.1 x 17 cm, and is copied in *naskh* with seventeen lines to the page. The two colophons appear on fols. 120b and 230b. The colophon on fol. 120b, marking the completion of the first *juzʾ*, is dated "at the end of [the month of] Safar the blessed in the year 649," and the scribe writes his name as Yahya b. Mahmud b. Kuwwariha. The colophon on fol. 230b, marking the completion of the last book, is dated "at the end of the 'day of parting' (*yawm al-rāḥil*) in the middle ten days of Rabiʿ I in the year 649 (June 1251)," and the scribe writes his name as Yahya b. Mahmud b. Yahya b. Kuwwariha al-Wasiti.

65. Abd el-Fattah Kilito, "Le genre 'Séance': Une introduction," *Studia Islamica* 43 (1976): 25–51, at 48. For another breakdown, see James, *Masterpiece of Arab Painting*, 36.

66. James, *Masterpiece of Arab Painting*, 37–41. This offers an expansion and refinement of the structure he described in his 1974 essay, "Space-Forms," 306–8. The listing here is from the 1974 essay (and missing only *maqāma* 27); there are lacunae in James' 2013 book, and one instance of a *maqāma* (no. 19) classed in two types.

67. James describes this phenomenon in al-Wasiti's 1237 *Maqāmāt* as "lateral expansion" and provides detailed explanations of how it worked: "Space-Forms," 308. O'Kane provides further commentary on the double-page paintings ("Text and Paintings," esp. 44–49), suggesting that though they are not without precedent, al-Wasiti's invention was "to employ it systematically in a totally unprecedented manner, in at least sixteen instances" ("Text and Paintings," 50).

68. No paintings: 27 and 35; one painting: 1, 6, 9, 11, 13, 17, 22, 24, 33, 36–38, 45, and 48; two paintings: 3, 7, 8, 10, 14, 15, 19, 21, 26, 28–34, 40–43, 46, 49, and 50; three paintings: 2, 4, 5, 12, 16, 20, 23, 25, 44, and 47; four paintings: 18; five paintings: 39.

69. Al-Ḥarīrī, *Assemblies*, trans. Chenery, 1:114.

70. Philip E. Kennedy, "The *Maqāmāt* as a Nexus of Interests: Reflections on Abdelfattah Kilito's *Les Séances*," in *Writing and Representation in Medieval Islam: Muslim Horizons*, ed. Julia Bray (London: Routledge, 2006), 153–214, at 154.

71. Richards, "*Maqāmāt* of al-Hamadhānī," 99.

72. Mattock, "Early History of the *Maqāma*," 16.

73. Jareer Abu-Haidar, "*Maqāmāt* Literature and the Picaresque Novel," *Journal of Arabic Literature* 5 (1974): 1–10, at 3–4.

74. Ibid., 8.

75. A statistical listing of the corpus of thirteen illustrated *Maqāmāt*s may be found in Grabar, *Illustrations of the Maqamat*, 8–17, with separate charts (appendices 1 and 2) recording the distribution of illustrations in each manuscript. The manuscript of the group with the lowest rate of illustration, 39 paintings to 187 fols., is dated 1222: Paris, Bibliothèque nationale de France, Ms. Arabe 6094.

76. Al-Ḥarīrī, *Assemblies*, trans. Chenery, 1:120–21.

77. Ibid., 1:198–99.

78. Al-Ḥarīrī, *Assemblies*, trans. Steingass, 2:178–79.

79. Ibid., 2:182.

80. Al-Ḥarīrī, *Assemblies*, trans. Chenery, 1:207–8.

81. Ibid., 1:208.

82. For further analysis of this image, and others in the poem, see al-Ḥarīrī, *Assemblies*, trans. Chenery, 1:430–31; and al-Ḥarīrī, *Makamat or Rhetorical Anecdotes*, trans. Preston, 131–32.

83. Al-Ḥarīrī, *Assemblies*, trans. Chenery, 1:208–9.

84. Ibid., 1:211.

85. Ibid., 1:214.

86. Ibid., 1:222–23.

87. Concerning this point, Grabar states that al-Wasiti never realized a consistent iconographic type for Abu Zayd and concludes: "It is as though al-Wasiti kept hesitating between creating an image and interpreting a text": Grabar, *Maqamat al-Hariri Illustrated by Y. al-Wasiti*, 14. Though there are some paintings in which Abu Zayd is less easily identifiable, what came across to Grabar as ultimate failure could also be understood as intended pictorial equivocation (and comparable to Abu Zayd as trickster).

88. In this respect, al-Harith is his perfect opposite. Kilito notes that while "[a]l-Harith b. Hammam is as mobile as Abu Zayd….sometimes young, sometimes old, sometimes rich or poor…his action reflects his being…and obeys strictly, in every circumstance, the code of the man of culture [*adīb*]": Kilito, "Contribution à l'étude de l'écriture 'littéraire' classique," 34–35.

89. On Abu Zayd's various forms of intemperance, especially his love of alcohol, see Katia Zakharia, "Intempérance, transgression et relation à la langue dans les *Maqāmāt* d'al-Ḥarīrī," *Arabica* 41, 2 (1994): 198–213.

90. Kilito, "Contribution à l'étude de l'écriture 'littéraire' classique," 26.

91. From the French translation in Zakharia, "Norme et fiction," 218. Chenery's translation is: "And both these persons are obscure, not known; vague, not to be recognized": al-Ḥarīrī, *Assemblies*, trans. Chenery, 1:105.

92. Kilito, "Contribution à l'étude de l'écriture 'littéraire' classique," 27. Kilito provides several additional examples.

93. Al-Ḥarīrī, *Assemblies*, trans. Chenery, 1:107.

94. Zakharia, "Norme et fiction," 218. For Ibn al-Khashshab's biography and his other writings, see H. Fleisch, *EI2*, s.v. "Ibn al-Khashshāb."

95. Ibid., 218–22. For her subsequent development of the reception history of al-Hariri's *Maqāmāt*, among several other themes related to the work, see Katia Zakharia, *Abū Zayd*

al-Sarūǧī, imposteur et mystique: Relire les Maqāmāt d'al-Harīrī (Damascus: Institut français d'études arabes de Damas, 2000).

96. Richard Ettinghausen, "Early Shadow Figures," *Bulletin of the American Institute for Persian Art and Archaeology* 6 (1934): 10–15. The insights of Ettinghausen and other scholars were recently developed and fleshed out in an article by George, "Illustrations of the *Maqāmāt* and the Shadow Play," which contains many references to pertinent studies since the 1980s.

97. See M. M. Badawi, "Medieval Arabic Drama: Ibn Dāniyāl," *Journal of Arabic Literature* 13 (1982): 83–107. Not least among the overt similarities is the fact that the introducer of Ibn Daniyal's third play, al-Mutayyam, likens himself to al-Harith b. Hammam and that the second play—*al-'Ajīb wa al-gharīb* (which pairs a preacher and a stranger)—presents a series of characters who are different kinds of tricksters. For the shadow play, also see Paul Kahle, "Islamische Schattenspielfiguren aus Ägypten," *Der Islam* 1 (1910): 264–99; vol. 2 (1911): 143–95; and Paul Kahle, "The Arabic Shadow Play in Egypt," *Journal of the Royal Asiatic Society of Great Britain and Ireland* 1 (1940): 21–34.

98. These passages were quoted and discussed in Ettinghausen, "Early Shadow Figures," 11, and Badawi, "Medieval Arabic Drama," 85, and repeated in George, "Illustrations of the *Maqāmāt* and the Shadow Play," 3 and 18, though he uses different translated sources and makes his own adaptations to them.

99. I would not go so far as George as to suggest that the practice of painting in illustrated *Maqāmāt*s—and the wider range of contemporary illustrated Arabic manuscripts—had a causal relation to the shadow play. He believes that the illustrations of the *Maqāmāt* "reflect a figural style and a mode of scene visualization rooted in the shadow theater and largely shaped by its requirements of performative expressivity and clarity," and continues "[i]n other books

of this era, including other illustrated versions of Dioscorides, the imprint of the shadow play is also perceptible, though it is rarely as pronounced as in this copy of the work and in the *Maqāmāt*. The earliest dated Arabic manuscript to show the imprint of the new idiom is a *Kitāb al-Diryāq...* completed in 1199": George, "Illustrations of the *Maqāmāt* and the Shadow Play," 13 and 27.

100. One of the main purposes of illustrated *Maqāmāt*s, as proposed by George ("Orality, Writing and the Images," esp. 21–22), was their use as adjuncts to oral recitation. To develop this point, he highlights the large size of some *Maqāmāt*s, which would facilitate group activity (an enhanced visibility for painting and text), but then has to posit a "more private form of reading" for manuscripts of smaller stature; he does not then account for the many variables that could engender such a difference between illustrated books. Moreover, the strongest evidence for the use of the *Maqāmāt* in contexts of oral recitation is associated with its copying (i.e., dissemination), the making of licensed transmissions of the text (we know that physical copies were used, such as in the *aṣl* studied by MacKay, "Certificates of Transmission"). Notwithstanding an asymmetry of evidence, a verified context (the creation of books) versus a conjectured one (the activation of books by recitation), in the actual use of *Maqāmāt* manuscripts—George's essay is replete with many useful historical references to practices of storytelling and develops some of the same points made in his earlier "Illustrations of the *Maqāmāt* and the Shadow Play." Even if we accept George's point—that the illustrated *Maqāmāt*s "were, in sum, probably meant to be used and appreciated in a convivial setting centred on the oral delivery of the text" (ibid., 22)—its effect is, again, to take us out of the book prematurely, letting us imagine how audiences projected their own values onto them.

ABOLALA SOUDAVAR

THE PATRONAGE OF THE VIZIER MIRZA SALMAN

One often makes suggestions, or proposes theories, without ever discovering new material to reassess them. Thus, when in 2000 I surmised, in *Muqarnas* 17, that the *Dīvān* of Hafiz originally dated 989 (1581) (Topkapı Palace Museum Library [henceforth TSMK], Ms. H. 986) was made for the vizier Mirza Salman (d. 1583), I never expected additional corroborating elements to come up one day. My proposition then rested on the fact that the Topkapı *Dīvān* was illustrated by artists who subsequently worked on the vizier's 990 (1582) *Ṣifāt al-ʿāshiqīn* (Attributes of Lovers), and was thus likely to have been prepared for the same patron.[1] Two additional manuscripts, which recently appeared on the art market, not only confirm those assumptions and attributions, but also shed more light on the patronage of Mirza Salman and his relationship with the artist Muhammadi (fl. sixteenth century): one is a copy of the *Būstān* of Saʿdi dated 987 (1579) and the other a manuscript of the *Salāmān va Absāl* dated 979 (1572), which are both now part of the E. M. Soudavar Trust Collection.[2] In this article I shall discuss the merits of each and try to illustrate the role of Mirza Salman in filling the void in Safavid courtly patronage after the devastating blows that Shah Ismaʿil II (r. 1576–78) inflicted upon the Safavid royal family, and hence, on royal patronage. The key figure in our discussion shall be the painter Muhammadi, whose uncanny ability to pick up stories for allegorical and double-purpose illustrations endeared him to erudite patrons in need of producing thematically sophisticated manuscripts. In conclusion, I shall emphasize once more the pivotal role of the library-atelier of Sultan Ibrahim Mirza (d. 1577), the nephew and son-in-law of Shah Tahmasb I (r. 1524–76), in the training of artists who would pave the way for the development of the next important school of painting—namely that of Riza ʿAbbasi (d. ca. 1630–31) and his followers—and the central role of Muhammadi as the lead figure in this transition process.

I. THE 1579 *BŪSTĀN* OF SAʿDI

The 1579 *Būstān* is a sumptuous manuscript whose probable passage through the Indian lands has resulted in two types of damage.[3] The first consists of extensive wear and tear on the periphery of the manuscript, as well as termite holes close to the covers, including the colophon page (fig. 3 [figs. 1–24 are placed together at the end of the article]). The second is damage through an act of vandalism committed by a religious bigot, who took it upon himself to deface the miniature figures in a most vicious way: by removing the paint with the tip of a sharp knife, penetrating sometimes into the core of paper (fig. 1). Luckily though, he lacked thoroughness in his destructive aims, since one illustration escaped his attention and remains unscathed (fig. 5). The vandal also seems to have concentrated his defacing zeal on the courtiers, while sparing attendants and commoners. The smearing on the pages has now been cleaned, and lacunae have been filled through the efforts of the master restorer Ahmad Moghbel.[4] But the faces remain blank, as no restorer can recreate the expressions emanating from the brush of the original master painter.

The colophon of the manuscript (fig. 3) reads:

> (This book) was completed by the help of God and through His benevolence. Has written it, this sinful slave who longs for the forgiveness of the Lord of the Earth and Heavens, Sultan-Husayn, in the months of the year 987 of the Hijra (1579).

It obviously has much in common with the original colophon of the above-mentioned Topkapı manuscript (fig. 4), which reads:

> The (copying) of these noble and auspicious sayings was finished by the hands of this needy weakling who yearns for the favors of the Lord of the Two Worlds, Sultan-Husayn son of Qasim of Tun, may God forgive them both, on the 20th of the holy month of Ramadan of the year 985 after the Hijra (Nov. 30, 1577).[5]

They are both by the same hand, penned by the calligrapher Sultan-Hosayn of Tun. Similarly, the elaborate frontispiece of the 1579 *Būstān* is signed by 'Abdullah-i Muzahhib (fig. 2), in a location reminiscent of his signature on the frontispiece of the Topkapı *Dīvān* of Hafiz,[6] as well as on that of the Freer's celebrated *Haft Awrang* manuscript commissioned by Ibrahim Mirza.[7]

As for the illustrations of the 1579 *Būstān*, since none of them seem to belong to the known repertoire of illustrated *Būstān* manuscripts, I shall explain that they were chosen specifically to evoke important events in the political life of Mirza Salman,[8] who figures allegorically in each of the four paintings. Since as a group they narrate the vizier's rise to power, rather than present them in the order they appear in the manuscript, I shall weave them into a brief biography of the vizier in order to show the relevance of each illustration.

The historical narrative

Mirza Salman was a scion of the powerful Jabiri Ansari family of Isfahan, whose members traced their ancestry to Jabir b. 'Abdullah-i Ansari, one of the early companions (*anṣār*) of the Prophet Muhammad. His father had achieved high rank in the Safavid administration, and the young Salman followed suit under his tutelage.[9] He soon became the superintendent of the royal household (*nāzir-i buyūtāt*), and it is in this capacity that, after the demise of Shah Tahmasb (r. 1524–76), he accompanied Ibrahim Mirza to greet Tahmasb's successor, Isma'il II, on the outskirts of Qazvin in May 1576. He was initially appointed chief scribe to the vizier Mirza Shukrullah (d. 1581),[10] but he must have quickly gained the favor of the new shah, because within a year he was nominated as grand vizier (*vazīr-i a'lā*) in lieu of Mirza Shukrullah himself,[11] at a time when Isma'il had consolidated his power and was ready to eliminate all potential contenders.

"The Syrian king and the apprehensive dervishes" (*fig. 6*)

This folio, the third and, as noted earlier, only intact miniature of the book, illustrates Mirza Salman witnessing, from close quarters, the momentous decision of Isma'il II to decimate each and every possible contender to the throne (fig. 6). Being apprehensive about the Qizilbash amirs' reaction to such a decision, Isma'il moved cautiously and put a group of six princes under house arrest, each guarded by a trusted lieutenant. He then seized upon an incident, perhaps instigated by himself, to divert attention from his scheme: he neutralized the Qizilbash amirs by sending them to quell the unruly Safavid dervishes who had attacked the city guardsmen, while concurrently ordering his lieutenants to do away with the princes in their custody. Once he got word that all six princes had been killed, he came back and pardoned the arrested dervishes who had been brought to court.[12]

The *Būstān* story chosen to illustrate this episode is one from the fourth section, on the theme of humbling: while visiting the local markets in disguise, a Syrian king overhears two dervishes disparaging him; he summons them to his court in order to reprimand them, but heeds their pleas and ends up releasing them.[13]

The common denominator to the two stories embedded in this painting is that the dervishes who face punishment in both are ultimately pardoned. However, while the Sa'di story specifies the number of dervishes as only two, our miniature depicts one more—slightly apart—in order to allude to the higher number of Safavid dervishes involved in the attack against the city guardsmen. As witness to the shah's sinister ploy, Mirza Salman stands in the doorway holding a ministerial staff; he signals his detachment from the scheme by turning his head and feigning disapproval through a murmur addressed to a young subordinate, perhaps his own son. The king, though, is listening to the dervishes, and seems noticeably satisfied, presumably after receiving the reports of the execution of the Safavid princes, conveyed by the lieutenant holding a bow and standing behind him. In the Iranian tradition, the spilling of the

blood of princes portended bad omen. Consequently, they were usually executed through strangulation by a bowstring;[14] hence the brandishing of the bow by the shah's acolyte.

In my 2000 article in *Muqarnas*, I had enumerated a number of stylistic characteristics for Muhammadi's paintings,[15] many of which are recognizable here, including: his penchant for transgressing the text frame and blending the image into the margins; the inter-columnar gold foliage and arabesques on a lapis back-ground; pencil-thin headgear batons; the arrow-shaped fingers of his plane-tree leaves; and his signature motif of an interacting pair of foxes. The highly polished painted surface and the crispness of details notwith-standing, we can see the true measure of Muhammadi's genius in the facial expressions of his various actors (fig. 5): the dervishes have an apprehensive look fearing the wrath of the shah; the latter is attentive to the pleas of the dervishes and looks amused; Mirza Salman feigns disinterest, while his young subordinate urges him—through finger pointing—to listen to the shah's disin-genuous questioning of the dervishes.

"A black man abusing a young girl" (*fig. 7*)

The last painting in the manuscript, from the section on education, illustrates Mirza Salman's role in the discov-ery of Isma'il II's death (fig. 7).

Safavid princes often indulged in wine, opium, and homosexual affairs. Incarcerated for years in the remote fortress of Qahqaha, Isma'il had developed a penchant for all three. Once he consolidated his power and elim-inated his rivals, he set his eyes on one Hasan Bayg, the son of the *ḥalvāchī* (halva maker), who became his lover. On the eve of November 24, 1577, Isma'il and Hasan Bayg had roamed around town, consuming a fair amount of *falūniyā* (a potent mixture of opium and cannabis),[16] in addition to drinking heavily. Later in the night, they retired to Hasan Bayg's quarters, but neither could rise the next morning. By noontime, as a faint voice crying for help was heard through the locked doors, Mirza Salman took it upon himself to break the lock and enter the private quarters of the king's lover. A suffocated Isma'il lay motionless and breathless on the ground, while holding Hasan Bayg in his arms, whose limbs were equally numbed. The shah died shortly thereafter; his

debilitated lover, who survived, explained that the bot-tle of *falūniyā* (known as a *huqqa*) they had consumed the night before had been unsealed and tampered with, suggesting foul play from Isma'il's enemies, of which he had many.[17]

A story of Sa'di, in which he encounters a black man abusing his beautiful slave,[18] provides the necessary set-ting for the illustration of the decisive role that Mirza Salman played in the events that led to the discovery of Isma'il's death. Because suffocation is commonly referred to in Persian as "turning black," the image of a black man squeezing a young girl in his arms was meant to evoke the fate of Isma'il lying asphyxiated next to his beloved Hasan Bayg. Thus, the old man watching the entangled pair parallels the vizier bursting in on the scene and discovering the dying men.

The private quarters that Isma'il had set up for Hasan Bayg were next to the secretarial palace (*daftarkhāna*), and one door opened onto the royal equestrian square (*meydān-i asb*).[19] It was attached to the *dawlatkhāna* (government house), built during Tahmasb's reign as a pavilion surrounded by gardens.[20]

Although the death scene is transplanted into a gar-den in order to reflect the *Būstān* story, it is accurately placed by the side of the *dawlatkhāna*, marked by an elaborate dome not mentioned in the *Būstān*. The first building must be the *daftarkhāna*, with the small pavil-ion in between the *daftarkhāna* and the *dawlatkhāna* depicting the private quarters of the shah's lover, where they were actually found.

"Jealousy among rivals" (*fig. 8*)

This illustration, from the section on justice (the first section of the *Būstān*), depicts how the rise of a court functionary to the post of vizier arouses the jealousy of his predecessor (fig. 8).[21] It admirably reflects Mirza Salman's maneuvers to take the place of Shah Isma'il II's original vizier, Mirza Shukrullah. In the illustration, the kneeling Mirza Salman, as the newcomer, pleads his case before the king by refuting accusations brought by Mirza Shukrullah, portrayed as the older vizier in a red silk robe standing in the doorway and holding the ministerial staff.

In the preamble to this *Būstān* story, the newcomer deflects the attacks of his rival by arguing that:

کجا بر زبان آورد جز بد من حسودی که بیند بجای خودم

How can he not say bad things about me,
the jealous rival who sees me taking his place.

به فرسنگ باید ز مکرش گریخت وزیری که جاه من آبش بریخت

One must run far away, from the malevolence of a vizier
who lost face by my rise to prominence.

While some of these verses seem to be better than others in terms of encapsulating the key theme around which this miniature should have been composed,[22] the artist instead selected a verse in which the functionary cites, as proof of his devotion to the king, his long years of service in his retinue and how he lost his pearl-like teeth in the process:

دو رسته دُر مرد دهن داشت جای

چو دیواری از خشت سیمین بنای

I had two rows of pearl-like teeth in my mouth,
like a wall built out of silvery bricks.

We can only assume that the prominence of this verse in the composition was an obvious clue to the identity of Mirza Salman, one that a contemporary reader would have immediately understood. Unfortunately, no other document gives us a physical description of Mirza Salman to ascertain the veracity of this hypothesis. Two additional clues, however, corroborate the identity of the kneeling man: a) he has a golden pen box tucked into his waistband, befitting Mirza Salman's position as chief scribe before his assumption of the vizierate; and b) he is depicted with a distinctive black beard (figs. 9 and 11), consistent not only with all other images of him in this manuscript, but also with the elaborate face of a dervish depicted by the artist Shaykh Muhammad, which I had previously surmised to represent Mirza Salman (fig. 10).[23]

"A devout man being beheaded unjustly" (*fig. 12*)

The second illustration of the manuscript, also from the section on justice, is its grandest. It fittingly evokes the crucial event that propelled Mirza Salman to the forefront of the political stage and placed the reins of power in his hands, albeit for only a few years.

After Isma'il II's death, the amirs "in the company of the Asaf of the age [i.e., Mirza Salman][24] went to Pari Khan Khanum [d. 1578] in order to discuss the fate of the kingdom and kingship."[25] The latter was Tahmasb's influential daughter, who in the last years of her father's reign had become all powerful and acted as his *éminence grise*. Upon the death of Tahmasb, she championed the cause of Isma'il against all other candidates, thinking that some twenty years in prison had taken a toll on him, and that she could continue to play her role of *éminence grise* as before. But contrary to her expectations, no sooner had Isma'il ascended to the throne than he put her under house arrest and lured her powerful uncle, the Circassian Shamkhal Sultan (d. 1578), into the circle of his close lieutenants in charge of princely executions.

Mirza Salman knew very well that with Isma'il II gone, Pari Khan Khanum would take revenge on all those who had prospered at her expense, especially the grand vizier. Therefore, before the princess could close the gates of the city, he escaped toward Shiraz, where the only surviving son of Tahmasb, the blind Shah Muhammad (r. 1578–87), was preparing to go to the capital. In Shiraz, he offered his services to the new king and his very ambitious wife, Mahd-i Ulya (d. 1579), in whom he saw an ally against Pari Khan Khanum. Mahd-i Ulya quickly understood that unless the princess were eliminated, the amirs would gravitate toward her and not the queen. Thus, her first act upon arrival in Qazvin was to order the execution of Pari Khan Khanum, along with her uncle, Shamkhal Sultan.[26] The road was then cleared for the vizier not only to assume control of the administration, as before, but also to hold sway over the military, supposedly on behalf of the queen.

A joint attack by the Ottoman commander Özdemiroğlu Osman Pasha (d. 1584) and the Crimean Tatar prince 'Adil Giray Khan (d. 1578) provided the opportunity for Mirza Salman to prove his military valor. The invaders were defeated, Osman Pasha fled to Shirvan, and 'Adil Giray Khan was captured. Rather than allowing Mirza Salman to pursue his campaign, the queen summoned him back to court, along with his prisoner.

Capitalizing on "her" military victory, Mahd-i Ulya decided to settle some old scores with her own cousins, who, by a decision of Tahmasb, had taken the governorship of Mazandaran, once a fiefdom of her father. The first military expedition resulted in the capture of a local governor named Shams al-Din-i Div (d. 1578). Angry at the amirs' failure to capture Mirza Khan (d. 1578), the ruler of Mazandaran, whom she saw as a usurper, she ordered a new expedition. The two veteran commanders, Pira Muhammad and Shahrukh Sultan, realized that they could not seize the lofty mountain fortress in which Mirza Khan had taken refuge. They therefore negotiated his surrender by giving their word that he would not be executed. Meanwhile, Mahd-i Ulya not only commanded the execution of the Tatar prisoner, but paraded Shams al-Din through the city in a most humiliating way before killing him. When Mirza Khan arrived, she ordered his execution as well, despite the objections of the veteran amirs and the pleas from various courtiers for clemency. Seeing the vengefulness of the queen and fearing for their own lives, the Qizilbash amirs decided to eliminate her and she was executed shortly thereafter.[27]

The one who gained the most from all these events was, of course, Mirza Salman, who had a hand in the plot and now stood unchallenged in the political arena. With all his rivals eliminated, he further consolidated his position by marrying his daughter to the young prince Hamza Mirza (d. 1586), the elder son of the blind Shah Muhammad.[28] But less than two years later, the vizier's arrogance caused his own downfall, and he in turn was assassinated by the very Qizilbash amirs whom he had used to eliminate his enemies.

As a defining moment in the political career of Mirza Salman, the killing of Mirza Khan thus constituted an event that had to be grandly illustrated. To portray this scene, Muhammadi used the *Būstān* story of the beheading of an innocent, devout man on the order of the famous Umayyad viceroy of Iran, Hajjaj b. Yusuf (d. 714),[29] in lieu of the beheading of Mirza Khan, whom the Safavid chronicles describe as *Sayyidzāda-i bīgunāh* (the innocent descendant of the Prophet Muhammad).[30]

At the same time, the killing of the queen was a reprehensible deed that needed justification. It had to be portrayed as a reaction to an odious act, one reviled even by the queen's own son. The verses embedded at the top of the page, which explain the subject of the illustration, emphasize this point. But in the manuscripts of this period, this verse appears in two ways: in some, it is an anonymous person (*yakī* [one]) who addresses the king, but in others, it is the son (*pisar*) who stands before the ruler and pleads for the innocence of the about-to-be-executed kneeling man (in the table below, the former is presented in parentheses, while our manuscript's version is underlined):[31]

(یکی) پسرگفتش ای نامورشهریار (بیا) یکی دست ازین مرد صالح بدار	(One) *His son* told him, O great king, (come,) let this pious man be free, *at once*.
که خلقی بدو روی دارند و پشت نه رایست خلقی بیکبار کُشت	Whom many trust and rely upon, it is not wise to alienate with one stroke so many people.

Whether by chance or by choice, the version adopted for this manuscript is the one that most emphasized the opposition of Hamza Mirza to the king's decision (in reality his mother's) to behead the innocent sayyid.

II. INHERITING THE IBRAHIM MIRZA LIBRARY-ATELIER

With the discovery of this *Būstān* manuscript, which we have argued was commissioned by Mirza Salman, we can see that soon after the demise of Ibrahim Mirza, the vizier appropriated for himself the services of two painters from the prince's library-atelier, namely, Abdullah-i Muzahhib and Muhammadi, from whom he would later commission more works. This should come as no surprise, since his position as superintendent of royal households under Tahmasb had brought him into close contact with Ibrahim Mirza, who was court minister (*ishīk āqāsī bāshī*) at that time.[32] By the year 1579, the senior contributors to the prince's celebrated *Haft Awrang* (Freer 46.12), namely, Aqa Mirak, 'Abd al-'Aziz, Mirza 'Ali, and Muzaffar 'Ali must have either all died or been incapacitated.[33] The hand of Shaykh

Muhammad (fl. latter half of the sixteenth century), however, who was younger and still alive, is conspicuously absent in the first two manuscripts of the vizier, i.e., his 1579 *Būstān* of Sa'di and 1581 *Dīvān* of Hafiz. The artist's turbulent compositions may not have been to the liking of Mirza Salman, who seems to have favored more classical settings. Shaykh Muhammad's hand, however, reappears in the 1582 *Sifāt al-'āshiqīn*,[34] perhaps because the latter manuscript was commissioned as a gift destined for the crown prince Hamza Mirza. The addition of a work by a third painter from the library-atelier of Ibrahim Mirza (besides 'Abdullah-i Muzahhib and Muhammadi) would have enhanced the prestige of such a work, but his subtle humor may have amused the young prince as well. Indeed, in the last painting of said manuscript, namely "The poor man and the prince," Shaykh Muhammad adds a humorous touch by twisting the foot of the polo-playing prince backward (fig. 13). As a result, his foot engages the stirrup in the wrong direction and in an anatomically impossible manner! This is a device that the painter had tried for a pastoral scene, in which one of the princesses actually has two left hands (fig. 14).[35] A closer look even shows that this came as an afterthought, and the painter deliberately reworked the hand to create a physically impossible gesture.

Similarly, in a tinted drawing that is also attributable to Shaykh Muhammad, he has cleverly twisted the posterior of the main rider-huntsman by placing it where his knee should have been (fig. 15). Indeed, the two opening flaps of the Safavid overcoat must open in front and in continuation of the buttoned upper torso, while here they are situated on the opposite side (see, for instance, fig. 16, for a correct depiction of the same pose by 'Abdullah-i Muzahhib[36]). Humor, craftsmanship, and dexterity had all contributed to energizing the Mashhad school of painting that characterized the library-atelier of Ibrahim Mirza.

As Persian chronicles of this period emphasize, Ibrahim Mirza's atelier had produced a new crop of painters whose association with the prince was a source of enormous prestige. Thus, the legend *Bihzād-i Ibrāhīmī* on one of the paintings of the 1581 *Dīvān* of Hafiz clearly denotes affiliation to the prince's library-atelier (fig. 17). But said painting is visibly attributable to Muhammadi, and, as argued elsewhere, this added attribution must

have been the result of confusing explanations provided by the Safavid mission that brought the manuscript to the Porte, circa 1587.[37] Members of that mission were surely trying to enhance the value of their gifts by explaining that Muhammadi was like the "Bihzad" of Ibrahim Mirza. The metaphor was probably lost on the Ottomans, who simply seem to have understood the painter's name as *Bihzād-i Ibrāhīmī*. From our perspective, though, this appellation is indicative of the state of mind of the Safavid delegation, as well as of the prestige of Ibrahim Mirza's atelier in Safavid circles. Bypassing any reference to Tahmasb, they were equating Ibrahim Mirza's library-atelier with that of the Timurid Sultan Husayn Bayqara (r. 1469–1506), and regarded the painter Muhammadi as its Bihzad.

The Gulistan Library's Silsilat al-dhahab

If Muhammadi was really the star of Ibrahim Mirza's atelier—at least in its latter days—we should be able to find more of his works from this period. I believe that an illustrated manuscript of the *Silsilat al-dhahab* of Jami at the Gulistan Library in Tehran (no. 671), copied in Ramadan 977 (February–March 1570) by the calligrapher Babashah, may be relevant in this respect.[38] Although of modest size (24.5 cm × 15.5 cm), it is distinguished by its glittering, gold-speckled margins and the beauty of its fourteen miniatures, a few of which are attributable to Muhammadi. "Moses carrying a sheep on his shoulders" (fig. 20), for instance, already incorporates many elements that we have recognized as characteristic of his style: a typical ascending mountainous landscape sprinkled with red and blue flowers, an imposing plane tree with his favored autumn-colored leaves, a prominent running stream, and, most importantly, a goat descending the rocks alongside his favorite black-and-white colored goat. This is a subject that he revisited in the 1580s, with his single contribution to Hamza Mirza's magnificent *Haft Awrang* (TSMK, Ms. H. 1483, fol. 130b).[39] Another painting, "The imam Zayn al-'Abidin visiting the Ka'ba" (fig. 21), displays Muhammadi's fondness for scrollwork illumination, visible on the blue and black portions of the Ka'ba coverings. As for the faces, one can already notice his penchant for open-ended eye contours as well as for a black beauty spot on the cheek, which characterizes, for instance, the face of the prince

and even that of simple attendants in his painting in the 1582 *Ṣifāt al-ʿāshiqīn* (figs. 18 and 19).[40]

This manuscript also puts into evidence Muhammadi's talents as an illuminator and book cover painter. We had previously attributed a Topkapı binding to him on the basis of its figures.[41] The illumination pattern on the binding here (fig. 22) ties in with the margin illumination of the "Jealousy among rivals" in the *Būstān*, as well as the decorative scheme of the back wall therein, especially in terms of its pheasants perched in the trees and flapping their wings (fig. 8). We thus see in Muhammadi an accomplished painter who could by himself manage the entire illustrative and decorative program of a manuscript, including its binding.

While the study of this magnificent manuscript merits a separate monograph, on the basis of the published material, one can already attribute at least two paintings in it to Muzaffar-ʿAli, as well as one to ʿAbdullah-i Muzahhib.[42] Therefore, not only does its roster of artists point to an affiliation with the library-atelier of Ibrahim Mirza, but its sumptuousness vouches for an expensive production affordable only by a prince of high rank. As for Babashah, he was the master calligrapher who was credited with bringing the *nastaʿlīq* script to full maturity during the sixteenth century.[43] And as such, he was the most accomplished calligrapher of his age, and the most suitable choice for a connoisseur such as Ibrahim Mirza, in lieu of calligraphers like Malik-i Daylami (d. 1562), who had participated in the production of the Freer *Haft Awrang* but was no longer available. It is with the Gulistan Library's *Silsilat al-dhahab* in mind that we shall speculate on the patronage of our next manuscript.

The Salāmān va Absāl

Copied in Dhu'l-Hijja 979 (April–May 1572) by the same calligrapher, Babashah, one could, of course, see the *Salāmān va Absāl* as a sequel to the previous manuscript, especially since its lone illustration is attributable to Muhammadi (fig. 24). Both texts are part of the *Haft Awrang* of Jami, but whereas the *Silsilat al-dhahab* shines by its opulence, the *Salāmān va Absāl* is a mere shadow of the former work. Slightly smaller in size (20.1 cm × 11.9 cm), its decorative program is meager, with just the one illustration (fig. 24) and one small opening

heading. Its binding, however, closely imitates that of the *Silsilat al-dhahab* (fig. 23). It is as though a member of the prince's circle such as Mirza Salman, having seen the previous manuscript, desired to have a similar one, but unable to afford it, settled on a more modest version. Given the constant presence of Muhammadi in the later manuscripts of Mirza Salman, one can reasonably speculate that the relationship between the two developed at an earlier stage, when the artist was still in the employ of Ibrahim Mirza. For it seems that, in addition to his talent as an artist, Muhammadi had the intellectual capacity to find a suitable text and match it with an inventive composition in order to allude to contemporary events. From one patron to another, he continued to create such compositions, even during the Uzbek occupation of Herat (1588–98).[44] It may be precisely this intellectual capacity that endeared the artist to Mirza Salman, who was himself fond of metaphors, and famously pronounced this verse from Jami, "To be 'double-sighted' is to be fickle / the object of love is one and only one," to prevent the split of the Safavid empire between two competing factions, one supporting Hamza Mirza and the other his younger brother, ʿAbbas, the future Shah ʿAbbas I (r. 1587–1628).[45]

CONCLUSION

In the person of Mirza Salman we can see a patron who was well acquainted with the library-atelier of Ibrahim Mirza, who had built a rapport with its artists, and who, for a short while after the demise of the prince, picked up his mantle and began to commission a series of prestigious manuscripts in the same tradition. At the center of this new activity stood Muhammadi, who, by mixing the styles of his predecessors, namely Mirza ʿAli and Shaykh Muhammad, pushed the development of Persian painting into a looser and more fluid mode, thereby paving the way for the next generation of painters.[46]

While there was perhaps a short lull in patronage from the assassination of Ibrahim Mirza to the ascendance of Mirza Salman—in which period Muhammadi reverted to tinted drawings[47]—the vizier's ambition to pick up the mantle of Ibrahim Mirza must have generated much hope for the remaining Safavid artists. In addition, the coming of age of Hamza Mirza and the for-

mation of his princely atelier invigorated Safavid artis-
tic activity. In both cases, the lead artist had been
trained in the atelier of Ibrahim Mirza: the vizier had
taken Muhammadi under his wings, while the prince
relied on Farrukh Beyg, who was from a family of Geor-
gian slaves devoted to the Safavid household.[48] Even
though the vizier had strengthened his ties to Hamza
Mirza by giving him his own daughter in marriage, one
feels that there was nevertheless a sense of competition
between the two in terms of patronage. The prince,
however, had the edge because of his vaster resources—
not only in terms of artists but also because of the works
he had inherited from Ibrahim Mirza's atelier, such as
the unfinished *Haft Awrang* (TSMK, Ms. H.1483), which
he gave to Farrukh Beyg to refurbish.[49] Both ateliers
were short-lived and disappeared with the early deaths
of their respective patrons, Mirza Salman in 1583, and
Hamza Mirza in 1586. In terms of a legacy though, it was
the school of Muhammadi that marked the next gener-
ation of Persian artists. Muhammadi's fluid style and
airy penmanship had a lasting impact because it was
adopted and propagated by the celebrated Riza

'Abbas—who referred to Muhammadi as *ustād* (mas-
ter).[50] On the other hand, Farrukh Beyg's highly pol-
ished style and his emphasis on elaborate idiosyncratic
facial expressions were best suited to the Indian sub-
continent—where he took refuge after leaving the Safa-
vid court circa 1585—and abandoned in Iran after his
departure.

Finally, should our assessment of the patronage of
the 1572 *Salāmān va Absāl* and 1579 *Būstān* manuscripts
be correct, we can view them as evidence of a growing
trend among non-royal patrons who commissioned
illustrated manuscripts in parallel or in competition
with princely ateliers. But in this context, it is the occa-
sional interaction of erudite viziers such as Mirza
Salman with sophisticated painters such as Muham-
madi that gave rise to the creation of sumptuous but
enigmatic manuscripts such as the 1579 *Būstān,* whose
illustration program cleverly mirrored the historical
events described in the text.

Independent scholar,
Houston, Texas

Fig. 1. Detail, showing examples of damaged faces, of fig. 12, "A devout man being beheaded unjustly," by Muhammadi. From the *Būstān* of Saʿdi, dated 987 (1579). Houston, E. M. Soudavar Trust Collection. (Photo: Abolala Soudavar)

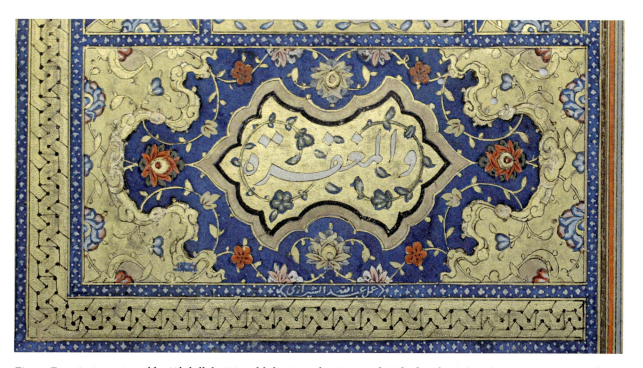

Fig. 2. Frontispiece, signed by ʿAbdullah-i Muzahhib. From the *Būstān* of Saʿdi, dated 987 (1579). Houston, E. M. Soudavar Trust Collection. (Photo: Abolala Soudavar)

Fig. 3. Colophon of the *Būstān* of Saʿdi, dated 987 (1579). Houston, E. M. Soudavar Trust Collection. (Photo: Abolala Soudavar)

Fig. 4. Colophon of the *Dīvān* of Hafiz, dated 989 (1581). Istanbul, Topkapı Palace Museum Library (TSMK), Ms. H. 986. (Photo: courtesy of the Topkapı Palace Museum Library)

Fig. 5. Detail, showing the variety in facial expressions, of fig. 6, "The Syrian king and the apprehensive dervishes," by Muhammadi. From the *Būstān* of Saʿdi, dated 987 (1579). Houston, E. M. Soudavar Trust Collection. (Photo: Abolala Soudavar)

Fig. 6. Muhammadi, "The Syrian king and the apprehensive dervishes." From the *Būstān* of Saʿdi, dated 987 (1579). Houston, E. M. Soudavar Trust Collection. (Photo: Abolala Soudavar)

Fig. 7. Muhammadi, "A black man abusing a young girl." From the *Būstān* of Saʿdi, dated 987 (1579). Houston, E. M. Soudavar Trust Collection. (Photo: Abolala Soudavar)

Fig. 8. Muhammadi, "Jealousy among rivals." From the *Būstān* of Sa'di, dated 987 (1579). Houston, E. M. Soudavar Trust Collection. (Photo: Abolala Soudavar)

Fig. 9. Detail of fig. 8, Muhammadi's "Jeal-ousy among rivals," showing a golden pen box tucked into the waistband of a figure identified as Mirza Salman. From the *Būstān* of Saʻdi, dated 987 (1579). Houston, E. M. Soudavar Trust Collection. (Photo: Abolala Soudavar)

Fig. 10. Detail, showing Mirza Salman, of fig. 12, "A devout man being beheaded unjustly," by Muhammadi. From the *Būstān* of Saʻdi, dated 987 (1579), Houston, E. M. Soudavar Trust Collection. (Photo: Abolala Soudavar)

Fig. 11. Detail, showing Mirza Salman, of "The poor man and the prince," by Shaykh Muhammad. From the *Ṣifāt al-ʿāshiqīn*, dated 989–90 (1582), fol. 55r. Abolala Sou-davar, *Art of the Persian Courts: Selections from the Art and History Trust Collection* (New York, 1992), cat. 90c. (Photo: Abolala Soudavar)

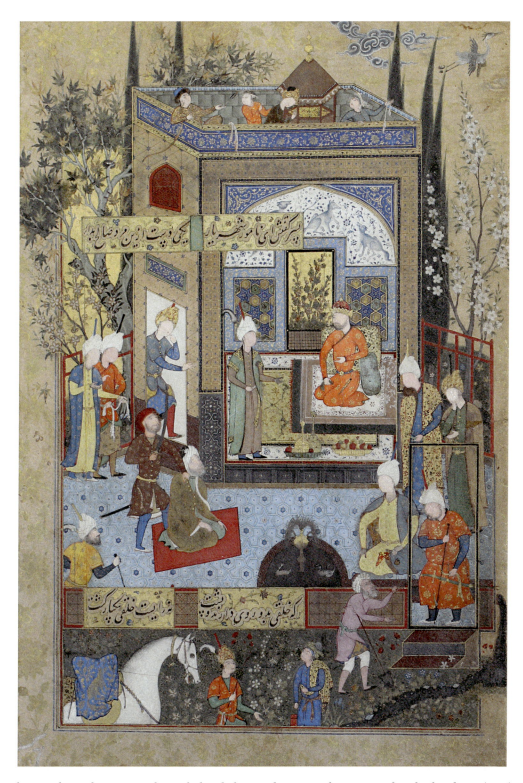

Fig. 12. Muhammadi, "A devout man being beheaded unjustly." From the *Būstān* of Sa'di, dated 987 (1579). Houston, E. M. Soudavar Trust Collection. (Photo: Abolala Soudavar)

Fig. 13. Detail, showing a twisted foot, of "The poor man and the prince," by Shaykh Muhammad. From the *Ṣifāt al-ʿāshiqīn*, dated 989–90 (1582), fol. 55r. Soudavar, *Art of the Persian Courts*, cat. 90c. (Photo: Abolala Soudavar)

Fig. 14. Detail, showing a princess's twisted right hand, of the pastoral scene "Ladies preparing a picnic," by Shaykh Muhammad. University of Oxford, Bodleian Library, Ms. Elliot 180, fol. 192. (Jon Thompson and Sheila R. Canby, eds., *Hunt for Paradise: Court Arts of Safavid Iran 1501–1576* [Milan, 2006], 132.)

Fig. 15. Detail of a "Hunting scene," attributable to Shaykh Muhammad (single folio). Washington, D.C., Freer Gallery of Art, F1954.32. (Photo: Abolala Soudavar)

Fig. 16. Detail of "Horseman and running page," by ʿAbdullah-i Muzahhib (single folio). Washington, D.C., Arthur M. Sackler Museum, 1958.62. (Photo: courtesy of the Arthur M. Sackler Museum)

Fig. 17. Detail of "Dervishes together," attributed to Bihzad-i Ibrahimi (i.e., Muhammadi). From the *Dīvān* of Hafiz, dated 989 (1581). Istanbul, Topkapı Palace Museum Library (TSMK), Ms. H. 986, fol. 21b. (Photo: courtesy of the Topkapı Palace Museum Library)

Fig. 18. Detail, showing the beauty spot and open-ended eye contours, of "Throwing down the impostor," by Muhammadi. From the *Ṣifāt al-ʿāshiqīn*, dated 989–90 (1582). Soudavar, *Art of the Persian Courts*, cat. 90b. (Photo: Abolala Soudavar)

Fig. 19. Detail, showing the beauty spot and open-ended eye contours on two faces in "Throwing down the impostor," by Muhammadi. From the *Ṣifāt al-ʿāshiqīn*, dated 989–90 (1582). Soudavar, *Art of the Persian Courts*, cat. 90b. (Photo: Abolala Soudavar)

Fig 20. Muhammadi, "Moses carrying a sheep on his shoulders." From the *Silsilat al-dhahab* of Jami. Tehran, Gulistan Library, Ms. 671. (Photo: Abolala Soudavar)

Fig. 21. Muhammadi, "The imam Zayn al-'Abidin visiting the Ka'ba." From the *Silsilat al-dhahab* of Jami. Tehran, Gulistan Library, Ms. 671. (Photo: Abolala Soudavar)

Fig. 22. Binding of the *Silsilat al-dhahab* of Jami. Tehran, Gulistan Library, Ms. 671. (Photo: Abolala Soudavar)

Fig. 23. Binding of the *Salāmān va Absāl* of Jami, dated 979 (1572). Houston, E. M. Soudavar Trust Collection. (Photo: Abolala Soudavar)

Fig. 24. Muhammadi (attr.), "Salaman seated with Absal." From the *Salāmān va Absāl* of Jami, dated 979 (1572). Houston, E. M. Soudavar Trust Collection. (Photo: Abolala Soudavar)

NOTES

1. Abolala Soudavar, "The Age of Muhammadi," *Muqarnas* 17 (2000): 62–65.

2. Christie's, London, *Islamic Art and Manuscripts*, Oct. 12, 2004, lot 186; and Christie's, London, *Art of the Islamic and Indian Worlds*, Oct. 7, 2008, lot 350.

3. Termite holes usually indicate that a manuscript passed through Indian lands, and the disfiguration is akin to the damage in the pages of the famous Akbar-period *Hamzanāma*.

4. In 2005, Ahmad Moghbel restored the miniatures by filling the damaged spots in order to arrest the flaking process. Moghbel, who previously had an atelier in Houston, now resides in Rome.

5. The Topkapı manuscript has three colophons, all of which are discussed in Soudavar, "Age of Muhammadi," 62–65. The above quote pertains to the second colophon of the manuscript.

6. Filiz Çağman and Zeren Tanındı, "Remarks on Some Manuscripts from the Topkapı Palace Treasury in the Context of Ottoman-Safavid Relations," *Muqarnas* 13 (1996): 135, fig. 4.

7. Marianna S. Simpson, *Sultan Ibrahim Mirza's* Haft Awrang: *A Princely Manuscript from Sixteenth-Century Iran* (Washington D.C., 1997), 34.

8. While I could not find any of the four subjects depicted as a group in earlier manuscripts of the *Būstān*, later or contemporary copies such as Ms. Or. 10909 of the British Library may include one of the scenes (the story of the Syrian king on fol. 85a): see Norah M. Titley, *Miniatures from Persian Manuscripts: A Catalogue and Subject Index of Paintings from Persia, India, and Turkey in the British Library and the British Museum* (London, 1978), 146. Significantly, a *Kulliyāt* (Complete Works) of Sa'di with 72 illustrations (London, British Library, Ms. Add 24944) contains none of our miniatures: Titley, *Miniatures from Persian Manuscripts*, 148–50.

9. Colin P. Mitchell, *Encyclopaedia Iranica* (Online edition, 2007), s.v. "Jāberi": http://www.iranicaonline.org/articles/jaberi.

10. Qāżī Aḥmad Qumī, *Khulāṣat al-tavārīkh*, ed. Iḥsān Ishrāqī, 2 vols. (Tehran, 1359 [1980]), 2:618.

11. Ibid., 2:648.

12. Iskandar Bayg Munshi-yi Turkmān, *Tārīkh-i 'ālamārā-yi 'Abbāsī*, ed. Iraj Afshār, 2 vols., 2nd ed. (Tehran, 1350 [1971]), 1:208–9; Qāżī Aḥmad, *Khulāṣat*, 2:628–30, 643.

13. Shaykh Muṣliḥ al-Dīn Sa'dī Shīrāzī, *Būstān*, ed. M. A. Nāṣiḥ (Tehran, 1371 [1992]), 500; see www.ganjoor.net/saadi/boostan/bab4/sh14 (accessed March 2, 2013).

14. Iskandar Bayg, for instance, gives the added information that princes were strangled with a cord (*rīsmān* [Iskandar Bayg, *Tārīkh*, 1:212]), or with a bowstring (*bi zih-i kamān* [Iskandar Bayg, *Tārīkh*, 1:240]). The practice goes back to Sasanian times—Ibn Balkhi reported that both Khusrau II (r. 590–628) and his father were killed by a bowstring. Ibn-i Balkhī, *The Fārsnāma of Ibnu'l Balkhī*, ed. G. Le Strange and R.A. Nicholson (London, 1968), 100 and 107.

15. Soudavar, "Age of Muhammadi," 55–57.

16. On *falūniyā*, see 'Alī Akbar Dihkhudā, *Lughatnāma* (Tehran, 2003), accessed online at www.loghatnaameh.org, s.v. "falūniyā."

17. Qāżī Aḥmad, *Khulāṣat*, 2:652–53; Iskandar Bayg, *Tārīkh*, 1:218–19.

18. Sa'dī, *Būstān*, ed. Nāṣiḥ, 645–46; see also www.ganjoor.net/saadi/boostan/bab7/sh9/ (accessed March 2, 2013).

19. Qāżī Aḥmad, *Khulāṣat*, 1:653; Iskandar Bayg, *Tārīkh*, 1:218.

20. Abolala Soudavar, "Between the Safavids and the Mughals: Art and Artists in Transition," *Iran* 37 (1999): 62n45; 'Abdī Bayg Shīrāzī, *Takmilat al-akhbār*, ed. 'Abd al-Ḥusayn Navā'ī (Tehran, 1369 [1990]), 94.

21. Sa'dī, *Būstān*, ed. Nāṣiḥ, 67–73; see also www.ganjoor.net/saadi/boostan/bab1/sh2 (accessed March 2, 2013).

22. In his research on the *Shāhnāma* manuscripts, Farhad Mehran has concluded that the last verse in the upper half of the illustration (which he calls the break-line verse) is the one that sets the tone for the illustration and provides its major compositional element: Farhad Mehran, "The Break-line Verse: The Link Between Text and Image in the 'First Small' Shahnama," in *Shahnama Studies*, ed. Charles Melville (Cambridge, 2006–), 1:151–69. I believe that this was an almost universal practice and that the break-line verses in the illustrations of our manuscript also define their composition.

23. Abolala Soudavar, *Art of the Persian Courts: Selections from the Art and History Trust Collection* (New York, 1992), 235.

24. Since Asaf was the vizier of the Prophet Solomon and the paragon of wise justice, his name was often used in reference to a prominent vizier, especially Mirza Salman, who was referred to as such in the colophon of his *Ṣifat al-'āshiqīn*: Soudavar, *Art of the Persian Courts*, 227.

25. Qāżī Aḥmad, *Khulāṣat*, 2:656.

26. Iskandar Bayg, *Tārīkh*, 1:226.

27. The primary source for these events is Qāżī Aḥmad's *Khulāṣat*, 2:690–702, in which he recounts how Shams al-Din was paraded about on a camel, beardless and dressed as a woman, with a man hugging him from behind.

28. Both Mahd-i Ulya and Mirza Salman had leaned on Hamza Mirza to consolidate their powerbase. See Hirotake Maeda, "Ḥamza Mirzâ and the 'Caucasian Elements' at the Safavid Court: A Path toward the Reforms of Shâh 'Abbâs I," *Orientalist* 1 (2001): 159.

29. Sa'dī, *Būstān*, ed. Nāṣiḥ, 178–79-; see www.ganjoor.net/saadi/boostan/bab1/sh21 (accessed March 2, 2013).

30. Qāżī Aḥmad *Khulāṣat*, 2:690–702.

31. Sa'dī, *Būstān*, ed. Nāṣiḥ, 178. The most popular prints of the *Būstān* are based on the Furughi edition—Sa'dī, *Būstān*, ed. Muḥammad 'Alī Furūghī (Tehran, 1316 [1898–99])—which includes the word *pisar*: یکی پسرگفتش ای نامور شهریار / دست ازین مرد صوفی بدار
The Furughi reference manuscripts from the Malik Library in Tehran all use the word *yakī* instead of *pisar* (nos. 5618, 5939, and 5979), except for no. 5954, which has a spurious date of 623 (1226). Other manuscripts, such as AHT no. 73, also use *yakī*, while the version of the *Būstān*

included in a manuscript of the collected works of Saʿdi at the British Library (Ms. Add 7741, dated 901 [1495–96]) uses the word *pisar*.

32. Qāżī Aḥmad, *Khulāṣat*, 2:618.

33. For the Freer Jami paintings attributed to these artists, see Stuart Cary Welch, *Royal Persian Manuscripts* (London, 1976), 24–27, 98–125; Simpson, *Sultan Ibrahim Mirza's* Haft Awrang, 366–68.

34. Soudavar, *Art of the Persian Courts*, 235.

35. For a complete reproduction of this painting in color, see Jon Thompson and Sheila R. Canby, eds., *Hunt for Paradise: Court Arts of Safavid Iran, 1501–1576* (Milan, 2003), 132.

36. Previously attributed to the painter Qadimi by Stuart Cary Welch in his *Wonders of the Age: Masterpieces of Early Safavid Painting, 1501–1576* (Cambridge, Mass., 1979), 202, this painting should be attributed to ʿAbdullah-i Muzahhib—for the same reasons that I also attributed to him four paintings of the Freer manuscript of Jami that Welch had attributed to Qadimi: see Abolala Soudavar, "*Le chant du monde*: A Disenchanting Echo of Safavid Art History," *Iran* 46 (2008): 253–76, 257.

37. As I have argued in "Age of Muhammadi," 66–67, the Safavid library had been badly depleted, and the Safavid mission that Hamza Mirza was preparing to send to the Ottomans (before his sudden death in 1586) had to refurbish many manuscripts, including the 1581 *Dīvān* of Hafiz, to make them worthy of the Ottoman sultan Murad III (r. 1574–95), a known bibliophile and avid collector. The merits of these newer works had therefore to be explained and advertised by the mission that Shah ʿAbbas sent along with Hamza Mirza's son. But in the post-Tahmasb era, neither the provincial atelier of Ibrahim Mirza nor the short-lived patronage of Mirza Salman or Hamza Mirza had established any reputation beyond Safavid courtly circles. The multiple colophons of the 1581 *Būstān* clearly showed the Safavid concern that this splendid manuscript would not be accepted as "royal," since it was commissioned by Mirza Salman—hence the manipulation of its colophon by naming a fictitious "Sultan Sulayman" as its patron. One may conjecture that the *Bihzād-i Ibrāhīmī* notation was added at the same time by the Safavids. On the other hand, some erroneous information relayed by the Ottoman writer Mustafa ʿAli (d. 1600) tends to show that the Ottomans' confusion was due to Safavid efforts to aggrandize the value of the gifts sent to the Porte: Soudavar, "Age of Muhammadi," 66–67. One may therefore presume that this notation was added after the work was presented to the Ottomans, especially since

an album page (TSMK, H. 1483, fol. 130b) that was probably gifted at the same time has two drawings by Muhammadi, one bearing his authentic signature and the other a Safavid attribution naming him as "*Ustād Muḥammadī*": see Anthony Welch, "Painting and Patronage under Shah ʿAbbas I," in *Studies on Isfahan: Proceedings of the Isfahan Colloquium Sponsored by the Fogg Museum of Art, Held at Harvard University, January 21–24, 1974*, ed. Renata Holod, Iranian Studies 7, 3–4 (Chestnut Hill, Mass., 1974), 502. One could therefore argue that the Safavids would have used the same legend, i.e., "*Ustād Muḥammadī*," rather than "*Bihzād-i Ibrāhīmī*." In either case, the source of this fanciful and erroneous notation was Safavid propaganda. While in my article in *Muqarnas* 17 I had only envisaged the latter possibility, I am indebted to Gülru Necipoğlu for prompting me to consider the other alternative as well.

38. See Muḥammad Ḥasan Simsār, *Kākh-i Gulistān* (Tehran, 1379 [2001]), 188–95; Badrī Ātābāy, *Fihrist-i dīvānhā-yi khaṭṭī-yi Kitābkhāna-i Salṭanatī* (Tehran, 1355 [1976]), 223–24. I wish to thank Ms. P. Seghatoleslami for granting me permission to take photos of Ms. 671 in the Gulistan Library.

39. Soudavar, "Age of Muhammadi," 65; Soudavar, "Between the Safavids and the Mughals," 58.

40. Painting P6 in Soudavar, "Age of Muhammadi," 54, 60, and figs. 9 and 10.

41. Binding of the *Dīvān* of Amīr Shāhī, copied by Shah Mahmud Nayshaburi in 1542 (TSMK, R. 999): see Soudavar, "Age of Muhammadi," fig. 22.

42. Of the paintings reproduced in Ātābāy, *Fihrist-i dīvānhā-yi khaṭṭī-yi Kitābkhāna-i Salṭanatī*, p. 224+4, five are attributable to Muzaffar-ʿAli, and the one on p. 224+3 to ʿAbdullah-i Muzahhib (illustrated pages in this volume do not bear page numbers, hence the numbering "+" from the last numbered page).

43. The celebrated Mir ʿImad was but a follower of the canons developed by Babashah; Mahdī Bayānī, *Aḥvāl va āsār-i khūshʹnavīsān*, 4 vols. (Tehran, 1345 [1966]), 1:85–91.

44. Soudavar, "Age of Muhammadi," 67–69.

45. Soudavar, *Art of the Persian Courts*, 228.

46. Soudavar, "Age of Muhammadi," 69.

47. Ibid., 60.

48. Soudavar, "Between the Safavids and the Mughals," 58–60.

49. Ibid.

50. Sheila R. Canby, *The Rebellious Reformer: The Drawings and Paintings of Riza-yi ʿAbbasi of Isfahan* (London, 1996), 44 and 198. For Riza's indebtedness to his predecessors, see Soudavar, "Age of Muhammadi," 69.

LÂLE ULUÇ

AN *ISKANDARNĀMA* OF NIZAMI PRODUCED FOR IBRAHIM SULTAN

This paper describes a copy of the *Iskandarnāma* of Nizami from the Majlis Library[1] in Tehran for the first time and discusses its various features, together with comparable examples from the same period. It then attempts to interpret one of its illustrations, hoping to fulfill what David Summers called "the most basic task of art history," namely, "to explain why works of art look the way they look."[2]

The Tehran *Iskandarnāma* is a significant document since the medallion on its opening folio (fol. 2r) bears a legend specifying that it was prepared for the treasury of Ibrahim Mirza: *Bi rasmi khizāna al-kutub Ḥaḍrat al-Mawlā al-Ṣulṭān al-a'zam Ibrāhīm Mīrzā khallada Allāh mulkahu* (by the order of the library of His Majesty the Great Sultan Ibrahim Mirza, may God make his kingship eternal) (fig. 3 [figs. 1–8 are placed together at the end of the article]). It also ends with a colophon that provides the date 839 (July 27, 1435–July 15, 1436) and the name of the scribe, 'Ali Katib (fol. 101r [fig. 8]).[3] It is not an unknown manuscript; Francis Richard lists it among the manuscripts prepared for Ibrahim Mirza.[4] It has not, however, been the subject of closer examination, and the three illustrations in it have remained unpublished.

The date 839 helps us to identify the dedicatee of the manuscript as Abu'l-Fath Ibrahim Sultan b. Shah Rukh b. Timur, who was the Timurid governor of the provinces of Fars, Kirman, and Luristan during the period between 817 (1414–15) and his death on 4 Shawwal 838 (May 3, 1435),[5] just over two months before the beginning of the year cited on the colophon of our manuscript. By then he had been succeeded by his son, 'Abd Allah, who was three or four years of age at the time,[6] as the nominal governor of the area. At the same time,

the grandfather of the child governor, the Timurid ruler Shah Rukh (r. 1409–47), had sent an amir from Herat, Shaykh Muhibb al-Din Abu'l-Khayr b. Shaykh al-Qarra'i, to assume control of the real gubernatorial power.[7] Ibrahim Sultan's death and the accession of 'Abd Allah did not create a break in Shiraz manuscript production,[8] which continued without interruption even after the latter lost the governorship of the area in the internecine fighting among the Timurid princes that followed the death of Shah Rukh in 1447.

For the Timurids, like other Turkic and Turko-Mongolian dynasties stemming from Central Asia, ostentatious expenditure on and conspicuous consumption of the arts were significant symbols of power. The accumulation of cultural prestige, as manifested through patronage of the arts, implied control over immeasurable sums of money as well as dynastic authority and, by extension, suggested the legitimacy of rule.[9]

The Timurid princes were refined individuals and their courts, including that of Ibrahim Sultan at Shiraz, appear to have been cultural showplaces for their occupants. Ibrahim Sultan was a man of letters whose "activities as calligrapher and historian" are considered to have been "his most enduring legacy."[10]

The Timurid historian Dawlatshah (d. 1488) noted that he was an accomplished calligrapher,[11] while the sixteenth-century Safavid author Qadi Ahmad remarked that he was "a recognized master of the *thuluth* style."[12] And according to Qadi Ahmad's Ottoman counterpart, Mustafa 'Âli (d. 1600), when Ibrahim Sultan copied the work of the renowned calligrapher Yaqut al-Musta'simi (d. 1298) and sent it to the bazaar to be sold, no one could tell the difference.[13] Five extant copies of the Koran transcribed by the prince bear evidence of his cal-

ligraphic skills,[14] while he is reported to have person-
ally designed the inscriptions of the two madrasas he
founded in Shiraz, as well as others.[15]

Ibrahim Sultan was also a notable patron of the arts
of the book, with a surviving corpus that testifies to his
ample patronage.[16] Besides the Tehran *Iskandarnāma*,
four illustrated manuscripts are associated with his
patronage. The earliest is the so-called Anthology of
Baysunghur, since it bears an illuminated medallion
(*shamsa*) in the name of "*Abu'l-Ghāzī Bāysunghur
Bahādur Khān*."[17] It was copied in Shiraz, however,
in 823 (1420), by a scribe named Mahmud al-Katib
al-Husayni, and its illustrations are stylistically similar
to those of manuscripts made for Ibrahim Sultan. Con-
sequently, it is generally agreed that Ibrahim Sultan had
commissioned it as a gift for his brother Baysunghur (d.
1434).[18] The second, an undated copy of the *Shāhnāma*
of Firdawsi, is unquestionably connected with the
prince, since it bears a dedication in his name.[19] The
third is a dispersed copy of the *Ẓafarnāma* of Sharaf
al-Din ʿAli Yazdi (d. 1454) dated Dhu 'l-Hijja 839 (June
16–July 15, 1436). This is the illustrated history of the life
and conquests of Timur (r. 1370–1405), commissioned
by his grandson, Ibrahim Sultan, who requested that the
author himself come to his court to supervise the com-
pilation and writing of the work. The text appears to
have been completed by 821 (1418–19), but the dispersed
copy dated 839 is the earliest example known to be
extant.[20] The fourth is the Anthology of Prose Texts,
now in Istanbul,[21] which contains an abbreviated ver-
sion of the *Kalīla va Dimna*, as well as selections from
the *Marzubānnāma* and *Sindbādnāma*. Although the
colophon of the manuscript is lost, a *shamsa*, which
includes the legend "*Abu'l-Fath*," has been partially pre-
served on folio 1r, and folio 205v has a prayer or a eulogy
for "*Abu'l-Fath Ibrāhīm Ṣulṭān*."[22]

Ibrahim Sultan commissioned unillustrated volumes
as well. Among these are a *Maṣnavī-i maʿnavī* of Jalal
al-Din Rumi dated 822 (1419–20),[23] a *Jāmiʿ al-ṣaḥīḥ* dated
832 (1428–29),[24] and a *Dīvān* of Amir Khusraw Dihlavi
dated 834 (1430–31).[25] Two further manuscripts were
copied for him by a scribe named Bayazid al-Tabrizi
al-Sultani: the first is a copy of the *Khamsa* of Nizami,
dated 831 (1427–28)[26] and the second a copy of the
Khamsa of Amir Khusraw Dihlavi, the whereabouts of

which are unfortunately not known, though it is
reported to be almost the same size as the *Khamsa* of
Nizami copied by the same scribe.[27] Ibrahim's name is
associated with two more manuscripts that bear their
scribes' names. The first is an unillustrated copy of the
Kulliyyāt of Saʿdi dated 829 (1425–26), with an illumi-
nated dedication specifying that it was copied for the
treasury (*khizāna*) of Sultan Mughith al-Din Abu'l-Fath
Ibrahim (fols. 1v–2r).[28] Its colophon specifies that it was
copied by the scribe Muzaffar b. Abdallah, at the order
of his master, Khwaju Giyath al-Din Muhammad Fara-
jallah, but was intended for the sultan.[29] The second is
a copy of the Koran dated 823 (1420) and copied by
Mahmūd al-mulaqqab bi-Quṭb al-Mughīthī al-Ṣulṭānī.[30]
The scribe's use of the words "*al-Ṣulṭānī*" as well as his
nisba (element of a name indicating relation or origin),
"*Mughīthī*," indicates that he was in the service of Mugh-
ith al-Saltana va al-Din Ibrahim Mirza.[31]

A treatise called the *ʿAnīs al-nās* (The Good Compan-
ion) dedicated to Ibrahim Sultan contains some addi-
tional circumstantial evidence that he accorded unusual
privileges to authors. It was written around 830 (1426–
27) by an otherwise unknown author named Shujaʿ,[32]
who declared in this work that when he was imprisoned
he was told that writing a book for the prince of Shiraz
would save him—this was why he wrote the treatise
and was consequently released from prison.[33]

The Tehran *Iskandarnāma* dedicated to this biblio-
phile prince that is the subject of the present paper is
the fifth illustrated manuscript associated with Ibrahim
Sultan's patronage. At 18 cm × 11 cm (fig. 2), it is small
and, unfortunately, not in good condition, showing evi-
dence of having had some water damage. The text, writ-
ten on a rectangular surface 12 cm × 9.3 cm, is in an early
nastaʿlīq, in four columns of nineteen lines. The rubrics
are in gold *thuluth* script delicately edged in black over
a background of floriated *islīmī* (foliate arabesques)
scrolls (fig. 5). The text block and the columns are ruled
in gold and edged in black. At the end of the manuscript,
the text is written in diagonal sections so that the col-
ophon could be placed at the bottom of the last page.
The colophon, on folio 101r, is in *tawqīʿ* script (fig. 8).
This is not unusual, however, since writing the colophon
in another script was a common enough practice. Two
other extant manuscripts completed between 1435 and

1437 in the Shiraz style of the period have colophons written in a script that is different from the one used for their texts. Both of these colophons have floral golden decorations on either side, similar to those flanking the colophon of the Tehran *Iskandarnāma*. The first of these manuscripts is a *Khamsa* of Nizami dated 839 and copied by the scribe 'Abd al-Rahman *al-kātib* in *nasta'līq* script, with the colophon in *thuluth*.[34] The second is a *Shāhnāma* of Firdawsi dated 840 (1436–37) and copied in *nasta'līq* by 'Imad al-Din 'Abd al-Rahman *al-kātib*,[35] possibly the same scribe who copied the previous manuscript, with its colophon in *tawqī'*.[36]

Besides the wear and tear it displays, the Tehran *Iskandarnāma* has severe textual problems as well. Although its leaves are numbered in sequence, some are missing and those that are currently bound together were mixed up during a rebinding process. When the text is compared with the published version of Nizami's *Iskandarnāma*,[37] it is interrupted in sixteen instances, some with lacunae, which are specified in the appendix (after figs. 1–8).[38] As a result, none of the manuscript's three illustrations are in their proper order within the text. The three paintings represent "Iskandar conversing with Aflatun" on folio 42v (fig. 5), "The contest of *Rūmī* and *Chīnī* painters" on folio 63r (fig. 6), and "Iskandar's seventh battle with the *Rūs*" on folio 97r (fig. 7). These works are also in bad condition, with some water damage and cracked pigment.

The Tehran *Iskandarnāma* must have been rebound after being subject to water damage, since the binding itself, which appears to date from the end of the sixteenth century, does not show any evidence of it (fig. 1). It is of dark brown leather with a central medallion decorated with large pressure-molded *khatā'ī*s (stylized lotus motifs) and serrated leaves on a gold background. A similar design was used on both the outer covers and the doublures of the binding of a copy of the *Qir'ān al-Sa'adayn* of Amir Khusraw Dihlavi now in the Calouste Gulbenkian Museum in Lisbon.[39] The colophon of the *Qir'ān al-Sa'adayn* specifies that it was copied by Sultan Muhammad Nur and completed in 921 (1515–16),[40] but the binding appears to date from a later refurbishment of the manuscript, possibly just before 1608. This was when it also received the endowment seal of Shah 'Abbas I (r. 1587–1629), identifying it as part of the

1608 donation (*waqf*) he made to the Safavid shrine of Shaykh Safi al-Din in Ardabil. This manuscript's three illustrations, signed by Nur al-Din Muhammad Musavvir, are in a style that developed during the reign of Shah 'Abbas I, with the male figures wearing a type of turban that was fashionable around the year 1600. Its binder, Muhammad Salih al-Tabrizi, who signed his name on the doublure of the flap, is unfortunately otherwise unknown. A second Safavid binding that can be dated to the same period (and which is now in the Louvre Museum) also has a similar large *khatā'ī* and serrated leaf design.[41]

Stylistically, the Tehran *Iskandarnāma* is consistent with the date supplied in its colophon. The decoration was never completed, however. The title is missing from its heading, the illumination of which was also left unfinished (fig. 4). The illustration depicting "Iskandar's seventh battle with the *Rūs*" lacks rulings (fig. 7), and there are sections that have not been colored in, such as the crowd of attendants behind the throne in the painting "Iskandar conversing with Aflatun (Plato)" (fig. 5). This may well have been due to the death of its patron some months before the completion of the manuscript.[42]

The three illustrations that remain in the manuscript in its present condition are stylistically close to the ones in Ibrahim Sultan's two well-known manuscripts, namely, the Oxford *Shāhnāma* of Firdawsi[43] and the dispersed *Zafarnāma* of Yazdi, completed in the same year, 839 (1435–36), as the Tehran *Iskandarnāma*.[44] The compositions are reduced to a few major elements, each contributing to the internal balance and cohesion of the images. This is in contrast to the stylistically additive approach seen in the illustrations of the manuscripts completed in Shiraz in the second half of the 1430s and the 1440s, which tend to submerge the compositions in an increasing accumulation of subsidiary detail. Each of the illustrations of the *Iskandarnāma* also retains the contrast between figures and ground that is characteristic of the paintings dating from Ibrahim Sultan's period.

The first and the third illustrations (according to their present placement within the manuscript), showing "Iskandar conversing with Aflatun" and "Iskandar's seventh battle with the *Rus*," have generic settings and their

subjects can only be determined through the accompanying explanatory texts (figs. 5 and 7). Depictions of Iskandar's various battles with the *Rūs* are more commonly seen than either of the other two subjects. The first one, "Iskandar conversing with Aflatun," seems to be the earliest representation of this scene and does not appear to have become popular later. The Tajik scholar Larisa Dodkhudoyeva lists only two others, both of a later date,[45] and the Topkapı Palace Museum Library in Istanbul has a further example, again of a later date.[46]

The second illustration, "The contest of *Rūmī* and *Chīnī* Painters," however, depicts a specific tale in the *Iskandarnāma*, which takes place during Iskandar's visit to China, when a disagreement occurs about the superiority of *Rūmī* (Greek) or *Chīnī* (Chinese) painters (fig. 6). To settle the argument, painters from both groups are asked to execute paintings on either side of a vault especially constructed for this purpose and divided down the center by a curtain. The *Rūmī* artists paint their side, while the *Chīnī* artists burnish theirs. When the curtain is raised, Iskandar, who was asked to be the judge, is puzzled, since the paintings appear to be the same. The *Rūmī* are ultimately declared superior in painting (*ṣūrat-garī*), while the *Chīnī* are declared superior in burnishing (*ṣaql*).[47]

Although Nizami implies that each excels in its own way, the earlier authors Ghazzali (d. 1111) and Jalal al-Din Rumi (d. 1273) used the same story as a spiritual paradox to demonstrate "the superiority of the mystical experience over acquired knowledge."[48] In both of these earlier versions, the reflection is judged to be superior to the painting, even though Ghazzali's version, like that of Nizami, has the *Chīnī* artists polish their side, while Rumi reverses the roles to depict the *Rūmī* artists polishing.[49]

This story was only rarely illustrated: Dodkhudoyeva lists only three manuscripts that contain this image.[50] The earliest one, from the Chester Beatty Library in Dublin, is an Anthology with two dates, 838 (1434–35) and 840 (1436–37), which is from roughly the same time as the Tehran *Iskandarnāma*.[51] The next two images of the contest can both be attributed to western Iran under Qaraqoyunlu Turkman rule. The first, from a copy of the *Khamsa* of Nizami now in the Metropolitan Museum of Art in New York, is dated 853 (1449–50).[52] The second

is from an undated manuscript of the *Khamsa* of Nizami in the Topkapı Palace Museum Library that is attributed to the middle of the fifteenth century.[53] The Topkapı Collection has three further copies of Nizami's *Khamsa* that include this scene, increasing the total number of known versions to seven.[54]

The version in Ibrahim Sultan's *Iskandarnāma*, which seems to be either the earliest or at least one of the earliest representations of the scene, appears to contain a personal reference to its Timurid patrons, Ibrahim Sultan, who commissioned the work, and his young son, who had become the nominal governor of Shiraz at the time of its completion. Of the three illustrations that remain in the Tehran *Iskandarnāma*, "The contest of *Rūmī* and *Chīnī* painters" is the only one that was finished. It is also the most significant, since it is the only one that continues the practice of full-page paintings seen in the copies of the *Shāhnāma* of Firdawsi and the *Ẓafarnāma* of Yazdi produced for the same prince.

An unusual feature of the miniature is that it appears to include a biographical note for Ibrahim Sultan. It contains not just Iskandar, who was the designated judge of the contest, but a second crowned figure as well, who is absent in every other known depiction of the incident. Iskandar is clearly the younger of these two rulers, since he is the one staring up at the image and its reflection on the walls of the specifically constructed vault. The older king must be the Khaqan of China, since the incident occurs when Iskandar is visiting him. The Chinese emperor is standing in an unmistakably deferential pose, with his hands folded in front of him. He is also submissively casting a sideward glance at Iskandar, thus guiding the spectators' gaze toward the young king. Members of lesser rank usually assume a similarly subservient pose in contemporaneous Timurid illustrations. An example can be found in the *Ẓafarnāma* illustration showing Timur holding a feast after his conquest of Delhi in December 1398.[55] In the image from the Tehran *Iskandarnāma*, Iskandar's two attendants, one of whom stands directly behind Iskandar holding his mace, highlight his higher status in comparison with the Chinese emperor, who lacks this noteworthy royal signifier.

The interpretation of an artist's work based on his biography has long been a staple of Western art histor-

ical methodology. More recently, within the field of Islamic manuscripts, images have been thought to include biographical material related to their patrons.[56] Within this context, Ibrahim Sultan is an excellent subject, since he intended to have his own biography recorded. First, though, he had his grandfather Timur's biography, the *Zafarnāma*, completed. In this work, the author Yazdi recounts how Ibrahim Sultan requested that he come to Shiraz from the central court of his father, Shah Rukh, at Herat for this project, which was to be the first of a trilogy of histories, to be followed by similar biographies of Shah Rukh and Ibrahim Sultan himself.[57] In the preface Yazdi explains the methodology employed in compiling the *Zafarnāma* and states clearly that Ibrahim Sultan himself was involved in the process of writing, "with the cooperation of a numerous concourse of scholars and men of talent, who, in those days, were gathered for that particular purpose in the service of the Mirza in *Dār al-Mulk* Shiraz."[58] The prince is described as having "spent great sums" collecting and editing various accounts of Timur's life from archives and libraries.[59]

Including historically identifiable depictions of members of the Timurid dynasty and court circles in the illustrated manuscripts of the period had become popular in the Timurid cultural sphere. A number of scholars have suggested that various scenes from royal manuscripts produced in the Mongol and Timurid-Turkman worlds contain personal references to their patrons.[60] The concept of the affiliation of a work of art as a trace of the individuals involved in its production (artists, designers, and patrons) may be important in this case as well.

According to Priscilla Soucek, who has developed a theory of the relationship between image and referent with specific regard to portraits, the seemingly generic portraits found in Timurid princely manuscripts, and especially in their frontispieces, meet the criteria of a true portrait. She maintains that although they were not individualized portraits, they "would nevertheless have been recognized by contemporary viewers as the depiction of a specific person" and "could have evoked in the spectator a memory of that person." She also points out the importance of the setting of the portrayal, since it allowed the viewer to link the image with a specific per-

son, and sometimes even with a particular event in the life of the subject.[61] In modern studies, it is generally accepted that the noble personages depicted in the frontispieces of the manuscripts prepared for Timurid princes depict those works' respective patrons.[62]

Representations of historically identifiable persons are especially prominent in Ibrahim Sultan's *Zafarnāma* dated 839 (1435–36), since its illustrations are of historically recorded incidents. Several of its images are connected to events in which Ibrahim Sultan participated. Soucek convincingly presents a case for one of the double-page paintings from the *Zafarnāma* (fols. 413v–414r), which shows Ibrahim Sultan marching at the head of the Timurid army "with drums beating and banners flying," to quote Yazdi's words.[63]

This particular incident took place in the immediate aftermath of Timur's death during his Chinese campaign of 1405, a year that was "pivotal in Ibrahim's life," according to Soucek. Only eleven years old at the time, he had been assigned a large territory to rule in China, which, though never previously conquered by the Timurids, Timur had hoped shortly to occupy. Ibrahim Sultan was to accompany the Timurid army to claim his territory as soon as it was invaded. When Timur died unexpectedly, his amirs placed Ibrahim at the head of the military until an older and more able prince could reach them. Ibrahim led the army, impersonating Timur, and even slept in Timur's tent with his horsetail standard at its entrance, if only for a short while, before the campaign was abandoned.[64] The text on the left-hand page of the *Zafarnāma* illustration describes Ibrahim leading the Timurid army on this occasion. Although the prince depicted has a beard, which would belie Ibrahim Sultan's youth, according to Eleanor Sims the face of the princely figure in the illustration had been repainted with this beard and mustache, probably the result of a later intervention. Other images from the *Zafarnāma* also have personal connections to Ibrahim. One example is the representation of Amir Shaykh Nur al-Din, the seasoned officer chosen to accompany Ibrahim during the Chinese campaign and the only Timurid amir depicted in any of the manuscript's illustrations.[65]

Furthermore, Soucek has persuasively argued that the scene in one of the double-folio representations

found in Ibrahim Sultan's *Shāhnāma* and depicting the prince in battle, corresponds to the descriptions of the battle near Salmas found in Timurid historical sources.[66] This long battle, of at least two days' duration, took place in Dhu 'l-Hijja 832 (September 1429) against the Qaraqoyunlu army, and Ibrahim himself led the charge. Contemporary sources stress the role of Ibrahim Sultan and his troops from Fars in eventually forcing the Turkman army, led by one of the Qaraqoyunlu princes, into retreat. The prince on the right-hand page of the battle scene from the front matter of Ibrahim's *Shāhnāma* can therefore be interpreted as Ibrahim Sultan leading his troops to victory, while on the left, Iskandar b. Qara Yusuf, biting his finger in consternation, turns back to glance at his men, who are depicted facing the viewer, as if uncertain whether to advance or retreat.[67]

In the discussion of works of art for which there are no known extrinsic documentary sources, the work of art itself must be brought as evidence into an art historical argument. Rather than dealing with the formalist devices of sources or influences that have for a very long time been at the center of art historical argument, a consideration of both the conceptual relationship of the work as a trace of its patron and its reception may enrich our understanding of it. According to Mieke Bal, in the study of texts and their illustrations, the theoretical question of what can be rendered in which medium is a crucial one. She maintains that texts are never fully illustrated, nor are the corresponding images ever fully understood with reference to the text, and insists that images are themselves readings. They do not function as a re-telling of a text, but a use of it. In other words, an image does not replace a text but is one.[68]

Poststructuralist theory emphasizes that images are cultural constructs freighted with social and personal meanings. They comprise value-laden references that are reused and reworked in building the visual culture of a society.[69] Looking at a work of art synchronically rather than diachronically helps the viewer to achieve a historical reconstruction of the likely meaning of the discernible codes that it has at any given instance and to base an additional interpretation on this reconstruction as well as on one that is provided by the accompanying text. This perspective allows the art historian to analyze the meaning-making phase of a work of art

not only in its own time but also as an active participant in the production of culture. It implies that to understand the historically mediated meanings of images, one has to consider its sources of influence, reception, and interaction with changing audiences in its post-production afterlife.[70]

To understand what a work of art meant at the time of its production, it is necessary to consider its reception.[71] Manuscript illustrations, which can only be viewed after the preliminary actions of actually holding a book and turning its pages, tend to provoke certain questions: Who is to see all this? What is the social or interpersonal dimension of such images? And finally, what is the nature of the viewer's gaze?

Images were clearly not created with a future audience in mind. Their makers had their own concerns, their own messages. For the Tehran *Iskandarnāma*, the primary viewer was presumably its patron, Ibrahim Sultan, the initiator of the project, as well as his young son, who had replaced him as the governor of Shiraz by the time the manuscript was completed in 839 (1435–36). Although it is debatable whether it is possible to "see through" the surfaces of a work of art to its meaning, it seems plausible to consider that in viewing the *Iskandarnāma* images, or perhaps displaying them before others, the gaze of the owner of the manuscript would in part be the gaze of satisfaction, or rather, of contemplation of the imagined extent of his power, which was somehow embodied in the picture as long as the manuscript lasted.[72] In shared viewings in court gatherings (sing. *majlis*) by small groups of courtiers, intimates, and/or family members, it would reflect the residual glory of the important role he played for their gaze as well.[73]

In the image of "The contest of *Rūmī* and *Chīnī* painters" discussed above, the message of the image appears to be inverted. Although the subject of the scene is a painting contest narrated in the text, in the image the foregound theatricality of the older emperor of China, who is depicted in a submissive role with respect to the young Greek/Timurid prince, represents a competition that is more important than the one between the painters of the two realms taking place in an uncertain space within the image (beyond, above, in another room, etc.). The image interprets the text in a way that flatters the viewer into a conviction of his—or his

ancestor's—own superiority by helping him create an eidetic space that will transport him away from the real time and space of reading Nizami's words, into the Timurid (eternal) time and space of inward vision.[74] It thus creates a personal *lieu de mémoire* for Ibrahim Sultan,[75] who had been promised the rule of an extensive territory in China on what was to become the last military campaign of his grandfather Timur.[76]

Among the Timurid princes who patronized the production of illustrated manuscripts, Ibrahim Sultan holds a particularly interesting place, since illustrated manuscripts prepared for him show his concern for personalized manuscripts as well as significant inventiveness in their illustrations. As we have seen, especially important was the illustrated version of Yazdi's *Ẓafarnāma*

prepared at his court, with almost all of its paintings depicting identifiable "living or once living people."[77] The artistic corpus of his court comprises independent and highly original creations that arose out of the local tradition of Shiraz and proved inspirational for the manuscripts that followed, inducing a long-lived impact on the subsequent workshop/scriptorium (*kitābkhāna*) traditions of the city. The small Tehran *Iskandarnāma* copy prepared for this calligrapher prince reasserts his interest in personalized manuscripts, confirming his role as a trendsetter while also subtly reminding the viewer of his military and political aspirations.[78]

Department of History,
Boğaziçi University, Istanbul

Fig. 1. Binding, outer cover. Nizami, *Iskandarnāma*, dated 839 (1435–36). Tehran, Majlis Library, Ms. 61866. (Photo: courtesy of the Majlis Library)

Fig. 2. Binding, doublure. Nizami, *Iskandarnāma*, dated 839 (1435–36). Tehran, Majlis Library, Ms. 61866. (Photo: courtesy of the Majlis Library)

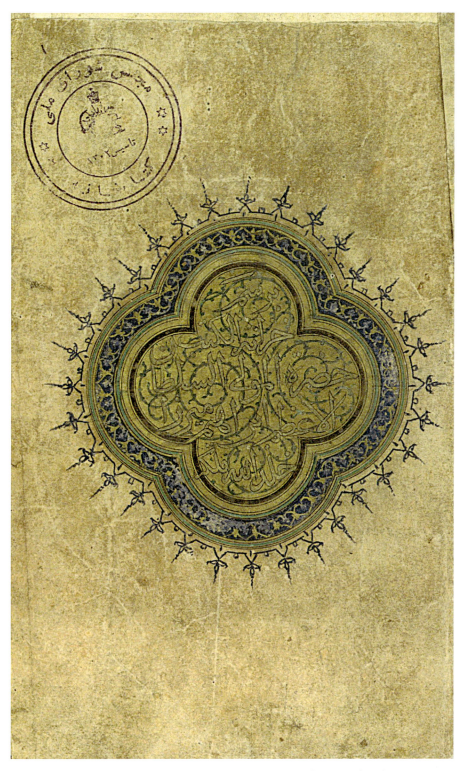

Fig. 3. Dedication medallion. Nizami, *Iskandarnāma*, dated 839 (1435–36). Tehran, Majlis Library, Ms. 61866, fol. 2r. (Photo: courtesy of the Majlis Library)

Fig. 4. Heading illumination. Nizami, *Iskandarnāma*, dated 839 (1435–36). Tehran, Majlis Library, Ms. 61866, fol. 2v. (Photo: courtesy of the Majlis Library)

Fig. 5. "Iskandar conversing with Aflatun (Plato)." Nizami, *Iskandarnāma*, dated 839 (1435–36). Tehran, Majlis Library, Ms. 61866, fol. 42v. (Photo: courtesy of the Majlis Library)

Fig. 6. "The contest of *Rūmī* and *Chīnī* painters." Nizami, *Iskandarnāma*, dated 839 (1435–36). Tehran, Majlis Library, Ms. 61866, fol. 63r. (Photo: courtesy of the Majlis Library)

Fig. 7. "Iskandar's seventh battle with the *Rūs*." Nizami, *Iskandarnāma*, dated 839 (1435–36). Tehran, Majlis Library, Ms. 61866, fol. 97r. (Photo: courtesy of the Majlis Library)

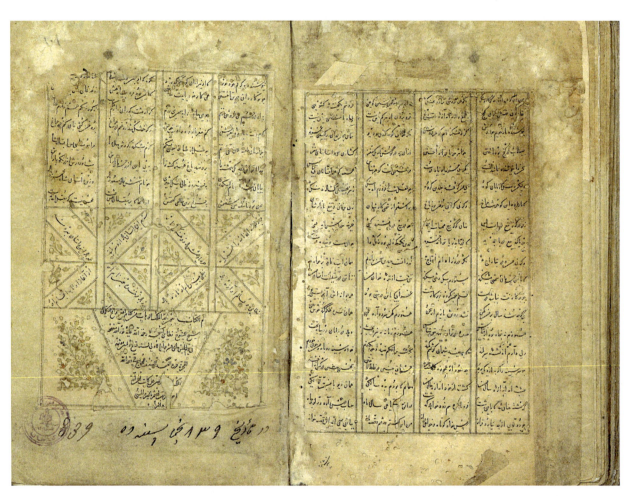

Fig. 8. Colophon. Nizami, *Iskandarnāma*, dated 839 (1435–36). Tehran, Majlis Library, Ms. 61866, fol. 101r. (Photo: courtesy of the Majlis Library)

APPENDIX

Misbound Folios and Lacunae[78]

Manuscript folios:		Printed text pages:	Section
1r–2r	Medallion, 2r		
2v–7v	Illumination, 2v	954–981	*Sharafnāma*
8r–8v		990–995	*Sharafnāma*
9r–15v		1016–1047	*Sharafnāma*
16r–16v		1012–1016	*Sharafnāma*
17r–22v		1047–1074	*Sharafnāma*
23r–23v		1136–1140	*Sharafnāma*
24r–37v		1078–1136	*Sharafnāma*
38r–40v		1140–1152	*Sharafnāma*
41r–44v	Illustration, 42v	1385–1400	*Iqbālnāma*
45r–66v	Illustration, 63r	1156–1246	*Sharafnāma*
67r–71v		1255–1275	*Sharafnāma*
72r–73v		1400–1408	*Iqbālnāma*
74r–82v		1413–1450	*Iqbālnāma*
83r–95v		1454–1509	*Iqbālnāma*
96r–97v	Illustration, 97r	1275–1282	*Sharafnāma*
98r–101r	Colophon, 101r	1518–1533	*Iqbalnāma*

Total:	Total:	Difference:
7,325 couplets	10,506 couplets	3,181 couplets

Lacunae
981–990
995–1012
1074–1078
1152–1156
1246–1255
1282–1385
1408–1413
1450–1454
1509–1518

NOTES

1. Tehran, Majlis Library (*Kitābkhāna-i Majlis-i Shūrā-yi Islāmī*), Ms. 61866.

2. David Summers, "'Form,' Nineteenth-Century Metaphysics, and the Problem of Art Historical Description," *Critical Inquiry* 15, 2 (Winter 1989): 372–406.

3. *Tamma al-kitāb bi-ʿawni Allāh al-Malik al-Wahhāb min kalām afṣaḥ al-amlaḥ al-mutakallimīn shaykh al-shuyūkh Niẓāmī al-Ghanjawī raḥma Allāh ʿalayhi nawwara Allāh madjaʿahu fī yawm al-khamīs ḥādī ʿashar Jumāda al-awwal al-sana tāsiʿ wa thalāthīn wa thamāna miʾa al-hijriyya ḥarrarahu al-ʿabd al-ḍaʿīf al-muḥtāj al-raḥma Allāh... ʿAlī*

al-kātib aḥsana Allāh aḥwālahu (The book of the words of the most eloquent and charming of orators, Shaykh of Shaykhs Nizami Ghanjavi, may God's mercy be upon him, may God illuminate his grave, was completed with the divine aid of God, the Sovereign, the Bestower, on Thursday, the eleventh day of Jumada I of the Hijri year 839 [December 2, 1435]. The weak slave, the one in need of God's mercy, ʿAli al-Katib, may God beautify his state, wrote it).

4. Francis Richard, "Naṣr al-Solṭāni, Naṣir al-Din Moẕahheb et la bibliothèque d'Ebrāhīm Solṭān à Šīrāz," *Studia Iranica* 30 (2001): 92.

5. Priscilla P. Soucek, "Illustrated Manuscripts of Nizami's Khamseh, 1386–1482" (PhD diss., New York University, 1971), 265; Priscilla P. Soucek, "Ibrāhīm Sulṭān's Military Career," in *Iran and Iranian Studies: Essays in Honor of Iraj Afshar*, ed. Kambiz Eslami (Princeton, N.J.: Zagros, 1998), 32; and Eleanor G. Sims, "Ibrāhīm-Sulṭān's Illustrated *Ẓafar-Nāmeh* of 839 (1436)," *Islamic Art* 4 (1990–91): 175.

6. Ghiyāth al-Dīn Khwāndamīr, *Tārīkh-i Ḥabīb al-siyar*, ed. Jalāl al-Dīn Humāʾī, 4 vols. (Tehran: Intishārāt-i Khayyām, 1380 [2002]), 3:621–22, cited by Soucek, "Illustrated Manuscripts of Nizami's Khamseh," 265.

7. Ibid.

8. Soucek, "Illustrated Manuscripts of Nizami's Khamseh," 269.

9. Maria E. Subtelny, "Art and Politics in Early 16th Century Central Asia," *Central Asiatic Journal* 27, 1–2 (1983): 130. Subtelny cites as the bases of this model the concepts of "cultural prestige" and "power prestige" of Max Weber, *Economy and Society: An Outline of Interpretive Sociology*, 3 vols. (New York: Bedminister Press Incorporated, 1968), 2:926.

10. Priscilla P. Soucek, *Encyclopaedia Iranica Online*, s.v. "Ebrāhīm Solṭān": www.iranicaonline.org, last accessed January 16, 2011.

11. Wheeler M. Thackston, *A Century of Princes: Sources on Timurid History and Art* (Cambridge: Aga Khan Program for Islamic Architecture, 1989), 34, citing Dawlatshāh Samarqandī, *Taẕkirat al-shuʿarāʾ*, ed. Muḥammad ʿAbbāsī (Tehran: Bārānī, 1337 [1959]). An album from the Topkapı Palace Museum Library (hereafter TSMK) includes a calligraphic scroll that Ibrahim copied (TSMK, H.2152, fol. 6r): see Thomas W. Lentz and Glenn D. Lowry, *Timur and the Princely Vision: Persian Art and Culture in the Fifteenth Century* (Los Angeles: Los Angeles County Museum of Art, 1989), 370.

12. Qāḍī Aḥmad Qummī, *Calligraphers and Painters: A Treatise by Qāḍī Aḥmad, Son of Mīr-Munshī (circa A.H. 1015/A.D. 1606)*, trans. Vladimir Minorsky, Freer Gallery of Art Occasional Papers 3 (Washington D.C.: Smithsonian Institution, Freer Gallery of Art, 1959), 63.

13. Thackston, *A Century of Princes*, 34n56, citing Muṣṭafā ʿĀlī, *Menākib-i Hünerverān*, ed. Ibnülemin Mahmut Kemal [İnal], Türk Tarih Encümeni Külliyatı 9 (Istanbul: Matbaʿa-ı Āmire, 1926), 26.

14. These are: New York, Metropolitan Museum of Art, inv. no. 13.228.1–2; Istanbul, TSMK, Ms. M.6; Mashhad, Imam Riza Library, Mss. 215 and 414; and Shiraz Pars Museum, 430 M/P. See Lentz and Lowry, *Timur and the Princely Vision*, 370.

15. Qāḍī Aḥmad Qummī, *Calligraphers and Painters*, 70–71; Soucek, "Ebrāhīm Solṭān." Also see Assadullah Souren Melikian-Chirvani, "Le royaume de Salomon. Les inscriptions Persanes de sites achéménides," *Le Monde Iranien et L'Islam* 1 (1971): 24–26, for an inscription by Ibrahim dated 826 (1422–23) that was added to the inscriptions at Persepolis.

16. Lentz and Lowry, *Timur and the Princely Vision*, 369–71, gives an index of manuscripts associated with Ibrahim Sultan. This list is considerably extended by Richard, "Naṣr al-Solṭāni," 89–95. Eleanor Sims also discusses the corpus of works associated with this prince: Sims, "Ibrāhīm-Sulṭān's Illustrated *Ẓafar-Nāmeh* of 839 (1436)"; Eleanor G. Sims, "Ibrahim Sultan's Illustrated *Zafarnama* of 1436 and Its Impact in the Muslim East," in *Timurid Art and Culture: Iran and Central Asia in the Fifteenth Century*, ed. Lisa Golombek and Maria Subtelny (Leiden: E.J. Brill, 1992), 142n40; and Eleanor G. Sims, "The Hundred and One Paintings of Ibrahim-Sultan," in *Persian Painting from the Mongols to the Qajars: Studies in Honour of Basil W. Robinson*, ed. Robert Hillenbrand, Pembroke Persian Papers 3 (London and New York: I.B. Tauris, 2000), 120.

17. Berlin, Staatliche Museen, J.4628.

18. Ernst Kühnel, "Die Baysonghur-Handschrift der islamischen Kunstabteilung," *Jahrbuch der Preussischen Kunstsammlungen* 52, 3 (1931): 133–152; Volkmar Enderlein, *Die Miniaturen der Berliner Bāisonqur-Handschrift* (Frankfurt: Insel Verlag, 1970); Eleanor G. Sims, "Towards a Study of Šīrāzī Illustrated Manuscripts of the 'Interim Period': The Leiden *Šāhnāmah* of 840/1437," in "La civiltà timuride come fenomeno internazionale," ed. Michele Bernardini, special issue, *Oriente Moderno*, n.s., 15, 2 (1996): 618; Sims, "Hundred and One Paintings of Ibrahim-Sultan," 119–120; and Eleanor G. Sims, "The Iconography of the Illustrated Timurid *Ẓafarnāma* Manuscripts," in *Image and Meaning in Islamic Art*, ed. Robert Hillenbrand (London: Altajir World of Islam Trust, 2005), 131–32.

19. University of Oxford, Bodleian Library, Ms. Ouseley Add. 176. See Basil W. Robinson, *A Descriptive Catalogue of the Persian Paintings in the Bodleian Library* (Oxford: Clarendon Press, 1958), 16–22; Firuza Abdullaeva and Charles Melville, *The Persian Book of Kings: Ibrahim Sultan's Shahnama* (Oxford: Bodleian Library, 2008).

20. Sims, "Ibrāhīm-Sulṭān's Illustrated *Ẓafar-Nāmeh* of 839 (1436)," 175; Sims, "Ibrahim Sultan's Illustrated *Zafarnama* of 1436 and Its Impact in the Muslim East"; Sims, "Hundred and One Paintings of Ibrahim-Sultan"; and Sims, "Iconography of the Illustrated Timurid *Ẓafarnāma* Manuscripts," 130.

21. Istanbul, Süleymaniye Library, Ms. Fatih 3682.

22. Lentz and Lowry, *Timur and the Princely Vision*, 370; Ernst J. Grube, "Ibrahim-Sultan's Anthology of Prose Texts," in Hillenbrand, *Persian Painting from the Mongols to the Qajars*, 101–19.

23. Lisbon, Calouste Gulbenkian Foundation, Ms. L.A.168. See Lentz and Lowry, *Timur and the Princely Vision*, 370.

24. Istanbul, Süleymaniye Library, Ms. Feyzullah 429. Lentz and Lowry, *Timur and the Princely Vision*, 370.

25. Istanbul, Museum of Turkish and Islamic Art, Ms. 1982. See Oktay Aslanapa, "The Art of Bookbinding," in *Arts of the Book in Central Asia, 14th–16th Centuries*, ed. Basil Gray (Boulder, Colo.: Shambhala Publications, Inc., and Paris: UNESCO, 1979), 78, fig. 36; and Lentz and Lowry, *Timur and the Princely Vision*, 370.

26. Georgian Academy of Sciences, Ms. P-458. See Sims, "Hundred and One Paintings of Ibrahim-Sultan," 125n14. In the same publication, the author remarks that Ibrahim Sultan had commissioned at least five *Khamsa*s of Nizami (p. 120).

27. Sims, "Hundred and One Paintings of Ibrahim-Sultan," 125n14.

28. Lahore, Punjab University Library, Ms. 318.

29. Richard, "Naṣr al-Solṭāni," 91.

30. London, Khalili Collection, acc. no. QUR212.

31. London, Khalili Collection, acc. no. QUR212; David James, *After Timur: Qur'ans of the 15th and 16th Centuries*, The Nasser D. Khalili Collection of Islamic Art 3 (New York: The Nour Foundation, in association with Azimuth Editions and Oxford University Press, 1992), 26–27, and 245, cat. no. 4.

32. Tehran, Majlis Library, Ms. 6550. See Charles-Henri de Fouchécour, "'The Good Companion' (*Anīs al-Nās*): A Manual for the Honest Man in Shīrāz in the 9th/15th Century," in Eslami, *Iran and Iranian Studies: Essays in Honor of Iraj Afshar*, 42.

33. Fouchécour, "'The Good Companion' (*Anīs al-Nās*)," 45. Although this may well be a trope, Ibrahim is known from other sources as an able calligrapher and a transcriber of the Koran.

34. London, British Library, Ms. Or.12856. See Basil Gray, "A Newly-Discovered Illustrated Nizāmī of the Tīmūrid School," *East and West* 14, 3–4 (1963): 219–223.

35. Leiden University Library, Codex Oriental 494. See Sims, "Leiden *Šāhnāmah* of 840/1437," pl. XXIII, fig. 10.

36. I would like to extend my thanks to Bora Keskiner, who identified the colophon scripts of both the British Library *Khamsa* (Ms. Or.12856) and the Leiden *Shahnāma*.

37. Niẓāmī, *Kulliyyāt-i Khamsa-i Ḥakīm Niẓāmī Ganjavī: Sharafnāma va Iqbalnāma*, ed. Shiblī Nuʿmānī, 2 vols. (Tehran: Chapkhāna-i Aḥmadī, 1376 [1997]), 2:1034–1529.

38. It has around 3,000 couplets missing: see appendix.

39. Inv. no. LA 187.

40. Richard Ettinghausen, *Persian Art: Calouste Gulbenkian Collection* (Lisbon: Fundação Calouste Gulbenkian, 1972), 197, 6–7n19; Maria Queiroz Ribeiro, "Binding of *Qirān-i Saʿadayn*," in *Only the Best: Masterpieces of the Calouste Gulbenkian Museum*, ed. Katharine Baetjer and James David Draper (New York: The Metropolitan Museum of Art, 1999), 76–77, cat. no. 35; and also in *The Art of the Book from*

East to West and Memories of the Ottoman World: Master-pieces of the Calouste Gulbenkian Museum, Lisbon (Istanbul: Sabancı University Sakıp Sabancı Museum, 2006), 148–49, cat. no. 30.

41. Paris, Louvre Museum, inv. no. 20073. See Lâle Uluç, "Leather Binding of an Arabic Grammar Book," in *Three Empires of Islam: Istanbul, Isfahan, Delhi; Master Pieces of the Louvre Collection* (Valencia: Fundación Bancaja, 2008), 50–51, cat. no. 3; and also in *Istanbul, Isfahan, Delhi: 3 Capitals of Islamic Art; Masterpieces from the Louvre Collection* (Istanbul: Sakıp Sabancı Museum, 2008), 170–71, cat. no. 63.

42. Sims, "Hundred and One Paintings of Ibrahim-Sultan," 122, suggests that the sparse illumination of Ibrahim-Sultan's *Zafarnāma* was also due to the fact that the prince died before the manuscript was completed.

43. University of Oxford, Bodleian Library, Ms. Ouseley Add. 176. See Abdullaeva and Melville, *Ibrahim Sultan's Shahnama*.

44. Sims, "Ibrāhīm-Sulṭān's Illustrated *Zafar-Nāmeh* of 839 (1436)."

45. Larisa N. Dodkhudoeva, *Poemy Nizami v srednevekovoi miniatiurnoi zhivopisi* [The Poems of Nizami in Medieval Miniature Painting] (Moscow: Nauka, 1985), 262. These are: 1) a *Khamsa* of Niẓāmī, Herat school, ca. 1440, London, Royal Asian Society, Ms. Morley 246, fol. 227: for a reproduction, see Adolf Grohmann and Thomas W. Arnold, *The Islamic Book: A Contribution to Its Art and History from the VII–XVIII Century* (New York: The Pegasus Press, Harcourt Brace & Co., 1929), pl. 54B; 2) an *Iqbalnāma* of Niẓāmī, dated 883 (1478), St. Petersburg, Institute of Oriental Manuscripts, Ms. D408, fol. 14: Dodkhudoeva, *Poemy Nizami*, 262, identifies the illustration as "Mavarannahr school, 2nd half of the 16th century."

46. A *Khamsa* of Niẓāmī, copied at Shiraz in 918 (1512–13) by Murshid al-Dīn Muḥammad, Istanbul, TSMK, Ms. H. 770, fol. 360. See Ivan Stchoukine, *Les peintures des Manuscrits de la "Khamseh" de Niẓâmî au Topkapı Sarayı Müzesi d'Istanbul* (Paris: Paul Geuthner, 1977), pl. LVII.

47. Priscilla P. Soucek, "Niẓāmī on Painters and Painting," in *Islamic Art in the Metropolitan Museum of Art*, ed. Richard Ettinghausen (New York: Metropolitan Museum of Art, 1972), 12–14; and Soucek, "Illustrated Manuscripts of Nizami's Khamseh," 167.

48. Soucek, "Niẓāmī on Painters and Painting," 14.

49. Both Ghazzali and Rumi equate the burnishers with Sufis, whose hearts reflect the radiance of God, while Nizami does not advance this mystical standpoint. Soucek suggests that the difference in Nizami's interpretation means that his version was not based on Ghazzali, but that both were based on a common source. For the three versions of Ghazzali, Nizami, and Rumi, see Soucek, "Niẓāmī on Painters and Painting," 12–14; Serpil Bağcı, "Gerçeğin Suretinin Saklandığı Yer: Ayna," in *Sultanların Aynaları* (Istanbul: T. C. Kültür Bakanlığı, 1998), 15–20; Michael Barry, *Figurative Art in Medieval Islam and the Riddle of Bihzâd of Herât (1465–1535)* (Paris: Éditions Flammarion, 2004), 9 and 128.

For the versions of Amir Khusraw Dihlavi and 'Abdi Beg Shirazi, see Angelo M. Piemontese, "La leggenda persiana del contesto fra pittori cinesi e greci," in *L'arco di fango che rubò la luce delle stelle: Studi in onore di Eugenio Galdieri per il suo settantesimo compleanno*, ed. Michele Bernardini, Federico Cresti, Maria Vittoria Fontana, Francesco Noci, and Roberto Orazi (Lugano: Edizioni Arte et Moneta, 1995), 295–99.

50. Dodkhudoeva, *Poemy Nizami*, 262. These are: 1) an Anthology dated 838–840 (1434–1437), Dublin, Chester Beatty Library, Ms. P.124, fol. 242a; 2) an undated *Khamsa* of Niẓāmī, Istanbul, TSMK, H.753, fol. 304; and 3) a *Khamsa* of Niẓāmī dated 853 (1449–50), New York, Metropolitan Museum of Art, 13.228.3, fol. 322a. Eleanor Sims reproduces the image from the New York Metropolitan Museum of Art and mentions four versions, but does not enumerate them. Eleanor G. Sims, with Boris I. Marshak and Ernst J. Grube, *Peerless Images: Persian Painting and Its Sources* (New Haven and London: Yale University Press, 2002), 316–17, fig. 238. My thanks go to Olga Vasilyeva for providing me with the information from Dodkhudoeva's study.

51. Dublin, Chester Beatty Library, Ms. no. P.124, fol. 242. I am most grateful to Elaine Wright for making available the image of this scene. It is, however, a somewhat problematic image. I have not seen the manuscript, nor even the images of any other illustrations from it. The fact that the illustrations are later than the transcription of the text may possibly explain a style that is otherwise difficult to interpret: see especially fol. 279v. For a discussion of the difficulty of assigning the manuscript to any definite provenance, see Caroline Singer, "A Study of the Illustrations of the Sharaf-Nama in the Chester Beatty Library's Anthology: Pers. 124 of 1435–36," *Persica* 16 (2000): 67–107. She reproduces fol. 279v as pl. 23.

52. New York, Metropolitan Museum of Art, Ms. no. 13.228.3, fol. 322r. See Soucek, "Niẓāmī on Painters and Painting," 13, fig. 2. For a color reproduction, see Sims, *Peerless Images*, 316, fig. 238.

53. Istanbul, TSMK, Ms. H.753, fol. 304r. For the reproduction of the image, see Ivan Stchoukine, "La Khamseh de Niẓāmī, H.753, du Topkapı Sarayı Müzesi d'Istanbul," *Syria* 49 (1972): pl. IX; Stchoukine, *Les peintures des manuscrits de la "Khamseh" de Niẓâmî*, pl. XXXVIIIa; Bağcı, "Gerçeğin Suretinin Saklandığı Yer: Ayna," 18, fig. 5; and Barry, *Figurative Art in Medieval Islam*, 5. For the manuscript, see additionally David Roxburgh, ed., *Turks: A Journey of a Thousand Years, 600–1600* (London: Royal Academy of Arts, 2005), 246, cat. no. 210; Lâle Uluç, *Turkman Governors, Shiraz Artisans and Ottoman Collectors: Sixteenth-Century Shiraz Manuscripts* (Istanbul: İş Bankası Kültür Yayınları, 2006), 57–60. For additions to the manuscript (Istanbul, TSMK, Ms. H.753) at the Ottoman court, see Zeren Tanındı, "Additions to Illustrated Manuscripts in Ottoman Workshops," *Muqarnas* 17 (2000): 147–61. This is one of a small number of royally owned manuscripts that help us to understand the transmission of workshop/scriptorium (*kitābkhāna*)

practices in the Timurid-Turkman-Safavid world in the latter half of the fifteenth century and the beginning of the sixteenth. It changed hands several times and contains illustrations that were added to it under each new ownership. It appears to have been produced under the Qaraqoyunlu Turkmans, when some of its illustrations were completed. "The contest of the *Rūmī* and *Chīnī* painters" can be attributed to this period. Some of its illustrations were then completed during the early Safavid period, with one dated 916 (1510–11) (fol. 19b). For a reproduction of the dated image, see Uluç, *Turkman Governors*, 58–59, fig. 26. The only noticeable difference in the images produced for the new patrons is in the shape of the turbans, which were depicted in the distinctive style favored by the Safavids, wrapped around a cap with a high central baton, known as the *taj-i Ḥaydarī*. Finally, some of its illustrations were added after it reached the Ottoman court.

54. These are: 1) Istanbul, TSMK, Ms. H.778, a *Khamsa* of Niẓāmī dated 900 (1494–95), fol. 324r: see Stchoukine, *Les peintures des manuscrits de la "Khamseh" de Niẓâmî*, pl. LIIIb, and Bağcı, "Gerçeğin Suretinin Saklandığı Yer: Ayna," 19, fig. 6; 2) Istanbul, TSMK, Ms. H.788, a *Khamsa* of Niẓāmī dated 919 (1513–14), fol. 319r: see Stchoukine, *Les peintures des manuscrits de la "Khamseh" de Niẓâmî*, pl. LVIIa, and Bağcı, "Gerçeğin Suretinin Saklandığı Yer: Ayna," 20, fig. 7; 3) Istanbul, TSMK, Ms. R.856, a *Khamsa* of Niẓāmī dated 935 (1528–29), fol. 311v.

55. Sims, "Ibrāhīm-Sulṭān's Illustrated *Ẓafar-Nāmeh* of 839 (1436)," 189, fig. 15; and Lentz and Lowry, *Timur and the Princely Vision*, 105, fig. 38. An image from the copy of the *Shāhnāma* of Firdawsi dated 848 (1444–45) and copied by a scribe named Muhammad *al-ṣulṭānī* (Paris, Bibliothèque nationale, Supp. Pers. 494, fol. 14v) repeats the exact pose. It can be attributed stylistically to Shiraz and the scribe's epithet, *al-ṣulṭānī*, suggests that he was attached to the gubernatorial court of 'Abdallah b. Ibrahim. For the manuscript, see Francis Richard, *Splendeurs persanes: Manuscrits du XIIe au XVIIe siècle* (Paris: Bibliothèque nationale de France, 1997), 81; Annie Vernay-Nouri, with contributions from Annie Berthier, *Enluminures en terre d'Islam: Entre abstraction et figuration* (Paris: Bibliothèque nationale de France, 2011), 69. For a web image, see http://gallica.bnf.fr/ark:/12148/btv1b8432263q/f34.item.r=supplement+persan+494.lang EN.

56. Priscilla P. Soucek, "The Ann Arbor *Shahnama* and Its Importance," in Hillenbrand, *Persian Painting from the Mongols to the Qajars*, 267–83, for example, presents a case for the Qaraqoyunlu prince Pir Budaq.

57. According to Rieu, Yazdi's statements in his preface and epilogue show that he intended to write two more books (*maqāla*) devoted to the history of Shah Rukh and Ibrahim Sultan. See Charles Rieu, *Catalogue of the Persian Manuscripts in the British Museum*, 3 vols. & Supplement (London: British Museum, 1879–95), 1:174. Also see İlker Evrim Binbaş, "The Histories of Sharaf al-Dīn 'Alī Yazdī: A Formal

Analysis," *Acto Orientalia Academiae Scientarum Hung.* 65, 4 (2012): 391–417.

58. Sims, "Ibrāhīm-Sulṭān's Illustrated *Ẓafar-Nāmeh* of 839 (1436)."

59. Thackston, *A Century of Princes*, 63–65.

60. Soucek, "Ann Arbor *Shahnama* and Its Importance."

61. Soucek, "Ibrāhīm Sulṭān's Military Career"; Priscilla Soucek, "The Theory and Practice of Portraiture in the Persian Tradition," *Muqarnas* 17 (2000): 98 and 104.

62. Lentz and Lowry, *Timur and the Princely Vision*, 126–32; Soucek, "Ibrāhīm Sulṭān's Military Career," 38–39; Soucek, "Theory and Practice of Portraiture," 104–5; Soucek, "Ann Arbor *Shahnama* and Its Importance," 267–81; and Sims, "Hundred and One Paintings of Ibrahim-Sultan," 121.

63. Sharaf al-Dīn 'Alī Yazdī, *Ẓafarnāma*, ed. Muhammad 'Abbasī, 2 vols. (Tehran: Amīr Kabīr, 1336), 2:480, cited by Soucek, "Ibrāhīm Sulṭān's Military Career," 27–29. For the reproduction of the image, see Sims, "Ibrāhīm-Sulṭān's Illustrated *Ẓafar-Nāmeh* of 839 (1436)," 194, figs. 36 and 37. Yazdi's words seem to recall Firdawsi's description of Iskandar's entry into Mecca at the head of his army with "drums rolling and trumpets blaring"; cited by Marianna Shreve Simpson, "From Tourist to Pilgrim: Iskandar at the Ka'ba in Illustrated *Shahnama* Manuscripts," *Iranian Studies* (2010): 128n3.

64. Soucek, "Ibrāhīm Sulṭān's Military Career," 27–29.

65. Sims, "Ibrāhīm-Sulṭān's Illustrated *Ẓafar-Nameh* of 839 (1436)," 188–89, figs. 13, 16.

66. University of Oxford, Bodleian Library, Ms. Ouseley Add. 176, fols. 6v–7r. See Soucek, "Ibrāhīm Sulṭān's Military Career," 33–36. For a color reproduction of the image, see Abdullaeva and Melville, *Ibrahim Sultan's Shahnama*, 23, fig. 9; or the Cambridge *Shahnama* Project Site: http://shahnama.caret.cam.ac.uk/new/jnama/card/ceillustration:604187385.

67. Soucek, "Ibrāhīm Sulṭān's Military Career," 33–36.

68. Mieke Bal, *On Meaning-Making: Essays in Semiotics* (Sonoma, Calif.: Polebridge Press, 1994), 217.

69. Keith Moxey, *The Practice of Theory: Poststructuralism, Cultural Politics, and Art History* (Ithaca: Cornell University Press, 1994), 102–3.

70. Ibid., 110.

71. Thomas James Clark, *Image of the People: Gustave Courbet and the Second French Republic, 1848–1851* (Greenwich, Conn.: New York Graphic Society, Thames and Hudson, 1973), 12.

72. Norman Bryson, *Looking at the Overlooked: Four Essays on Still Life Painting* (Cambridge, Mass.: Harvard University Press, 1990), 127–29.

73. For passing references to audiences in album prefaces that imply viewings, see David J. Roxburgh, *The Persian Album, 1400–1600: From Dispersal to Collection* (New Haven: Yale University Press, 2005), 193–194; and David J. Roxburgh, *Prefacing the Image: The Writing of Art History in Sixteenth-Century Iran* (Leiden: E. J. Brill, 2001), 63–65, and 69–70.

74. This reading is based on the constative and performative levels of images explored by Bryson, *Looking at the Over-looked*, 119.

75. Pierre Nora, "Between Memory and History: *Les Lieux de Mémoire*," in "Memory and Counter Memory," special issue, *Representations* 26 (Spring 1989): 11–12, maintains that the moment of *lieu de mémoire* occurs at the same time that an immense and intimate fund of memory disappears, sur- viving only as a reconstituted object beneath the gaze of critical history.

76. Soucek, "Ibrāhīm Sulṭān's Military Career," 27–29.

77. Richard Brilliant, *Portraiture* (London: Reaktion Books, 1991), 8.

78. I would like to express my thanks to Mustafa Çiçekler, who tirelessly helped me pick up the text from the correct point whenever it got hopelessly tangled.

SERPİL BAĞCI

PRESENTING *VAṢṢĀL* KALENDER'S WORKS: THE PREFACES OF THREE OTTOMAN ALBUMS

The Ottoman bureaucrat and historian Mustafa ʿÂli (d. 1600) added a verse epilogue (*ẕeyl*) to his *Menāḳıb-ı Hünerverān* (Exploits of the Artists), which he completed in 1587.[1] At the end of his text, the first biography dedicated to calligraphers in Ottoman literature and the only existing work on the masters of painting, illumination, and paper decoupage, ʿÂli notes that the last step (*āḫir-i kār*) in the completion of a book is the joining (*vaṣl*) of the entire volume at the spine. As it was fitting to cite in the epilogue the name of a paper joiner who produces rarities (*vaṣṣāl-i nādire-kār*), ʿÂli dedicates a piece of poetry to the *vaṣṣāl* Kalender Çavuş (d. 1616).

In his eulogy, ʿÂli provides invaluable information about the artistic identity of Kalender Çavuş as he praises his technical competence in joining and conserving sheets of paper, as well as his virtuosity in other aspects of the arts of the book. According to ʿÂli, Kalender was also unmatched among equals in his skill as a bookbinder. His ability to join *qiṭ'a*s (a single-sheet calligraphy, painting, or drawing), which he composed of colorful sheets of paper, resembles the rainbow across the face (i.e., page) of the sky. No one can discern the line where he attaches the sheets; the eye of the imagination perceives these as single pages. When he joins paper and leather, even the most discerning, those able to see the finest things, find no words to describe his work. God has bestowed upon him the arts of *ḥalkār* (illumination with varying dilutions and densities of gold) and *zerefşān* (gold sprinkling), as well as *cedvel* (framing) and *pervāz* (margining). Each of his knotted patterns in the margins surrounding the *qiṭ'a*s "bewilders the viewer and binds a knot around the feet of the mind." ʿÂli also mentions Kalender's ability to mend torn pieces of paper with his preparations, just

like the "sherbet of reunion revives the heartbroken beloveds."[2]

Kalender, who was so praised by ʿÂli, a writer who rarely offers compliments, began his career as a royal herald (*çavuş*) at the imperial palace. The historian Selaniki (alive in 1600) notes that Kalender Çavuş was appointed as the trustee of Sultan Selim I's endowments in late April/early May 1598 (*evāḫir-i Ramażān* 1006). He also identifies him as steward at the Porte (*ḳapu ketḫüdası*) and cites him among those presented with robes of honor (*ḫilʿat*) after the trial and execution of a pasha who rebelled on February 7, 1600 (22 Rajab 1008).[3] The rank of *ḳapu ketḫüdası* is not only important within the hierarchy of the palace but also indicates that Kalender enjoyed close ties with the palace eunuchs and inner palace pages. The contemporary historian Mehmed-i Rumi b. Mehmed (d. 1640–41) mentions in his *Tārīḫ-i Āl-i ʿOs̱mān* (History of the House of Osman) that Kalender was a member of the corps of court ushers, as well as a trustee of sultanic endowments in Istanbul. According to Mehmed, he worked as a keeper of the imperial purse (*ḫarc-ı ḫāṣṣa emīni*) for an extended period of time. Since officers of this rank served at the palace, Kalender mingled with the eunuchs of the harem (*dārü's-saʿāde aġaları*) and other palace eunuchs and pages (*aġalar*) during this period, ultimately affiliating himself with the palace pages (*ḳapu oġlanları*). In particular, he earned the favor of the chief black eunuch el-Hacc Mustafa Agha (d. 1624), and, upon his recommendation, was appointed as second treasurer (*defterdār-ı s̱ānī*).[4] Subsequently, when a building supervisor (*binā emīni*) was needed in 1610 (1018) for the construction of the mosque of Sultan Ahmed I (r. 1603–17), Mustafa Agha recommended that Kalender be desig-

nated financial supervisor of construction (*ḥāfiẓ-ı māl*). In November 1614 (Shawwal 1023), when Kalender was eagerly carrying out the duties of these posts, the vizier Yusuf Pasha died and Kalender inherited both his vizierate and properties.[5] He died two years later and was interred in the garden of the Atik Ali Pasha Mosque.[6] Mehmed concludes his narrative of Kalender Pasha by noting that he was not only moderate (*muʿtedil*) and abstinent (*perhīzkār*) but also an unequaled paper joiner (*vaṣṣālī*) and bookbinder (*mücellid*).[7]

The artist's name (or perhaps his sobriquet) implies his association with antinomian dervish groups. Besides the reference to his skill as an artist, a verse in ʿÂli's above-quoted poem, which defines him as a mine of talent (*kān-ı maʿrifet*), could be understood—albeit indirectly—as related to the ability to know God with the heart's eye on the path to Sufism.[8] The metaphor of the crescent moon as Kalender's earringed slave, in the second hemistich of the same couplet, brings to mind the earrings worn by dervishes.[9] Furthermore, Mehmed b. Mehmed's description of Kalender as "abstinent" (*perhīzkār*), an adjective connoting self-restraint and avoidance of sin and sexuality, suggests Kalender's preference for celibacy (*mücerred*). According to Bektashi tradition, celibate dervishes wore heavy, metal earrings in the shape of horseshoes or rings after their ears had been pierced during special ceremonies. These earrings were signs of celibacy in line with certain Bektashi dervishes and clergy, allegedly including Hacı Bektaş and Balım Sultan (d. 1516).[10] Mehmed b. Mehmed's indication that the young Kalender was a learned/wise *bābā* among the court novices (*cümlenüñ ʿizālarında bir bābāy-i ʿālim*) also implies his association with the celibate Bektashi *bābā*s, the high-ranking dervishes whose organization was most likely founded after the 1550s.[11] These subtle intimations bring to mind Kalender's Sufi affiliations. It is still impossible to establish which Sufi order Kalender Pasha may have belonged to, if any, but three factors suggest he may have been a Bektashi: first, the Bektashi order had been recognized to some extent at the Ottoman court, particularly after the sixteenth century; second, within the army, the janissaries had special connections to the Bektashis; and, finally, "Kalender" was commonly used as a name and sobriquet among the Bektashis.[12]

KALENDER'S ALBUMS FOR SULTAN AHMED I

Today we are familiar with *Vaṣṣāl* Kalender from his close association with the arts of the book—which exceeded that of a mere hobbyist—and from various surviving works of art in his hand. The art of paper joinery consists of attaching pieces of paper to one another so as to mask the individual joints. However, *vaṣṣāl*s also demonstrated their talents by restoring manuscripts and framing pages within a margin (*pervāẓ*) in order to enlarge them, as well as by designing books. This particular process is especially important in the production of albums, which combine independent calligraphies, paintings, and drawings (*qiṭʿa*s) that differ in content, as well as dimension, style, and technique. Undoubtedly, the traditional principles of the arts of the book guided the artists who produced such album-books. At the same time, the creation of artistic collations that were otherwise unrelated to each other resulted in independent, original works of design. In addition to introducing the artist and his work, the texts that Kalender placed at the beginning of his albums also present clues regarding this process of design.

Three albums that were certainly compiled by Kalender are known today, and some folios with stylistic and distinctive features attributable to him survived in other albums. Kalender composed these albums in almost identical format and style, though each contains diverse content, fulfills distinct purposes, and is the result of different processes of production. These three albums, which have approximately the same dimensions, contain prefaces written in the *naskh* script that each directly address the contents of their respective volumes.

The motifs and colors of the illuminations at the beginning of all three album prefaces relate to those of a *tughra* (calligraphic monogram) of Sultan Ahmed I that was signed by Kalender and appears at the beginning of the *Fālnāme* (Book of Omens), his final work (fig. 5). The stylistic similarity between the heading illuminations of the prefaces and the *tughra* suggests that they are all by the same artist. While the overall conception of motifs and colors is almost identical in all of the works, they are designed differently. The gold wash (*ḥalkārī*) decoration in the margins, which at times are

Fig. 1. Opening page of the Ahmed I Album. Topkapı Palace Museum Library, B. 408, fol. 1a. (Photo: courtesy of the Topkapı Palace Museum Library)

Fig. 2. Closing page of the *Fālnāme*. Topkapı Palace Museum Library, H. 1703, fol. 41b. (Photo: courtesy of the Topkapı Palace Museum Library)

dyed brown, maroon, green, blue, or dusty rose, features large vegetal and floral motifs in the *rūmī* and *ḥaṭāʾī* styles. They also incorporate serrated leaves, at times placed in cartouches. The distinct decorative vocabulary and style function much like a signature, as if to announce that the entire marginal design is the work of Kalender. The same technique and motifs are also evident in the full-page illuminations. Inspired by the designs of book covers, they were inserted into the opening and concluding sections of the manuscripts and occasionally throughout the volume (figs. 1 and 2). Some of these full-page decorations, which incorporate enlarged geometric patterns—often composed of interlocking circles—and split-palmettes, constitute Kalender's original contributions to the repertoire of Ottoman

illuminated designs. Most of the motifs are executed in paper-joining technique, which appear almost like colored drawings. Kalender masterfully hides the seams of the attached split-palmettes with gold lines, demonstrating the laudatory comments of Mustafa ʿÂli in his eulogy: "No one could possibly detect the joinings / Even the most visionary eyes would think it a single piece" (figs. 3–6 and 15).[13] His command of geometry (*hendese*), underlined several times in the preface of his calligraphy album, H. 2171 (see Appendix I for the facsimile, transliteration, and translation), examined below, must have shaped his highly original compositions. These designs are at times arranged at an angle to evoke a layered sense of dimensionality. Kalender made every effort to vary his layouts by paying particular attention

Fig. 3. Opening page of the calligraphy album. Topkapı Palace Museum Library, H. 2171, fol. 1a. (Photo: courtesy of the Topkapı Palace Museum Library)

Fig. 4. Closing page of the calligraphy album. Topkapı Palace Museum Library, H. 2171, fol. 73b. (Photo: courtesy of the Topkapı Palace Museum Library)

Fig. 5. Opening folios of the *Fālnāme*. Topkapı Palace Museum Library, H. 1703, fols. 1b–2a. (Photos: courtesy of the Topkapı Palace Museum Library)

Fig. 6. Decorative page from the so-called Bellini Album. The Metropolitan Museum of Art, Louis V. Bell Fund, 1967 (67.266.7.1v) © 2013. Image copyright The Metropolitan Museum of Art/Art Resource/Scala, Florence.

to detail. The artist also placed tiny squares and rectangles of different colored papers in the frames surrounding the specimens (figs. 3, 4, 7–11, 13–17, and 19).[14] It is highly possible that he was also responsible for the bindings of his works. Two manuscripts (H. 2171 and H. 1703) were rebound at the Zü'l-vecheyn Library, founded at the Yıldız Palace during the reign of Abdülhamid II (r. 1876–1909). The bindings of albums B. 408 (see Appendix II for the facsimile, transliteration, and translation) and B. 409, on the other hand, are almost identical, except for some motifs used in the frames on the outer covers.[15] Their similarity demonstrates that they are the work of a single artist, most likely Kalender, whom the aforementioned Mehmed b. Mehmed identified as a bookbinder.

All three prefaces are addressed to Sultan Ahmed I and all but one are authored by Kalender, who dedicated them to his royal patron. After briefly introducing the three works, I will focus in this essay on the

prefaces, which elucidate the relationship between an Ottoman compiler-artist and his work, as well as his relationship to the content and function of the albums. More specifically, these prefaces offer insight into Kalender's identity as an artist.

A CALLIGRAPHY ALBUM
FROM KALENDER'S COLLECTION: H. 2171

The first of these albums, all of which are preserved in the Topkapı Palace Museum Library, contains calligraphies that most likely belonged to Kalender's own collection (H. 2171 [see Appendix I]).[16] In his poem, Mustafa ʿĀli mentions Kalender's passion for collecting, his peerless holdings of *qitʿa*s, and his extravagance in supporting artistic talent.[17] Kalender's interest can allegedly be traced back to the 1580s, when collecting, particularly samples of calligraphy, was popular among Istanbul's intellectual elite. Many passages in the *Menāḳıb-ı Hünerverān* demonstrate how these single-sheet calligraphies and paintings were highly esteemed by "men of refinement," including Sultan Murad III (r. 1574–95), his chief white eunuch, Gazanfer Agha (d. 1603), and his tutor and chief mufti, Hoca Saʿddeddin Efendi (d. 1599).[18] The album of calligraphies that Kalender presented as a gift to the sultan contains works by various celebrated calligraphers mentioned by ʿĀli. Among these artists were the Iranian calligraphers Mir ʿAli (d. 1544) and Sultan ʿAli (d. 1520?), whose *qitʿa*s, according to the author, were prized among the collectors of Istanbul at the time he completed his work in 1587.[19] In addition, works by Qutb al-Din Muhammad Yazdi and ʿAbdallah Kırımi (d. 1590) specifically indicate Kalender and ʿĀli's common interest, taste, and knowledge in the art of calligraphy (fig. 7). ʿĀli stresses the importance of these two artists, both for their skills and their erudition in the history of the calligraphic arts, which were of great benefit to him while he was writing his book. Qutb al-Din Muhammad Yazdi was the most important inspiration for ʿĀli; they met in 1585–86, when ʿĀli was the finance secretary in Baghdad. ʿĀli spent many days and nights with him, and, upon his suggestion, Qutb al-Din wrote a treatise on fifty masters of the *naskh* and *nastaʿlīq* scripts. ʿĀli apparently owned a copy of this treatise, which he

Fig. 7. Two pages from the calligraphy album, with calligraphies by Abdallah Kırımi (right, dated 1589–90 [998]) and by Qutb al-Din Muhammad Yazdi (left [middle], dated 1580–81 [988]). Topkapı Palace Museum Library, H. 2171, fols. 25b–26a. (Photo: courtesy of the Topkapı Palace Museum Library)

sometimes quoted and sometimes compared with other sources. It is highly probable that ʿÂli and Kalender had many conversations concerning Qutb al-Din's merits. Mevlana Abdullah Kırımi, known as Tatar Katib, was one of the salaried scribes at the Ottoman court and also a respected calligrapher, who provided ʿÂli with information on the artists of fine writing.[20] In other words, the album's content sheds light on Kalender's connoisseurship and collection. It reveals his interest in Timurid, Safavid, and contemporary Ottoman calligraphers, as well as the availability of these works on the Istanbul art market in the late 1500s.

This was probably the first album that Kalender presented to Sultan Ahmed I, as a token of gratitude for his appointment as the financial building supervisor of the sultan's mosque, under construction at the time. The way he assembled the album demonstrates his connois

seurship and skills, as well as his command of the art of drawing, proportion, and geometry, all prerequisites—as emphasized in the preface—for his new assignment as building supervisor.[21]

The calligraphy album, which measures 48 by 34 centimeters, includes seventy-three folios. It contains chapters and verses from the Koran, samples of hadith and poetry executed in different styles by Ottoman and Iranian calligraphers, and paper decoupage writings by the legendary Ottoman artist Fahri of Bursa (d. ca. 1610). Kalender's formal and conceptual arrangement openly mirrors his knowledgeable and diligent approach to his work as an album designer. The layout of the pages, clearly inspired by sixteenth-century Safavid examples, is designed in Kalender's personal style. He encloses the *qitʿa*s with his typical frames, which consist of variously colored papers cut into very small squares and rectangles

and mounted into the frames, at times diagonally. These frames sometimes consist of decorated paper strips (fig. 7). The rather large margins are also in his characteristic manner. In addition to his regular gold wash decorations on brown, maroon, beige, or dusty pink papers, he also uses marble papers to surround the calligraphic samples and pages from manuscripts. Kalender opens and closes his volume with almost identical full-page decorated papers. With their bold, almost psychedelic circles, these illuminated pages affirm Kalender's original contribution to Ottoman design (figs. 3 and 4). The circular medallions consist of thin strips of cut paper, demonstrating his skill in the art of *vaṣl*, which involved cutting and pasting, as well as joining papers.

The first fourteen folios of this album are from the Koran, except for fol. 9a, which features a text on the art of calligraphy. Before the preface (fols. 17b–23b), Kalender inserted three decorated pages as a buffer between the word of God and prosaic introductory text.[22] Starting on folio 24a, facing pages are governed by certain complementary formal principles. Most of the facing pages are designed in relation to one another, with one side including samples of *taʿlīq* or *nastaʿlīq* script while the other includes *naskh* or *thuluth*, thus pointing to a certain visual principle used in designing the bi-folios (fig. 7). This visual rhythm is applied almost throughout the entire manuscript, attesting to Kalender's sensitive and conceptual approach to displaying his collection.

The preface, between folios 17b and 23b, is written in a clear, voweled *naskh* hand and decorated with gilding between the lines. The text was written by the then-current chief army judge (*kazasker*) of Rumeli, who, among all the learned class, was valued and distinguished by the sultan.[23] The author does not give his name, but he begins the *qaṣīda* at the end of the preface with his sobriquet, *Kemālī*—the penname of the prominent statesman and scholar Taşköprizade Kemaleddin Efendi (d. 1621). As a member of the celebrated Taşköprizade family, the preface's author was educated under distinguished teachers and worked as a professor at some of Istanbul's main madrasas. After holding judgeships in various important cities, he was several times appointed chief judge of Anatolia and in April 1612 (Safar 1021) became chief judge of Rumeli. His first term there ended on October 25, 1612 (29 Shaʿban 1021), and he was sub-

sequently reappointed several times. Apart from composing poetry under the penname *Kemālī*, he wrote and translated many historical and religious works, including some in Arabic.[24] Based on the years he first held the office of chief judge of Rumeli, the completion of Kalender's album can be attributed to sometime between April and October 1612.

As Kalender authored the presentation texts of his subsequent works, Album B. 408 and the *Fālnāme*, his decision to have a reputable statesman and literary figure compose the preface of this first known work—which relates it to another Ottoman literary genre, *takrīẓ* (a eulogizing preface by an important literary figure for another writer's book)—suggests Kalender's desire to remain anonymous and have someone else laud him and his work.

The author of the preface recounts that when the artist (Kalender) completed his work, he was asked to compose a foreword (*dībāçe*) to describe the album and praise the sultan. Allegedly, the author first declined, asserting his inadequacy in the art of poetry and composition and his inability to produce anything worthy of the sultan.[25] Yet Kalender refuted his excuses, reminding him that he had executed several works of prose and poetry for the sultan, most of which he had admired, and that he had bestowed various gifts upon him in return.[26]

The preface follows the Timurid and Safavid models, first praising God, the Prophet Muhammad, and ʿAli, and then Sultan Ahmed I.[27] The author then proceeds to relate the story of the album's production, a biography of its compiler, and a summary of the book's contents. In invoking God, the author refers to Him as the creator of the divine pen that wrote on the Preserved Tablet (*Levḥ-i Maḥfūẓ*) "all that was and would be" on His order. The creation of the universe is likened to the act of album compiling, using terms from the practice of album making: "[He] joined (*vaṣl u ilṣāḳ*) this subtle page (*ṣaḥīfe-i laṭīfe*) [i.e., the Preserved Tablet] to the folios and layers of the celestial spheres (*evrāḳ u aṭbāḳ-ı eflāk*). Together with the rays of light from the sun and awe-inspiring colors and ornate design of the stars, this beautiful album (*muraḳḳaʿ-ı zībā*) [i.e., the universe], which fascinates painters and decorators, who are incapable of producing anything like it, was created."[28]

The author's praise for Muhammad is also peppered with references to the pen, further strengthened with verses from the Koran.[29] Then, following the Persian tradition of album prefaces, he mentions 'Ali as the leader (*pīşvā*) and exemplar (*muḳtadā*) of all calligraphers, especially in the Kufic script.[30] After citing the calligraphers who follow their patron saint 'Ali in creating fine writings that "delight the eyes of the connoisseurs (*erbāb-ı ma'ārif* and *merd-i 'ārif*) and in inventing new styles," the author underlines the value of the masters of album compiling (*üstādān-ı murakka'sāzān*) and their contribution to the conservation of art: "album makers save and protect those attractive writings from withering and getting scattered and lost overtime."[31] The preface author implicitly refers to Kalender's calligraphy album for Sultan Ahmed when he writes: "They gather and join the beautiful *qiṭ'a*s together, arrange (*tertīb*) and decorate (*tezyīn*) them with designs and paintings in gold wash (*naḳş ü nigār-ı ḥalkārī*), and make them gifts for the royal assemblies (*mecālis-i selāṭīn*) and for the splendor of the library (*kütübḫāne*) of the just sovereign."[32] Then the author turns to the Ottoman sultan, whose royal assembly and library were the destination of the very album for which he was composing a foreword. After a lengthy section devoted to the praise of Sultan Ahmed, both in prose and in verse, he introduces the story of the album, in a historical-narrative style that is largely structured as a series of dialogues: through the communications between the sultan and the chief black eunuch el-Hacc Mustafa Agha, as well as between the artist and the composer of the preface, the album's inception, intention, and content are described, as are Kalender's skill and merits.

According to the text, "when it occurred to the sultan of the world to have a heavenly mosque built in a pleasant part of the city," he summoned el-Hacc Mustafa Agha, stating that "it was necessary to appoint from among the servants of his imperial palace a superintendent for that solid and strong building. According to the sultan's royal mind, the appointment was most suited to the second treasurer, Kalender Efendi, a trusted man and a man of the arts (*ṣāḥib-i emānet ve merd-i hüner*), knowledgeable in matters of construction (*aḥvāl-i binā'*) and the science of geometry (*'ilm-i hendese*), and aware of every craft (*her kārdan āgāh*)."[33] Mustafa Agha

responded that "no one among the sultan's servants was more suitable for that great duty, for he [Kalender Efendi] was intelligent, perceptive (*ṣāḥib-i ẕekā vü fiṭnat ve ehl-i kiyāset ü firāset*), and experienced (*umūr-dīde ve kār-āzmūde*)." Furthermore, [Kalender] "was skillful in the science of geometry and capable of inventing all sorts of designs, images, and drawings (*īcād-ı envā'-ı ṭarḥ u ṣuver u rüsūma ḳādir*)." The agha recognized that all those skills qualified Kalender as a perfect paper joiner and album-maker among his colleagues in both the Ottoman lands (*Rūm*) and Iran ('Acem).[34] The author uses this laudatory language, voiced through both the sultan and the agha, to offer his own praise for Kalender. He also states how important being knowledgeable in geometry is for the arts of the book and album compiling. Given the Ottoman elite's appreciation of Persian literature and visual arts, Kemaleddin Mehmed Efendi's reference to Iranian album making, a popular Timurid and Safavid practice, evokes a common intellectual tradition. However, he compares Kalender to both Iranian and Ottoman (*Rūmī*) artists, suggesting that the two traditions were equally important.

In the next section, Kemaleddin Mehmed Efendi focuses on the album's content and on Kalender's intent. He underlines once again Kalender's aptitude in geometry and construction, but identifies the sultan's fondness for fine calligraphy as the main reason for the creation of the work. The ruler also enjoyed "the subtleties of design and depiction and his noble heart was inclined to exquisite books and charming albums."[35] This comment is not a mere tribute to Sultan Ahmed I; in fact, his fondness for perusing the albums in his library is attested by the notes he wrote in two of the Topkapı Palace albums.[36] The author continues, remarking that considering the sultan's inclination, "his abovementioned servant [Kalender] collected innumerable examples of calligraphy by ancient masters and depictions and designs done by painter-designers from Cathay and China, joined them by the art of paper joining (*ṣan'at-ı vaṣṣālī*), and created an album in an excellent manner (*ṭarz-ı ḥūb*) and novel style (*bedī'ü'l-üslūb*) to present as a gift to the royal court and to his Majesty."[37] The author defines the completed work as a wondrous album (*murakka'-ı ġarīb*) of amazing style

and design (*üslūb u ṭarḥ-i ʿacīb*), thus praising the arts of gathering and joining, which would certainly "bewilder and astound the minds of the masters" (*ʿuḳūl-i üstādān ʿāciz ü ḥayrān olmaḳ muḳarrerdür*).[38] The focus on the informative quality of the album, consisting of the works of renowned calligraphers and painter-designers, points to the importance placed on its didactic function in fostering a certain taste and connoisseurship. In fact, a similar assertion is stressed in the preface written by Kalender himself in his other work, the album of Ahmed I, to be discussed below. In the case of the calligraphy album, the elegance of its decoration and paintings are described as evocative of the image of the beloved (*nigār-i maḥbūb*), who is "adorned with varyingly embroidered (*münaḳḳaş*) garments and is decorated and jeweled (*müzeyyen ü muḥallā*) with heart-attracting gems (*ḥilye vü cevāhir-i dilkeş*)." The author once again applauds the art of joining the pages of the album.[39]

After the story of the composition of the preface, which I analyzed above, the text concludes with a *qaṣīda* and prayers dedicated to Sultan Ahmed.

A COMPILATION OF *QIṬ ʿA*S FROM THE ROYAL COLLECTION: AHMED I ALBUM, B. 408

Kalender's next album with a preface is called "The Album of the World Emperor Sultan Ahmed Khan," as stated in its illuminated heading (see facsimile in Appendix II).[40] At 48 by 35 centimeters, this thirty-two-folio album is almost identical in size to the previous one and retains its original binding. Even though the binding was restored at an unknown time, folios 12 and 25 are damaged, most likely due to the copper content of the green pigment of their margins; they are also detached from the binding and torn along their edges. Another five pages are reattached to the spine with strips of paper (fols. 23, 24, 26, 28, and 31).[41]

Like Album H. 2171, with respect to the overall design of its pages, this work also recalls sixteenth-century Safavid examples. It comprises calligraphic specimens, paintings, and drawings, which, according to its preface, were given to Kalender by the sultan to gather in an album. Both the calligraphies and images are mostly by Ottoman artists, except for a few of Iranian and Central Asian provenance.

The album has only a few examples of calligraphy, including pages from manuscripts. Except for two pages in the beginning, the calligraphy examples consist of Persian couplets with mystical and romantic content, written in the *nastaʿlīq* script.[42] The first of these is separated from the preface by an illuminated page (fig. 1) and contains the traditions of the Prophet Muhammad (fol. 5b). Kalender obviously regarded this page as important since he placed it opposite a page featuring verses from the Koranic chapters al-Aʿraf and al-Baqara, hadith, and a saying of ʿAli (fol. 6a). This seems unusual at first glance, especially in view of its unsophisticated quality. Sultan Ahmed's signature provides an explanation for this rather unexpected placement.[43] The rest of the calligraphies are scattered among the pages with images, mostly displayed on separate folios. Pieces from certain calligraphers, such as the legendary Timurid/Safavid calligrapher Shah Mahmud Nishaburi (d. 1564), were evidently considered more valuable than others. The layout of the folio, featuring the opening page from a copy of the *Būstān* (Orchard) of Saʿdi (d. 1291), is designed in an unprecedented manner, with paper-cut frames and concentric roundels surrounding the text block (fig. 8).[44] In addition, certain Ottoman calligraphies were differentiated by being mounted on elaborately designed folios. For example, Kalender seems to have prioritized the mystical works of Derviş Receb Rumi, who was perhaps also a distinguished friend. All but one of his *qiṭʿa*s are displayed alone and feature two different margins.[45] One *qiṭʿa*, combining Persian and Arabic hemistiches, is surrounded by an extraordinary frame that displays Kalender's proficiency in the art of *vaṣl*, this time joining cut sheets of paper with leather (fig. 9).[46] This frame, which is reminiscent of wood inlaid with precious ivory sheets, is unique in the album.[47]

Another work, by Katib al-Sultani Emir Mehemmed Emin of Tirmiz, a court scribe, includes a dedication to Kalender: "Written for Kalender Efendi, Long may he live" (*bi-jihat-i Ḳalender Efendi, ṭāla ʿumruhu nivishta shud*) (fol. 12b).[48] This note is highly unusual in the calligraphy tradition not only because it addresses a specific owner/patron, Kalender, but also because it

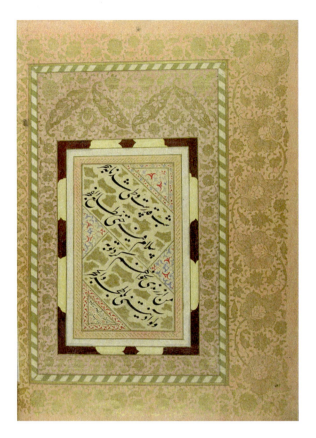

Fig. 8. Page from the Ahmed I Album, with calligraphy by Shah Mahmud Nishaburi. Topkapı Palace Museum Library, B. 408, fol. 22a. (Photo: courtesy of the Topkapı Palace Museum Library)

Fig. 9. Page from the Ahmed I Album, with calligraphy by Derviş Receb Rumi. Topkapı Palace Museum Library, B. 408, fol. 11b. (Photo: courtesy of the Topkapı Palace Museum Library)

indicates that he contributed at least one work from his own collection to Sultan Ahmed's album, implying that he himself was one of the artists mentioned in the album preface as having donated artworks to the sultan as gifts.

The album's images consist primarily of figural studies, portraits of Ottoman sultans, narrative paintings, ink drawings, and unfinished works.[49] Among these, paintings of individual figures are the most numerous. These small-scale images depict various figures from Ottoman society, men and women, young and old, ranging from the palace elite to non-Muslim subjects and from scholars and saints to bathhouse attendants and male dancers (figs. 10–12). Except for a few examples set against a landscape, most of the portraits are drawn on plain paper, with no background to place the figures in

a narrative context. Stylistically, they belong to two distinct groups, the first of which is executed with a relatively thick, fast brush by a repetitive artist, whose style is closely related to the manner of professional artists working independently of the court, the so-called bazaar painters.[50] The second group of single-figure portraits seems to be the work of a more accomplished artist or artists, most likely associated with the royal atelier.

These single-figure portraits drew upon the Safavid tradition of album painting, some directly emulating late sixteenth-century Safavid examples, others bearing their influence. One picture, reproduced here, of a kneeling young man (fig. 10, bottom row, middle), for instance, is a reversed variation of a Safavid model. Even though it is not possible to trace back the specific original from which this painting was copied, it is directly

Fig. 10. Page from the Ahmed I Album with an assemblage of portraits. Topkapı Palace Museum Library, B. 408, fol. 8b. (Photo: courtesy of the Topkapı Palace Museum Library)

Fig. 11. Page from the Ahmed I Album with an assemblage of portraits. Topkapı Palace Museum Library, B. 408, fol. 27b. (Photo: courtesy of the Topkapı Palace Museum Library)

related to an image attributed to Qazvin, circa 1587, which was also copied by Riza-i 'Abbasi, in 1602–3 or 1603–4.[51] In other words, at least some of these images belong to the visual repertory of the single-sheet paintings in the Safavid album tradition, which was apparently well known and well regarded by Ottoman painters and patrons.

However, another genre well established in the Ottoman painters' own milieu must have fostered this prevailing taste for single-sheet portraits, namely, the costume book. The latter also consists of autonomous art works, which owe their thematic and contextual coherence to the fact that they satisfied a specific function and were intended for a particular audience.

Fig. 12. Page from the Ahmed I Album with an assemblage of portraits. Topkapı Palace Museum Library, B. 408, fol. 16a. (Photo: courtesy of the Topkapı Palace Museum Library)

Starting in the mid-sixteenth century, costume books containing single-leaf portraits of Ottoman individuals, executed by both European and Ottoman painters, began to be made, mostly for a European clientele.[52] The figures included in Ahmed's album, representing a wide stratum of Ottoman society, link its content to costume albums prepared primarily to introduce the Ottomans to European patrons. The figures in these paintings are depicted with rather generic physiognomies and often repeat certain prototypes, but they may also have portrayed actual individuals known in the city and court, or contemporary personalities popular among Istanbulites.[53] For instance, one image represented in two different copies, pasted on fols. 18b and 27b (fig. 11, below, left), depicts a young man kneeling and holding a book, a fur cap with a feather and an aigrette on his head. Apart from the headgear, no other attribute distinguishes these figures from the others. However, another work depicting the same sitter, which survives in an album now housed in the Chester Beatty Library of Dublin, includes a label that identifies the kneeling youth as Mirzazada of Shirvan, the pupil of Khwaja Hafiz.[54] The Dublin portrait of Mirzazada, probably slightly earlier and depicting him in similar outfits of different colors, was likely used as the model for the young men reading a book in Album B. 408—or all of them were perhaps derived from a common prototype.

Costume albums generally include the portrait of the reigning sultan in the beginning, followed by the grandees of the ruling elite, and the palace eunuchs.[55] Ahmed I's album also contains two portraits, of Selim I (r. 1512–20) and perhaps Ahmed I (fols. 11a and 27b), by a city painter (fig. 11, top row). Kalender mounted the sultans' portraits together with two images, one of a privy chamber page and a black eunuch flanking the sultan, and another of a page carrying food. Through the reorganization of separate images, Kalender gave these group portraits a ceremonial content, thus changing their meaning.

Ahmed I's album also contains narrative paintings. In addition to compositions that repeat certain traditional tropes known from literary and historical manuscripts— such as hunting, camping, and entertainment scenes, as well as literary gatherings—these paintings also depict possibly contemporaneous anecdotes, events, and scenes from Ottoman daily life.[56] Kalender grouped them in line with their stylistic features and thematic content, and generally mounted them together on one page, placing those pages in the volume according to a certain rhythm.

Two other groups of images impart an undisputed Ottoman quality to the album and link it to the visual culture of the court. The first of these consists of six images from a historical book written in Turkish verse (fig. 13). The style of the artist is known from historical manuscripts executed in the last two decades of the sixteenth century by court painters.[57] The text is a copy of a *Cām-ı Cem-āyin* (The World-displaying Cup of Cem), written by Hasan b. Mahmud Bayati in 1481–82. This Turkish genealogy—which according to its author was based on a certain *Oğuznāme* (Book of the Oghuz)— links the Ottomans to the Oghuz clan known as Kayı and, through it, to Adam. The text recounts brief biographies of the Kayı leaders, who are defined in the explanatory headings above the first painting as the ancestors of the House of Osman (*Āl-i ʿOṣmān ecdādı*). The surviving pictures must have come from an uncompleted illustrated copy that was executed at the royal atelier to be integrated into the corpus of illustrated histories of the Ottoman dynasty.[58] In fact, between 1578 and 1580, the court historian Seyyid Lokman Ashuri probably used the *Cām-ı Cem-āyin* for his *Hünernāme* (Book of Skills), which recounts the various skills and qualities of the Ottoman sultans, as he cites an *Oğuzname* among his sources.[59]

Another Ottoman court tradition that dominates the Ahmed I Album is the art of sultanic portraiture, represented here by three independent images and a series of the first twelve sultans. One of the three independent single portraits is a partially overpainted Italianate bust of Mehmed II (r. 1444–46; 1451–81), dated to the 1470s (fol. 15b). Another, depicting the young Murad III (r. 1574–95), is attributed to Nakkaş Hasan Pasha, who was a contemporary of Kalender's (fig. 10, above, left).[60] The serial portraits depict twelve Ottoman sultans from Osman I to Murad III, most of whom are shown holding golden globes (*kızıl elma* [red apple]), symbolizing Ottoman conquests (fig. 14).[61] Together with the pictures from *Cām-ı Cem-āyin*, these portraits establish the royal/historical context of the album. Instead of

Fig. 13. Page from the Ahmed I Album with scenes from *Cām-ı Cem-āyin*. Topkapı Palace Museum Library, B. 408, fol. 6b. (Photo: courtesy of the Topkapı Palace Museum Library)

Fig. 14. Page from the Ahmed I Album with portraits of Ottoman sultans. Topkapı Palace Museum Library, B. 408, fol. 32a. (Photo: courtesy of the Topkapı Palace Museum Library)

scattering them haphazardly among the other images, Kalender placed the sultans from the series and their ancestors at the beginning and end of the album, thus stressing the continuity of the Ottoman dynasty.

As opposed to the more coherent group of works he assembled together in his calligraphic compilation, the mixed content of Ahmed I's album must have been a challenging task for Kalender as an album compiler/designer. Using his typically large margins decorated with gold wash and frames made of small papers in differing colors, he managed to impart a visual unity to those mixed pages. In addition, the order of the works, grouped thematically and stylistically, mirrors a certain arrangement, which contributes to the effect of an unbroken narrative.

The portraits of sultans, which taken together depict the House of Osman, serve both to link the album to the Ottoman family and to represent their rule over the lands inhabited by Ottoman subjects depicted in the other images. The volume opens with a gold wash decorative page, designed to echo the composition of the inner cover of the binding (fig. 1). Following the seven-page preface comes another decorative folio, to prepare the viewer to peruse the body of items included. The two pages containing the traditions and Koranic chapters are followed by pages on which the Ottoman dynasty's ancestors and first four sultans are represented. After forty pages (fols. 8b–28a) composed of images and writings, the volume concludes with the pages containing images of the last eight sultans and their ancestors. These last folios also include decorative pages displaying Kalender's innovative compositions and skill in the art of *vaṣl* (fig. 15).[62] These full-page decorations do not seem to be used as mere separators; rather, they showcase the virtuosity of the artist. In fact, in notes written at the edges of the pages, an unknown connoisseur deemed these all examples of "extraordinary paper joining" (*vaṣṣāle-i nādire*).[63]

We know the preface to the album was written by Kalender, even though he does not provide his name. In addition to the stylistic characteristics and format of the folios, many references to himself as the compiler of the album make this attribution valid. Here, the laudatory tone of the preface to Album H. 2171 is replaced by one that provides invaluable information about Kal-

Fig. 15. Decorative page from the Ahmed I Album. Topkapı Palace Museum Library, B. 408, fol. 29b. (Photo: courtesy of the Topkapı Palace Museum Library)

mankind through God's spirit breathed into his body (15:29 and 38:72) and through the honor conferred on him by God (17:70). After praising the Prophet and the four Sunni caliphs, he applauds the sultan, stressing his interest in exquisite speeches (words) and images. Kalender compliments the sultan on his knowledge and expertise, as well as on the beautiful paintings that are housed in his palace and royal pavilions.[65] By referring to the works in the royal residences, Kalender seems to relate the sultan's wisdom and knowledge to his taste and appreciation for the arts, thereby exalting the arts and their meaning. By extension, he implies that understanding and collecting art requires intellectual refinement.

In the next section, Kalender expands on the concept of art as a reflection of beautiful works that help one to perfect the self and gain peace of mind; the act of gazing upon beautiful things (referring to the works compiled in the album) serves to deepen one's wisdom and develop one's learning through example.[66] He further notes that perusing the album will help the sultan face the evils of the world. Kalender uses the mirror as a metaphor for paintings reflecting the beauties of the world and stresses the relationship between the mirror and the beholder, in other words, the act of contemplating a work of art.[67] According to him:

> inasmuch as the mirror of the polished nature of time has always been an object of instruction for those possessed of insight, it constantly reflects images of designs and figures, but is sometimes tarnished with the verdigris of untoward vicissitudes. In such infelicitous times, if some instructive images from predecessors and successors are gazed upon and remembered, imagining and picturing to oneself the various sorts of chameleon designs, images of strange traces and marvelous shapes that occur with the passage and appearance of the spinning of the celestial sphere will certainly cause the acquisition of the capital of the science of wisdom, will result in the perfection of the eye of learning by example, and will additionally console the felicitous person and the troubled heart of the mighty sovereign by enlivening his mind and by pleasing his luminous inner self and his illuminated heart...[68]

This passage, expressed in the voice of Kalender—who, according to ʿÂli, owned an unparalleled collection of *qiṭʿa*s upon which he spent a fortune—speaks to his own relationship with art.

ender's aesthetic concerns and technique, as well as about his views concerning the benefits and value of the calligraphic and visual arts, both as an artist and a collector. The text is essentially self-referential, informing the reader about the examples that have been selected, the creation of the album, and the history of its compilation. Kalender also elaborates on Sultan Ahmad's role as owner and patron of the album. The text begins with praises to God, stressing that He is the originator of novel and marvelous works (*bedāyiʿ-i ġarībetüʾl-āṣār*) and the inventor of amazing crafts (*ṣanāyiʿ-i ʿacībetüʾl-etvār*). The intention is most likely to link the works included in the album with the divine creation.[64] Kalender continues to praise God, this time emphasizing His creation of Adam, the ancestor of all humans, through Koranic references that imply the exaltation of

After explaining the benefits and value of contemplating art, Kalender turns to the works in the album and the sultan's involvement in its compilation. The artists—former calligraphers, painters, and illuminators—presented their creations to the sultan either to secure a royal favor or simply as gifts.[69] As an artist himself, Kalender shows his appreciation for the unequaled calligraphies and images produced by these men, who devoted their lives to their creations.[70]

According to Kalender, it was Ahmed I who first conceived of the idea of an album. The sultan, he explains, wished that these *qiṭʿa*s and pages should be gathered in one place, arranged according to their relationship to one another, and thus turned into a perfect illuminated and bound album.[71] Kalender then describes his own involvement in the album's compilation, glorifies his master, and stresses his intimate relationship with the sultan. Presenting himself as the slave of the sultan, Kalender makes notes of his master, Muhammad Sharif of Baghdad, a distinguished man of his time and a maker of extraordinary paper joinings (*vaṣṣāle-i nādire-kār u mūteʿayyināt-ı rūzgār*).[72] He had long ago taught him how to join *qiṭʿa*s by master calligraphers and folios with depictions to colorful papers, keeping in mind their relation to one another, in order to assemble them into an album.[73] Apparently, Sultan Ahmed's familiarity with Kalender as a master album compiler, whom he already knew through one or two albums and manuscripts, played a role in the sultan's selection of the artist for the commission.[74] Among Kalender's surviving works, the sultan must have had the aforementioned calligraphy album (H. 2171) in mind.

After a lengthy prayer for the sultan, Kalender continues by recounting how he undertook this work and his considerations therein: when the sultan gathered the leaves with images and calligraphies and sent them to Kalender, he set himself to work to the best of his ability on crafts and marvels never before seen or heard of to make the specimens into an album.[75] For the margins and frames of the works, he would either use colorfully decorated papers of various sorts,[76] or he would attach tiny papers in layers of two or three at the edges of each *qiṭʿa*, as though they were colored striped cloth.[77] These frames, consisting of tiny squares and rectangles, at times attached to each other diagonally,

were Kalender's trademark in his albums and he defines them as one of the novel and never before seen crafts referred to earlier. He was proud enough of his skill in the art of paper joinery to state that only attentive connoisseurs could see these joinings: "It is not unknown or hidden (*ḫafī vü pūşīde*) to those with acute perception and sagacious people of insight (*ḫurdebīnān u ḫurdedān ehl-i ʿirfān*) that by looking at each one of them with a scrutinizing gaze, if attention is paid, (*imʿān-ı naẓarla iltifāt müteʿalliḳ olsa*), God willing, the four corners and the facing one are all in harmony with and conforming to each other, be it in color or in size and length and width."[78] He thus reveals his aesthetic and technical considerations in attaching the papers together.[79] After beseeching the sultan not to desist in his patronage, Kalender then provides further information on his career, showcasing once again the sultan's involvement. He informs us that he is old and has spent all his energy working with finesse and care (*bu denlü diḳḳat ü ihtimām*) throughout the years. He further explains that until the present he had studied with many men of dignity and knowledge, and acquired skill and knowledge through his association and affiliation with such learned and experienced masters. He expresses his hope that this skill and knowledge will not have been acquired in vain, thanks to the patronage of the sultan. He gives thanks to God and to the Prophet and prays that these skillful works, whether detached or bound (*şikeste vü beste olan taṣannuʿāt*), occasionally enjoyed by the sultan whenever he cast his peerless gaze upon them, might be acceptable and pleasing in his noble presence, and that, in accordance with his felicitous order, all of them were arranged in their proper place and completed.[80] The preface closes with praises to the sultan.

A COMPILATION OF PICTURES FOR DIVINATION: THE *FĀLNĀME* OF SULTAN AHMED

Kalender's last known work is a *Fālnāme* (Book of Omens). Larger in size than the others (68.3 cm x 47.5 cm), it also differs from his other works in its contents.[81] Since Kalender refers to himself as a vizier in the preface, the *Fālnāme* must have been completed between

1614 and 1616. *Fālnāma*s are album-books that contain pictorial auguries with accompanying divinatory texts.[82] Based on physical and contextual links between word and image, these works occupy a distinct place in the tradition of illustrated Islamic manuscripts. The narratives of *Fālnāma*s are not continuous wholes. An image is placed on the verso of a page while the corresponding divination text appears on the recto of the following one. Omen seekers with a particular question could thus open the volume to a random page and encounter both an image and a text. In all likelihood, they would first focus on the most striking element, namely, the image on the right-hand page. Turning to the left-hand side, they would see a poem inspired by the image and the divination text, which is where they would read what the future held regarding the issue at hand. In this way, one may think of the combination of image and text as a unified narrative, or of the entire book as an album made up of such pairs. Based on the nature of the content, one could argue that the *Fālnāme* stands closer to albums than to illustrated manuscripts, and shows a typological affinity to Kalender's other works. Most likely inspired by Persian *Fālnāma*s, one of which is still in the Topkapı Palace Museum Library, Kalender Pasha gathered the large pictorial auguries from various sources, coupled them with the prognostication texts in Turkish, and enlarged all the leaves with decorated margins in his typical style.[83] He thus transformed the separate folios into an integrated whole that resembles his other albums and presented it to Sultan Ahmed. Not commissioned by the sultan, the *Fālnāme* may have been a token of Kalender's gratitude for his appointment to the Imperial Divan as a vizier in 1614.

The images, depicting defining moments from the lives of the Prophet Muhammad, his descendants, Abrahamic prophets, sages, heroes, and villains, as well as astrological and eschatological themes, belong to a broader repertory of pictorial auguries that are found in Persian *Fālnāma* manuscripts. The deeds of the prophets and other personages, as well as their responses, highlight their faithful and patient approach to unfortunate events and serve, as emphasized in Kalender's preface, as models for augury seekers in overcoming their own challenges. In other words, the acts of the protagonists in the images are meant to inspire the seeker to develop the eye that learns by example (*ʿayn-ı ibret*); this was a metaphor used by Kalender in his discussions on the benefits of art in his previous preface to Album B. 408.

Unfortunately, Kalender informs us of neither the sources of the images nor the author of the augury texts. A passage from Evliya Çelebi's account of the parade held in 1638–39 (1048) for the Baghdad campaign of Sultan Murad IV (r. 1623–40) describes an aged fortune-teller, Mehmed Çelebi, the only representative of the guild of diviners who used images (*fālcıyān-ı muṣavvir*). According to Evliya, Mehmed's profession was to recite poetry evoked by the images chosen by his customers in order to provide their omens. Evliya also mentions that the diviner Mehmed was so old that he had practiced his profession even at an audience before Sultan Süleyman (r. 1520–66). This information prompts us to suggest that the augury pictures had been in circulation in Istanbul at least between approximately 1560 and 1630, and that Kalender could have acquired his images in the city.[84] The paintings are the work of different artists who were not directly associated with the metropolitan styles of Safavid or Ottoman painting of the late sixteenth and early seventeenth centuries. However, the first two images of the *Fālnāme* are Ottoman, attributable to Nakşî Bey and Nakkaş Hasan Pasha. Nakşî Bey, of whom we know nothing other than his name and his distinctive style of painting, was probably a member of the palace elite. His painting, to which I shall return shortly, depicts the Persian poet Saʿdi disguised as a Chinese monk visiting a temple. The second painting, which features the expulsion of Adam and Eve from Paradise, reflects the style of another artist-cum-statesman, the aforementioned Nakkaş Hasan Pasha.[85] These artists, active between about 1580 and 1620, contributed significantly to Ottoman court painting, both in terms of style and iconography. Sharing the same milieu, these contemporaries of Kalender were most likely close acquaintances of his, who provided their works as contributions to his volume.

Kalender Pasha thus brought together images that he had probably gathered from various sources with the augury texts, which were contextually and formally related to earlier Persian examples. With the layout of the pages conceived as bi-folios, and the overall arrange-

ment of the volume constructed on rhythmic repetition, the volume recalls the consistent style of his other works. As in those, here he inserts the pages containing images and text within margins dyed brown, pink, dusty rose, or green and illuminated with gold wash. He surrounds the text block with margins within margins, the inner ones decorated on beige paper, the outer ones colored to match those surrounding the images. The first page features an illuminated *tughra* of the sultan signed by Kalender, and is followed by three decorative pages with his typical large *ḥaṭāʾī* and split-palmette compositions, creating a repertoire of designs and motifs in the paper-joining technique (fig. 5). Once again, to complete the volume, Kalender inserts a decorative page that echoes those in the beginning, thus turning the autonomous pairs of pages into one integrated ensemble. Although this volume differs from the others, its preface directly relates to its contents, as is the case in his other works.

The illuminated heading identifies the volume as the Book of Omens of Sultan Ahmed and reconfirms its royal ownership, already suggested by the *tughra* on the first page. Like his preface to Album B. 408, his introduction to the *Fālnāme*, which begins by praising God, also stresses the creation of humankind: "God created the human as the most brilliant and noble creature to enter this world with fortunate beauty (*ferhunde-fāl*), and He has given the image gallery of the universe (*ṣūretḫāne-i kāʾināt*) brightness and purity through humankind by creating him."[86] The terms and adjectives Kalender has chosen to describe God's greatness are implicitly connected to the book's content, which is a compilation of images of Adam and his descendants. The next sentence refers to the divine pen used by God during creation, an allusion frequently used in album prefaces, including Kalender's calligraphy album (H. 2171). "In order to show clear evidence of his oneness, God has increased the adornment and value [of his creation] by inscribing the brightness of the stars on the pages of day and night, using the pen of his omnipotence."[87] Here, the content directly refers to the images and related texts on the celestial sphere, the Sun, and the planets Saturn and Mars.[88]

In the subsequent poem, Kalender indicates that God, who is beautifully perfect (*cemāl-i cemīl*) and adorns everything that exists, and whose wrath (*celāl*) informed the condition of the tribes of Ad and Thamud, led the Earth with His light to a fortunate prophecy. He then notes that "the world resembles, in its meaning, a book in which the conditions of all nations are written line by line. Both fears and desires may be found in this book, on whose leaves are depicted the morning and the night. Hence, if an augury is taken [using the book], the image of the beginning and the end can be seen."[89] With all these references to an illustrated book, Kalender must be implying that his work, which teaches the world a lesson through images, takes its inspiration from the work of God, or that it is a reflection of it. Indeed, the images of the *Fālnāme* contain instructive scenes depicting the condition of many nations; some show fear, others warnings, and all seem to reverberate with the desires and apprehensions of those who consult the *Fālnāme*.

Kalender Pasha then offers his praise and prayers to the Prophet Muhammad and notes that the Prophet took the people to the path of Islam and faith by breaking down the idols of misbelief and sin in the temples of Mecca (*Baṭḥā*) and Medina (*Yeẟrib*).[90] It therefore cannot be a mere coincidence that after a few folios the first painting of the *Fālnāme* (in other words, the opening picture), which is attributed to Nakşî, refers visually to a similar idea (fig. 16). The painting represents the Persian poet Saʿdi, disguised as a Chinese monk, looking at an idol. The augury on the opposite page tells a story taken from Saʿdi's *Būstān*, abridged and altered to a certain extent in order to conform with the image. The story alludes, quite directly, to the false power of idols. During his travels, Saʿdi comes upon a Chinese temple, where he encounters an idol that raises its hand when people rub their faces on its foot. After hiding and observing it from a distance, he discovers how the statue moves and exposes the ruse.[91] The reference in the preface of the *Fālnāme* to the Prophet Muhammad's smashing of the statues of the Arab gods, along with the depiction of a very similar subject in the first painting of the work, once again demonstrates that Kalender conceived of his presentation texts and paintings as a unit; this also points to his conscious attempt to preempt accusations of idolatry.

Kalender Pasha's preoccupation with this matter must have been related to Ahmed I's proclivities and piety, as well as to contemporary events. In the

Fig. 16. Sa'di, disguised as a Chinese monk, from the *Fālnāme*. Topkapı Palace Museum Library, H. 1703, fols. 6b–7a. (Photo: courtesy of the Topkapı Palace Museum Library)

Zübdetü't-Tevārīḫ (Cream of Histories), a chronicle of the reign of Sultan Ahmed I, in a section concerning the sultan's religious sentiments, there is a detailed account of how he personally destroyed the mechanical organ that Elizabeth I of England sent to his father, Mehmed III (r. 1595–1603), because it was unlawful to have moving images around places of prayer. According to the text, which was penned by the sultan's personal imam, Mustafa Safi, the organ contained a clock, and featured birds as well as figures that danced and played musical instruments.[92]

Kalender's preface continues with a poem in praise of the Prophet Muhammad. In it, he refers to the sultan as *Ahmedine'l-Muṣṭafā*, most likely to suggest Sultan Ahmed as a namesake of the Prophet. According to Kalender, "the light upon the candle of his beautiful face is so bright that no one can distinguish his countenance

from that light. Every one of the images of the conditions of the prophets who precede him is a leaf from his maturity."[93] Here, most likely referring to his own work, Kalender continues his poem by saying that "in presenting these images from the lives of the previous prophets, his intention is to reach the Prophet, and to pray for and thank him, his children, his companions, and other holy figures."[94] In other words, Kalender cautiously stresses the function of his images as intermediaries leading the believer to the Prophet, rather than replicating his image, which is not even visible behind the holy light.

Kalender then explains his intention in composing and presenting the *Fālnāme*:

> [Since] ancient times, men of spiritual knowledge and companions of taste and conscience, upon stepping into the world, contemplated the situation of the world with the eye

of learning by analogy, and have confirmed that previous events constitute guiding models for people and that it is possible to draw lessons from the past on every important decision. It is especially necessary for the greatest sultans and kings of exalted rank—who are the source of order for both state and nation and the originators of rules for the foundation of subjects and realm—to observe the deeds of past rulers and the stories of the prophets and saints and to consider their beginnings and ends, in order to compare them with and understand the consequences of their own affairs. For this reason, they ordered that the indications and allusions to events that took place during the reign of past sultans (while they were seated on the throne of felicity) be written and drawn (*taḥrīr*)[95] on pages, so that whichever of those pages is opened through the method of taking an omen, the omen seeker should adapt his/her condition to the circumstances of the prophets and sultans, which have been written or depicted on those pages, and by comparing those with the affairs that s/he desires, should act accordingly.[96]

Kalender concludes this section with a couplet advising the omen seekers to learn from past events in order to increase their own reputation and honor: "if you wish your power and glory to increase, let your gaze always be upon past events."[97] In this passage, Kalender emphasizes the didactic power of images in helping viewers to learn by analogy and guiding them to act properly to achieve their desires, rather than revealing information regarding the future. He also places the tradition of taking omens from pages with word and image in historical context, and, by attributing the practice to past rulers, showcases its longevity and endurance.

Kalender continues, explaining why he presented his royal gift and when and how the sultan seeks an omen using the *Fālnāme*:

> This is why this slave, Kalender, the sultan's humble, most insignificant slave, the least of servants, [who has been] immersed in freedom and benevolence among respected viziers, collected, composed, arranged, and adorned those above-mentioned illustrated pages and leaves, and presented this album as a gift to his imperial seat so that whenever he has a royal wish, or whenever he wants to take an omen, he can seek his augury after reciting the Fatiha (the first chapter of the Koran) once, the Ikhlas (Koran 112) three times, and invoking noble blessings (*ṣalavāt-i şerīf*) [on the Prophet] three times. [Kalender hopes that] when he opens [the volume] in accordance with the above-mentioned manner, the images of the prophets and saints

written on the auspicious right-hand side page (*ṣaḥīfe-i yümnīsinde*)[98] of whichever illustrated and ruled bi-folio his invaluable exalted gaze comes to rest will produce abundant inspirations and blessings to his noble nature, and that his augury will be agreeable to his royal wish, decision, and consultation.[99]

Kalender completes his preface with a verse prayer to the sultan, wishing him an auspicious omen. He describes the heavens as consisting of pages (*ṣaḥīfe-i felek*) on which the Sun draws a line (*cedvel*) on the horizon with the ground vermillion of dawn every morning, and thereby transforms the celestial spheres into a book.[100] He thus draws a parallel between his own book and the description of nature. Similarly, in wishing for the entire world to transform itself into a book and for the sultan of the world's fortune to be auspicious in it, he may be implying that his own book encapsulates the world.

KALENDER'S PAGES IN NEW CONTEXTS: ALBUM B. 409 AND THE BELLINI ALBUM

While this article has focused on Kalender's albums with prefaces, it is worthwhile to include two others containing folios attributable to him.

The first is an album of calligraphy housed in the Topkapı Palace Library (B. 409). Similar to his other albums, the forty-eight folios in this one measure 49 by 34 centimeters, and closely relate to those in Album H. 2171 in both content and style. It retains its original binding, which is virtually identical to that of Ahmed I's album (B. 408), suggesting that it, too, may have been executed by Kalender. The layout of the pages with their illuminated margins is also indicative of Kalender's style (figs. 17 and 18). The album does not, however, include a preface, and an elaborate inscription on fol. 2a states that it is dedicated to Ahmed I's son, Sultan Osman II (r. 1618–22), who was enthroned two years after Kalender's death. The dedicatory inscription is followed by a *qaṣīda* addressed to Sultan Osman and written by a poet with the pen name of Melihî (fols. 2b–3b). These and several other folios feature marginal decoration in Kalender's style, but with slightly lighter colored papers that have been burnished to a high sheen. The differences between these papers and the rest in the album suggest that they were probably inserted into the

Fig. 17.　Two pages from a calligraphy album. Topkapı Museum Palace Library, B. 409, fols. 13b–14a. (Photo: courtesy of the Topkapı Palace Museum Library)

Fig. 18.　Two pages from a calligraphy album. Topkapı Palace Museum Library, B. 409, fols. 40b–41a. (Photo: courtesy of the Topkapı Palace Museum Library)

volume at a later time. Certainly this album might have been compiled during the reign of Osman, since, in contrast with the frames including small pieces of paper, neither the marginal decorations nor the plain frames of paper strips surrounding the specimens were created by Kalender exclusively. However, it is tempting to speculate that Kalender initially produced this album as a gift for the aforementioned el-Hacc Mustafa Agha, the powerful chief black eunuch during the reigns of Ahmed I and Osman II. Since Mustafa Agha was one of Kalender's strongest supporters and played a key role in his appointment as the building supervisor of the sultan's mosque, Kalender, to thank to him, may have presented him with a calligraphy album whose content and design were similar to the one he had assembled and presented to the sultan for the very same reason (i.e., H. 2171). With many works by the same calligraphers featured in the album assembled for Ahmed I, the proposed Mustafa Agha compilation represents a more modest version of the former: the borders, which in Ahmed I's album are composed of small pieces of papers, are replaced here with strips, which are either plain, gold sprinkled, or colored and decorated in gold wash; these were attached to each other through the craft of *vaṣl*. In 1618, when Osman acceded to the throne, Mustafa Agha might have in turn offered it to Osman II, with a dedicatory inscription and *qaṣīda*, and a number of new folios.

Mustafa Agha was an active member of the palace faction that, only three months after the death of Ahmed I, dethroned his brother Mustafa I in favor of Osman II.[101] As an important courtier, Mustafa Agha presented other illustrated manuscripts to Osman, such as a Turkish version of Firdawsi's *Shāhnāma*, translated or rewritten by the court storyteller Medhî (d. after 1620). The agha's patronage in the translation and illustration of the text is documented in Medhî's preface to the Turkish *Shāhnāma*, as well as in the frontispiece painting, which depicts him presenting the book to the sultan.[102] The illustrations of the manuscript are attributable to Nakşî, who also contributed a painting to the *Fālnāme*, thus indicating the agha's continuing association with an artistic milieu that also included Kalender.

The second compilation with folios most probably designed by Kalender is in New York, at the Metropolitan Museum of Art (67.266.7). Generally known as the

Bellini Album, it measures 46 by 34 centimeters, and includes Ottoman, Persian, and European calligraphies and images.[103] The folios belong to a larger compilation that the Swedish collector and dealer Fredrik R. Martin purchased in Istanbul at the turn of the twentieth century.[104] In his 1912 publication, Martin maintained that the album included a painting of a Turkish prince by Gentile Bellini, to which it owes its name. He noted that he had purchased the "Bellini Album," which was a larger collection in its original form and included "a large number of uninteresting European engravings," from the son of an Ottoman dignitary.[105] Martin attributed the album to about 1600 and believed it was made for Ahmed I, which seems accurate on the basis of some of the folios in the Metropolitan Museum album. The former Ottoman owner may have informed Martin of the album's date, which in turn suggests that Kalender's designs for Ahmed I may have still been recognizable to Ottoman connoisseurs. Five folios feature Kalender's large margins with gold wash decoration and borders around the *qiṭ'a*s made of small pieces of multicolored papers. Their stylistic affinity to examples in two of Kalender's other albums (H. 2171 and B. 408) allows us to attribute some of the Metropolitan Museum folios to him. The majority of these folios include Dutch, Italian, French, and Polish engravings depicting devotional and mythological scenes. One, set in borders decorated with small squares and diagonally placed rectangles of paper, is dedicated to *Andrea di Prochnik* (fig. 19). Jan Andrej Próchniki was the Bishop of Kamieniec (1607–14) and Archbishop of Łwów (1614–33). The inscription identifying him as *Episcopo Camanecen* confirms an attribution to the first decade of the seventeenth century, and thus to the reign of Sultan Ahmed I.

Another folio features full-page decorations composed of cut papers joined according to the *vaṣl* technique on both the recto and verso sides. In their style and technique, these compositions recall Kalender's decorative pages, in particular the ones he used in the *Fālnāme* (figs. 6 and 5).[106] The high quality of these six pages suggests that they were designed by Kalender for Ahmed I, and the prints could have belonged to the sultan's collection. Since the binding of Ahmed I's album was restored at an unknown time, these folios may even have been extracted from B. 408, and as a group of European works, they may have been offered for sale to an

Fig. 19. A page with a European engraving from the so-called Bellini Album. The Metropolitan Museum of Art, Louis V. Bell Fund, 1967 (67.266.7.2r) © 2013. Image copyright Metropolitan Museum of Art/Art Resource/Scala, Florence.

avid European collector, such as Martin. Alternatively, these folios could also have come from another album no longer extant in its original form, which was compiled by Kalender for the sultan.

CONCLUSION

Undoubtedly, archival documents will contribute to our understanding of the life and career of Kalender Pasha, who rose from the rank of court herald to that of vizier and was entrusted by Sultan Ahmed I with his treasury and the expenses of his mosque. On the basis of his works, the statements made by others, and his own words, Kalender was not only a highly capable and loyal official but also a multitalented artist, collector, and connoisseur.

Kalender's extant works demonstrate his extraordinary creativity as a *vaṣṣal*, illuminator, and bookbinder.

His prolific artistic accomplishments went beyond that of a pastime of a talented official at the Ottoman court. As recorded by Mustafa 'Âli, Kalender's fame as a *vaṣṣal* can be traced back at least to the last decade of the sixteenth century. His skills also earned him the favor and patronage of Sultan Ahmed, who was known for his own interest in albums. Their common passion for the arts of the book must have allowed the sultan and Kalender to forge a strong bond, which in turn resulted in the production of three innovative albums by the artist.

The numerous Timurid, Turkmen, Safavid, and Ottoman albums in the royal collection demonstrate the Ottoman enthusiasm for this genre. Beginning with the earliest examples, albums compiled for the court include works of different provenance. The preponderance of calligraphies, drawings, and paintings of Safavid provenance in these albums shows that Ottoman patrons embraced and recognized these works as part of a shared artistic taste. Kalender's three albums also suggest an appreciation of Safavid works, which must have served him as a source of inspiration. In his capacity as a distinguished and enthusiastic courtier, Kalender probably had ready access to the royal collection of Safavid albums. His innovative style and technique in decorating the works he compiled, however, lent them a distinct Ottoman quality, transforming them into original interpretations of an established artistic tradition.

Not only did Timurid and Safavid inspirations shape Kalender's visual vocabulary, but his texts also drew upon Persian prefaces. The album prefaces, as well as the text of the *Fālnāme*, however, differ from their Persian counterparts both in language and content. Kalender's albums with prefaces are also highly unusual within the Ottoman tradition. Except for one, which is an identical copy of a Persian preface originally written in 1494, there exists, to my knowledge, no other Ottoman album with a preface.[107] Kalender's keenness for including prefaces in all his works must have been related to his personal artistic and theoretical approach to the arts. This attitude is echoed in the contents of the prefaces, as each one highlights a different aspect of the art of the book and the art of collecting.

Department of Art History,
Hacettepe University, Ankara

APPENDIX I: PREFACE TO THE CALLIGRAPHY ALBUM, H. 2171, FOLS. 17B–23B, TOPKAPI PALACE MUSEUM LIBRARY

A. Facsimile of H. 2171, fols. 17b–23b

(Photos: courtesy of the Topkapı Palace Museum Library)

Calligraphy Album, H. 2171, fol. 17b.

Calligraphy Album, H. 2171, fol. 18a.

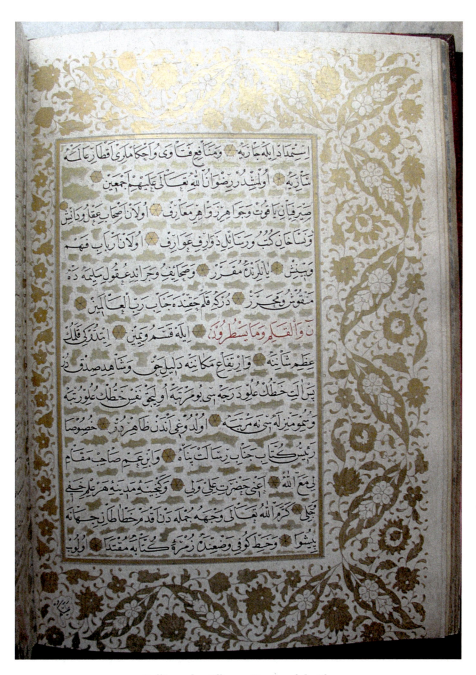

Calligraphy Album, H. 2171, fol. 18b.

Calligraphy Album, H. 2171, fol. 19a.

Calligraphy Album, H. 2171, fol. 19b.

Calligraphy Album, H. 2171, fol. 20a.

Calligraphy Album, H. 2171, fol. 20b.

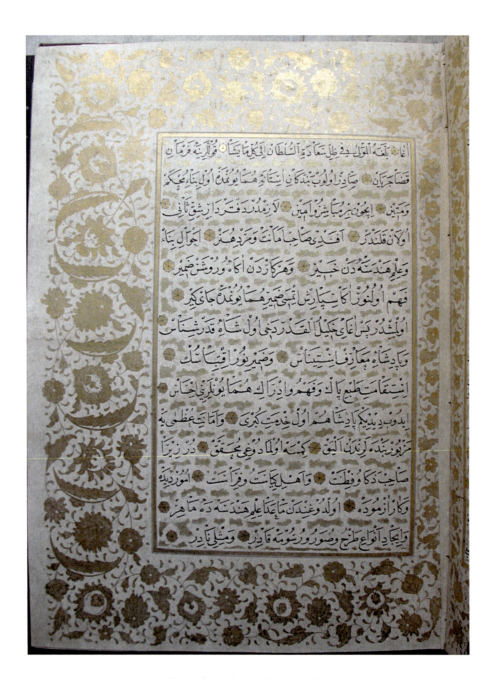

Calligraphy Album, H. 2171, fol. 21a.

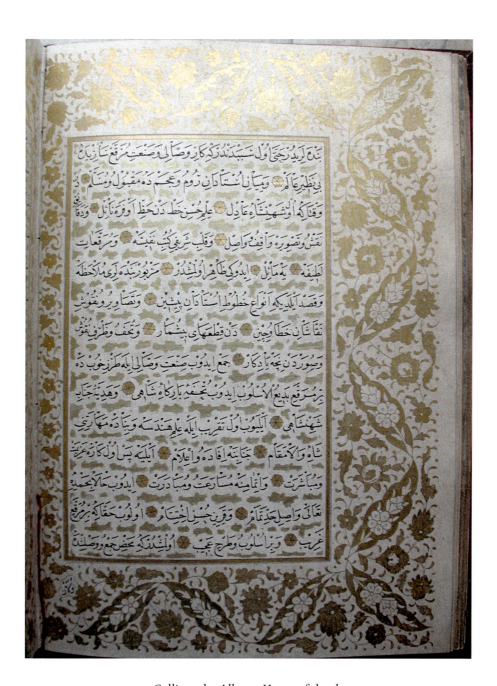

Calligraphy Album, H. 2171, fol. 21b.

Calligraphy Album, H. 2171, fol. 22a.

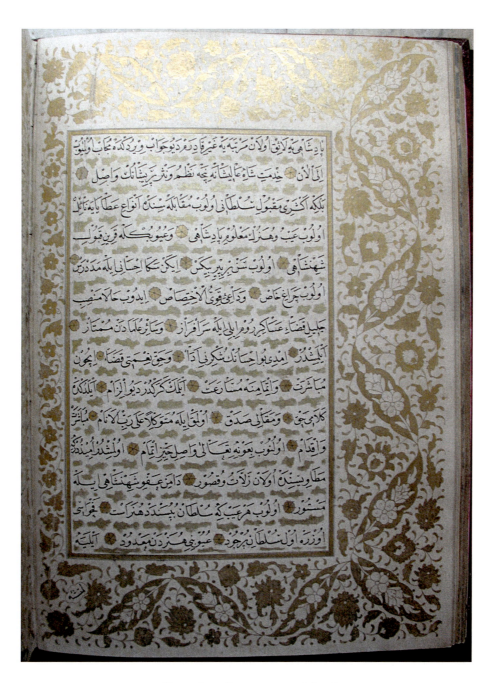

Calligraphy Album, H. 2171, fol. 22b.

Calligraphy Album, H. 2171, fol. 23a.

Calligraphy Album, H. 2171, fol. 23b.

APPENDIX I

B. Transliteration of the Preface to the Calligraphy Album, H. 2171 (fols. 17b–23b), by Wheeler M. Thackston

Ḥamd-i nāmaʿdūd ve şükr-i nāmaḥdūd ol mālikü'l-vücūd cenābına lāyıḳ u sezādur ki īcād-ı ʿālem ve ḫalḳ-ı ṭavāʾif-i ümem ḥuṣūṣan zümre-i benī-Ādeme irādet-i ʿaliyye ve meşiyyet-i ezeliyyesi taʿalluḳ edüp evvelā ber-muḳtezā-yı *awwalu mā ḫalaḳa 'llāhu 'l-ḳalam* ḳalemi ḫalḳ u ibdāʿ ve cemʿ-i *mā kān ve mā sa-yakūn* aḥvālini anda īdāʿ (beyt)

*Harçi būdast u hast u ḫwāhad būd * sabt farmūda dar ṣaḥīfa-i cūd*

feḥvāsınca cenāb-ı ilāhīden emr ü işāret ile ṣaḥīfe-i levḥ-i maḥfūẓ üzere kitābet edüp ol ṣaḥīfe-i laṭīfeyi evrāḳ u aṭbāḳ-ı eflāke ilṣāḳ ve vaṣl u ilzāḳ edüp pertev-i envār-ı āfītāb-ı ʿālemtāb ile mücellā ve elvān-ı ġarībe ve nuḳūş u eşkāl-i ʿacībe-i nücūm-ı zāhire ile [18a] müzeyyen u muḥallā bir muraḳḳaʿ-ı zıba ve cerīde-i ṣafā-efzā olmışdur ki ʿuḳūl-ı naḳḳāşān-ı cihān resmini iḥāṭada ḥayrān ve hezārān Mānī vü Bihzād naẓīrini naḳş ü taṣvīrde ʿāciz ü sergerdān olmışdur.

Ve dürūd-ı ḥuceste-vürūd ol ṣāḥib-i ḥavż-ı mevrūd ve mecmūʿ-ı ʿāleme ʿillet-i ġāʾiyye-i vücūd olan ḥabīb-i ḥudā aʿnī ḥażret-i Muṣṭafāʾya ihdāʿ olunur ki ol hengām-ı nüzūl-ı vaḥy-ı rabbānī ve naẓm-ı muʿciz-beyān-ı tenzīl-i āsmānī vāḳıʿ olduḳda *iḳraʾ wa-rabbuka 'l-akramu 'llaẕī ʿallama bi'l-ḳalami ʿallama 'l-insāna mā lam yaʿlam* kelām-ı şerīfi nāzil ve ḳalb-i cenān-ı Muḥammadīʾye vāṣıl olup ber-muḳtezā-yı feḥvā-yı *hal yastawī 'llaẕīna yaʿlamūna wa-'llaẕīna lā yaʿlamūna* eşref-i ṭavāyif-i benī Ādem olan ʿulemānuñ ālet-i kesb-i ʿulūmları ḳalem idügi zāhir u müsellem olmıştur *ṣalla 'llāhu ʿalayhi wa-sallam* ve daḫı zümre-i āl ü aṣḥāb ve firḳa-ı etbāʿ u aḥbāb daḫı ol ṣalāt-ı saʿādet-medārdan ḥiṣṣe-dār olalar ki aḳlām-ı ʿulemāʾ-ı aʿlām anlaruñ midād-ı ictihādlarından [18b] istimdād ile cāriye ve menāfiʿ-i fetāvā vü aḥkāmları aḳṭār-ı ʿāleme sāriye olmıştur *riḍwānu 'llāhi taʿālā ʿalayhim acmaʿīn.*

Ṣayrafiyān-ı yāḳūt u cevāhir-i zevāhir-i maʿārif olan aṣḥāb-ı ʿaḳl u dāniş ve nessāḫān-ı kütüb ü resāʾil-i zevārif-i ʿavārif olan erbāb-ı fehm ü bīniş yanlarında muḳarrer, ve ṣaḥāʾif ü cerāʾid-i ʿuḳūl-ı selīmede menḳūş u muḥarrerdür ki ḳalem ḥaḳḳında cenāb-ı rabbiʾl-ʿālemīn *nūn wa'l-ḳalami wa-mā yasṭurūna* ile ḳasem ü yemīn ittügi ḳalemüñ ʿiẓam-ı şānına ve irtifāʿ-ı mekānına delīl-i ḥaḳḳ ve şāhid-i ṣıdḳtur. Pes ālet-i ḫaṭṭuñ ʿulüvv-i derecesi bu mertebe olıcaḳ nefs-i ḫaṭṭuñ ʿuluvv-i rütbe ve sümüvv-i menzilesi ne mertebe olduğı andan ẓāhirdür, ḥuṣūṣen reʾīsüʾl-küttāb-ı cenāb-ı risālet-penāh ve ibn-i ʿamm-ı ṣāḥib-maḳām-ı *lī maʿa 'llāh,* aʿnī ḥażret-i ʿAlī-yi velī ve gencīne-i medīne-i her-ʿilm-i ḫafī vü celī *karrama 'llāhu wachahu* cümleden aḳdem ḫaṭṭāṭān-ı cihāna pīşvā ve ḫaṭṭ-ı kūfī vażʿında zümre-i küttāba muḳtedā olup [19a] *ʿalaykum bi-ḥusni 'l-ḫaṭṭi fa-innahu min mafātīḥi 'r-rizḳ* dimekle ḫaṭṭ-ı ḫūb miyān-ı ʿālemiyānda maḳbūl u merġūb olup miftāḥ-ı rızḳ u rūzī ve sebeb-i ḥuṣūl-ı envāʿ-ı niʿam-ı şebānrūzī olmasına işāret ve taḥṣīline taḥrīż u delālet buyurmıştur. Nitekim vaṣf-ı ḥüsn-i ḫaṭṭa demişlerdür, *khaṭṭ ke az shāʾibeh-i husn tahīst * bahre-i kāğhıd azū rū-siyahest* ol sebebden üstādān-ı pīşīn ve ḫaṭṭāṭān-ı müteḳaddimīn ḫuṭūṭ-ı gūnāgūn ibdāʿ ve ṣuver-i ḥurūfda envāʿ-ı şekl-i ḫūb ve mevzūn iḫtirāʿ edüp mānend-i ṣūret-i efrād-ı insān her birinde bir ḥüsn-i maḥṣūṣ ve şān u ān ẓāhir ü nümāyān olup neẓẓāresinde dīde-i erbāb-ı maʿārif rūşen ve temāşāsında ḫāṭır-ı merd-i ʿārif şād u şen olur. Ve li-hāẕā üstādān-ı cihān kitābet ittükleri evrāḳ-ı laṭīfe vü ḫuṭūṭ-ı nefīse-i naẓīfe teḳālīb-i leyl ü nehār ve mürūr-ı eyyām-ı rūzgār ile mānend-i berg-i ḫazān pejmürde vü perīşān ve bī-nām u nişān olmayup ṣaḥīfe-i ʿālemde bāḳī ve tündbād-ı ḥavādisden ḥāfıẓ u vāḳī [19b] olmaḳ içün baʿż-ı üstādān-ı muraḳḳaʿ-sāzān ol ḳıṭʿahā-yı ḫūbī ki her biri mānend-i cüvān-ı ḫaṭṭ-āverde-i maḥbūbdur ṣayd u taḥṣīle ṭālib ve cemʿ ü vaṣlına rāġıb olup envāʿ-ı mecālis-i tertīb ü tezyīn ve naḳş ü nigār-ı ḫalkārī ile mānend-i mecālis-i ḫuld-ı berīn idüp tuḥfe-i mecālis-i selāṭīn ve revnaḳ-baḫş-ı kütübḫāne-i pādişāh-ı ʿadālet-āyīn ede gelmişlerdür. *Bi-ḥamdihi taʿālā* ḥālā pādişāh-ı rubʿ-ı meskūn ve şehinşāh-ı sükkān-ı zīr-i çarḫ-ı nīlgūn ʿulemā vü ṣulehāya ve fuḳarā vü żüʿafāya meded-resān müm-tesil-i emr-i *inna 'llāha yaʾmuru bi'l-ʿadli wa'l-iḥsān*

sulṭān-ı gerdūn-vekār hem-nām-ı ḥażret-i Aḥmed-i
muḫtār şāh-ı Sikender-ṣavlet [ve] ḫākān-ı Ferīdūn-
ḥaşmet zıllullāhi teʿālā fi'l-arż mālik-i ekālīm-i basīṭi'l-
ġabrā bi'ṭ-ṭūl ve'l-ʿarż faḫr-i dūdmān-ı āl-i ʿOsmān
es-sulṭān ibn üs-sulṭān es-sulṭān Aḥmed Ḫān ibnü's-
sulṭāni'l-ġāzī ü'l-mücāhid fi'l-meʿārik ve'l-meġāzī
Meḥemmed Ḫān ibni's-sulṭān Murād Ḫān ibni's-sulṭān
Selīm Ḫān ibni's-sulṭān Süleymān Ḫān (ayyada 'llāhu
taʿālā ayyāma dawlatihi [20a] 'l-ḳāhira wa-anāra
'l-ʿālamīna bi-shumūsi salṭanatihi 'z-zāhiri mā dāmati
'l-aflāku dā'iratan wa-ʿuyūnu nucūmi's-samā'i sāhiratan)

Li-münşi'ihi'l-faḳīr:

Ḥalḳ olaldan bu gümbed-i devvār * geşt eder kā'inātı leyl
 ü nehār.
Gözlerini açup nücūm-ı semā * şarḳ u ġarbı olupdurur
 seyyār.
Görmedi böyle bir şeh-i ʿādil * kim ide sāyesinde ḥalḳ
 ḳarār.
Kārı her dem ʿibādet ü ṭāʿat * fikri dā'im niẓām-ı mülk
 ü diyār.
Devlet ü dīni eyledi tecdīd * oldı maʿmūr cümle-i aḳṭār.
Maraż-ı ẓulm ile mizāc-ı cihān * ḥaste olup iderken āhla
 zār.
Anı defʿ etti ol şeh-i ʿādil * şerbet-i ʿadl ile idüp tīmār.
Cümle şāhān olup aña bende * ḳulı olmaġa ettiler iḳrār.
Verdi aña ḫarāc şāh-ı ʿacem * oldı kemter ġulāmı ḫān-ı
 tātār.
Böyle ḳuvvet bu deñlü şevket ü cāh * nice dehr oldı
 görmedi ebṣār.
Cümlenüñ bāʿis ʿadālettür * kim o şeh anı eyledi iẓhār.
Böyle şāhı ḫudā ide bāḳī * ola baḫtı güşāde vü bīdār.
 [20b]

Vaḳtā ki ol şāh-ı ʿādil ve sulṭān-ı bīnaẓīr ü muʿādil mā'il-i
cumʿa vü cemāʿat ve rāġıb-ı ʿibādāt u ṭāʿāt ve ʿāzim-i
eṣnāf-ı ḥayrāt u müberrāt oldı ise şehrüñ bir cāy-ı
feraḥfezāsında bir cāmiʿ-i behişt-āsā bināsına şürūʿ vü
niyyet ve sürʿat-i itmāmına ʿazīmet idüp bir binā'-ı ʿālīye
mübāşeret eylemişdür ki ṭarz-ı ḥūb-ı bedīʿu'l-üslūbını
mülāḥaẓada ʿuḳūl-i miʿmārān-ı cihān ve ṭarḥ-ı maṭbūʿ
u merġūbını resm ü taṣvīrde efkār-ı mühendisān-ı
cihān ʿāciz ü sergerdāndur bu daḫi ol şāh-ı Cem-cāh
ḥaẓretine maḥż-ı ilhām-ı rabbānī ve feyż-i sübḥānīdür
ki gūyā ḳuṣūr-ı cināndan bir ḳaṣr-ı ʿālīnüñ taṣvīr-i
dilpezīri āyīne-i taṣavvur-ı şāh-ı bīnaẓīrde rūnümā
vü cilveger olup ol ṭarḥa muvāfıḳ ve ol üslūb-ı bedīʿe
muṭābıḳ binā' olınmışdur. Vaḳtā ki bu re'y-i sedīd ḫāṭır-ı
feyż-meʿāsir-i şāh-ı cihānda ẓāhir ü bedīd oldı ṣāḥib-i

fikr-i sāḳib ve ṭabʿ-ı vaḳḳād ve ṣarrāf-ı cevāhir-i ʿuḳūl-i
merdümān-ı naḳḳād olan maḳbūl-i bārgāh-ı sulṭānī ve
ḫāzin-i esrār-ı cihānbānī muʿtemidü'd-devleti'l-ʿaliyye
ve muʿtaḳidü'l-ḥażreti'l-behiyye, aʿnī aġa-yı Dārü's-
Saʿāde el-ḥācc Muṣṭafā [21a] Aġā (ballaghahu 'l-mawlā
fī ẓilli saʿādati 's-sulṭān ilā kulli mā yaşā') ḳullarına
fermān-ı ḳażā-cereyān ṣādır olup bendegān-ı āsitāne-i
hümāyūnumda ol binā'-ı muḥkem ü metīn içün bir
mübāşir ü emīn lāzımdur. Defterdār-ı şıḳḳ-ı sānī olan
Kalender Efendī ṣāḥib-emānet vü merd-i hüner aḥvāl-i
binā vü ʿilm-i hendeseden ḫabīr ve her kārdan āgāh
u rūşen-ẓamīr fehm olunur aña sipāriş etmesi żamīr-i
hümāyūnumda cāygīr olmışdur. Pes Āġā-yı celīlü'l-ḳadr
daḫi ol şāh-ı ḳadrşinās ve pādişāh-ı maʿārif-istīnās ü
żamīr-i nūr-iḳtibāsuñ istiḳāmet-i ṭabʿ-i pāk vü fehm u
idrāk-i hümāyūnlarını iḥsās idüp dedi kim "Pādişāhum,
ol ḫıdmet-i kübrā vü emānet-i uẓmāya mezbūr bende-
lerinden elyaḳ kimse olmaduġı muḥaḳḳaḳdur zīrā
ṣāḥib-ẓekā vü fıṭnat ve ehl-i kiyāset ü firāset umūr-dīde
ve kār-āzmūde olduġından māʿadā ʿilm-i hendesede
māhir ve īcād-ı envāʿ-ı ṭarḥ u ṣuver u rüsūma ḳādir ve
misli nādir [21b] benderīdür ḥattā ol sebebdendür
ki kār-ı vaṣṣāli ve ṣanʿat-ı muraḳḳaʿ-sāzīde bīnaẓīr-i
ʿālem ve miyān-ı üstādān-ı Rūm u ʿAcem'de maḳbūl ü
müsellemdür." Vaḳtā ki ol şehinşāh-ı ʿādil ʿilm-i ḥüsn-i
ḫaṭdan ḥaẓẓ-ı evfere nā'il ve deḳā'iḳ-i naḳş u taṣvīre vāḳıf
u vāṣıl ve ḳalb-i şerīfi kütüb-i nefīse vü muraḳḳaʿāt-ı
laṭīfeye mā'il idügi ẓāhir olmışdur mezbūr bendeleri
mülāḥaẓa vü ḳaṣd eyledi ki envāʿ-ı ḫuṭūṭ-ı üstādān-ı
pīşīn ve teşāvīr ü nuḳūş-ı naḳḳāşān-ı Ḫaṭā vü Çīn'den
ḳıṭaḥā-yı bīşümār ve tuḥaf u ẓarf-ı nuḳūş u ṣuverden
nice yādigār cemʿ idüp ṣanʿat-i vaṣṣāli ile ṭarz-ı ḥūbda
bir muraḳḳaʿ-ı bedīʿu'l-üslūb idüp tuḥfe-i bārgāh-ı şāhī
ve hediyye-i cenāb-ı şehinşāhī eyleyüp ol taḳrīb ile
ʿilm-i hendese ve binā'da mehāretini şāh-ı vālā-maḳām
cenābına ifāde vü iʿlām eyleye. Pes ol kāra ʿazīmet ü
mübāşeret ve itmāmına müsāraʿat u mübāderet edüp
ḥālā bi-ḥamdihi teʿālā vāṣıl-ı ḥadd-i tamām ve ḳarīn-i
ḥüsn-i iḫtitām olup ḥaḳḳā ki bir muraḳḳaʿ-ı ġarīb ve bir
üslūb u ṭarḥ-ı ʿacīb olmışdur ki maḥż-ı cemʿ ü vaṣlında
[22a] olan ṣanāyiʿde ʿuḳūl-i üstādān ʿāciz ü ḥayrān
olmaḳ muḳarrerdür. Ve bi'l-cümle ol pādişāh-ı gerdūn-
penāh cenābına ithāf olınmaġa lā'yıḳ ve ḳalb-i nāzük
ü ṣāf ve ṭabʿ-i müşikāflarına muvāfıḳ bir kitāb-ı ḥūb
pesendīde-üslūb olmışdur ki ḳavāʿid-i ḫaṭṭına naẓar
olunsa ṣanʿat-ı üstādān-ı selefden ḫaber virür bir kitāb-ı

muṣannaʿ u ḫūbdur ve leṭāfet-i naḳş u nigārına baḳılsa
gūyā envāʿ-ı libās-ı münaḳḳaş ve ḥilye vü cevāhir-i dilkeş
ile müzeyyen ü muḥallā bir nigār-ı maḥbūbdur ṣanʿat-ı
vaṣṣālīsi bir kārdur ki neẓāre muḥayyer-efkār olup her
görenler (beyt)

*Böyle ṭarḥı nice fikr idüp getürdi yādına * şud hezārān
āferīn ol ṣanʿatuñ üstādına.*

diyüp envāʿ-ı taḥsīn ile hezārān āferīn dirler. Vaḳtā
ki mezbūr bendeleri ol ḫıdmeti itmām ve ol ṣanʿatda
mehāretini iẓhārda ihtimām eyledi, bir dībāce inşā edüp
muraḳḳaʿı vaṣf ve bāʿiṣ-i kār olan cenāb-ı ḫudāvendigārı
medḥ u taʿrīf ḫıdmetini bu ʿabd-i żaʿīfe teklīf idüp bu
faḳīr daḫı beyān-ı ʿöẕr u taḳṣīr edüp "Fenn-i şiʿr ü inşāda
rācil ü ḳāṣir ve ḫıdmet-i [22b] pādişāhīye lāʾıḳ olan
mertebeye ġayr-i ḳādirem" diyü cevāb virdükte mücāb
olmayup "İleʾl-ān ḫıdmet-i şāh-ı ʿālīşāna niçe naẓm u
neṣr-i perīşānuñ vāṣıl belki ekṣeri maḳbūl-ı sulṭānī olup
muḳābelesinde envāʿ-ı ʿaṭāyāya nāʾil olup ʿayb u
hünerüñ maʿlūm-ı pādişāhī ve ʿuyūbuñla ḳarīn-i ḳabūl-i
şehinşāhī olup sen bir pīr-i bīkes iken saña iḥsānı ile
meded-res olup çerāġ-ı ḫāṣṣ ve dāʿī-i ḳaviyyüʾl-iḫtiṣāṣ
idüp ḥālā manṣıb-ı celīl-i ḳażāʾ-ı ʿasākir-i Rūm ili ile
serefrāz ve sāʾir ʿulemādan mümtāz eylemişdür imdi bu
iḥsānuñ şükrini edā ve ḥaḳḳ-ı niʿmeti ḳażāʾ için
mübāşeret ve itmāmına müsāraʿat eylemek gerektür"
diyü ilzām eyledükte kelāmı ḥaḳḳ ve maḳāli ṣadaḳ
olmaḳ ile *mutawakkilan ʿalā rabbiʾl-anām* mübāşeret ve
iḳdām olunup *bi-ʿawnihi taʿālā* vāṣıl-ı ḥayz-i itmām
olmışdur. Ümmīddür ki maṭāvīsinde olan zellāt u ḳuṣūr
dāmen-i ʿafv-i şehinşāhī ile mestūr olup *har ʿayb ki
sulṭān bupusandad hunar ast* faḥvāsı üzre ol sulṭān-ı
pür-cūd ʿuyūbını hünerden maʿdūd eyleye [23a]

Li-munşiʾihi ʾl-faḳīr
Ey Kemālī, çü neṣr-i dībāce * ʿavn-ı Ḥaḳḳile buldı pāyānı.

Rişte-i saṭra naẓma saʿy eyle * ʿaḳd-i dürr-i duʿā-yı
sulṭānī.
İbtidāsı çü ḥamd-i Ḥaḳḳ oldı * āḫiri ola medḥ-i ḫāḳānī.
Medḥ idüp ʿadd iderdüm evṣāfın * ḥaṣra ḳābil olaydı
iḥsānı.
Budur icmāli kim o şāh-ı cihān * aña delīl içre yoḳdurur
ṣānī.
Oldı bu dūdmān içinde o şāh * behcet-efzā-yı nesl-i
ʿoṣmānī.
İtti iḥyā vücūd-ı dünyāyı * şimdi oldur bu ʿālemüñ cānı.
Bendesi olmaġile faḫr eyler * Mekke eşrāfı vü Kırım
ḫānı.
Ḳosa bir şeh işigine başın * geçer ol demde başı keyvānı.
Yā ilāhī, ol şāh-ı pür-cūduñ * cümle āfetten ol nigehbānı.
Müddet-i ʿömr-i Nūḥʾa vāṣıl ḳıl * devletiyle o şāh-ı
devrānı.
Eyle ṣābit o rükn-i islāmı * ṣābit oldukça dehrüñ erkānı.
[23b]

Tā ki nesāyim-i nefeḥāt-i ilāhī ve şemāyim-i fütūḥāt-i
nāmütenāhī mehebb-i ġaybdan mütenessim ve şevā-
riḳ-ı envār-ı ʿināyāt-ı ezelī maṭlaʿ-ı lā-reybden müte-
bessim ola pādişāh-ı gerdūn-vaḳāruñ ṭavāliʿ-i devlet ü
iḳbāli ufḳ-ı teʾyīdāt-ı raḥmānīden raḫşān u fürūzān ve
levāmiʿ-i ʿizz u iclāli tutuḳ-ı ʿināyāt-ı rabbānīden tābān u
dıraḫşān olup saʿādet-i simāṭ-ı mekārim-ṣıfātları serīr-i
salṭanat-ı cihānbānī ve sedīr-i celālet-i cāvidānī üzre
celīs idüp türāb-ı bāb-ı ʿatebe-i refīʿüʾl-cenābları mercīʿ-i
meʾāb-ı selāṭīn-i kāmgārān ve südde-i seniyyeleri melceʾ
ü melāẕ-i fiʾe-i erbāb-ı ḥavāḳīn-i nāmdārān olmadan
ḫālī olmaya, āmīn bi-ḥürmet-i seyyidiʾl-mürselīn
Muḥammedin Muṣṭafā (*ṣallā ʾllāhu ʿalayhi wa-sallam*).

İdeli devlet ile taḫta cülūs * oldı aʿdā ḥużūrdan meʾyūs.
Sāye-i ʿadli olalı memdūd * oldı dervāze-i fiten mescūd.
Reşeḥāt-ı seḥāb-ı iḥsānı * eyledi tāze gülşen-i cānı.
Ola ʿömr ü saʿādet-i şeh-i dīn * cāvidān rūz-ı ḥaşra dek
āmīn.

APPENDIX I

C. Translation of the Preface to the Calligraphy Album, H. 2171 (fols. 17b–23b), by Wheeler M. Thackston

Innumerable praises and unlimited thanks are appropriate for that possessor of existence through whose exalted and eternal will the universe and all peoples were brought into being, especially the best of the children of Adam, by first creating the pen in accordance with the dictum, "The first thing God created was the pen," and by placing therein "all that was and would be." According to the line,

All that has been and is and will be was recorded on the page of goodness,

by divine command it wrote on the page of the Preserved Tablet, and by joining that subtle page to the folios and layers of the celestial spheres, with rays of light from the world-illuminating sun, [such] a beautiful album and pleasure-increasing book, adorned with such strange colors and amazing designs of stars, came into being [18a] that the minds of this world's painter-designers are dumbfounded in comprehending its design and myriads of Manis and Bihzads are stymied in depicting its like.

Praise be given to him who is the final goal of the existence of the universe, the beloved of God, namely the Chosen One, His Highness Mustafa (i.e., the Prophet Muhammad) who, when divine inspiration and inimitable scripture descended from heaven, to his heart came the words, "Recite, for your Lord is the most generous, who taught by the pen, taught mankind what he knew not," and the instrument of acquisition of knowledge for the learned, who are the most noble of all nations of human beings in accordance with the words, "Are they who know equal to them who know not?" is clearly the pen. So also may the best of his house and companions, followers, and devotees share in those prayers, for the pens of the learned are aided by the ink of their endeavors [18b] and their beneficial decisions and commands go to all parts of the world. God's contentment be with them all.

It is established by people of reason and knowledge, who are assessors of gems and jewels of learning, and by people of understanding and insight, who are copiers of books and treatises of erudition, and it is engraved and written on pages of sound minds that, with regard to the pen, the fact that the Lord of all worlds has sworn "by the pen and what they write" is true evidence and proof of the greatness and loftiness of the status of the pen. Therefore, the rank of the instrument of writing being at this level, it is clear at what exalted level writing itself is, especially since the chief of all writers of the prophetic excellency and cousin, he who stood at the station of *li ma'a 'llah,* i.e., His Excellency 'Ali, saint and treasury of the city of every knowledge visible and invisible (may God ennoble his countenance), the foremost of all the calligraphers of the world and leader of all scribes in establishing the Kufic script, [19a] by saying, "Have good writing, for it is among the keys of sustenance," indicated that beautiful writing was esteemed and desirable among the people of the world and that it was the key to livelihood and a cause for obtaining all sorts of good things, and he encouraged its acquisition. In fact, because they have described beautiful writing as "When writing is devoid of the gray hair of beauty / The paper gains from it only the blackness of shame," past masters and calligraphers have created various scripts and invented beautiful and harmonious forms for the shapes of letters, and, just like the forms of human beings, there is a special beauty and glory in each of them, which delights the eye of connoisseurs who gaze at them, and induces joy in the minds of experts who contemplate them. Therefore, in order to protect and guard graceful pages and exquisite writings produced by masters of the world of calligraphy from the maelstrom of the vicissitudes of time, lest they wither like autumn leaves and become scattered and lost with the succession of days and nights and the passage of days, [19b] some masters of album-making hunted down those beautiful examples, every one of

which was like a beloved youth sprouting down, assembled them, joined them together, made them like assemblies in paradise above by arranging and adorning them with designs and gold wash, and made them gifts for the assemblies of rulers to give splendor to the library of the just sovereign. Thanks be to God, the current ruler of the inhabited quarter of the globe and king of kings of all those who dwell beneath the celestial sphere, he who carries out the command, "God commands justice and beneficence," by giving assistance to the learned and pious and to the poor and weak, is the mighty sultan who shares a name with His Highness Ahmed (i.e., the Prophet Muhammad) the Chosen, king as puissant as Alexander, emperor as magnificent as Feridun, the Shadow of God on earth, possessor of the climes of the dusty expanse in all its length and breadth, the pride of the dynasty of the family of Osman, the Sultan, son of the Sultan, Sultan Ahmed Khan, son of the Sultan Ghazi who fought in battles and raids, Mehmed Khan, son of Sultan Murad Khan, son of Sultan Selim Khan, son of Sultan Süleyman Khan (may God assist the days of his all-conquering fortune [20a] and illuminate the world with the suns of his flourishing rule as long as the celestial spheres spin and the eyes of the stars in the sky are awake at night). By the humble composer:

> *Ever since this spinning dome was created, it has traversed the universe day and night. / The stars in the sky open their eyes and move east and west. / They have not seen such a just king in whose shadow people rest. / Every moment his labor is worship and obedience; his thought is always to maintain order in his realm. / The state and religion he has renewed; all realms have become flourishing. / The constitution of the world having become ill with the disease of tyranny, the people cried out. / That just king has repulsed it and treated the world with the potion of justice. / All kings have become slaves to him and have confessed their servitude. / The king of Iran has given tribute to him; the khan of the [Crimean] Tatars has become his most humble servant. / Such might, magnificence, and glory for many ages the eyes have not seen. / The cause of it all is the justice that the king made manifest. / May God make such a king everlasting; may his fortune be vast and awake. [20b]*

Since that just king and peerless sovereign was inclined to observe Friday prayers in congregation and to perform religious observances and charitable acts, he determined to begin and soon complete in a delightful spot in the city the building of a paradisiacal mosque, contemplating the beautiful and novel architectural style of which astonishes the minds of the world's architects and the admired design of which the world's engineers are unable to picture and depict. And it was as if the magnificent king had been divinely inspired by the pleasing representation of a lofty palace in paradise that became reflected in the mirror of his imagination. It was built in accordance with that design and novel style. When this perception manifested itself in the mind of the king of the world, he issued an order to his servant—a possessor of piercing intelligence, an assayer of mental gems among critics, he who was acceptable at the royal court and treasurer of the secrets of world rule, trusted servant of the Exalted State and loyal believer in his Glorious Majesty, by whom I mean the Agha of the Imperial Harem, el-Hacc Mustafa Agha (may the Lord cause him to attain in the shadow of the sultan's felicity whatever He wills). According to this order that must be obeyed, it was necessary to have a trusted overseer for that strong and solid building from among servants of the imperial threshold. It occurred to the royal mind that the task should be turned over to the Finance Officer of the Second Financial Division, Kalender Efendi, a trusted man and a man of the arts, who was an expert in the matters of construction and in the science of geometry and aware of every craft. The glorious Agha, intuiting what was in the ruler's mind, said, "My sovereign, it is certain that no one is more suitable for that great service among Your Majesty's servants because he is intelligent and perceptive and, as well as being experienced, is an expert in the science of geometry and capable of inventing all sorts of designs, images, and drawings, [21b] and his equal is rare. It is for that very reason that he is firmly established among the masters of the Ottoman lands and of Iran as peerless in the arts of paper joining and making albums." Since that just monarch was much inclined to the art of beautiful writing and cognizant of the subtleties of design and depiction, and his noble heart was inclined to exquisite books and charming albums, his abovementioned servant collected innumerable examples of calligraphy by ancient masters and designs and pictures by painter-designers from Cathay and China, joined them by

the art of paper joining and created an album in an excellent manner and novel style to present as a gift for the royal court and to his His Majesty, so as to show His Highness his expertise in the science of geometry and his skill in building. Having set forth on that labor and hastening to complete it, thanks to Him, it has now been finished, and truly it is such a wondrous album that the arts of gathering and joining manifested in it will surely bewilder the minds of the masters. [22a] In sum, it is a book worthy of being presented to that majestic sovereign, endowed with a refined and pure heart, and is in conformity with his critical nature. It has become a beautiful book of praiseworthy style such that if one gazes at the canonical rules embodied in its calligraphies, it furnishes information on the artistry of past masters, as a book of artifice and beauty. And if one gazes at the subtlety of its designs and pictures, it is as if it were a beloved who is adorned with variously embroidered garments and is decorated and jeweled with heart-attracting gems. The art of joining exhibited therein is a work that astonishes the eye, and everyone who sees it says, "How did he bring to his mind such a design; a hundred thousand praises for the master of that art," and heaps upon it thousands of bravos. When his aforementioned servant set about completing that task and exhibiting his expertise in that art, he charged this humble servant with composing a foreword and praise of the album and the sovereign for whom it was created, but I expressed my apologies and inability, pleading my pedestrian attempts in the arts of poetry and composition [22b] and saying that I was incapable of producing anything worthy of the sovereign, but he replied that my excuses were unacceptable, saying, "Prior to now you have produced several scattered specimens of poetry and prose for the exalted monarch and most of them were esteemed by the sultan, and in return for them you received various gifts. Your faults and skills are known to His Majesty and, despite your flaws, you have been found acceptable to the monarch." He convinced me by saying, "You, a poor old man, have been rewarded and honored with the position of chief judge of the troops of Rumelia and distinguished among all the learned. In thanks for such generosity you should hasten to undertake and complete it." Relying

on the Lord of humanity, I undertook the task, and with his assistance it was completed. It is hoped that any mistakes and shortcoming enveloped within it may be pardoned by the sovereign. In accordance with the dictum, "Every flaw the sultan approves is a virtue," may that generous sovereign reckon its flaws as skills. [23a] By the poor composer:

> *O Kemali, since the prose of the foreword has, with God's help, come to an end, / Now try to versify a necklace of pearls of prayer for the sultan. / As the beginning was praise of God, let the end be praise of the sovereign. / I have recounted his praiseworthy qualities and beneficence insofar as was possible. / This is the summary of it all, that in the world that lord of the world has no equal. / That king has become in this dynasty the glory of the Ottoman progeny. / He has revived the body of the world: now he is the soul of the universe. / The nobles of Mecca and the khan of Crimea are proud to be his slaves. / The moment a king places his head on his threshold, his head rises far above Saturn. / O God, protect that generous king from all calamities. / Let that king of the age live as long as Noah with good fortune. / Make firm that pillar of Islam for as long as the pillars of the world remain firm.* [23b]

So long as breezes of divine breaths and wafts of infinite miracles blow from the other world and dawning rays of eternal favor break from the supernal realm, may the majestic sovereign's ascendant stars of good fortune twinkle and shine from the horizon of godly assistance and may the lights of glory and magnificence glow from the sanctuary of heavenly favor, and may the felicity of his excellent qualities cause him to occupy the throne of majesty and world rule, and may the dust of the gate to his exalted threshold be the resort of mighty rulers, and may his glorious threshold be ever the refuge of renowned emperors. Amen, through the sanctity of the Lord of Apostles, Muhammad the Chosen (may God pray for him and give him peace).

> *Since he has sat upon the throne in fortune, enemies have despaired of comfort. / Since his shadow of justice has been extended, the gate of tribulation has been shut. / Drops from the cloud of his beneficence have given new life to the garden of the soul. / May the life and prosperity of the king of religion be eternal until the day of resurrection. Amen.*

APPENDIX II: PREFACE TO THE AHMED I ALBUM, B. 408, FOLS. 1B–4B,
TOPKAPI PALACE MUSEUM LIBRARY

A. Facsimile of B. 408, fols. 1b–4b

(Photos: courtesy of the Topkapı Palace Museum Library)

Ahmed I Album, B. 408, fol. 1b.

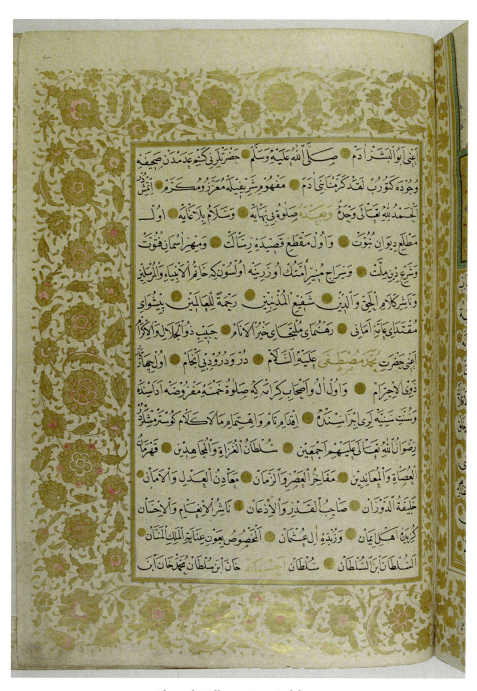

Ahmed I Album, B. 408, fol. 2a.

Ahmed I Album, B. 408, fol. 2b.

Ahmed I Album, B. 408, fol. 3a.

Ahmed I Album, B. 408, fol. 3b.

Ahmed I Album, B. 408, fol. 4a.

Ahmed I Album, B. 408, fol. 4b.

APPENDIX II

B. Transliteration of the Preface to the Ahmed I Album, B. 408 (fols. 1b–4b), by Wheeler M. Thackston

Muraḳḳaʿ-ı Pādişāh-ı Cihān Sulṭān Aḥmed Ḫān

(*Ḥallada 'llāhu mulkahu wa-abbada salṭanatahu ilā yawmi 'l-ḥaşri wa'l-mīzān. Āmīn.*)

Ḥamd-i bī-ḥadd u bī-ḥisāb ve şükr-i lā-yuʿadd u bī-irtiyāb ol cenāb-ı rabbü'l-erbāb u müsebbibü'l-esbāba ki mubdiʿ-i bedāyiʿ-i ġarībetü'l-āṣār ve mūcid-i ṣanāyiʿ-i 'acībetü'l-eṭvārdur maṣnūʿāt-ı 'izz ü şāna ve mükevvināt-ı fażāʾ-ı birr ü iḥsāna vüfūr-i ḳudret-i kāmile ve ẓuhūr-ı meşiyyet-i şāmilesinden bu gümbed-i mīnā ve çarḫ-ı felek-fersā ve dünyā vü māfīhāyı ol *"lawlāk lawlāk lamā ḫalaḳtu'l-aflāk"* elḳābıyla müşerref olan iki cihān faḫrı ḥażret-i risālet-penāh yüzi ṣuyına ḫalḳ edüp ve her eşyanuň sebeb-i ḫilḳatin ve cibillet ve ṭabīʿatin ḳudret ü ḥikmetine mebnī ḳılup ve āb u ḫāk u āteş u bāda imtizāc verüp kendü dest-i ḳudretiyle 'anāṣır-ı erbaʿadan taḥmīr ü taṣvīr edüp *nafaḫtu fīhi min rūḥī* ḫiṭābıyla teşrīf ḳılup ol bāʿis ü bādī-i vücūd-ı insān nebi-yi aḳdem, mübārek-ḳadem, ṣafī, ṣafī-dem [2a] aʿnī ebū'l-beşer Ādem (*ṣallā 'llāhu 'alayhi ve-sallam*) ḥażretlerini ketm-i 'ademden ṣaḥīfe-i vücūda getürüp *laqad karramnā banī Ādam* mefhūm-ı şerīfiyle muʿazzez ü mükerrem itmiştür.

Elḥamdu lillāhi teʿālā vaḥdehü ve baʿdehü ṣalāt-ı bī-nihāye ve selām-ı bilā-ġāye ol maṭlaʿ-ı dīvān-ı nübüvvet ve ol maḳṭaʿ-ı ḳaṣīde-i risālet ve ol mihr-i āsmān-ı fütüvvet ve şerʿ-ı dīn-i millet ve sirāc-ı münīr-i ümmetüň üzerine olsun ki ḫātimü'l-enbiyā ve'l-mürselīn ve nāṣirü kelāmi'l-ḥaḳḳ ve'd-dīn, şefīʿü'l-müznibīn, raḥmeten lil'ālemīn, pīşvā-yı muḳtedā-yı 'āmme-i emānī, rehnümā-yı mülteca-yı ḫayrü'l-enām, ḥabīb-i zü'l-celāl ve'l-ikrām, aʿnī ḥażret-i Muḥammed-i Muṣṭafā (*'alayhi 's-salām*)dur, ve dürūd-ı bī-encām ol çahār-yār-ı zevī'l-iḥtirām ve ol āl ü aṣḥāb-ı kirāma ki ṣalāt-ı ḫamse-i mafrūże edāsında ve sünnet-i seniyyeleri icrāsında iḳdām-ı tām ve ihtimām-ı mālā-kelām göstermişlerdür, *riḍwānu'llāhi taʿālā 'alayhim acmaʿīn.*

Sulṭānü'l-ġuzāti'l-mücāhidīn, ḳahramānü'l-'uşāt ve'l-muʿānidīn, mefāḫirü'l-'aṣr ve'z-zamān, maʿādinü'l-'adl ve'l-amān, ḫalīfetü'd-devrān, ṣāḥibü'l-ḳadr ve'l-iʿzān, nāṣirü'l-inʿām ve'l-iḥsān, güzīde-i ehl-i īmān ve zübde-i āl-i 'Osmān, el-maḫṣūṣ bi-'avni 'ināyeti'l-meliki'l-

mennān, es-sulṭān ibni's-sulṭān Sulṭān Aḥmed Ḫān ibn-i Sulṭān Meḥmed Ḫān ibn-i [2b] Sulṭān Murād Ḫān (*ayyada 'llāhu taʿālā mulkahu wa-dawlatahu wa-salṭanatahu ilā yawmi'l-waʿd wa'l-mīzān*) ki der-i devlet-niṣāb ve vücūd-ı nāyābları südde-i saʿādet-medār ve 'atebe-i 'āliye-i 'adālet-ḳarār u şehinşāh-ı sipihr-iḳtidār u maʿdilet-āṣārdur dāyimā cevāhir-i 'irfān-ı 'avārif ü le'ālī-i maʿānī vü maʿārif birle ḳalb-i laṭīfleri memlū olmaġile ol dürer-i ġurer-i ṣanāyiʿ ü bedāyiʿi sarāy-ı bī-ʿayb u serāperde-i lāreybde olan enfes-i nefāyis-i maḳālāt ve aḥsen-i maḥāsin-i muṣavverāt benāt-ı nükāta ḥilye-i ḥulel-i elfāẓ u ebṣārla zīver ü zīb verüp zīnet-i dilfirīb ile ḳulūb-ı cihānbānı firīfte ve ṭabʿ-ı ehl-i dilānı alüfte vü āşüfte itmişlerdür. İmdi her bār ki āyīne-i ṭabʿ-ı mücellā-yı rūzgār manẓar-ı iʿtibār-ı üli'l-abṣārdur dāyimā ṣūretnümā-yı naḳş u nigār iken ḥavādis-i rūzgār-ı nāhemvārdan jeng vāḳiʿ ola. Anuň gibi eyyām-ı nāfercāmda baʿżī ṣuver-i muʿteber u siyer-i pür-'iber-i selef ü ḫalef manẓūr ve mezkūr olıcaḳ mürūr u ẓuhūr-ı gerdiş-i gerdūn ve envāʿ-ı eṣnāf-ı naḳş-ı būḳalemūn ile nümāyān olan āṣār-ı ġarībe vü eşkāl-i 'acībenüň taḫayyülāt ü taṣavvurātı bāʿis-i taḥṣīl-i sermāye-i 'ilm-i ḥikmet ve sebeb-i tekmīl pīrāye-i 'ayn-ı 'ibret olduğundan māʿadā ol ẕāt-ı ferhunde-sumāt-ı pādişāh-ı 'ālī-derecāta mūcib-i tenşīṭ-i ḫāṭır-ı ḫaṭīr u müstevcib-i taṭyīb-i żamīr-i münīr ve ḳalb-i müstenīr olmaḳ muḳarrer u muḥaḳḳaḳdur. Bināʾen 'alā hāẕā, ol ẓıll-i ẓelīl-i hümā-sāye, aʿnī pādişāh-ı felek-pāye ve şehinşāh-ı Ḫudā-sāye ḥażretlerine Rūm'da [3a] vü Aʿcāmda meşhūr u müteʿārif olup her birisiniň ḫaṭṭ u naḳş-ı pür-āṣārı maḳām-ı iʿcāzda olan Mīr 'Alī ve Şāh Maḥmūd ve Nūr 'Alī ve daḫi niçe bunlar mertebesine vāṣıl u nāyil olan ḫoşnüvīsān-ı selef ü naḳşbendden naḳḳāşı ve āṣārından müʾesseri müşāhede olunan Bihzād u Erjeng u Mānī mānendi naḳḳāşān-ı pīşīn ve envāʿ-ı saʿy u kūşiş ile 'ilm-i mūşikāfta diḳḳatle ḳılı ḳırḳ yarar yārı aḳrānı müzehhibān-ı müteḳaddimīn 'ömrlerin ve maḳdūrların

ḥarc u ṣarf edüp yazup ve çizüp vücūda getürdükleri bīnaẓīr u bī'adīl ḥaṭṭ u taṣvīrlerden ba'żı tuḥaf u hediyye vü armaġān vü ba'żısı daḫı ṭaleb-i ricā-yı in'ām u iḥsān-ı pādişāhī içün virdükleri muḳaṭṭa'āt u evrāḳ bir yere cem' olup her birisinün biri birisine münāsebeti ile tertīb olunup bir müzehheb vü mücelled vü mükellef muraḳḳa' olması 'aẓametlü vü sa'ādetlü pādişāh-ı dādāver ḥażretlerinüñ murād-ı şerīfleri olup ve ḥadd-ı zāt-ı sa'ādet-sumātlarında bu maḳūle ma'ārif-i cüz'iyye vü külliyye vü tuḥaf vü tefāruḳ-ı hediyye ḳılmaġa meyl-i şerīfleri olmaġın ve bu ḳulları daḫı ḳadīmden bu maḳūle üstād ḫaṭlarıyla olan muḳaṭṭa'āt u taṣvīrāt evrāḳını biri birisine münāsebeti ile [3b] envā'-ı reng-āmīz kâġıdlara vaṣl edüp muraḳḳa' etmeği ḳadīmden bu güzergāh-ı pür-'iberde vaṣṣāle-i nādire-kār u müte'ayyināt-ı rūzgār olup bu ḥaḳīrüñ üstādı Muḥammed Şerīf-i Baġdādī'den görüp muḳaddemā daḫı bir iki def'a cenāb-ı ni'melme'ābları içün ba'żı cönger ve kitāblar te'līf ü tertīb ü taṣnīf ü tezyīb olunduḳta şevketlü vü sa'ādetlü pādişāh-ı Cem-cāh ḥażretlerinüñ kerem-i ṭab'-ı pür-himemlerinden maḳbūl-ı şerīf ü pesendīde-i laṭīfleri olmış idi. Ḥaḳḳ (*calla wa-'alā*) vücūd-ı pür-cūd naẓar-ı bī-naẓīrlerin ḫaṭā vü ḫaṭarlardan maḥfūẓ u maṣūn idüp yevmen fe-yevmen 'adl ü dād ve ṭā'at u 'ibādetlerin ziyād ve memālik-i maḥrūseleri rebbi'l-'ibād ābād edüp 'ömr ü devlet-i sermedī müyesser u muḳadder itmiş ola. Āmīn, *bi-ḥurmati sayyidi 'l-mursalīn.*

Yine bu def'a daḫı cümle ṣuver u ḫuṭūṭ evrāḳını birikdürüp bu 'abd-ı ḳalīlü'l-biżā'a cānibine gönderdiklerinde hemān cān u dilden *sem'an ve ṭā'aten* deyüp fermān-ı hümāyūn-ı sulṭānī her ne ise şeref-i rütbet-i a'lā ve ḫıdmet-i şerīfleri cān-'azīzüme minnet-i 'uẓmā farż idüp dāyire-i imkānda olan ṣanāyi'-i nādīde vü bedāyi'-i nāşenīde ḫarc u ṣarf idüp eger [4a] rengāreng olan naḳş-ı būḳalemūnī ebrī vü sulṭānī vü aḥmedābādī vü devletābādī vü ḫıṭāyī vü 'adilşāhī vü ḥarīrī vü semerḳandī evrāḳtur ve eger ṣan'at-ı vaṣṣālīde her bir ḳıṭ'anuñ kenārlarına fereskūrī alaca ḳumāş ṭarzında ikişer ü üçer ḳāt ḫurde evrāḳtur ḫurdebīnān u ḫurdedān ehl-i 'irfāna

ḫafī vü pūşīde değildür her birisine im'ān-ı naẓarla iltifāt müte'alliḳ olsa inşā'allāhu te'ālā çār gūşeleri vü muḳābelesi cem'an biri birisine eger renginde vü eger cirminde vü ṭūl-ı 'arżında muvāfıḳ u muṭābıḳ vāḳi' olmıştur. Sa'ādetlü vü şevketlü vü marḥametlü pādişāh-ı Cem-cāh-ı 'aẓamet-şi'ār ḥażretlerinden mercū vü mütevaḳḳi'dür ki dāyimā bu ḳullarını ḫıdmet-i şerīfleri ile teşrīf buyurup naẓar-ı iltifātları ile muġtenem idüp dil-nüvāzluḳdan ḫālī olmayalar ve bu kemīne-i dīrīne bendelerinüñ daḫı bu rūzgār-ı rūzgār-ı serī'ü'd-devvārda bu deñlü diḳḳat ü ihtimām ile maḳdūr ṣarf eylemekten murād bu āna degin niçe erbāb-ı ḥaysiyyet ü aṣḥāb-ı me'ārifle ḫulṭa idüp rūzgār-dīde vü kār-āzmūde üstādlara muḳārin olup vü bu deñlü zamāndan berü taḥṣīl eyledüğüm ma'rifet eyyām-ı sa'ādet-i şehriyārī ve hengām-ı devlet-i tācdārīde żāyi' olmayup *al-ḥamdu lillāhi ta'ālā wa-li-rasūlihi* [4b] böyle bir 'adl-güster, ra'iyyetperver, ḥaḳ-şinās devlet-esās, ehl-i naẓar pādişāh-ı dīnpenāh ḥażretlerinüñ ḥużūr-ı şerīflerinde şikeste vü beste olan taşannu'āt maḳbūl-ı şerīfleri vü pesendīde-i laṭīfleri olup gāhī naẓar-ı bī-naẓīrleri müte'alliḳ olduğı maḥżā devlet-i 'uẓmā vü sa'ādet-i kübrā olmaġın fermān-ı sa'ādet-'unvānları üzere her birisi yerlü yerine tertīb ü tekmīl olunmıştur.

Hemīşe sulṭān-ı āftāb-ı 'ālemtāb serīr-i mıṣr-ı gerdūn-nīlgūn üzere eşi'a-i leme'āt-ı fāyiżu'l-envār birle nümāyān u tābān olup envār-ı meymenet-āṣārından müfāriḳ-ı 'āmme-i maḥlūḳāt müstenīr ü müstefīż ola. Pādişāh-ı Cem-cāh u 'ālem-penāhumuñ ḥıyām-ı vācibi'l-ihtirām vücūd-ı pür-cūd-ı mes'ūdları evtād u aṭnāb-ı imtidād-ı ḫulūd birle ilā yevmi'l-mev'ūd keşīde vü memdūd olup farḳ-ı ferḳadsāy-ı iḳbāl-i ebed-ittiṣāl vü tārek-i milk-i hümā-yı devlet-i bī-iḫtilālleri gevher-i tāc-ı ibtihāc birle mücellā olup şevket-i salṭanat-i 'adālet-nümūnları rūz-be-rūz efzūn ve a'dā-yı devletleri şikeste vü maḥzūn olup memālik-i İslāmiyye sāye-i ḥimāyetlerinde āsūde ve farḳ-ı 'aduvvları sümm-i semend-i sa'ādetleri altında fersūde ola. Āmīn *bi-ḥurmati sayyidi 'l-mursalīn.*

APPENDIX II

C. Translation of the Preface to the Ahmed I Album, B. 408 (fols. 1b–4b), by Wheeler M. Thackston

Album of the World Emperor Sultan Ahmed Khan

(May God perpetuate his kingdom until doomsday. Amen)

Limitless and unending praise and untold thanks are fitting for the Lord of Lords, the causer of all causes who is the originator of strange marvels and inventor of amazing crafts, who created this blue dome, the wheel of heaven, and the world and everything that is in it for the sake of His Prophetic Excellency, the pride of this world and the next who was dignified by the words, "Were it not for you, were it not for you, I would not have created the celestial spheres," in order to show his total power and all-encompassing will to those things fashioned by his might and those things brought into existence in the space of beneficence. Having based the creation and nature of all things on his power and wisdom, and having mixed together water, earth, fire, and air, with his own puissant hand he kneaded and fashioned the four elements, addressed them, saying, "I breathed into him of my spirit," and brought onto the page of existence the original human, the most ancient prophet, he of blessed footsteps, the pure [2a] father of humankind, Adam (may God pray for him and give him peace), from the hidden recesses of nonexistence, and then he ennobled him with the words, "We ennobled the sons of Adam."

Praise be to God alone, and then may there be limitless prayers and greetings for him whose name stands at the head of the register of prophecy, the last name in the ode to apostlehood, the sun in the heaven of chivalry and legislation of the religion of the nation, the shining lamp of the community, he who is the seal of the prophet and apostles, the broadcaster of the word of truth and religion, the intercessor on behalf of sinners, a mercy to all worlds, leader of the people of hope, the guide in whom the best of people take refuge, beloved of the Almighty, i.e., Muhammad the Chosen (peace be upon him). And unending greetings be upon the venerable Four Friends, upon his family, and upon his noble companions, who have undertaken com-

pletely and concentrated their attention beyond doubt on performing the obligatory five prayers and implementing the glorious tradition. May God be pleased with them all.

Sultan of religious warriors, conqueror of rebels and opponents, pride of the age and time, mine of justice and peace, caliph of the age, puissant and mighty one, spreader of beneficence and charity, chosen one from the people of faith, best of the Ottoman family, he who has been singled out for divine favor, the sultan, son of the sultan, Sultan Ahmed Khan, [2b] son of Sultan Mehmed Khan, son of Murad Khan (may God assist his kingdom, state, and rule until the promised day of the balance), he whose gate is felicitous, whose existence is rare, around whose throne happiness revolves, whose lofty threshold is the abode of justice, a king of kings as mighty and just as the celestial sphere. In addition to the fact that his delicate heart is always filled with gems of knowledge and pearls of learning, those matchless pearls of crafted marvels, the personages of precious words and best of the features of depicted things are matchless pearls of crafted marvel in the flawless palace and heavenly castle adorned with words garbed in raiment of words and insight, which seduced the hearts of world rule and mussed the natures of the people of the heart with their beguiling beauty.

Now, inasmuch as the mirror of the polished nature of time has always been an object of instruction for those possessed of insight, it constantly reflects images of designs and figures, but is sometimes tarnished with the verdigris of untoward vicissitudes. In such infelicitous times, if some instructive images from predecessors and successors are gazed upon and remembered, imagining and picturing to oneself the various sorts of chameleon designs, images of strange traces and marvelous shapes that occur with the passage and appearance of the spinning of the celestial sphere will certainly

cause the acquisition of the capital of the science of wisdom, will result in the perfection of the eye of learning by example, and will additionally console the felicitous person and troubled heart of the mighty sovereign by enlivening his mind and by pleasing his luminous inner self and his illuminated heart.

Therefore, every one of the past calligraphers and designers known in the Ottoman lands and Iran [3a] who have reached the level of Mir 'Ali, Shah-Mahmud, Nur-'Ali, painters of old like Bihzad, Arzhang, and Mani, from whose works their creator is seen, have produced fragments and leaves of unparalleled calligraphy and depiction, and have so endeavored in the meticulous art that they could split a hair into forty parts, and artists of old have spent their lives and done their utmost in writing, drawing, and bringing such things into existence. Some of their works have been given as gifts to the one blessed by the shadow of the phoenix of regality, i.e., the exalted monarch and emperor shadow of God, in hopes of regal favor and regard, and they have been gathered into one place and arranged, each with some conformity to the others, since it was His felicitous Majesty's desire that they should be gilded and bound into an elaborate album. And in point of fact, because in his felicitous person there was an inclination for such gifts and presents of little or great skill, this slave of his, having seen long ago his master, Muhammad Sharif Baghdadi, join leaves of specimens and depictions of such master calligraphers [3b] to colorful paper and make them into an album, when once or twice some albums and books were composed, arranged, and adorned for his patron, they were acceptable and pleasing to the magnificent sovereign. May the deity preserve and keep the gracious person's peerless gaze from error and danger, may the lord of all servants increase his justice, religious observance, and worship day by day and cause his protected realms to flourish, and may he grant him eternal life and prosperity, by the sanctity of the Lord of Apostles.

This time, when he brought together all the leaves of pictures and calligraphies and sent them to this humble servant, I responded, saying, "I hear and obey." Whatever a royal command may be, considering service to be an obligation upon my very soul, I expended, insofar as possible, crafts unseen and marvels unheard of. [4a] Whether chameleon design of various colors in

ebrī, sultanī, Ahmadabadī, Dawlatabadī, Khatayī, Adilshāhī, harirī, or Samarqandī papers, or whether with the art of joining there be two or three small leaves at the edges of every specimen in the fashion of fereskuri (?) striped cloth, it is not unknown or hidden to those with acute perception and sagacious people of insight that by looking at each one of them with a scrutinizing gaze, if attention is paid, God willing, the four corners and the facing one are all in harmony with and conforming to each other, be it in color or in size and length and width. It is hoped from the felicitous, mighty, and merciful sovereign that he will always ennoble his servants with such services and will take the opportunity to cast his favorable glance, and that they will not be without favor. May the credit that this least of his old servants, who has expended his time insofar as possible with such meticulousness and concern during these fast-moving days, has acquired over such a period by associating with several master artisans, becoming equal to experienced and learned masters, not be lost during the felicitous days of his monarchy. Praise be to God and to His Apostle, [4b] in the hopes that in the noble presence of such a majestic, just, kind, appreciative, and discriminating monarch, who is the refuge of the religion, this slapdash piece of handicraft may be acceptable and pleasing, and that, if he occasionally casts his peerless gaze upon it, it will be the greatest felicity, and in accordance with his felicitous command every one has been arranged in its proper place to perfection.

May the sultan of the world-illuminating sun shine forever with flashing rays of emanating lights on the throne of the dark firmament, and may the heads of the totality of creatures be enlightened and brightened by his felicitous lights. May the respected tents of my sovereign as mighty as Jamshed, refuge of the world, be extended and stretched with the eternal pegs and ropes of his generous, felicitous being until the promised day, may the sky-scraping top of his eternal fortune be crowned with pearls in the crown of rejoicing, may the might of his just rule increase daily, may the enemies of his state be crushed and driven to despair, may the Islamic realms repose in the shadow of his protection, and may the heads of his enemies be trampled beneath the hooves of his steed of fortune. Amen, through the sanctity of the Lord of Apostles.

NOTES

Author's note: This article, originally written in Turkish, was submitted in 2007 for inclusion in the festschrift volume for Dr. Filiz Çağman, which, unfortunately, has yet to be published. This revised English version is, of course, dedicated to Filiz Çağman, to whose scholarly mentorship and generous friendship I owe so much. This small gift, which in turn introduces the gifts presented to Sultan Ahmed by Kalender—one who, like Filiz, spent his life on the arts of the book—would not have been possible without the support of my colleagues and friends. I am grateful to Tülün Değirmenci, Massumeh Farhad, Cornell H. Fleischer, Cemal Kafadar, Mehmet Kalpaklı, Fatma Kutlar, Gülru Necipoğlu, Leslie M. Schick, Zeren Tanındı, Gönül Alpay-Tekin, Bahattin Yaman, and Zeynep Yürekli for their comments and contributions. I also want to thank Wheeler M. Thackston, who kindly provided the transliteration and English translation of two of the prefaces. I did not include the translation of the entire text of the *Fālnāme*'s preface, since it was already published by Sergei Tourkin in the catalogue of the 2009 exhibition held in the Arthur M. Sackler Museum at the Smithsonian in Washington, D.C. See Massumeh Farhad with Serpil Bağcı, *Falnama: The Book of Omens* (Washington, D.C., 2009), 295–96.

1. According to the events and sources 'Āli mentions in his book, he most likely started to write in 1585–86, when he was on duty in Baghdad, completing the work in 1587 in Istanbul. I have not been able to find out when this epilogue (*ẕeyl*) was composed. The text used in the 1926 edition, dated August 10–20, 1599 (*evāḫir-i Muḥarrem* 1008), includes this *ẕeyl*. See Mustafa 'Āli, *Menāḳıb-ı Hünerverān*, ed. İbnülemin Mahmud Kemal (Istanbul, 1926), 76–77. Another relatively early copy, of December 1601 (*Cemāẕiyü'l-āḫir* 1010), also includes the poem (Ms. E.H. 1231, fol. 73a–b). Esra Akın-Kıvanç, who published an extensive study on the text, does not include the poem in her translation but gives a transcription of it: *Mustafa 'Āli's Epic Deeds of Artists: A Critical Edition of the Earliest Ottoman Text about the Calligraphers and Painters of the Islamic World*, ed., trans., and annot. Esra Akın-Kıvanç (Leiden, 2011), 422n18. Akın-Kıvanç proposes that the poem was composed by the scribe of E.H. 1231, Ya'kub İskilibi, who copied a 1494–95 (1003) version of the text, but she does not further discuss her attribution: Akın-Kıvanç, *Mustafa 'Āli's Epic Deeds*, 74.

2. *Bir ṣāḥib-i hünerdür o vaṣṣāl-ı mu'teber / Erbāb-ı ma'rifetde bulunmaz aña miṣāl*
 Her ḳıṭ'ada ki vaṣl ile elvānı derc ider / Ḳavs-ı ḳuzaḥla ṣafḥa-i çarḫa olur hemāl
 Vaṣl itdügi yirüñ iremezler ḫayāline / Yekpāre ẓann ider anı hep dīde-i ḫayāl
 Kāġıd u post ḳılsa ḳılı ḳırḳ yarmada / Her mū-şikāf olan idemez aña ḳīl ü ḳāl
 Ḥalkārı zerfişānı vü pervāzı cedveli / Ḳılmış musaḥḥar aña o Ḥallāḳ-ı ber-kemāl
 Pejmürde kāġıdı ider iḥyā 'ilāc ile / Dil-ḫaste 'āşıḳı nitekim şerbet-i viṣāl

Ey ḫāme gel bu beyt ile yaz ver cevābını / Kimdür deyü iderler ise nāmını su'āl
Ol kān-ı ma'rifet ki Ḳalender Çavuş durur / Olsa ġulām-ı ḥalḳa be-gūşı n'ola hilāl
Pervāz-ı ḳıṭ'ada ki ider naḳş-ı pür-girih / Her biri pāy-ı 'aḳla olur bend ile 'iḳāl
Bir kimse mālik olmadı bu deñlü ḳıṭ'aya / Hem ḳılmadı ma'ārife bu resme bezl-i māl
Sa'y itmek ile girmez ele dād-ı Ḥaḳḳ durur / 'Ālemde sa'y u bezl ile bu mertebe muḥāl
Sözi uzatma ḫatm-i kelām it du'ā ile / Çünkim zebān-ı nāṭıḳa vaṣfında oldı lāl
Her ṣubḥ u şām niteki ḳudretle şun'-ı Ḥaḳḳ / Çarḫ u şafaḳla göstere vaṣl-ı kebūd u āl
Ayırmasun vücūdını levḥ-i zamāneden / Çesbān idüp şafāyile ol Ḥayy-ı lāyezāl.

A shorter version of the epilogue, translated into English by Yorgos Dedes, is published in Serpil Bağcı, "The Falnama of Ahmed I (TSM H.1703)," in *Falnama: The Book of Omens*, ed. Massumeh Farhad with Serpil Bağcı, exh. cat. (Washington D.C., 2009), 68.

3. Selânikî Mustafa Efendi, *Târih-i Selânikî*, ed. Mehmet İpşirli, 2 vols. (Istanbul, 1989), 2:741–42, 2:847. For Kalender, see also Banu Mahir, "Kalender Paşa," in *Yaşamları ve Yapıtlarıyla Osmanlılar Ansiklopedisi*, ed. E. Çakıroğlu, 2 vols. (Istanbul, 1999), 1:692; Tülün Değirmenci, *İktidar Oyunları ve Resimli Kitaplar: II. Osman Devrinde Değişen Güç Simgeleri* (Istanbul, 2012), 74–75.

4. Kalender's connection to Mustafa Agha was clearly well known and talked about, and was also mentioned by other historians. In fact, when relating the events of the year 1613, Naîmâ (d. 1715) notes that when the grand vizier Nasuh Pasha was trying to place his own men in the position of treasurer, he was not able to have the third treasurer, Kalender, dismissed, since he was also the building supervisor of the new mosque and a close affiliate of Mustafa Agha (*Cāmi'-i Cedīd'in bināsına emīn ve Dārüssa'āde Aġası Muṣṭafā Aġa'ya ḳarīn olmakla aña ta'arruẓ edemedi*): Naîmâ Mustafa Efendi, *Târih-i Na'îmâ*, ed. Mehmet İpşirli, 4 vols. (Ankara, 2007), 2:402.

5. Naîmâ gives the date of this appointment as November 25 (22 *Şevvāl*): *Târîh-i Naîmâ*, 2:418.

6. Kalender Pasha, who is mentioned twice in the 1616 expense records for the complex of Sultan Ahmed I, was still building supervisor on May 9, 1616 (22 *Rebiyü'l-aḫir* 1025). In a document from December 15, 1616 (5 *Zilhicce* 1025) he is mentioned as being deceased: Ömer L. Barkan, *Süleymaniye Cami ve İmareti İnşaatı (1550–1557)*, 2 vols. (Ankara: 1972–79), 2:287. 'Abdülkadir Efendi (d. after 1644) notes in his *Tārīḫ* (History) that Kalender was still a member of the Imperial Council in July–August 1616 (*Receb* 1025), so he must have died between August and December of 1616: Abdülkâdir Efendi, *Topçular Kâtibi 'Abdülkâdir (Kadrî) Efendi Tarihi: Metin ve Tahlîl*, ed. Ziya Yılmazer, 2 vols. (Ankara, 2003), 1:647.

7. Mehmed b. Mehmed, *Tārīḫ-i Āl-i ʿOsmān*: Istanbul, Süleymaniye Library, Ms. Lala İsmail Efendi, 300, fol. 64b. I am grateful to Tülün Değirmenci for drawing my attention to this text. Mehmed Süreyya notes that Kalender Pasha rose through the ranks of the treasury and was appointed as the third treasurer in 1613. See Mehmed Süreyya, *Sicill-i Osmanî*, ed. Nuri Akbayar and Seyit A. Kahraman, 6 vols. (Istanbul, 1996), 3:858.

8. He is the minefield of skill, Kalender Çavuş / Ah, if even the moon were his earringed slave, it would not be astonishing.

9. The fifteenth- and sixteenth-century texts mention that members of the Haydari order wore iron earrings in the shape of hoops, an allusion to their avoidance of superfluous conversations. Ahmet T. Karamustafa, *God's Unruly Friends: Dervish Groups in the Islamic Later Middle Period 1200–1550* (Salt Lake City, 1994), 68–69.

10. John Kingsley Birge, *The Bektashi Order of Dervishes* (London, 1994), 164–65. Also see Nurhan Atasoy, *Derviş Çeyizi: Türkiye'de Tarikat Giyim-Kuşam Tarihi* (Istanbul, 2000), 251–52.

11. The institutionalizing of the cadre of celibate dervishes was attributed to Balım Sultan in earlier literature: Birge, *Bektashi Order*, 58. In her recent study, Zeynep Yürekli states that it was instituted after 1550, by Sersem ʿAli Baba. See Zeynep Yürekli, *Architecture and Hagiography in the Ottoman Empire: The Politics of Bektashi Shrines in the Classical Age* (Farnham, Surrey, and Burlington, Vt., 2012), 36–38.

12. On the sixteenth-century Ottoman Bektashis, their relations with the central imperial authority and the mediating role of Balım Sultan, see Yürekli, *Architecture and Hagiography*, 24–47. On the same matter and the use of "*Kalenderî*" as an adjective among the Bektashis, see Ahmet Yaşar Ocak, *Osmanlı İmparatorluğunda Marjinal Sûfîlik: Kalenderîler; XIV–XVII. Yüzyıllar* (Ankara, 1992), 205–10.

13. Although the decorative pages that Kalender composed demonstrate his virtuosity in paper cutting, they were defined exclusively as examples of the art of *vaṣl*, which suggests a clear distinction between paper joining and paper decoupage (*ḳaṭıʿ*), where the skill is in cutting the papers rather than in hiding the seams.

14. These frames, used by Kalender exclusively, were imitated in the early eighteenth century, when calligraphy albums became popular, during the reign of Sultan Ahmed III (r. 1703–30), himself a distinguished calligrapher. For examples, see *Topkapı à Versailles: Trésors de la cour ottomane*, exh. cat. (Paris, 1999), 173, 175, cat. nos 129, 131; Filiz Çağman and Şule Aksoy, *Osmanlı Sanatında Hat*, exh. cat. (Istanbul, 1998), 48–49, cat. no. 31; M. Uğur Derman, "Ahmed III: Sultan and Affixer of the 'Tuğra'," in *Thirteenth International Congress of Turkish Art: Proceedings; 3–7 September 2007*, ed. Géza Dávid and Ibolya Gerelyes (Budapest, 2009), figs 5–8.

15. It is not definitively known whether Album B. 409 is Kalender's work. This issue will be discussed below, and at least some folios will be attributed to Kalender. Indeed, the resemblance of B. 409's binding to that of B. 408 strengthens this attribution.

16. The album was featured in a 1999 exhibition in France: *Topkapı à Versailles: Trésors de la cour ottomane*, no. 146. The unpublished catalogue of the albums in the Topkapı Palace also includes detailed information on this and Album B. 408.

17. *Bir kimse mālik olmadı bu deñlü ḳıṭʿaya / Hem ḳılmadı maʿārife bu resme bezl-i māl* (Just as no one before him has possessed so many *qiṭʿa*s / No one has spent so much for talent, either.)

18. ʿÂli, *Menāḳıb*, 6, 55.

19. ʿÂli says that during the years when he wrote his book, of course under Sultan Murad's patronage, learned men, poets, men of refinement, calligraphers, illuminators, painters, and all of the talented creators of curious things were held in high esteem, and calligraphy of all styles (*kalem*) was in high demand. He states that men of refinement were pleased to possess the *qiṭʿa*s of Mir ʿAli (of Herat) and Sultan ʿAli (of Mashhad). Istanbulites who wanted to buy a *qiṭʿa* of Mir ʿAli were willing to pay a hundred filori, and if that proved insufficient, they were ready to plead and beg. Following the 1585–86 debasement, 100 filori was equivalent to 12,000 aspers (for the exchange rates, see Şevket Pamuk, *A Monetary History of the Ottoman Empire* [Cambridge, 2000], 136, 144). While the expenditure of such a substantial sum was undoubtedly reserved for a select few calligraphers, it nevertheless demonstrates what fortunes could be spent on a single *qiṭʿa*. Additionally, ʿÂli writes that some chancery secretaries and scribes spent 40,000–50,000 gold coins, or even more, on a single album containing such illuminated and arranged *qiṭʿa*s. ʿÂli's observations suggest that this taste or fashion spread from the court bureaucrats. ʿÂli returns to the prices of their *qiṭʿa*s in his chapter on the calligraphers of the *nastaʿlīq* script. This time, probably referring to the monetary value prior to the devaluation, he states that on a couple of occasions he saw the collectors paying 5,000–6,000 aspers for a *qiṭʿa* of Mir Ali, and 400–500 for one by Sultan Ali. ʿÂli, *Menāḳıb*, 6, 44.

20. ʿÂli, *Menāḳıb*, 7, 8, 53.

21. The relation between the science of geometry (*hendese*) and the shapes of forms is important; Kalender's command of shapes (as a designer and illuminator) was owing to his knowledge of geometry.

22. He used paper decoupage motifs of arabesques composed of lobed medallions (*shamsa*) in these full-page decorations (fols. 14a, 14b, 15a, 15b), very similar to the ones he used in his next album, B. 408.

23. H. 2171, fol. 22b: "...*ḥālā manṣıb-i celīl-i ḳażā-ı ʿasākir-i Rūm İli ile ser-efrāz ve sā'ir-i ʿulemādan mümtāz eylemişdür....*"

24. For his career and books, see Mehmet İpşirli, *Türkiye Diyanet Vakfı İslâm Ansiklopedisi* (Istanbul: Türkiye Diyanet Vakfı, 2011), s.v. "Taşköprizâde Kemâleddin Efendi."

25. H. 2171, fol. 22a.

26. H. 2171, fol. 22b.

27. This first section is closely related to Persian album prefaces, analyzed by David J. Roxburgh in *Prefacing the Image: The Writing of Art History in Sixteenth-Century Iran* (Leiden, 2001), esp. 88–103. For the texts of these prefaces, see Wheeler M. Thackston, *Album Prefaces and Other Documents on the History of Calligraphers and Painters* (Leiden, 2001).

28. H. 2171, fols. 17b–18a. The identification of the creation of the universe with the creation of an album was a trope also used by Timurid writers. See Roxburgh, *Prefacing the Image*, 89–90, 92.

29. H. 2171, fols. 18a–18b.

30. H. 2171, fols. 18b–19a.

31. H. 2171, fol. 19a.

32. H. 2171, fol. 19b.

33. While almost all contemporary historians note that Kalender's appointment as the keeper of the mosque was made possible through the recommendation of Mustafa Agha, the text indicates that the offer came from the sultan. Rather than attempting to determine the accuracy of either of these theories, it is more interesting to consider why a text presented to the sultan would make a point of emphasizing that the decision had, in fact, been up to the sultan. On Mustafa Agha's career, the intimate relationship between him and Sultan Ahmed I, the agha's effective patronage of the arts of the book, and his role in Kalender's successful career, see Değirmenci, *İktidar Oyunları*, 59–78.

34. H. 2171, fols. 21a–21b: "...peerless in joining paper, in the art of album making (*kār-i vaṣṣāli ve ṣanʿat-ı muraḳḳaʿ-sāzī*), and...highly esteemed and recognized among the Ottoman and Persian masters" (*miyān-ı üstādān-ı Rūm u ʿAcemde maḳbūl ü müsellemdür*).

35. H. 2171, fol. 21b: *deḳāʾiḳ-i naḳş u taṣvīre vāḳıf u vāṣıl ve ḳalb-i şerīfi kütüb-i nefīse ve muraḳḳaʿāt-ı laṭīfeye māʾil idügi ẓāhir olmışdur....*

36. For these notes in H. 2153, fol. 87b, and H. 2160, fol. 4a, see Filiz Çağman, "On the Contents of the Four Istanbul Albums H. 2152, 2153, 2154, and 2160," in *Between China and Iran: Paintings from Four Istanbul Albums; A Colloquy Held 23–26 June 1980*, ed. Ernst. J. Grube and Eleanor Sims (New York, 1985), 34, fig. 16.

37. H. 2171, fol. 21b.

38. H. 2171, fol. 21b.

39. H. 2171, fol. 22a.

40. *Muraḳḳaʿ-ı Pādişāh-ı Cihān Sulṭān Aḥmed Ḫān*: Istanbul, Topkapı Palace Museum Library, B. 408. The album of Ahmed I has been mentioned in many works on Ottoman painting. For information concerning the contents of the work, a reproduction, and a French translation of its preface, see Ahmet Süheyl Ünver, "L'album d'Ahmed Ier," *Annali dell'Istituto Universitario Orientale di Napoli* 13 (1963): 127–62. Recently, Emine Fetvacı examined the album's content from different angles in two articles: "Love in the Album of Ahmed I," in "Festschrift in Honor of Walter G. Andrews II," ed. Mehmet Kalpaklı, special issue, *Journal of Turkish Studies/Türklük Bilgisi Araştırmaları Dergisi* 34, 2 (December 2010): 37–49, and "The Album of Ahmed

I," *Ars Orientalis* 42 (2012): 127–38 (where she also analyzes passages from the preface).

41. I would like to thank paper conservator Nil Çıngı Baydar for sharing her observations with me.

42. Fetvacı, "Love in the Album of Ahmed I," examines the romantic content of the poetry in relation to the juxtaposed images.

43. *Ketebe Sulṭān Aḥmed Ḫān İmām el-Müslimīn* (B. 408, fol. 5b). For the reproduction of this page, see Ünver, "L'album d'Ahmed Ier," 152.

44. The overall effect of this page recalls the Ottoman genealogical histories, where the sections on the Prophet Muhammad and the four Sunni caliphs are designed in a similar manner.

45. B. 408, fols. 11b, 26b, and 31a.

46. Once again, I would like to thank Nil Çıngı Baydar for drawing my attention to the difference in the material used.

47. The Ottoman biographical dictionaries of calligraphers cite a certain Receb Dede, who was a member of the Mevlevi order. In his treatise, Mustakimzade Süleyman Saʿdeddin Efendi (d. 1788) mentioned seeing a copy of the Koran by Receb Dede completed in 1610–11: Mustakimzade Süleyman Saʿdeddin Efendi, *Tuhfe-i hattâtîn*, ed. Ibnülemin Mahmut Kemal (Istanbul, 1928), 202. Receb Dede, who was a contemporary of Kalender's, might very well be the same calligrapher. In Ahmed I's album, only one of his qitʿas is paired by Kalender—with a work of paper decoupage by a Mevlevi artist (fol. 22b)—reinforcing Receb Dede's identity as a Mevlevi. For the reproduction of a qitʿa by Derviş Receb, see Fetvacı, "Album of Ahmed I," fig. 6.

48. Katib al-Sultani Emir Mehemmed Emin of Tirmiz may be Seyyid Mehmed Emin Hüseyni, known as Tirmizi. In his book on Ottoman calligraphers, Şevket Rado mentions having seen a manuscript copied by Seyyid Mehmed Emin Hüseyni in *taʿlīq* dated 1599, demonstrating that he was a contemporary of Kalender: Şevket Rado, *Türk Hattatları: XV. Yüzyıldan Günümüze kadar Gelmiş Ünlü Hattatların Hayatları ve Yazılarından Örnekler* (Istanbul, 1983–85), 84.

49. Apart from the seven-page preface, the album includes 166 images, 24 calligraphic specimens, and 11 text pages. The unfinished works are Safavid underdrawings of narrative scenes, with notes on the figures or furniture depicted therein giving the names of the colors they were to be painted (fol. 20a); these indicate that not all the images were specifically selected ones. Some of the Safavid underdrawings seem to have been painted or repainted by Ottoman artists (fols. 17a and 18b).

50. The so-called bazaar painters are thought to have been active from the seventeenth-century onwards, producing single-page pictures, albums, and costume books for a cosmopolitan clientele. These painters and their works still need to be thoroughly studied. The term was coined by Metin And, who introduced these painters and their works: Metin And, "17. Yüzyıl Türk Çarşı Ressamları," *Tarih ve Toplum* 16 (1985): 40–45.

51. The earlier one, attributed to the sixteenth-century Safa-
 vid artist Shaykhzade, who worked for Shah Tahmasp, his
 brother Ibrahim Mirza, and Shah Abbas I, is in the Sadrud-
 din Aga Khan Collection (Ir. M. 73). See Anthony Welch and
 Stuart Cary Welch, *Arts of the Islamic Book: The Collection of
 Prince Sadruddin Aga Khan*, exh. cat. (Ithaca and London,
 1982), 88–90, cat. 28, and Sheila R. Canby, *Princes, Poets &
 Paladins: Islamic and Indian Paintings from the Collection of
 Prince and Princess Sadruddin Aga Khan*, exh. cat. (London,
 1998), 65–66, cat. 40. For the signed copy of Riza-i 'Abbasi,
 which is now in St. Petersburg, The Hermitage (P2–1074),
 see Ivan Stchoukine, *Les peintures des manuscrits de Shāh
 'Abbās Ier à la fin des Safavīs* (Paris, 1964), 191, pl. XXXIIa,
 and Sheila R. Canby, *The Rebellious Reformer: The Drawings
 and Paintings of Riza-yi Abbasi of Isfahan* (London, 1996),
 69–72, cat. 39.

52. For costume albums and their contents, in addition to
 M. And's "17. Yüzyıl Türk Çarşı Ressamları," see Günsel
 Renda, "17. Yüzyıldan bir Grup Kıyafet Albümü," *17. Yüzyıl
 Osmanlı Kültür ve Sanatı Sempozyumu Bildirileri, 19–20
 Mart 1998* (Istanbul, 1998), 153–78; Leslie Meral Schick,
 "Ottoman Costume Albums in a Cross-Cultural Context,"
 *Art turc/Turkish Art. 10th International Congress of Turkish
 Art / 10e Congrès international d'art turc, Genève–Geneva,
 17–23 Septembre 1995, Proceedings / Actes*, ed. F. Déroche
 and C. Genequand (Geneva, 1999), 625–28; Leslie Meral
 Schick, "Meraklı Avrupalılar için Bir Başvuru Kaynağı:
 Osmanlı Kıyafet Albümleri," *Toplumsal Tarih* 106 (2003):
 4–9; Nermin Sinemoğlu, "Bir Osmanlı Kıyafet Albümünün
 Takdimi," *Mimar Sinan Üniversitesi Fen-Edebiyat Fakültesi
 Dergisi* 1, 1 (December, 1991): 204–12.

53. For these individuals, mostly young men (defined as city
 boys—*şehir oğlanları*) and women, and their presence
 in social life and literature, see Walter G. Andrews and
 Mehmet Kalpaklı, *The Age of Beloveds: Love and the Beloved
 in Early-Modern Ottoman and European Culture and Society*
 (Durham and London, 2005), 39–58, and Tülün Değirmenci,
 "An Illustrated Mecmua: The Commoner's Voice and the
 Iconography of the Court in Seventeenth-Century Ottoman
 Painting," *Ars Orientalis* 41 (2011): 193–94.

54. Ms. T. 439, fol. 12b. For the twelve folios from an album
 and a reproduction of the portrait, see V. Minorsky, with
 an introduction by J. V. S. Wilkinson, *The Chester Beatty
 Library: A Catalogue of the Turkish Manuscripts and Minia-
 tures* (Dublin, 1958), 68–71, pl. 34a. In light of the stylistic
 features of its paintings, the unbound Dublin album, which
 is smaller in dimensions, must be contemporary with, or
 slightly later than B. 408. The construction and layout of the
 folios are quite different from B. 408, although they share
 many similar images. It includes a black ink drawing of a
 fairy, which also attests to the interrelation between two
 albums. This bust drawing (fol. 11b) must have been copied
 from an original in B. 408 (fol. 9b) signed as "..... *Kalem-i 'Ali
 Beg*." For the reproduction, see Ünver, "L'album d'Ahmed
 Ier," 158.

55. See n. 52 above, and Metin And, "17. Yüzyıl Türk Çarşı
 Ressamlarının Padişah Portreleri," *Türkiyemiz* 58 (1989):
 4–13.

56. Fetvacı, "Love in the Album of Ahmed I," examines these
 paintings as images of daily life in Istanbul. She discusses
 their common focus on the theme of love, linking them to
 the literary interest of the age. Another group of paintings,
 smaller in size and depicting young men banqueting and
 reading books in meadows (fols. 16a, 17a, and 28a), is also
 displayed in the Dublin album, showing that this theme
 was fashionable at the turn of seventeenth century, in line
 with social trends. See n. 53 above.

57. The painter's other works are found in the second volume
 of the *Şehinşâhnâme* (Book of the King of the Kings), by the
 court historian Seyyid Lokman Ashuri, which recounts the
 history of the years 1580 to 1584. The illustrated copy, com-
 pleted in 1597–98, is in the Topkapı Palace Museum Library
 (B. 200). For the manuscript and its paintings, see Serpil
 Bağcı, Filiz Çağman, Günsel Renda, and Zeren Tanındı,
 Ottoman Painting (Istanbul, 2010), 153–57.

58. The text is identified by Değirmenci, *İktidar Oyunları*, 76.
 It is also mentioned in Fetvacı, "Album of Ahmed I," 132.

59. *Hünername*, vol. I: Istanbul, Topkapı Palace Museum
 Library, H. 1523, fols. 1b and 13b. See Bekir Kütükoğlu,
 "Şehnameci Lokman," in *Prof. Dr. Bekir Kütükoğlu'na
 Armağan* (Istanbul, 1991), 44, and Tahsin Öz, "Hünername
 ve Minyatürleri," *Güzel Sanatlar Dergisi* 1 (1939): 4. Two
 modern editions based on two different copies and dated
 1592 and 1599 suggest that the text was in circulation dur-
 ing these years. See Hasan ibni Mahmud-i Bayatî, *Câm-ı
 Cemâyin: Silsilenâme-i Selâtin-i Osmaniye*, ed. Ali Emiri
 (Istanbul [Dersaadet], 1915–16 [1331]), and *Câm-ı Cem-Âyîn*,
 ed. Fahrettin Kırzıoğlu (Istanbul, 1949).

60. For these portraits, see *The Sultan's Portrait: Picturing the
 House of Osman*, exh. cat. (Istanbul, 2000), 91, 271, cat nos.
 8 and 49.

61. Ibid., 272, cat. no. 50.

62. Folio 31, the only folio disturbing this order that features
 two calligraphic specimens, was most likely inserted
 between the decorative pages and the sultans' portraits by
 mistake, when it was reattached to the spine with a strip
 of marbled paper during a later restoration.

63. As mentioned above, the binding was repaired at an
 unknown time, which suggests that the order of the images
 may be attributed to a later intervention. Yet Kalender's
 apparently conscious approach to the organization of his
 albums leads us to believe that he was responsible for the
 order of the folios.

64. B. 408, fol. 1b. In her article on the album, Emine Fetvacı
 points to the emphasis on creation in the opening of the
 preface, and she aptly discusses the way the preface high-
 lights the importance of the visual arts: Fetvacı, "Album of
 Ahmed I," 128.

65. B. 408, fol. 2b: *dāyimā-cevāhir-i 'irfān-ı 'avārif ü le'ālī-i
 ma'ānī vü ma'ārif birle kalb-ı latīfleri memlū olmağile ol
 dürer-i gurer-i şanāyi' ü bedāyi'i sarāy-ı bī-'ayb u sarāperde-i
 lāreybde olan enfes-i nefāyis-i makālāt ü ahsen-i mahāsin-i*

muṣavverāt benāt-ı nükāta ḥilye-i ḥulel-i elfāẓ u ebṣārla zīver ü zīb verüp zīynet-i dil-fīrīb ile ḳulūb-ı cihānbānı fīrīfte ve ṭab'-ı ehl-i dilānı ālüfte vü āşüfte itmişlerdür.

66. The characterization of art as a means to wisdom is also included in the Safavid texts on art, such as Mir Sayyid Ahmad's preface to the Amir Ghayb Beg Album, dated 1564–65, which opens with a sentence stating this concept: see Thackston, *Album Prefaces*, 24. However, Kalender's text elaborates much more on this matter.

67. The association of the mirror reflection with painting is a common theme in Persian and Ottoman mystical literature. For a discussion of Persian examples, see Priscilla P. Soucek, "Nizami on Painters and Painting," in *Islamic Art in The Metropolitan Museum of Art*, ed. Richard Ettinghausen (New York, 1972), 11–15, and Roxburgh, *Prefacing the Image*, 181–89.

68. B. 408, fol. 2b.

69. Apparently these gifts also include the one presented by Kalender, as I mentioned above. Although the past participle form of the verb, *virdükleri* ("the ones that they gave"), denotes that the works were given to the sultan by the artists, the album includes some images and calligraphies executed in the fifteenth and sixteenth centuries that could not have been presented by the artists themselves. Rather, they were already housed in the treasury and inherited by Sultan Ahmed after his enthronement. This seemingly anachronistic statement can be interpreted as Kalender's approach to the Ottoman dynasty as a whole, with no differentiation made among the sultans.

70. Fol. 3a ... *'ömrlerin ve maḳdūrların ḥarc u ṣarf edüp yazup ve çizüp vücūda getürdükleri bīnaẓīr u bī'adīl ḫaṭṭ u taṣvīrler...*

71. Fol. 3a: ...*muḳaṭṭa'āt ve evrāḳ bir yere cem' olup her birisinin biri birisine münāsebeti ile tertīb olunup bir müzehheb vü mücelled vü mükellef muraḳḳa' olması...*

72. I did not come accross any source mentioning Muhammad Sharif, other than Kalender's statement.

73. Fols. 3a–b: *bu maḳūle üstād ḫaṭlarıyla olan muḳaṭṭa'āt u taṣvīrāt evrāḳını biri birisine münāsebeti ile envā'-i rengāmīz kāġıdlara vaṣl edüp muraḳḳa' itmegi...*

74. Fol. 3b: ...*muḳaddemā daḫi bir iki def'a cenāb-ı ni'me 'l-me'āblarıiçün ba'żı cüngler ü kitāblar te'līf ü tertīb ve taṣnīf ü tezyīb (tezyīn?) olındukda...*

75. Fol. 3b: *dāyire-i imkānda olan ṣanāyi'-i nādīde vü bedāyi'-i nāşenīde ḥarc u ṣarf idüp...*

76. Fol. 4a: *ebrī vü sulṭānī vü aḥmed-ābādī vü devlet-ābādī vü ḫutāyī vü 'adilṣāhī vü ḥarīrī vü semerḳandī*

77. Fol. 4a: *ṣan'at-ı vaṣṣālīde her bir ḳıṭ'anuň kenārlarına fereskūrī (?) alaca ḳumāş ṭarzında ikişer ü üçer ḳāt ḫurde evrāḳdur*

78. Fol. 4a.

79. Fol.4a: ... *çār güşeleri vü muḳābelesi cemī'an biri birisine eger renginde vü eger cirminde vü ṭūl-ı 'arżında muvāfiḳ u muṭābiḳ vāḳi' olmışdur...*

80. Fol. 4a.

81. Istanbul, Topkapı Palace Museum Library, Album H. 1703. Apart from general publications on Ottoman painting, for

essays focusing on the manuscript, see Nureddin Sevin, "A Sixteenth-Century Turkish Artist Whose Miniatures Were Attributed to Kalender Paşa," in *IVème congrès international d'art turc: Aix-en-Provence, 10–15 septembre 1971* (Aix-en-Provence, 1976), 209–16, and Serpil Bağcı, "Falnama of Ahmed I (H. 1703)," in Farhad with Bağcı, *Falnama*, 68–75.

82. Rather than repeating a standard text or a pictorial cycle, the copies of the *Fālnāme* are examples of a literary genre. Six versions have survived other than Kalender's, all in Persian. Each one of these constitutes an original work independent of the others, even as they are also directly linked to one another, and all of them are nurtured by a common oral, written, and visual culture. Three important examples were exhibited between October 2009 and January 2010 at the Arthur M. Sackler Museum at the Smithsonian in Washington, D.C. For the historical, social, and cultural contexts, and for an extensive bibliography on *Fālnāme*s, see the catalogue published with the exhibition: Farhad with Bağcı, *Falnama*. Sergei Tourkin's English translation of Kalender's preface to the *Fālnāme* is also included. All of the interpretations made here regarding Kalender's *Fālnāme* draw on the exhibition catalogue. In the present essay I will briefly explain the content of the *Fālnāme* and focus on its introduction.

83. For the Persian Topkapı *Fālnāma*, which may have served as a model of inspiration for Kalender's royal gift, see Serpil Bağcı and Massumeh Farhad, "The Topkapı Persian Falnama (TSM H. 1702)," in Farhad with Bağcı, *Falnama*, 52–59.

84. Evliya Çelebi b. Derviş Muhammed Zıllî, *Evliya Çelebi Seyahatnâmesi: Topkapı Sarayı Bağdat 304 Yazmasının Transkripsiyonu, Dizini*, 10 vols. (Istanbul, 1996–2007), vol. 1 (ed. Orhan Şaik Gökyay), 292. For the English translation of Evliya's passage, see Farhad with Bağcı, *Falnama*, 28.

85. For Nakşî (d. after 1622) and his paintings, see Esin Atıl, "An Eclectic Painter of the Early 17th Century," in *Fifth International Congress of Turkish Art*, ed. G. Fehér. (Budapest, 1978), 103–22; Bağcı, Çağman, et al., *Ottoman Painting*, 212–27; Değirmenci, *İktidar Oyunları*, 309–17. On Hasan Pasha (d. ca. 1620), whose career and surviving works are better known, see Zeren Akalay (Tanındı), "XVI. Yüzyıl Nakkaşlarından Hasan Paşa ve Eserleri" in *I. Milletler Arası Türkoloji Kongresi: İstanbul, 15–20 X. 1973; Tebliğler*, 3 vols. (Istanbul, 1979), 3:607–625; Bağcı, Çağman, et al., *Ottoman Painting*, 178–85, 188–211; Emine Fetvacı, *Picturing History at the Ottoman Court* (Bloomington, Ind., 2013), 258–65.

86. ...*cemāl-i ferḫunde-fāl-i Ādemi maṭla'-ı vücūd-ı ġurre-i ġarrā-yı ẓuhūr u şühūd idüp ṣūret-ḫāne-i kā'ināta anuňla revnaḳ ü ṣafā virmişdür*: fol. 3b, "Appendix A.3: The Falnama of Ahmed I (TSM H. 1703)," trans. Sergei Tourkin, in Farhad with Bağcı, *Falnama*, 295.

87. ...*ve vaḥdāniyyet-i ẕāt-ı bī-miṣāline delīl-i vāżıḥ olmaġiçün ḳalem-i ḳudretiyle ṣaḥā'if-i leyl ü nehāra hey'et-i kevākib-i şevākibla ziynet ü bahā artdurmışdur*: fol. 3b, "Appendix A.3: The Falnama of Ahmed I," trans. Tourkin, 295.

88. Fols. 17b–18a, 28b–29a, 30b–31a, and 39b–40a.

89. *Ey cemāl [-i]cemīl-i mülk-i celāl / Pertevünle cihān humāyūn-fāl*
Ṣūret-ārā-yı kārgāh-ı vücūd / Muḥbir-i ḥāl-i ḳavm-i ʿĀd u Ṡemūd
Maʿnīde bir kitābdur ʿālem / Anda meṡtūr ḥasb-ı ḥāl-i ümem
Anuñ evrāḳıdur ṣabāḥ u mesā / Hem muṣavver içinde ḫavf u recā
Ḳıl tefeʾül nedür murāduñ gör / Ṣūret-i mebdeʾ [ü] maʿāduñ gör: fols. 3b–4a, "Appendix A.3: The Falnama of Ahmed I," trans. Tourkin, 295.

90. *Yeṡrib ve Baṭḥā büt-ḫānelerinde olan aṣnām-ı küfr ü āṡāmı Yadu Allāhi fawqa ʿaydīhim mażmūn-ı şerīfi ḳuvveti ile pest ü şikest idüp münkir-i dīn-i Ḥaḳḳ olanları ṭarīḳ-i şerāyiʿ-i İslām ve īmāna getürmişdür*: fol. 4a: "Appendix A.3: The Falnama of Ahmed I," trans. Tourkin, 295.

91. In the original story of Saʿdi, the event takes place in Sumnat, India, and the poet disguises himself as an Indian monk: Saʿdī, *Morals Pointed and Tales Adorned: The Būstan of Saʿdī*, trans. G. M. Wickens (Toronto and Buffalo, 1978), tale 140. Kalender's image, which portrays the poet in Chinese garb, draws upon the fifteenth-century Chinese royal grooms included in the famous Bahram Mirza Album and the so-called Yaqub Bey or Saray Albums of the Topkapı Palace (H. 2154, H. 2153, and H. 2160): see Çağman, "On the Contents of the Four Istanbul Albums," 35, figs. 83–86. It was modified by adding a small shrine with an idol at the top right corner, on the sight line of Saʿdi. And in turn, Kalender modifies Saʿdi's text, this time in order to conform with the painting, and transports the setting to China. For the painting, its interpretation, and the full text of the augury, see Farhad with Bağcı, *Falnama*, 148–49, 297.

92. Safi recounts that since it was unlawful (*ḫilāf-ı meşrūʿ*), the sultan did not tolerate the "images of forms and assemblage of representation of figures" (*ṣuver-i eşkāl ve cemʿiyyet-i şuḫūṣ-ı timṡāl*) near the abode of worship, and grabbed an ax and smashed those representations of idols (*temāṡil-i aṣnām*). İbrahim Hakkı Çuhadar, *Mustafa Sâfî'nin Zübdetü't-tevârîh'i*, 2 vols. (Ankara, 2003), 1:36.

93. *Nūr urur şemʿ-i cemālinde berḳ / Nūrdan itmez yüzüni kimse farḳ*
Ṣūret-i ḥāl-i rüsül-i mā-sebaḳ / Vaṣf-ı kemālinden anuñ bir varaḳ: fol. 4a, "Appendix A.3: The Falnama of Ahmed I," trans. Tourkin, 295.

94. *Maḳṣadınā inna tawassul ilayh / Rabbi uṣallā wa uṣallam ʿaleyh*
Wa ʿalā ālihiʾl-kirām / Wa aṣḥābihi wa atḳiyāʾiʾl-ʿiẓām: fol. 4a–b: "Appendix A.3: The Falnama of Ahmed I," trans. Tourkin, 295–96.

95. Kalender's use of the word "*taḥrīr*" implies a connection to both writing and drawing, indicating that such pages (books) commissioned by past rulers included both texts and images.

96. *Bu muḳaddimāt-ı belāġat-simātuñ tertīb ü taḳdīminden murād ve bu ṣuver ü eşkāl günāgunuñ cemʿ ü telfīḳ olunmasından müddeʿā-yı fuʾād oldur ki ḳadīmüʾz-zamāndan feżā-yı ʿāleme ḳadem baṣup ve aḥvāl-i ʿāleme ʿibret gözüyle baḳup ṣuret-i ḥāli fehm ü izʿān iden erbāb-ı*

ʿirfān ve āṣḥāb-ı ẕevḳ u vicdān bunı muḳarrer bilmişler ki aḥvāl-i selef kişiye düstūruʾl-ʿamel olup her mühimde geçenlerden sebaḳ almaḳ münāsibdür. Ḫuṣūṣen sebeb-i niẓām-ı mülk ü millet ve bāʿiṡ-i aḥkām-ı esās-ı reʿāyā vü memleket olan selāṭīn-i ʿiẓām ve mülūk-i ʿsālī-maḳāma lāzımdur ki ḳıṣaṣ-ı enbiyā vü evliyāya ve sergüzeşt-i ümerā-yı māżiyyeye naẓar idüp ve bidāyet ü nihāyetlerin mülāḥaẓa eyleyüp ʿāḳibet-i umūrların anlardan ḳıyās ü idrāk eyleyeler. Ol taḳdīr üzere selāṭīn-i māżiyyenüñ serīr-i devletde iken vāḳiʿ olan veḳāyiʿi heyʾetin īmā vü işāret ile baʿżı evrāḳa taḥrīr itdiler ki tefeʾül ṭarīḳiyle ol evrāḳdan her ḳangı varaḳ ki açıla, ṣāḥib-i fāl ol varaḳda enbiyā vü selāṭīn aḥvālinden her ne ki meṡtūr ve muṣavver ise kendü ḥālin ana taṭbīḳ idüp murādı olan umūrı ol aḥvālden ḳıyās eyleyüp mūcibi ile ʿamel ḳıla: fols. 4b–5a, "Appendix A.3: The Falnama of Ahmed I," trans. Tourkin, 296.

97. *İster iseñ kim saña efzūn ola ḳudr ü şeref / Dāʾimā manẓūruñ olsun vāḳıʿāt-ı mā-selef*: fol. 5a, "Appendix A.3: The Falnama of Ahmed I," trans. Tourkin, 296.

98. The word "*yümn*" means both auspicious and the right-hand side. The fact that the image appears on the right when the book is opened demonstrates that Kalender uses the word in both meanings.

99. *...sulṭān bin es-sulṭān veʾl-ḥāḳān bin el-ḥāḳān Sulṭān Ahmed Ḫān... ḥażretlerine tuḥfe ve hediyye olmaḳ içün bu faḳīr [ü] ḥaḳīr [ve] kemter ü aḥḳar-ı ʿubeyde vü ḥademe ve eḳall-i memlūke ve ḥaşeme veʾl-mustaġrıḳ be-nevāl-i berre ve kereme beyneʾl-vüzerāʾiʾl-muvaḳḳar, aʿnī bu ʿabd-i Kalender zikr olunan evrāḳ ü elvāḥ-ı muṣavveri müzehheb ü muḥarrer cemʿ ü tedvīn ve tertīb ü tezyīn idüp muʿriż-i humāyūnlarına ʿarż eyledi ki her ne niyyet-i humāyūnları olup tefeʾül murād buyurdukda evvelā sūre-i Fātiḥa ve üç İḫlāṣ okuyup ve üç ṣalavāt-ı şerīfden ṣoñra tefeʾül eyleyeler. Her niresinden açarlar ise yukarıda zikrolunan vech üzere ol varaḳ-ı muṣavver ü mücedvel manẓūr-ı enẓār-ı ʿaliyye-i bī-bedelleri olduḳda ṣaḥīfe-i yümnisinde meṡtūr olan ṣuver-i enbiyā vü aṣfiyādan ṭabʿ-ı şerīflerine füyūżāt-ı vāfire ve berekāt-ı mütekāṡire ḥāṣıl olup tefeʾülleri murād-ı humāyūnlarına muvāfıḳ ve istiḫāre vü istişārelerine muṭābıḳ ola*: fol. 6a, "Appendix A.3: The Falnama of Ahmed I," trans. Tourkin, 296.

100. *Yā Rabb ṣaḥīfe-i felek üstünde ber-ḳarār / Olduḳça ṣūret-i meh ü encümle āfitāb Çekdükçe ṣubḥ levḥine cedvel ufuḳ müdām / Şengerf ezüp şafaḳ ide gerdūnı bir kitāb Fālı mübārek ola şehinşāh-ı ʿālemüñ / Her niyyeti ki ide yaḳīn ola fetḥ-i bāb*: fol. 6a, "Appendix A.3: The Falnama of Ahmed I," trans. Tourkin, 296.

101. On the close relationship between Mustafa Agha and Osman II during the latter's reign and the illustrated manuscripts that Mustafa Agha commissioned to present to the sultan, see Değirmenci, *İktidar Oyunları*, 79–116. For Mustafa Agha's active involvement in Sultan Osman's enthronement, see also Baki Tezcan, "Searching for Osman: A Reassessment of the Deposition of the Ottoman Sultan Osman II (1618–1622)" (PhD diss., Princeton University, 2001), 155–66.

102. On the illustrated copies of Medhî's translation and Mustafa Agha's patronage, mentioned in the preface of the text,

see Tülün Değirmenci, "'Legitimizing' a Young Sultan: Illustrated Copies of Medhî's 'Şehnâme-i Türkî' in European Collections," in Dávid and Gerelyes, *Thirteenth International Congress of Turkish Art*, 157–72.

103. For the list of the works included, see *Catalogue of Highly Important Oriental Manuscripts and Miniatures*, Sotheby's (London), 6 December, 1967, pp. 75–76, lot 213.

104. The provenance of the Safavid album pages from the Metropolitan volume is traced by David J. Roxburgh in his article on Martin's involvement in the dispersal of the Bahram Mirza Album in the Topkapı Palace: see David J. Roxburgh, "Disorderly Conduct?: F. R. Martin and the Bahram Mirza Album," *Muqarnas* 15 (1998): 32–57. Roxburgh also mentions the similarity between some of the folios in the Bellini volume and the album pages made during Sultan Ahmed I's reign, like those of B. 408; he quotes Martin's attribution of the compilation of the Bellini Album to the 1600s, for Ahmed I.

105. F. R. Martin, *The Miniature Painting and Painters of Persia,*

India and Turkey, from the 8th to the 18th Century (London, 1912), 59.

106. F. R. Martin acknowledged the virtuosity of these compositions, which he reproduced in his book: ibid., pl. 269.

107. The album (Vienna, Österreichische Nationalbibliothek, Codex Mixtus, 313), including a copy of a Persian preface that was originally composed for an album for Mir Ali Shir Nawa'i, is dated 1572 and dedicated to Murad III (r. 1574–95). See Dorothea Duda, "Das Album Murad III in Wien," in *Ars Turcica: Akten des VI. Internationalen Kongresses für Türkische Kunst, München vom 3. bis 7. September 1979*, ed. Klaus Kreiser, 3 vols. (Munich, 1987), 2:475–489; Aimée Froom, "Adorned like a Rose: The Sultan Murad III Album (Austrian National Library, Cod. Mixt. 313) and the Persian Connection," in "Pearls from Water, Rubies from Stone: Studies in Islamic Art in Honor of Priscilla Soucek," part 1, ed. Linda Komaroff, special issue, *Artibus Asiae* 66, 2 (2006): 137–54. For the text of the preface, see Thackston, *Album Prefaces*, 30–31.

GÜLRU NECİPOĞLU

"VIRTUAL ARCHAEOLOGY" IN LIGHT OF A NEW DOCUMENT ON THE TOPKAPI PALACE'S WATERWORKS AND EARLIEST BUILDINGS, CIRCA 1509

This article, which I dedicate to Dr. Filiz Çağman, introduces an unpublished document concerning the water distribution network of the Topkapı Palace. Preserved in the Topkapı Palace Museum Archive, the document examined here sheds light not only on the palace's waterworks, but also on the locations and names of its earliest buildings (see appendix). It is undated, but as we shall soon see, certain clues in the text suggest that it was written immediately after the great earthquake of 1509, known as the "Little Apocalypse" (ḳıyāmet-i ṣuġrā). The heading of the document reads: "Description of the fountains and water jet fountains, some of which have been flowing since olden times and some of which were added later" (Tafṣīl-i çeşmehā ve şādırvānhā ki ba'żı ḳadīmden aḳagelmişdür, ve ba'żı ṣoñradan olmışdur). This oldest written source on the hydraulic landscape of the Topkapı Palace during the reigns of Mehmed II (r. 1444–46; 1451–81) and his successor, Bayezid II (r. 1481–1512), lists the palace's water towers, distribution chambers, cisterns, water jet fountains, fountains, and faucets. It thus elucidates the original layout of the palace complex in that period, confirming the hypothetical reconstruction proposed years ago in my dissertation and subsequent book on the subject.[1]

Of the documents published thus far on the water supplies of the Topkapı Palace, the earliest dated example is the distribution register (tevzī' defteri) of the Kırkçeşme and Kağıthane waters that was prepared in 1568–69 (976) by the chief architect Sinan (d. 1588). The Kırkçeşme system, supplied from the Cebeciköy area, was renovated by Mehmed II and further expanded by Sinan with new sources from the Belgrade forest. Its waters, which entered the city from the gate of Eğrikapı and ran along steep slopes overlooking the Golden Horn, collected in the sixth-century Basilica Cistern (Yerebatan Sarayı). Because the Kırkçeşme waters were lower than the main courts of the Topkapı Palace, they first filled wells before being lifted to the correct height by water wheels.[2]

Another early source is the water distribution map drawn in 1584 by the architect Davud (d. 1598), a former superintendent of imperial water channels. The map exists in two copies and shows the Halkalı Channel's "imperial" (mīrī, also known as ḫāṣṣa or beylik) branch, up to the point where it reaches the Old Palace (eski sarāy), built for Mehmed II in the 1450s. An inscription on the map indicates that since the reign of Mehmed this branch had provided the waters of the "imperial palace" (sarāy-ı 'āmire), namely, the Topkapı Palace, constructed by the same sultan between 1459 and 1478. (It was originally called the "New Palace" [yeñi sarāy], in relation to the old one at the center of the city.) The water carried by the imperial branch of the Halkalı Channel entered the city from the Edirne Gate and passed over the fourth-century Aqueduct of Valens (Bozdoğan Kemeri, renovated by Mehmed II) before reaching a distribution chamber (maḳsem) located at a corner of the Old Palace's walled enclosure. From here it was distributed to various other locations, including the Topkapı Palace. Unfortunately, the part of the map showing the continuation of the channel's imperial branch to the Topkapı Palace is absent.[3] This missing section of the conduit is, however, recorded in later maps of the Halkalı Channel dated 1607 (1016) and 1748 (1161), which indicate that its water flowed from a water tower near Hagia Sophia to other water towers and distribution chambers within the palace grounds (fig. 1).[4]

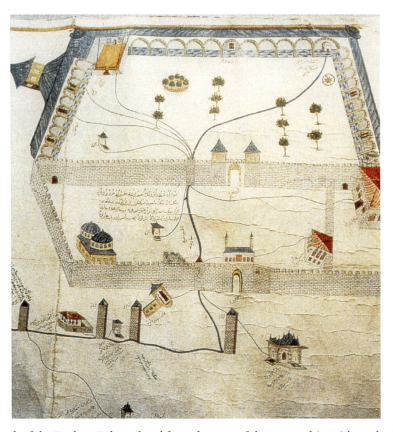

Fig. 1. Hydraulic network of the Topkapı Palace: detail from the map of the imperial (*mīrī*) branch of the Halkalı Channel, dated 1161 (1748). Istanbul, Topkapı Palace Museum Library (TSMK), H. 1815. (Photo: courtesy of Ersu Pekin)

The document under examination here records the rehabilitation of the Topkapı Palace's waterworks in the aftermath of the 1509 earthquake. Later, in the 1520s, the chief architect 'Alaüddin (d. 1539, nicknamed 'Acem 'Ali, or Persian 'Ali) would reconfigure this hydraulic system when he renovated the palace complex to reflect the changing notions of splendor that marked the reign of Süleyman I (r. 1520–66).[5] Our document is thus significant for understanding the water distribution networks of the palace before this far-reaching Süleymanic rebuilding campaign. After the heading quoted above, the document lists eighteen fountains of different types. It should be noted at the outset that the term *şādırvān*, though usually associated with ablution fountains, is used here for water jet fountains that spout water into basins, as opposed to regular fountains designated by the term *çeşme*, whose water flows from spigots. The term *muşluḳ*, on the other hand, denotes a simpler, util-itarian faucet. An explanation at the end of the list of fountains reveals that the document was a petition presented to an unnamed sultan in order to outline the proposed distribution method and amount of water to be provided to each of the eighteen outlets. The author may have been the chief of water channels (*ser-rāh-ı āb, ṣuyolcı başı*), or the agha of the palace (*sarāy aġası*), who was responsible for construction projects at the Topkapı Palace.[6]

According to the document, the amount of "imperial water" (*ḫāṣṣa ṣu*) brought to the palace from afar measured ten *lüle*s (a *lüle* being a spout or pipe of standard diameter, 73.58 millimeters, for measuring the amount and rate of waterflow). These ten *lüle*s comprised six *lüle*s and another four *lüle*s of water, each amount brought to the palace by a different architect, whose identities will be discussed below. We learn that the six *lüle*s of water from an unspecified *ayāzma* (sacred

spring), which previously supplied the palace, was no longer sufficient. It is unclear whether these six *lüles* are the same as those mentioned above (as part of the ten *lüles*), or whether they constituted an extra amount of water, adding up to a total of sixteen *lüles*. It is more probable, however, that only four *lüles* were added to the former water supply, and that the old subterranean water channel carrying the six *lüles* was perhaps renewed after being damaged during the 1509 earthquake. The two conduits that brought the ten *lüles* of imperial water to the Topkapı Palace were probably the Halkalı and Kırkçeşme Channels, which in later periods conducted approximately the same amount of water to the palace.[7]

Because our document relates only the manner of distributing the ten *lüles* of water brought to the palace by the two architects, it does not list water wells and cisterns supplied by rainwater or natural springs located within the palace grounds. Only five cellars (sing. *bodrum*) are mentioned at the end. These the sultan had ordered to be used as cisterns for watering the palace's outer garden: "It has been ordered that the aforesaid cellars, which are to be filled with rain water in winter and with the water brought to the palace, must be used for the garden. [But] except in winter, when water is plentiful, it is impossible at other times for water to collect in them as ordered."

Before identifying the waterworks listed in the document, more must be said about its explanatory section, in which it is proposed that the ten *lüles* of water should be distributed from an "outside" water tower (*terāzū*) to other water towers and distribution chambers (*maksem*) located within the inner core of the palace complex. Into each of the water towers and distribution chambers would be placed *lüle* pipes of full-, half-, and quarter-sized diameters, in order to control the amount of water supplied to designated fountains. It is suggested that this work be carried out without changing the palace's existing subterranean water channels (*su yolları*). The lack of any reference in the document to newly built water towers implies that they too were probably already in place at the time it was written. Curiously, the explanatory section of the petition is in the present tense rather than the future, as one would expect from a project proposal. It translates as follows:

Some of this water is [to be] distributed to its location [directly] from the water tower (*terāzū*) on the outside; and some of it comes from the outside water tower to a water tower in the vicinity of the Timber Frame Palace (*çatma sarāy*) and is distributed thence; and some of it comes to a water tower in the vicinity of the Large Chamber (*büyük oda*) and is distributed thence; and some of it comes to a water tower in the vicinity of the fountain of the stables and is distributed thence. If approved by the Sublime Command, let there be no intervention whatsoever to the [existing] water channels (*su yollarına*), let the water be apportioned to each [tower's] distribution chamber (*maksem*) from the outside water tower, and after sufficient water has reached the other water towers, it should be distributed from those water towers to each appointed place. And small *lüle* pipes should be installed so that, God willing, the aforesaid quantity of water continually flows through each of them. And in this distribution [system], which has been petitioned, some [places] have been apportioned full *lüles*, some half *lüles*, and others quarter *lüles*. [In sum:] the water flowing from the outside water tower measures ten *lüles*; for these ten *lüles* of water, there are separate water towers; and when two [*lüles*] of water collect in the same place, in order to know the amount whenever one takes a look, there are water towers and *lüle* pipes from which the water is distributed. Of these said ten *lüles* of imperial water, six *lüles* is the water brought by the architect ʿAcem [ʿAli], and four *lüles* by the architect Hamza. The *ayāzma* water was what previously flowed to the imperial palace. Now this *ayāzma* water is a quantity of water measuring six *lüles*; it is no longer sufficient for the designated places. There appears to be no possibility other than what is petitioned [here]. The command is His Majesty's, the Refuge of the Universe, to make.

There are two clues here to help us date the document: first, the names of the architects who brought the waters, and second, the inclusion of the Timber Frame Palace (*çatma sarāy*) among the places mentioned within the palace complex. This no-longer-extant timber frame structure was built for Bayezid II after the earthquake of 1509. According to Ruhi Edrenevi, the chronicler of that period, the Byzantine sea walls on the Marmara side of the Topkapı Palace collapsed during the earthquake. While no damage came to the sultan's actual residence—the domed Privy Chamber complex at the far left corner of the third court—the bath on the right-hand side of the same court developed cracks and had to be repaired (fig. 2a [C], and 2b [48–53, 38]): "And there being no defect in the actual domed palace (*aṣıl*

Fig. 2, a and b. Hypothetical reconstruction plans of the Topkapı Palace, ca. eighteenth and nineteenth centuries, with numbers and letters added in accordance with pls. 10 and 11 in Gülru Necipoğlu, *Architecture, Ceremonial, and Power: The Topkapı Palace in the Fifteenth and Sixteenth Centuries* (Cambridge, Mass., and London, 1991).

Fig. 2a. Hypothetical reconstruction plan of the palace precinct, identifying only the places mentioned in this article: A) first court; B) second court; C) third court; D) walled private garden terraces adjoining the third court; 1) Imperial Gate; 4) Gate of the Cold Fountain (Soğukçeşme Kapısı); 7) Iron Gate; 9) storehouse for wood; 10) Hagia Irene (armory); 11) court workshops; 12) terrace gate of the Tile Palace (Çinili Köşk); 14) gates to the courtyard of the stables; 19) Corps of the Water Wheel; 20) gate between the pantry and the Corps of the Water Wheel; 21) Middle Gate; 22) Gate of Felicity; 26) Column of the Goths; 28) site of the İshak Pasha Pavilion; 31) Christos Sotiros Spring (Ayazma Christos Sotiros); 37) site of the Byzantine church that was converted into an aviary; 39) Museum of the Ancient Near East; 41) Tile Palace (Çinili Köşk); 44) site of the Shore Kiosk (Yalı Köşkü); 46) site of the imperial boathouses; 47) site of the dormitory of royal gardeners; 48) Seraglio Point (Saray Burnu).

Fig. 2b. Hypothetical reconstruction of the second and third courts of the Topkapı Palace, identifying only the spaces mentioned in this article: A) second court; B) third court; C) Harem with walled private garden; D) walled private garden terraces adjoining the third court; 1) Middle Gate; 6) gate between the pantry and Corps of the Water Wheel; 7) pantry gate; 8) gate of the imperial kitchen; 9) gate of the confectionary; 10) courtyard of the kitchens; 11) courtyard of the stables; 13) gate of the stables, connected to the terrace of the Tile Palace (Çinili Köşk); 25) Old Council Hall; 26) water distribution tank, known as Silver; 27) Gate of Felicity; 33) Large Chamber; 34) small garden of the bath furnace; 35) Chamber of Petitions; 37) site of the Pool Pavilion (Havuz Köşkü), now occupied by the eighteenth-century library of Ahmed III; 38) site of the bath, now occupied by the eighteenth-century Chamber of the Expeditionary Force; 39) portico of the Treasury-Bath complex; 40–45) Treasury-Bath complex: 42) loggia of the treasury, 45) disrobing chamber of the bath; 46) dormitory of pantry pages; 47) dormitory of treasury pages; 48–53) Privy Chamber complex: 50) throne hall, 51) Antechamber of the Water Jet Fountain (Şadırvan Sofası); 54) pool of the marble terrace; 55) marble terrace; 56) walled private garden terrace adjoining the third court; 57) lower terraces of the walled private garden adjoining the third court; 60) Mecidiye Kiosk, built over the basement of a late fifteenth-century pavilion; 66) tower kiosk of Selim III; 67–69) Courtyard of the Favorites: 69) large pool in front of the Courtyard of the Favorites; 70) walled private garden of the Harem; 71) large pool at the Courtyard of the Favorites, under the bedroom pavilion of Murad III.

ḳubbe sarāyları) of the Sultan of Rum, Sultan Bayezid, Almighty God protected it, and it remained intact. But there was an inner bath (*içerü ḥammām*) on which some cracks appeared, and they resolidified it." The sultan immediately moved to Edirne and returned to the Topkapı Palace about two months later, In 1510, taking up residence in the newly completed Timber Frame Palace (*çatma sarāy*, also referred to as *çatma evler*, Timber Frame Houses).[8]

Designed to withstand earthquakes, this timber frame (*çatma*) construction was most probably located in the walled private garden terraces adjoining the third court, which extend in front of the Privy Chamber complex and Harem quarters (fig. 2b [C, D]).[9] The core of the Harem dates back to Mehmed II's period, for Kritovoulos and Jacopo de Promontorio de Campis, writing in 1465 and 1475, respectively, tell us that women, too, were living at the Topkapı Palace. If we are to locate the Timber Frame Palace within the garden of the Harem, it is the only structure mentioned in our document to which water was allocated in that area, suggesting that the women's quarters were relatively small and probably supplied by nearby cisterns or wells. When Sultan Süleyman ordered the aforementioned renovation and expansion of the Harem quarters, then known as the Palace of the Girls (*sarāy-ı duḥterān*), among the structures added was a timber frame house (*ḥāne-i çatma*). It is unclear whether this structure, located in the walled Harem garden—perhaps near today's Courtyard of the Favorites (fig. 2b [67–69])—was a renovated version of the one built for Bayezid II.[10]

According to Ruhi Edrenevi, immediately after Bayezid II moved into the newly completed timber frame structure in 1510, he "made repairs to the Old Palace and ordered that water be brought to it."[11] As mentioned earlier, the Old Palace received its water from the Halkalı Channel through the Aqueduct of Valens, part of which had been damaged by the earthquake. A swamp formed around a section of the aqueduct that had collapsed, in the vicinity of the Old Palace.[12] The consequent repairs most likely entailed extending the damaged water channel to the New Palace, where the sultan was residing. In a register of royal gifts (*inʿām defteri*) pertaining to Bayezid II's reign, we find mention of rewards given to those who worked on "the new water channel" (*rāh-ı āb-ı cedīd*), also referred to as "the imperial water channel" (*rāh-ı āb-ı ḥāṣṣa*), which was completed in 1511. Those who were carrying out repairs at the Topkapı Palace also received bonuses.[13]

Several months before the new water channel was completed, rewards were conferred on individuals involved in the addition of a massive buttress to the garden façade of the damaged bath in the third court of the Topkapı Palace: "buttress of the wall of the imperial palace" (*ṭayama-i dīvār-ı sarāy-ı ʿāmire*). An elevation drawing of that "buttress" (*ṭayama*) is annotated with the details of its position, dimensions, and cost. This drawing, executed on a sheet of early sixteenth-century Italian-watermarked paper, is housed in the palace archive (fig. 3).[14] While old photographs show the buttress in its entirety (fig. 4), only the lower part now remains.[15] The elevation drawing, which depicts the buttress together with the bath's garden façade, identifies a domed hall with three double-tiered windows as "the disrobing chamber of the bath" (*ḥammām cāmekānı*). Written under a double-tiered window of the adjacent hall on the right are the words "imperial treasury" (*ḥizāne-i ʿāmire*), and over the wall shown on the far left is an inscription stating, "This is the curtain wall at the edge of the kitchen" (*bu maḥal maṭbaḥ kenarınuñ germesidür*). These annotations prove that the building that adjoins the bath and is known today as the Fatih Köşkü (Mehmed the Conqueror's Pavilion) was already in use at that time as the imperial treasury of the inner palace. The annotations also reveal that the courtyard of the kitchens in the second court extended, as now, up to the curtain wall (*germe*) separating the second and third courts (fig. 2b [10]).

The repair of the bath must have overlapped with the renovation of the palace's waterworks. Among the individuals Bayezid II rewarded in 1511 for their work on the imperial water channel were thirty-five "water channel builders" and their chief, the architect Miʿmar Hayrüddin, who perhaps prepared our document. The royal architects who received rewards in the same year included Miʿmar ʿAli bin ʿAbdullah and his son Miʿmar Hamza.[16] I believe that this father-son pair are the two architects mentioned in our document as having brought ten *lüle*s of water to the Topkapı Palace: ʿAcem Miʿmar and Miʿmar Hamza. The architect referred to as

Fig. 3. Elevation drawing of the buttress on the garden façade of the bath in the third court of the Topkapı Palace, ca. 1509–11. Istanbul, Topkapı Palace Museum Archive (TSMA), E. 12307, no. 2. (Photo: courtesy of the Topkapı Palace Museum Archive)

Fig. 4. Old photograph of the Topkapı Palace from the Sea of Marmara, showing the sea walls, the Treasury-Bath complex before its restoration in the 1940s, and the kitchens. (After Sedat Hakkı Eldem and Feridun Akozan, *Topkapı Sarayı: Bir Mimari Araştırma* [Istanbul, 1981], pl. 168)

'Acem Mi'mar must be Mi'mar 'Ala'üddin, whose nick-
name was 'Acem 'Ali (Persian 'Ali). Bayezid II's gift reg-
ister calls him both Mi'mar 'Ali bin 'Abdullah and
Mi'mar 'Ala'üddin Halife.[17] He was the leading assistant
(ḥalīfe) to the chief architect, Mi'mar Ya'qub Şah bin
Sultan Şah, during the construction of this sultan's
mosque (1501–5) in Istanbul before the earthquake. Rıfkı
Melul Meriç, who published certain sections of the gift
register, hypothesized that Mimar 'Ali bin 'Abdullah
must have inherited the post of chief architect from
Ya'qub Şah, who no longer appears in the register after
1509 and may have died around that time.[18]

This theory was also taken up by Aydın Yüksel: "Even
though it is argued that 'Acem 'Ali came to Istanbul with
the Iranian campaign of Selim the Grim (r. 1512–20), we
regard him as the leading assistant to the chief archi-
tect Ya'qub Şah bin Sultan Şah during the construction
of Bayezid II's mosque complex in Istanbul. 'Acem 'Ali
served as assistant architect in the reign of Bayezid II
and then probably as chief architect from 1510 until his
death in 1537 [sic, actually ca. 1538–39], in the course of
Selim I's reign and the early part of Sultan Süleyman's."
I am also of this opinion.[19] To begin with, 'Acem 'Ali is
not listed among the masters of the arts whom Selim I
brought back from Tabriz in 1514.[20] And though the
exact year of his appointment as chief architect is
unknown, wage registers from the 1520s and '30s refer
to him as the "chief of architects, 'Ala'üddin" (ser-
mi'mārān 'Alā'üd-dīn).[21] That he was also called 'Acem
'Ali is known from his 1525 waqfiyya (endowment deed),
as well as from the subsequent chief architect Sinan's
Teẕkiretü'l-Bünyān (Biographical Memoir of Construc-
tion), datable to the 1580s. The waqfiyya, which is writ-
ten in Arabic, refers to 'Acem 'Ali as 'Ali bin 'Abd
al-Karim, whereas he is named 'Ali bin 'Abd al-Wahhab
in his second waqfiyya, dated 1537, and 'Ali bin 'Abdullah
in the gift register discussed above. The use of multiple
patronymics undermines the prevalent assumption—
not based on any document—that 'Acem 'Ali was an
Azeri Turk from Tabriz, and instead indicates that he
was an Iranian convert to Islam, possibly an Armenian
like his master, Ya'qub Şah, whose nephew resided in
Amasya.[22]

The 1537 waqfiyya of 'Acem 'Ali mentions a son by
the name of Hamza Çelebi, who is surely to be identi-

fied with the architect called Hamza in our document
and in Bayezid II's gift register. Hamza is not listed as
either an architect or a water channel builder in the
wage registers for the years 1523 to 1537.[23] Given that
he was still living in 1537, when 'Acem 'Ali's second
waqfiyya was written, Hamza may have changed pro-
fessions or moved to another region before 1523. This
provides a terminus ante quem for our document. More
specifically, I believe that it was presented as a petition
to Bayezid II sometime between 1509 and 1511, when the
buttress of the palace bath and the new imperial water
channel were being constructed.

As chief architect in the 1520s, during the early part
of Sultan Süleyman's reign, 'Acem 'Ali was entrusted
with the extensive renovation of the Topkapı Palace and
its waterworks, alluded to above. Like his successor,
Sinan, and the latter's immediate successors, then, this
architect was a preeminent hydraulic engineer, an
expertise demonstrating the immense value attached
to waterworks in Ottoman architectural practice.[24]
Hydraulic engineering projects involved the application
of fluid mechanics principles in the collection, trans-
portation, storage, measurement, distribution, and use
of water in both architecture and landscape architec-
ture, two spheres that were intimately interconnected
in the Topkapı Palace.

WATER TOWERS

The availability of water had played a determining role
in the selection of the site for Mehmed II's New Palace;
the sultan authorized construction of the building only
after being convinced by experts that bringing water to
it was feasible.[25] The project proposal submitted to his
successor largely concerned the distribution network
and the amount of water involved, without detailing the
water supply system that brought the ten lüles of water
to the palace. Hence, neither the sources of the "impe-
rial water" (ḥāṣṣa ṣu) nor the location of the ayāzma
are specified. As I have suggested above, the waters in
question were probably conveyed to the Topkapı Palace
by the Halkalı and Kırkçeşme Channels. Further archi-
val work and archaeological investigations will add to
our knowledge of where these waters originated and

of the combined network of aqueducts and subterranean channels that transported them to the palace.[26] For the time being, we are in a better position to consider the water towers (*terāzū*)—also referred to by the term *maksem* (water distribution chamber)—that our document enumerates (table 1).

In the 1748 map of the Halkalı Channel, the imperial water is distributed from the first water tower on the palace's fortress wall at the left side of the Imperial Gate to a second water tower to the left of the Middle Gate. From here, the water reaches a distribution chamber at the far right corner of the second court (figs. 1 and 2a [1, 21, 22]). The first of these towers—that near the Imperial Gate—can still be identified today, and is mentioned in our document as "the water tower on the fortress wall" (*ḥiṣār dīvārındaki terāzū*).[27] Another water tower close by is referred to in the document as being "next to the armory," namely, the Church of Hagia Irene, on the left side of the first court, which Mehmed II converted into the palace armory. This unknown water tower seems to have been located in the vicinity of the palace workshops in that area, which extended along the imperial fortress wall toward the Golden Horn, up to the present Soğukçeşme Gate (Cold Fountain Gate) (fig. 2a [10, 11]). The water tower may have accompanied two recently discovered huge wells at the royal mint, near Hagia Irene.[28] As we shall see, our document shows that this tower would supply water to two of the underground cellars the sultan ordered to be used as cisterns for watering the outer garden. There is also a reference to a water distribution cistern (*ṣavak*) that required no extra water: "Regarding the water distribution cistern in front of the gate, it is not necessary to make [additional] water flow there, for when the water seeps into the ground and overflows the pipe, it flows from there." This *ṣavak* appears to have been located in front of one of the fortress gates that provided access into the outer garden, along the same wall running from the Imperial Gate down toward the Golden Horn. The absence of any information regarding the places to which the *ṣavak* distributed water suggests that it too supplied the outer garden. If so, this cistern may have been close to the Cold Fountain or Iron Gates of the fortress wall (fig. 2a [4, 7]).[29]

What the document calls "the water tower on the outside" (*taṣra[da]ġı terāzū, taṣradaki terāzū*)—henceforth the outside tower—distributed water not only to three water towers in the second and third courts, but also directly to some fountains and water jet fountains within these courts (table 1). Situated outside these inner courts of the palace, the outside tower was probably somewhere in the first court. Though no traces of it survive, it can be identified with the water tower depicted on the left side of the Middle Gate on the 1748 map of the Halkalı Channel (figs. 1 and 2a [21]). Perhaps the remains of this water tower may be found behind a large fountain currently abutting the inner face of the wall flanking this gate.

The three water towers supplied by the outside tower were located "next to the Timber Frame Palace," "next to the Large Chamber," and "next to the fountain of the stables." The first of these towers probably stood in the vicinity of the walled private garden terraces abutting the third court, close to the Privy Chamber and the part of the Harem known today as the Courtyard of the Favorites. Between the Privy Chamber and this courtyard, which features two large pools (fig. 2b [69, 71]), is a structure called the Tower Pavilion (*kule köşkü*), built by Selim III (r. 1789–1807). The three superimposed water depots under this pavilion may have been associated with a now-lost water tower (fig. 2b [66]).[30]

The second water tower supplied by the outside tower was located next to the Large Chamber, a dormitory for novice boys that extended on the right-hand side of the Gate of Felicity, leading into the third court. Its remains can still be found at the lavatory in the far right corner of the second court (fig. 2b [26, 33]).[31] This structure is illustrated on the 1748 map of the Halkalı Channel, where it is labeled the "water distribution chamber (*su maksemi*) known as Silver (*gümüş*), near the Gate of Felicity" (fig. 1).[32] Our document shows that this *maksem* only supplied the third court and a nearby garden pavilion. Its function is described as follows in the 1607 map of the Halkalı Channel: "This is the gathering place of water (*su mecmāʿı*) behind the Large Chamber inside the Imperial Palace; water for the Imperial Palace gathers [there] and is then distributed; its water consists of three *lüle*s, two *kamış*, and one *maṣura*." (The latter two terms refer to water-measur-

Table 1. DISTRIBUTION NETWORK OF WATER TOWERS (waterworks are numbered according to their order in the document).

- **The water tower next to the Timber Frame Palace** (*çatma yanındaki terāzū, çatma sarāy civārın[d]a bir terāzū*)

WALLED PRIVATE GARDEN TERRACES ADJOINING THE THIRD COURT:
 1. Water jet fountain of the terrace (1 *lüle*).
 2. Water jet fountain of the Timber Frame Palace (1/2 *lüle*).

- **The outside water tower** (*ṭaṣradaki terāzū*)

THIRD COURT:
 3. Water jet fountain under the throne hall (1/2 *lüle*).
 8. Reservoir of the bath (1 *lüle*).
 9. Fountain of the gazebo (1 *lüle*).
 11. A faucet in front of the treasury and pantry [dormitories] (1/4 *lüle*).

SECOND COURT:
 12. Fountain of the stables (1 *lüle*).

- **The water tower next to the Large Chamber** (*büyük oda yanındaki terāzū*)

THIRD COURT:
 4. Water jet fountain of the New Palace (1/2 *lüle*).
 5–7. Water jet fountain[s] of the bath (3 in number, 2 *lüle*s).
 10. A faucet in front of the Large Chamber (1/4 *lüle*).

OUTER GARDEN:
 15. Fountain of the Marble Kiosk (1/4 *lüle*).

- **The water tower on the wall of the imperial kitchen** (*ḥāṣṣ maṭbaḫ dīvārındaki terāzū*)

SECOND COURT:
 13. Fountain of the imperial kitchen (1/2 *lüle*).
 14. Fountain of the confectionary (1/2 *lüle*).

- **The water tower next to the fountain of the stables** (*aḫur çeşmesi yanındaki terāzū*)

OUTER GARDEN:
 16. Fountain of the Tile Palace (1/4 *lüle*).

- **The water tower inside the [outer] garden** (*bāġ içindeki terāzū*)

OUTER GARDEN:
 17. Fountain of the kiosk next to the Tile Palace (1/4 *lüle*).
 18. Fountain of the Mansion/Palace (1/4 *lüle*).
 E. Cellar under the garden.

OTHER WATER TOWERS ON OR NEAR THE FORTRESS WALL

- **The water tower on the fortress wall** (*ḥiṣār dīvārındaki terāzū*)
 B. Cellar at the storehouse for wood.
 C. Cellar in front of the gate of the Tile Palace.

- **The water tower next to the armory** (*cebeḫāne yanındaki terāzū*)
 A. Cellar outside the fortress gate.
 D. Cellar at the Mansion/Palace.

- **The water distribution cistern in front of the gate** (*ḳapu öñinde olan ṣavāḳ*).

ing pipes that are smaller than the *lüle*). The amount of water controlled by the distributing chamber comes strikingly close to the three *lüle*s that our document assigns to this *maḳsem*. We learn from the mid seventeenth-century French traveler Jean-Baptiste Tavernier that an official was stationed next to it to allocate water to the third court, where water flowed following the movements of the sultan from one space to the next: "A *Baltacı* (Halberdier) stays there all day long to distribute water, depending on how he is ordered, and when the Grand Signor passes from one quarter to the other, the fountain of the one where he is found begins to play immediately upon a signal that is given to the *Baltacı*."[33]

The third water tower fed by the outside tower stood next to the fountain of the stables. This must be the twin fountain attached to the inner face of the retaining wall that separates the courtyard of the stables from the second court, and is thought to date from Mehmed II's reign. As for the now-lost water tower that stood by it, our document mentions only the quarter *lüle* of water it would supply to the neighboring Tile Palace (*sırça sarāy*). Known today as the Çinili Köşk (Tiled Pavilion), this garden pavilion is sited on a vaulted terrace of the outer garden, which is connected by a gate to the courtyard of the stables (fig. 2a [14, 41]; 2b [11, 13]).

The document also mentions two additional towers, "on the wall of the imperial kitchen" and "inside the [outer] garden." The first of these would furnish water to the courtyard of the kitchens, whose wall it adjoined, providing water to two fountains: that of the imperial kitchen and that of the confectionary. Perhaps this water tower is the depot across from the pantry (*kilār*) in the same courtyard, which today houses the palace archive. It is adjacent to the curtain wall separating the courtyard of the kitchens from the second court (fig. 2b [6–10]). A door next to it opens onto the former site of the Corps of the Water Wheel (*dolab ocaġı*), at the far right corner of the first court, which was charged with operating the two extant water wells with spiral steps in this area (fig. 2a [19 and 20]). It is generally believed that these huge wells had collected the Kırkçeşme waters since the time of Mehmed II and that the chief architect Sinan added a "new water wheel" (*dolab-ı cedīd*) next to them during the reign of Süleyman. Although the two ancient wells, interconnected by a

water channel, are not mentioned in our document, they probably supplied the nearby water tower "on the wall of the imperial kitchen."[34] It seems that these wells began to be used to their full capacity after Sinan increased the amount of water coming from the Kırkçeşme Channel.

The other water tower was located in the palace's outer garden, on the side overlooking the Golden Horn. It supplied two no-longer-extant pavilions near the Tile Palace, which will be discussed below (fig. 2a [41]). A fifteenth-century poem eulogizing the Tile Palace, built by Mehmed II, mentions a now-lost pool and water wheel in the "paradise garden" extending in front of it. The water wheel is located in the garden below the vaulted terrace of the Tile Palace in a map of Istanbul from 1875. The waterworks in this area may have been destroyed together with the garden terraces and other structures that were razed during the creation of Gülhane Park in 1912.[35] Of the water towers mentioned in our document, only those of the first and second courts are shown on the 1748 map of the Halkalı Channel (fig. 1). Because this map and its predecessor, dated 1607, omit the third court of the palace and the outer garden, they do not reflect the full complexity of the Topkapı Palace's waterworks, which, as noted above, were also supplied by the Kırkçeşme Channel.

WATER JET FOUNTAINS, FOUNTAINS, AND FAUCETS

The document's list of different types of fountains helps us visualize the overall layout of the Topkapı Palace during the reigns of Mehmed II and Bayezid II (table 2). Giovanni Maria Angiolello, who served at Mehmed's court between 1474 and 1481, described the palace complex as consisting of three large walled courts, each entered through a double gate. These contiguous courts were surrounded on all three sides by an outer garden, itself delimited by a fortress wall (figs. 5–7). Our document echoes this arrangement: starting with the waterworks of the third court's walled private garden terraces, it proceeds to those of the third court itself, then the second court, and finally the outer garden (table 2). This hidden order within the document makes it easier to

Table 2. LOCATIONS OF WATER JET FOUNTAINS, FOUNTAINS, AND FAUCETS (waterworks are numbered according to their order in the document).

- **WALLED PRIVATE GARDEN TERRACES ADJOINING THE THIRD COURT**

 1. Water jet fountain of the terrace (*ṣādırvān-ı ṣoffa*)
 (1 *lüle* from the water tower next to the Timber Frame [Palace]).

 2. Water jet fountain of the Timber Frame Palace (*ṣādırvān-ı çatma*)
 (1/2 *lüle* from the water tower next to the Timber Frame [Palace]).

- **THIRD COURT**

 3. Water jet fountain under the throne hall (*ṣādırvān, dīvānḫāne altında*)
 (1/2 *lüle* from the outside water tower).

 4. Water jet fountain of the New Palace (*ṣādırvān-ı yeñi sarāy*)
 (1/2 *lüle* from the water tower next to the Large Chamber).

 5–7. Water jet fountain[s] of the bath (*ṣādırvān-ı ḥammām*)
 (3 in number, 2 *lüle*s from the water tower next to the Large Chamber).

 8. Reservoir of the bath (*ḥazīne-i ḥammām*)
 (1 *lüle* from the outside water tower).

 9. Fountain of the gazebo (*çeşme-i çārdāḳ*)
 (1 *lüle* from the outside water tower).

 10. A faucet in front of the Large Chamber (*büyük oda öñinde bir muṣluḳ*)
 (1/4 *lüle* from the water tower next to the Large Chamber).

 11. A faucet in front of the treasury and pantry [dormitories] (*ḫazīne ile kilār öñinde bir muṣluḳ*)
 (1/4 *lüle* from the outside water tower).

- **SECOND COURT**

 12. Fountain of the stables (*çeşme-i aḫur*)
 (1 *lüle* from the outside water tower).

 13. Fountain of the imperial kitchen (*çeşme-i ḫāṣṣ maṭbaḫ*)
 (1/2 *lüle* from the water tower on the wall of the imperial kitchen).

 14. Fountain of the confectionary (*çeşme-i ḥelvacıyān*)
 (1/2 *lüle* from the water tower on the wall of the imperial kitchen).

- **OUTER GARDEN**

 15. Fountain of the Marble Kiosk (*çeşme-i mermer köşk*)
 (1/4 *lüle* from the water tower next to the Large Chamber).

 16. Fountain of the Tile Palace (*çeşme-i sırça sarāy*)
 (1/4 *lüle* from the water tower next to the fountain of the stables).

 17. Fountain of the kiosk next to the Tile Palace (*çeşme-i sırça sarāyıñ yanında olan köşk*)
 (1/4 *lüle* from the water tower inside the garden).

 18. Fountain of the Mansion/Palace (*çeşme-i mahall*)
 (1/4 *lüle* from the water tower inside the garden).

guess the specific locations of the water jet fountains (*ṣādırvān*), fountains (*çeşme*), and faucets (*muṣluḳ*) that are itemized with no further explanation.

It is noteworthy that the first eleven of the eighteen listed waterworks belong to the prestigious third court and the walled private garden terraces attached to this court. These are followed by the remaining water outlets, all of which are simple fountains (*çeşme*), three in the second court, and four in the outer garden. No mention is made of any fountain in the first court. It is known from Angiolello's description and from images depicting the Topkapı Palace in the last quarter of the fifteenth century that the left and right sides of this court were originally empty (figs. 5–7). Later, however, service buildings were added here, and the 1748 map of the Halkalı Channel shows the water conducted to an infirmary and bakery on the left-hand side of the first court, along with a freestanding fountain inside the court (fig. 1).[36]

The seven water jet fountains with which the list begins were the most elaborate in the palace's collection of waterworks. They all furnished running water to the third court's walled private garden terraces and to the royal apartments marking the two far corners of the

Fig. 5. Detail from Giovanni Andrea Vavassore's map of Istanbul, showing the Topkapı Palace, ca. 1479–81. Woodcut printed in Venice, ca. 1520–30. Bamberg, Staatsbibliothek, Sign. IV C44. (Photo: courtesy of the Staatsbibliothek)

Fig. 6. Detail from Cristoforo Buondelmonti's map of Istanbul, showing the Topkapı Palace. From the *Liber Insularum Archipelagi*, ink drawing, early 1480s. Düsseldorf, Universitäts- und Landesbibliothek, Ms. G. 13, fol. 54r. (Photo: courtesy of the Universitäts- und Landesbibliothek)

Fig. 7. Woodcut with a partial view of the Topkapı Palace, depicting the Nea Ekklesia (Güngörmez Kilisesi) being destroyed by lightning in 1490. From Hartmann Schedel, *Liber chronicarum* (Nuremberg, 1493). (Photo: courtesy of Ersu Pekin)

court itself, that is, the Privy Chamber complex in the left corner and Mehmed the Conqueror's Pavilion, with its adjoining bath, in the right (hereafter referred to as the Treasury-Bath complex) (fig. 2b [39–45, 48–53]). The first two water jet fountains—supplied by the water tower of the Timber Frame Palace (*çatma sarāy*)—are the *şādırvān-ı şoffa* and *şādırvān-ı çatma*. The prominent placement of these two fountains in the list was in itself confirmation of the prestige of the Timber Frame Palace, recently constructed as Bayezid II's residence, and of the nearby terrace (*şoffa*) of the domed Privy Chamber, raised on vaulted substructures. According to Mehmed II's *Ķānūnnāme* (Law Code) of circa 1477–81, the Privy Chamber complex in the third court was built after the Chamber of Petitions in the same court.[37] Angiolello provides a vivid eyewitness account of this complex along with its accompanying marble-paved terrace, which featured a large pool:

> On the left-hand side of the [third] court is the palace (*Palazo*) where the Grand Turk (*Gran Turco*) resides; most

of that palace is vaulted [domed] in construction and has many chambers and summer and winter rooms. The part that looks toward Pera [Galata] has a portico which is above the large garden, from which rise many cypresses that reach [the height of] the balconies of this portico, and that portico is built on two [rows of] columns and is completely vaulted, and in the middle is a fountain that flows into a beautiful basin worked in marble with profiles and colonnettes of porphyry and serpentine, and in this basin are many sorts of fish, and the Grand Turk derives great pleasure from watching them.[38]

Its multiple domes announcing its superior status with respect to other buildings in the same court, the Privy Chamber complex was not, as some believe, erected by Selim I. In any case, it is inconceivable that Mehmed II would have neglected this corner of the third court, commanding spectacular views over the city. We learn from Angiolello that the marble terrace of the Privy Chamber complex, which faced Pera, was, as today, host to a colonnaded double portico and a pool with a fountain spraying jets of water. The *şādırvān* "of the terrace" listed in our document likely belonged to this pool, decorated in red and green marble.[39] The domed summer chambers mentioned by Angiolello, in turn, appear to have been pavilions atop the marble terrace. One of these was a transparent crystal kiosk described by Menavino (ca. 1504–15), a Genoese page who lived in the palace during Bayezid II's reign. Its waters, cascading with a sweet murmur, were pleasing to the eye and the ear:

> In this seraglio is a room entirely made of transparent glass squares joined and fastened together with tin rods, and it is in the guise of a round cupola, resembling a stretched tent when seen from a distance. In the past, water once ran over it with a marvelous artifice, flowing down from the cupola and descending into the garden. The king frequently used to go there in the summertime to sleep during the day, to the cool and sweet murmur of the resounding waters. But at present, because its pipes are broken, this water is directed elsewhere.[40]

The water pipes, which had functioned in the past, may have been broken during the earthquake of 1509. This delightful domed kiosk was likely built for Mehmed II, rather than his successor. Later sources suggest that it stood near the pool on the terrace and had a polychrome

marble floor as well as a dome whose lantern rested on crystal colonnettes. The kiosk's transparent walls were formed of expertly joined crystal panels placed between six or eight marble columns. This extraordinary structure disappeared during subsequent renovations to the marble terrace and its pool.[41]

The third water jet fountain to be fed from the outside tower is specified in our document as being "under the throne hall" (*dīvānḫāne altında*). This may be the freestanding marble fountain at the center of the domed antechamber within the entrance from the third court into the *dīvānḫāne* of the Privy Chamber, known today as the *Şādırvān Sofası* (Antechamber of the Water Jet Fountain). The fountain was probably supplied by water from the vaulted basement under it (figs. 2b [50 and 51], and 8). From an ancient fluted bowl of green breccia at the top of the fountain, the water flows through pink granite spouts into a scalloped white marble basin below. This *all'antica* fountain, complete with classical pearl moldings and scallop-shell motifs, reflects Mehmed II's penchant for the antique, which was prompted by his familiarity with the Italian Renaissance.[42] The same taste appears to have informed the *şādırvān* of the pool terrace with its accompanying *tempietto*-like crystal kiosk, all of which would have presented a marked contrast to the porticoes of the Privy Chamber complex, built in a quintessentially Ottoman manner with pointed arches and *muqarnas* capitals. Abutting this marble-paved terrace was Mehmed's hanging garden, created in the 1460s. Enclosed by walls with round-arched grilled windows through which to look out, it resonated with the classically inspired *giardini pensili* of contemporaneous Italian palaces (fig. 2b [55, 56]).[43]

The Privy Chamber complex—which Ruhi Edrenevi, as quoted earlier, termed "the actual domed palace"— is clearly visible in a version of Cristoforo Buondelmonti's map of Istanbul datable to the beginning of Bayezid II's reign (fig. 6). This map, discovered and published by Ian Manners in 1997, sheds new light on the original layout of the Topkapı Palace, particularly its third court and outer garden. Manners dated it to the reign of Mehmed II, but I believe it must have been drawn shortly after this sultan's death in 1481, as it includes the mausoleum that Bayezid II built for his father (*sepulcrum soltani*

Fig 8. Water jet fountain at the entrance hall of the Privy Chamber complex, known as the Antechamber of the Water Jet Fountain (*Şādırvān Sofası*). (Photo: courtesy of Hadiye Cangökçe)

Meometi) in the latter's mosque complex.[44] Supporting an attribution to the early 1480s is the map's depiction of the Hagia Sophia with a single minaret. In a woodcut illustrating Hartmann Schedel's *Liber Chronicarum*, published in Nuremberg in 1493, the sanctuary is shown with its second minaret, which was added by Bayezid II (fig. 7).[45] This print is based on a drawing done in 1490, at the time when the ninth-century Nea Ekklesia (Güngörmez Kilisesi)—which had been converted into a gunpowder magazine—exploded after being struck by lightning.[46] Moreover, the Buondelmonti map does not include Bayezid II's mosque, built between 1501 and 1505 on a plot of land carved out from the garden of the Old Palace. It instead shows that garden when it still contained the Column of Theodosius I, pieces of which would later be incorporated into the base of the double-bath built for Bayezid II, circa 1505–8, next to his mosque.[47]

The Buondelmonti map is one of the most important visual documents for the Topkapı Palace's architecture prior to the earthquake of 1509. It depicts certain

structures not represented in the map of Giovanni
Andrea Vavassore, which is thought to be based on a
lost prototype datable to the years 1479–81, toward the
end of Mehmed II's reign (figs. 5 and 6).[48] Thus we learn
from the Buondelmonti map that the twin domes cur-
rently adjacent to the hipped-roofed main section of the
Treasury-Bath complex were part of the original design
(figs. 9 and 2b[44, 45]), though the hypothetical recon-
struction of Sedat Hakkı Eldem and Feridun Akozan
assumes that they were added later.[49] The dome cover-
ing the bath's disrobing chamber also appears in the
circa 1509–11 elevation drawing of the buttress, dis-
cussed above (fig. 3). The omission of the second dome,
surmounting the adjacent hall of the imperial treasury,
can be explained by the fact that this drawing primar-
ily concerns the position of the buttress and does not
aim to fully illustrate the garden façade of the Treasury-
Bath complex.

The Buondelmonti map also proves that the loggia
of the imperial treasury, featuring a central water jet
fountain, was not an eighteenth-century addition, as
some have supposed. Designed as a belvedere in the
building's outer corner, the loggia has round arches that
rest on *all'antica* composite Ionic capitals in the Renais-
sance manner. The arches and capitals are identical to
those of the Treasury-Bath complex's columnar portico,
which extends along the length of the third court (figs.
9, 10, and 2b [39, 42]).[50] These details reflect the same
penchant for the classical that we encountered in
Mehmed' II's Privy Chamber complex. Despite the dif-
ferent styles of their arcades, both buildings make use
of spoliated monumental white marble and green brec-
cia columns. The courtyard portico of the Treasury-Bath
complex once featured a ceiling decorated with figural
mosaics in the Byzantine manner. This unique edifice
blended the Ottoman architectural style with elements
inspired by the Byzantine and Italian Renaissance tra-
ditions, which referenced, respectively, the Eastern and
Western Roman Empires.[51] Its composite architecture,
together with the diversity of treasures and manuscripts
housed within it, articulated the universal imperial
vision of Mehmed II, who appropriated the title
"Emperor of Rome" (*Ḳayṣer-i Rūm*).[52]

Let us now turn to the remaining four *şāḍırvān*s listed
in the document, all of which seem to have been located

Fig. 9. Elevation drawings of the present Treasury-Bath com-
plex, from the outer garden and the third court. (After Eldem
and Akozan, *Topkapı Sarayı*)

along the right wing of the third court: one is called the
"water jet fountain of the New Palace" (*şāḍırvān-ı yeñi
sarāy*), while the other three are jointly referred to as
the "water jet fountain[s] of the bath, 3 in number"
(*şāḍırvān-ı ḥammām, 3 ḳıṭ'a*). These were all fed by the
water distribution chamber at the far right corner of the
second court, which abutted the Large Chamber of the
third court. The "New Palace" most likely refers to the
building at the far right corner of the third court, which
later came to be known as Mehmed the Conqueror's
Pavilion. Located adjacent to the recently renovated
bath, it was identified in a late Ottoman oral palace tra-
dition as the first royal mansion (*ḳaṣr*) this sultan con-
structed in his "New Palace," around 1462–63.[53]
According to the same tradition, it was originally
designed as a *lieu de plaisance* but was transformed by
Mehmed II into a treasury after the completion of other
structures. This impressive suite of three halls, with its
view-commanding loggia, was designed as a unified
whole together with the adjacent bath's disrobing
chamber, which constituted a fourth hall (figs. 2b [39–
45], and 9). Fronted by a continuous columnar portico

facing the third court, it is built in expensive ashlar masonry, unlike the Privy Chamber complex across from it, which is constructed in alternating courses of stone and brick.

If my identification is correct, the "water jet fountain of the New Palace" must be the scalloped white marble basin with spouting jets at the center of the open loggia (fig. 10). This fountain is carved from the same gray-streaked Marmara (Proconnesian) marble as the loggia's custom-made capitals, in a manner befitting their classicizing design. At some unknown date, this superb loggia and the matching portico along the third court were walled in to provide additional storage space for the imperial treasury. These arcades can no longer be seen in a painting from the *Hünernāme* dating from 1584–85, which depicts the third court and the outer garden (fig. 11). Photographs confirm that the magnificent loggia (fig. 4) and courtyard portico remained closed off by walls until the Topkapı Palace was renovated as a museum.[54]

The three *ṣādırvān*s of the bath adjoining the imperial treasury are lost (fig. 2b [38, 45]). A painting in the *Hünernāme* of Sultan Süleyman undressing in this bath shows that one of these water jet fountains, made of luxurious pink and green marble, marked the center of the domed disrobing hall (fig. 12). Descriptions of the bath mention not only this fountain but also two large swimming pools with water jets.[55] After listing the three fountains with spouting jets and the water supplied from the outside tower to the "reservoir of the bath" (*ḫazīne-i ḥammām*), our document turns to other fountains (*çeşme*) and faucets (*muṣluk*).

The absence of any further reference to a *ṣādırvān* in the remaining areas of the palace signifies the status and luxury of the main royal structures within the third court and its walled private garden terraces. This hierarchy attests to the primacy of water jet fountains as an extravagant form of conspicuous consumption and source of prestige. The "fountain of the gazebo" (*çeşme-i çārdāḳ*), which was supplied by the outside tower, may have stood in the small walled garden between the furnace of the bath and the Large Chamber (fig. 2b [33, 34]). According to Angiolello, this corner of the third court had an aviary with pigeons that wore pearl anklets and performed summersaults to the sound of a whistle.

Fig. 10. Loggia of the Treasury-Bath complex, with a central *ṣādırvān* and the courtyard portico. (Photo: courtesy of Hadiye Cangökçe)

Fig. 11. Double-page painting of the third court and outer garden of the Topkapı Palace. From Seyyid Lokman, *Hünernāme*, ca. 1584–85. Istanbul, TSMK, H. 1523, fols. 231v–232r. (Photo: courtesy of Ersu Pekin)

Another possible location for the gazebo fountain is the no-longer-extant Pool Pavilion (Havuz Köşkü), which once occupied the present site of the eighteenth-century freestanding library of Ahmed III, inside the third court (fig. 2b [37]). At the time it was demolished, the pavilion was attributed to Selim I, around 1519. However, I believe it is quite possible that this columnar open canopy with a domical vault, marking the center of a rectangular pool, was built earlier, by Mehmed II. Its twelve antique green porpyhry columns were reused in the extant eighteenth-century portico of the Chamber of the Expeditionary Force (fig. 2b [38]).[56] Listed after the "fountain of the gazebo" is the faucet in front of the Large Chamber (as mentioned earlier, a dormitory for novice boys), which was supplied by the water distribution chamber abutting it in the second court. The faucet in front of the dormitories of pages serving the treasury and pantry, meanwhile, was fed from the outside tower (fig. 2b [46 and 47]).[57]

The Buondelmonti map depicts these two dormitories, extending between the Treasury-Bath and Privy Chamber complexes, as a unified wing fronted by a continuous portico and covered by a hipped roof (fig. 6). The map also shows the hipped-roofed Chamber of Petitions—which is mentioned in Mehmed II's *Ḳānūn-nāme*—just inside the main entrance to the third court, the Gate of Felicity.[58] Our document does not mention any fountains in relation to the Chamber of Petitions and the Old Council Hall, built for the same sultan in the second court (fig. 2b [25, 35]). No space is left in the Buondelmonti map to represent the details of this court, which appears squeezed between the first and third courts. Only three fountains (*çeşme*) are listed in the second court: the "fountain of the stables: one *lüle* from the outside water tower"; the "fountain of the imperial kitchen, half a *lüle* from the water tower on the wall of the imperial kitchen"; and the "fountain of the confectionary, half a *lüle* from the same water tower" (table 2). In his description of the stables and kitchens, respec-

Fig. 12. Detail from a two-page painting, showing Sultan Süleyman undressing in the disrobing chamber of the bath in the third court. From Seyyid Lokman, *Hünernāme*, ca. 1584–85. Istanbul, TSMK, H. 1524, fol. 148r. (Photo: courtesy of the Topkapı Palace Museum Library)

tively on the left and right sides of the second court, Angiolello states, "nearby, there are some fountains, which provide water for the kitchens and for the horses to drink."[59] The fountain of the stables was not supplied by the water tower located next to it, but from the outside tower. Though the aforementioned twin fountain with a trough, thought to date from Mehmed II's reign, still stands in the courtyard of the stables, no old fountains survive in the courtyard of the kitchens, which was heavily remodeled by Sinan after a fire in 1574.[60]

All of the four remaining fountains (*çeşme*) in the list belong to pavilions in the palace's outer garden. The first of these was the fountain of the "Marble Kiosk"

(*Mermer Köşk*). Because it received water from the water tower next to the Large Chamber, this fountain, together with the kiosk itself, may be identified with the nearby İshakiye Kiosk. Built for Mehmed II between 1470 and 1472 on the Marmara side of the outer garden, downhill from the Treasury-Bath complex, it was demolished in the second half of the nineteenth century (fig. 2a [28]).[61] Another possibility is that the Marble Kiosk stood on the walled garden terrace, extending in front of the Treasury-Bath complex. The edge of the terrace that overlooks the Sea of Marmara contains the basement of a long rectangular pavilion attributed to Mehmed II, the upper part of which was replaced in the nineteenth century with the present neoclassical Mecidiye Kiosk (fig. 2b [60]).[62]

The other three fountains were in the part of the outer garden facing the Golden Horn. There is no mention in our document of the small wooden kiosk that we know Bayezid II built in this area, outside the Byzantine sea walls of the palace. The aforementioned *Hünernāme* painting (ca. 1584–85) and a panoramic view of the Topkapı Place in an Austrian Habsburg Album (ca. 1590) show the kiosk after it had been renovated in 1583 (figs. 11 and 13). This wooden pavilion, in turn, was replaced between 1591 and 1593 with the domed Shore Kiosk (*Yalı Köşkü*), built more luxuriously in ashlar masonry and surrounded by a marble colonnade. The latter is seen in the Dryden Album, datable to the late 1590s (figs. 2a [44], and 14[a and b]).[63]

The "fountain of the Tile Palace" (*sırça sarāy*) was no doubt located in the garden pavilion known today as the Çinili Köşk (Tiled Pavilion). This monumental structure was built for Mehmed II in 1472 in the international Timurid-Turkmen mode and decorated in the manner of the Karamanid principality of central Anatolia, which had recently been subjugated by the sultan. Its original name, "Tile Palace," is repeated by Tursun Beg in his late fifteenth-century chronicle of Mehmed II's reign, as well as by Menavino (*Sercessarai*). The fountain was supplied by the water tower next to the fountain of the stables, located nearby (fig. 2a [14, 41]).[64]

The second fountain, identified as belonging to the "pavilion next to the Tile Palace" (*sırça sarāyıñ yanında olan köşk*), was instead fed from the neighboring water tower of the outer garden. The pavilion in question must be the one that Tursun Beg describes as being in the

Fig. 13. Detail from a panoramic view of Istanbul, showing the Topkapı Palace from the Golden Horn. From an Austrian Habsburg Album, ca. 1590. Vienna, Nationalbibliothek, Ms. Vienna, Cod. 8626*, fols. 159v–160r. (Photo: courtesy of the Nationalbibliothek)

"Ottoman mode" (*ṭavr-ı 'Os̱mānī*), as opposed to the "Tile Palace" (*sırça sarāy*) in its vicinity, which was constructed in the "mode of the Persian kings" (*ṭavr-ı ekāṣire*). No longer extant, this pavilion seems to have stood over the Byzantine substructure now occupied by the Museum of the Ancient Near East (fig. 2a [39]).[65] The Ottoman-style pavilion and its Persianate counterpart shared the edge of the same terrace raised on vaulted substructures, judging by the *Hünernāme* painting of the outer garden, where these two pavilions are depicted side by side, overlooking a large, no-longer-extant pool with cracked retaining walls (fig. 11). The paired pavilions are also seen in the views of the Topkapı Palace included in the Austrian Habsburg and Dryden Albums (figs. 13 and 14[a and b]). With each featuring a prominent projecting bay window, the two imposing pavilions at the far right side of these panoramic views are situated in the section of the outer garden that extends between Hagia Irene and the sea walls behind the Shore Kiosk. The pyramidal-roofed building in the far right is the Ottoman-style pavilion. Its Persianate companion to the left has a similar roof, now removed,

which was added later on as a protective outer cover over the small dome, which rests on a flat terrace.[66]

Also supplied by the outer garden's water tower was the last fountain listed in our document: the "fountain of the Mansion/Palace" (*çeşme-i maḥall*), probably referring to a third palatial structure known to have existed in the vicinity of the previous two garden pavilions, a less likely candidate being the Harem quarters. Angiolello describes the three monumental garden pavilions —all built for Mehmed II—as "palaces" (*palazzi*), and differentiates them from the Byzantine churches (*chiesiole*), with which they shared the outer garden:

> Around the palace complex is a garden that embraces all the three courts mentioned above In this garden are some small, vaulted [domed] churches (*Chiesiole*), and the Grand Turk has had one of them, which is decorated in mosaic, repaired. And in this garden there are three palaces (*Palazzi*) about a stone's throw from one another, and they are built in various modes. One is built in the Persian mode (*alla Persiana*), decorated in the mode of the country of Karaman, and is covered with wattle and daub; the second is built in the Turkish mode (*alla Turchesca*); the third in the Greek mode (*alla Greca*), covered with lead.[67]

a.

b.

Fig. 14. a) View of the Topkapı Palace from the Golden Horn, ca. late 1590s; b) detail showing the Shore Kiosk (*Yalı Köşkü*), Tile Palace (*Çinili Köşk*), and Ottoman-style Pavilion. From the Dryden Album, late 1590s. Cambridge, Trinity College Library, Ms. R.14.23, fol. 54r. (Photo: courtesy of the Master and Fellows of Trinity College, Cambridge)

Grouped together, these stylistically distinguished pavilions represented the three kingdoms—Karamanid, Ottoman, and Byzantine—united in Mehmed II's empire. Of the trio, only the Persianate Çinili Köşk has survived. All three pavilions are clearly visible on the Vavassore map, in the section of the outer garden that faces the Golden Horn (fig. 5). To the left of the domed *alla Persiana* pavilion is the *alla Turchesca* pavilion with its pyramidal roof. If the cluster of buildings close to the sea wall on the right side of the Tile Palace is the *palazzo* Angiolello characterizes as *alla Greca*, it may have been built in a manner reminiscent of a Byzantine monastery. The Vavassore map identifies this complex as "*Tennu*," meaning prison; a prison known as the Chief Gardener's Gazebo (*bostancıbaşı çardağı*) once stood near this area.[68] At the Seraglio Point (the tip of the triangular promontory), the map depicts the monastic Church of St. Demetrius (*S. Demetri*), which is seen in the same spot on the Buondelmonti map. This was a mosaic-decorated church and monastery complex, transformed into a dormitory for the Corps of Royal Gardeners and later replaced by a modern medical school (figs. 5 and 6). The rectangular complex with a central courtyard is represented in the double-page *Hünernāme* painting near the left margin of the page on the right, where it is identified as the "Dormitory of Gardeners" (*bostancılar odası*) (figs. 2a [47, 48], and 11). Perhaps the small domed church (*chiesiole*) decorated in mosaic that Angiolello says was repaired by Mehmed II belonged to this dormitory, which complemented the three *Palazzi* he built close to one another in the outer garden.[69]

Because the Buondelmonti map is drawn from the Marmara side, it does not include all three pavilions. Instead, it shows two domed churches near the Seraglio Point, labeled "*S. demetri[us]*" and "*S. Paulus*." It may be that the *palazzo* in the Greek style incorporated the remains of the Church of St. Paulus, sited approximately where the cluster of buildings labeled *Tennu* is shown in the Vavassore map. I suggested above that the third palatial garden structure mentioned by Angiolello was probably the one that our document calls the "Mansion/Palace" (*maḥall*). This building can perhaps be identified with what the French merchant Jean-Claude Flachat would in 1740 describe as the "old seraglio" (*vieux serrail*), which had a fine colonnaded portico and

mosaics. He explains that it was held by some to be a Constantinian palace, and by others to have been a college under the patronage of the Byzantine emperors. Behind several boathouses lined along the shore, the Austrian Habsburg Album's view of the Topkapı Palace shows a garden pavilion whose conical roof boasts a gilded crescent, as do the palace's other royal edifices (figs. 2a [46], and 13). One wonders whether this may have been the *palazzo* in the outer garden built in the *alla Greca* mode.[70]

The siting of Mehmed II's three pavilions indicates the precedence given to the Golden Horn side of the outer garden, which is densely planted with trees in the *Hünernāme* painting (fig. 11). The Marmara side, by contrast, is represented without trees, and contained kitchen depots, a waste incinerator, animal pens, an aviary with ponds, and a playing field for equestrian sports.[71] Angiolello tells us that in addition to various animals such as deer, foxes, hares, sheep, goats, and cows, which were kept in separate places, this part of the garden also had a marshy lake planted with reeds, where Mehmed II enjoyed shooting the ducks and wild geese that gathered there.[72]

UNDERGROUND CISTERNS AND OTHER BYZANTINE STRUCTURES

Of the Byzantine substructures included in a map of the precincts of the Topkapı Palace prepared by Hülya Tezcan, it seems that most of those found on the Marmara side of the outer garden were used as storehouses.[73] It can be deduced from clues in our document that the five "cellars" (*bodrum*) listed in it were located on the Golden Horn side; the sultan had ordered these to be used as cisterns for watering the outer garden.

The five cellars are specified as being "outside the fortress gate"; "at the storehouse for wood"; "in front of the gate of the Tile Palace"; "at the Mansion/Palace"; and "under the garden" (table 3). The first cellar is probably the one known to have extended between the palace's fortress wall and Hagia Sophia. It was to be fed by the water tower "next to the armory," namely, Hagia Irene, which is labeled "*S. elini*" on the Buondelmonti map (figs. 2a [10], and 6). The second cellar seems to be an

Table 3. UNDERGROUND CELLARS TO BE USED AS CISTERNS FOR WATERING THE OUTER GARDENS.

A. Cellar outside the fortress gate (ḥiṣār ḳapusınuñ ṭaṣrasında bir bodrum)
(supplied from the water tower next to the armory).

B. Cellar at the storehouse of wood (odunlıḳda bir bodrum)
(supplied from the water tower on the fortress wall).

C. Cellar in front of the door of the Tile Palace (sırça sarāy ḳapusı öñinde bir bodrum)
(supplied from the water tower on the fortress wall).

D. Cellar at the Mansion/Palace (maḥallde bir bodrum)
(supplied from the water tower next to the armory).

E. Cellar under the garden (bāġ altında bir bodrum)
(supplied from the water tower inside the garden).

L-shaped cistern, shown on Tezcan's map between the fortress wall and Hagia Irene, under the spot where the storehouse for wood used to stand (fig. 2a [9]).[74] It was to be fed by the water tower "on the fortress wall," which still exists next to the Imperial Gate (fig. 1). The third cellar might be a square cistern identified in Tezcan's map beneath the Byzantine substructures supporting the terrace on which the Tile Palace stands.[75] Alternatively, it may have been a cistern in the zone of the court workshops, situated across from the gate of the Tile Palace's terrace (fig. 2a [11, 12]). The water of this cellar, too, would be supplied from the tower on the fortress wall. Still in this area, the fourth cellar, at the "Mansion/ Palace," was probably within the grounds of the palazzo built in the Greek style. The water tower assigned to feed it was located next to the armory. The fifth cellar, described as being "under the garden," was to be supplied from the water tower "inside the garden." This could be the cistern that was revealed when part of the outer garden was turned into Gülhane Park in 1912.[76]

There is no reference in our document to the churches of the outer garden mentioned by Angiolello, which likely had their own sources of water. The Marmara side of the outer garden had several natural water sources, including the Christos Soteros Ayazma (fig. 2a [31]).[77] A little further from St. Demetrius, along the Marmara sea

wall, the Buondelmonti map shows the "*S. georgius*" Church. The remains of this building, which once had a high dome and mosaic revetments, were discovered during excavations around the Byzantine Mangana Palace.[78] Outside the sea wall near that church, the same map depicts an imperial arsenal—*darsinale regiu[m]*—which may have disappeared when the earthquake of 1509 brought down the Byzantine walls in this area.[79]

Again on the Marmara shore, near the intersection of the palace's sea and land walls, the Buondelmonti map shows another domed church, labeled "*S. maria*" (fig. 6). The woodcut published by Schedel appears to confuse this church with that of "S. Geor[g]ius," which stood in the more northerly Mangana area (fig. 7). The identity of the church—converted by Mehmed II into an aviary comprising several ponds—remains disputed, and it is up to Byzantinists to revisit the question in light of the new information provided by the Buondelmonti map (fig. 2a [37]).[80] It is likely that the water wheel of the "aviary of the imperial palace," mentioned in Sinan's 1568–69 water distribution register of the Kırkçeşme and Kağıthane Channels, was located near the converted church.[81]

CONCLUSION

The archival document introduced in this article is among the oldest written sources to shed light on the hydraulic system and early buildings of the Topkapı Palace. Combining the new information contained in it with what we know from late fifteenth- and early sixteenth-century sources, the "virtual archaeology" I have here attempted indicates that the palace established by Mehmed II was left largely unchanged during the reign of Bayezid II. As we can gauge also from Angiolello's detailed description, the overall layout of the palace has to this day remained basically true to its original scheme. That scheme was not, as some have claimed, a haphazardly erected mass of unassuming structures, but an ambitious ensemble whose organization was fully codified in Mehmed II's *Ḳānūnnāme*. Bayezid II was therefore content to add to it only a few kiosks and the Timber Frame Palace.[82] After the 1509 earthquake,

Bayezid, to quote the chronicler Kemalpaşazade, "did not merely restore that great building to its old form, but he also reinforced and solidified it, rendering it a thousand times stronger than before." The renovated palace, "the like of which not even the painter of the imagination could depict ... announced and made manifest the full power of the supremely mighty sultan."[83]

In order to interpret more securely the clues our document provides about the topography of water circulation, waterworks, and now-lost edifices of the Topkapı Palace, it is necessary to undertake additional archival research, as well as surface and sub-surface archaeology.[84] We must not forget in this regard that the palace and its grounds constitute an unmatched archaeological site. Built on the hill of the ancient acropolis of Byzantion as an architectural expression of Mehmed II's vision of universal empire, the palace complex, comprising terraced gardens surrounded by fortified walls, was a veritable open-air museum. The antiquities that the sultan "collected" here included churches converted for various uses, spoliated columns incorporated into the porticos of the palace's most prestigious buildings, imperial sarcophagi and baptismal fonts reused as water tanks and fountain troughs, and the Column of the Goths (figs. 2a [26], and 14[a]), which had been erected near Seraglio Point by an emperor to commemorate a Roman victory over the invading Goths.[85]

Sited at the meeting point of two continents (Europe and Asia) and two seas (the Mediterranean Sea and the Black Sea), the palace complex was an emblem of Mehmed II's dominion over these lands and waters. The unrivalled promontory that it occupies is astutely labeled "*Bizantion*" on the Buondelmonti map (fig. 8).[86] Ever since I conducted research for my doctoral dissertation, it has been my hope that all the institutions standing today within the imperial fortress that are not museums would be relocated elsewhere, so that the palace precinct can be turned into a protected zone for archaeological research. I conclude by reiterating my wish that this unique site—so important to the archaeology of both the Ottoman and pre-Ottoman periods—might one day be elucidated by the kind of systematic investigation it deserves.

Aga Khan Program for Islamic Architecture, Department of History of Art and Architecture, Harvard University, Cambridge, Mass.

APPENDIX I: FACSIMILE OF D. 10137, TOPKAPI PALACE MUSEUM ARCHIVE

(Photos: courtesy of Topkapı Palace Museum Archive)

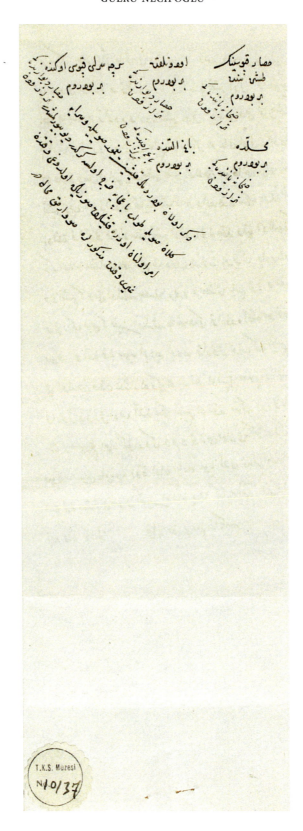

APPENDIX II: TRANSLITERATION OF D. 10137, TOPKAPI PALACE MUSEUM ARCHIVE

[fol. 1b]

Tafṣīl-i çeşmehā ve şādırvānhā ki baʿżı ḳadīmden aḳagel-
mişdür ve baʿżı ṣoñradan olmışdur.

[1] *Şādırvān-ı ṣoffa, bir lüle, çatma yanındaki terā-*
 zūdan

[2] *Şādırvān-ı çatma, nīm lüle, meẕkūr terāzūdan*

[3] *Şādırvān, dīvānḫāne altında, nīm lüle, ṭaşradaki*
 terāzūdan

[4] *Şādırvān-ı yeñi sarāy, nīm lüle, büyük oda*
 yanındaki terāzūdan

[5–7] *Şādırvān-ı ḥammām, 3 ḳıṭʿa, iki lüle, meẕkūr*
 terāzūdan

[8] *Ḫazīne-i ḥammām, bir lüle, ṭāşradaki terāzūdan*

[9] *Çeşme-i çārdāḳ, bir lüle, ṭaşradaki terāzūdan*

[10] *Büyük oda öñinde bir muṣluḳ, rubʿ lüle, büyük oda*
 yanındaki terāzūdan

[11] *Ḫazīne ile kilār öñinde bir muṣluḳ, rubʿ lüle,*
 ṭaşradaki terāzūdan

[12] *Çeşme-i aḥur, bir lüle, ṭaşradaki terāzūdan*

[13] *Çeşme-i ḫāṣṣ maṭbaḫ, nīm lüle, ḫāṣṣ maṭbaḫ*
 dīvārındaki terāzūdan

[14] *Çeşme-i ḥelvācıyān, nīm lüle, meẕkūr terāzūdan*

[15] *Çeşme-i mermer köşk, rubʿ lüle, büyük oda*
 yanındaki terāzūdan

[16] *Çeşme-i sırça sarāy, rubʿ lüle, aḥur çeşmesi*
 yanındaki terāzūdan

[17] *Çeşme-i sırça sarāyıñ yanında olan köşk, rubʿ lüle,*
 bāġ içindeki terāzūdan

[18] *Çeşme-i maḥall, rubʿ lüle, bāġ içindeki terāzūdan*

Ḳapu öñinde olan ṣavāḳ, anda ṣu aḳmaḳ lāzım gelmez,
meger ṣu ṣavġ olub künke ṣıġmayıcaḳ anda daḫı aḳar.

[fol. 2a]

Bu ṣuyıñ baʿżı maḥalline ṭaşra[da]ġı terāzūdan ve baʿżı
ṭaşra[da]ġı terāzūdan çatma sarāy civārına bir terāzūya

varub andan taḳsīm olur, ve baʿżı büyük oda cānibinde
bir terāzūya varub taḳsīm olur, ve baʿżı daḫı aḥur çeşmesi
civārında bir terāzūya varub taḳsīm olur. Eger emr-i
ʿālī olursa şu yollarına hiç vechīle daḫl olınmayub her
maḳseme taḳsīm olacaḳ şu ṭaşradaki terāzūdan taḳsīm
olub, sāʾir terāzūlara kifāyet miḳdār ṣu vardukdan ṣoñra
her maḥalle taʿyīn olınan terāzūlu terāzūsında taḳsīm
olınub, lülecıḳlar vażʿ olınsun ki ẕikr olınan miḳdārı
şu dāʾim el-evḳāt inşāʾallāh her birinde cārī ola. Ve bu
taḳsīm ki ʿarż olmışdur, baʿżında bir lüle ve baʿżında
yarım lüle ve baʿżında bir lülenüñ rubʿı ki taʿyīn olmışdur.
Ṭaşradaki terāzūdan aḳan şu on lüle şudur, bu on lüle
şuya ayruca ayruca terāzūlar olub, girü ikisi bir yire cemʿ
olduġı vaḳt ne miḳdār idügi her bār naẓar oldıḳça maʿlūm
olacaḳlayın terāzūlar ve lüleler olub, andan ṣoñra taḳsīm
olınur. Meẕkūr on lüle şunıñ altı lülesi ʿacem miʿmār
getürdügi ve dört lülesi miʿmār ḥamza getürdügi ḫāṣṣa
şudur. Sarāy-ı ʿāmirede evvel aḳan ayāzma şuyı idi, şimdi
ayāzma şuyı altı lüle miḳdārı şudur, taʿyīn olınan yirlere
kifāyet itmez, ʿarż olandan ġayrı mecāl görinmez, fermān
ḥażret-i ʿālempenāhuñdur.

[fol. 2b]

[A] *Ḥiṣār ḳapusınuñ ṭaşrasında bir bodrum, cebeḫāne*
 yanındaki terāzūdan

[B] *Odunlıḳda, bir bodrum, ḥiṣār dīvārındaki*
 terāzūdan

[C] *Sırça sarāy ḳapusı öñinde bir bodrum, ḥiṣār*
 dīvārındaki terāzūdan

[D] *Maḥallde bir bodrum, cebeḫāne yanındaki*
 terāzūdan

[E] *Bāġ altında bir bodrum, bāġ içindeki terāzūdan*

Ẕikr olan bodrumlar ḳışın yaġmur şuyıyla ve sarāya
gelen şuyla ṭolub bāġçaya ḫarc olsa gerekdür deyü
buyurılmışdur, emr olınan üzre ḳışlarda şu ziyāde olduġı
vaḳtden ġayrı vaḳtde meẕkūrlara şu varmaḳ muḫāldür.

APPENDIX III: TRANSLATION OF D. 10137, TOPKAPI PALACE MUSEUM ARCHIVE

[fol. 1b]
Description of the fountains and water jet fountains, some of which have been flowing since olden times and some of which were added later.

[1] Water jet fountain of the terrace: one *lüle* from the water tower next to the Timber Frame [Palace].

[2] Water jet fountain of the Timber Frame Palace: half a *lüle* from the same water tower.

[3] Water jet fountain under the throne hall: half a *lüle* from the outside water tower.

[4] Water jet fountain of the New Palace: half a *lüle* from the water tower next to the Large Chamber.

[5–7] Water jet fountain[s] of the bath, 3 in number: two *lüles* from the same water tower.

[8] Reservoir of the bath: one *lüle* from the outside water tower.

[9] Fountain of the gazebo: one *lüle* from the outside water tower.

[10] A faucet in front of the Large Chamber: a quarter *lüle* from the water tower next to the Large Chamber.

[11] A faucet in front of the treasury and pantry [dormitories]: a quarter *lüle* from the outside water tower.

[12] Fountain of the stables: one *lüle* from the outside water tower.

[13] Fountain of the imperial kitchen: half a *lüle* from the water tower on the wall of the imperial kitchen.

[14] Fountain of the confectionary: half a *lüle* from the same water tower.

[15] Fountain of the Marble Kiosk: a quarter *lüle* from the water tower next to the Large Chamber.

[16] Fountain of the Tile Palace: a quarter *lüle* from the water tower next to the fountain of the stables.

[17] Fountain of the kiosk next to the Tile Palace: a quarter *lüle* from the water tower inside the garden.

[18] Fountain of the Mansion/Palace: a quarter *lüle* from the water tower inside the garden.

Regarding the water distribution cistern in front of the gate, it is not necessary to make [additional] water flow there, for when the water seeps into the ground and overflows the pipe, it flows from there.

[fol. 2a]
Some of this water is [to be] distributed to its location [directly] from the water tower on the outside; and some of it comes from the outside water tower to a water tower in the vicinity of the Timber Frame Palace and is distributed thence; and some of it comes to a water tower in the vicinity of the Large Chamber and is distributed thence; and some of it comes to a water tower in the vicinity of the fountain of the stables and is distributed thence. If approved by the Sublime Command, let there be no intervention whatsoever to the [existing] water channels; let the water be apportioned to each [tower's] distribution chamber (*maksem*) from the outside water tower, and after sufficient water has reached the other water towers, it should be distributed from those water towers to each appointed place. And small *lüle* pipes should be installed so that, God willing, the aforesaid quantity of water continually flows through each of them. And in this distribution [system], which has been petitioned, some [places] have been apportioned full *lüles*, some half *lüles*, and others quarter *lüles*. [In sum:] the water flowing from the outside water tower measures ten *lüles*; for these ten *lüles* of water, there are separate water towers; and when two [*lüles*] of water collect in the same place, in order to know the amount whenever one takes a look, there are water towers and *lüle* spouts from which the water is distributed. Of these said ten *lüles* of imperial water, six *lüles* is the water brought by the architect ʿAcem [ʿAli], and four *lüles* by the architect Hamza. The *ayāzma* water was what previously flowed to the imperial palace. Now this *ayāzma* water is a quantity of water measuring six *lüles*; it is no longer sufficient for the designated places. There appears to be no possibility other than what is petitioned [here]. The command is His Majesty's, the Refuge of the Universe, to make.

[fol. 2b]

[A] A cellar outside the fortress gate, from the water tower next to the armory.

[B] A cellar at the storehouse for wood, from the water tower on the fortress wall.

[C] A cellar in front of the gate of the Tile Palace, from the water tower on the fortress wall.

[D] A cellar at the Mansion/Palace, from the water tower next to the armory.

[E] A cellar under the garden, from the water tower inside the garden.

It has been ordered that the aforesaid cellars, which are to be filled with rainwater in winter and with the water brought to the palace, must be used for the garden. [But] except in winter when water is plentiful, it is impossible at other times for water to collect in them as ordered.

NOTES

Author's note: My acquaintance with Dr. Filiz Çağman goes back to the early 1980s, when I was conducting research for my doctoral dissertation on the Topkapı Palace. Discussing my ideas with her as I pored over manuscripts in the palace library proved to be highly inspirational to me. It is therefore particularly appropriate to dedicate to her this article on an archival source regarding the Topkapı Palace. Presented as a paper at the "International Symposium in Honor of Dr. Filiz Çağman: The Topkapı Palace and Ottoman Art" (Topkapı Palace Museum, February 7, 2005), the Turkish version of my article was submitted that year for publication in her festschrift. Since that publication has been delayed, I decided to include the article in this *Muqarnas* volume. I am grateful to Ünver Rüstem for translating it into English. While editing his excellent translation, I have added some new observations and updated several endnotes.

1. The book that resulted from my dissertation (completed at Harvard University in 1986) will be cited repeatedly for the more detailed information and references it gives regarding the structures mentioned in the main text of this article: Gülru Necipoğlu, *Architecture, Ceremonial, and Power: The Topkapı Palace in the Fifteenth and Sixteenth Centuries* (Cambridge, Mass., and London, 1991). The two plans of the palace (fig. 2[a–b]) included in this article are reproduced from my book, without changing their numbering system, so that cross-references to the book can be more easily followed. In the revised Turkish edition of the book, I included some observations based on the archival document published here: *15. ve 16. Yüzyıllarda Topkapı Sarayı: Mimarî, Tören ve İktidar* (Istanbul, 2007).

2. This document is published in Kâzım Çeçen, *Mimar Sinan ve Kırkçeşme Tesisleri* (Istanbul, 1988), 165–69, where it is noted, on the basis of Tursun Bey's history, that Mehmed II restored the Kırkçeşme line. See also Kazım Çeçen and Celâl Kolay, *Topkapı Sarayına Su Sağlayan İsale Hatları* (Istanbul, 1997). For a working drawing of the Kırkçeşme water distribution system, executed by Sinan, and an annotated topographic painting of this system, identifying its "ancient" and new sections in Seyyid Lokman's Persian *Tārīkh-i Sulṭān Sulaymān* (History of Sultan Süleyman), dated 1579—Chester Beatty Library, Dublin, Ms. T. 413, fols. 22v–23r—see Gülru Necipoğlu, *The Age of Sinan: Architectural Culture in the Ottoman Empire* (London and Princeton, N. J., 2005; 2nd ed., London, 2011), 113–14, 140–42, 171–72.

3. For the two copies of the map (Fatih Millet Library, no. 930; and Topkapı Palace Museum Archive [henceforth TSMA], E. 12481), see Kâzım Çeçen, *İstanbul'un Vakıf Sularından Halkalı Suları* (Istanbul, 1991), 37–39, maps 1 and 2. An aqueduct has the following inscription above it: "This is the large aqueduct, which has conveyed the water of the Imperial Palace since the time of His Majesty Sultan Mehmed Khan, may he rest in peace" (*Büyük kemerdür ki merḥūm Sulṭān Meḥmed Ḫān ṭābe serāhu ḥaẓretleri zamānından berü sarāy-ı ʿāmireleri ṣuyı üstünden cārīdür*). See Aygen Bilge,

"Fatih Zamanında Topkapı Sarayı Suyu," *Türk Sanatı Tarihi Araştırma ve İncelemeleri* 2 (1969): 217. Believed to be the remnant of a pre-Ottoman system, the aqueduct in question, which Mehmed II restored, is the Mazul Aqueduct. It carried waters from the Halkalı springs to the Aqueduct of Valens: see Çeçen and Kolay, *Topkapı Sarayına Su Sağlayan İsale Hatları*, 28–30.

4. These maps at the Topkapı Palace Museum Library (henceforth TSMK), dated 1016 (TSMK, H. 1816) and 1161 (TSMK, H. 1815), are published in Çeçen, *İstanbul'un Vakıf Sularından Halkalı Suları*, 39–46, maps 3 and 4. The Halkalı Channel comprises sixteen separate branches: Fatih, Turunçluk, Mahmud Paşa, Bayezid, Koca Mustafa Paşa, Süleymaniye, Mihrimah, Ebussuud, Köprülü, Cerrah Paşa, Sultan Ahmed, Saray Çeşmeleri, Miri (Imperial), Hekimoğlu Ali Paşa, Kasım Ağa, and Nuruosmaniye. Two main lines of aqueducts carried water to pre-Ottoman Constantinople. The second-century Aqueduct of Hadrian, fed by water sources close to the city (near Cebeciköy) and later extended to the Begrade forest, probably entered the city's land walls near the Kırkçeşme distribution center outside Eğrikapı by the Golden Horn. Running parallel to the Golden Horn, this channel supplied water to lower areas, especially the Great Palace abutting the Hippodrome and neighboring public baths. This water collected in Justinian's sixth-century Basilica Cistern (Yerebatan Sarayı). The fourth-century Aqueduct of Valens (Bozdoğan Kemeri), expanded in the fifth century, was supplied from distant springs in Thrace and the closer Halkalı springs. It brought water to higher areas in the city (including the Forum of Theodosius), and its terminal point was the Binbirdirek Cistern. The Hadrianic line partly corresponded to the Ottoman Kırkçeşme system (supplying lower areas). The Aqueduct of Valens, which ceased to carry long-distance waters after the twelfth century, served the Halkalı system (supplying higher areas) in the Ottoman period. See James Crow, "Water and the Great Palace in Constantinople," in *The Byzantine Court: Source of Power and Culture. Papers from the Second International Sevgi Gönül Symposium, June 2010*, eds. N. Necipoğlu, A. Ödekan, and E. Akyürek (Istanbul, 2013); J. Crow, J. Bardill, and R. Bayliss, *The Water Supply of Byzantine Constantinople* (London, 2008). See n. 26 below for the Ottoman-period Kırkçeşme and Halkalı Channels.

5. For sources on this architect's constructions at the palace between 1525 and 1529, see Necipoğlu, *Architecture, Ceremonial, and Power*, 23, 79–82, 98–100, 194–98, 259–62 (Appendix A).

6. Mimar Hayrüddin, one of the royal architects serving Bayezid II, held the post of chief of water channels (*serrāh-ı āb*) in 917 (1511): see Rıfkı Melul Meriç, *Beyazıd Câmii Mimarı: 2. Sultan Bâyezîd Devri Mimarları ile Bazı Binaları; Beyazıd Câmii ile Alâkalı Hususlar, Sanatkârlar ve Eserleri* (Ankara, 1958), 27. The repairs made to the water channels of the Topkapı Palace between 1019 and 1020 (1610–11) were recorded in a register prepared by Hasan, the superintendent (*nāẓir*) of water channels, and presented to

Osman Agha, the palace agha: see Istanbul, TSMA, E. 7257. Another palace agha, Kemankeş Mustafa, wrote on the 1607 map of the Halkalı Channel that a new water source had been found at the command of Ahmed I: see Çeçen, *İstanbul'un Vakıf Sularından Halkalı Suları,* 40.

7. According to the 1607 map, via its imperial (*mīrī*) branch the Halkalı Channel supplied the Topkapı Palace with four *lüles,* one *kamış,* and one *maṣura*'s worth of water (the *kamış* and *maṣura* are smaller measures than the *lüle*). We learn from the 1748 map of the Halkalı Channel that the addition of new water sources had increased this quantity to five *lüles* and one *maṣura.* See Çeçen and Kolay, *Topkapı Sarayına Su Sağlayan İsale Hatları,* 37, 48. Sinan's 1568–69 water distribution register shows that the Kırkçeşme Channel was providing the palace with six *lüles,* three *kamış,* and one *maṣura* of water: see Çeçen, *Mimar Sinan ve Kırkçeşme Tesisleri,* 165–69. Based on these figures, the overall amount of water coming to the palace from the Halkalı and Kırkçeşme Channels was close to the ten *lüles*—four and six combined—outlined by our document. For the view that both the Halkalı and Kırkçeşme Channels had conducted water to the Topkapı Palace since Mehmed II's reign, see Bilge, "Fatih Zamanında Topkapı Sarayı Suyu," 216, 218. Our document seems to imply that only the *ayāzma* water (measuring six *lüles*) may have supplied the Topkapı Palace before Bayezid II increased this amount to ten *lüles* of piped water, carried by two channels.

8. "*Ve Sultān-ı Rūm Sultān Bāyezīdiñ ki aṣıl ḳubbe sarāylarıdur, hiç ḫaṭā olmayub Allāhu Taʿālā saḳlayub bekledi; amma içerü ḥammām var idi, anda baʿżı derzler iẓhār oldı, girü berkitdüler.*" When the sultan, who had left Istanbul for Edirne on 9 Rajab 915 (October 23, 1509), returned to the capital on 27 Shawwal (February 7, 1510), "the Timber Frame Houses were completed; the sovereign entered them on Wednesday, the fourth of Dhu'l-Qaʿda (February 13, 1510) in the same year. And he [then] made repairs to the Old Palace and ordered that water be brought to it (… *çatma evler tamām oldı; hüdāvendigār sene-i mezkūrun ẕi'l-ḳaʿde ayının dördünde çehārşenbe gün içine girdi ve eski sarāya meremmet idüb şuyını getürmek buyurdı*). See Rūḥī Edrenevī, *Tārīḫ-i Āl-i ʿOsmān:* Berlin, Staatsbibliothek, Ms. Or. Quart 821, fols. 191r–192v. For the repairs the sultan ordered during his absence in Edirne—which were completed in two months and concerned the Topkapı Palace's sea wall, as well as "some exemplary buildings in the noble inner palace" (*ḥarīm-i kerīmde baʿżı binā-yı ʿibret-nümā*)— see Kemālpaşazāde (İbn Kemāl), *Tevārīḫ-i Āl-i Osmān. VIII. Defter (Transkripsiyon),* ed. Ahmet Uğur (Ankara, 1997), 279–80.

9. According to Menavino, a Genoese page who lived at the Topkapı Palace between 1505 and 1514, Bayezid II built a two-story structure in which to reside, using its basement on hot and cold days. We do not know whether this structure, whose location is not indicated, was the Timber Frame Palace built in 1509: see Giovantonio Menavino, *I cinque libri della legge, religione, et vita de' Turchi* (Flor-

ence, 1548), 91, cited in Necipoğlu, *Architecture, Ceremonial, and Power,* 144, 287n109.

10. For sources showing that women lived at the Topkapı Palace during the reigns of Mehmed II and Bayezid II, see Necipoğlu, *Architecture, Ceremonial, and Power,* 159–160. Account books dated 1527–29 (933–36) and today kept in the Prime Ministry Archives (Başbakanlık Osmanlı Arşivleri, hereafter BA) record the structures that Sultan Süleyman added to the Harem in the vicinity of today's Courtyard of the Favorites. One account book (BA, MM. 17884, fols. 53–54, 69, 71), for instance, contains a note that reads "For building a walled enclosure and constructing a timber frame house, and kiosk, and fountain, and a water channel for the fountain of the water tank near the Palace of Girls at the side of the imperial garden" (*Becihet-i sāḫten-i dīvār-ı ḥavlı ve sāḫten-i ḫāne-i çatma ve köşk ve şādırvān ve rāh-ı āb-ı şādırvān-ı ābḫāne der nezd-i sarāy-ı duḫterān ʿan ṭaraf-ı bāġçe-i ʿāmire*). Another document (BA, KK. 7097, fols. 22, 24, 58) records a project undertaken at the same time "[f]or building a walled enclosure around the pool and its water channel near the Palace of Girls at the side of the imperial garden" (*Sāḫten-i dīvār-ı ḥavlı der etrāf-ı ḥavż ve rāh-ı āb-ı o der nezd-i sarāy-ı duḫterān der ṭaraf-ı bāġçe-i ʿāmire*). See Necipoğlu, *Architecture, Ceremonial, and Power,* 261 (Appendix).

11. See n. 7 above.

12. The swamp is indicated on the 1607 map of the Halkalı Channel as the place called "the big swamp" (*büyük baṭaḳ*): see Çeçen, *İstanbul'un Vakıf Sularından Halkalı Suları,* 40.

13. Meriç, *Beyazıd Câmii Mimarı,* 70–72. The register of gifts also records the rewards given in 1505 to those who had completed the water channel sponsored by (and today named after) Bayezid II for the provision of water to his mosque complex: ibid., 54–55. This water channel, like the imperial branch (*mīrī, ḫāṣṣa*) restored in 1511, was one of the branches of the Halkalı Channel.

14. Among the supervisors rewarded on 5 Safar 917 (May 3, 1511) for their work on "the construction of the buttress of the wall of the imperial palace" (*binā-i ṭayama-i dīvār-ı sarāy-ı ʿāmire*) was a certain Solak ʿAli, who belonged to the cavalry corps (*ebnā-i sipāhiyāndan*): see Meriç, *Beyazıd Câmii Mimarı,* 70. This must be the same ʿAli referred to as the building superintendent (*binā emīni*) in a note on the elevation drawing published in Necipoğlu, *Architecture, Ceremonial, and Power,* 128–29 (fig. 3 in this article). For a more detailed description of this drawing and its inscriptions, see Gülru Necipoğlu-Kafadar, "Plans and Models in 15th- and 16th-Century Ottoman Architectural Practice," *Journal of the Society of Architectural Historians* 45, 3 (September 1986): 224–43.

15. Necipoğlu, *Architecture, Ceremonial, and Power,* 128.

16. For Miʿmar Hayrüddin, see n. 6 above; and Meriç, *Beyazıd Câmii Mimarı,* 70–71.

17. In the gift register, the name Miʿmar ʿAli bin ʿAbdullah appears in one instance as "*ʿAlāʾüʾd-dīn Ḫalīfe, miʿmār*": Meriç, *Beyazıd Câmii Mimarı,* 54 (no. 59).

18. Ibid., 27, 30–31.

19. Aydın İ. Yüksel, *Osmanlı Mimârîsinde Kânûnî Sultan Süleyman Devri (926–974/1520–1566): İstanbul* (Istanbul, 2004), 9, and also 9–16. For the view that I share with Yüksel, and arrived at before the publication of his 2004 book, see Necipoğlu, *Age of Sinan*, 155. In a study that came to my attention after submitting the Turkish version of this article in 2005 for publication in Dr. Filiz Çağman's festschrift, the late Stefanos Yerasimos independently reached the same conclusion. See his article "15. ve 16. Yüzyıl Osmanlı Mimarları: Bir Prosopografya Denemesi," in *Afife Batur'a Armağan: Mimarlık ve Sanat Tarihi Yazıları,* ed. Aygül Ağır, Deniz Mazlum, and Gül Cephanecigil (Istanbul, 2005), 37–62, esp. 41.

20. These masters are listed in TSMA, E. 9784: *Tafṣīl-i esāmī-i üstādān ki Tebrīzden gelmişdür.* Published in Oktay Aslanapa, "Tabriser Künstler am Hofe der Osmanischen Sultane in İstanbul," *Anatolia* 3 (1958): 15–17.

21. See Necipoğlu, *Age of Sinan*, 155, and Appendix 4.2 on p. 563.

22. For the claim that he was an Azeri Turk, as well as a detailed bibliography, see Özkan Ertuğrul, *Türkiye Diyanet Vakfı İslâm Ansiklopedisi* (Istanbul, 1988–), s.v. "Acem Ali." For the Armenian identity of Ya'qub Şah, and for his nephew, see Necipoğlu, *Age of Sinan*, 130, 155.

23. See Necipoğlu, *Age of Sinan*, 155, Appendix 4.1 on p. 563. For the reference in the *waqfiyya*, see Halim Bakî Kunter, "Mimar Ali Bey'in Bilinmeyen İki Vakfiyesi," *V. Türk Tarih Kongresi, III. Seksiyon* (Ankara, 1960), 442. The names of architects in wage registers from the 1520s and 1530s are recorded in Necipoğlu, *Age of Sinan*, Appendix 4.2 on p. 563.

24. For Sinan's waterworks and the expertise of Ottoman chief architects in hydraulic engineering, see Necipoğlu, *Age of Sinan*, 127–47, 153–86, and Appendix 4.5 on p. 565.

25. Mustafa 'Âli, *Künhü'l-aḫbār*, Istanbul University, Ms. İÜ, T. 5959, fol. 84v, cited in Necipoğlu, *Architecture, Ceremonial, and Power,* 49–50, 271n98.

26. The Kırkçeşme waters, which came from dams and streams that were subject to pollution, could only supply places of low altitude. The Halkalı waters, on the other hand, originated in clean underground springs and were conveyed via the Aqueduct of Valens and various water towers to higher locations. See Çeçen and Kolay, *Topkapı Sarayına Su Sağlayan İsale Hatları,* 6–66. For the aqueducts of Hadrian (supplying water to lower areas) and of Valens (distributing water to higher areas) in the Byzantine period, see n. 3 above.

27. "It is impossible to determine the original form" of this much-altered water tower, though "some of the pipes embedded in the wall are very likely original": ibid., 48, 59, 70–72. On the 1607 map of Halkalı Channel, it is described as "the water tower on the inner face of the Imperial Gate" (*bāb-ı hümāyūnuñ iç yüzündeki terāzūdur*): ibid., 33. The 1748 Halkalı Channel map, meanwhile, includes a water tower-like structure on the fortress wall to the left of the Imperial Gate, labeled "water tower" (*terāzū*) as well as "water distribution chamber" (*maḳsem*) (fig. 1): ibid., 48 (nos. 135–37).

28. Çeçen and Kolay, *Topkapı Sarayına Su Sağlayan İsale Hatları,* cited in the preceding note, does not include a water tower near the Hagia Irene. For the two wells, see n. 84 below.

29. There is a sacred spring (*ayāzma*) in the vicinity of the Cold Fountain Gate, outside the palace fortress, by the door next to the Iron Gate. Formerly associated with the Church of St. Therapon, the curative waters of this spring are today in a well reached by stairs. "It is found at the foot of the wall after passing the Iron Gate and before reaching the second, side door (the Sokollu Gate)": see Hülya Tezcan, *Topkapı Sarayı ve Çevresinin Bizans Devri Arkeolojisi* (Istanbul, 1989), 115–16.

30. For the three depots at the Tower Pavilion, see Çeçen and Kolay, *Topkapı Sarayına Su Sağlayan İsale Hatları,* 61, 69. It is hoped that the results of new archaeological explorations, which have located water channels and an "unknown room related to the channels" under the Harem, will shed more light on the position of the water tower "next to the Timber Frame Palace": see n. 84 below.

31. For the plan and elevation of this structure as it currently stands, see ibid., 72–73.

32. "*Bābü's-saʿāde ḳurbinde gümüş taʿbīr olınan şu maḳsemi*".

33. "*Sarāy-ı ʿāmire içinde büyük odanuñ ardında şu mecmāʿıdur, sarāy-ı ʿāmireye şu cemʿ olub bādehū taḳsīm olur; üç lüle, iki ḳamış, bir maṣura şudur.*" Jean-Baptiste Tavernier, *Nouvelle relation de l'intérieur du serrail du grand seigneur* (Paris, 1675), 81–82, cited in Necipoğlu, *Architecture, Ceremonial, and Power* 49–50n101.

34. For the fountain of the stables, see Bilge, "Fatih Zamanında Topkapı Sarayı Suyu," 118, 220 (figs. 4 and 5). According to Sinan's distribution register of 1568–69, the water that the Kırkçeşme Channel brought to the Topkapı Palace was handled by a "new water wheel" (*dolab-ı cedīd*) and by three other wheels in the outer garden. I have proposed probable locations for the other three water wheels in n. 81 below. For the Corps of the Water Wheel, the two wells, and Sinan's new water wheel, see Çeçen and Kolay, *Topkapı Sarayına Su Sağlayan İsale Hatları,* 6–66, 74–76; and Çeçen, *Mimar Sinan ve Kırkçeşme Tesisleri,* 165–69, 178–80. On the recent discovery of the channel connecting the two wells and another channel extending from those wells toward the Marmara side of the outer garden, see n. 84 below. In his autobiography, titled *Tezkiretü'l-Bünyān,* Sinan describes his discovery of an ancient water well in a royal garden of Sultan Süleyman; this is generally misidentified as one of the step-wells in the Topkapı Palace's Corps of the Water Wheel, a mistake I repeated in my own book: *Architecture, Ceremonial, and Power,* 50. The well discovered by Sinan was actually in the suburban royal garden that once belonged to İskender Çelebi: see Gülru Necipoğlu, "Preface: Sources, Themes, and Cultural Associations of Sinan's Autobiographies," in *Sinan's Autobiographies: Five Sixteenth-Century Texts,* ed. Howard Crane and Esra Akın (Leiden, 2006), xiii, 127.

35. The poem, by Veliyüddin Ahmed Pasha, is discussed in Necipoğlu, *Architecture, Ceremonial and Power*, 217. The 1875 map of Istanbul is published in Ekrem Hakkı Ayverdi, *19. Asırda İstanbul Haritası* (Istanbul, 1958). For the water wheel, also see Çeçen and Kolay, *Topkapı Sarayına Su Sağlayan İsale Hatları*, 66. The barracks, terraces, cisterns, and walls that were destroyed in 1912 with the establishment of the Gülhane Park are mentioned in Tezcan, *Topkapı Sarayı*, 25–26, 407.

36. Giovanni Maria Angiolello, *Di Gio. Maria Angiolello e di un suo inedito manoscritto*, ed. A. Caparozzo (Vicenza, 1881), 22–24. The water supplied to the infirmary, which was built by Sultan Süleyman, came from the water tower next to the Imperial Gate, as recorded on both the 1607 and 1748 maps of the Halkalı Channel. The bakery's water supply—shown only on the 1748 map—came instead from the water tower of the Middle Gate (which seems to be the outside tower of our document). An extant water tower in the middle of the curtain wall on the right-hand side of the first court was built in the nineteenth century. See Çeçen and Kolay, *Topkapı Sarayına Su Sağlayan İsale Hatları*, 33 (no. 105), 48 (nos. 138, 140, and 141), 67. Our document makes no mention of two freestanding fountains that are depicted on the left-hand sides of the first and second courts in manuscript paintings from Süleyman's reign onwards; the 1748 map indicates that these too received their water from the water tower next to the Middle Gate.

37. Abdülkadir Özcan, "Fatih'in Teşkilat Kanunnamesi ve Nizam-ı Alem için Kardeş Katli Meselesi," *Tarih Dergisi* 33 (1982): 42.

38. Angiolello, *Di Gio. Maria Angiolello*, 24, cited and discussed in Necipoğlu, *Architecture, Ceremonial and Power*, 141–42, 286n102.

39. For the chronology of the construction of the Privy Chamber complex and its marble terrace, see Necipoğlu, *Architecture, Ceremonial, and Power*, 141–58, 184–200. Remains of an older and larger pool have been found under the pool that currently occupies the terrace: see Sedat Hakkı Eldem and Feridun Akozan, *Topkapı Sarayı: Bir Mimari Araştırma* (Istanbul, 1981), figs. 77, 85.

40. Menavino, *I cinque libri*, 91, cited in Necipoğlu, *Architecture, Ceremonial and Power*, 192, 293n22.

41. For the hypothetical location of the crystal kiosk and further descriptions of it, see Necipoğlu, *Architecture, Ceremonial, and Power*, 192–94.

42. Hülya Tezcan dates the bowl of the fountain to the fourth century and also considers the marble basin beneath to be antique: see Tezcan, *Topkapı Sarayı*, 377, figs. 545 and 546. For Mehmed II's familiarity with and patronage of Italian Renaissance art, and additional bibliography, see Gülru Necipoğlu, "Visual Cosmopolitanism and Creative Translation: Artistic Conversations with Renaissance Italy in Mehmed II's Constantinople," *Muqarnas* 29 (2012): 1–81.

43. Necipoğlu, *Architecture, Ceremonial, and Power*, 184–89.

44. Ian R. Manners, "Constructing the Image of a City: The Representation of Constantinople in Christopher Buondel-monti's *Liber Insularum Archipelagi*," *Annals of the Association of American Geographers* 87, 1 (1997): 87–94. For the building of Mehmed II's mausoleum by his son Bayezid II, see Gülru Necipoğlu, "Dynastic Imprints on the Cityscape: The Collective Message of Imperial Funerary Mosque Complexes in Istanbul," in *Cimetières et traditions funéraires dans le monde Islamique*, ed. Jean-Louis Bacqué Grammont and Tibet Aksel, 2 vols. (Ankara, 1996), 2:23–36. I dated the Buondelmonti map to the early 1480s in Necipoğlu, *Age of Sinan*, 91–92n85, and in Necipoğlu, "Artistic Conversations with Renaissance Italy in Mehmed II's Constantinople," 14, 26, 68–69n119. This map is dated to Mehmed's reign, ca. 1480, in Çiğdem Kafescioğlu, *Constantinopolis/Istanbul: Cultural Encounter, Imperial Vision, and the Construction of the Ottoman Capital* (University Park, Pa., 2009), 144–54. It is dated to the second half of the 1480s, on the basis of its watermark from around 1484, in Arne Effenberger, "Die Illustrationen—Topographischen Untersuchungen: Konstantinopel/Istanbul und ägäische Örtlichkeiten," in *Cristoforo Buondelmonti: Liber Insularum Archipelagi; Universitäts und Landesbibliothek Düsseldorf Ms. G 13, Faksimile*, ed. Irmgard Siebert, Max Plassmann, et al. (Wiesbaden, 2005), 23–28; see also the introduction on pp. 9–20.

45. For the minaret that Bayezid II added to the Hagia Sophia, see Gülru Necipoğlu, "Life of an Imperial Monument: Hagia Sophia after Byzantium," in *Hagia Sophia: From the Age of Justinian to the Present*, ed. Robert Mark and Ahmet Ş. Çakmak (Cambridge, 1992), 195–225.

46. Albrecht Berger and Jonathan Bardill, "The Representations of Constantinople in Hartmann Schedel's *World Chronicle* and Related Pictures," *Byzantine and Modern Greek Studies* 22 (1998): 2–37.

47. On the Column of Theodosius I (r. 379–95), see G. Becatti, *La Colonna coclide istoriata: Problemi storici, iconografici, stilistici* (Rome, 1960). The French antiquarian Pierre Gilles, who was in Istanbul between 1544 and 1547, and again in 1550, reports that this monumental column had been dismantled "more than forty years before," for the construction of Bayezid II's bath (i.e., ca. 1504 or earlier): See *Pierre Gilles' Constantinople: A Modern English Translation with Commentary*, trans. Kimberly Byrd (New York, 2008), 150–51. The bath was built around 1505–8, rather than in 1517, after the death of Bayezid (d. 1512), as is generally assumed: See Semavi Eyice, *Türkiye Diyanet Vakfı İslâm Ansiklopedisi*, s.v. "Beyazıt Hamamı." For the argument that it was Bayezid II who dismantled the Column of Theodosius I, as opposed to its having been destroyed in a cyclone in 1517, see Necipoğlu, "Artistic Conversations with Renaissance Italy in Mehmed II's Constantinople," 26–27, 69–70n123.

48. The Buondelmonti map in Düsseldorf, first published by Manners in 1997, was not known in 1991, when my book on the Topkapı Palace appeared. I incorporated references to this map in the 2007 Turkish edition of my book, *15. ve 16. Yüzyıllarda Topkapı Sarayı*. For the date and bibliography on the now-lost visual source of the so-called Vavassore map, see Necipoğlu, "Artistic Conversations with Renaissance Italy in Mehmed II's Constantinople," 27, 70–71n125.

49. I had dated only one of the two domes (that over the disrobing chamber of the bath) to the reign of Mehmed II, prior to the discovery of the Buondelmonti map, where both of the domes are depicted: Necipoğlu, *Architecture, Ceremonial, and Power*, 130. For a hypothetical reconstruction of this building without its two domes, see Eldem and Akozan, *Topkapı Sarayı: Bir Mimari Araştırma*, 75–77.

50. For the unconvincing argument that the columns with classicizing capitals were added in the eighteenth century, see Uğur Tanyeli, "Topkapı Sarayı Üçüncü Avlusu'ndaki Fatih Köşkü (Hazine) ve Tarihsel Evrimi Üzerine Gözlemler," *Topkapı Sarayı Müzesi Yıllık* 4 (1990): 150–207. The composite Ionic capitals differ in style from their eighteenth-century "Ottoman Baroque" counterparts. Moreover, the marble blocks of the matching half-capitals at each end of the courtyard and loggia arcades are clearly incorporated into the original wall fabric. The loggia and courtyard portico remained walled in between the sixteenth century and modern renovations (see n. 54 below); thus, there would have been no incentive or possibility in the eighteenth century to add lavish colonnades to a building that was locked up as a treasury. Ekrem Hakkı Ayverdi correctly interpreted the columns as belonging to Mehmed II's original building: see his *Fatih Devri Mimarisi* (Istanbul, 1953), 336–39. This judgment is repeated in Eldem and Akozan, *Topkapı Sarayı: Bir Mimari Araştırma*, 75–77.

51. In his description of the imperial treasury, the seventeenth-century traveler Jean-Baptiste Tavernier states that the ceiling of its portico has "excellent paintings in mosaic that represent diverse personages, and that are believed to have been made for the reception of some great prince in the time of the Greek Emperors." He goes on to say that only the personages' bodies survived, the human faces having been effaced because of the Turks' opposition to figural images. See Tezcan, *Topkapı Sarayı*, 18, and Necipoğlu, *Architecture, Ceremonial, and Power*, 137. Tavernier furthermore believed that the portico had once been open on both sides, though the structure is clearly of a piece with the rest of the pavilion, sharing as it does the round arches and composite Ionic capitals of the loggia. The portico's original ceiling was entirely removed in the course of a restoration carried out in 1944. As well as housing Mehmed's library and treasures comprising both Eastern and Western objects, the imperial treasury also preserved various Byzantine relics: see Necipoğlu, *Architecture, Ceremonial, and Power*, 133–41. The basement, known as the Underground Treasury (*bodrum ḫazīnesi*), includes a Byzantine baptistery whose quatrefoil marble basin was used by the Ottomans for storing gold coins: see Tezcan, *Topkapı Sarayı*, 104–12.

52. The sultan's imperial vision is interpreted in Necipoğlu, "Artistic Conversations with Renaissance Italy in Mehmed II's Constantinople," 1–81.

53. The oral tradition, mentioned by the nineteenth-century Ottoman historian ʿAtâ, is cited in Necipoğlu, *Architecture, Ceremonial, and Power*, 134.

54. The Treasury-Bath complex was twice restored, following the earthquake of 1556–57 and the fire of 1574. It may have been in the course of these repairs that the portico and loggia were walled in, if not earlier during Bayezid II's reign, following the damage done to this building in the 1509 earthquake. In 1555, Ogier Ghiselin de Busbecq, the ambassador of the Holy Roman Emperor, referred to a new treasury hall that Rüstem Pasha had added to the building: see Necipoğlu, *Architecture, Ceremonial, and Power*, 129, 138–39.

55. Ibid., 124–33, fig. 75.

56. Angiolello, *Di Gio. Maria Angiolello*, 23–24, cited in Necipoğlu, *Architecture, Ceremonial, and Power*, 123, 284n1. For the Pool Pavilion, see Necipoğlu, *Architecture, Ceremonial, and Power*, 123–24.

57. For the Large Chamber and dormitories of the treasury and pantry pages, see Necipoğlu, *Architecture, Ceremonial, and Power*, 111–20.

58. Özcan, "Fatih'in Teşkilat Kanunnamesi," 42. Mehmed II's Chamber of Petitions was replaced in the 1520s by that of Sultan Süleyman, which is still extant: see Necipoğlu, *Architecture, Ceremonial, and Power*, 19–21, 96–110.

59. Angiolello, *Di Gio. Maria Angiolello*, 23, cited in Necipoğlu, *Architecture, Ceremonial, and Power*, 53, 273n4.

60. For the fountain of the stables, see n. 34 above. The 1607 map of the Halkalı Channel reveals that the water tower to the left of the Middle Gate (which I have hypothetically identified as the outside tower of our document) supplied three *maşuras* to the imperial stables (*ḥāṣṣ aḫur*), as well as one to the chamber of halberdiers (*teberdārlar odası*); the latter structures were added during Sultan Süleyman's reign: see Çeçen and Kolay, *Topkapı Sarayına Su Sağlayan İsale Hatları*, 33 (nos. 108 and 109). The 1748 map records the waters distributed by the same water tower to two freestanding fountains on the left sides of the first and second courts, as well as to the buildings along the left side of the second court (*bāb-ı sulṭān, ḳoz bekçiler, zülüflü teberdārān*). Since there is no water channel connected to the kitchens in this map, their water supply probably came from the neighboring two wells of the Corps of the Water Wheel, fed by the Kırkçeşme waters, in the far right corner of the first court: see n. 34 above, and Çeçen and Kolay, *Topkapı Sarayına Su Sağlayan İsale Hatları*, 48 (nos. 138, 143–46).

61. For the İshakiye Kiosk, see Necipoğlu, *Architecture, Ceremonial, and Power*, 217–18.

62. For the basement of the rectangular pavilion, see Necipoğlu, *Architecture, Ceremonial, and Power*, 98–200; and Tezcan, *Topkapı Sarayı*, 109–10.

63. In Melchior Lorichs' panorama (1559–60s), the original shore kiosk of Bayezid II is labeled "das lusthauss des Kaisers": see Eugen Oberhummer, *Konstantinopel unter Sultan Suleiman dem Grossen, aufgenommen im Jahre 1559 durch Melchior Lorichs aus Flensburg* (Munich, 1902), 10, pl. 3; Cyril Mango and Stephan Yerasimos, *Melchior Lorichs' Panorama of Istanbul, 1559* (Bern, 1999), 8 (sheet 3). The two shore kiosks that successively replaced that of Bayezid II are discussed in Necipoğlu, *Architecture, Ceremonial, and Power*, 231–40. I am grateful to Mr. Sandy Paul, Sub-Librar-

ian of Trinity College Library, who showed me the Dryden Album (Ms. R.14.23) during my stay in Cambridge in March 2013, and for providing the digital images of the painting, as well as the permission to publish it.

64. For the Çinili Köşk and a wall fountain inside one of its halls, which features a renovation inscription dated 1590–91, see Necipoğlu, *Architecture, Ceremonial, and Power*, 210–17; Menavino, *I cinque libri*, 90; Tursun Beg, *History of Mehmed the Conqueror by Tursun Beg*, facsimile edition with introduction by Halil İnalcık and Rhoads Murphey (Minneapolis and Chicago, 1978), fols. 58r, and 59r–v.

65. Tursun Beg's description shows that the two pavilions stood in the outer garden that extended between the fortress wall and the main core of the palace complex: see Tursun Beg, *History of Mehmed the Conqueror*, fols. 58r, 59r–v. For the Byzantine substructure of the Museum of the Ancient Near East, see Tezcan, *Topkapı Sarayı*, 25. The buildings are discussed in Necipoğlu, *Architecture, Ceremonial, and Power*, 210–12; and, more recently, in Necipoğlu, "Artistic Conversations with Renaissance Italy in Mehmed II's Constantinople," 25–30, 33–34.

66. The two garden kiosks are also seen in Melchior Lorichs, *Panorama of Istanbul*, ca. 1559–60s: Leiden University Library, Ms. Cod. 1758, reproduced in Necipoğlu, *Architecture, Ceremonial, and Power*, pls. 25d–e.

67. The term *"mahall"* is used for the women's quarters in Mughal palaces. Hence, the water tower in the outer garden that supplied the "fountain of the Mansion/Palace" could be associated with the Harem quarters. A cellar under this edifice was supplied by the water tower next to the armory (i.e., Hagia Irene): Angiolello, *Di Gio. Maria Angiolello*, 24; discussed in Necipoğlu, *Architecture, Ceremonial, and Power*, 210–17, 298n1; and Necipoğlu, "Artistic Conversations with Renaissance Italy in Mehmed II's Constantinople," 25–30, 33–34.

68. For the prison, see Jean-Claude Flachat, *Observations sur le commerce et sur les arts d'une partie de l'Europe, de l'Asie, de l'Afrique, et même des Indes Orientales*, 2 vols. (Lyons, 1766–67), 2:209, 211, cited in Necipoğlu, *Architecture, Ceremonial, and Power*, 207, 297n117. The complex appears, again with the label *"Tennu,"* in Melchior Lorichs' *Panorama* (ca. 1559–60s). It is a monastery-like structure surrounded by a wall with towers, shown at the left side of the Tile Palace, beneath the stables: see Oberhummer, *Konstantinopel*, 10–11 (figs. 4 and 5); Mango and Yerasimos, *Melchior Lorichs' Panorama*, 8 (sheets 4 and 5). These images are reproduced in Necipoğlu, *Architecture, Ceremonial, and Power*, pls. 25d–e.

69. On the church and monastery of St. Demetrius, see Tezcan, *Topkapı Sarayı*, 70–74. Giovannni Battista Donato, who saw this ruined church with its mosaics in 1681, wrote that the palace gardeners resided there: see Necipoğlu, *Architecture, Ceremonial, and Power*, 207.

70. For the Church of "S. Paulus," see Tezcan, *Topkapı Sarayı*, 70. On the college associated with this church, see R. Browning, "The Patriarchal School at Constantinople in the Twelfth Century," *Byzantion: Revue Internationale des*

Études Byzantines 32, 1 (1962): 167–202. Flachat, *Observations sur le commerce*, 2:210, cited in Necipoğlu, *Architecture, Ceremonial and Power*, 207, 297n120. It seems less likely that the structure described by Flachat is the church and monastery of St. Demetrius, on Seraglio Point. This monastic complex, used as the dormitory of the Corps of Royal Gardeners, was not so close to the *alla Persiana* and *alla Turchesca* pavilions. Mehmed II's three garden pavilions were a stone's throw from one another, according to Angiolello.

71. The various sections and structures of the outer garden are described in Necipoğlu, *Architecture, Ceremonial, and Power*, 200–41.

72. Angiolello, *Di Gio. Maria Angiolello*, 24–25, cited in Necipoğlu, *Architecture, Ceremonial, and Power*, 202, 295n62.

73. For the cisterns and cellars in the palace grounds, see the topographic map of the Topkapı Palace and descriptions of these Byzantine structures in Tezcan, *Topkapı Sarayı*, 187–240. Tezcan recorded about forty-two wells and cisterns on the grounds of the Topkapı Palace.

74. Ibid., 231–33. I find it likely that the cellar "outside the fortress gate" may have been located under the "imperial storehouse" (*mīrī anbar*), near the madrasa of the Ayasofya Mosque, which Sinan demolished to widen the street extending between Hagia Sophia and the Topkapı Palace: see Necipoğlu, *Age of Sinan*, 112.

75. Tezcan, *Topkapı Sarayı*, 223–24.

76. Cemil Pasha (Topuzlu), who was the city prefect (*şehremīni*) of Istanbul at the time and the man largely responsible for establishing the park, would describe the discovery of the cistern as follows: "No sooner did we bring down one of these [garden-terrace] walls than the ruins of an old church together with an enormous cistern of ten columns appeared before us" (*Bu duvarlardan birini bir gün indirir indirmez önümüze eski bir kilise harabesi ve 10 sütunlu kocaman bir sarnıç çıktı*). According to Wulzinger, this cistern may have been the substructure of a monastery or part of a bath: See Tezcan, *Topkapı Sarayı*, 226–28.

77. Tezcan, *Topkapı Sarayı*, 94–99. Some of this holy water flowed from a fountain in the basement of the Pearl Kiosk (İncili Köşk), completed in 1591. According to Tezcan, there was another *ayāzma* in the same area belonging to the Church of S. Maria Hodegetria: Tezcan, *Topkapı Sarayı*, 55–61. She identifies the ruins of a hexagonal structure with a marble pool, discovered in the vicinity, as the baptistery of this church. But Berger holds that it belongs to a lost bath: see Albrecht Berger, *Untersuchungen zu den Patria Konstantinupoleos*, Poikila Byzantina 8 (Bonn, 1988), 376–78.

78. Following the Ottoman conquest of Istanbul, this monastery and church complex was used for a period as a dervish lodge: see Tezcan, *Topkapı Sarayı*, 78–84; and Berger and Bardill, "Representations of Constantinople," 21–22.

79. The arsenal seems to have been replaced by the imperial boathouse (*kayıkhāne-i ḫāṣṣa*) on the Golden Horn shore of the palace, depicted in Melchior Lorichs' panorama, ca.

1559–60s, where it is annotated as *"des Kaysers galehen hauss, mit welcher er spazieren fereth."* See Oberhummer, *Konstantinopel*, 11 (pl. 4); Mango and Yerasimos, *Melchior Lorichs' Panorama*, 8 (sheet 4); Necipoğlu, *Architecture, Ceremonial, and Power*, 207–8. Also see the row of boathouses shown on the shore in the Austrian Habsburg Album's view of the Topkapı Palace, reproduced in this article (fig. 13), and the plan of the palace precinct (fig. 2a [46]).

80. I previously read the inscription on Schedel's woodcut as "S. Grovus": see Necipoğlu, *Architecture, Ceremonial, and Power*, 204. Recent alternative readings include "S. Granus" and "Lazarus": see Fırat Düzgüner, *Iustinianus Dönemi'nde İstanbul'da Yapılar: Procopius, Birinci Kitap* (Istanbul, 2004), 62–63. The correct reading is probably "S. Geor[g]ius," as proposed in Berger and Bardill, "Representations of Constantinople," 21–22. Berger and Bardill suggest that the depicted church is that of "St. Lazarus" or St. Michael, arguing that the Monastery of Theotokos Hodegetria (S. Maria Hodegetria)—which they regard as having been located outside the palace walls—could not have stood on the site. Tezcan, however, believes S. Maria Hodegetria to have been within the palace grounds (see n. 77 above).

81. Of the four water wheels on the palace grounds that are mentioned in Sinan's water distribution register of the Kırkçeşme Channel, only one is indicated as being new: that of the Corps of the Water Wheel in the first court (*dolab-ı cedīd der sarāy-ı ʿāmire*): see Çeçen and Kolay, *Topkapı Sarayına Su Sağlayan İsale Hatları*, 63–66; Çeçen, *Mimar Sinan ve Kırkçeşme Tesisleri*, 167–69; and nn. 34 and 60 above. The remaining three wheels were, to my mind, located as follows: that of the "aviary of the imperial palace" (*kuşhāne-i sarāy-ı ʿāmire*) was, as I argue above in the main text, by the converted church near the intersection of the palace's land and sea walls on the Marmara side (fig. 2a [37]); that of the "imperial garden" (*bāġçe-i ḫāṣṣ*) was probably near the dormitory of the Corps of Royal Gardeners on the Golden Horn side (fig. 2a [47]); and that of "His Majesty the Sultan" (*dolab-ı ḥażret-i sulṭān*) may have been in the vicinity of the Privy Chamber's and Harem's walled private garden terraces. For the Corps of the Aviary, see Necipoğlu, *Architecture, Ceremonial, and Power*, 204.

82. One of Bayezid II's new pavilions was outside the sea wall on the shore of the Golden Horn: see n. 63 above. An account book dated 893 (1488) describes another of Bayezid II's pavilions as the "new kiosk above the imperial palace" (*köşk-i cedīd der bālā-yı sarāy-ı ʿāmire*). In the article in which I published this previously unknown account book, I wrote that the kiosk in question may have been built in either Istanbul or Edirne, because another account book

dated 895 (1490) refers to the "repair of the painting of the ceiling of the kiosk above the imperial palace" in Edirne (*meremmet-i naḳş-ı tavan-ı ḳaṣr-ı bālā der sarāy-ı ʿāmire*). However, I now believe that the kiosk built in 1488 was more likely part of the Topkapı Palace. The reference in the account book to the kiosk's use of lead "brought from Edirne" (*Edrene'den gelen*) seems to support this view. Given that this building—which must have stood on an elevated point of the palace—incorporated seven windows, a single door, and two columns, it was most probably octagonal in plan and fronted by a two-columned entrance porch. See Gülru Necipoğlu-Kafadar, "The Account Book of a Fifteenth-Century Ottoman Royal Kiosk," in "Raiyyet Rüsumu: Essays Presented to Halil İnalcık on His Seventieth Birthday," special issue, *Journal of Turkish Studies* 11 (1987): 31–46.

83. "*Ol binā yı ʿaẓīmi resm-i ḳadīm üzerine itmām itmekle ḳomayub iḥkāmda vu ibrāmda evvelinden hezār-bār bek eyleyüb, maʿmūre-i mezkūrenüñ, ki miẟālini muṣavvir-i ḫayāl taṣfīr idemezdi, naẓīrini iḥdāṣa sulṭān-ı ḳader-tevānuñ kemāl-i iḳtidārını iʿlān ve āşikār itdiler.*" See İbn Kemâl, *Tevârîḫ*, 280.

84. A team of archaeologists led by Dr. Çiğdem Özkan-Aygun of Istanbul Technical University briefly investigated the Topkapı Palace's hydraulic system in 2009, after having analyzed that of the Hagia Sophia in 2005 and 2009. The results of these preliminary investigations on the palace grounds are summarized in Çiğdem Özkan-Aygün, "New Findings on Hagia Sophia Subterranean and Its Surroundings," *Bizantinistica, Rivista di Studi Bizantini e Slavi*, Serie Seconda 12 (2010): 57–77. The team discovered channels under the second courtyard and Harem; the channel connecting the two huge wells of the Corps of the Water Wheel (Dolap Ocağı) in the first courtyard, and another channel extending from those wells towards the cisterns and substructures of the Mangana region of the outer garden along the Marmara Sea; as well as two similar huge wells in the courtyard of the Ottoman Mint behind Hagia Irene. The "non-destructive" method employed was "direct survey in the channels and cisterns," including diving, ibid., 57–59. Archaeological investigations in the future, however, need to be accompanied by archival research and scrutiny of written narrative sources.

85. For the sarcophagi and other antiquities found at the palace grounds, see Tezcan, *Topkapı Sarayı*, 251–389.

86. Mehmed II's conquest of Constantinople and his dominion over the "Two Continents" and "Two Seas" are specified in the palace's foundation inscription on the Imperial Gate, dated 1478: see Necipoğlu, *Architecture, Ceremonial, and Power*, 34, 36.

EBBA KOCH

THE WOODEN AUDIENCE HALLS OF SHAH JAHAN: SOURCES AND RECONSTRUCTION

The court of Shah Jahan (r. 1628–58) was highly conscious of architecture. Not only are a large number of buildings preserved that were commissioned by the *pādshāh*, his family, and the nobility, but we also have detailed descriptions in primary sources to match them. This evidence allows us to understand the form, function, and meaning of the buildings, as well as the historical context in which they were created. Besides the great mausoleum project of the Taj Mahal (1632–43/48) and the tomb for his father, Jahangir, at Lahore (1628–38), Shah Jahan's interest was directed towards palaces and gardens. The palace was a major focus of his urban projects at Agra and Shahjahanabad. The emperor commissioned mosques on a large scale only in his later reign and the madrasa as a building type of its own never played a great role in Mughal India.

Since the middle of the 1970s, I have been engaged in documenting and analyzing all the palaces and gardens of Shah Jahan.[1] The large number of preserved buildings and the evidence about them in the primary sources give us unique insights into a building type about which much less is known elsewhere in India and the Islamic world.[2]

In this paper, I reconsider the audience halls of Shah Jahan. Previously, I discussed the stone halls as we see them today in the Mughal fortress palaces of Agra, Lahore, and Delhi (figs. 1–3), exploring them from the perspective of their design, purpose, and symbolic significance.[3] But this left several questions open, and I addressed only briefly the immediate sources of the halls, namely, their wooden precursors, which were constructed by Shah Jahan soon after he came to the Mughal throne on February 14, 1628. The wooden halls represented his first expression of official ceremonial palace

architecture and were of considerable importance in the realization of his new program of palace buildings. But they lasted only ten years and by 1637 were replaced by permanent stone halls at Agra and Lahore. In the new palace of Delhi (completed in 1648), a stone hall was built following the same pattern but without a wooden precursor. No trace is left of the wooden halls that are here the subject of my investigation, and their ephemeral nature necessitates a reconstructive exploration of the primary sources. The issue is, indeed, quite complex, since it involves considering the sources on different levels.

I understand these sources in two different ways: first in the conventional manner, as textual records that speak about the inception and development of the halls. And, since I am an art historian, I also devote much attention to the visual records, which confront us with the problem of the representation of the halls in contemporaneous history painting. Second, I understand "source" as a starting point from which to consider where the idea of the wooden halls came from as they appear in Shah Jahani palace architecture.

Lastly, I would like to distinguish "source" from "origin" when I look at how Shah Jahani audience halls became a model of architectural inspiration for the Safavids. An idea that had its origin in the Achaemenid dominions was reformulated at the Mughal court and came to be an incentive for further architectural exploration back in Iran.

I. TEXTUAL SOURCES

In Shah Jahan's time, we observe the emergence of rich texts on architecture. They do not, however, form a

genre of their own—the Mughals had no written archi-
tectural theory. In India one would have expected the
Mughals to have become interested in this genre be-
cause treatises on art and architecture, the *shilpa
shāstras* and *vāstû shāstra*, represent an ancient tradi-
tion of the subcontinent. It is surprising that the exten-
sive Mughal translation program of Sanskrit texts under
Akbar (r. 1556–1605) did not include works of this type—
the more so since the Mughals, like the Muslim dynas-
ties before them, continued to absorb Indian traditions
into their art and architecture, and even reinvigorated
them.

Despite the lack of written evidence, theory was not
absent from Mughal architectural thinking, and in Shah
Jahan's time we have clear evidence that it was ex-
pressed in the buildings themselves, the most telling
example being the Taj Mahal.[4]

Historiography as a forum for architecture

Although no theory of architecture was written down,
we do have detailed Mughal texts dealing with architec-
ture, namely, descriptions that inform us about the con-
struction history, form, and function of a building. They
begin to appear in the official historiography (*tārīkh*)
after the accession of Shah Jahan. These texts are not
concerned with how to build, but rather give an assess-
ment of the status quo, of a finished building and its use.
They may also describe what a building will look like, a
kind of project study, as it were. While these texts have
attracted the attention of art historians like Wayne
Begley and myself,[5] they have largely been ignored by
historians and scholars of Indo-Persian literature, since
the historiography and poetry produced for Shah Jahan
has, in general, received little attention.[6]

The appearance of architecture in the historiography
gives expression to a distinct interest of Shah Jahan. The
construction of his own history was one of his driving
concerns, the intention being to leave to posterity the
image of an ideal ruler and an ideal state. His search for
a suitable historian took over ten years, and several can-
didates were considered for the part, including 'Abd al-
Latif of Gujarat, Hakim 'Abd al-Haziq of Fatehpur, Mir
Jalal al-Din Tabataba'i of Isfahan (d. 1636; commissioned
in 1632),[7] and Muhammad Amin of Qazvin (d. 1646/47;
in imperial service as a munshi since 1632 and commis-

sioned to write the *Pādshāhnāma* in 1636). Shah Jahan
ultimately settled, in about 1638, on 'Abd al-Hamid La-
hawri (d. 1654), an elderly historian from Lahore who by
then had retired to Patna.[8] The emperor expected him
to compose a history that would rival the *Akbarnāma*,
the great historical work that Abu'l Fazl (d. 1602) had
created for Shah Jahan's grandfather Akbar. In his
Pādshāhnāma Lahawri covered the first twenty-six
years of Shah Jahan's reign, that is, two cycles of ten
years and six years of the third cycle. When he had to
retire from the task because of his declining health, Mu-
hammad Warith (d. 1680) continued the remaining four
years of the third cycle. Muhammad Sadiq Khan (of
whom little is yet known) wrote a *Shāhjahānnāma/
Tavārīkh-i Shāhjahāni* or *Pādshāhnāma*,[9] and Muham-
mad Salih Kanbo (d. 1674/75) authored the *'Amal-i Ṣāliḥ*,
also called the *Shāhjahānnāma*, a parallel history.[10] The
circumstances of the last work's composition are not
quite clear, although recent research by Saqib Baburi
has suggested that it might also have been an imperial
commission. Kanbo's style is highly panegyrical and
metaphorical, which makes him a principal source for
establishing the symbolism and program of imperial
buildings. He also points out the function of architec-
ture, pomp, and show as an instrument of rule.[11] Lastly,
there was Chandar Bhan Brahman (d. 1662–63), the
munshi and poet who wrote the *Chahār Chaman* (The
Four Gardens). This work, which is difficult to classify,
describes, inter alia, activities and ceremonies of Shah
Jahan's court and also contains eulogizing accounts of
provinces, cities, and buildings of the Mughal empire.[12]

Architecture in poetic works

There were also the poets Abu Talib Kalim Kashani (d.
1650), Hajji Muhammmad Jan Qudsi Mashhadi (d. 1646),
and Mir Muhammad Yahya Kashi (d. 1653), who all em-
barked on the project of a versified *Pādshāhnāma* in the
style of the *Shāhnāma* of Firdawsi, although none of
these versified histories gives a full account of Shah Ja-
han's reign.[13] The work by Kalim, Shah Jahan's most
eminent poet, covers the ruler's ancestry and prince-
hood, as well as the first decade of his reign.[14] Its descrip-
tions of imperial building projects contain a surprising
amount of factual information. Kalim is, for instance,
the only one of Shah Jahan's authors to give us the tech-

nical details of how the foundations of buildings at Agra, including the Taj Mahal, were laid by means of wells sunk into the sandy terrain of the river bank.[15]

Kalim, Qudsi, and Kashi also wrote eulogies of Shah Jahan's buildings and poetic chronograms on the occasions of their completion. Panegyric poetry with its metaphors and *epitheta ornantia* (specific glorifying phrases repeatedly used for the emperor or his buildings) represents a potential source for establishing the meaning of a building, though as I have pointed out elsewhere, the greatest problem is to recognize which themes and concepts were merely literary conventions and which had a bearing on actual works of art.[16]

Epigraphy

Rounding out the picture was epigraphy (the inscriptions on a building), which may proclaim the program of a structure, as in the case of the Koranic inscriptions of the Taj Mahal, expressing the eschatological concept of the mausoleum.[17] Shah Jahani epigraphy was more often written in Persian and provided information, in panegyric terms, about the date of completion, the patron, and the costs involved in constructing the building.[18]

While descriptions, eulogies of buildings, and epigraphy can be found elsewhere in the Persian-speaking world, the architectural descriptions embedded in Shah Jahan's histories in prose and verse are in the fullest stage of their development, outstanding in their time with regard to their complete and exact assessment of a building, precise detail, measurements, and consistency in the application of architectural terms.[19] A perfect example is the building-by-building description of the Taj Mahal complex on the occasion of its official completion on 17 Dhu 'l Qa'da 1052 (February 6, 1643).[20] And we have full and detailed accounts of all major Shah Jahani palaces and formal gardens. Only the architectural projects of the emperor were recorded in detail; those of the princes, imperial women, and nobility were merely mentioned, if at all, when they were reported as completed, or when the emperor paid them a visit. Also described were buildings that were built by a member of the imperial family or the nobility for the emperor's use.

In these descriptions we observe an idiosyncratic use of Persian and Arabic expressions, and an enrichment of the vocabulary, with terms assimilated from Indian languages applied to architectural forms derived from older Indian architecture.[21] Shah Jahan wanted to have his architecture—the monument of his reign—recorded in exact terms for posterity; he directed the scientific interest in the visual world, which he had inherited from his predecessors, toward his own artifacts. Babur and Jahangir described the works of nature, the flora and fauna of Hindustan, in long passages in their complex autobiographies; Shah Jahan had his architecture assessed in a corresponding manner through the genre of historiography (*tārīkh*).

Descriptions of the first wooden audience hall of Agra

Architectural descriptions of such quality did not appear out of the blue; indeed, they took some time to develop. The first building to which Shah Jahan's historians and poets directed their efforts was the audience hall that Shah Jahan had built in the palace fortress of Agra soon after his accession in August 1628. Up to this time, a tent (*īvān az parcha*) had been used. The new hall was described as an *īvān* and called *Dawlat Khāna-i Khāṣṣ -u-ʿAmm*, as well as *Chihil Sutun* (Forty Columns). In Mughal Persian, *īvān* means a pillared construction of any dimension and plan; *dawlat khāna* can be rendered as "house of royal power and authority," and is used for an imperial palace or palace building; *khāṣṣ*, meaning "the special, the close ones," referred to the group that represented the highest ranks of the empire; and *ʿāmm* were all the others. *Īvān-i Dawlat Khāna-i Khāṣṣ-u-ʿĀmm* can thus be translated as "State Hall for High and Low," or "Hall of Public Audience," while *Īvān-i Chihil Sutūn* means "Hall with Forty Columns."

The Mughals did not use large audience halls before Shah Jahan, and thus his Dawlat Khana-i Khass-u-ʿAmm (in common language shortened to Divan-i ʿAmm), or Chihil Sutun, represented a new type in the Mughal palatial building program. It was described by his historians, who emphasized the emperor's personal involvement, as an "invention of Shah Jahan."[22] The credit for his buildings, even for their overall concept, had to go to Shah Jahan as the supreme architect, and his advisers and builders were hardly ever recognized. Jahangir acknowledged the role of these behind-the-scenes players, referring to them as *mardum-i ṣāḥib-i*

vuqūf—men of superior knowledge—when he mentions how he consulted them in the rebuilding of the tomb of his father, Akbar, at Sikandra, Agra.[23] Shah Jahan's "invention" refers, obviously, to the hypostyle construction of a large audience hall, not to the term *chihil sutūn.* Palace buildings called *chihil sutūn* appear in Timurid, Safavid, and early Mughal texts. We can assume that they had pillars, though not necessarily forty of them, since the term was mostly used in a generic way. Otherwise, we do not know what they looked like.[24]

We learn that the purpose of Shah Jahan's new hall was to provide an architectural frame for the viewing window from which he presided over the general court assembly, the Jharoka-i Khass-u- 'Amm, in the courtyard, the Sahn-i Dawlat Khana-i Khass-u- 'Amm, of the palace of Agra, and to give protection to those who took part in the court session. Corresponding halls were built at Lahore and, according to Sadiq Khan, also at Burhanpur in Khandesh, in central India, and in other great

cities of the Mughal empire.[25] We learn further that these audience halls were first built of wood and were later replaced by the stone versions of the Red Fort of Agra (fig. 1), the Fort of Lahore, much altered in the nineteenth and early twentieth century (fig. 2), and the Red Fort of Delhi (fig. 3). Earlier scholars largely ignored the existence of the wooden halls and applied what Shah Jahan's historians said about them to their later stone replacements.[26]

Since the wooden audience halls were built at the time when Shah Jahan was trying out various historians, we have descriptions of them from the pens of several authors. Jalal al-Din Tabataba'i begins his history on 28 Sha'ban 1041 (March 20, 1632), with an account of the Nawruz celebration at Burhanpur; the *bargāh-i chihil sutūn-i- 'āmm-u-khāṣṣ* (forty-columned audience hall for the wider public and the special ones) features right at the beginning of his account, but he provides no details about it.[27] The following historians carefully describe

Fig. 1. Divan-i 'Amm, Agra Fort, completed 1637. (Photo: Ebba Koch)

Fig. 2. Divan-i ʿAmm, Lahore Fort, after 1628, with later alterations. (Photo: Ebba Koch, 2013)

Fig. 3. Divan-i ʿAmm, Delhi Fort, completed 1648. The hall was originally covered with white stucco plaster (*chunā*). (Photo: Ebba Koch)

the first wooden hall of Agra, which became the blue-print for the rest, and further mention that the hall at Lahore was built in the same way. Tabataba'i's successor, Qazvini, refers to the Agra hall as "one of the innovations of Hazrat Sahib-i Qiran-i Thani" in his description of the daily court proceedings, where he explains its function and organization. He gives a separate description of the hall in Dhu 'l Hijja 1037 (August 1628), in his chronologically ordered account of the first year of Shah Jahan's reign.[28] The official and final description was

that of 'Abd al-Hamid Lahawri, who reported the com-
pletion of the hall on 4 Dhu 'l-Hijja 1037 (August 5, 1628).
He combined the two descriptions of Qazvini and fol-
lows him closely when he writes (see appendix I for a
transcription of the following passage):

> In the time of the rule of His Majesty Arsh Ashyani [post-
> humous name of Akbar, r. 1556–1605] and [during] the
> sultanate of His Majesty Jannat Makani [posthumous
> name of Jahangir, r. 1605–1627] and after the accession
> (julūs) of His Majesty the World protector (jahān-bān
> [=Shah Jahan]), up to this date, there was no build-
> ing in front of the Jharoka-i Khass-u- 'Amm,[29] in which
> all the servants (jamī'-yi bandagān) would receive the
> honor (dawlat) of audience (bār) and the bliss of view-
> ing [the pādshāh], and where the servants of the carpet
> of his presence (multazimān-i basat) would get protec-
> tion from rain and heat. [Merely] an īvān of cloth was
> put up, as has been mentioned before.[30] As in this auspi-
> cious time whatever available means of comfort of world
> rule (jahān-bānī) through [all] possible efforts have come
> onto the wide stage [of existence] (ba-mazhar-i fahal)
> and whatever decoration and adornment of the world
> have been rushed from the depth of nonexistence (hazīz-i
> 'adam) to the zenith of existence (awj-i vujūd),[31] due to
> the world-adorning order [of the pādshāh], wonderwork-
> ing architects (mi'mārān jādū āsār) and carpenters, who
> are in their work like Azar (najjārān-i Āzar-kār),[32] built
> a lofty hall (īvān-i 'alá) that raised its head to the planet
> Saturn and a high building (binā'-i-rafī') that reached to
> the lote tree in Paradise (sidratu 'l-muntahá), and it was
> completed in front of the jharoka (viewing window) of
> the Dawlat Khana-i Khass-u- 'Amm. In length [it was] 70
> gaz and in width 22 gaz pādshāhī.[33] It was completed in
> forty days [exactly] in the manner in which it had cast its
> light in the bright mirror of the mind of His Majesty the
> world conqueror (gītī-satān). Also, for those who stand
> in front of the world-ruling throne, it was new protection
> from rain (lit. water) and sun, and a boundless decora-
> tion to the court (bārgāh) as high as heaven. Three sides
> of this īvān of high foundations have a passage (rāh) from
> which the high nobles (umarā') and the ones whose duty
> is to serve (khidmat-i pishgan) and other close rank hold-
> ers (mansabdārān-i rū-shinās) come in, and a railing of
> silver (mahjar az nuqra) has been put up [around it]. In
> this īvān stand the servants worthy of their rank at the
> place that has been established for them in the manner
> suitable to the assemblies of glorious and powerful sul-
> tans. Most of them stand with their back facing the rail-
> ing, and a few that are distinguished by being close [to the
> emperor] stand adjacent to the two columns (sutūn) that

> frame [lit. are right next to] the jharoka.[34] And the bearers
> of the qūr[35] with golden flags ('ālam) and golden emblems
> (togh) and the imperial qūr (qūr-i khāssa) stand on the left
> side,[36] with their backs close to the wall. In front of this
> heaven-like building is a wide courtyard (sahn), around
> which is a wooden-colored railing (chūbīn-i mahjar-i
> rangīn) on which they spread hangings (sāyabān) of bro-
> caded velvet (makhmal-i zarbaft). In this place, whoever
> has a rank (mansab) less than 200[37] and the personal
> guard (ahadī) who are archers (kamān-dār) and muske-
> teers (tufangchīyān) of excellent aim and some of the fol-
> lowers of the umarā' are received at court. At the gates of
> the Dawlat Khana-i Khass-u- 'Amm and [those] of each
> of the two railings, reliable mace bearers and supervi-
> sors (yasāwulān: masters of ceremonies?) and doorkeep-
> ers stand in precious robes. They do not allow access to
> strangers or anyone whose position is not up to the ranks
> [entitled to enter inside].

> Talib Kalim, the creator of meaningful verses, com-
> posed this quatrain in praise of this house of high foun-
> dations, and brought it to the most holy attention [of the
> emperor]. And the skirt of his expectations became heavy
> with the weight of the imperial reward.

> This new building, which is under the same shadow as the
> throne ('arsh) of God [= is its neighbor in the highest stage
> of heaven],
> loftiness is only a word next to the height of its plinth.

> It is a garden (bāgh) and each of its green columns is a
> cypress (sarv),
> so that the repose of high and low (khāss-u-'āmm) is under
> its shadow.

> And the holy order had the honor of being issued that at
> the capital (Dār al-Saltanat) Lahore, likewise in front of
> the Jharoka-i Dawlat Khana-i Khass-u-'Amm, they should
> construct a high īvān in the same manner.[38]

Then there is Muhammad Salih Kanbo's description of
the hall, which I adduce here in the translation of
S. M. Yunus Jaffery (see appendix II for a transcrip-
tion):[39]

> Laying the foundation of Chihil Sutun in the courtyard
> of khāss-u-'āmm to give room to high and low, especially
> those who stand under the shadow of the favor and com-
> passion of his Majesty, near the leg of the throne of Solo-
> mon's dignity.

> The special favor of the emperor of the world is by the
> grace of God directed not only towards a particular
> class or a particular person among the different groups
> of people and individuals, but as a common necessity
> has included all living beings, low and high ('avāmm-u-

khavāṣṣ). Consequently, the shadow of his benevolence includes the whole world and like the generosity of God, the Self-Existent, covers each and every person. The effects of the spring rain of his beneficence have reached everywhere, in the same way that the beautiful rain of the blessings [of God] has poured not only on the dry and wet [parts of the earth], but also on the sea, as well as on the land. It is for this reason that the emperor has always the intention in his actions and thoughts [lit. externally and internally] to acquire the peace of mind and happiness of the hearts of the people; therefore, none of the moments of his blessed time passes without him meditating about the case and the comfort of the people of the world. The royal determination is always busy to prepare designs to collect means of peace and protection for the people. One evidence of this claim is the innovation of the royal audience hall (*bārgāh*) named Chihil Sutun (Forty Columns), which has recently been built in the spacious courtyard of *khāss-u-ʿāmm*. The reason for laying the foundation of this building, which is a copy of the seven gardens of King Shaddad (*nuskha-i sabʿ-i Shaddād*)[40] and the court of justice and equity (*dīvānkada-i ʿadl-u-dād*) and which has drawn a veil on the audience hall of Solomon (*bārgāh-i Sulaymān*) and the *Īvān-i Nawshirwān*,[41] is that everybody from every direction has hopes of this place of refuge and a large number of the people, with the intention of presenting their requests, come here repeatedly, settling their petitions, and the execution of their requirements and necessities. But there was no shade or shelter [for them], to protect them from the water of rain and the violent heat of the sun. Therefore, due to the exigency of the infinite compassion of the emperor, a *farmān* (order) running like destiny and bearing the impression of the royal signet was issued with the content that: In the great Dar al-Khalifat [title of Agra] as well as in most of the big cities of all the provinces of the empire, where royal palaces have been built, and particularly in Dar al-Saltanat Lahawr [title of Lahore], in front of the Jharoka-i Khass-u-ʿAmm, a place where indigent persons successfully fulfill their needs, should be laid the foundations of a hall (*īvān*) with forty columns (*chihil sutūn*) seventy *ẕirāʿ* [=*gaz*]) long and twenty-two *ẕirāʿ* wide; and it should be completed at once, so that all the attendants of the court, without bearing the trouble of the heat of the sun, might be able to offer their petitions without restraint.

In short, at the royal command, such an audience hall, where dignity takes abode, was built on forty magnificent columns. Its threshold is so high that it has diminished the glory of the Ivan-i Kisra.[42] The base of this sacred monument is so firm that the castles of the Caesar (*qasr-i Qayṣar*), being anxious of its exaltation, became defeated in their foundations. Such a long and wide building with so many pleasant designs and geometrical figures was built within forty days, and it caused amazement for spectators.

Verses (*abyāt*):

During the reign of Sahib Qiran-i Thani, the world is so well furnished, as never before in the last hundred centuries.
A magnificent building has been raised on forty columns, and it is more upright than the mountain Bisutun.[43]
When this building glitters in the ruddy crepuscule, the sky out of envy sinks up to his waist into blood.

When this cheerful building was completed in every respect and came into being in its full form, the astronomers (*akhtar shumārān*) and astrolabe-consulting persons chose the day of 25 Dhu 'l Hijja 1037 (August 25, 1628) as an auspicious time that was free from ill fate. The emperor of this heaven-like court, after 20 *gharī* [of this day][44] had passed, entered this paradisiacal assembly, decorated with various things of adornment and beauty, and sat on the throne of fortune and put on the crown of dignity and splendor.[45] By giving a general audience at this special court (*bārgāh-i khāṣṣ*), he praised with his thanks-paying tongue the creator of men and genies, and raised his God-worshipping hands to pardon the sinners and granted gifts to the poor. On this occasion, the eulogists, the minstrels and singers who had prepared the musical notes of eternal joy, were favored with suitable awards, including Taliba-i Kalim, the composer of the following *rubāʿī* (quatrain) in praise of this Solomonic audience hall (*bārgāh–i Sulaymānī*), which was brought to the notice of the emperor:

rubāʿī

This new building, which is under the same shadow as the throne (*ʿarsh*) of God [= is its neighbor in the highest stage of heaven],
loftiness is only a word next to the height of its plinth

It is a garden (*bāgh*) and each of its green columns is a cypress (*sarv*),
so that the repose of high and low (*khāṣṣ-u-ʿāmm*) is under its shadow.[46]

Abu Talib Kalim Kashani not only composed the quatrain quoted by Qazvini, Lahawri, and Kanbo, but also featured the audience hall more fully in his versified *Pādshāhnāma* (see appendix III for a transcription):

One of the buildings of that powerful king
under whose shadow Time is at rest

Is Chihil Sutun of the glory of the sky,
which is placed against the viewing place of high and low
(*manẓar-i khāṣṣ-u-ʿāmm* [= the *jharoka*])

At that place when to kiss the ground before the *shāh*
gathered together the heads of the army

There was no building to cast shade
so that they might be cheerful in this assembly

Neither during the rule of Shah Jannat Makan [posthumous title of Jahangir]
nor during the period of Khaqan ʿArsh Ashyan [posthumous title of Akbar].

Sometimes the assembly was [exposed] to the heat of the sun,
sometimes they became wet with the rain of the clouds.

By the order of the Second Sahib Qiran [Shah Jahan]
soon in the imperial reign

A hall (*īvān*) of forty columns was built,
it raised its head high to the sky.

Its length was determined to be of seventy *gaz*,
to twenty-two was increased the figure of its width.

[The viewer's eyes] are glued to the spectacle of its ceiling,
his head in the air like a column of *khāṣṣ-u-ʿāmm*.

The artist has painted its ceiling
like painter Spring the flower garden.

The eyes [of the beholder] are so drawn to the flowers of the ceiling
that he finds it difficult to look where he is walking [lit. to look before his feet].

A column is a cypress and the bird of the vision is a ring dove,
on each cypress it has made a hundred nests.

There are many cypress trees in the garden of the world
(*gulshān-i ʿālam*),
but cypresses of an equally great stature there are few.

By the order of the *shāh* of the grandeur of the stars
at Lahore in the place of assembly of high and low
(*majmaʿyi khāṣṣ-u-ʿāmm*).

They made a Chihil Sutun of the same design (*ṭarḥ*)
and it raised its head in exaltation to the sky.[47]

Lastly, ʿInayat Khan gives an abridged version of the earlier descriptions:

Construction of a Forty-Columned Portico in front of the Balcony of the Hall of Public Audience

The public assembly of the world monarch was always held in front of the royal balcony (*jharoka*) of the Hall of Public Audience in the Akbarabad Fort. However, during the reigns of the late emperors Akbar and Jahangir, no coverings had existed over the area reserved for those standing in the royal presence; and accordingly, many had to bear the hardship of rain in the monsoon and heat in the summer. To alleviate this, His Majesty ordered a spacious Forty-Pillared Hall (*Chihil-Sutun*) to be built; and it was completed on the 4th of Zi'l-Hijja this year 1037 (August 5, 1628). Orders were issued that a similar hall should be built in front of the balcony at the Lahore capital, and that the building of the Royal Tower (Shah Burj) in the palace should be completed.[48]

I have adduced these texts in full to show their different approaches. Lahawri is less concerned with the form of the building than with its function in the context of the ceremonial program of the palace. In his subsequent descriptions of other buildings of Shah Jahan, such as the palaces of Agra, Lahore, and Delhi, he will become more precise in his architectural details. Kanbo does his best to impress the Mughal court with his elaborate style and his metaphorical comparisons. These specific conventions of Mughal court rhetoric have the potential to guide us to the motivation for constructing a building, to its program and/or symbolic meaning. Kanbo's panegyric statements that Shah Jahan's halls will surpass the legendary audience hall of Solomon, the ultimate king of Islamic thinking, prompted me to read the halls as a Mughal recreation of the multi-columned halls of Persepolis, which in Islamic times was connected with Solomon. As noted earlier, Shah Jahan's halls were referred to as Chihil Sutun. In addition to being a generic term for a multi-columned hall, Chihil Sutun was used as an alternate proper name for Persepolis.[49] Moreover, all the authors emphasize Shah Jahan's intention to provide his courtiers with protection from heat and rain through the construction of hypostyle halls. This motivation thus seems to resonate deeply with all of them. Arab historians cite protection from the sun as the reason behind the building of the first mosque in the house of Muhammad at Medina.[50] Shah Jahan here emulated a gesture of the Prophet himself, sheltering his followers with a hypostyle construction that was patterned on a mosque.[51]

As to the actual shape of the halls, we get the most architectural detail from the poetic description of Kalim. We learn that the hall had green columns "like cypresses," and a ceiling with painted flower designs so attractive that "the bird of the vision" was anxious to build its nest in it, meaning that the viewer's eyes were glued to the beautiful painted patterns of the ceiling.

II. VISUAL SOURCES

Visual evidence enables us to arrive at a fuller understanding of the audience halls. It can be found in the paintings that illustrate the history of Shah Jahan. These works belong to the genre generally described as "miniature painting," but they are in fact highly informative history paintings in small format, embodying all the ambition of the genre.

The hall in the images of the Windsor Castle Pādshāhnāma

Court reception, or *darbār*, scenes form the largest and most important group of the so-called Windsor Castle *Pādshāhnāma*, the only manuscript of Lahawri's history with contemporary illustrations so far known.[52] It seems that several copies were planned, since individual paintings also exist that were probably meant to illustrate other copies of the *Pādshāhnāma*. The *darbār* scenes of the Windsor manuscript are all done according to the same formula: they show the emperor in the *jharoka* presiding over the proceedings of the Dawlat Khana-i Khaṣṣ-u-ʿAmm. The architecture is not represented for its own sake, but to provide a frame for the court event. Four paintings of the eleven *darbār* scenes of the Windsor Castle *Pādshāhnāma* show the audience halls (in the others only the *jharoka* is visible). These are:

A) Fol. 72b: The presentation of Prince Dara Shikoh's wedding gifts. Agra, Divan-i ʿAmm, February 4, 1633. Painted by Balchand, ca. 1635 (fig. 4).[53]
 The hall is represented by two pairs of high, slender columns that frame the *jharoka* on each side in a perfectly balanced composition. The columns and their brackets support the flat roof, which is white and topped with an in-and-out crenellation pattern (*kangura*) and

shows a slanting eave (*chajja*) above which are fixed rings to attach tentage. The base of the columns is red, while the shafts and the brackets are green, decorated with a pattern in gold. The topmost part of the column below the capital is set off in red and a different golden pattern. Above the capital, the red element (again with a different gold pattern) is extended to represent the red underside of the frontal bracket of a cruciform arrangement of brackets. A golden railing with a central door regulates access to the hall.

B) Fol. 98b: Shah Jahan receives the Persian ambassador Muhammad ʿAli Beg at Burhanpur in the Divan-i ʿAmm, March 1631. Attributed to the "Kashmiri painter," ca. 1633 (fig. 5).[54]
 The hall stands behind the audience tent, which fills the center of the composition. Only the upper parts of its green and red columns are visible in the corners of the painting, supporting a flat roof similar to the one in fol. 72b/A (fig. 4), from which hangs a red eave (*chajja*) awning with a yellow flounce.[55]

C) Fol. 147b: The departure of Prince Shah-Shujaʿ for Kabul. Agra, Divan-i ʿAmm, March 16, 1638. Painted by Murar, ca. 1640 (fig. 6).[56]
 Similar to fol 72b/A (fig. 4). Here the red strip above the capital clearly appears as the underside of the brackets.

D) Fol. 214b: Shah Jahan honoring Prince Aurangzeb at Agra before his wedding, April 27, 1637. Painted by Payag, ca. 1640 (fig. 7).[57]
 Similar to fol. 72b/A (fig. 4).

E) Fol. 217b: The arrival of Prince Aurangzeb at the court in Lahore. Lahore, Divan-i ʿAmm, January 9, 1640. Painted by Murar, ca. 1645 (fig. 8).
 In this painting, more of the hall is visible than in any of the paintings discussed so far—the artist is obviously concerned to highlight its idiosyncratic features. Murar conforms to the convention of fol. 72b/A (fig. 4), fol. 147b/C (fig. 6), and fol. 214b/D (fig. 7) in the frontal rendering of the two outer green and red columns of the hall that frame the composition. However, he moves them towards the edge of the painting to show two more columns flanking the *jharoka* in a different perspective,

Fig. 4. (A) The presentation of Prince Dara Shikoh's wedding gifts. Agra, Divan-i 'Amm, February 4, 1633. Painted by Balchand, ca. 1635, *Pādshāhnāma*, fol. 72b. Windsor Castle, Royal Library, OMS 1616. (Photo: courtesy of the Royal Collection Trust / © Her Majesty Queen Elizabeth II 2013)

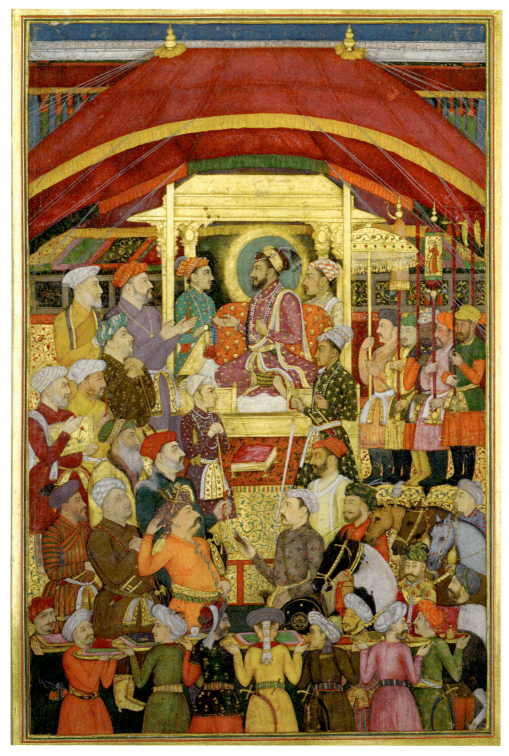

Fig. 5. (B) Shah Jahan receives the Persian ambassador Muhammad 'Ali Beg at Burhanpur in the Divan-i 'Amm, March 1631. Attributed to the "Kashmiri painter," ca. 1633, *Pādshāhnāma*, fol. 98b. Windsor Castle, Royal Library, OMS 1619. (Photo: courtesy of the Royal Collection Trust / © Her Majesty Queen Elizabeth II 2013)

Fig. 6. (C) The departure of Prince Shah-Shuja' for Kabul. Agra, Divan-i 'Amm, March 16, 1638. Painted by Murar, ca. 1640, *Pādshāhnāma*, fol. 147b. Windsor Castle, Royal Library, OMS 1634. (Photo: courtesy of the Royal Collection Trust / © Her Majesty Queen Elizabeth II 2013)

Fig. 7. (D) Shah Jahan honoring Prince Aurangzeb at Agra before his wedding, April 27, 1637. Painted by Payag, ca. 1640, *Pādshāhnāma*, fol. 214b. Windsor Castle, Royal Library, OMS 1645. (Photo: courtesy of the Royal Collection Trust / © Her Majesty Queen Elizabeth II 2013)

Fig. 8. (E) The arrival of Prince Aurangzeb at the court in Lahore. Lahore, Divan-i 'Amm, January 9, 1640. Painted by Murar, ca. 1645, *Pādshāhnāma*, fol. 217b. Windsor Castle, Royal Library, OMS 1646. (Photo: courtesy of the Royal Collection Trust / © Her Majesty Queen Elizabeth II 2013)

three dimensional and free-standing, which allows him to document their peculiar shape as fully as possible. Above their capitals, the columns are topped not by the red-colored part of the shaft (as in the other examples discussed so far) but instead by red projecting impost blocks with a square section topped by yet another capital, which supports the brackets, arranged in a cruciform. Their red underside is here divided by a bluish-green stripe. The undersides of the eaves of the *jharoka* feature painted birds, and angels appear in a (painted?) sky on both sides of the *jharoka* below the ceiling, paraphrasing an actual feature of the palace of Lahore (fig. 9).[58]

In addition, on folio 194b, though the columns of the hall are not shown, the *jharoka* rests on short pilasters projecting from the back wall, which pick up the green color topped by a red capital. (Only the left pilaster is

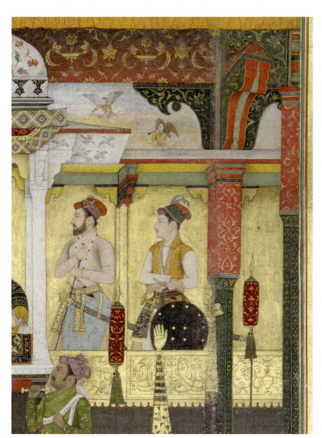

Fig. 9. Detail of fig. 8: The arrival of Prince Aurangzeb at the court in Lahore.

visible, the other being hidden by an attendant bearing a *chawrī* [fly whisk]).[59]

The hall in individual paintings

The wooden audience hall also features in four separate paintings that were obviously created at some point to illustrate copies of the history of Shah Jahan but were eventually pasted onto pages of albums.[60] Only the one now in the Bodleian Library follows the *darbār* formula (though the *jharoka* appears in an asymmetrical position). The other three show more of the architecture of the hall. In chronological order they are:

F) Shah Jahan in the *darbār* at Agra, August 5, 1628(?). Ascribed to Murar, ca. 1630, and mounted in the St. Petersburg Album (fig. 10).[61] This painting was perhaps done on the occasion of the completion of the halls on August 5, 1628.[62]

The composition of this early painting of a Shah Jahani court reception does not as yet display the strict protocol observed in the later *darbār* scenes. Shah Jahan does not sit in the *jharoka* but in front and below it, on a squarish, four-poled platform (*takht*) with a baldachin placed on the floor of the hall. This sort of "throne bed" represented the prevailing throne form of Shah Jahan. He appears at equal height with his sons and courtiers, who stand around him in two opposing profile groups whose interlocking formation is still indebted to Jahangiri *darbār*s.[63] Also, the deep perspective of the hall will later be replaced by a flattened minimalistic rendering of the architecture (see A, C, and D [figs. 4, 6, and 7]). We get a full view into the hall from below, with three of its columns on each side, the outer most ones framing the painting, similar to Murar's rendering of the hall of Lahore (E [fig. 8]). The columns support the flat, heavily decorated ceiling, partly covered with patterned textiles, on brackets arranged in a cruciform. The bracket construction is also similar to E (fig. 8); the columns, however, are not topped by red impost blocks but merely with the red element corresponding to the width of their shafts, as in A, C, D, and H (figs. 4, 6, 7, and 13). The interest shown in the depiction of architecture is characteristic of the artist Murar.

Fig. 10. (F) Shah Jahan in the *darbār* at Agra, August 5 1628(?). Ascribed to Murar, ca. 1630, and mounted in the St. Petersburg Album. St. Petersburg, Russian Academy of Sciences, Institute of Oriental Manuscripts, Ms. E.14, p. 34a. (Photo after *The St. Petersburg Muraqqaʿ: Album of Indian and Persian Miniatures of the 16th–18th Centuries and Specimens of Persian Calligraphy of ʿImād al-Ḥasanī*, ed. Oleg. F. Akimushkin [Milan: Leonardo Arte, 1996], pl. 125)

G, a and b) A night celebration of the Prophet's birthday. Agra, Divan-i 'Amm, September 16, 1633. Attributed by Milo Beach to Bulaqi, ca. 1635, detached from the St. Petersburg Album. Washington, D.C., Smithsonian Institution, Freer Gallery of Art, Purchase F 1942.18a and 17a (figs. 11 and 12).[64]

This is the only representation of the hall to extend over two pages. It is also the only instance in which Shah Jahan is shown in a "convivial" situation, partaking in a public meal.[65] In the left-hand painting, Shah Jahan sits under a four-poled, white baldachin[66] on the floor of the hall below the *jharoka*, which is framed on each side by a row of four columns in a flat, silhouetted arrangement; in the right-hand painting, members of the religious orthodoxy of Agra sit between and around two rows of columns arranged in the same way. The columns are green throughout; the capitals are delineated in red, and brackets arranged in a cruciform support the red beams of the flat, red ceiling topped by a grayish roof.

H) Shah Jahan receives the Persian ambassador Yadgar Beg. Divan-i 'Amm, Lahore, November 22, 1638. Attributed to Payag, ca. 1640. University of Oxford, Bodleian Library, Ms. Ousely Add. 173, no. 13 (fig. 13).[67]

The composition deviates from the *darbār* formula in that the *jharoka* is not placed in the center, and on the left side we get a view into the court. The outer row of three silhouetted columns on the left side here represents the beginning of the hall. On the left side of the *jharoka* is a pair of two columns and on the right, a column is visible lining the edge of the painting. A frieze of painted European putti runs below the ceiling on both sides of the *jharoka*, alluding, as mentioned in the discussion of E (fig. 8) above, to an actual feature of the Lahore palace decoration, though not necessarily of the audience hall.

I) The emperor Shah Jahan on the Peacock Throne. Attributed by inscription to 'Abid, son of Aqa Riza, dated

Fig. 11. (G) A night celebration of the Prophet's birthday. Agra, Divan-i 'Amm, September 16, 1633. Attributed to Bulaqi, ca. 1635, detached from the St. Petersburg Album, left half of double-page. Washington, D.C., Smithsonian Institution, Freer Gallery of Art, Purchase F 1942.18a. (Photo: courtesy of the Freer Gallery of Art)

Fig. 12. (G) A night celebration of the Prophet's birthday. Agra, Divan-i 'Amm, September 16, 1633. Attributed to Bulaqi, ca. 1635, detached from the St. Petersburg Album, right half of double-page. Washington, D.C., Smithsonian Institution, Freer Gallery of Art, Purchase F 1942.17a. (Photo: courtesy of the Freer Gallery of Art)

Fig. 13. (H) Shah Jahan receives the Persian ambassador Yadgar Beg, Divan-i ʿAmm, Lahore, November 22, 1638. Attributed to Payag, ca. 1640. University of Oxford, Bodleian Library, Ms. Ousely Add. 173, no. 13. (Photo: courtesy of the Bodleian Library)

the 13th year of the reign = 1639–40. San Diego Museum of Art, 1990:352 (fig. 14).[68]

The painting shows a complex architectural composition in deep central perspective. As mentioned above, such perspectival constructions are unusual in Shah Jahani painting and would be in line with the artistic temperament of the artist 'Abid, who liked to take liberties with the impositions of official imperial representation. The painting follows the conventional formula in that the architectural arrangement is centered on Shah Jahan, who does not sit in the *jharoka* but on his fabled Peacock Throne. Behind him is a high baldachin raised on four high poles flanked by two yurts, which are, as Peter Andrew has shown, a symbolic statement of the nomadic origin of the Mughals.[69] Behind appears the audience hall, of which we see mainly the carpeted floor

Fig. 14. (I) The emperor Shah Jahan on the Peacock Throne. Attributed by inscription to 'Abid, son of Aqa Riza, dated the 13th year of the reign = 1639–40. Opaque water color and gold on paper, mounted as an album page, 1640, 14 7/16 in. × 9 27/32 in. (36.7 × 25 cm). Edwin Binney 3rd Collection, San Diego Museum of Art, 199.352 (www.sdmart.org). (Photo: courtesy of the San Diego Museum of Art)

and, on each side, five extremely foreshortened green columns. The arrangement looks like a pastiche, an architectural composition made up of elements of the highest ceremonial importance to the Mughals.

Mughal painting rarely gives an exact image of the architecture it portrays. This is even true of Shah Jahani painting, where carefully observed details misled scholars to take everything represented at face value.[70] Typical features of the architecture are often mixed with freer inventions, or we get paraphrases of a building. Also, painting is more conservative than architecture, and in several instances the wooden audience hall features in the depiction of an event that took place long after it had been replaced by the stone hall.[71]

III. ARCHITECTURAL SOURCES AND RECONSTRUCTION

The case of Shah Jahan's first wooden audience halls is special because we know of at least three different halls—those in Agra, Lahore, and Burhanpur—showing purportedly the same design. This is also true of their later stone replacements at Agra, Lahore, and the new hall at Delhi, which follow the same plan, although with varying proportions and details. If we take all the evidence together, both written and visual—a quite clear picture of Shah Jahan's first wooden audience hall emerges.

It was a large hall, on high slender columns, with a flat roof, around 56.90 meters by 17.90 meters (figs. 15–18). The height is not given. If we compare these measurements with those of the surviving stone halls, they come close to those of the Delhi hall (54.66 m x 18.41 m x 12.66 m) and the Lahore hall (54 m x 18.32 m x 10.57 m); the hall at Agra was longer (61.48 m x 20.72 m x 11.55 m) (figs. 19 and 20). We can thus assume for the wooden hall a height between 10.50 and 12.50 meters. The hall was thus extremely large for a wooden construction, certainly longer (but less high) than the wooden hall of its later namesake, the Chihil Sutun at Isfahan (1647), which measures about 37 meters by 19.50 meters; its columns are 13.05 meters high (without the plinth and the roof) (fig. 21).[72] It is likely that the columns of Shah Jahan's wooden halls were arranged in the same way as in the stone halls. Both types were referred to as Chihil Sutun

Fig. 15. The wooden audience hall of Shah Jahan, reconstructed plan. (Drawing: R. A. Barraud and © Ebba Koch)

Fig. 16. Reconstruction of the wooden audience hall of Shah Jahan, omitting the back wall with the *jharoka*, perspectival view. (Drawing: R. A. Barraud and © Ebba Koch)

Fig. 17. Reconstruction of the wooden audience hall of Shah Jahan, omitting the back wall with the *jharoka*, with detail of one column. (Drawing: R. A. Barraud and © Ebba Koch)

Scale 1:10

Scale 1:25

Fig. 18. Elevation of column and detail of bracket of the reconstructed wooden audience hall. (Drawing: Ulderico Micara and © Ebba Koch)

and indeed had forty columns, with four rows of ten columns, ten on the long side and four on the short side. Rows of four columns are visible in the Freer painting (G, a and b [figs. 11 and 12]), but not in the San Diego painting (I [fig. 14]), where we see five columns on each side; 'Abid's version is also otherwise a free paraphrase. In all the paintings, the columns are green, like cypresses, as Kalim also tells us, and their thin shafts, probably faceted (see C, E, and H [figs. 6, 8, and 13]), are painted with a pattern in gold. The topmost part of the shafts below the capital was red, or had a red, oblong impost block inserted, and supported brackets, which were also green with gold decoration, like the columns; their undersides were painted red. As in similar constructions of stone architecture, the arrangement of the brackets depended on the position of the columns in the hall, and the freestanding columns had a cruciform arrangement of four brackets. All the brackets supported the beams of the flat ceiling, which showed a rich, painted decoration, proving Kalim right again.

The unclear point concerns the red tops of the columns. We cannot establish with certainty whether in

Fig. 19. Ground plans of the stone Divan-i 'Amms of Agra, Lahore, and Delhi (from top to bottom). (Drawing: R. A. Barraud and © Ebba Koch)

the depictions of the Agra hall this feature represented merely a differently colored part of the shaft, or whether this was an abbreviated way of showing the wider impost block that Murar indicates for the Lahore hall. Payag's depiction of the Lahore hall in the Bodleian painting (H [fig. 13]) shows the upper part of the columns as just a red extension. Still, I feel Murar's depiction of the specific shape of the columns of the Lahore hall (E [figs. 8 and 9]; see also fig. 18) could be correct and applicable to all the halls because it is not imagined but a form of real architecture. The high impost blocks above the capitals of the shafts are a characteristic element of the vernacular wooden architecture of regions of the Mughal empire that are today situated in Pakistan and Afghanistan. Such columns appear in the wooden architecture of Uchchh Sharif in northern Sind, in Mughal times part of the ṣūba (province) of Multan. It was an ancient spiritual center with its own distinct building tradition. Examples particularly close to Murar's painted architecture are found in the columned interior halls of the mosque and tomb of Jalal al-Din Surkh Bukhari (fl. early fourteenth century) (figs. 22–24), the father of the famous pir Makhdum-i Jahaniyan Jahangasht (d. 1384), and in the tomb of Sadr al-Din Rajan Qattal.[73] These tombs were

Fig. 20. Elevations of the Divan-i 'Amms of Agra, Lahore, and Delhi (from top to bottom). (Drawing: R. A. Barraud and © Ebba Koch)

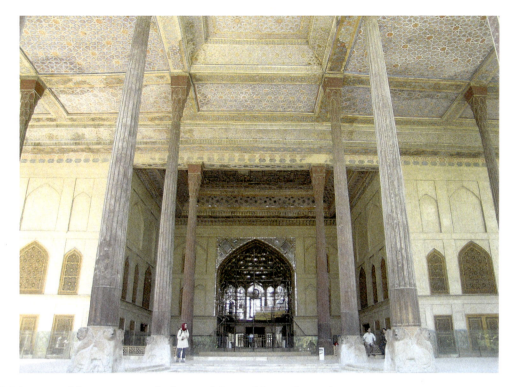

Fig. 21. Chihil Sutun, Isfahan, 1646–47, rebuilt 1706. (Photo: Ebba Koch, 2004)

rebuilt in the nineteenth or early twentieth century, but scholars assume that the renovation followed the existing architecture. Columns with high impost blocks also appear in the wooden architecture of the Hindu Kush. In the Swat valley, which in Mughal times belonged to the *ṣūba* of Kabul, close forms of columns appear in the old Jumat (Friday mosque) of Madyan and in wooden houses of the region (fig. 25).[74] The dating here is also difficult: Dani assumes that the Madyan mosque "was built more than two hundred years ago."[75] Other examples of such columns from the Hindu Kush region come from the recently published shrine of the Isma'ili spiritual teacher Nasir Khusraw (d. ca. 1075) in Hazrat Sayyid, in the Yumgan Valley, Badakhshan, today in Afghanistan, near the border with Pakistan. The complex consists of a tomb, a columned hall, and a mosque, all with wooden columns topped with, inter alia, high impost blocks, built and rebuilt since the eleventh century (fig. 26). For the last major rebuilding, there is an inscription dated 1109 (1697) on a beam of the ceiling of the tomb chamber.[76]

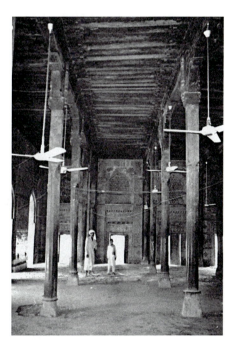

Fig. 22. Wooden columned hall, mosque of Jalal al-Din Surkh Bukhari, early fourteenth century, Uchchh, Pakistan. (Photo: Ebba Koch, 1996)

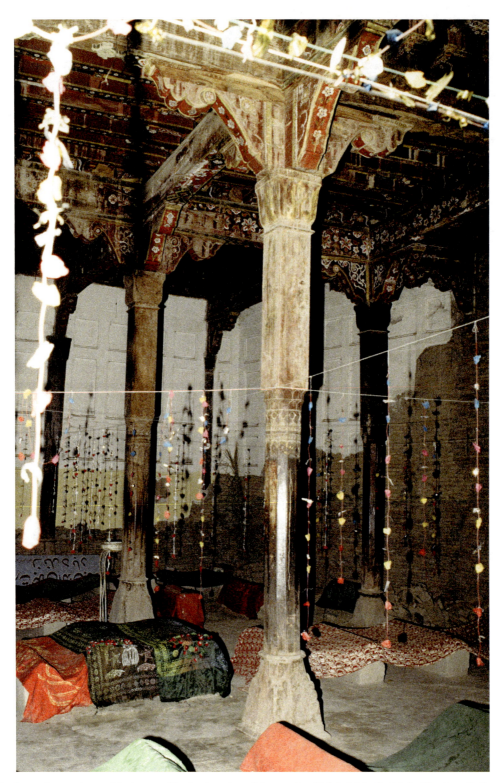

Fig. 23. Wooden columns topped by impost blocks, interior of the tomb of Jalal al-Din Surkh Bukhari, early fourteenth century, Uchchh, Pakistan. (Photo: Ebba Koch, 1996)

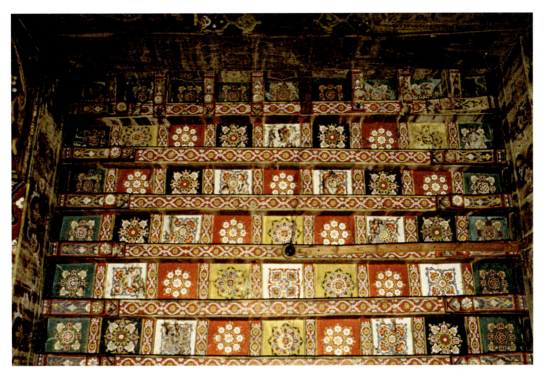

Fig. 24. Wooden ceiling, tomb of Jalal al-Din Surkh Bukhari, early fourteenth century, Uchchh, Pakistan. (Photo: Ebba Koch, 1996)

Fig. 25. Old Jumat (Friday mosque), Madyan, Swat Valley, uncertain date. (Photo after Johannes Kalter, *The Arts and Crafts of the Swat Valley: Living Traditions in the Hindu Kush* [London: Thames and Hudson, 1991], fig. 72)

Fig. 26. Wooden pillared hall, interior of the tomb of Nasir Khusraw (d. ca. 1072–78), built and rebuilt since the eleventh century, Yumgan Valley, Badakhshan, Afghanistan. (Photo: Marcus Schadl)

Clearly, wooden columns with high impost blocks above the capital, supporting double or cruciform brackets that in turn support the beams of the roof, were a feature of the regional architecture of the western and northwestern parts of the Mughal empire.[77] The depiction of the columns of the Lahore hall in Murar's painting and the wooden halls of regional architecture formed the basis of my reconstruction of Shah Jahan's audience halls as they were built at Agra, Lahore, and possibly also other palaces (figs. 15–18).[78] Of all the painters of Shah Jahan's atelier, Murar appears to have been the most accurate in his architectural and topographical depictions.[79]

To take a particular aspect of regional vernacular architecture and raise it to palace level would be entirely in tune with Mughal architectural practice; a distinct feature of Shah Jahani palace architecture is the *bangla*, which, as its name indicates, was derived from the vernacular hut of Bengal with a curved-up roof. Translated into marble, it gave its shape first to the Bangla-i Darshan, the pavilion in which the emperor appeared every morning to his subjects, and from its exclusive use in the palace made its way back out to eventually become a widely used feature of Indian architecture.[80]

Wooden hypostyle mosques and talārs

The regional architecture of the northwestern areas of the Mughal empire that inspired the halls of Shah Jahan is linked to a wider tradition of wooden architecture best represented by mosques of Central Asia, Kashmir, northwestern Iran, and post-Seljuk Anatolia. The oldest known example of hypostyle wooden mosques is the Jamiʿ Masjid of Khiva. Reconstructed in the eighteenth century, it has preserved its wooden columns, which date from different periods, reaching back to the ninth century and earlier (fig. 27).[81] The columns of the Jamiʿ Masjid of Khiva have an elongated baluster form extensively used in the vernacular architecture of Central Asia, which, translated into marble, was to have its own carrier in Shah Jahani palace architecture.[82] It is noteworthy that this baluster type of Central Asian column was not used for Shah Jahan's audience hall, though it might have contributed to the idea of a wooden hypostyle hall with high, slender columns. We note here a clear differentiation in the reception of regional forms in the palace. Another wooden mosque tradition with which the Mughals were familiar was that of Kashmir. The most impressive example is the Jamiʿ Masjid of Srinagar, founded in 1400. Its grand columns have faceted shafts with simple bases and capitals, and date from the early twentieth century.[83] The prevailing type of columns in the wooden mosques of northwest Iran (fig. 28)[84] and post-Seljuk Anatolia (fig. 29)[85] have a faceted shaft topped by a *muqarnas* capital, a form also widely used in stone architecture, though with different details and proportions, and varying bases.[86] The painted ceilings of these wooden halls give us an impression of how the ceiling of Shah Jahan's hall, so admired by Kalim, might have looked (fig. 24).

To sum up, we can state that we do have, from Central Asia to Anatolia, a widespread medieval tradition of wooden hypostyle constructions, with mosques repre-

Fig. 27. Jamiʿ Masjid, Khiva, Uzbekistan. (Photo: Britta Elsner, 2010)

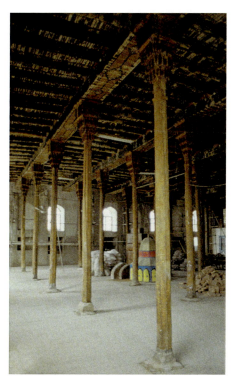

Fig. 28. Masjid-i Mulla Rustam, ca. mid-sixteenth century, Maragha, Iran. (Photo: Markus Ritter)

Fig. 29. Eşrefoğlu Cami (1296–99), Beyşehir, Turkey. (Photo: Ebba Koch, 2013)

senting the closest examples for the overall shape of Shah Jahan's audience halls and the wooden architecture of the northwestern regions of the Mughal empire providing the closest relatives for the shape of the columns. No monumental hypostyle halls in wooden post-and-beam construction are preserved in pre-seven-

teenth-century palace architecture. We know, however, of wooden buildings or porches called *talār*s in Central Asia and Iran,[87] which occur as well in Mughal India. Babur mentions in the autumn of 1528 a "squat, inharmonious wooden *talār*" that his man Rahimdad had built in his garden at Gwalior; and later in the year he describes a "newly erected octagonal *talār*" covered with scented grass (*khas*) that was used for receptions in one of his gardens at Agra.[88] Similarly, Babur's associate Zayn Khan speaks of "colored and decorated *talār*s and stone edifices on the sides and environs" of the Hasht Bihisht Garden at Agra.[89] *Talār*s are still mentioned in Shah Jahan's time, when we learn, on the occasion of the emperor's visit to Kashmir in June 1634, about a colorful, double-storied *talār* in the midst of four *chinār* (plane) trees on one of the two terraces of the Bahr Ara Garden (*miyān-i chinārhā talārī sākhta* and *dū martaba dar kamāl rangīnī*), which was an imperial garden situated on the bank of Dal Lake, opposite (*muhāḥzá, barābar*) the *jharoka* of the palace in the fortress of the Hari Parbat at Srinagar.[90]

The Mughals brought the tradition of Timurid *talār*s to India and applied the term to pillared wooden pavilions, which could be of different shapes and would be painted, but the expression does not seem to have been used for large halls. Still, such gaily-colored *talār*s used in garden architecture and also in a ceremonial context would have contributed to the idea of a wooden audience hall, with green and red columns and a richly decorated ceiling. It was an experiment that gave way to the aesthetic emphasizing pure white in imperial buildings, where color appeared mainly in the interior and in the form of textiles (cf. figs. 1 and 16).

The Indo-Islamic tradition of wooden audience halls

We have, furthermore, literary evidence for a grandiose wooden audience hall at Delhi predating the Mughal halls. Tony Welch and Howard Crane have drawn attention to a vast wooden hall for public audiences named Hazar Sutun, which was built for the Delhi sultan Muhammad b. Tughluq in 1343 in his palace at Jahanpanah-Delhi.[91]

Ibn Batuta describes this palace and says about the hall:

> The third door opens into an immense and vast hall called Hazar Ustun, which means [in Persian] "a thousand columns." The columns are of painted wood and support a wooden roof, most exquisitely carved. The people sit under this, and it is in this hall that the Sultan sits for public audience.[92]

The court poet Badr al-Din Chach eulogizes its completion in Muharram 744 (June 1343) and calls it Khurrambad (Abode of Joy), pointing out that the king used it as a court of justice.[93]

The Hazar Sutun was visited in 1398 by Timur's ladies as one of the famous sites of Delhi,[94] and its memory was kept alive in Mughal historiography. At the end of the sixteenth century, Abu'l Fazl described it more grandiosely as "a lofty hall (*buland īvāni*) with a thousand columns of white marble (*hazār sutūn az sangi rukhām*)."[95] Shah Jahan and his builders certainly knew of it when they planned the new Mughal audience hall. The way Abu'l Fazl represented the Tughluq hall may have influenced the decision to have the halls eventually redone in stone "made marble white with plaster."

Thus, we have a tradition of wooden audience halls in the Muslim architecture of north India for which Shah Jahan's wooden audience halls represent the earliest surviving examples. They predate the first monumental wooden halls of the Safavids at Isfahan by about ten years. Sussan Babaie calls the Isfahan buildings with these halls *talār*-palaces and establishes their dates: the earliest, the Talar-i Tavila dates from 1637, the Aynakhana was built for Shah Safi I in the 1630s, and the Chihil Sutun (fig. 21) and the *talār* of the Ali Qapu date from 1647. For Babaie, *talār*-palaces, a combination of a monumental wooden hall and a masonry building, were specific to mid-seventeenth-century Isfahan—"nowhere else did they emerge or could have been appropriated"—and she sees their inspiration in the small structures of the vernacular *talār*s of Mazandaran, which are formally different from those in Isfahan.[96] She also argues that they proclaim a distinctive Perso-Shi'i performance of kingship, with altered ceremonial needs of conviviality, different from the earlier compact pavilion type, the *hasht bihisht*.[97]

But it seems that by the 1630s the idea of monumental wooden audience halls could have easily come from India, though, as I have shown in my earlier discussion of Shah Jahan's halls, the concept of constructing large

hypostyle audience halls seems in turn to have gone back to ancient Iran, the Achaemenid halls of Persepolis.[98] Ideas travelled back and forth; for instance, in 1633, Shah Jahan sent an image of the newly conquered Dawlatabad, probably painted by Murar, to Shah Safi, to impress him not only with the conquest but also with its topographic depiction.[99] Similarly, it is quite possible that knowledge of the new wooden audience halls of Shah Jahan reached Isfahan and that the Safavids wanted to come up with their own version, a *talār*-palace tailored to their ceremonial requirements. By the time of Shah Jahan, the Mughals were no more on the receiving side, and Iran began to look to India for inspiration.[100]

The wooden audience halls, however, grand as they were with their forest of tall green columns and painted ceilings praised by the poets, did not represent the ultimate solution for Shah Jahan in his quest for perfection, which resulted in a stylistic and architectural harmony in all his creations. (It has a parallel in his search for the best historian.) The success of his quest is borne out by the evidence that even in their experimental and transitional stages, these halls became an inspiration to be consumed by others.

University of Vienna,
Austrian Academy of Sciences

APPENDIX I

'Abd al-Ḥamīd Lāhawrī, *Pādshāhnāma,* Persian text ed. M. Kabīr al-Dīn Aḥmad and M. 'Abd al-Raḥīm, 2 vols. (Calcutta: Asiatic Society of Bengal, 1867–72), vol. 1, pt. 1, pp. 221–23.

در عهد فرمان روائی حضرت عرش اشیانی و سلطنت حضرت جنت مکانی و بعد از جلوس حضرت
جهانبانی تا این تاریخ پیش جهروکهٔ دولتخانهٔ خاص و عام که دران جمیع بندگان به دولت بار و سعادت
دیدار می‌رسند عمارتی که ملتزمان بساط حضور را از باران و گرما پناه باشد- نبود- ایوانی از پارچه
استاده می‌کردند چنانچه نکاشته [= نگاشته] شد- و چون درین زمان مسعود هر چه سرمایهٔ آسایش
جهانبانی است از ممکن قوت بمظهر فعل آمده، وآنچه پیرایهٔ آرایش جهان است از حضیض عدم باوج وجود
شتافته، بحکم عالم آرا معماران جا در آثار- و نجاران آزر کار، ایوانی عالی که به سر [۲۲۲] بکیوان کشیده
است و بنائی رفیع که بسدرة المنتهی رسیده در پیش جهروکهٔ دولت خانهٔ خاص و عام بطول هفتاد گز و
عرض بیست و دو گز پادشاهی در چهل روز چنانچه در مراة ضمیر نورانی حضرت گیتی ستانی پرتو
افکنده بود باتمام رسانیدند- هم ایستادگان پیشگاه اورنگ جهانبانی را از آب و آفتاب پناهی تازه هم رسید
و هم روی بارگاه آسمان جاه را زینتی بی‌اندازه- سه طرف این ایوان والا بنیان که هر طرف راهی دارد و
ازان امرا و خدمت پیشگان و دیگر منصبداران روشناس درمی‌آیند محجری از نقره نصب کرده‌اند. درین
ایوان بندها در خور پایه بجائی که معین است به آئینی که لائق محفل سلاطین با فرّ و تمکین باشد
می‌ایستند بیشتری پشت بمحجر و چندی که بنسبت قرب امتیاز دارند متصل بدو ستونی که نزدیک
جهروکه است و قور برداران با علمهای زرین و طوغهای زرین و قور خاصه در جانب چپ پشت بدیوار
قیام می‌نمایند- در پیش این بنای آسمان سا صحنی است وسیع بر دوران چوبین محجری رنگین که بران
سایبانهای مخمل زربفت برمی‌افرازند- درین جا هر که منصبش از دوصدی کمتر است و احدیان کماندار و
تفنگچیان قدر انداز و برخی از تابینان امرا بار می‌یابند- بر دروازه‌های دولت خانهٔ خاص و عام و هر دو
محجر گرز برداران معتمد و یساولان و دربانان بلباسهای فاخر می‌ایستند- تا بیگانه را و هر که لایق مرتبه
ازین مراتب بار نباشد راه ندهند- معنی بردار شعر طراز طالب کلیم این رباعی در وصف این مکان والا
بنیان نظم نموده بعرض اقدس رسانید- و بصلهٔ پادشاهانه دامن امید او [۲۲۳] گران بار عطا گردید.

شعر

این تازه بنا که عرش همسایهٔ اوست رفعت حرفی ز رتبت پایهٔ اوست

باغیست که هر ستون سبزش سرویست کاسایش خاص و عام در سایهٔ اوست

و حکم مقدس شرف صدور یافت که در دار السلطنت لاهور نیز پیش جهروکهٔ دولت خانهٔ خاص و عام
به همین آئین ایوانی عالی بنا کنند-

APPENDIX II

Muḥammad Ṣāliḥ Kaṅbō, *ʿAmal-i Ṣāliḥ or Shāh Jahānnāma*, rev. and ed. Vaḥīd Qurayshī, based on the Calcutta ed. of 1912–46 by Ghulām Yazdānī, 2nd ed., 3 vols. (Lahore: Majlis-i Taraqqī-yi Adab, 1967–72), vol. 1 (1967), pp. 258–60.

[۲۵۸] جای دادن خواص و عوام خصوص ایستادگان پایهٔ سریر سلیمانی در سایهٔ عنایت و ظل مرحمت
یعنی اساس نهادن ایوان چهل ستون در صحن خاص و عام

بحمد الله که عنایات خاص پادشاه جهان بعوام و خواص از جمیع وجوه اقتضای عموم و شمول نموده به
صنفی از اصناف و شخصی از اشخاص انسان اختصاص ندارد- چنانچه ظلال عاطفش که شامل حال
عالمی است مانند جود حضرت واجب الوجود همه را فرو گرفته- و آثار نیسان احسانش که بر خشک و
تر و بحر و بر بارانست چون فیض باران رحمت همه جا رسیده- لهذا پیوسته همت والا در ظاهر و
باطن بر تحصیل اطمینان قلب و فراغ خاطر اهل گیتی بسته‌اند- چنانچه هیچ لحظه از روزگار سعادت
آثار نمی‌گذرد که آسایش و آرامش عالمیان منظور نظر نباشد- و عزیمت ملوکانه بر بسیج سرمایهٔ امن و
امان اهل زمین و زمان مقصود نبود- از جمله شواهد صدق این دعوی احداث بارگاه چهل ستون
همایونست که درین ایام در فضای کریاس خاص و عام اساس یافته- و سبب بنیاد این نسخهٔ سبع شداد
و دیوانکدهٔ عدل و داد که رو کش بارگاه سلیمان و ایوان نوشیروان بود اینست که چون همه را از همه سو
روی امید بدین جناب است- وعالمی را بقصد عرض مقاصد و رفع مطالب و برآمد حوایج و مآرب بدین
مرجع عالمیان بازگشت است- ازین جهت که هنگام عرض و مجری از زحمت بارش برسات و آسیب تف
تموز حجابی و پناه گاهی نبود- لاجرم بمقتضای مرحمت نامتناهی فرمان قضا جریان بدین مضمون توقیع نفاذ
یافت- که در دار الخلافهٔ کبری و همچنین در اکثر اعاظم بلاد محروسه هر جا که دولت سرای
بنیاد یافته باشد- خاصه در دار السلطنت لاهور در پیشگاه جمروکهٔ خاص و عام که محل انجاح حاجت
جهانیان است ایوانی مشتمل بر چهل ستون بطول هفتاد ذراع و عرض بیست و دو ذراع طرح افگنده
زود باتمام رسانند- تا سایر بندهای درگاه بی‌زحمت [۲۵۹] تابش آفتاب و تشویش بارش سحاب فارغ البال
بعرض مطالب اشتغال توانند نمود- جملا بامر ارفع بدینسان بارگاه رفعت پناه مشتمل بر چهل ستون به
عظمتی اساس یافت که رفعت آستانش باعث کسر شان ایوان کسری گشته- و از این دست والا بنیاد
مقصورهٔ [= مقصوره ای] که از رشک متانت اساسش قصور در بنای قصر قیصر راه یافته در عرض
چهل روز با این طول و عرض و وضع غریب و هندسهٔ بدیع خاطر فریب باتمام رسیده باعث حیرت
نظارگیان گشت:

ابیات

در روزگار ثانی صاحب قران که دهر یکره ندیده است قرینش بصد قرون

عالی اساس بارگهی شد بنا که راست از کوه بی‌ستون بود افزون بچل ستون

از رشک تابش در و دیوارش از شفق در خون نشسته تا بکمر چرخ نیلگون

چون این فرخنده بنا همه معنی سمت اتمام و صورت انجام پذیرفت اختر شماران سطرلاب نظر ساعتی بری از نحوس و قرین سعود در تاریخ بیست و پنجم ذی حجه سنه هزار و سی و هفت هجری برگزیدند- شاهنشاه فلک بارگاه بعد از انقضای بیست گهری روز در ساعت مختار اندیشه رسای دقایق رسان درین محفل بهشت آئین که بانواع زیب و زینت تزئین داشت اورنگ نشین سریر اقبال و اکلیل گزین افسر جاه و جلال گشتند- و جمهور انام را در آن بارگاه خاص بار عام داده زبان سپاس گزار بستائش آفریدگار انس و جان و دست حق پرست به بخشایش و بخشش گنهگاران [= گنهکاران] و محتاجان بر کشادند [= گشادند]- و سایر ثنا گستران و همچنین سرود سرایان و نغمه پردازان را ساز عیش جاویدی آماده نموده طالبای کلیم را که این رباعی بوصف آن بارگاه سلیمانی در سلک نظم کشیده بعرض مقدس رسانید صلهٔ شایسته مرحمت فرمودند:

رباعی

این تازه بنا که عرش همسایهٔ اوست رفعت حرفی ز رتبهٔ پایهٔ اوست [260]

باغیست که هر ستون سبزش سرویست کاسایش خاص و عام در سایهٔ اوست

APPENDIX III

Abū Ṭālib Kalīm Kāshānī, *Pādshāhnāma*: London, British Library, Ethé no. 1570, Ms. Or. 357, fol. 117 (transcript by Y. Jaffery: p. 213).

<div dir="rtl">

که آسوده در سایه‌اش روزگار	یکی از بناهای آن کامگار
که چسپیده بر منظر خاص و عام	بُود چل ستون سپهر احتشام
فراهم شدندی سران سپاه	در آنجا چو هر زمین بوس شاه
که یابند از آن راضی انجمن	بنایی نمی‌بود سایه فکن
نه در دور خاقان عرش آشیان	نه در عهد شاهی جنّت مکان
گهی تر ز بارندگی چون سحاب	گهی خلق در تاب از آفتاب
پس پادشاهی به اندک زمان	به فرمان ثانی صاحبقران
به گردون سر رفعت افراخته	شد ایوانی از چل ستون ساخته
دو بر بیست افزای عرضش شمار	به هفتاد گز یافت طولش قرار
ستون وار سر در هوا خاص و عام	بُود در تماشای سقفش مدام
که در گلستان نقشبند بهار	به سقفش همان کرده صنعت نگار
نظر پیش پا دیدنش مشکل است	به گلهای سقفش ز بس مایل است
به هر سرو صد آشیان ساخته	ستون سرو و مرغ نگه فاخته
ولی اینقدر سرو همقد کم است	بسی سرو در گلشن عالم است
به لاهور در مجمع خاص و عام	به فرمان شاه ثریّا مقام
به چرخش سر رفعت افراختند	به این طرح هم چل ستون ساختند

</div>

NOTES

Author's note: This article was written in the context of my project "The Palaces and Gardens of Shah Jahan (rul. 1628–58)," sponsored by the Austrian Science Funds (FWF Project No. P 21 480-G21), which I am carrying out as a senior researcher at the Institute of Iranian Studies, part of the Austrian Academy of Sciences (2009–14). I would like to thank Dr. Sayyid Muhammad Yunus Jaffery for his help in the study and translation of the Mughal sources. The architect Richard A. Barraud prepared the drawings of the existing audience halls and drew with great enthusiasm my new reconstruction of the wooden halls. I am grateful as well to Sunil Kumar for reading the manuscript and making helpful suggestions to clarify the introduction and conclusion. And I also thank Stephan Popp for digitizing the Persian texts in the appendices.

1. A publication of it is in preparation. I explained the project briefly in Ebba Koch, "The Taj Mahal: Architecture, Symbolism, and Urban Significance," *Muqarnas* 22 (2005): 128–29.

2. On the situation of palace studies, see Gülru Necipoğlu, "An Outline of Shifting Paradigms in the Palatial Architecture of the Pre-Modern Islamic World," *Ars Orientalis* 23 (1993): 3–19.

3. Ebba Koch, "Divan-i ʿAmm and Chihil Sutun: The Audience Halls of Shah Jahan," *Muqarnas* 11 (1994): 143–65, esp. 143, 158nn1–2, repr. in Ebba Koch, *Mughal Art and Imperial Ideology: Collected Essays* (New Delhi: Oxford University Press, 2001), 229–54, esp. 229–31nn1–2; Milo C. Beach and Ebba Koch, with new translations by Wheeler M. Thackston, *King of the World: The Pādshāhnāma: An Imperial Mughal Manuscript from the Royal Library, Windsor Castle* (London: Azimuth Editions, and Washington, D.C.: Smithsonian Institution, 1997), 135 and cat. nos 14, 32, 43, and 44; Ebba Koch, "Reflections on Mughal Buildings in the Punjab in the Context of an Austrian Project on Islamic Architecture of the Indian Subcontinent," in *Austrian Scholarship in Pakistan: A Symposium Dedicated to the Memory of Aloys Sprenger* (Islamabad: Austrian Embassy, 1997), 97–143, esp. 112–16; Ebba Koch, "The Mughal Audience Hall: A Solomonic Revival of Persepolis in the Form of a Mosque," in *Royal Courts in Dynastic States and Empires: A Global Perspective*, ed. Metin Kunt, Tülay Artan, and Jeroen Duindam (Leiden: Brill, 2011), 313–38.

4. Koch, "Taj Mahal," 137–39; see also Ebba Koch, *The Complete Taj Mahal and the Riverfront Gardens of Agra* (London: Thames & Hudson, 2006), 104–5.

5. See, e.g., W. E. Begley and Z. A. Desai, *Taj Mahal, the Illumined Tomb: An Anthology of Seventeenth-Century Mughal and European Documentary Sources* (Cambridge, Mass.: Aga Khan Program for Islamic Architecture at Harvard University and the Massachusetts Institute of Technology, and Seattle: University of Washington Press, 1989); all of my work on Shah Jahani architecture is based on a study of the

6. textual sources relating to his reign: see, e.g., Koch, *Mughal Art and Imperial Ideology*; and Koch, *Complete Taj Mahal*.

 Recently, Harit Joshi, "L'espace cérémoniel dans la cour de l'empereur moghol Shāh Jahān," *Journal Asiatique* 298, 1 (2010): 31–107, has taken up Shah Jahani court studies and has translated and discussed passages of the historians of Shah Jahan relating to ceremonial spaces and the role of imperial officers in the court proceedings. Wheeler M. Thackston has translated descriptions of Mughal gardens: see his "Mughal Gardens in Persian Poetry," in *Mughal Gardens: Sources, Places, Representations, and Prospects*, ed. James L. Wescoat Jr. and Joachim Wolschke-Bulmahn (Washington, D.C.: Dumbarton Oaks, 1996), 233–58. Paul Losensky analyzed the treatment of architecture in poetic works of Shah Jahan's period in an unpublished paper entitled "Building a Career: Architecture in the Life and Poetry of Kalim Kashani," given at a Table ronde ("Patronage in Indo-Persian Culture") held in Paris, March 21–23, 2001, and organized by Nalini Delvoye. Sunil Sharma has discussed the poetic description of cities in "The City of Beauties in Indo-Persian Poetic Landscape," *Comparative Studies of South Asia, Africa and the Middle East* 24, 2 (2004): 73–81; and in a Deccani context comparable to that of the Mughals, in Sunil Sharma, "The Nizamshahi Persianate Garden in Zuhūrī's *Sāqīnāma*," in *Garden and Landscape Practices in Pre-Colonial India: Histories from the Deccan*, ed. Daud Ali and Emma J. Flatt (New Delhi and Abdington: Routledge 2012), 159–71.

7. Jalāl al-Dīn Tabātabāʾī, *Pādshāhnāma*, or *Shāh Jahān nāma*: London, British Library, Ms. Or. 1676, fol. 1b.

8. For this and the following, see ʿInāyat Khān, *The Shah Jahan Nama of ʿInayat Khan: An Abridged History of the Mughal Emperor Shah Jahan, Compiled by His Royal Librarian. The Nineteenth-Century Manuscript Translation of A. R. Fuller (British Library, Add. 30,777)*, rev. and ed. W. E. Begley and Z. A. Desai (New Delhi: Oxford University Press, 1990), introduction, pp. xiii–xxix. Shah Jahan's historiography has also been studied by Stephan Conermann, in *Historiographie als Sinnstiftung: Indo-persische Geschichtsschreibung während der Mogulzeit (932–1118/1516–1707)* (Wiesbaden: Reichert, 2002), but since it was written in German, it has not attracted much attention on the part of Mughal historians.

9. D. N. Marshall, *Mughals in India: A Bibliographical Survey* (Bombay: Asia Publishing House, 1967), 424.

10. Muḥammad Ṣāliḥ Kanbō, *ʿAmal-i Ṣāliḥ or Shāh Jahānnāma*, rev. and ed. Vaḥīd Qurayshī, based on the Calcutta ed. of 1912–46 by Ghulām Yazdānī, 2nd ed., 3 vols. (Lahore: Majlis-i Taraqqī-yi Adab, 1967–72). For a brief discussion of Kanbo's history, see Begley and Desai, *Taj Mahal, the Illumined Tomb*, pp. xxviii–xxix.

11. Koch, *Mughal Art and Imperial Ideology*, 56, 104–5, and 131.

12. Chandar Bhān Brahman, *Chahār Chaman*, Persian text ed. Sayyid Muhammad Jaffery, special issue, *Qand-i Pārsī* 22 (New Delhi: Office of the Cultural Counselor, Embassy of the Islamic Republic of Iran, 1383 [2004]); Rajeev Kumar Kinra, "Secretary-Poets in Mughal India and the Ethos of

Persian: The Case of Chandar Bhān 'Brahman'" (PhD diss., University of Chicago, 2007).

13. See Begley and Desai, *Taj Mahal, the Illumined Tomb*, pp. xxvii–xxviii.

14. Kalim's *Pādshāhnāma* is still unpublished. I have used British Library, Ethé no. 1570, Ms. Or. 357, which has been transcribed in typescript by S. M. Yunus Jaffery. For Kalim's work, see Wheeler M. Thackston, "The Poetry of Abū-Tālib Kalim: Persian Poet-Laureate of Shāhjahān, Mughal Emperor of India" (PhD diss., Harvard University, 1974). The *Pādshāhnāma* does not, though, form part of his study.

15. Koch, *Complete Taj Mahal*, 96.

16. Koch, *Mughal Art and Imperial Ideology*, 236.

17. Wayne E. Begley, "Amanat Khan and the Calligraphy on the Taj Mahal," *Kunst des Orients* 12 (1978–79): 5–39; Wayne E. Begley, "The Myth of the Taj Mahal and a New Theory of Its Symbolic Meaning," *Art Bulletin* 61, 1 (1979): 7–37; and Begley and Desai, *Taj Mahal, the Illumined Tomb*.

18. Wayne E. Begley, "The Symbolic Role of Calligraphy on Three Imperial Mosques of Shah Jahan," in *Kalādarśana: American Studies in the Art of India*, ed. Joanna G. Williams (New Delhi: Oxford and IBH, in collaboration with the American Institute of Indian Studies, 1981), 7–18. The epigraphy of Shah Jahani palaces has not, as of yet, been studied systematically.

19. A remarkable exception has been discovered by R. D. McChesney, "An Early Seventeenth-Century Palace Complex (*Dawlatkhāna*) in Balkh," *Muqarnas* 26 (2009): 95–117. It is the description of a palace built by Nazr Muhammad Khan at Balkh around 1611–12, which appears in the *Baḥr al-asrār fī manāqib al-akhyār*, a universal history written by Maḥmūd b. Āmir Valī (born in about 1595). He had travelled to India before becoming the personal librarian of the khan who commissioned him to write this work. The problem with this very detailed description is that it stands by itself; there is no surviving building to match it, which makes the interpretation difficult, and several architectural terms remain enigmatic. The description of the Balkh palace was written by 1635, at around the same time that the first descriptions of palaces start to appear in Shah Jahan's history.

20. See Koch, *Complete Taj Mahal*, 256–57.

21. Over the years I have been compiling a glossary of Mughal architectural terms, which can be found in Ebba Koch, *Mughal Architecture: An Outline of Its History and Development, 1526–1858*, 2nd ed. (New Delhi: Oxford University Press, 2002); Koch, *Mughal Art and Imperial Ideology*; and Koch, *Complete Taj Mahal*. For instance, one major term that was assimilated was *jharoka*, the term for the imperial viewing window. The word's origin is not quite clear. Simon Digby felt that it was a vernacular Indian term "made official" by Abu'l Fazl: personal communication, n.d. See *The Āʾīn-i Akbarī by Abūʾl-Fazl ʿAllāmī*, trans. in 3 vols.: vol. 1 by H. Blochmann, 2nd ed. rev. and ed. D. C. Phillott (Calcutta, 1927; repr. New Delhi, 1977–78), 56. The Indologist Joachim Deppert suggested that there might be a connection to the

Sanskrit term *jhālākshaka*, meaning grille or eye: personal communication, February 13, 1992. John T. Platts, *A Dictionary of Urdū, Classical Hindī and English* (Oxford, 1884; repr. New Delhi, 1977), 403, has it under "*jharokhá*" and gives its meaning as, inter alia, "window." In a review of the 2002 edition of my book *Mughal Architecture*, Pramod Chandra stated categorically that: "'*jharoka*,' more correctly *jharokha* [I am using the Mughal spelling, which is *jharoka*] is not a Sanskrit but a Hindi word, derived from the Skt [=Sanskrit] *jala-gavakṣa*.": Pramod Chandra, "Review of *Mughal Architecture: An Outline of Its History and Development, 1526–1858* by Ebba Koch; *Mughal Art and Imperial Ideology: Collected Essays* by Ebba Koch," *Journal of the American Oriental Society* 123, 4 (2003): 911.

22. Muḥammad Amīn Qazvīnī or Amīna-yi Qazvīnī, *Pādshāhnāma*: London, British Library, Asia, Pacific and Africa Collections, Persian Ms. Or. 173, fol. 162a; unpublished typed transcript by S. M. Yunus Jaffery (1988), pp. 242–43.

23. Jahangir, *The Jahangirnama: Memoirs of Jahangir, Emperor of India*, trans., ed., and annot. Wheeler M. Thackston (New York and Oxford: Freer Gallery of Art and Arthur M. Sackler Gallery, in association with Oxford University Press, 1999), 98–99; Persian text: *Jahāngīrnāma: Tūzuk-i Jahāngīrī*, ed. Muḥammad Hāshim (Tehran: Intishārāt-i Bunyād–i Farhang-i Īrān, 1359 [1980]), p. 87, fol. 61a.

24. On this point, see Koch, *Mughal Art and Imperial Ideology*, 236–39.

25. Muḥammad Sādiq Khān, *Tavārīkh-i Shāhjahāni*: London, British Library, Persian Ms. Or. 174, fol. 9a (repagination: 11a); he is followed by Muḥammad Hāshim Khāfī Khān, *Muntakhab al-lubāb*, Pers. text ed. Kabīr al-Dīn Aḥmad, 3 vols. (Calcutta: Asiatic Society of Bengal, 1869–74), 1:404.

26. The earlier literature is cited in Koch, "Divan-i ʿAmm and Chihil Sutun," 160n26, repr. Koch, *Mughal Art and Imperial Ideology*, 236n26.

27. Jalāl al-Dīn Tabātabāʾī, *Pādshāhnāma*, fol. 1b.

28. Qazvīnī, *Pādshāhnāma*, fols. 137b and 162a / Jaffery, transcript, pp. 206 and 242. At Shah Jahan's accession the hall had not yet been built; there was a tent hall, as Lahawri says. See below.

29. Qazvīnī, *Pādshāhnāma*, fol. 162a / Jaffery, transcript, p. 242, calls it the *majlis-i-dīvān-i Sulaymān-i zamān*, the assembly council of the Solomon of the age; his description is altogether richer in expression than the later one by Lahawri, and he emphasizes that the hall was also for pomp and magnificence, so that the glory of the court (*shukūh-i bārgāh-i jalāl*) might increase "the glory of the workshop of creation."

30. ʿAbd al-Ḥamīd Lāhawrī, *Pādshāhnāma*, Persian text ed. M. Kabīr al-Dīn Aḥmad and M. ʿAbd al-Raḥīm, 2 vols. (Calcutta: Asiatic Society of Bengal, 1867–72), vol. 1, pt. 1, p. 146, mentions the "*īvān az pārcha*" in the context of his description of the emperor's daily routine after the description of his accession on 8 Jumada al-Thani 1037 (February 14, 1628). It was enclosed on three sides by a wooden balus-

trade (*chūbīn maḥjar*) 50 *gaz* long and 15 *gaz* wide, with three entrances. The *gaz* is the Mughal linear yard, also called the *zirāʿ*. The prevailing *gaz* for architecture was the *gaz-i Ilāhī*, introduced under Akbar. In Shah Jahan's time it was called *gaz-i pādshāhī*, and its length was circa 80–82 centimeters. Based on my study of the measurements of Shah Jahani buidings, I calculate the ideal Shah Jahani *gaz* as 81.28 centimeters. The railing around the tent hall would thus have measured 40.64 meters by 12.19 meters.

31. This is an example of Mughal crypto- or neo-Platonic thinking; things necessary for world rule pre-exist in an outer worldly domain and are called into existence by the *pādshāh*.

32. The Koranic Azar was Abraham's father, an idol maker; see Koran 6:74. See also A. Jeffery, *Encyclopaedia of Islam, Second Edition* (henceforth *EI2*) (Leiden, 1954–2002), s.v. "Āzar."

33. For the length of the *gaz* or *zirāʿ*, see n. 30 above. The dimensions would thus corresponded to 56.89 meters by 17.88 meters.

34. Meaning they frame the *jharoka* on both sides.

35. The *qūr*, or *qūr-i khāṣṣa*, was a collection of ceremonial arms, flags, and other insignia that followed the emperor wherever he went. See Koch in Beach and Koch, *King of the World*, 194–95.

36. Meaning to the left, when seen from the emperor's position; see Beach and Koch, *King of the World*, fols. 50b, 72b, 98b, 116b, 147b, 194b, 195a, 214b, and 217b, corresponding to cat. nos. 10, 14, 17, 19, 32, 38, 39, 43, and 44.

37. The Mughal system depended not on aristocratic origin but on merit. The central expression of this meritocracy was the *mansab*, or numerical rank, which defined the status and income of its holder, known as the *mansabdar*. The *mansabdari* system was established by Akbar, who used it to turn a loose military confederation of Muslim nobles into a multi-ethnic bureaucratic empire, integrating Muslims and Hindus. Upon appointment, every office holder was given a *mansab* or, beginning in 1595, a pair of *mansabs*, subdivided into *zat* and *sawar*, which indicated his rank, payment, and military and other obligations. By the early seventeenth century, ranks ranged from as low as 20 to a maximum of 7,000 *zat*, but rank inflation set in rapidly and princes were able to obtain *mansabs* in the tens of thousands. See M. Athar Ali, *The Apparatus of Empire: Awards of Ranks, Offices, and Titles to the Mughal Nobility (1574–1658)* (Delhi: Oxford University Press, 1985); and J. F. Richards, *EI2*, s.v. "Mansab and Mansabdar."

38. Lāhawrī, *Pādshāhnāma*, vol. 1, pt. 1, pp. 221–22. The passage has been translated by Nur Bakhsh, "Historical Notes on the Lahore Fort and Its Buildings," *Archaeological Survey of India Annual Report* (1902–3): 218–24, but with some omissions; hence, I have prepared a new translation with the help of Dr. S. M. Yunus Jaffery.

39. Dr. Jaffery authorized me to carry out some editing of his translation and to adjust the architectural terminology. I have also added annotations.

40. Shaddad is a mythical and perhaps historical king of the city of Iram of the Pillars in southern Arabia, which features in Koran 89:6–8.

41. Also called Taq-i Kisra or Ivan-i Kisra, the large, vaulted niche built by the Sasanian kings at Ctesiphon in the sixth century. It was used proverbially to refer to any grand royal building. For the meaning of these buildings and further literature, see Koch, "Divan-i ʿAmm and Chihil Sutun," 149–52, repr. in Koch, *Mughal Art and Imperial Ideology*, 242–43.

42. See previous note.

43. Bisutun is a mountain circa 30 kilometers east of Kirmanshah on the main road from Baghdad to Hamadan. High above the road is the famous bas-relief of Darius the Great with cuneiform inscriptions in Old Persian, Akkadian, and Elamite. Below was the relief of the Parthian king Gotarzes. The trilingual inscription provided the key to the decipherment of all cuneiform inscriptions. Bisutun was regarded as a world wonder by the Muslims. See Ernst Herzfeld and R. N. Frye, *EI2*, s.v. "Bīsutūn."

44. One *gharī* represents the space of twenty-four minutes; see F. Steingass, *A Comprehensive Persian-English Dictionary: Including the Arabic Words and Phrases to Be Met with in Persian Literature: Being Johnson and Richardson's Persian, Arabic, and English Dictionary, Revised, Enlarged, and Entirely Reconstructed* (London, 1892; repr. New Delhi: Oriental Books Reprint Corporation, 1973), 1107. Twenty *gharīs* are thus eight hours.

45. Since the Mughals did not use a crown, the phrase is either meant in a metaphorical sense or refers to a turban with jeweled ornaments or the like.

46. Kanbō, *ʿAmal-i Ṣāliḥ*, 1:258–60; see also Koch, "Divan-i ʿAmm and Chihil Sutun," 149–53, repr. in Koch, *Mughal Art and Imperial Ideology*, 242–43. For a translation of part of the passage into French, see Joshi, "L'éspace cérémoniel," 60.

47. Kalīm, *Pādshāhnāma*, fol. 117 margin / Jaffery, transcript, p. 213. My translation is based on the earlier one I did with Yunus Jaffery.

48. ʿInāyat Khān, *Shah Jahan Nama*, 25. I have not changed the terminology of this translation, though I would not translate "*īvān*" as "portico" in this case, since the large hall is certainly more than that, nor "*jharoka*" as "balcony."

49. I have discussed how Persepolis was known, visited, and referred to through the centuries, and how it would have been known during Mughal times, in Koch, "Divan-i ʿAmm and Chihil Sutun," 148–49, repr. in Koch, *Mughal Art and Imperial Ideology*, esp. 239–43. There I also pointed out that contrary to common belief, Humayun did not visit the site during his Persian exile. The assumption is based on an error of Charles Stuart in his translation of Jawhar, *The Tezkereh al vakiāt: Or, Private Memoirs of the Moghul Emperor Humāyūn* (London: Oriental Translation Fund, 1832; repr. Delhi: Idarah-i Adabiyāt-i Delli, 1972), 66–67, 71. Stuart took the Takht-i Sulayman where Humayun hunted with Shah Tahmasp in 1544 to be Persepolis, while Jawhar was actually speaking of the Takht-i Sulayman southeast of Lake Urmiya in northwestern Iran.

50. See Jeremy Johns, "The 'House of the Prophet' and the Concept of the Mosque," in *Bayt al-Maqdis, Part Two: Jerusalem and Early Islam*, ed. Jeremy Johns, Oxford Studies in Islamic Art 9, 2 (Oxford: Oxford University Press, 1999), 73.

51. Koch, "Mughal Audience Hall," 337.

52. Milo C. Beach and Ebba Koch, with new translations by Wheeler Thackston, *King of the World: The Pādshāhnāma; An Imperial Mughal Manuscript from the Royal Library, Windsor Castle* (London: Azimuth Editions, and Washington, D.C.: Smithsonian Institution, 1997).

53. Ibid., cat. no. 14, pp. 46–47 (color illus.), 172–73.

54. Ibid., cat. no. 17, pp. 52–53 (color illus.), 176–77.

55. For the tents of Shah Jahan, see Peter A. Andrews, *Felt Tents and Pavilions, The Nomadic Tradition and Its Interaction with Princely Tentage*, 2 vols. (London: Melisende, 1999), 1:1131–210; the tents of this painting are discussed on pp. 1174–76.

56. Beach and Koch, *King of the World*, cat. no. 32, pp. 82–83 (color illus.), 190–91.

57. Ibid., cat. no. 43, pp. 104–5 (color illus.), 206–7.

58. The artist clearly introduced these features to further denote the hall as the one in the Lahore palace. Birds and angels are also elements in a program of mural decoration in the Lahore palace dating from the time of Shah Jahan's father, Jahangir. Birds and angels—derived from a European putti type transmitted to the Mughal court by the Jesuits—are featured prominently in the vault of the so-called Kala Burj, where they appear in an extravagant Europeanizing interpretation of traditional Islamic iconography, that of the flying retinue surrounding the prophet-king Solomon on his airborne throne. See Koch, *Mughal Art and Imperial Ideology*, 12–37. With this imagery, based on the Islamic legends woven around the Koranic prophet-king, Jahangir is here celebrated as a second Solomon.

59. Beach and Koch, *King of the World*, cat. no. 38, illus. on p. 95.

60. On this point, see the introduction by Milo Beach in Beach and Koch, *King of the World*, 15–19.

61. Stuart C. Welch, in *The St. Petersburg Muraqqa': Album of Indian and Persian Miniatures of the 16th–18th Centuries and Specimens of Persian Calligraphy of 'Imād al-Ḥasanī*, ed. Oleg. F. Akimushkin (Milan: Leonardo Arte, 1996), 92–93, pl. 125/fol. 34. Welch does not comment on the architecture depicted on the hall; he ascribes the painting to Murad (= Murar), one of the artists of the Windsor illustrations, and points out his accuracy in the representation of architectural features.

62. Wayne E. Begley, "Illustrated Histories of Shah Jahan: New Identifications of Some Dispersed Paintings and the Problem of the Windsor Castle *Padshahnama*," in *Facets of Indian Art: A Symposium Held at the Victoria and Albert Museum on 26, 27, 28 April and 1 May 1982*, ed. Robert Skelton, Andrew Topsfield, Susan Stronge, Rosemary Crill, and Graham Parlett (London: The Victoria and Albert Museum 1986), 151, suggested that the *darbār* represented the second enthronement of Shah Jahan on August 16, 1628. Ellen Smart suggested it was held on March 16, 1630: see Welch, *St. Petersburg Muraqqa'*, 92.

63. For the development of the Shah Jahani group portrait, see Ebba Koch, "The Hierarchical Principles of Shah-Jahani Painting," in Beach and Koch, *King of the World*," 133–37, repr. in Koch, *Mughal Art and Imperial Ideology*, 133–44.

64. See Milo Beach, *St. Petersburg Muraqqa'*, entries for pls. 180 and 181, p. 107; Beach, in Beach and Koch, *King of the World*, 218–19. For a color illustration, see Stuart Cary Welch, *Imperial Mughal Painting* (London: Chatto and Windus, 1978), 31–32.

65. Term of Sussan Babaie, *Isfahan and Its Palaces: Statecraft, Shi'ism and the Architecture of Conviviality in Early Modern Iran* (Edinburgh: Edinburgh Studies in Islamic Art, 2008).

66. Andrews, *Felt Tents and Pavilions*, 1:1094–95, 1126–27, established the term *namgīra* for this type of white horizontal canopy on four poles.

67. Andrew Topsfield, *Paintings from Mughal India* (Oxford: Bodleian Library, 2008), 74–75 (color illus.).

68. B. N. Goswamy and Caron Smith, *Domains of Wonder: Selected Masterworks of Indian Painting*, exh. cat. (San Diego: San Diego Museum of Art, 2006), 142–43, color illus. on pl. 55. The authors of the catalogue note the hall, but they are not aware that it represents the wooden audience hall of Shah Jahan.

69. For yurts in Mughal palace settings, see Andrews, *Felt Tents and Pavilions*, 2:1119–21, 1147–49, figs. 206 and 207, color pls. XI and XII; for his discussion of the tents and the architecture of the San Diego painting, see pp. 1172–74.

70. Andrews went to the extreme in calculating measurements of buildings and tents from their representations in Mughal painting: see, e. g., his discussion of Shah Jahani tents in ibid., 1156–210.

71. I have mentioned this in my discussion of the representation of architecture in the Windsor *Pādshāhnāma*: see Beach and Koch, *King of the World*, 191.

72. Measurements scaled from the plan of Mario Ferrante, "Čihil Sutūn: Études, relevés, restauration," in *Travaux de restauration de monuments historiques en Iran*, ed. Giuseppe Zander (Rome: IsMEO, 1968), 299, fig. 1; for the height of the columns, see p. 294.

73. Ahmad Nabi Khan, *Uchchh: History and Architecture* (Islamabad: National Institute of Historical and Cultural Research, 1980), 54–55, pl. IV (a and b), showing the columned hall of the tomb of Jalal al-Din Bukhari. A plan of the columned halls of the tomb and its mosque can be found in Kamil Khan Mumtaz, *Architecture in Pakistan* (Singapore: Concept Media, 1985), fig. 3.13. The hall of the tomb of Rajan Qattal is illustrated in Kamran Mufti, "Concept of Tomb Architecture at Uchch," in *Sultanate Period Architecture: Proceedings of the Seminar on the Sultanate Period Architecture in Pakistan, Held in Lahore, November 1990*, ed. Siddiq-a-Akbar, Abdul Rehman, and Muhammad Ali Tirmizi (Lahore: Anjuman Mimaran, 1991), fig. 15. The author assumes that the design of the columns with high impost blocks is influenced by Seljuk architecture. For a

discussion of the monuments, see also C. E. Bosworth, *EI2*, s.v. "Učč h: 1. History"; and Yolande Crow, *EI2*, s.v. "Učč: 2. Monuments."

74. Johannes Kalter, *The Arts and Crafts of the Swat Valley: Living Traditions in the Hindu Kush* (London: Thames and Hudson, 1991), fig. 72; see also fig. 3. For related columns in other buildings of the Swat Valley, see his figs. 55, 116, 154, and 167. See also Max Klimburg, "The Wooden Mosques in the Northern Areas of Pakistan," in *Austrian Scholarship in Pakistan* (n. 3 above), 148–74.

75. Ahmad Hasan Dani, *Islamic Architecture: The Wooden Style of Northern Pakistan* (Islamabad: National Hijra Council, 1410 [1989]), 84.

76. Marcus Schadl, "The Shrine of Nasir Khusraw: Imprisoned Deep in the Valley of Yumgan," *Muqarnas* 26 (2009): 63–94. Schadl interprets the impost block with the rectangular section and the capital as one capital unit because the regional forms do not always show a clear distinction between capital and block: personal communication in an e-mail dated August 25, 2010. I thank him for providing me with the photograph seen in my fig. 26.

77. The wooden architecture of Uchchh and the Hindu Kush also shows other regional forms adapted by Mughal imperial architecture, namely, the Central Asian baluster columns in its Mughal transformation combined with multicusped arches. Thus, we cannot exclude the possibility that the columns with high impost blocks were also inspired by the imperial halls, but it is still clearly a form deeply rooted in vernacular architecture, widely used in simple, less well-defined forms. See Kalter, *Arts and Crafts of the Swat Valley*, figs. 55, 116, 154, and 167.

78. The reconstruction was worked out through computer-assisted design (CAD) by Ulderico Micara in New York in 1996 and was then redrawn by hand by Richard Barraud in New Delhi. We worked out the new version showing the whole hall in color in June 2013.

79. This is also borne out by his topographical view of the fortress of Dawlatabad discussed below.

80. Koch, *Mughal Architecture*, 93, 106, 115, and 132.

81. See, inter alia, Thomas Leisten, "Islamic Architecture in Uzbekistan," in *Uzbekistan: Heirs to the Silk Road*, ed. Johannes Kalter and Margareta Pavaloi (London: Thames and Hudson, 1997), 80–81, fig. 148.

82. Ebba Koch, "The Baluster Column: A European Motif in Mughal Architecture and Its Meaning," *Journal of the Warburg and Courtauld Institutes* 45 (1982): 251–62; repr. in Koch, *Mughal Art and Imperial Ideology*, 38–60; repr. in *Architecture in Medieval India: Forms, Contexts, Histories*, ed. Monica Juneja (Delhi: Permanent Black, 2001), 328–61.

83. The mosque was destroyed by fires and rebuilt several times; the plan seems to follow the original design but not the form of the columns: see Pratapaditya Pal, *The Arts of Kashmir* (New York: Asia Society, 2007), 132–35, figs. 141 and 142. Based on the drawings and information kindly provided by Sameer Hamdani, an architect at the Indian National Trust for Art and Culture (INTACH), Jammu &

Kashmir Chapter, with whom I have had a fruitful exchange about the architecture of the valley, I would say that most of the columns of the preserved wooden architecture of Kashmir are inspired by the baluster column of Shah Jahan. They have a thin, elongated form with leaf decoration typical of the eighteenth and nineteenth centuries; some are also topped by a thin, elongated impost element, different from the heavier impost block of the type used in Shah Jahan's wooden audience hall. See INTACH, Jammu & Kashmir Chapter, Drawing NO CW/SH-01: "Types of Columns."

84. For the wooden mosques of northwestern Iran, see Parvīz Varajāvand, "Chihil Sutūn-i Masjid-i Mullā Rustam, Marāgheh," *Barassīhā-yi Tārīkhī* 61, 6 (1340 [1961–62]): 1–22; and "Chihil Sutūnhā-yi pur-shukūh-i Bunāb," *Hunar va Mardum* 162 (Farvardin 2535 [1975]): 5–9. He calls them *chihil sutūn*. Markus Ritter, *Moscheen und Madrasabauten in Iran 1785–1848: Architektur zwischen Rückgriff und Neuerung* (Leiden: Brill, 2006), discusses hypostyle mosques in chapter 6 and pre-Qajar mosques, including wooden ones, in the introduction. I thank Markus Ritter for providing me with the photograph for fig. 28.

85. Kenneth Hayes, "The Wooden Hypostyle Mosques of Anatolia: Mosque- and State-Building under Mongol Suzerainty" (PhD diss., Middle East Technical University, Ankara, 2010), chap. 5.

86. A variant of this type of column appears in stone in the later, permanent versions of the audience hall of Shah Jahan.

87. See below.

88. *Khas* is a kind of scented grass (*Andropogon muricatus*) used in India to make mats that are put in the doors or windows of buildings and sprinkled with water to keep out the heat. For the text, see Ẓahīru'd-Dīn Muḥammad Bābur, *Bābur-Nāma (Memoirs of Bābur)*, trans. Annette Susannah Beveridge (London: Luzac and Co., 1921; repr. New Delhi: Oriental Books Reprint, 1970), 610 and 631; *Bāburnāma: Chaghatay Turkish Text with Abdul-Rahim Khankhanan's Persian Translation*, ed. and trans. Wheeler M. Thackston, 3 vols. (Cambridge, Mass.: Department of Near Eastern Languages and Civilizations, Harvard University, 1993), 3:727, 747; *The Baburnama: Memoirs of Babur, Prince and Emperor*, trans., ed., and annot. Wheeler M. Thackston (Washington, D.C.: Freer Gallery of Art and Arthur M. Sackler Gallery, Smithsonian Institution, 1996), 406, 416.

89. Zayn al-Dīn Wafāʾī Khwāfī, *Zain Khan's Tabaqat-i Baburi*, trans. Sayed Hasan Askari, annot. B. P. Ambastha (Delhi: Idarah-i Adabiyāt-i Delli, 1982), 157.

90. Lāhawrī, *Pādshāhnāma*, vol. 1, pt. 2, pp. 26–27. See Qazvīnī, *Pādshāhnāma*, fol. 315b.

91. Anthony Welch and Howard Crane, "The Tughluqs: Master Builders of the Delhi Sultanate," *Muqarnas* 1 (1983): 148–49. Their references guided me to the sources cited in the following two notes.

92. Ibn Baṭṭūṭa, *The Travels of Ibn Baṭṭūṭa, A.D. 1325–1354*, ed. C. Défrémery and B. R. Sanguinetti, trans. and rev. H. A. R. Gibb, 5 vols., Hakluyt Society, 2nd ser., 110, 117, 141, 178,

and 190 (New Delhi: Munshiram Manoharlal, 1993), 3:658–60.

93. Henry Miers Elliot and John Dowson, *The History of India, as Told by Its Own Historians. The Muhammadan Period*, 8 vols. (London, 1867–77; repr. Lahore: Islamic Book Service, 1976), 3:570–72.

94. Ibid., 3:445, 503.

95. Abu'l Fazl ʿAllāmī, *Āʾīn-i Akbarī*, ed. H. Blochmann, 2 vols. (Calcutta: Asiatic Society of Bengal, 1872–77), 1:513; Abu'l Fazl ʿAllāmī, *Āʾīn-i Akbarī*, trans. H. Blochmann and H. S. Jarrett, ed. D. C. Phillott, ed. and annot. Jadunath Sarkar, 3 vols. (Calcutta: Asiatic Society of Bengal, 1948–49; repr. New Delhi: Oriental Books Reprint, 1977–78), 2:284.

96. Babaie (*Isfahan and Its Palaces*, esp. 157–82) provides an extended discussion of the *talār* buildings of Isfahan, the roots of which she sees in the vernacular architecture of Mazandaran, an area in which, as she says, wood, open porches, and thatched roofs predominated. Shah ʿAbbas began to build palaces here at Farahabad and Ashraf in 1611–12; these included *talār*s, but nothing specific is mentioned about their form.

97. Ibid., 164–65.

98. See the literature cited in n. 3 above. Babaie (*Isfahan and Its Palaces*, 179–82, 188, 252–57, passim) is aware that Shah Jahan's wooden halls predate the Safavid *talār* buildings, but she postulates an independent development at Isfahan that had its origin in the wooden architecture of Mazandaran.

99. Ebba Koch, "The Symbolic Possession of the World: European Cartography in Mughal Allegory and History Painting," in *Cultural Dialogue in South Asia and Beyond: Narratives, Images and Community (Sixteenth–Nineteenth Centuries)*, ed. Corinne Lefèvre and Ines G. Županov, special issue, *Journal of the Economic and Social History of the Orient* 55 (2012): 572–74, fig. 13.

100. For the orientation of Mughal art and culture towards Iran, see Ebba Koch, "How the Mughal Pādshāhs Referenced Iran in Their Visual Construction of Universal Rule," in *Universal Empire: A Comparative Approach to Imperial Culture and Representation in Eurasian History*, ed. Peter Fibiger Bang and Dariusz Kołodziejczyk (Cambridge: Cambridge University Press, 2012), 194–209. In the seventeenth century, the picture began to change, and even more so later, as the Safavids and the Qajars began to look to Mughal India. Not much work has been done on this issue because traditionally Iran is regarded as the source of inspiration of the Persian-speaking world and of societies shaped by Persian culture. The reversal of influence has been best researched for painting. While the dominant figures of Mughal painting were in the foundation-period painters that Humayun had brought from the court of Shah Tahmasp, Safavid painting of the seventeenth century shows clear inspiration from India—for instance, in the work of the painters Ali Quli Jabbadar, and Muhammad (Paolo?) Zaman. On the latter point, see, e. g., Eleanor G. Sims, "Five Seventeenth-century Persian Oil Paintings," in *Persian and Mughal Art*, ed. B.W. Robinson (London: Colnaghi & Co. Ltd, 1976), 221–48, esp. pp. 228–30; and Abolala Soudavar, *Art of the Persian Courts: Selections from the Art and History Trust Collection* (New York: Rizzoli, 1992), 365–79.